WITHDRAWN

Bouguereau to Matisse
French Art at the Hermitage
1860–1950

Albert Kostenevich

Booth-Clibborn Editions

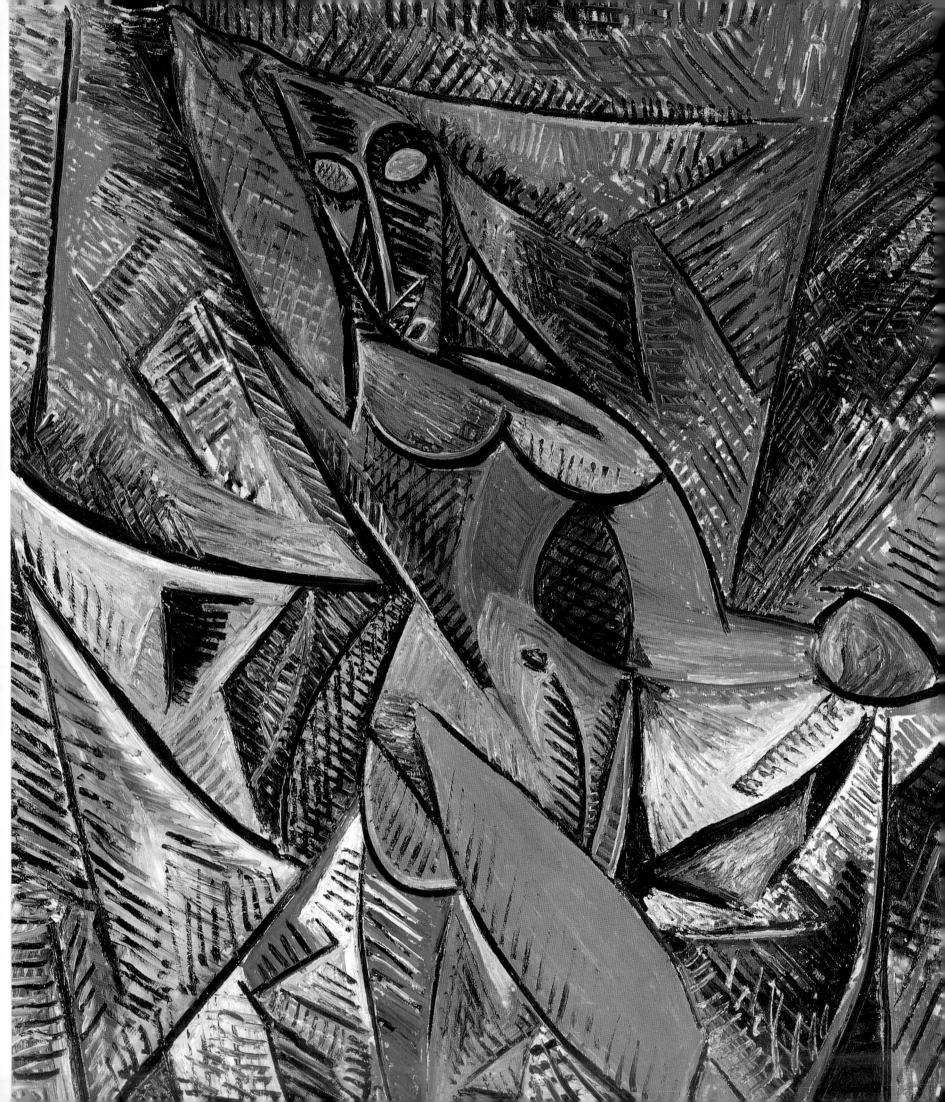

Introduction:
The French at the Hermitage

The Hermitage Museum is home to a magnificent collection of French art. Numerous masterpieces by the world's greatest artists stand alongside lesser-known works; here, too, are the works of artists who have yet to regain their former popularity. This book by Albert Kostenevich, curator of the museum's collection of nineteenth- and twentieth-century French art, brings together for the first time not only the works of the finest French painters, graphic artists and sculptors of the time, but also pieces by many artists who have remained in the shade over the last few decades. The result is more dazzling than any of its predecessors, for it illustrates the tastes not just of today's auction-houses, but also of French and Russian collectors of a former age. I am equally certain that it will also help define the interests of future generations.

The analysis provided in the book is both profound and inspired; it will be of interest to specialists and amateurs alike. It explores the fascinating history of French art through periods of conflict and reconciliation; and it follows the struggle and concessions made by the art world to the demands of the *bourgeoisie* – what we now call the 'middle classes'.

The extraordinary collection at the Hermitage, illustrated and analysed in this book, provides a comprehensive guide to nineteenth- and twentieth-century French art in its entirety. The combination of seminal work with little-known or previously unpublished material enhances the interest for the reader, to whom this entire stratum of cultural richness is revealed through scholarly research and specialist knowledge. This new book is to some extent the culmination of the work of those who have gone before, but it owes a great deal to the years of intense spiritual labour on the part of the author, his teachers and colleagues. All of them have played their part in sharing the Hermitage's riches with art-lovers throughout the world, through permanent displays and numerous exhibitions.

The reader will discover not only many supreme masterpieces of European painting, but also an insight into the creative and human qualities of the people who created them, as well as elucidating ideas and information about the artistic process itself. Here are Claude Monet's *Corner of the Garden at Montgeron*, Renoir's *Portrait of Jeanne Samary*, Van Gogh's *Memory of the Garden at Etten*, Gauguin's *Woman Holding a Fruit*, Cézanne's *Large Pine near Aix*, Matisse's *Dance, Music, Red Room* and *Arab Café*, Picasso's *Dance with Veils* and *Three Women*, Derain's *Portrait of an Unknown Man Reading a Newspaper*, Van

Dongen's *Red Dancer* and Bonnard's *On the Mediterranean*. All of these works are milestones on the path of twentieth-century art, of which, as the century draws to a close, we can be genuinely proud.

The story of the collectors who first brought these works to Russia is a dramatic one – a story of struggle and revolution. The whole range of Russian collectors stands before us, from high-born aristocrats to enterprising merchants, people who strove to uncover genius before any of their contemporaries. It is a bloody tale, but is told here for the first time without any of the traditional distortions and bias.

Pride of place, of course, belongs to Sergei Shchukin and Ivan Morozov, two titans of the art world, without whom Russia could not have played such a crucial role in the history of twentieth-century art. The story of how their collections were torn from their hands is at once gripping, tragic and instructive. For while nationalisation was larceny on a grand scale, it was only through nationalisation that these works were kept in Russia, where they have contributed to the education and enlightenment of subsequent generations of Russian artists, and to the preservation of genuine world-wide artistic taste during political and cultural isolation. For in a time of revolution, there is no such thing as absolute good or absolute evil; history alone can deliver its judgement.

Although it can be argued that chance brought these works together in the Hermitage, the collection of French art can also be seen as the culmination of a great Russian tradition. Catherine the Great did not buy only Old Masters, but also works by her contemporaries such as Greuze, Wright of Derby, and Reynolds, whom she commissioned. Nicholas I bought pictures by Caspar David Friedrich, who was still alive during his reign. Similarly, Count Kushelev-Bezborodko and Chancellor Gorchakov collected 'new' art. In this context the innovations of Shchukin and Morozov can be seen as a logical extension of Russian attitudes to Western art. And it is this tradition of openness to the outside world that the Hermitage is now so proud to continue.

Mikhail Piotrovsky
Director of the State Hermitage
Professor of St Petersburg State University
Doctor of Historical Sciences
Member of the Russian Academy of Sciences and
the Russian Academy of Arts

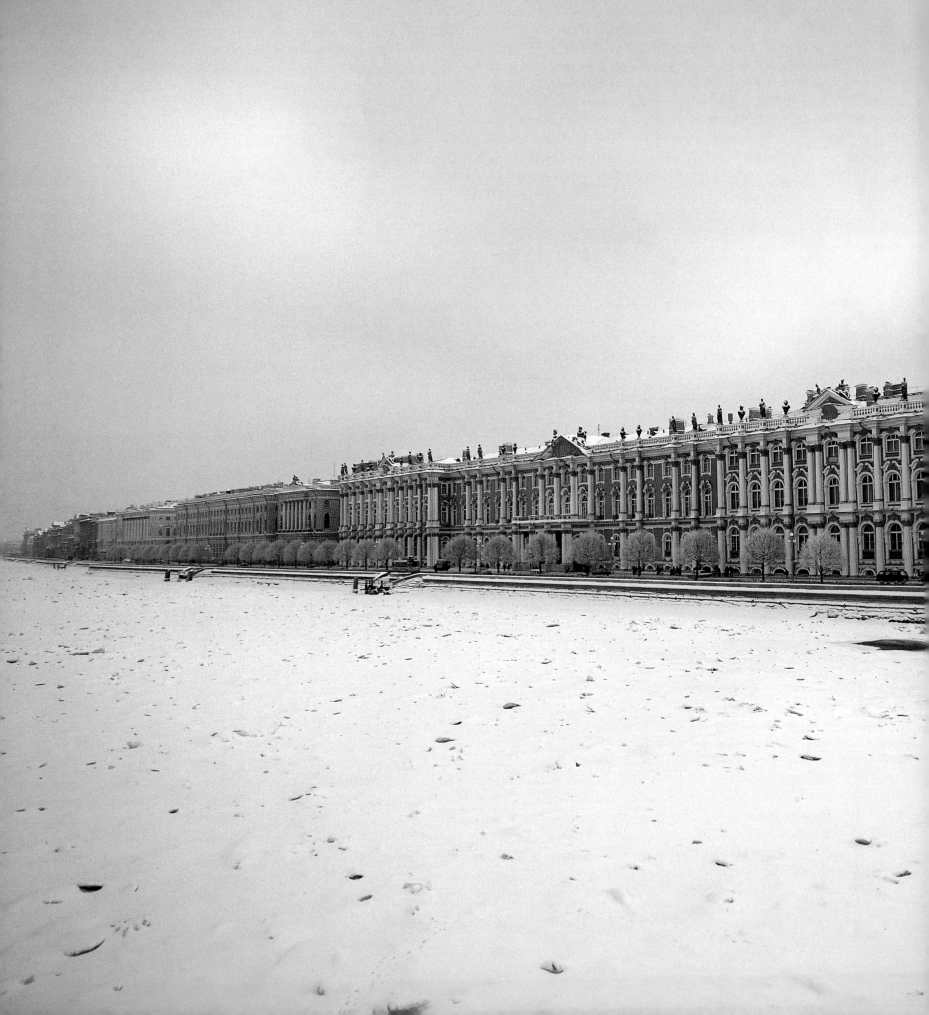

View of the Hermitage Museum from the Neva, with the Winter Palace (Rastrelli, 1753–62), the former residence of the Tsars, in the foreground, and the adjoining Small Hermitage building (Vallin de la Mothe, 1765–6), where the museum originated, and Large or Old Hermitage (Velten, 1770–84).

9

The Story of the Collection

France, from 1860 to 1950 – the place and period that witnessed some of the most significant developments in the history of art. And it is the collection of New French Art in the Hermitage which best testifies to the tremendous creative innovations which took place during those years. The most remarkable part of the collection is that dedicated to artists working at the most crucial time of all – around the turn of the century. We might be prompted to ask what the true impact of four decades of artistic development in a single European country can be, when compared to the thousands of years of cultural activity exhibited in Russia's greatest museum.

The history of art rarely divides up into periods of equal significance, for uniformity is altogether alien to the creative process. So it is that in some insignificant town or region, at a given moment in history, a group of artists come together whose work leaves an ineradicable mark on the development of society's consciousness for centuries afterwards. Within the context of civilisation's development, creative processes have volcanic characteristics: protracted periods of inactivity suddenly give way to furious creative eruptions, and these are the moments at which the most important works are created. Attempts to understand such outbursts through an analysis of political, economic, social or even religious influences on a group of artists shed little light on the secrets of artistic creation. How can we explain the fact that in German art nothing before or since has come close to the spiritual depth or artistic mastery of the brief period of Dürer, Holbein and Cranach? Did the Germans become less discerning? Similarly with the Old Dutch Masters: what is there to compare with the art of Jan van Eyck, Robert Campin or Rogier van der Weyden, whose works also span a short period in

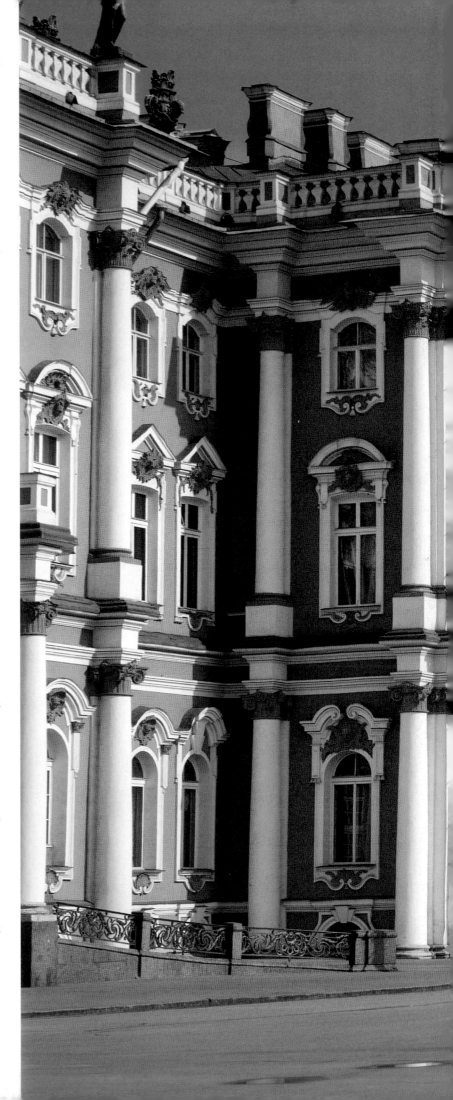

history? The New Era in France during the Second Republic saw an artistic efflorescence which could be compared to the Early Renaissance in the Netherlands or the High Renaissance in Italy.

If visitors to the Hermitage direct their steps with such regularity to the French Art of the late nineteenth and early twentieth centuries on the second floor of the Winter Palace, it can only be because this art has special significance for them. They are drawn there not only by the wonderful landscapes, still lifes and portraits, or by the expressiveness and effectiveness of the techniques developed at that time. It is more than that: they can feel just how much the development of culture in our own times, from Los Angeles to Madrid, from Munich to Tokyo, is determined by what went on in Paris one hundred years ago.

What is the great attraction of the Hermitage? The answers, of course, will vary widely, but it does not take an expert in sociology to know that the taste of the public – both Russian, and, in particular, foreign – currently leans towards two periods of European Art: the Old Masters and the French Impressionists. It is the same with every great museum that does not restrict itself to a national school or one particular period, but strives to reflect all aspects of world culture.[1] Of course, in a museum such as the Hermitage the art of the Old Masters and the Impressionists cannot be compared in numerical terms; the Impressionist collection is far smaller, and yet such is the interest provoked by these more recent paintings, that at times one forgets the disparity in quantity between them. Furthermore, when visitors talk about 'going to see the Impressionists', they do not just have in mind Monet, Renoir, Degas and their direct descendants, but also the 'dissidents' of Impressionism, as well as the avant-garde artists of the early twentieth century, led by Matisse and Picasso, who were directly opposed to the principles of the Impressionist movement.

The peerless reputation of the French collection at the Hermitage has long been beyond doubt. But how did this collection – with all its merits and its weaknesses – come about? The answer requires a small excursion into history. By the end of the eighteenth century the Hermitage was already one of Europe's finest museums. Catherine the Great had acquired not only a wide variety of classical works, but also paintings by contemporary French artists – and often the best available. Thus her museum defined the trends in collecting a century before the activity became popular. Her remarkable ability to avoid a wide disparity in quality between the old and the new set high standards for the collection that have been impossible to ignore ever since. These standards set by Catherine, incidentally, go some way towards explaining the subsequent slower rate of acquisition, even of Old Master paintings.

As for the so-called 'new art', other more important factors came into play. The early nineteenth century coincided with a period of aesthetic alienation. The new era, even as it proclaimed the importance of classical standards, developed its own sense of the beautiful in art, moving ever further from the aesthetic of the Old Masters. Contemporary painting could no longer be expected to be compared with Renaissance or Baroque masterpieces as easily as it had only a short time before.

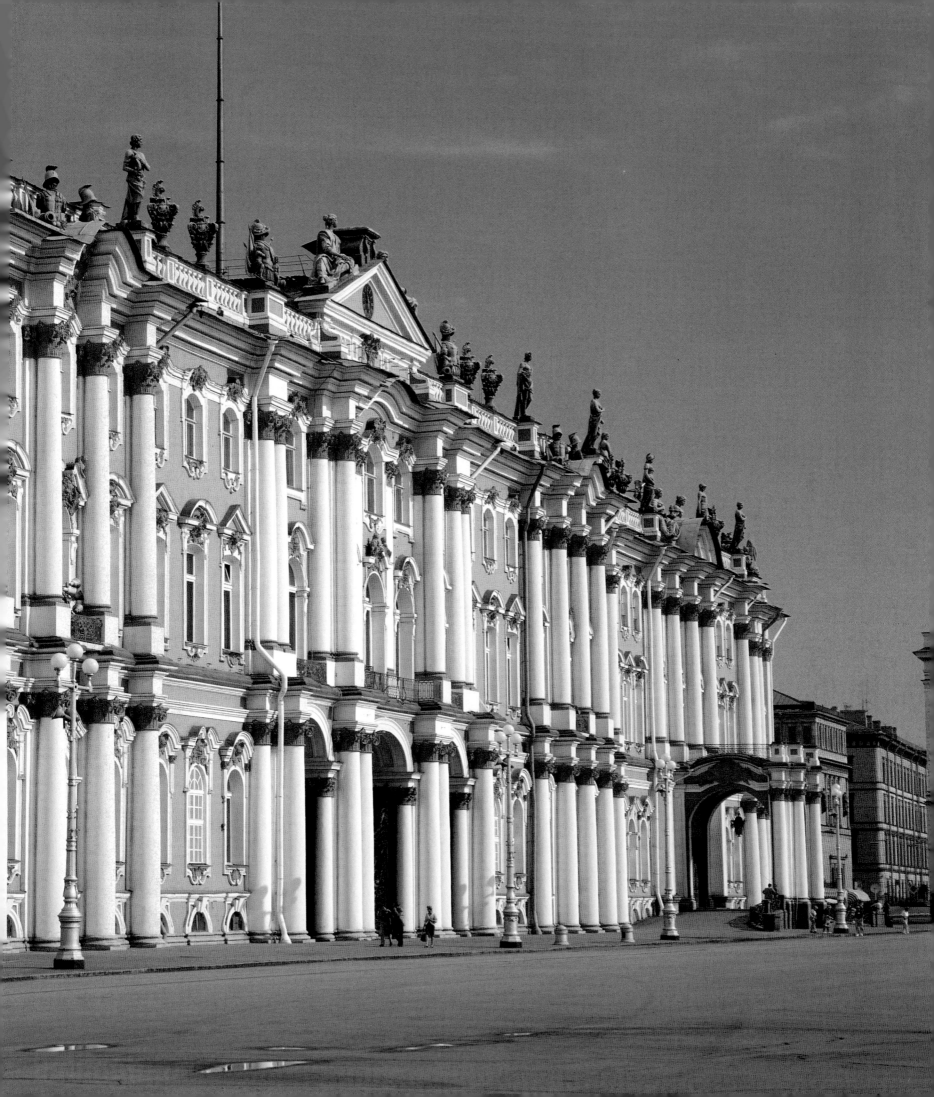

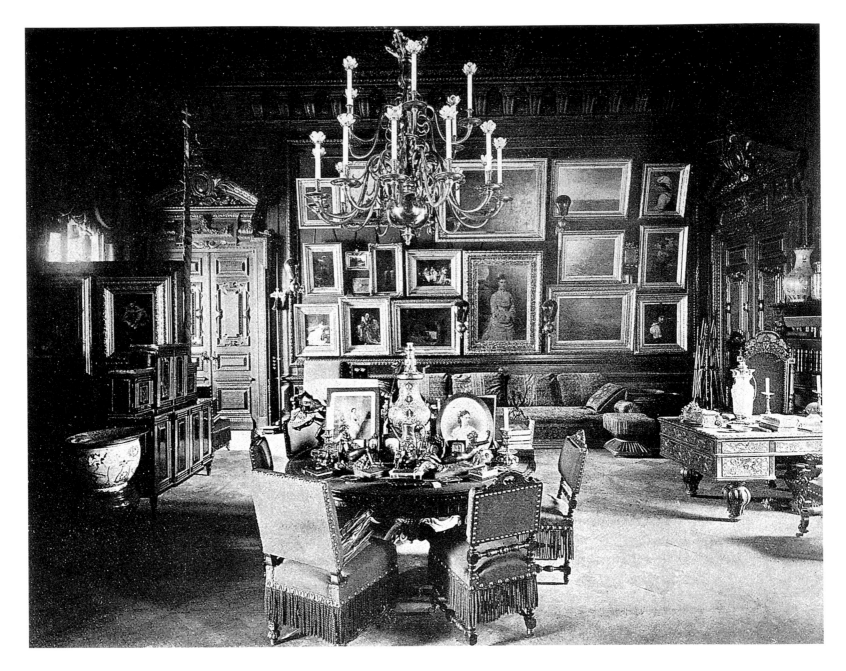

It is only with time that inconsistencies in collecting become apparent, and since artists are frequently underrated by their contemporaries, it is not so very surprising that those in charge of acquisitions for an imperial museum should be wary of the new. In general, the Hermitage collections were increased in size through acquisitions of Old Master paintings and classical antiquities. The works by Russian artists, which were exhibited in the picture gallery of the New Hermitage in the middle of the nineteenth century (and which subsequently, towards the end of the century, moved to the newly established Russian Museum of Emperor Alexander III) serve only to underline the absence of Western-European works of this period. In 1904, A. I. Somov, head of the picture gallery at the Hermitage, wrote in the *Brockhaus and Efron Encyclopaedia*, the most popular Russian directory of the time, that the

pictures displayed in his museum included 'examples of paintings from all the main schools (Italian, Spanish, German, Flemish, Dutch, French and English), dating to no later than the beginning of the nineteenth century'.[2] How strange this 'no later' sounds – an open admission of a whole century of painting not represented in the collection.

The creation of an art collection dedicated to the 'century of steam and electricity', which was to continue the traditions in terms of quality established by Catherine the Great and her advisors, only came about many years later, under Soviet rule. Its establishment had as much to do with the enthusiasm of those dedicated to an incomparable museum of world culture[3] as it did to a whole host of chance occurrences and dramatic upheavals that took place in the country.

Alexander III, in this monument by Paolo Trubetskoy, looks not so much the image of a man of high culture as the embodiment of brute force and absolute power. Trubetskoy worked on the statue from 1899 to 1906. When it was erected in 1909 on Znamenskaya Square, one of the most populous places in St Petersburg, it was long regarded not as an outstanding work of art, but as a symbol of Tsarism. In 1937, on the twentieth anniversary of the Bolshevik revolution, the monument was taken down, officially 'for reconstruction work to the square'. Miraculously it survived and now stands in the courtyard of the Marble Palace.

Petrograd's Collections: The End of Empire

Immediately after the 1917 revolution the Art and Historical Commission of the Winter Palace was founded, responsible not only for the former Tsar's palace, but for all buildings of artistic or cultural significance in Petrograd. Four years later the Commission became the State Museum Fund, and it was through this organisation that the Hermitage began to acquire individual works of art and entire collections left behind by owners who had fled the city, which by this time was becoming increasingly dangerous for people with property.

At the time of the fall of the Russian Empire, the capital contained a considerable number of paintings by nineteenth-century European artists – in the royal and Grand-Ducal palaces, in aristocratic residences and simply in wealthy households. Many of them found their way into the museums. The Soviet authorities quickly expropriated any items of artistic value, whether they belonged to the Tsar, the Church or the propertied classes. Nationalisation, often a euphemism for robbery, cannot be excused even when it has a solid ideological foundation. However, in examining the historical circumstances surrounding the confiscations of 1918 to 1920 there is a danger of ignoring the political context of the time. The onset of civil war was accompanied by a pervasive brutality, largely instigated by the powers themselves, which they tried not so much to prevent as to use for their own benefit. Under such circumstances confiscation by the State often ensured the preservation of artistic treasures; where nationalisation did not take place a number of pictures disappeared,[4] usually without trace and apparently forever. It is difficult to say what would have become of the private galleries of the Yusupovs or the Stroganovs in Petrograd, and those of Shchukin and Morozov in Moscow, if the State had not taken them under their protection. Pictures from various residences, including those of the Leuchtenbergs, Vorontsov-Dashkovs, Gorchakovs and Ferzens, entered the Hermitage or the Russian Museum, while the residences themselves were taken over for various purposes by the Soviets. The palaces of the Yusupov, Stroganov, Sheremetiev and Shuvalov families were nationalised soon after the October Revolution and became museums.[5]

Nationalisation was mostly aimed at the palaces of the royal family and the Grand Dukes, although it is true that only a few of the pictures from the private apartments of the imperial family were of a high enough quality for the Hermitage.[6] The last Russian Emperor was not blessed with a great understanding of art, or at least of Western art. Of the French pictures that decorated his private rooms, only Jules Lefebvre's *Mary Magdalene in the Cave* and Flameng's Napoleonic series, presented by Nicholas II to his wife Alexandra Feodorovna, are worthy of mention.

More interesting by far were the works collected by Nicholas II's father, Alexander III (1845–94), which were principally kept at the Anichkov Palace, the emperor's favourite residence. While still heir to the throne, Alexander acquired the Russian picture gallery of V. A. Kokorev with the intention of turning it into a museum.[7] 'He has filled two rooms in the Anichkov Palace with various pieces of art... a seventeenth-century chandelier hangs from the ceiling. Beneath it stands a long table, littered with rarities: here a Venetian glass candelabra, there a whole model of a fortress on a cliff made of walrus ivory, and a wonderful old Japanese cauldron. The walls all around are hung from top to bottom with ancient treasures: Italian maiolica with its wonderful milky tones, Old Master drawings in antique carved frames... The second room is in the style of the Renaissance. The friezes that run around the Renaissance-style arches do not contain armatures, pikes, sabres, guns or drums, but palettes laden with brushes. Here the tables are piled high with valuable trinkets, albums and small busts of biscuit and bone. The walls are covered with pictures, including those we have come to know and love from exhibitions – the works of Roybet, Jacque, Shishkin, Bogolyubov, Ge, Huns and Lagoriot. Several paintings are propped up on chairs and easels; at every turn you expect to find lying on a stool a palette and brush or an album with an unfinished sketch... The sovereign called these two halls dedicated to works of art 'My Museum'; but his study is no less of an art museum. The walls are hung from ceiling to floor with what are evidently his favourite pictures and portraits, while the fireplace, the walls, the cupboards and floors are strewn with a mass of delicate bronzes, terracottas, Japanese and Chinese cloisonné work and so forth.'[8]

Alexander III's great love of art and the educated seriousness of his approach undoubtedly mark him out from the other nineteenth-century Russian rulers. He regularly visited major exhibitions and, what is more remarkable, showed a distinct preference for the Wanderers (*peredvizhniki*) over the Academicians, personally insisting on the reform of the Academy of Arts. 'When he expressed a desire to buy this or that work, he was often told that it had already been sold to a private individual – more often than not, of course, to P. M. Tretyakov who was working zealously on the foundation of his famous gallery. The sovereign would protest graciously: "Ah well, it seems that whatever I ask for has been sold already; gentlemen, how I would like to be your first buyer!" After a while the sovereign began to go to the exhibitions of the Wanderers before their official opening. The artists themselves would then generally employ the following phrase as a condition for all other potential buyers: "unless purchased by the sovereign emperor".'[9]

'The sovereign was a great admirer of the works of the western Realist schools, and his tastes inclined above all towards French artists. The development of his interest in artists of the Russian Realist school, who were considered advanced at the time, was undoubtedly assisted in large part by his trusted advisor A. P. Bogolyubov. While heir to the throne the sovereign visited the studios of Russian artists in Paris, which by this time – as the centre of the Realist movement – had replaced Rome as their base.'[10]

Although canvases by Russian artists predominated in Alexander III's private collection – particularly in the Anichkov Palace, though less so at Gatchina – the Western European section was also extremely notable. He admired Clodion and the French artists of the eighteenth and early nineteenth centuries, possessing, in particular, fine landscapes by Hubert Robert, Couture's *Study of a Woman's Head*, Gérôme's *Pool in a Harem*, Huguet's *Arab Encampment*, Roybet's *Odalisque* and Meissonier's *Musketeer*, as well as *After the Meeting* by Laurens, *Young Watercolourist in the Louvre* by Dagnan-Bouveret, Ziem's *Harbour in Constantinople*, pictures by the Belgians Gallait and Willems, the Danish Melbye, the German Knaus, and sculptures by Carrier-Belleuse and D'Epinay: all artists of high official repute. But it is worth noting that the Anichkov Palace also contained works by the Realists: *Peasant Woman Nursing an Infant* by Dalou, and pictures by the members of the Barbizon School – Théodore Rousseau, Daubigny, Troyon and Jacque. The paintings from the Anichkov Palace that entered the Hermitage in 1918 and 1919, which can be seen as the foundation stones of the future collection, were still not what really mattered. An important moment came in 1922 when the entire contents of the Kushelev Gallery were transferred to the Hermitage from the Academy of Arts: this was to become the real core of the museum's collection of nineteenth-century European art.

The founder of the Kushelev Gallery was Nikolai Alexandrovich Kushelev-Bezborodko (1834–62), who, when still a very young man, inherited an enormous fortune as well as part of a group of Old Master paintings from A. A. Bezborodko, one-time chancellor of Catherine the Great. Kushelev set himself the aim of adding contemporary art to the collection. Fated to live for all too short a time, he nevertheless managed in the space of five years to establish a genuine museum. Wherever possible he tried to reflect the whole spectrum of creative life. This he did by travelling throughout Western Europe, buying pictures by the Germans Achenbach and Knaus, the Dutchmen Weissenbruch and Ten Kate, and the Belgians Gallait and Leis, though he always retained a distinct preference for French artists. Relying purely on his personal tastes and knowledge, Kushelev-Bezborodko brought back to Russia not only pictures by such fashionable artists as Gérôme, Bouguereau and Meissonier, but also the works of Delacroix, Decamps, Courbet, Millet, Théodore Rousseau, Dupré, Daubigny, Diaz de la Peña and Corot. This was at a time when the work of these artists had yet to meet with universal approval even in their own homeland, and was often crudely attacked.

The young collector's residence soon became a meeting-place for all kinds of artistic people. 'He loved to surround himself with artists, writers and academics,' wrote B. K. Veselovsky, the compiler of the Kushelev Gallery's catalogue. 'To this day, many people remember those lively gatherings, where the Count was the life and soul, surrounding himself with all that was finest in St Petersburg's literary and artistic circles.'[11] On his death Kushelev-Bezborodko left his gallery to the Academy of Arts 'to be open at all times to artists and the public, without any constraints on dress'.[12] These last are the words of a truly enlightened educator – a bold challenge to the social restrictions in place at that time, both in the Hermitage and at temporary exhibitions. Kushelev-Bezborodko was certainly possessed of greater courage and foresight in terms of collecting than Alexander III, who was nonetheless influenced by the former's gallery. The young count's death left a vacuum in St Petersburg that was never to be filled. From that moment the centre of activity for collectors increasingly became Moscow.

Moscow's Merchant Collectors

It was Moscow that saw the emergence of a new type of collector in Russia. In the second half of the nineteenth century, a group of patrons began to emerge from among the representatives of Moscow's industrial and mercantile class. For these men, an interest in art gradually turned into their life's work. Members of rich merchant families like the Tretyakovs, Shchukins and Morozovs were convinced that it was their duty to serve Russian society, and they combined a love of art with their business initiative and acumen. The significance of the gallery created by the Tretyakov brothers cannot be overstated. Even at the beginning of his collecting activities, Pavel Mikhailovich Tretyakov drew up a will in which the majority of his capital was assigned to the 'establishment in Moscow of an art museum or public picture gallery'.[13] The will also contained the following remarkable lines: 'I dare to hope – and while not entirely certain, let us at least say that I suggest – that through bequests of other true art-lovers it might even be possible for whole collections to pass from private homes into the national or people's gallery that we are proposing.'[14] Pavel Tretyakov himself put all his efforts into Russian art, while Sergei concentrated on European art.

Before the appearance of Sergei Shchukin and the Morozov brothers, who, following the example of the Tretyakovs, established their galleries with the aim of turning them into national property, the two finest collections of European nineteenth-century art in Russia were the Kushelev Gallery in St Petersburg and the Tretyakov in Moscow. Both collections centred on Realist art with a distinctly romantic flavour: during the middle and much of the second half of the nineteenth century such was the predominant taste of collectors and public alike. Both galleries were above all oriented towards the Parisian art scene, following a tradition established in Russia in the eighteenth century.

S. M. Tretyakov (1834–92) followed in the footsteps of his contemporary, Kushelev-Bezborodko, although he started collecting much later. While Kushelev considered himself a participant in the art world itself, Tretyakov saw himself only as a collector. Thus, whereas the Kushelev collection began to play a revolutionary role immediately after the gallery was founded, when Tretyakov started to collect similar pictures two decades later they were regarded quite differently, for by then they were admired all over Europe. Tretyakov's unerring eye led him to purchase many wonderful canvases, from Géricault and Delacroix to Corot. Like Kushelev-Bezborodko before him, Tretyakov's favourite artists belonged to the Barbizon group, who achieved realistic mastery in landscape painting one step ahead of the rest of Europe. This, at least, was the situation in the middle of the century, when Kushelev-Bezborodko was at his most active, but with the arrival of the Impressionists the situation changed. For now the new era belonged to them, and not the Barbizon group.

Was Sergei Tretyakov familiar with the works of the Impressionists? There can be no doubt, and yet the nearest he came to them were his purchases of pictures by those skilful but impassive imitators of Monet and Pissarro – artists like Heilbuth, Loir and Bastien-Lepage. Thus it was not Manet's more famous painting, but the infinitely more carefully decorated, choreographed and – in the full sense of the word – theatrical canvas of Laurens entitled *The Last Moments of Emperor Maximilian* that adorned the Tretyakov Gallery. Tretyakov's paintings remained principally in Moscow. Only a few (works by Corot, Laurens, Heilbuth and De Neuville) were transferred to the Hermitage in 1948 when the Museum of Modern Western Art, where they had been displayed, was abolished. 1948 was the year which defined the Hermitage collection of nineteenth-century European art once and for all – but to this we will return later. Up until then pictures of the first half and the middle of the nineteenth century predominated in the Hermitage collection, works that had come to St Petersburg thanks to Kushelev-Bezborodko and Alexander III. It is true that some early twentieth-century paintings from the collection of G. E. Haasen (including works by Vallotton, Marquet and Manguin)[15] were transferred to the Hermitage around the same time, thereby dramatically shifting the collection's temporal boundary forward. However, there remained a significant gap between Haasen's pictures and the romantic scenes or Barbizon landscapes of the mid-nineteenth century. It was quite impossible to rectify this omission from local sources, for there were no Impressionist or Post-Impressionist pictures in the St Petersburg collections.

The situation in Moscow was entirely different. There, thanks to the activities of the Shchukin and Morozov brothers, superb collections of art from the second half of the nineteenth and the early twentieth centuries had come into being. On the eve of the First World War, the collections of Sergei Shchukin and Ivan Morozov were rightly considered to be among the very finest collections of new French painting anywhere in the world. In 1918 they became the First and Second Museums of Modern Western Painting respectively. Five years later they combined to form the State Museum of Modern Western Art, which at the time was the only museum of its kind in the world.

The only place from which the Hermitage could obtain the pictures it lacked was the Museum of Modern Western Art, and this, of course, was precisely what the director of the Museum of Modern Western Art wanted to avoid. Threats to the integrity of the Shchukin and Morozov collections, which had first arisen in 1918 but had been averted by nationalisation, appeared again at the end of the 1920s. By this time the Moscow arts community was already reconciled to losing part of the Museum of Modern Western Art's assets – preferably a small and not too important part – in order to receive in return some Old Master paintings from the Hermitage. The 'redistribution', however, turned out to be a far from simple process. The minutes of meetings of the commission, made up of some of the most influential art historians from Moscow and representatives from the Hermitage, have survived. Meetings dragged on endlessly and were conducted under considerable pressure. The exchange eventually agreed upon could not in any way be called equal.[16] However, it did at last enable the Hermitage to obtain works by the Impressionists and Post-Impressionists. Fortunately, among the pictures acquired from the Museum of Modern Western Art between 1930 and 1934 were not just works by second-rate artists like Lobre and Dufrenoy and the third-rate Maglin and Lissac, but also such masterpieces as *Lady in the Garden* and *Bank of the Pond in Montgeron* by Monet, Renoir's *Woman in Black* and *Girl with a Fan*, Cézanne's *Smoker* and *Still Life with Drapery*, *Sacred Spring* by Gauguin and *Lilac Bush* by Van Gogh, as well as Matisse's *Conversation* and *Still Life with Blue Tablecloth*, and Picasso's *Portrait of Soler* and *Dryad*. The transfer of part of the collection was also forced upon the directors of the Museum of Modern Western Art, for when the First and Second Museums of Modern Western Painting merged, the combined museum had lost the rights to the Shchukin residence,[17] and Morozov's alone was not big enough to house all the pictures.

As the first pictures from the Museum of Modern Western Art began to arrive at the Hermitage, Sergei Ivanovich Shchukin (1854–1936), the man to whom Russia owed the appearance of such works as Van Gogh's *Lilac Bush* and Picasso's *Dryad*, was living in poverty in Paris. He can scarcely have imagined, when collecting canvases of the Impressionists and avant-garde artists of the early twentieth century, that in his life-time they would come to form part of the collection of the Hermitage – that sanctuary of classical art which seemed to present an impenetrable façade to contemporary painting. He was in no doubt, however, that his paintings were worthy of museum status. As early as 1907 he had written in his will that his collection was to pass to the Tretyakov Gallery.[18]

Even now, at the end of an era rich in examples of the enterprise of collectors, one is still struck by Sergei Shchukin's remarkable vision at the turn of the twentieth century.[19] He came from an old Muscovite merchant family. In childhood and even in adolescence few would have dared predict such a glittering future for him. No one could even have imagined that he was destined to succeed his father as head of the family firm of I. V. Shchukin and Sons, which played a major role in the textiles trade in Russia. And it was to Sergei that his father would leave the family house, the eighteenth-century former Trubetskoy Palace. This third son, a sickly child with a stammer, seemed the least likely to take over from Ivan Vasilievich, a man of huge authority in the world of commerce. So bad was Sergei's stammer that his parents decided not to send him to school, and instead invited his teachers to come to the family house. The circumstances in which he spent his childhood and youth, removed from the society of his contemporaries, had a marked effect on the development of the child's character. He grew up to be a highly independent man, able to overcome any hesitations, to make decisions even when they went against commonly held opinion. It was this combination of strong character and highly developed sensitivity that made him into such a great collector.

Sergei Shchukin's family was an unusual clan indeed. His father, Ivan Vasilievich, despite a bare minimum of education, had a reputation in Moscow as a businessman of genius.[20] In 1849 he married Ekaterina Botkina, the eldest daughter of the tea magnate P. K. Botkin, and thus became a kinsman to several of the country's most important commercial families. Thanks to this marriage the Shchukins came into contact with some of the most gifted practitioners of science, culture and the arts. Ekaterina's sister, Maria Botkina, married the poet Afanasy Fet, while their nephew Sergei, a professor at the Academy of Military Medicine, married the daughter of Pavel Tretyakov. The artist Ilya Ostroukhov, himself of merchant stock, married Nadezhda, Shchukin's niece. The brothers Mikhail and Dmitry Botkin were exceptional collectors in their own right. The former's collection was an eclectic mix, ranging from antique terracottas to Limoges enamel of the Middle Ages and Italian Renaissance maiolica,[21] while the latter concentrated on nineteenth-century European art, and possessed works by the Barbizon group – Corot, Courbet and Millet.[22] Their collections were always open to Shchukin, as was the collection of their famous contemporary, Pavel Tretyakov, long before it became the Tretyakov Gallery. It is, of course, no more than a coincidence that Pavel Tretyakov acquired his first paintings in the year that Sergei Shchukin was born, and that Shchukin himself began to buy pictures immediately after the Tretyakov brothers donated their gallery to Moscow. However, there is something fitting about such a confluence of dates. The two greatest Russian collectors of art collected entirely different pieces, and had quite different ideas about art, but for both collecting became a higher calling. Each was 'called' precisely at the moment when history required it.

It is no coincidence that Moscow was the field of activity for the families of both men. The St Petersburg merchant class could not have produced anyone like them. In their attempts to join high society, the merchants of St Petersburg were too slavish to its tastes and fashions to produce

even one truly important collector. With the death of Kushelev-Bezborodko, private collecting in the Russian capital entered a period of stagnation. Aristocrats who owned large collections added to them little and infrequently, and usually only when vanity required them to commission their own portraits from some luminary of the Paris Salon. The Moscow mercantile class was altogether more independent and democratic, and more concerned with developing contacts in the spheres of science and the arts. From the middle of the century regular gatherings were held in the houses of rich merchants, to which artists, musicians and university professors were invited. In his *Letters about Moscow* of 1881, P. D. Boborykin, the perceptive St Petersburg writer, noted that 'commercial and industrial Moscow is beginning to serve as the breeding-ground for an educated kingdom.'[23]

By the time these lines were written, Pavel Tretyakov had made entry to his gallery entirely free. It was still too early for the Shchukins to compete with him, but this was the moment when they began to take their first independent steps.[24] It appears that the Shchukins' house was originally decorated with paintings as a way of confirming the family's prestige in society. Ivan Vasilievich himself had no particular love of art. He led a very simple life and regularly attended church. He did, however, have a box at the Bolshoi Theatre and was a great lover of Italian opera. He tried to give his eleven children the very best education available, and the two eldest, Nikolai and Piotr, studied in both St Petersburg and Finland. Ivan Vasilievich was very keen that Sergei, too, should receive a foreign 'finish' – a plan that initially seemed impracticable, due to the young man's debilitating stammer. When Sergei was nineteen, his father took him to Germany for a cure, which, although only partially successful, nevertheless enabled him to enter the Practical Commercial Academy in the Thuringian town of Gera. Sergei also spent some time studying in France, and on his return to Moscow at the end of 1878 he began to help his father in the management of the firm. It very quickly became apparent that the young stammerer's grasp of business far exceeded that of his brothers.

Over time, Sergei's management of textile mill production and trade operations, and his ability to navigate his way skilfully through the Russian and international markets, earned him a reputation in the financial world as a 'minister of commerce'. From 1912 he was head of the Moscow Board of Merchants, but long before that he had earned respect for his bold and enterprising behaviour, most notably during the nationwide strikes of 1905. In the midst of the general panic that seized the business community, Sergei cornered the market in textiles and, after the suppression of the revolt, inflated the prices of his products. It is interesting to note that for nearly a decade and a half, Sergei Shchukin's business successes did not give rise to any desire to spend his money on art, at least no more than was necessary to create the desired effect of a merchant doing well for himself.

Indeed, in terms of art collecting, initially the example was set by Sergei's elder brothers. Nikolai collected silver and for three years also filled his house with paintings until he tired of it all: he had little genuine desire to be a collector. However, Piotr (1853–1912) had this

The Shchukin family outside their dacha near Moscow, c. 1900. In the middle of the front row is Lydia Shchukina (1864–1907), first wife of Sergei Shchukin, and, to the right of her, their son Sergei (1888–1906), while their second son, Grigory (1887–1910), is on the far left of the same row. From left to right in the middle row are Ekaterina (1890–1977), daughter of Sergei and Lydia Shchukin; Piotr Shchukin (in the hat), and Sergei Shchukin. Ivan (1886–1975), eldest son of Sergei and Lydia Shchukin, is seated on the railings in the top left of the photograph.

desire in abundance. He began to collect while still a child, starting with photographs and lithographs, then turning his attention to old books, engravings, documents and pieces of old Russian tableware. Piotr Shchukin was not noted for his selectivity, and certainly lacked the discernment of his younger brother Sergei; common breadbaskets and distaffs would sit alongside ancient Russian coins, and woven Polish sashes lay next to Persian carpets. While he concentrated on Russian antiquity, Piotr by no means ignored his other interests, striving – as he himself put it – 'to show clearly the influence that East and West have had on Russian culture'.[25]

In 1892, following the example of P. M. Tretyakov, Piotr Shchukin began to construct a building for his own museum, which was to house a colossal collection: 23,911 items in all, some of which were

themselves made up of whole groups of objects. Most valuable were undoubtedly various historical documents, notably the archives of numerous leading figures of the Russian State (including the Demidovs, Vorontsovs, Shakhovskys and A. P. Yermolov), and a considerable number of unique pieces of applied art. As soon as the doors of the Shchukin Museum opened in 1895 (with the right of free entry for all), artists began to frequent it. Vasily Surikov drew his sketches here when working on *Stepan Razin*, Apollinary Vasnetsov found old illustrations of Moscow buildings for his historical landscapes, while Valentin Serov was drawn to the Persian miniatures, finding them an inspiration for his designs for Diaghilev's Theatre. To mark the creation of the museum, which was a gift to Moscow – or, more accurately, to the Historical Museum – the Tsar promoted Piotr Shchukin to the rank of General and full State Councillor, an advancement that undoubtedly flattered

Piotr Shchukin in his study. Piotr Ivanovich acquired Oriental carpets and French fabrics, as well as Ancient Russian artefacts, old manuscripts, and historical documents. He tirelessly listed the works, painstakingly annotating each one in the so-called 'Shchukin Books' (only 10 volumes were published).

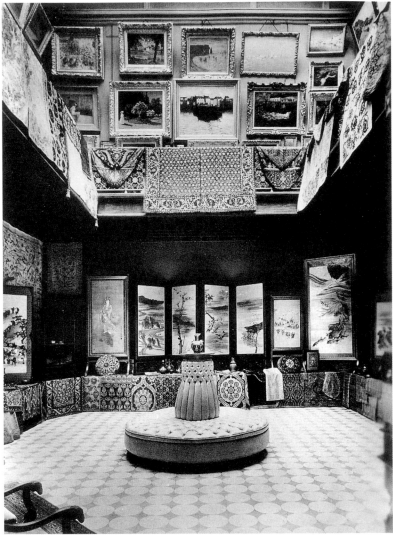

Room in Piotr Shchukin's museum, 1906 (photograph by K. A. Fischer). At the top can be seen paintings by the French Impressionists, which were in the museum until 1912. From the banisters hang Persian and Central Asian carpets, and, below, Chinese paintings, all reflecting the collector's diverse interests.

the vanity of this merchant's son. It should be mentioned that he possessed a certain naïvety, clearly reflected in his collecting, but his was a generous, truly Russian, nature. His natural curiosity compelled him to dedicate every free minute to his collections. The result was a feast of rare treasures, the true value of which has yet to be recognised.[26]

It was not only Piotr, but also Sergei's younger brothers, Dmitry and Ivan, who set off on the collector's path before Sergei himself. Dmitry assembled the finest collection of Old Master paintings in Moscow of the pre-Revolutionary years. In 1924 he was required to hand over the 146 paintings and pastels he owned to the State Museum of Fine Arts in Moscow (later the Pushkin Museum of Fine Arts), when its picture gallery was starting to be assembled. Dmitry himself was fortunate: he was appointed head of the gallery's Italian section, a secondary position but at least one that allowed him to be near his paintings. His devotion to them was such that he dismissed any thought of leaving Moscow, where life was becoming increasingly difficult and dangerous.

In their attitudes to art, each of the brothers trod his own path. But while the lives of the elder brothers were inextricably tied to Moscow and the work of the family firm, Ivan (1869–1908), who really belonged to the next generation, received permission from his father to pursue his own career outside the family business and instead studied at the History and Philology Faculty of Moscow University. While there, alongside his scientific studies, he began to collect rare books and engravings. In 1893 he settled in Paris, from where he wrote a column under the pseudonym Jean Brochet (*brochet* being the French for 'pike', which in Russian is *shchuka*). He worked principally for the influential liberal St Petersburg newspaper *Novoe Vremya*.

For some fifteen years Ivan's Parisian apartments served as an important centre for the Russian community. Visitors included A. S. Suvorin, the editor of *Novoe Vremya*, the writers V. I. Nemirovich-Danchenko, D. S. Merezhkovsky, K. D. Balmont and M. A. Voloshin, and the artists I. E. Grabar and A. N. Benois. Anton Chekhov described Ivan Shchukin in a letter to his wife as an interesting man, adding that the two had lunch

Museum of Piotr Shchukin on Malaya Gruzinskaya Street, Moscow (photograph by K A. Fischer), 1906, built in the Ancient Russian 'Terem' style by Boris Freidenberg in 1892–5. In 1905 Shchukin donated the museum's buildings and collections, comprising more than 300,000 exhibits, to the city of Moscow, and personally guaranteed to cover its future running costs. The museum thus became a branch of the Historical Museum until 1917, when the Soviet government ordered the transfer of the collections to the main Historical Museum building on Red Square. Much of the collection remains unsorted to this day.

19

Фотогр. и худож. фотот. К. А. Фишеръ, Москва.

together whenever Chekhov was in Paris.[27] To Shchukin's apartments on Avenue de Wagram also came Degas, Renoir, Rodin, Redon, Huyssmans and Durand-Ruel. He was flattered that they took him for a Russian aristocrat, sometimes addressing him as 'count'. But most importantly he threw himself into discussions about art, and had unrivalled opportunities to acquire works by great artists with whom he could pass the time of day. Sadly, nothing can now be said about this part of his collection, which was dispersed without trace. It seems that its only legacy is a wonderful pastel by Degas in the Neue Pinakothek in Munich, which has the dedication 'A M[onsieur] J. Stchoukine. Degas'. A significant part of the collection – canvases by Carrière, Puvis de Chavannes and others – was sold by Ivan Shchukin himself in 1900. His collection of Old Masters was of far greater value, as was confirmed in particular by a sale in Berlin in 1907.[28] Among the 107 pictures included, Dutch artists – especially painters of landscapes and still lifes – predominated: Jacob and Salomon van Ruysdael, Jacob and Philips Koninck, Willem and Adriaen van de Velde, Kalf, Heda, Huysum, Van Beyeren, Hondecoeter and others. Shchukin also owned

a small number of English portraits by Reynolds, Raeburn and Lawrence, which were fashionable at the turn of the century. His most notable paintings were those by Spanish and Italian artists (Tintoretto, Bronzino, Guardi, El Greco and Goya), which included pictures such as El Greco's *Mary Magdalene*, now in the Museum of Fine Arts in Budapest and widely accepted as one of the artist's finest works.

Ivan Shchukin had a tendency to spend more than he earned. He was constantly short of funds, and sold his share in the family business to Sergei, who paid him an annual fee of 2,200 roubles. In his fervour for collecting, Ivan Shchukin's acquisitions of superb paintings might appear to have been highly profitable. His appetites, however, were rather greater than his desire to pay the bills. With ever-increasing urgency he would telegraph his elder brother requesting further transfers of money. Sergei, however, did not have large sums at his disposal: dividends were automatically paid back into the firm. In the end Sergei and Piotr advised Ivan to sell his pictures. Collectors themselves, they could not have failed to understand how cruel their

Ivan Shchukin, *c.* 1904, by Ignacio Zuloaga (Hermitage). Unlike his elder brothers, Ivan Shchukin, here depicted as the epitome of the Parisian dandy, took no part in the running of the family firm. Having settled in the French capital, he occupied himself by writing articles for Russian journals and lecturing at the School of Oriental Languages. Despite his various literary and artistic undertakings, Ivan never found his true *métier*, but the important role he played as Piotr and Sergei's 'French connection', keeping them informed about the cultural and artistic life of Paris, is undeniable.

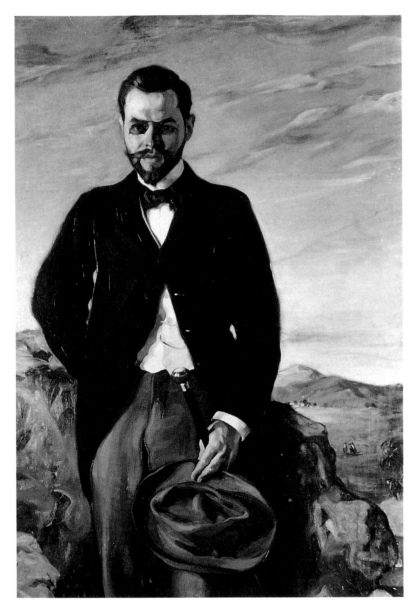

of course there is no way of proving whether Ivan Shchukin was the victim of a hoax or of a simple mistake made by the so-called 'experts'.[30]

This all took place in 1908. A decade earlier, however, Ivan Shchukin had been at his peak, in effect the first Russian who not only began to understand the Impressionists, but also dared to acquire their works. Through his acquaintance with Paul Durand-Ruel, the dealer who supported the Impressionists through the most difficult moments of their struggle for recognition, Ivan Shchukin was able to 'pull strings' for his elder brothers. It was Ivan who brought his brother Piotr to the Durand-Ruel Gallery in 1898. By this time Piotr was already the eminent director of his own museum, to which he soon added paintings by Monet, Renoir, Degas, Pissarro and Sisley. Later additions included works by Mary Cassatt, Raffaelli, Cottet, Forain, Helleu, Moreau and Denis.

Without the help of Ivan, Piotr Shchukin could scarcely have made his decisions so faultlessly. With his first purchases from the elderly Durand-Ruel, he became the owner of some true masterpieces of French art. Among them was a work by the father of Impressionism, Camille Pissarro: *Place du Théâtre Français*. He bought the painting fresh, its paint scarcely dry, and at the time it was one of the very latest manifestations of the vitality of the Impressionist movement. Another purchase was *Villeneuve-la-Garenne* by Sisley – then known as *Village on the Banks of the Seine*. In contrast to Pissarro's painting, this earlier work showed the continuing link between Impressionism and classical European landscape painting. The purchase of Monet's *Lady in the Garden*, one of the supreme examples of the artist's early work, gave the small collection of French art in the museum of Piotr Shchukin true significance. The way in which the Impressionist canvases were exhibited in his museum – hung frame to frame, their different colours juxtaposed, as though in an antique shop – may raise a smile nowadays. There was, however, a certain logic to this bric-à-brac style of exhibiting. The new landscapes of Western art, hung at the top, contrasted with the old Far Eastern landscapes below. The dark Persian rugs that separated the two layers were connected with neither one nor the other, but in addition to the frames they formed an extra, part refined, part home-made environment for these wonderfully sparkling 'windows on nature'.

advice must have appeared. There was no choice, although Ivan did not want to relinquish his collection, especially his Spanish canvases which were his last and deepest passion. Some of these had been bought on the advice of Ignacio Zuloaga, who had become his closest friend;[29] with Rodin they had travelled around Spain together.

The Berlin auction only postponed the moment of truth. No longer counting on the help of his brothers, Ivan Shchukin decided to sell his El Grecos, but the experts who came to value the pictures dismissed them as fakes. The collector took this as a sentence of death, and ended his life by poison. His unique library passed to the School of Oriental Languages and for a long time remained the finest collection of Russian books in France; it was sold, however, in a hurry and at a knockdown price. But how accurate was the expert valuation of the El Grecos? It can now be stated with certainty that it was not accurate, though

In 1898, the year in which he acquired the landscapes by Pissarro, Monet and Sisley, Piotr Shchukin also purchased two pictures that were not intended for public display. These were Degas's *Woman Combing Her Hair* and Renoir's *Nude* (1876; Moscow, Pushkin Museum).[†] It was said that the latter was 'thrown into the bargain' with his purchase of a Japanese screen, which may well have been the same one that occupied the central part of the wall under the Impressionist paintings. By displaying such works in his museum, however, the collector put his reputation at serious risk. Pictures from the series to which *Woman Combing Her Hair* belonged had caused a scandal at the Impressionists' exhibition of 1886 – and this had been in Paris, which had long since accepted portrayals of the female nude. What would be the reaction in Russia, with its stricter traditions for centuries supported by Orthodoxy? No doubt one or two people knew

[†] Date and location of works not in the Hermitage are included in the text; full details of Hermitage paintings are given in the catalogue section at the back of the book.

Nude, 1876, by Auguste Renoir (Pushkin Museum, Moscow). This work, one of Renoir's best canvases, created a scandal at the second Impressionist exhibition, where the influential critic Albert Wolff described the painting as a 'complete putrification of a corpse'. It belonged to the composer Emmanuel Chabrier. After his death it came to the Durand-Ruel Gallery where it was purchased by Piotr Shchukin, who felt unable to put it on public display. It only finally saw the light of day in 1912 when it passed to Piotr's younger brother Sergei.

21

of the pictures in Shchukin's private apartments, and viewed them as a forgivable weakness in an old bachelor. Both works, however, belong to the highest achievements of French painting, particularly Renoir's *Nude* (also known as *The Beautiful Anna*). Piotr Shchukin's private rooms also housed *Figures in a Spring Landscape* (or *Sacred Grove*) by Maurice Denis. This may be why he did not show the painting to the artist when he visited in 1909.[31] For regardless of his Symbolist intentions, this picture was treated with the same disapproval as were the works of Renoir and Degas, since it, too, showed the naked female form.

Sergei Shchukin: Patron of Matisse and Picasso

Sergei Shchukin bought his first Impressionist pictures at the same time as Piotr, and it is likely that he, too, took advice from their brother Ivan in Paris. By that stage Sergei was already a collector of some experience. It is difficult to say precisely when he began buying pictures, but it was probably around the end of the 1880s or early 1890s. His first purchases were works of the Russian Realists – the Wanderers – of which he later grew ashamed. His interest in Russian art at that time is revealed by his participation in the first congress of Russian artists and art-lovers, held in Moscow in 1894. But from around 1896 or 1897, Shchukin's interests turned to the West.

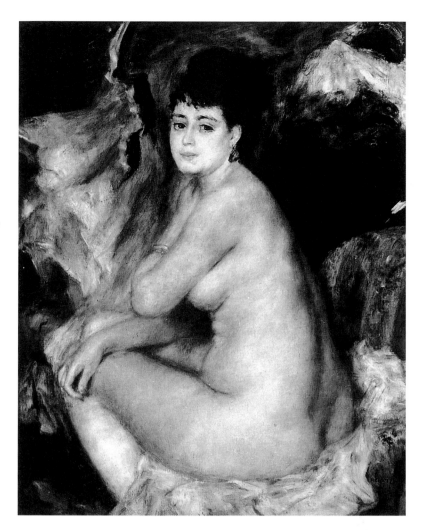

In 1899 Shchukin clearly thought that pieces from his collection were worthy of public interest, and he showed two pictures at an exhibition organised by the journal *Mir iskusstva* (*World of Art*): Forain's *At the Races* (1888) and *Theatre Foyer* (mid-1890s), both of which are now in the Pushkin Museum in Moscow. At this stage Shchukin was the first Russian collector of new French art. At the same time, or shortly thereafter, he managed to obtain Courbet's *Hut in the Mountains* (1874–6; Moscow, Pushkin Museum), a picture that became the starting point of his collection. It was as if Shchukin had decided to establish a line of demarcation between his own collection and that of Sergei Tretyakov, which finished with a painting by Courbet (*Sea*, 1867; Moscow, Pushkin Museum). A little earlier Shchukin had also acquired several works by contemporary Realists from the so-called Bande Noire, as well as pictures by Realists who were beating on the door of the Salon.

'Shchukin's first acquisitions at the end of the nineties', wrote Yakov Tugendkhold, a critic who was close to the collector and who wrote some wonderful early studies of the Shchukin Gallery, 'were landscapes by [Frits] Thaulow, [James] Paterson, [Charles] Cottet and [Lucien] Simon, as well as Zuloaga's "Spanish" works. These were examples of art of the golden mean – that is, works that stood aside from the great and stormy flow of contemporary art.'[32] The list clearly shows the collector's lack of definition at the time: a Norwegian, a Scotsman, two Frenchmen and a Spaniard – a cosmopolitan group, although all the pictures were purchased in Paris. These pictures reflect a certain quasi-romantic banality, much favoured by amateur collectors. They include Paterson's *Enchanted Castle in Scotland* (1896; Moscow, Pushkin Museum), Cottet's Venetian silhouettes fading into the evening light, and the bravura *Spanish Women in a Box at the Plaza de Toros* by Zuloaga (*c.* 1899–1900; Moscow, Pushkin Museum). Here, too, of course, were the simple folk of Lucien Simon (*Boatmen*; Moscow, Pushkin Museum), a massive canvas that Muscovites compared with Repin's widely known and much admired *Volga Boatmen* (St Petersburg, State Russian Museum). On a visit to Oxford in 1897 Shchukin went to Exeter College Chapel where he saw a tapestry made in William Morris's famous workshops at Merton Abbey from a design by Burne-Jones. He ordered a copy for himself, originally intended for his dining-room. Such commissions were extremely expensive, but Shchukin's subsequent decision to avoid this type of work was probably based on the limited creative potential of 'woven pictures' rather than on any considerations of price.

It was to be another year or two before Shchukin decided that he needed to limit himself to only one school – the French. However, even here he did not immediately find the path that was to lead him to his exalted position as a collector with an unerring eye. Who now has heard of painters such as Guilloux and Maglin? Shchukin brought their pictures back from Paris in 1898; at the time the sense of mystery in their work attracted him. In the same year, however, he purchased a landscape by Monet from Durand-Ruel's gallery entitled *Rocks at Belle-Ile* (1886; Moscow, Pushkin Museum).[33] And while it remains somewhat unclear in what order these pictures arrived in Moscow, it is important

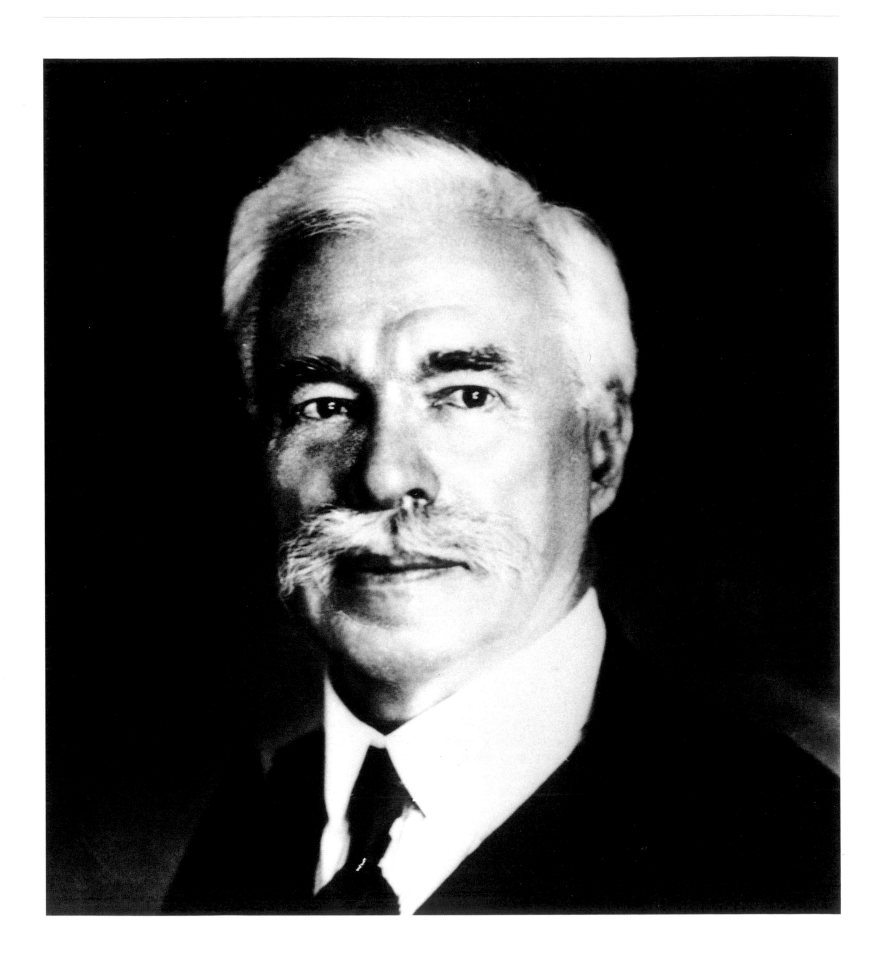

House of Sergei Shchukin in Bolshoi Znamensky Pereulok, Moscow, 1913 (photograph by Orlov). The house was built in the late 1770s for Prince Shakhovskoy (the architect is traditionally believed to have been the Italian Camporesi). At the beginning of the nineteenth century it passed to the princes Trubetskoy, and is still frequently known as the Trubetskoy Palace. Ivan Vasilievich Shchukin acquired the house in 1882, and, four years later, he handed it on to his son Sergei, when Sergei's eldest son, Ivan, was born. Ivan Vasilievich believed that Sergei was the most likely member of his family to carry on the business.

23

to note that they were the first of their kind. Within a year Shchukin's residence on Bolshoi Znamensky Pereulok was adorned with another magnificent Monet landscape: *Haystack at Giverny*. Is it true, therefore, to say that Shchukin by now understood the language of the new art, and had taught himself to make his choices unerringly? Not yet. Alongside Monet's canvases he also purchased interiors painted by Lobre under the influence of the Impressionists. While beautifully coloured and skilfully executed, these were essentially second-rate works with few significant revelations. The collection was supplemented by compositions of the Symbolist Ménard as well as works by La Touche, an artist close to Symbolism who was very fashionable at the beginning of the twentieth century but is now largely forgotten. La Touche's *Transference of the Holy Relics*, brought back by Shchukin from the Paris Exposition Universelle of 1900, is more a literary attempt to convey religious ecstasy than a piece of true art. It is vividly coloured, but it is not really a 'Shchukin-esque' work at all. This is not surprising: there was a period of apprenticeship in Shchukin's collecting career, for he was a man who was easily offended and did not like taking advice; in essence he always operated as an autodidact.

The artist Vasily Perepletchikov recorded in his diary a visit to the Shchukin residence in the winter of 1900. He lists the works of Simon (*Compassion*, 1890; Hermitage), Brangwyn (*The Market*, 1893; Moscow, Pushkin Museum) and Whistler (three small sketches now in the Hermitage). All these paintings reveal the same qualities as the works by Cottet and Lobre. ' "Here is Monet", says Sergei Ivanovich Shchukin. "Look how alive it is! When you look at it from a distance in electric light you do not feel the paint at all – it is as if you are looking out of a window one morning somewhere in Normandy, the dew is still wet, it is going to be a hot day... Now look at Pokhitonov. He seems completely black next to Monet, he needs to be got rid of. Here is Degas and his jockey [*Race Horses*, early 1880s; Moscow, Pushkin Museum] and his dancers [*Dancers at Rehearsal*, 1875–7; Moscow, Pushkin Museum], and here's Simon... come into the dining-room where I have a Puvis de Chavannes." '[34]

A year and a half before the first Impressionist paintings – belonging to the Shchukin brothers – appeared in Moscow, an article by I. E. Grabar entitled 'Decline or Rebirth'[35] caused a great stir among art-lovers.

Gallery of Sergei Shchukin in Moscow, showing some of his early acquisitions, which were mostly semi-Symbolist, semi-Realist works fashionable among the leading circles at the turn of the century. Seen here in the top row, left to right, are *The Hermit* by Zuloaga; *Transference of the Holy Relics* by

La Touche; *Stormy Evening* by Cottet; and *Boatmen* by Simon. Below, from left to right, *Seascape with Venice in the Distance* by Cottet; *Woman with a Child on her Lap* and *Woman Leaning on a Table* by Carrière; and *Spanish Women in a Box at the Plaza de Toros* by Zuloaga.

The young critic sharply criticised traditions that led to worthless copying. He came out strongly in favour of innovation based on the traditions of the Old Masters, and this struck a deep chord with Shchukin's own views. Shchukin was already beginning to feel that the Barbizon group alluded too closely to the Dutch landscape painters of the seventeenth century, and that French art really owed its most significant innovations not to them but to the Impressionists.

Soon, the most characteristic feature of the Shchukin collection was a constant attempt to 'ride the wave' of contemporary developments in art. Of course, it was first necessary to establish exactly what the latest phase of artistic development was. For the Russian art-lover of the 1890s this was far from simple, as is described by the artist and art historian Alexandre Benois, the finest chronicler of the age:

'Up until the 1890s Impressionism was really akin to an underground movement, known only to a small circle. Even smaller was the circle of people who not only knew of the existence of some artists who called themselves Impressionists, but who also valued their work, and considered it exciting and wonderful. Most people had only heard of artists like Manet, Degas, Monet and Renoir very occasionally; if ever their names appeared in print it was always with a hint of irony or indignation. These people who are now indisputable representatives of "la gloire française" were to the vast majority madmen, if not charlatans. On the contrary, the true glory of France was thought to belong to Gérôme, Benjamin Constant, J.-P. Laurens, Henner, Meissonier, Bonnat, Bouguereau, Roybet and Jules Lefebvre. The real bravehearts were those who went a little further, and with respect, interest or even admiration looked on artists like Puvis de Chavannes, Gustave Moreau, Bastien-Lepage, Carolus-Duran, Dagnan-Bouveret, and Carrière, while the boldest of all might get as far as admiring Besnard. Even our most gifted artist, I. E. Repin, who spent several years in Paris right at the time when the Impressionists were beginning to flourish, had a poor opinion of them and regarded them with contempt.'[36]

If the Impressionists were taken for charlatans by the most enlightened members of society, then anyone who dared to collect their paintings was, to the vast majority, an even greater fool. In 1914, when the memories of the Shchukin collection's early years were still fresh, Yakov Tugendkhold wrote: 'The first landscapes by Monet that Shchukin brought back caused the same uproar as Picasso does nowadays: not without reason was one of Monet's pictures scribbled over by the protesting pencil of one of Shchukin's guests.'[37] And it is clear that the episode described took place not in the 1890s, but a decade later, when the gallery was already open to the public.

Shchukin's approach to collecting was not the comprehensive, meticulous approach of the natural collector; he started too late to be considered a 'born' collector. Rather, the most characteristic aspect of his collecting was the desire to concentrate on what was most important. Having developed a passion for the Impressionists, Shchukin concluded that the most important figure in the movement was Monet. The words of P. P. Muratov, author of the first summary of the Shchukin gallery, can be assumed to express the collector's own views as well: 'Claude Monet developed a technique in art which became famous under the name Impressionism.'[38] For Shchukin, Impressionism and Monet were synonymous, and he became increasingly convinced that this artist was the most powerful exponent of the Impressionist method. For this reason Shchukin spent the first seven years (1898–1904) collecting eleven of Monet's canvases, and later acquired two more from his brother Piotr. At the same time he steered clear of Sisley, Morisot and Cassatt, and bought only one painting by Pissarro, albeit one of the very finest (*Avenue de l'Opéra, Paris*, 1899; Moscow, Pushkin Museum). Even the other Impressionists stood in Monet's shadow: Shchukin bought four works by Degas and only two by Renoir.

By the turn of the century Shchukin was captivated by art of the most up-to-date and vibrant kind, art in which he himself was able to play an active role. He tried to buy fresh, new work such as Monet's *View of Vétheuil* (1901; Moscow, Pushkin Museum) in 1902, and two years later his *Seagulls* (1904; Moscow, Pushkin Museum); these are pictures that are remarkable for the way in which the artist manages to convey the elusive shades of pure light. For Shchukin they represented the pinnacle of Monet's art, and he did not buy any of the artist's later works.

By 1903 Shchukin's interests had already turned to Post-Impressionism. He pursued the very boldest innovators, and from this point on his collection reflected the rapid development of French art. If we discount his very earliest purchases, Shchukin's activities as a collector can be divided into three stages: the first, from 1898 to 1904, was principally concerned with Monet; the second, from 1904 to 1910, is the period of Cézanne, Van Gogh and Gauguin; and the third, from 1910 to 1914, can be linked to the names of Matisse, Derain and Picasso. Although these three phases were generally distinct, there was some crossover between them. Thus, for example, Shchukin bought his first paintings by Gauguin and Cézanne in 1903, long before they were widely recognised in Europe. It was only a few years later that his Gauguin collection was to become the finest in the world. Similarly, by 1910 he

Mardi Gras (Pierrot and Harlequin), 1888, by Paul Cézanne (Pushkin Museum, Moscow). This painting, which depicts the artist's son Paul and his friend Louis Guillaume in Shrovetide carnival costumes, is considered to be one of Cézanne's best works. It was bought from Cézanne by his friend, the great French collector Victor Chocquet. After his death it came to the Durand-Ruel Gallery where it was 'discovered' by Sergei Shchukin. *Mardi Gras* finds an echo in another of Cézanne's 'Russian' works: Morozov's *Still Life with Drapery*, which features the same fabric.

25

was already the owner of several exceptional works by Matisse, including *Red Room*. In 1904 Shchukin purchased one of Cézanne's most wonderful pictures – *Mardi Gras (Pierrot and Harlequin)* (1888; Moscow, Pushkin Museum). He also bought *Flowers in a Vase* by the same artist, which had earlier been in the collection of Victor Chocquet, the great French collector and champion of the Impressionists and Cézanne. Shchukin had been the first person in Russia to buy a painting by Cézanne when, in 1903, he had bought *Fruits*, a still life previously owned by the Havemeyers (who had the finest collection of Impressionist paintings in America at the turn of the century). Ten years later Shchukin obtained *The Smoker* and *Mont Sainte-Victoire* (both in the Pushkin Museum). It is clear that he made a sharp distinction between the work of Cézanne and that of the Impressionists with whom Cézanne exhibited; he followed Cézanne's progress closely, something he did not do with Monet, Degas and Renoir. Shchukin saw in Cézanne's works not just the very latest word in European art; he also sensed a blood relationship with the foundations of world culture. 'In Paris,' Matisse recalled, 'Shchukin's favourite pastime was to visit the ancient Egyptian rooms in the Louvre. There he found parallels with Cézanne's peasants.'[39]

Gauguin, too, attracted Shchukin's attention. It was not simply the decorative beauty of his canvases, or the exotic allure of distant Tahiti, although to an indefatigable traveller who had visited India, Palestine and Egypt, this was not to be ignored. Rather, Shchukin understood the strong links in Gauguin's work with various movements in world culture – from medieval Europe to the ancient East. His Gauguin collection occupied the main wall of the dining-room, a hall of almost the same size as the music-room which contained Monet's paintings. It was as if in the mind of the collector Gauguin's works were akin to the iconostasis in a Russian Orthodox church – an idea noted by visitors to the gallery at the time: 'Gauguin once wrote [in his *Notes Eparses*]: "When you go into a Gothic cathedral, you see painting on glass, but you are at such a distance that it is impossible to tell what is portrayed. But all the same you find yourself captivated by their magical polyphony – this, too, is the music in a painting." I always remember these words whenever I cross the threshold of one of Shchukin's rooms, and, still not knowing what they portray, I see Gauguin's paintings open up before me. It is strange how far from his thoughts must have been the idea that his Tahitian paintings would end up in Moscow; strange, too, how his own words are so apt for Shchukin's presentation. For herein lie the true tastes of the owner himself. The pictures are tightly arranged, and at first you do not notice where one ends and the next begins: the impression is of one mighty fresco before you, one iconostasis.'[40]

After Gauguin it was the turn of Van Gogh. In 1905 the Shchukin residence took possession of *Arena at Arles*, then *Lilac Bush*, and, in 1908, *Memory of the Garden at Etten* and *Portrait of Dr Rey* (1899; Moscow, Pushkin Museum): only four pictures, but each contained something unique, something of the utmost importance, so that we cannot fail to consider Shchukin's selection extraordinary. The addition of works by Cézanne, Gauguin and Van Gogh to the paintings of Monet and the other Impressionists gave Shchukin's collection significance throughout Europe.

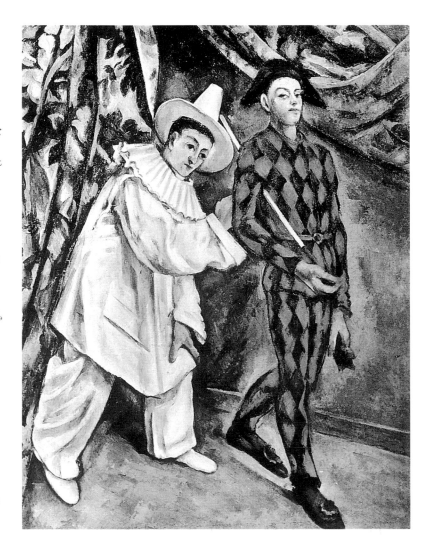

The collector himself could now no longer avoid thinking about turning his collection into a real museum. The sudden death of his beloved wife Lydia was the event that convinced Shchukin to act decisively. On the night of 4 January 1907 he wrote a will leaving his collection to the city, or, more precisely, to the Tretyakov Gallery. Shchukin had been hit by a string of tragic blows: the death of his son Sergei, who had thrown himself into the Moscow river a year earlier, the death of his wife, the suicide of his youngest son Grigory – these were enough to break any man. Certainly they greatly changed the collector's attitude towards his service to art, and he decided to open his collection for regular free visits. Famous artists had always been able to visit, but now every Sunday his doors were thrown open to the general public.

The influence of the gallery began to be felt quite swiftly. As early as 1908, before the acquisition of some of its most radical pictures, P. P. Muratov rightly commented: 'The picture gallery of S. I. Shchukin in Moscow is among the most remarkable Russian collections of art. It has for a long time been widely known and rightly praised among artists and enlightened art-lovers. But that is not all: this gallery has had a most decisive influence on the fate of Russian art over the last

Gallery of Sergei Shchukin, 1913 (photograph by Orlov). Among the paintings visible here are: *View from the Window* by Derain; *Nude* and *Girls in Black* by Renoir; *Poor Fisherman* by Puvis de Chavannes; *Woman Combing Her Hair* by Degas; and *The Visitation* and *Martha and Mary*, both by Denis.

Music-Room (known as the Monet Room) in Shchukin's house, 1913. Alongside works by Monet (two views of Rouen Cathedral; *Cliffs near Dieppe; Meadow in Giverny; Lady in a Garden; Poppy Field*) are paintings by Pissarro and Sisley. On the far wall are works by Denis, Guérin, Degas and Cézanne.

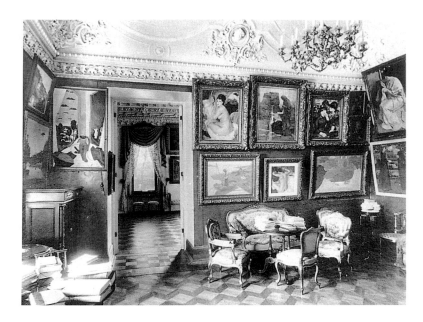

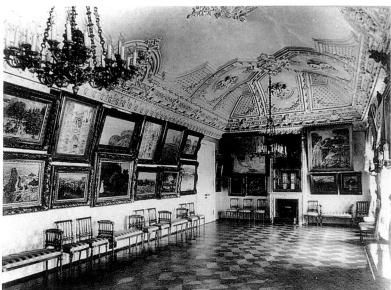

few years. It has been destined to become the strongest catalyst for the introduction into Russia of Western artistic movements, so brilliantly expressed in its works by Claude Monet, Cézanne and Gauguin.'[41]

By the time these words were written, Shchukin had already established a special relationship with Matisse. Some time earlier, word had reached Russia of the scandal caused by the appearance of the Fauves at the Salon d'Automne of 1905. But with the first revolution of 1905 under way, Russian art-lovers had other things on their minds, and it was some time before any attention was paid to the reports. Shchukin, however, had kept abreast of what was going on. In May 1906 he asked Vollard for Matisse's address.[42] Shortly after, Matisse told Manguin that he had sold a large still life to Shchukin, which the latter had found in the attic of his workshop.[43] The Muscovite collector, along with the American Stein family, who were based in Paris, and the German Karl Ernst Osthaus from Hagen, immediately believed in Matisse. Thanks to Shchukin, Russia became the first country to 'import' Matisse's work. By 1908 Shchukin had acquired the most important paintings: the recently painted *Game of Bowls* and a whole series of still lifes of various dates; he had commissioned *Statuette and Vase on an Oriental Carpet* (1908; Moscow, Pushkin Museum), and had agreed that this would be followed by *Harmony in Blue*. These commissions indicated that Shchukin had become Matisse's patron. It is no exaggeration to say that the co-operation between artist and collector was a necessary condition for the creation of a number of outstanding works. For Matisse the strengthening of his ties to Shchukin was all the more essential because at that time, as at the beginning of the 1900s, he was in a somewhat precarious position: the Americans Leo and Gertrude Stein, who had been his patrons, owning several of his most significant canvases, were beginning to distance themselves from him.

It took real courage on the part of Shchukin to display *Game of Bowls* in 1908, and even more, knowing Matisse's work, to commission a decorative panel for the dining-room, as *Harmony in Blue* promised to

become. Shchukin envisaged the blue of *Harmony* combining well with the golden-yellow tones of Gauguin, whose works predominated in the room. It is no coincidence that the place of the reworked *Harmony in Blue* was subsequently taken by the dark blue *Conversation*. Having transformed *Harmony in Blue* into *Harmony in Red (Red Room)*, Matisse achieved an effect which even he, perhaps, did not expect. Not surprisingly, he risked an adverse reaction from the Muscovite collector, for such a pure expanse of red – albeit extremely dramatic – had never before been seen in European art. However, to someone acquainted with the scarlet tones of ancient Russian icons, it was perhaps easier to come to terms with such an expanse of a single colour. The picture was a challenge to all existing artistic conventions; it was not, however, painted in order to shock, but to find a hitherto undiscovered harmony that corresponded to the spirit of the new century. And such was the astonishing success of this harmony, that it became a manifesto of the new art. In this sense *Red Room* can be seen as going beyond the other great canvases acquired earlier by Shchukin – Monet's *Déjeuner sur l'herbe* (1865; Moscow, Pushkin Museum), Gauguin's *Rupe rupe* (1899; Moscow, Pushkin Museum) or Van Gogh's *Lilac Bush*.

The appearance in Moscow of *Red Room*, *Game of Bowls* and *Nymph and Satyr* turned Shchukin's gallery into a showcase of the latest and most daring developments of the European avant-garde. But he had no thought of stopping there, ordering for the staircase of his home *Dance* and *Music* – the culmination of Matisse's and Shchukin's co-operation. The creation of this ensemble, which marks a true milestone in the history of European art, is a tribute not only to Matisse, but also to Shchukin. When asked if his father would have painted the panels on such a scale without Shchukin, Pierre Matisse, who had become one of the major dealers of the age, replied 'Why – for whom?'[44] I remember the genuine respect with which Pierre Matisse talked about Sergei Shchukin, when he stood before his father's famous portrait of the collector:[45] he underlined not only Shchukin's boldness as a patron, but also his especial delicacy – a man who never demanded anything

Large Dining-Room (known as the Gauguin Room) in Shchukin's house, 1913 (photograph by Orlov). On the far wall is the *Adoration of the Magi* by Burne-Jones. The densely arranged works by Gauguin, hung frame to frame in one golden ensemble, led early visitors to compare the overall effect to an iconostasis.

Large Dining-Room (Gauguin Room), 1913. On the far wall can be seen Matisse's *Conversation*, flanked by *Nasturtiums and 'Dance'*, and *Corner of the Studio*. In this room, Shchukin achieved his idea of a decorative juxtaposition of blue (the Matisse triptych) and golden-yellow (the Gauguin ensemble).

27

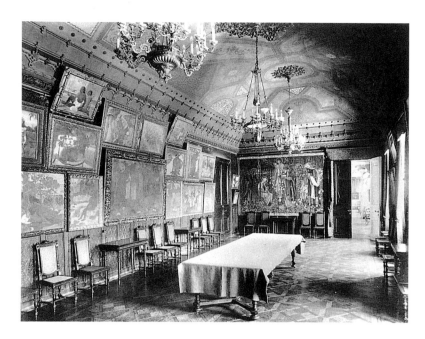

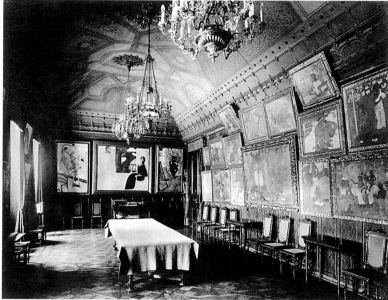

of the artist, and never tried to interfere in the creative process. Furthermore, it was Shchukin who suggested to Matisse the ideas for such important works as the *Seville* and *Spanish* still lifes and *Family Portrait*. The evolution of Matisse's art from the early still lifes to *Red Room*, through his decorative-symbolic canvases (*Game of Bowls, Nymph and Satyr, Dance* and *Music*) to his Moroccan cycle, could not have taken place without Shchukin. The collector's tastes were defined by his attitudes to new art in its various guises, and here his contacts with Matisse played a significant role. Matisse, without any doubt, was the most completely 'Shchukinesque' artist of all those displayed in the gallery, and Shchukin was not at all afraid that his purchase of a great number of often large-scale canvases by Matisse might somehow create an imbalance in his collection.

Occasionally Shchukin would be seduced by a second-rate painting, like Herbin's *Mill on the Marne*; towards the end of his collecting career, however, this rarely occurred. Shchukin's interests were directed less at making his collection comprehensive than at catching the latest development in art. Intuition led him to believe that true innovation, as opposed to pseudo-original novelty, could be expected above all from Matisse and Picasso (something that now seems self-evident, but which was recognised at the time by very few). Creative revelations from these two giants of painting filled him with awe. When he received *Arab Café*, Shchukin wrote to Matisse that every day he spent at least an hour look-ing at it, and that he liked it better than all the others.[46] This was not to say that *Arab Café* remained the pinnacle for Shchukin ever afterwards. In letters to Matisse, he commented more than once that he loved all his paintings, and admired them all every day.

Here, however, is a rather more hesitant letter that Shchukin wrote to Matisse telling him of the arrival of *Dance* and *Music*: 'Your panels have arrived and have been hung. The effect is not bad at all. Unfortunately in the evening the blue changes greatly in the electric light. It becomes

rather murky, almost black. Overall, however, I find the works interesting and hope one day to come to love them. I retain full confidence in you. The public may be against you, but the future is yours.'[47] It is a remarkable admission, revealing at once the struggle between the head and the heart. The words 'I find the works interesting' hint at some doubt, a certain duality of response, and yet Shchukin knew from his own experience that aesthetic emotion, when alive, cannot remain immutable. He retained his faith in Matisse at a difficult time, for he believed that one of the most important strands of contemporary art ran through Matisse's work.

After Shchukin opened his doors to the general public in 1909, the house became both a museum of new painting and an exhibition space, since some works arrived straight from the artists' studios. Furthermore, it served as a kind of schoolroom for young artists. These were principally students at the School of Painting, Sculpture and Architecture, and they became among the most ardent visitors to the gallery. Conflicts between the School's students and teachers, who were rather more forward-looking than the professors of the St Petersburg Academy of Arts, were enlivened by the works which the young artists began to imitate at Shchukin's residence.

Even as subtle and thoughtful an artist as Valentin Serov reacted to Shchukin's purchases with suspicion, calling Cézanne's *Mardi Gras (Pierrot and Harlequin)* 'wooden dolts'.[48] Although he later admitted that he could not get these dolts out of his mind, Bastien-Lepage's *Rural Love* in the Tretyakov Gallery (now in the Pushkin Museum) remained closer to his heart. But if Serov did eventually recognise Cézanne, many of Shchukin's later acquisitions left him bewildered. S. D. Miloradovich, a colleague of Serov, recalled: 'The plague of modernism has infiltrated all the classes, even Serov's studio... Serov now advises his fellow teachers, "You must stop your students from going to the Shchukin Gallery".'[49] The word 'plague' was widely used

Left: **Pierre and Jacqueline Matisse** in front of Henri Matisse's *Portrait of the Artist's Wife* in the Hermitage, September 1987 (photographed by Rosamond Bernier and published with her kind permission).

Portrait of Sergei Shchukin, 1912, by Henri Matisse (charcoal drawing; private collection). Matisse intended to paint a large portrait in oils after this sketch, but it was not to be. While the drawing was being done in Paris, Shchukin heard of his brother Piotr's death and immediately returned to Moscow.

29

among the defenders of Realism, and much later one of Serov's pupils, Kuzma Petrov-Vodkin, summed it up thus: 'The plague originated on Znamensky Pereulok, at Shchukin's.'[50]

Moscow's young painters, who soon joined to form the Jack of Diamonds group (of which the first honorary member, incidentally, was Sergei Shchukin) were strongly influenced by Shchukin's paintings. We need only compare Shchukin's works with paintings by Larionov or Goncharova to see this clearly. Thus Larionov's *Lilac* (1904; Moscow, Tretyakov Gallery) forms a pair with Monet's *Lilacs at Argenteuil* (1873; Moscow, Pushkin Museum), while his smoking *Soldier* (1910–11; Moscow, Tretyakov Gallery) replicates the pose of Cézanne's *Smoker*. Similarly, Goncharova's sunflower variations closely reflect Gauguin's *Sunflowers*. The principle behind such similarities was a sense of the shared language of Primitivism. This did not mean primitiveness or simplification – although that was how it seemed to many at the time. For these artists, Primitivism signified the most direct route to the essence of things, an attempt – through means at once naïve and insightful – to reveal the truth in the face of the artificiality imposed by schools of art. The members of the Jack of Diamonds came out in defence of folk art (signboards, trays, popular prints [*lubki*] and so forth). Like Kandinsky and Malevich, Larionov believed himself to be a primitive exponent of the new art, and he studied decorative folk art as a means of understanding the true essence of things. Shchukin's approach to unprofessional, untutored art was the same. There were hardly any sculptures in his collection, for he had taste neither for classical marbles nor for Rodin's style of work. He did, however, bring back several sculptures from Africa and was the first in Russia – and one of the first in the world – to exhibit such pieces in his gallery. Who awakened this interest in him – Matisse or Picasso – is not really important. What does matter is that alongside their works such sculptures served as a crucial reminder of the universality of human values and creative techniques.

Shchukin was also the first of the major collectors to purchase the works of the customs official Henri Rousseau – something that seemed strange to even the most enlightened of Shchukin's admirers.[51] Shchukin, however, himself a self-taught man in the field of art, was no admirer of diplomas, valuing instead true talent underpinned by self-belief. He understood that the 'douanier' was not just a Sunday-afternoon painter, that his special feeling for colour and the arabesque entitled him to his place in the history of art. The seven pictures by Rousseau that Shchukin collected between 1910 and 1913 formed the only group of its kind in the world.

He was quick to recognise the prophetic significance of Picasso. It is thought that Matisse introduced the two, when he brought his Russian patron to Picasso's studio in the Bateau-Lavoir in September 1908.[52] That first visit resulted in the purchase of *Woman with a Fan*, and other Cubist canvases began to arrive in Moscow subsequently. As he started to penetrate to the heart of Picasso's creative significance by following closely his latest works, Shchukin also collected the artist's earlier pictures, something he would not have done with a painter of

lesser importance. The same process took place with Derain, the third of Shchukin's young contemporaries, after Matisse and Picasso, that the collector singled out as the leading artists of the age.

The first Cubist paintings that appeared in Shchukin's gallery attracted him with their strange, paradoxical closeness to real life. Thus he knew Picasso's friend Fernande Olivier, and could have guessed that *Woman with a Fan* (1908) was her transformed image. While visiting Gertrude Stein in Paris, it is likely that he met the Cone sisters. He may also have had contact with them through Matisse, for whom the sisters felt a deep affection. Picasso portrayed Etta Cone in another version of *Woman with a Fan* (1909; Moscow, Pushkin Museum). This painting was also purchased by Shchukin, as Picasso informed Gertrude Stein with satisfaction, referring to the picture as the 'portrait with a fan'.[53] There is nothing particularly remarkable in these first steps towards Cubism.

Muse Inspiring the Poet, 1909, by Henri Rousseau (Pushkin Museum, Moscow). This painting – a naïve depiction of Guillaume Apollinaire and Marie Laurencin – was bought from the artist by Apollinaire himself for 300 francs. It then came to Shchukin, who was one of the first to appreciate Rousseau's work.

Woman with a Fan, 1909, by Pablo Picasso (Pushkin Museum, Moscow). This is believed to be the first painting by Picasso that Shchukin acquired. By mid-1914 he owned 51 of the artist's works – a collection that was unrivalled anywhere in the world.

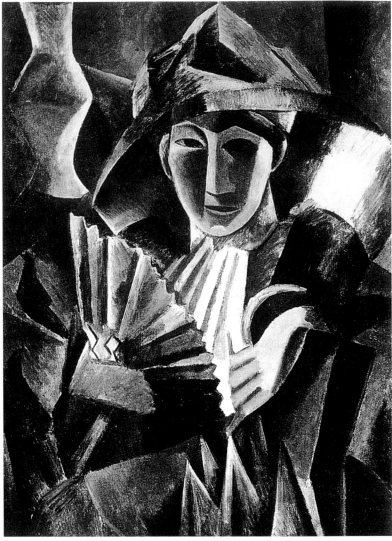

A similar path was followed by Ivan Morozov, to whom Cubism was utterly alien, but who bought one of the finest Cubist masterpieces: Picasso's *Portrait of Ambroise Vollard* (1910; Moscow, Pushkin Museum).

It is clear that when he bought his first paintings by Picasso, Shchukin was to some extent going against his instincts. A few years later Tugendkhold observed with good reason: 'Let us but follow the example of Shchukin, who even when he does not understand Picasso says, "Probably he is right, and not I".'[54] Whatever the reason, Shchukin's most extensive purchases in his later years were of the Paris-based Spaniard. In Shchukin's own copy of the catalogue of his collection[55] the last entries are written by hand, and above all they refer to works by Picasso.

Nikolai Preobrazhensky, a visitor to Shchukin's gallery, recounted, in the collector's own words, Shchukin's reaction to the works of Picasso: 'I did not like this painter and did not buy any of his paintings.

I had a large collection of various artists, but there were no Picassos. Friends told me that I ought to buy at least one of his works, if only for the sake of completeness, but I continued to demur. Somehow, however, they managed to persuade me, especially since someone was selling one of Picasso's paintings cheaply. When I brought it back to Moscow, for a long time I did not hang it, because I realised that there was nothing to hang it alongside in my gallery: it was at odds with everything and brought a harsh note of dissonance to the whole collection. Eventually I hung it not far from the entrance, in a darkened corridor, where there were no other paintings. I had to walk along this dark corridor every day to get to the dining-room for lunch. And as I walked past the painting, I would sometimes involuntarily glance at it. After a time it became a habit and I started unconsciously to look at it on my way past every day. A month passed and I began to realise that if I had not looked at the painting I wasn't quite myself at the lunch table – something was missing. Then I began to look at it for longer, and I got a feeling exactly as if I had a piece of broken glass in my mouth. And at the same time I found myself looking at it not just on my way to lunch, but at other times too.

Picasso Room in the Shchukin Gallery, 1914 (photograph by Orlov). After the uplifting 'iconostasis' effect of his Gauguin paintings, Shchukin followed a similar principle for hanging his works by Picasso: closely arranged, frame to frame. But with Picasso the effect was entirely different: a powerful and disturbing energy seemed to emanate from these paintings, evoking a sense of the tragic. In this comparatively small room, the randomly arranged ensemble made a lasting impression on all who saw it.

31

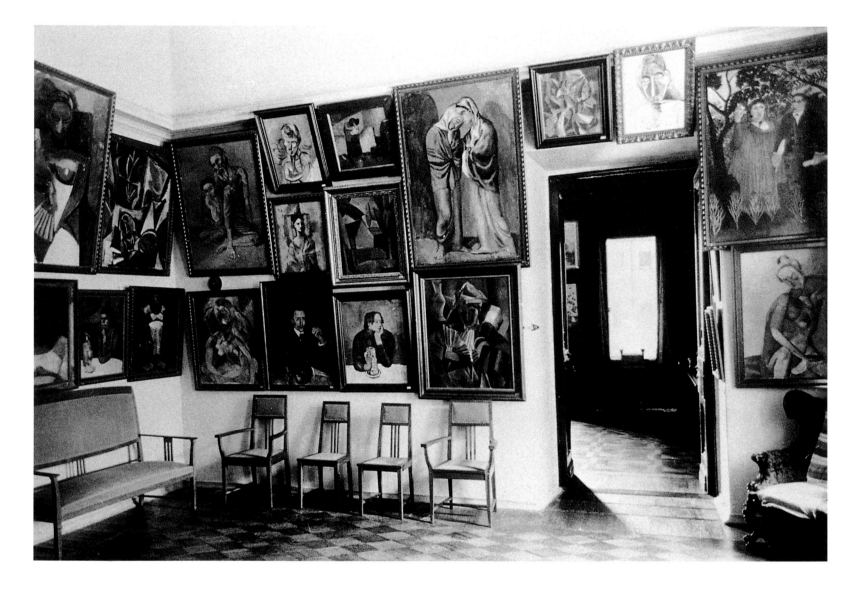

Then one day I was horrified because I felt that in the picture – despite the fact that it had no subject – there was a core of iron, an implacable strength. I was horrified because suddenly all the other pictures in my gallery seemed to me to be lacking this core, to be made simply of cotton-wool, and – worst of all – I no longer wanted to see them, they had lost all interest and meaning for me. I bought a second Picasso. Already I felt that I could not do without him. I bought another… and eventually he possessed me, and I began to buy picture after picture, and would not look at any other artist. So it was that the gallery received 51 pictures by Picasso, far more than any other artist.' Recounting Shchukin's words, Preobrazhensky added: 'When he spoke of Picasso, Shchukin did not say that he admired him more than any other, or that Picasso was the best of all; no – he said that Picasso *possessed* him, just as if he were hypnotised or under a spell.'[56]

By 1914, Shchukin had assembled the world's finest collection of works by Picasso. Piotr Pertsov, the author of the first guide to the Shchukin Gallery, was quite right when he noted: 'For the last word in Western-

European art (for the time being) we need to turn to the distant capital of the East.'[57] The only collection that bore comparison with Shchukin's was that of Leo and Gertrude Stein, whom the Moscow collector knew well and admired greatly. Later, however, their collection was broken up, with the result that several masterpieces came to Russia, including *Three Women* and *Girl with a Ball* (1905; Moscow, Pushkin Museum), though the latter admittedly went not to Shchukin but to Morozov. David-Henri Kahnweiler, through whom most of Picasso's paintings passed, considered Shchukin the only major collector of avant-garde art. He related an occasion when he was in possession of a whole series of Picassos and immediately telegraphed Shchukin, who arrived in Paris forthwith. Can he have been referring to the unique selection of paintings in 1908? The art of this early stage of Cubism was concentrated in Shchukin's hands; now it stands unrivalled in the Hermitage.

While he was buying up Picasso's pictures, Shchukin literally forgot that his gallery was already filled to the limit. There was simply not enough space on the walls for the new pictures. They covered the walls

the words of Svidrigailov in Dostoevsky's *Crime and Punishment*, when he talks of eternity as a cramped hut, full of spiders. And indeed this room was akin to a hut, while the "spidery" impression came from the long sharp lines that hit you between the eyes – some reddish, some dark, but sinister all, covering every wall.'[58]

Shchukin's collecting activities went in great waves, stirred up not just by changes in his personal perceptions, but by the same impulses that so powerfully governed the development of European and Russian culture. It was not enough for him just to own works of supreme artistic merit. His pictures were intended to influence the artistic consciousness of the Russian public, and Shchukin was quick to bring to Moscow works that reached out to new, frightening and alluring horizons. He always made his purchases in Paris. For some reason he remained impervious to the fact that he could have bought from exhibitions of foreign paintings in Moscow and St Petersburg. He liked to discover his pictures himself; what is more, he loved the element of surprise. A picture dug out from Vollard's storerooms or Matisse's studio would be unknown to anyone in Moscow, whereas exhibitions from abroad were accessible to everyone. The only – but extremely important – purchase Shchukin ever made in Moscow was of a number of Impressionist paintings belonging to his brother Piotr. Muscovites treated this transaction, which took place in 1912, as an entirely natural family affair. 'As I heard it,' wrote B. N. Ternovets, 'the things were sold for a ridiculously low price – 10,000 roubles.'[59] Ternovets was misinformed. So confidential was the deal that even the usually well-informed director of the Museum of Modern Western Art did not know the details a decade later.

In 1907, having decided to get married fairly late in life, Piotr Shchukin had to leave his French companion, Mademoiselle Bourgeois, who had been living in his house. She was sent back to France, royally rewarded for her troubles. A short time later Piotr received a court summons from Bordeaux, where Mademoiselle Bourgeois had concluded that her settlement was insufficient. They resolved the matter, but in May 1912 even larger demands were made. Wishing to avoid publicity, Piotr Shchukin decided to give in, and sell his French collection to meet the demands. In an attempt to avoid a public sale, he turned to Sergei for help.

Sergei wrote to his elder brother: 'I shall be in Paris at the beginning of July, and will certainly talk to Durand-Ruel, Bernheim, Druet etc. about the sale of your pictures. On the other hand, it would be a great shame to me were such excellent things to leave Russia, so for my part I should be delighted to buy eight or ten pictures from you. You know that I will leave my collection to the city. Some of your pictures would suit it particularly well. Of course, I know that dealers often put pressure on the seller, saying that it will not be easy to sell them on, that the price needs to be reduced and so on. I will pay you a fair price, and am ready to take Degas, Renoir, Monet, Sisley, Pissarro, M. Denis, Cottet, Forain and Rafaëlli.'[60] After further discussions another letter arrived from Sergei in June: 'In any event we are agreed, and I shall give you 100,000 for six pictures and the Denis. Keep the other paintings for the time being.'[61] Thus, far from paying 'a ridiculously low price', Sergei paid ten times more, and the Parisian dealers offered considerably less.

of a relatively small room, in two or three rows, frame to frame, right up to the very ceiling. Shchukin's principles of display were, of course, those of the nineteenth century, and they differed little from the rules adopted by his forerunners, the Tretyakov brothers. Such an approach to exhibiting may seem alien to us nowadays, but this does not mean that Shchukin was indifferent to the way his canvases were hung. From time to time he liked to move them around. It did not matter to him whether the pictures of one artist were concentrated in one place: it was enough that they belonged to a single formation and, wherever possible, conformed to a principle of decorative harmony. In the Picasso room, however, it seemed that everything was deliberately mixed up in a whirlpool of conflicting forms: the 'blue period', the 'pink period', Cubism – and all out of chronological order, a disturbing crowd of faces and things, all herded into a cage. 'The secluded Picasso room was, in its way, well suited to these kinds of works, just as the large, bright, elegant Salon suited the elegant Matisse. When you were in the room, it was just as if you had been carried beyond the boundaries of the rest of art... One Russian writer [S. N. Bulgakov] likened Picasso's creations to

Cover of the catalogue of paintings in Sergei Shchukin's collection, Moscow, 1913.

33

a serf belonging to Count Riumin, received permission from the landowner to open a factory producing silk ribbons. The start-up capital consisted of five roubles from his wife's dowry. By 1820 he had built up a fortune of 17,000 roubles, with which he was able to buy his and his family's freedom. In 1837 he bought some land from his former masters near Orekhovo (now Orekhovo-Zuevo), where he relocated the factory. Savva Vasilievich and his sons were so successful in their work that by the end of the nineteenth century their extended family had become one of the most powerful trading and commercial dynasties in Russia. On the eve of the First World War 54,000 people worked in Morozov's textile factories, and annual turnover was more than 100 million roubles with a profit, on average, of thirty per cent per annum.

At the turn of the century the Morozovs were munificent patrons of the development of Russian culture. The most famous of them all was Savva Timofeyevich, the grandson of the founder of the dynasty and named in his honour. Savva Timofeyevich was a supporter of K. S. Stanislavsky and he contributed to the founding of the famous Moscow Arts Theatre, becoming its patron. His brother Sergei financed the journal *Mir iskusstva* [*World of Art*] and founded the Moscow Crafts Museum (now the Museum of Folk Art).

In the other branch of the family, which controlled the Tverskaya Textile Company, 'two women played particularly important roles; they were not Morozovs by birth, but by marriage. Varvara Alexeyevna, née Khludova, and Margarita Kirillovna, née Mamontova, made a significant contribution to the cultural life not only of Moscow, but of all Russia… Varvara Alexeyevna was a classic example of a progressive Muscovite patron.'[63] Her father owned several pictures and a unique collection of old Russian manuscript books, which were later to form the heart of the manuscript section of the Historical Museum in Moscow. After the death of her first husband, A. A. Morozov, Varvara Alexeyevna set up home with V. M. Sobolevsky, editor of the liberal newspaper *Russkie vedomosti* [*Russian News*], by whom she had two children. For a woman of the Khludov family, for whom religion was of paramount importance, a common-law marriage (a church wedding would have deprived her of her vast inheritance) was something of a trap. Once she had fallen into it, it was extremely difficult for her to find fulfilment. Varvara Morozova thus sought an escape through free-thinking ideas of female equality, through chairing the Moscow Women's Club, and through charitable and other social activities. She bequeathed the majority of her multi-million rouble share in the Tverskaya Textile Company to her employees. Her house, meanwhile, became a kind of literary and political salon. Visitors included the writers A. P. Chekhov, V. G. Korolenko, P. D. Boborykin, G. I. Uspensky, V. Y. Briusov, and the famous political journalists N. K. Mikhailovsky, N. V. Shelgunov and V. A. Goltsev.

'Varvara Alexeyevna was severe by nature, especially to those who knew her well,' recalled her daughter-in-law Margarita Kirillovna. 'On superficial acquaintance, she appeared most attractive, polite and even kind, for she did many charitable things, helping needy students and teachers, particularly women, with whom she identified closely. But those near to her, especially her family, found her difficult.

Since he was spending money on avant-garde pictures at that time, Sergei Shchukin had to limit himself to only the most important paintings in his brother's collection: Monet, Sisley, Pissarro, Renoir and Degas. *Figures in a Spring Landscape* by Denis was discussed separately; although by then Denis's art was of more historical than aesthetic interest for Sergei Shchukin, he made an exception of it. Upon the closure of Piotr Shchukin's museum, the other paintings went to the Historical Museum, where they remained until 1922 when they were transferred to the Morozov section of the Museum of Modern Western Art.

The Morozovs

While Piotr Shchukin's museum was being closed down,[62] Mikhail Morozov was becoming interested in new French painting, paving the way for his younger brother Ivan. Both of these men belonged to the next generation, and came from the most unusual background. In 1797 their ancestor Savva Morozov,

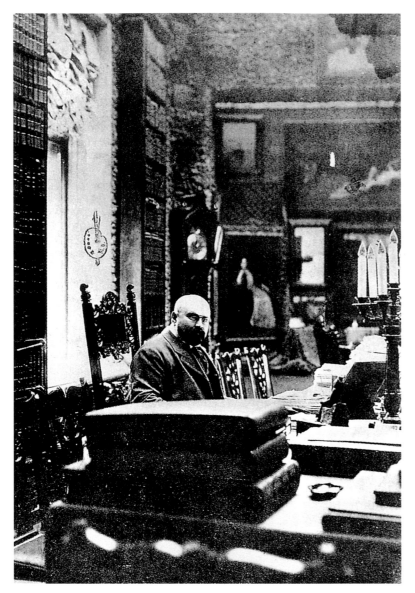

She was neither a loving mother nor wife; altogether it could not be said that there was anyone amongst those closest to her for whom she felt any strong affection.'[64]

Varvara Alexeyevna's relations with her three sons from her first marriage – Mikhail, Ivan and Arseny – worsened to the point of real enmity. The children quickly came to hate her professorial liberalism and the political gatherings in their home, and their own political and ideological orientation was diametrically opposed to hers. Such disagreements were probably less the result of convictions than of a conflict of characters, with neither side inclined to put up with being contradicted. The brothers were also completely unalike, and followed quite different paths. Arseny, the youngest, had no desire to follow Mikhail and Ivan, and did not buy pictures on principle, professing contempt for such an 'empty' occupation, although it must be said that he was hardly economical in furnishing his sumptuous mansion on

Vozdvizhenka in the 'Moorish' style. This house, situated not far from the Kremlin, became one of Moscow's most exotic sights, and was the building Tolstoy had in mind when he wrote in his novel *Resurrection* of a 'stupid, unnecessary palace for some stupid and unnecessary man'.

The most colourful of the brothers was Mikhail Morozov (1870–1903), a true original of a type rarely found even in Moscow, where individuality was highly valued. Historian, journalist, novelist, collector, bon vivant, gentleman and heavy drinker; a man who threw incalculable sums to the wind, and a tradesman who bargained hard as a point of principle: all this was to be found in one man, and he had energy enough for several, which he often expended in vain.

Mikhail Morozov 'showed from childhood a great interest and aptitude for science and art, and since he had not the slightest inclination to hear even a word about dedicating himself to commerce, he was allowed to choose his own occupation for himself.'[65] Until Mikhail reached his majority, however, his mother allowed him only 75 roubles a month – a sum that constrained him greatly. On the day of his twenty-first birthday everything suddenly changed: Mikhail received part of his parents' millions. He bought a house with marble columns on the corner of Smolensky Boulevard. On Sundays, numerous guests would gather here for lengthy breakfasts, entering his luxurious apartments via the Egyptian hallway, where a genuine Egyptian mummy stood alongside the telephone. Champagne of the most expensive kind flowed freely, and the very best cigarettes were set out on the tables. All Moscow knew the story of Morozov's astonishing losses at the English Club, where he was said to have lost a million roubles at cards in one evening.

So much was Morozov in the public eye that he even became a literary hero: few of his contemporaries had any doubt that Rydlov, the central character in A. I. Yuzhin-Sumbatov's play *The Gentleman*, was based on Morozov. Indeed, he came to be known by the sobriquet of 'the gentleman'. 'I am a critic, a musician, an artist, an actor and a journalist. How can this be? Because I am a natural-born Russian – softened, perhaps, by civilisation. The only problem I have is that I am constantly drawn from one thing to the next, for I feel I have too much energy.'[66] Sumbatov's mordant portrayal of his *Gentleman* verged on caricature. It did, however, contain many of the most characteristic features of Misha Morozov, as people tended to call him, contrasting his youthful immaturity with the image of a man of substance.

Having become fabulously wealthy even before leaving university, Mikhail Morozov did not, however, neglect his historical studies. In 1894 he published two monographs in Moscow under the pseudonym M. Yuriev: *Charles V and His Time* and *Disputed Questions of Western European History*. For some time he also reviewed art exhibitions for the press; V. V. Perepletchikov described him as a 'critic and mischief-maker'. He took particular pleasure in tearing into major artists like Serov, although not quite to the extent of destroying his relations with them completely. He also tried his hand at literature with a novel entitled *In the Darkness* (1903), although the Committee of Ministers ordered that all copies of the first edition be destroyed: it was too easy

to guess upon which of society's leading lights the characters were based. Morozov donated vast sums to shelters and hospitals, and at one point he tried unsuccessfully to undertake the duties of treasurer for the Moscow Conservatoire. Concerts were frequently held in his private mansion. Morozov's wife later recalled a trip with her husband and Vasily Surikov: 'We went to see A. N. Scriabin's wife, Vera Ivanovna, who proceeded to play us a long programme of Scriabin's works. In the 1890s my husband and I were invited by V. I. Safonov to join the board of the Russian Musical Society. This position brought us closer to Moscow's musical world.'[67]

Above all Morozov was attracted to art. Like his younger brother Ivan, he was a keen draughtsman from an early age. For two years he had twice-weekly lessons with the young Konstantin Korovin, then a student at the School of Painting, Sculpture and Architecture, and he remained close to the first Russian Impressionist thereafter. Later, hurling himself from one field of activity to the next, Mikhail Morozov put away his paintbrushes (Ivan, who had studied in Zurich, carried on painting landscapes 'for the soul'). Nevertheless he continued to enjoy playing the role of arbiter in discussions and arguments on art.

From 1893 a lively group of artists began to gather at Morozov's Moscow mansion. These included Korovin, Vrubel, Serov, Vinogradov, Ostroukhov and Apollinary Vasnetsov, all of whose works Morozov collected enthusiastically, having converted his former winter garden into a picture gallery. Surikov was also a frequent visitor. At the same time canvases by Western artists began to appear at the house on Smolensky Boulevard. 'I remember the famous merchant Mikhail Abramovich Morozov, his wonderful mansion in Moscow, the stunning halls and rooms in various styles, the many paintings in the house – old, brown and dark. The owner would point out a picture, and spreading his hands wide apart would say: "They say it's a Raphael or a Murillo, but who can tell? Or what about this one – a Titian, although apparently the figure on the right – the child – is not his but Correggio's. Work that one out if you can".'[68]

This is a revealing remark. The combination of names in itself raises doubts. There is no trace of a single one of these 'many paintings'. But it is not difficult to imagine the situation: the former student historian, from an early age an ardent admirer of the great figures in European art, had successfully bought up what he thought were some 'big-name' pictures (as it happens, from the era of Charles V), and had been looking forward to impressing people with his master-pieces by Raphael and Titian. It is clear that he dispensed of these paintings on the quiet, and no one later remembered them. Early experience had taught Mikhail Morozov that the purchase of pictures had to be based on solid knowledge and strong intuition. He regarded conversations with prominent Muscovites and St Petersburg artists as the best way of gaining this knowledge. He associated more with the former, not just because he lived in the same town as they, but also because they always remained closer to his way of thinking. His brother Ivan followed the same path, for whenever he visited from Tver he did his best not to miss any of the gatherings at Mikhail's house.

From this point on, in order to avoid any mistakes, Mikhail only bought from the painters themselves. His love of socialising and his grand hospitality meant that it was not difficult for him to keep the company of artists, especially since, like Vinogradov, they were the same age as Morozov or only a little older, like Serov and Korovin. Of the older generation he was close only to Surikov, one of the founders of the Society of Wanderers. Soon the mansion on Smolensky Boulevard was decorated with such masterpieces as Vrubel's *Fortune-teller* and *Swan Princess*, and Serov's portraits of father and son – Mikhail Abramovich and son Micky Morozov.

'His collection, which was built up over some five years,' wrote Serge Diaghilev in his obituary of Morozov, 'was supplemented each year by works of art bought abroad and in Russia. We can only imagine what kind of gallery this collection might have grown into, had not death cut short such felicitous beginnings.'[69] A correction should be made: it took Morozov at least eight years to build up his collection, although it was only in the last five years of his life that its creative direction became fully defined. Thus while Korovin painted a 'decoration in the style of Corot' for Morozov in 1895, this was more as an adornment to the house than as part of his collection. Although the several superb Russian pictures were not enough to form an actual collection, the situation changed when Morozov began to bring back paintings from abroad.

'Mikhail Abramovich's first purchases were Besnard's *Intimate Fairy-tale* and Weber's *Battle of the Women*, both bought in 1897. His tastes soon evolved to the "left": the initial purchases were mostly returned to Paris, and their place was taken by some superb examples of Impressionism: Manet, Renoir, Degas and Monet. Two artists were particularly indicative of Mikhail Abramovich's boldness and perspicacity: Gauguin and Van Gogh, who were then not highly rated at all.'[70] *Intimate Fairy-tale*, which had caused such a stir in the French capital (Diaghilev even referred to it in his obituary) was Morozov's first major collecting success. He was undoubtedly flattered that the picture 'all Paris' was talking about had come to him. The absence of documentation means that there is little to be said about how the purchases were effected. It might seem logical to suppose that initially the collector developed an interest in the Impressionists, and only afterwards turned to their successors. In fact it may not have been like that at all, since in the galleries of Vollard and Bernheim-Jeune, which Morozov frequented, pictures by both sets of artists could easily be found. We know, for example, that Monet's *Poppy Field* was in the Bernheim-Jeune Gallery in 1901, and thus could not have appeared in Moscow before this date. At the same time, the majority of Morozov's Post-Impressionist pictures entered the collection in the last year of his life. We also know that on 8 May 1903 Toulouse-Lautrec's *The Singer Yvette Guilbert* (1894; Moscow, Pushkin Museum) was bought by the Bernheim-Jeune Gallery along with the collection of Arsène Alexandre. It can therefore only have passed to Morozov after this date.

The only clue as to how the collection was built up comes from these lines of Diaghilev's obituary of Morozov: 'From the beginning of this year he became the only person in Russia to own works by artists such as Bonnard, Vuillard, Denis and Gauguin, pictures that even in Paris

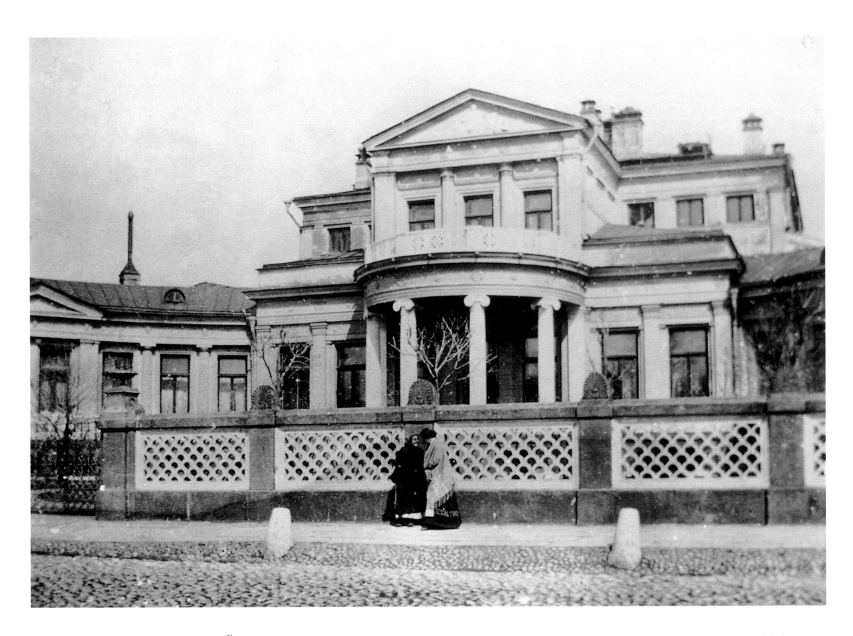

were not thought worthy of remark.'[71] Some clarification is necessary here: we know that the Shchukin brothers already owned works by Denis, and that there was no Vuillard in Morozov's collection (initially Russian critics frequently confused Vuillard and Bonnard). But there is no reason to disbelieve the statement that Morozov obtained pictures by Gauguin, Bonnard and Denis (to whom we should add Vallotton) only shortly before his death. The more intimate paintings of the Nabis might seem ill-suited to the collector's volatile temperament; nevertheless Morozov was the first person in Russia to rate such work highly.

It seems that Morozov discovered Gauguin even earlier than Sergei Shchukin. If we are to believe Korovin, he bought four pictures at the posthumous exhibition of Gauguin's work. 'He winked and proudly added, "I showed it to my brother and told him to have a look. He looked and looked and said: 'There's something in it...' Well of course there is. These are not your Impressionists".'[72]

The European part of Morozov's collection can be roughly divided into three groups. The first consists of non-French artists. As with Shchukin's collection, one of the very first pictures Morozov bought was probably a landscape by Thaulow (*Night*, mid-1890s; Hermitage). This was followed by other Scandinavians – Munch (*White Night*, c. 1899; Moscow, Pushkin Museum) and Gallen-Kallela (*River*, 1896; Moscow, Pushkin Museum) – and the Spaniards Gandara and Anglada. With the exception of Thaulow they all inclined towards Symbolism, and Morozov was really the only person in Russia who was seriously interested in Symbolist art. Morozov's group of Symbolists was later supplemented with works by Carrière and Denis. Shchukin also collected these last two, although for him they remained of secondary interest, while for Morozov this was clearly not the case. The second group of artists collected by Morozov was small, but consisted of indisputable Impressionist masterpieces led by Renoir's portrait of Jeanne Samary. The third group comprised the Post-Impressionists. This group was

M. K. Morozova, mid-1890s, by Nikolai Bodarevsky (present whereabouts unknown). At the turn of the century, Margarita Kirillovna Morozova was regarded as one of the most lively and attractive women in Moscow. After her husband's death she became a dedicated patron of the arts. A pupil of Scriabin, she took an active role in the musical life of the city. Her friends included the philosophers Trubetskoy and Bulgakov, the artist Serov, and the poet Bely. She directed her own publishing house, The Way. After the Revolution her house was nationalised and Morozova ended up renting rooms out of town.

37

made up of works by artists whose names have since faded (Déthomas, Guérin), and, more importantly, of canvases by Van Gogh and Gauguin: *Sea at Saintes-Maries* by the former (1888; Moscow, Pushkin Museum), *Te Vaa* and *Landscape with Two Goats* by the latter. Works by the Nabis may also be added to this group.

In terms of quantity the Western-European part of Morozov's collection was hardly enormous but its indisputable quality has earned it a worthy place in the history of Russian collecting. The pace at which he set off on his collecting career can only lead us to conclude that his early death deprived Russia of a collector of the stature of Sergei Shchukin.

Upon Mikhail Morozov's death his collection passed to his widow. Margarita Kirillovna Morozova (1873–1958) played a role in Moscow society no less important than her mother-in-law, Varvara Alexeyevna. 'The death of her husband was the beginning of a new era. Until then she had been a lady tired of life, but afterwards she became an enthusiastic pupil of Scriabin, even partly a disciple (at one stage, at least). When she got back to Moscow she was always in a fearful hurry, thirsting after new ideas – sometimes ridiculous, but often colourful; her mind swam with the most absurd concoction of Nietzsche, Kant, Scriabin and Vladimir Solovyov. Searching for self-fulfilment, but unable to decide where to direct her interests (whether towards art, philosophy or public works), she gathered around her the most contrasting elements imaginable, none of whom ever met outside her house, for friendly and intimate evenings of music and conversation.'[73] Thus wrote the poet Andrei Bely, one of Margarita Kirillovna's regular visitors, who was at one stage in love with her.

The words of P. A. Buryshkin, the historian of mercantile Moscow, give a different picture. 'With her co-operation and participation, religious and philosophical meetings were organised at her home, usually by Moscow philosophers led by Prince Sergei Nikolaevich Trubetskoy. On two or three occasions I managed to get into these extraordinary meetings – events of real significance.'[74] Buryshkin's irony may not be entirely out of place, if we consider the lady of the house's learned participation in the activities of the Solovyov Philosophical Society, as the fragile union of thinkers that gathered at Smolensky Boulevard was often known. But I heard from Trubetskoy's grandson, recounting the words of his parents, that although Margarita Kirillovna was hardly a brilliant woman, she had the rare gift of attracting intelligent and gifted people, who would never have met anywhere else.

Between 1903 and 1917 Margarita Kirillovna's life was filled with various endeavours and attempts to help others. She subsidised publications on art and philosophy (partly through her own publishing house, The Way), and participated actively in the music world. Although a first-class pianist, she only played at home, where her teachers were the composers Scriabin, to whom she provided material support for many years, and Nikolai Metner.

In March 1910 Margarita Kirillovna presented 60 of the 83 paintings in Mikhail Morozov's collection to the Tretyakov Gallery, presenting this action as the fulfilment of her husband's will.[75] Morozov's will, in fact, contained no mention of such a gift, although it is not impossible that the idea was expressed verbally. More likely, however, the donation to the Tretyakov Gallery was Margarita Kirillovna's own initiative. She selected the most significant works – all the Western-European paintings and the majority of the Russian – and kept for herself only family portraits and a few favourite pictures.

Ivan Morozov, *c.* 1908.

Ivan Morozov: the Man with the 'Amendment'

Mikhail Morozov's younger brother Ivan (1871–1921) began to assemble
his art collection later than the others in this circle, although his love
of art started at a very early age. 'Ivan Abramovich seemed to his mother
to be the son best suited to the role of head of the family business. And
indeed he really was born for this. He finished modern school in Moscow
and was then sent to Zurich, where he graduated from the university in
chemistry.'[76] In fact he graduated from the Polytechnical Institute,
where he studied engineering as well as chemistry. Having completed
his education in 1892 he settled in Tver, so that he would be able to have
direct control over production, and only returned to Moscow in 1900.

Shortly before his return, Ivan Morozov had bought an enormous old
house on Prechistenka Street in Moscow. Between 1904 and 1907 the
interiors were redone to make them as suitable as possible for hanging
pictures. After moving to Moscow, Ivan, following the example of his

elder brother, began to buy pictures. At first these were only works by
Russian artists. He set the standard with the purchase of a landscape by
M. K. Aladzhalov from an exhibition of the Wanderers in 1901. Then it
was the turn of rather more significant artists: Vrubel, Levitan, Korovin,
Serov, Golovin, Benois and Somov – the same artists that his brother
Mikhail collected. He rated Serov and Levitan particularly highly, and
like his brother rejected the older Wanderers, including even Surikov.
As time passed, the list of artists increased to include Kuznetsov,
Mashkov, Larionov, Goncharova, Kuprin, Konchalovsky and Chagall,
but not Kandinsky or Malevich – Ivan Morozov stopped short of the 'left'
movement. By the time he stopped making purchases his collection
consisted of 303 pictures and seven sculptures, the majority of which
are now in the Tretyakov Gallery in Moscow.[77]

Following in the footsteps of his brother, Ivan Abramovich decided to
supplement his collection of Russian works with foreign paintings.
It is likely that one of the first of these was the landscape *Sea Shore*

Preparations for the Corrida, 1903, by Ignacio Zuloaga (Hermitage). This was one of the first pictures acquired by Ivan Morozov. An enormous canvas (the two dressed-up, sultry Spanish women are depicted full size), it provides an instructive example of the new type of Salon painting which attracted the novice collector. The painting's merit lies not only in the sure execution, but also in such unexpected effects as the combination of El Greco's techniques and those of Impressionism. Reflecting the prevalent taste for Spanish themes, Morozov bought the work in Paris, but subsequently purchased mostly French paintings.

(1875; Moscow, Pushkin Museum) by the now-forgotten Russified German, Eugene Ducker. Later, in about 1903, he bought two striking Spanish works: Joaquin Sorolla's *Preparing Raisins* (1901; Moscow, Pushkin Museum) and Ignacio Zuloaga's *Preparations for the Corrida* (1903; Hermitage). Both bear comparison with Anglada's *Spanish Dance*, which had earlier been bought by Mikhail Morozov, and are bravura examples of Spanish painting.

With the purchase in 1903 of Sisley's landscape *Frost in Louveciennes* (1873; Moscow, Pushkin Museum), Ivan Morozov laid the foundations for the most important part of his collection: works by French artists. In the autumn of the same year he bought *The Apache's Dinner* by Louis Legrand (1901; Moscow, Pushkin Museum) at the Salon of the Société Nationale des Beaux-Arts. This work shows sound academic training: it is correct, if not particularly individual; the composition is skilful and the striking subject matter neatly conveys the relationship between the beautiful courtesan and her lover. Altogether it was a picture designed to please the majority of visitors to the Salon. But how different it is from another composition on a similar subject that, within five years, would also belong to Ivan Morozov – *Harlequin and his Companion* by Picasso (1901; Moscow, Pushkin Museum), a picture of powerful technique and astonishingly profound sentiment.

When he first entered the Parisian art market, Ivan Morozov was far from assured in his purchases, and he was assisted by his brother's former advisor, S. A. Vinogradov. On Vinogradov's recommendation he

bought Pissarro's *Ploughed Field* (1874; Moscow, Pushkin Museum) from Vollard in 1904. He then chose Sisley's *Garden of Ernest Hoschedé* and *Autumn Landscape* from the Durand-Ruel Gallery, although he returned the latter picture soon afterwards. Like Shchukin, he had an agreement with the dealer that he could return a picture if it did not suit his collection.

Over the first years of building up his collection (1903–5) Morozov's favourite painter was Sisley, and in 1905 another visit to the elderly Durand-Ruel secured him a further work by this artist: *Windy Day at Veneux*, which cost him 20,000 francs. Sisley's pictures had increased in value sharply over a few years, but Ivan Morozov was not looking for bargains: he took what he liked. It was to be another year before the first painting by Monet appeared in his collection – *Waterloo Bridge*. The choice of this picture was more an indication of the subtlety of Morozov's perception than of his boldness. He was attracted by the bright colours of the Impressionists, but predominantly chose paintings that were more restrained in terms of colour and tranquil in mood.

By this time, however, he was already achieving some considerable successes, including his purchase of Renoir's *Portrait of Jeanne Samary* in 1904 (1877; Moscow, Pushkin Museum). Ivan Morozov often stressed that he was continuing the work of his brother Mikhail, in whose collection pride of place belonged to a full-length portrait of the actress, but did Ivan actually take his brother's advice at this point? Certainly the circle of artists, both Russian and French, was basically described for Ivan Morozov by his brother. From the very outset, however, with each new purchase, Ivan showed that he was not simply mimicking his brother's example. This was not only demonstrated by his interest in Sisley, whom Mikhail ignored. In his attitude towards Monet, Degas and Renoir, whose work took pride of place in the house on Smolensky Boulevard, Ivan Morozov proved that he had his own point of view. Early on, his purchases were marked with an element of competitiveness. This rivalry of tastes was later to continue with Sergei Shchukin.

In 1906 the first pictures by Bonnard appeared in the mansion on Prechistenka – *Landscape at Dauphiné* and *A Corner of Paris* – as well as *Holy Spring at Guidel* by Denis. All three works are notable for the remarkable refinement of their colouring – particularly rare in the case of Denis, who was not always successful in his use of colour. 1906 marked Ivan Morozov's active participation in the Salon d'Automne, as part of which Diaghilev organised an exhibition entitled *Two Centuries of Russian Art*. Morozov loaned several of his paintings to the exhibition, at the end of which he was chosen as an honorary member of the Salon d'Automne and awarded the Légion d'honneur.

The year 1907 was a watershed for Ivan Morozov. The redecorating of the interiors of his mansion was completed. The Russian paintings that had hitherto predominated now had to be placed more closely together to allow space for the new acquisitions. Ivan Abramovich was intent on creating a gallery where French art would be displayed no less fittingly than in Shchukin's house.

The Apache's Dinner, 1901, by Louis Legrand (Pushkin Museum, Moscow). This striking pastel, which combines a non-Salon subject-matter with the new style of Salon art that was being promoted by the Société Nationale des Beaux-Arts, in opposition to the more traditional work of the Salon des Artistes

Français, was bought by Ivan Morozov soon after he started collecting. Morozov paid 1,500 francs for the pastel, and a few years later he also purchased Picasso's *Harlequin and his Companion*, a painting with a similar theme and completed around the same time. For the Picasso, Morozov paid five times less.

41

Morozov's purchases in 1907 revealed long-term plans. He did not concentrate on the works of one artist or even of one group. His sphere of interest encompassed the whole of French art over the preceding three decades. Such was the vigour with which he now operated, that he often outdid even Shchukin. 'The Russian who does not bargain' was how Vollard described him. Not bargaining, however, was not a sign of excessive haste. For this Russian was more thoughtful in his approach to collecting than almost anyone else. 'He is hardly off the train,' wrote Félix Fénéon, the eminent critic and artistic director of the Bernheim-Jeune Gallery, 'before you will find him at an art-dealer's, sunk deep in an armchair, made especially low so that it is difficult for him to get up, while canvases are paraded before him, like scenes from a film. By evening M. Morozov, who is remarkably attentive in his viewing, is too exhausted even to go to the theatre. After a few days following this regime he returns to Moscow, having seen nothing but pictures; some he takes with him, and these are the selected items.'[78]

Morozov's most striking successes were the works of Monet. He bought four canvases, each more significant than the next: *Boulevard des Capucines*, *Pond at Montgeron*, *Corner of the Garden at Montgeron*, and *Haystacks at Giverny*. *Boulevard* and *Haystacks* had formerly been

in the Faure collection. During the first exhibition of the Impressionists in 1874 one critic had written that Jean-Baptiste Faure was the only person to admire the Impressionists, if only because he always loved to be an original. At the second Impressionist exhibition half of Monet's pictures belonged to Faure. The Montgeron pictures had been in the collection of Ernest Hoschedé, a man who, like Faure, had been one of the few people brave enough to support Monet and his fellow Impressionists at the most critical moment of their struggle. Ivan Morozov found *Corner of the Garden at Montgeron* at the Durand-Ruel Gallery. At the same time, in Vollard's storeroom, he dug out a rolled-up canvas in rather poor condition, of similar proportions and with Monet's signature. Vollard sold it to him for a quarter of the asking price. He realised that the two pictures were connected, and indeed they had originally been painted as part of a series for Hoschedé. Thus began the remarkable section of the Morozov collection made up of unique decorative series of paintings by French artists. At the same time three masterpieces by Renoir were added to the collection on Prechistenka: *Bathing on the Seine: La Grenouillère* (1869; Moscow, Pushkin Museum), *Under the Arbour at the Moulin de la Gallette* (1875; Moscow, Pushkin Museum) and *Girl with a Fan*.

More important, however, were the first paintings by Gauguin and Cézanne, which Morozov acquired in 1907. At the time he had no particular preference for either one of these artists, and set about finding their best works. By then Sergei Shchukin was far ahead, and it might have seemed that there was no way of competing with him, particularly where Gauguin was concerned. Within a year, however, Morozov had acquired eight of Gauguin's most magnificent canvases (he collected eleven in total). Now Shchukin's 'iconostasis' was in competition with a group of pictures perhaps not so even, but no less remarkable in quality.[79] Certainly Morozov's works by Gauguin were not just beautiful: they were notable for an astonishing bright musicality. He began with *Matamoe: Landscape with Peacocks* (1892; Moscow, Pushkin Museum) and the more discreet, but no less expressive *Les Parau Parau: Conversation*. Within a few months the collector defined the boundary of his Gauguin ensemble with the purchase from Vollard's gallery of *Café at Arles* (1888; Moscow, Pushkin Museum) – the only work from Gauguin's Arles period in Russia – and *The Great Buddha* (1899; Moscow, Pushkin Museum). When he followed Shchukin into Gauguin's Tahitian paintings, he tried to present them in all their manifestations, from landscape and genre to Symbolist composition and still life.

Immediately after Gauguin, Morozov turned to Van Gogh. At that time their names were often mentioned in the same breath, and not just because in the autumn of 1888 they had worked side-by-side at Arles. Incidentally, the unusual contact between these two was nowhere more spectacularly reflected than in Morozov's collection, where two paintings on the same subject hung next to each other: Gauguin's *Café at Arles* and Van Gogh's *Night Café* (1888; New Haven, Yale University Art Gallery). More importantly, both artists, moving on from Impressionism, concentrated all their efforts on colour, and while quite different emotionally, there were similarities in the way the two artists

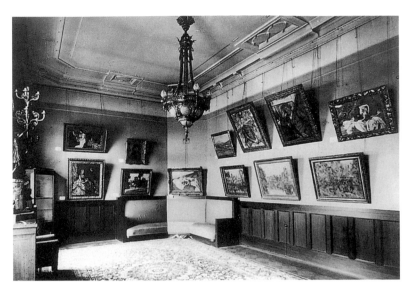

attempted to push colour to the very limits of its expressive power. Like Shchukin's, Morozov's paintings by Van Gogh were among the artist's greatest achievements, but of the two collections the Morozov paintings were more structured, more organised. Ivan Morozov, for example, would not have bought such a painting as Shchukin's *Arena at Arles*. It was perhaps appropriate that the first work by Van Gogh acquired by Morozov in 1908 should be *Cottages*, a work that, for all its expressiveness so typical of the artist, is nonetheless strictly organised. Morozov was deeply moved by the dramatic lucidity of *Cottages* and that other masterpiece *Landscape at Auvers after the Rain* (1890; Moscow, Pushkin Museum). Furthermore, he was greatly affected by *Night Café*, which was justifiably the most famous of the Van Gogh masterpieces in the Morozov collection.

In 1907 a posthumous exhibition of Cézanne's work was held at the Salon d'Automne. The significant influence of this exhibition on the fate of French and European art is well known. Ivan Morozov was one of the exhibition's most attentive visitors,[80] and it was at this time that he bought his first four paintings by Cézanne: *Road to Pontoise* (1875–7; Moscow, Pushkin Museum), *Mont Sainte-Victoire: View from the Road to Valcros* (1878–9; Moscow, Pushkin Museum), *Mont Sainte-Victoire*, and *Still Life with Drapery*.

Road to Pontoise dates from the Impressionist period, and Pissarro employed the same motif in *Les Mathurins, Pontoise* (1875); it is not unlikely that both pictures were painted at the same time. Morozov in all likelihood knew the Pissarro work (it was originally in the Durand-Ruel Gallery, and then later at the Cassirer Gallery in Berlin), and, comparing the two, saw how the master from Aix-en-Provence treated nature: he removed the clumps of trees, brought the background nearer and created a composition of such dynamism as could not have been expected of Pissarro (although Cézanne considered him his teacher). Cézanne's *Road to Pontoise* tells us more about its creator than it does about the natural motif itself, and it was precisely this quality that impressed Morozov.

In the first published account of the Morozov collection, S. Makovsky revealed not only his personal insights, but also the personal views of the collector. 'Cézanne's soul', he wrote, 'is most clearly expressed in the pictures that have no subject – the still lifes. By portraying countless times the same fruit and tableware, providing endless variations on the same theme – apples, pears or peaches, brightly staining the bluey-white of the crumpled cloth – he freed himself from compositional burdens, and became intoxicated with an insatiable thirst to "imitate nature". And this he achieved entirely, by seeing straight to the heart of nature in, as it were, its simplest manifestation; he attempted not so much to catch a perfect example of still life, not so much a substance in itself, as the very structure of that substance's fascination.'[81] These words related principally to *Still Life: Peaches and Pears* (c. 1890; Moscow, Pushkin Museum), Morozov's favourite still life.

One of the collector's other favourite pictures was Cézanne's *Blue Landscape*, the best example of Morozov's remarkably persistent pursuit of a picture. 'I remember during one of my first visits to the gallery,' wrote Makovsky, 'I was amazed to notice an empty space on a wall otherwise covered with Cézannes. "That place is reserved for a blue Cézanne (in other words, for a landscape from the artist's last period)", I. A. Morozov explained to me. "I've been looking at it for a long time, but I simply cannot come to a decision." For more than a year the Cézanne space remained empty, and only recently a wonderful new blue landscape, selected from among dozens of others, took its place alongside the other chosen ones.'[82]

The six further paintings by Cézanne that Morozov bought from Vollard in 1911–12 created a collection that was unrivalled in its extent. To the early masterpieces acquired three or four years earlier (*Girl at the Piano* and *Self-portrait*) and the later *Mont Sainte-Victoire*, were now added *Peaches and Pears*, *Bridge over the Marne at Créteil* (c. 1894; Moscow, Pushkin Museum) and *Portrait of Mme Cézanne in the Conservatory* (1891–2; New York, Metropolitan Museum of Art) – respectively the finest still life, landscape and portrait in the Cézanne oeuvre.

Music-Room in Ivan Morozov's house, 1912. Left panel (fifth in the series of Denis's *Story of Psyche*): *In the presence of the Gods, Jupiter grants Psyche immortality and celebrates her marriage with Cupid*; above the door (seventh panel): *Cupid carries Psyche to the heavens*. The furniture was designed by Denis.

The Story of Psyche. Seen here are the second, third and fourth panels of Denis's cycle, entitled: *Zephyr carries Psyche to the island of Bliss*; *Psyche discovers that her secret lover is Cupid*; and *The Vengeance of Venus: Psyche, opening the box of dreams of the underworld, sinks into sleep*.

43

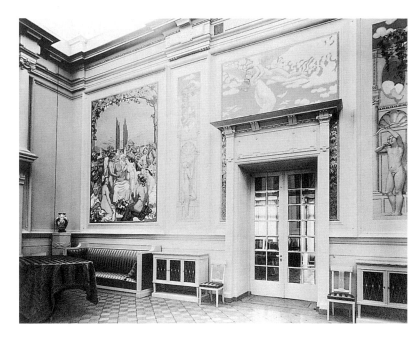
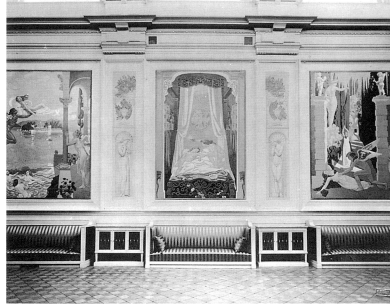

Morozov sometimes spent a long time wavering over works by the finest artists. His eye became extremely well-developed, but all the same he never lost a certain element of self-doubt. He required the advice of an artist friend or a trusted dealer to confirm his impulses. This was not to say that he always followed their advice; it was just that advice was essential as the first step in his dialogue with a work of art. 'When Morozov visited Ambroise Vollard,' said Matisse, 'he used to say, "I want to see an excellent Cézanne". Shchukin on the other hand would ask to see all the Cézannes on sale and would make his own choice.'[83] Both methods worked well since they suited the personalities of the collectors. For Cézanne, perhaps, whose works demanded particularly close attention, the second method gave the better results. Morozov, however, was able to rely on Vollard: however cunning the dealer may have been, he would not have allowed himself to offer the Muscovite collector anything less than a first-rate Cézanne. At the beginning of the twentieth century there is no doubt whatsoever that Morozov's Cézanne collection, consisting of eighteen masterpieces, was the finest in the world, although in number it took second place to the Parisian collection of Auguste Pellerin. Ivan Morozov was quite justifiably proud of his collection, and, when asked who his favourite artist was, he would invariably name Cézanne.[84]

As Morozov built up his collection piece by piece, he left a space not only for the blue Cézanne, but also for Manet, whom he considered to be one of the pillars of the new art. However, he needed not just a Manet, nor even a Manet of the highest quality, but one of the artist's finest landscapes, which would reveal his links with the Impressionists. For this reason Morozov did not respond to I. E. Grabar's advice to buy *Portrait of M. Pertuiset, the Lion Hunter* (1880–1; São Paolo, Museu de Arte). He also remained unmoved by *Bar at the Folies-Bergère* (1882), which now adorns the Courtauld Institute in London. He had the opportunity to buy this work at the exhibition *One Hundred Years of French Painting* in

St Petersburg in 1912; Morozov himself was on the exhibition's honorary committee. Strange as it may seem, at that time even the most knowledgeable Russian art-lovers reacted to *Bar at the Folies-Bergère* coolly.[85] This may have influenced Morozov, who was probably the only collector in a position to buy such a magnificent work.

There were many who knew of Ivan Morozov's interests, and he soon enlisted the help of Maurice Denis and Valentin Serov. Manet's wonderful landscape, *Rue Mosnier with Flags* (1878; former Mellon Collection), had belonged to Pellerin, who decided to sell his pictures by Manet and other Impressionists in order to buy some works by Cézanne. Such a sale could not take place without Vollard, who immediately wrote to Morozov in Moscow offering him the landscape. Morozov asked for assistance from Valentin Serov, who was in Paris at the time, but Serov considered the painting 'not interesting'. 'It has the look of a hurriedly completed sketch of a Parisian street... The general tone is not attractive. Overall the sketch is not particularly characteristic of Manet and is far from successful (in my opinion, I repeat).'[86] Morozov paid too much heed to the opinion of Serov, with whom he had often been to exhibitions in Paris, and he turned down Vollard's proposal. *Rue Mosnier* is one of Manet's boldest and most Impressionistic landscapes, and it is not surprising that Serov considered the work somehow second-rate. And in fairness it should be said that not all of Serov's advice was misguided. It was on his recommendation that Van Gogh's famous *Red Vineyards at Arles* (1888; Moscow, Pushkin Museum) and the *Prisoners' Round* (1890; Moscow, Pushkin Museum) were bought from Druet's gallery in Paris.

Fortunately, when Morozov turned from the 'old masters' of new art to the younger artists, he was altogether more decisive. By 1907 he already owned Matisse's *Bouquet*, its paint scarcely dry, and soon afterwards he bought *Blue Jug and Lemon*, which marked the beginning of Morozov's unique collection of Matisse's still lifes. These were followed

Music-Room in Ivan Morozov's house. On the side walls are the first and second panels of Denis's *Story of Psyche: Cupid in flight is struck by the beauty of Psyche* and *Zephyr carries Psyche to the island of Bliss*. Above the entrance is the sixth panel: *Psyche's parents abandon her on the mountain summit*.

Main staircase in Ivan Morozov's house. At the top of the stairs is Rodin's marble bust of A. G. Gabrichevsky (1911), in front of Bonnard's triptych *On the Mediterranean* (1911, Hermitage).

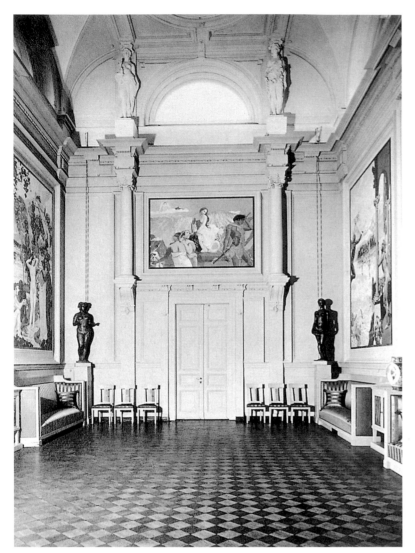

by Vlaminck's *Boats on the Seine* (1907; Moscow, Pushkin Museum) and *View of the Seine*, and Derain's *Drying the Sails* (1905; Moscow, Pushkin Museum) and *Mountain Road*. Paintings such as these were often bought at exhibitions and were usually inexpensive. *Mountain Road*, for example, was bought at the Salon des Indépendants in 1907 for 250 francs. Vlaminck's *View of the Seine*, one of the finest Fauve landscapes, was added for free by Vollard on top of a group of pictures that Morozov had bought. Vollard was hardly noted for his generosity, but with Ivan Morozov, as with Sergei Shchukin, he developed a special relationship. For Vollard and Kahnweiler co-operation with precisely this kind of collector was a mark of their own success in the pursuit of new art. Since the two collections in Moscow were developing into real museums with burgeoning reputations, the finest dealers had an interest in ensuring that genuinely exceptional works found their way there.

Ivan Morozov was not able to visit the Salon d'Automne of 1905, where *Drying the Sails* was one of the most scandalous of the pictures that marked the birth of Fauvism. A year and a half later, however, he made

up for the omission, and turned once more to Vollard. In addition to the works of Matisse, Derain and Vlaminck, works by Puy, Marquet and Valtat provided excellent examples of this new movement in French art that was working towards the total liberation of colour and brushstroke. All of these purchases highlighted the difference between Shchukin and Morozov. Shchukin was aware of his supremacy. It was he who introduced his young colleague to Matisse and then Picasso. He did not always understand Morozov's hesitancy, but he could not fail to respect him. Sometimes they would happen to visit exhibitions in Paris together. Their competitiveness remained, but now it played a secondary role, because both understood that they were supplicants at the same altar. Morozov's boldness cannot possibly be denied: how else could he have become interested in the Fauves so early? It was only compared to Shchukin that he showed indecision. Without decisiveness, however, he could not have been a collector of new art. Morozov's boldness was allied to a certain circumspection, and in this he had the advantage. Shchukin, as soon as he had conquered one summit, prepared for the next. At a given moment he would stop buying Monet and Gauguin, and turn his

attention instead to the very latest work. Morozov did not stand still, but whenever he had the opportunity to fill in a gap in his collection dedicated to the 'classics' of new art, he did not let it pass. For Shchukin, on the other hand, the classics eventually became a closed book.

They were different people,[87] although joined by a mutual interest. Ternovets wrote: 'Shchukin's passion was alien to Morozov. He was always careful and strict in his choices, fearful of harshness and quite unsettled. Morozov preferred a gentle rummage through Vollard's storerooms, while Shchukin's explorer's temperament led him to undiscovered shores. Morozov built his collection according to a clear, objective plan, calmly stringing one masterpiece after the next like pearls onto a thread.'[88] And elsewhere: 'The more expansive Shchukin liked to discover an artist, to cast him before an unsuspecting public; he was attracted to

the element of risk, and delighted in the amazement of his many visitors. The careful and reserved Morozov was less concerned with the pursuit of the latest innovators than with the creation of a full and clear representation of an era just passed.'[89]

'Perhaps we should put it this way', wrote Abram Efros, one of the finest Russian critics of the first third of the twentieth century. 'With Shchukin, the celebrities of Parisian art always appeared as if on stage, fully made-up, under pressure of performance. They approached Morozov quietly, intimately, unadorned. No sooner would a new reputation begin to reverberate around Paris than Shchukin would bare his teeth and, with a broad gesture, grab everything he could to carry off to Moscow. And as the young neophyte quickly became a master, it would transpire that his works were "at Shchukin's on Znamensky

Pereulok". Morozov, on the other hand, would spend ages looking fastidiously for something in a new artist that he alone understood; when finally he made his choice he would always introduce his own golden "amendment". "A Shchukin Master with the Morozov amendment": this is how I would describe the classic formula for Russian collecting of new West European art... This man with his "amendment" went about shrouded in silence, just as Shchukin went about surrounded by noise. Serov's "fashionable deputy" [Morozov], so well-proportioned and polished in the portrait, surrounded by invisible assistants and advisers, used to present his large, podgy figure at exhibitions unexpectedly, never on private views or busy days when all of Moscow might turn up. He would come on a normal working day, and would make his way through the empty halls alone and unhurried. People would greet him, but then leave him alone. He would view the paintings in zigzags, without any apparent order or system, neither along the walls, nor from one room to the next. He would walk into a room, go to one end then the other, come back, wander into some new corner... this was how I watched him at an exhibition of the Jack of Diamonds in 1916... And when he had left a painting behind, artists and admirers would gather before it. There was no argument: it was clear to everyone that Morozov had done what he usually did."[90]

Shchukin attempted to follow the main thread running through French art, which, in his opinion, stretched from the Impressionists to Cézanne, Gauguin and Van Gogh, and then to Matisse and Picasso. Artists of the Nabis group, who stood to one side of this continuous line, were therefore of little interest to him. Morozov worked differently, judging that even side-roads could lead to treasures, and this enabled him to find pictures of rare quality by Denis, Bonnard and Roussel. With Denis and Bonnard, Morozov established particularly strong links.

After the major refurbishment on Prechistenka Street, Morozov was struck by the opportunities his new rooms offered for unexpected and contemporary decorative designs. He decided that Maurice Denis was an artist capable of such work. The two had met in the spring of 1906, and in the summer of that year Morozov visited Denis at St Germain-en-Laye, outside Paris, where he reserved the unfinished *Bacchus and Ariadne* and ordered a complementary painting, *Polyphemus* (1907; Moscow, Pushkin Museum). A year later Morozov commissioned the *Story of Psyche*. Moscow had never before seen such a bold and ambitious commission for a private residence. Recalling his most significant works in old age, Maurice Denis referred in his diary to the Moscow ensemble, calling the time when he was working on it a period of 'ease and formula'.[91] Although the *Story of Psyche* is in fact not lacking in naturalness, it is refined and constrained in a manner more suited to the formulae of Art Nouveau. In Morozov's hall, decorative arts, sculpture and painting combined under a cover of fine architecture, but it was the paintings that predominated and set the tone. A little later, however, some large bronze statues joined the ensemble, which, in the context of European art, assumed greater importance than the paintings.

Denis introduced Morozov to Aristide Maillol, from whom the collector commissioned four figures for the Psyche hall. Maillol worked on the commission with great enthusiasm. Plaster casts of the first two statues – *Pomona* and *Flora* – were ready by the summer of 1910, and immediately met with success. Serov wrote to Morozov from Paris: 'Yesterday I saw the two Maillol statues made for you. They are very good – but the one with fruits is magnificent. This is real sculpture, original and complete.'[92]

Maillol became Morozov's favourite sculptor. In addition to the four large statues, the collector owned seven of his small bronzes. He also owned works by Rodin (*Eternal Spring* and *The Kiss*), Richard Guino, Henri Bouchard, Camille Claudel and Albert Marque, as well as several works by non-French artists. Overall, however, the sculpture section bore no comparison to the paintings: the only works that were worthy of the finest pictures remained Maillol's statues, which the collector had conceived as an addition to Denis's decoration, but which ultimately were the most outstanding part of the whole ensemble.

The success that the *Story of Psyche* had with his guests convinced Morozov to decorate the main staircase of his mansion with panels. This time he turned to Bonnard. It might have seemed that Bonnard did not have any particular qualities as a monumental artist, but his large triptych *On the Mediterranean* was to become one of the outstanding achievements of monumental decorative art. Bonnard had never been to Moscow, and the photograph of the staircase can hardly have given him a sufficient idea of the architectural space that he had to cover with his massive picture, divided into three parts by two demi-columns. One can only be astonished at how well Bonnard succeeded with the triptych. The secret of his success lay in his decision not to make the work a slave to the architecture. The painting is so full of *joie de vivre* and spontaneity that it would have made an impression in any context.

When Morozov, full of admiration for the triptych, commissioned two more panels from Bonnard, the artist turned to his habitual themes of early spring and late autumn (*Early Spring in the Country* and *Autumn: Fruit Picking*, both 1912; Moscow, Pushkin Museum).[93] These two paintings formed parentheses around the triptych, in which it is summer, and the whole ensemble thus became a cycle of the seasons. The triptych was to hang at the top of the staircase, fore-shortening the perspective; it therefore required a defined depth and illumination. The additional panels, intended for the side walls of the stairwell, were able to be more even and reserved in terms of colour. Here the patterned treatment of the trees is reminiscent of old tapestries.

Painting that revealed bright decorative qualities was always close to Morozov's heart, although not without exception. *Dance* and *Music* remained an enigma to him, although he rated Matisse's work highly and even intended to commission some decorative canvases from him. At the very beginning of 1913, Shchukin – not, presumably, without a certain irritation – wrote to Matisse: 'M. Morozov is always under the influence of other artists, who do not understand the evolution of your art over recent times. He wanted to commission you to decorate one of his rooms, but under the influence of these fine gentlemen he has bought instead a large panel by Bonnard for the room in question.'[94] On this occasion Shchukin was wrong to blame the decision purely on outside influences. The decisive factor was probably Matisse's slowness, since he had made Morozov wait too long for the completion of his previous commission.

The commission in question had been the Moroccan triptych (1912; Moscow, Pushkin Museum), which occupied pride of place among the eleven paintings by Matisse in Morozov's collection. Morozov had ordered two landscapes from the artist in the spring of 1911. As summer was drawing to a close, a letter arrived in Moscow: 'I have been thinking about your landscapes ever since I arrived in Collioure, but I fear that I will not manage to paint them this summer. Most likely I shall work on them in Sicily, where I intend to spend the winter.'[95] A year later another letter arrived: 'It is extremely painful for me to have to write to tell you that I have not managed to paint the two landscapes that I promised you, and that, as a result, they will not be at the Salon as I had told you. However, tomorrow I am setting off for Morocco, where I fully intend to paint them.'[96] It is likely that Morozov's commission was one of the reasons that persuaded Matisse to set off as soon as possible to work in the open air in the gardens of Tangiers. The overall design gradually changed and eventually resulted in three pictures entitled: *View from the Window, Tangiers; Zorah on the Terrace;* and *Entrance to the Casbah*. In the spring of 1913 Matisse informed Morozov with satisfaction that the triptych had met with great success at the exhibition of his Moroccan works. These various delays in fulfilling the commission would be hard to explain, were it not for the fact that Matisse, who had been to the house on Prechistenka Street, knew what a magnificent collection was on display there. He wanted his art, too, to be represented in the most fitting manner possible.

Whereas in Shchukin's collection Matisse and Picasso came sharply to the fore, Morozov deliberately avoided such an imbalance. He owned only three works by Picasso, but each one was a masterpiece. The first was *Harlequin and his Companion*, offered to Morozov by Vollard for the trifling sum of 300 francs. At that time Picasso stood only on the periphery of Morozov's field of vision, but within five years the collector had acquired two of the master's supreme works: *Girl on a Ball* (1905; Moscow, Pushkin Museum), the finest composition of the pink period, which had previously belonged to Gertrude Stein; and *Portrait of Ambroise Vollard* (1910; Moscow, Pushkin Museum), the supreme example of Cubism in the history of portrait painting.

In 1913 the collection was essentially complete. That year Morozov purchased two large decorative compositions by Roussel, Renoir's *Child with a Whip*, which had never before been shown in Moscow, and Cézanne's earliest romantic work, *Interior with Two Women and a Child* (c. 1870; Moscow, Pushkin Museum), as well as paintings by Marquet and Derain. He also intended to find works by Daumier, Seurat and Toulouse-Lautrec. But his habitual autumn journey to Paris in 1914 could not take place: the First World War had begun.

War and Revolution

The onset of war heralded the end of further additions to the collections of Ivan Morozov and Sergei Shchukin. And ahead of both men lay more serious trials. From February 1917 the situation in Moscow became increasingly uneasy. Already in the summer came rumours of anarchist groups forming, bringing with them the threat of robbery or 'revolutionary' expropriation. At the same time Shchukin joined the Moscow Council in charge of the arts, and then the Council of the Tretyakov Gallery. Unlike other collectors he had no intention of hiding away and craved activity. On 25 November (3 December by the new calendar) the newspaper *Novaya Zhizn* [*New Life*] reported that the famous collector Sergei Shchukin had suggested creating a national gallery from the five private Moscow collections of art, to be located in one of the Kremlin palaces. It is likely that this suggestion was considered even before the October Revolution. After it, the threats of total collapse began to appear with terrifying clarity. The collection had to be saved, but the new Soviet rulers had no need for 'bourgeois advice': they had their own ideas for the Kremlin. At the same time, with its slogan 'rob from the robbers' (or according to the supposedly 'academic' formulation of Lenin's Volapük, 'expropriate from the expropriators'), the government was letting the genie out of the bottle. It is true that they soon realised how this 'initiative of the masses' encouraged from on high easily acquired a criminal character; hastily rethinking, the new leadership began to take the necessary action. On 15 February 1918 the presidium of the Moscow Soviet ordered the recently created Commission for the Preservation of Works of Art and Antiquity to compile lists of private residences and palaces of particular value.

To help the Commission, a group of collectors came forward with the proposal that their collections and properties should be handed over to the Soviet Republic as a free gift and that they themselves should become their lifelong curators. This group comprised S. I. Shchukin, D. I. Shchukin, I. A. Morozov, A. V. Morozov, I. S. Ostroukhov, A. A. Bakhrushin and the heirs of L. K. Zubalov. The Commission accepted the proposal and declared in a decree of 5 March 1918 that the collections, together with the properties in which they were housed, were 'protected on an equal basis to other government depositories of works of art and antiquity'.[97]

But such decrees are easier to make than to implement. Anarchists seized Alexei Vikulovich Morozov's house and its unique collection, which came under the nominal protection of the resolution. The threat of plunder hung over other properties as well. Given the circumstances, this pillaging was just as likely to take place through 'revolutionary' initiative as it did on the authority of representatives of the self-styled government. Ivan Morozov recounted how he was once confronted by the envoy of some province who was ordered to 'requisition' a number of paintings purely on the grounds that the region had no works by Cézanne or Derain. It was only with the help of Grabar, then head of the Tretyakov Gallery, though more importantly right-hand man to the wife of Trotsky, that he was able to fight off this uninvited 'enthusiast'.[98]

For Shchukin, too, came a glimmer of hope. A man appeared in Moscow on whose patronage he could depend: the historian M. N. Pokrovsky, who was married to Lydia Shchukina's cousin. Pokrovsky, who had been in trouble as a student activist and sent into political exile where he was financially assisted by Shchukin, was now appointed assistant to Anatoly Lunacharsky, the People's Commissar for Enlightenment; according to the Bolsheviks' apportionment, it was this department that had responsibility for museums and collections. But the support of this former member of the Russian Social-Democratic Workers Party did not extend to deviating from the 'principles of social justice'. Shchukin had to submit to the general hardening of attitudes, and leave the rooms he shared with his family. Yury Annenkov, who at the time was painting portraits of one Bolshevik leader after another, told how he went to visit Shchukin's house with Trotsky, a great admirer of Picasso: 'On one occasion we called in at Shchukin's museum which is not far from the Revolutionary Military Council.[99] The museum had been nationalised and Shchukin himself – the man who discovered Picasso, discovered Matisse, the same Shchukin who had created in Moscow this priceless museum of the latest European painting – this most generous Shchukin was allotted in his own house "the servant's room" near the kitchen.'[100]

More terrible than domestic discomfort was the danger of arrest which Shchukin, as representative of the prominent bourgeoisie, underwent every hour of every day. He feared for his family above all. In 1915 he had embarked on his second marriage, to the pianist N. A. Konius. His last child, Irina, was born shortly after, and with the joy of late fatherhood also came constant worry. The state nationalisation of various industries carried out in the early summer of 1918 by the Soviet authorities convinced Shchukin that former owners, now without a role, would not be left in peace, and that to remain in Russia would be unsafe; this feeling was reinforced by his own experience of spending several

days under arrest. That summer he secretly sent his wife and daughter to Germany. Jewellery sewn into his daughter's doll proved invaluable a little later when Shchukin, once he knew that they had safely crossed the border, illegally joined them with his son Ivan. Of all his numerous journeys this was the most dangerous, and they were forced to travel light since any luggage would have aroused suspicions.[101]

In Moscow, meanwhile, museum organisation began to be put on a new footing. In October 1918 Lenin, Lunacharsky and Bonch-Bruevich signed a decree 'concerning the registration, inventory making and protection of works of art and antiquity in the possession of private individuals, societies and institutions'. It is most likely that the Shchukin Gallery was considered its most important target, and registration of the gallery was begun even before the decree's publication. Point 4 of the official instruction declared: 'Owners of registered works or collections will provide assistance in the matter of their curatorship and will be issued passes.' Point 11, however, bore a more ominous message: 'Those found guilty of non-fulfilment of this decree will be called to account with all the severity of the revolutionary laws, including the confiscation of their entire property, and loss of freedom.'[102]

The sculptor S. T. Konenkov, who was on the board dealing with museums and the protection of works of art and antiquity, recalled how he took a pass to Ivan Morozov. 'Ivan Abramovich was deeply concerned about the fate of the collection to which it can be said without exaggeration he had devoted his entire life. Some military institution had taken up residence on the first floor of Morozov's house on Prechistenka (now renamed Kropotkin Street), and of course they had rushed up the elegant white stone staircase leading to the second floor, where his unique collection of paintings was to be found in a suite of rooms arranged as a museum. Morozov noticeably cheered up on my arrival.'[103] It is likely that during the house's occupation by official institutions some of the furniture began to disappear – an insidious process responsible for the fact that today, of all the furniture created from drawings by Maurice Denis, only two chairs and one closet survive.

After the People's Committee's instructions regarding the nationalisation of the royal palaces and monasteries, it was the turn of the private collections. The first to undergo 'socialisation' was the gallery of Sergei Shchukin. On 5 November 1918 a decree was published in *Izvestia* signed by the chairman of the People's Committee V. Ulyanov [Lenin] and the executive manager V. Bonch-Bruevich which stated: 'Given that the art gallery of Shchukin represents an exceptional collection of great European masters, above all French masters of the late nineteenth and early twentieth centuries, and that its high artistic value gives it state-wide significance in terms of public education, the Soviet of People's Commissars has decreed: 1. That the art collection of Sergei Ivanovich Shchukin is declared state property of the Russian Socialist Federation of the Soviet Republic and its control is handed over to the People's Commissariat for Enlightenment on the same basis as other state museums. 2. That the building in which the gallery is housed (no.8 on Bolshoi Znamensky Pereulok), as well as its adjoining plot of land, formerly the property of S. I. Shchukin, is handed over with its entire

contents to the control and direction of the People's Commissariat for Enlightenment.'[104] The decree that appeared some six weeks later announcing the immediate nationalisation of three of the largest collections (those of I. A. Morozov, A. V. Morozov and I. S. Ostroukhov) made no mention of public education and was considerably more curt: 'these [collections] are declared state property'.[105]

By November 1918 Shchukin's gallery was already in operation as a state museum: the First Museum of Modern Western Painting. This did not require any great effort: the paintings already hanging were left unchanged. With Morozov's gallery, however, which was designated the Second Museum of Modern Western Painting, the situation was more complicated. It was not until the beginning of May 1919 that it opened to the public. On 11 April the Board dealing with museums and the protection of works of art informed Ivan Morozov of the following: 'B. N. Ternovets is appointed head custodian of the museum; you will be his assistant. Furthermore, V. V. Denisov is appointed political commissar.'[106] What possible role could the collector play alongside the new museum head and the political commissar?

Morozov's collection had originally occupied both floors of the house. After October 1917 the first floor was initially used as a hostel for workers of the Moscow military district; it then became the library store for Yaroslavl University, the Literature department of the Main Archive, the Chekhov Museum, and the nationalised collection of D. I. Shchukin. In the general confusion, with the most unlikely institutions being created and constantly expanding, the top floor was also under threat. Ivan Morozov, growing tired of the constant struggle and the nonsensical situation in which he was embroiled, managed in the summer of 1919 to gain permission to go abroad for necessary medical treatment. He settled in Germany, went on a trip to Paris and then returned to Carlsbad, where he suddenly died.

Sergei Shchukin settled in France. He was now a changed man, and no longer sought meetings with artists. Matisse, when he heard of his arrival in Nice, tried to resume contact, but Shchukin purposefully kept himself apart. Only once did he succumb to temptation when, together with Matisse, he went to visit Renoir in neighbouring Cannes (Renoir died shortly after this visit). Clearly Shchukin could not play his former role. The artists whom he had patronised had now achieved international recognition, and however friendly they still were towards him, Shchukin no longer felt on an equal footing. Deprived of his former riches, Shchukin was now in no position to collect. Galleries, keen to use his name to promote certain artists, would offer him money to buy pictures on their behalf; such a role, however, was demeaning to him. 'S. I. refused to do this, but said that had he been able to collect, he would have collected Raoul Dufy.'[107]

Dufy was an artist that Shchukin had let 'slip through his fingers' before the war. But the main reason for his interest in him probably lay elsewhere: Dufy caught with extraordinary precision the post-war mood in European society, the chaotic spirit of the *folle époque*. Shchukin, with his heightened awareness of period, was inevitably drawn to such

I. V. Stalin and K. E. Voroshilov in the Kremlin, 1937, by A. M. Gerasimov (Tretyakov Gallery, Moscow). This enormous canvas, one of the clearest examples of Socialist Realism, was painted by Gerasimov, the future president of the USSR Academy of Arts, for an exhibition, *Twenty Years of the Red Army* (1938).

The servile Gerasimov called the painting *Guardians of the Peace*, but it quickly became known as 'Reigning Leaders after the Rain' (Russian: 'Dva vozhdya posle dozhdya'). The artist has subtly flattered Stalin and his Minister of War: here they cut imposing figures, belying their small stature.

work. He was unable to restrain himself and did in fact buy three of Dufy's canvases. More intimate with Le Fauconnier, he commissioned several paintings from him. He also owned a portrait drawing of his own sister-in-law by Picasso. But this was the full extent of his new collection, if it can be so described.[108]

In Russia, meanwhile, after the first stage of museum organisation there followed a restructuring. In 1923 the Shchukin and Morozov collections were merged, and the new State Museum of Modern Western Art acquired works from several nationalised collections: those of M. P. and N. P. Ryabushinsky, S. A. Shcherbatov, M. O. Tsetlin and others. In 1925 the Western European paintings given by M. K. Morozova to the Tretyakov Gallery were also transferred to the Museum of Modern Western Art, the Tretyakov receiving in its turn Russian paintings from the Morozov collection. However, fairly soon after this concentration of all the new Western art into the Morozov residence, the Museum of Modern Western Art had to forgo part of its collection, which was handed over to the Hermitage owing to exchanges between Moscow and Leningrad. This first stage in the exchanges coincided with a tragic period in the life of both cities' museums: some of the best works of art were secretly sold to Western buyers (the secret, of course, was only kept from the Soviet people)[109] with the sales originally being carried out in Berlin. Certain complications arose from these sales due to the emigrants whose collections had been nationalised: 'It was also said that S. I. Shchukin was planning to save his collection through legal means. I remember that when I asked S. I.

Evacuation from Sverdlovsk, 3 October 1945. The photograph shows trucks belonging to the Urals Military District outside the entrance to Sverdlovsk Art Museum. They are being loaded with crates containing works of art from the Hermitage that had been stored at the museum during the course of the war. After four years' safekeeping in the Urals, during which time the contents of the crates were not even unpacked, the works of art were finally returned to Leningrad in two consignments at the beginning of October 1945.

51

whether this was true, he became very agitated. He always stammered, and now began to stammer even more and said: "You know, P. A., I was doing it not so much for myself but for my country and my people. Whatever may become of our country, my collections must remain there".[110]

For the time being the emissaries of the Antiquariat, the body set up to raise funds from the sale of art, took instruction as much from the People's Commissariat for Foreign Trade as from the GPU [secret police], and they did not disturb the Museum of Modern Western Art. The main object of plunder was the Hermitage, with its renowned picture gallery, from which masterpieces by some of the greatest artists, including Van Eyck, Raphael, Titian, Perugino, Rubens, Van Dyck, Rembrandt, Hals and Poussin, were removed without compunction. But in 1932 it was finally the turn of the Museum of Modern Western Art. Andrew Barnes, who owned the only collection in the West that could rival the Shchukin

and Morozov collections,[111] began to put out feelers regarding paintings by Cézanne. For *Mardi Gras* the Antiquariat asked 450,000 German marks. Doubtless the price was considered high, and it led to nothing. The Antiquariat's activities in the American art market were necessarily conducted with great care and secrecy. Potential buyers in America were wary of transactions that could result in legal action being taken by the former owners of nationalised collections, or by their heirs. At the beginning of 1933 it became clear that the new president of the United States, Roosevelt, was likely to recognise the Soviet Union, and that consequently America – as a result of the possible risk of various prosecutions – would cease to serve as a convenient place for such transactions. The Antiquariat and the Knoedler Gallery in New York, with which it was secretly associated, took immediate action. (It is worth noting that in the background lurked none other than Armand Hammer, that well-known 'friend' of various Soviet leaders, who later came to own the gallery.) In April, the director of the Knoedler Gallery sent the following telegram:

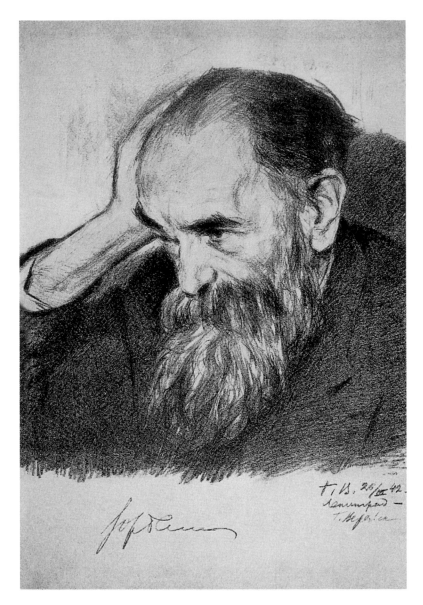

'Have client extremely interested in Cézanne's *Madame van Gogh's café* Renoir's *Waitress* Degas' *Green Singer*. Could you name an interesting price...'[112] The client turned out to be the collector Stephen Clark, and the paintings were despatched to him there and then.[113]

Fortunately for the various Russian collections, it was just at this time that political changes on the world scene forced the Soviet government to desist from further sales. Hitler's rise to power meant that the People's Commissariat for Foreign Trade could no longer use Germany as a place to trade in Russia's national property. Furthermore, Stalin and his circle began to realise at last that such sales, which undermined the country's prestige, brought few advantages in return. In the thirties the storm clouds that gathered over the Museum of Modern Western Art became increasingly threatening. The period of post-revolutionary cat-and-mouse between the authorities and the avant-garde was well and truly over. There was now no shortage of volunteers willing to prove that

the paintings in the Museum of Modern Western Art were generally harmful to the workers. In an attempt to save the museum, its directors gradually made concessions to the ruling ideology. They tried to show that the so-called revolutionary art of the West was an active propaganda tool. This art, as a rule, was of an amateurish standard and its popularisation did not extend beyond the limits of its political application. But to high-ranking comrades the very existence of the museum was unacceptable.[114] Had war not broken out in 1941, the museum would doubtless have closed earlier. The war resulted in the evacuation of all the paintings to Siberia. The large canvases were rolled up, and remained in this state for several years. The museum itself suffered from the bombing.

After their return to Moscow, the pictures were temporarily housed in the storerooms of the Museum of Eastern Culture. The repairs to the Morozov mansion had been carried out, but the re-opening of the Museum of Modern Western Art continued to be delayed. 1948 was a year noted in Russian history for ideological struggles and campaigns: against Weismannism/Morganism, Formalism, Cosmopolitanism and admiration for the corrupt West. V. S. Kemenov, once a post-graduate at the Museum of Modern Western Art and later to become the *éminence grise* of the USSR Academy of Arts, who had attained a prominent position in the KGB, wrote a series of articles providing pseudo-academic grounds for lambasting Picasso. And Alexander Gerasimov, the first president of the newly founded Academy, and painter of the endlessly reproduced *Lenin at the Rostrum*, was even more outspoken: 'If anyone dares to exhibit Picasso, I'll hang him.'

The re-opening of the Museum of Modern Western Art now depended on Stalin himself, and his acolytes did their best to second-guess him. At that time the member of the Politburo responsible for culture was Marshal K. E. Voroshilov. It was later said that Voroshilov's reputation in the highest party circles as a man of culture was based on his enormous library, made up of books confiscated at one time or another. This was the man whom the curators of the museum awaited with fear: a talentless military man, who before the Second World War had had a hand in the murder of practically the whole of the Soviet high command, and who had brought about the collapse of several of the most important operations during the war itself. Almost overnight the curators were ordered to re-hang the whole exhibition. N. V. Yavorskaya, who was head of the museum's academic work at the time, recalled these events forty years later: 'Someone high up guessed that we had been canny, and were not showing the "risky" pieces (it seems strange to write about it now, when all of these works are on display in the Hermitage). There was another telephone call. A. K. Lebedev[115] ordered that by 11 o'clock the following morning (that is, in time for Voroshilov's visit) Matisse's *Music* and *Dance* should be taken off their rolls and put on display. I presented various reasons why this was impossible: in order to unroll the paintings we needed the restorers, and none of them were about. But restorers were provided, and we laid both of the Matisse panels out on the floor. It is true that we placed Jean-Paul Laurens's rather more realistic *Last Moments of Maximilian* alongside.'[116] When the Marshal arrived, accompanied by Alexander Gerasimov, 'he started his visit not from the beginning, as we had intended, but from the end. So it was

S. D. Merkurov working on his monument to Gogol, 1947. Sergei Dmitrievich Merkurov (1881–1952) was singled out in his youth as one of Russia's foremost sculptors. He was commissioned to do the death mask of Tolstoy in 1910, and of Lenin in 1924. Under Stalin, Merkurov enjoyed a privileged position, undertaking the most coveted official commissions, and gradually dissipating his great talent. The Soviet regime was consumed by megalomania, and Merkurov proved suited to the role. In 1944 he was made director of the Pushkin Museum, helping to strengthen its position during the difficult post-war years.

53

that he came straight to the Matisses. When Voroshilov looked at the paintings, he let out a "heh-heh", and his whole suite followed with their own "heh-heh-heh". Many years have passed, but I can still hear this tittering chorus ringing in my ears.'[117]

The fate of the museum was decided; in essence it had already been decided before this high-ranking visit. The USSR Academy of Arts moved into the Morozov residence, celebrating its victory over such despised art, and from that moment on declared a vicious war on 'bourgeois influences'. The academy's installation in the enemy camp was seen as a symbolic act. 'The museum section of the Arts Committee decided to disperse the works among various provincial museums, and to destroy several completely. Only the best were to be given to the Museum of Fine Arts [Pushkin Museum] and to the Hermitage.'[118]

Until recently these words of N. V. Yavorskaya seemed little more than an echo of unfounded rumours. However, the publication in 1998 of a secret government resolution, signed by Stalin himself, has provided firm evidence. The resolution reads:

'The USSR Council of Ministers considers that the State Museum of Modern Western Art in Moscow contains within its collections principally works of Western-European bourgeois art of a non-ideological, anti-national, formalistic nature, which are lacking in any kind of progressive or educational significance for the Soviet visitor. These formalistic collections belonging to the State Museum of Modern Western Art were bought in Western-European countries around the end of the nineteenth and beginning of the twentieth centuries; they have been a breeding-ground for formalistic viewpoints and servile obeisance to the decadent bourgeois culture of the age of Imperialism, and have brought great harm to the development of Russian and Soviet art. Displaying the museum's collection to the popular masses is politically harmful and promotes the spread of alien, bourgeois, formalistic views in Soviet art. At the same time, the art museums of the capitalist Western-European countries and America are wholly lacking in any display of this country's works of art, not only contemporary, advanced Soviet art, but also works by the progressive artists of the great Russian Realist School, the important educational significance of which is incontrovertible. The USSR Council of Ministers thereby RESOLVES: 1. To liquidate the State Museum of Modern Western Art. 2. To oblige the Arts Committee of the USSR Council of Ministers, a) under the personal responsibility of comrades P. I. Lebedev and P. M. Sysoev[119] to select the most valuable works from the collection of the State Museum of Modern Western Art and within 15 days to hand them over to the A. S. Pushkin State Museum of Fine Arts and other art museums... b) within 10 days to transfer the building as well as the furnishings and museum-exposition material of the State Museum of Modern Western Art, Moscow, to the USSR Academy of Arts... [Signed by] Chairman of the USSR Council of Ministers, J. Stalin'.[120]

This selection of 'the most valuable works', whether carried out by Lebedev, Sysoev or whoever, could have resulted in catastrophe for many of these paintings that were declared formalistic and 'anti-

national', particularly since the Pushkin Museum, the intended destination for most of the works from the State Museum of Modern Western Art, essentially did not have enough space to house them.

At this point I. A. Orbeli, the director of the Hermitage, set off for Moscow to meet the director of the State Museum of Fine Arts, S. D. Merkurov. The former was an archaeologist, far removed from and disapproving of modern Western art. The latter, Merkurov, had shown some interest in such art in his youth, when he studied at the Munich Academy of Arts, and later when he worked in Paris. His granite statue of K. A. Timiryazev (1922) remains one of the finest works of Russian sculpture. Soon after this, however, Merkurov had placed his studio at the service of the Stalin regime. He was rewarded with the most 'responsible' commissions for enormous statues of Lenin (although the most monumental, which was to adorn the Palace of the Soviets, was never made), and works in honour of the 'people's leader', Stalin.

For all their dissimilarities, however, these two directors did have something in common: both were supreme courtiers, but also powerful people, who were able to act decisively when circumstances demanded it. Orbeli and Merkurov immediately reached agreement over the division of the Museum of Modern Western Art.[121] The speed with which the museum was closed down – a process from which all the museum's curators were excluded – was reflected in the haphazard distribution as a whole; sometimes even works of one group of paintings were separated. The logic behind the process was clear: the Pushkin Museum, where the distribution was actually taking place, obviously had the upper hand, and managed to keep the earliest paintings in Moscow. Thus Moscow retained not only pictures by Courbet and Manet, but also the more realistic, semi-Salon works of Bastien-Lepage and Dagnan-Bouveret. Most of the works of the Impressionists and Post-Impressionists were moved to the Pushkin Museum as well. The division was as follows (the first number indicating those paintings given to the Pushkin Museum, the second

those that went to the Hermitage): Monet, eleven against four; Renoir, five against three; Degas, four against two; Pissarro, three against one; Cézanne, fourteen against seven; Van Gogh, five against two; Gauguin, fourteen against eight. In a few cases, where the Hermitage had already received works from the Museum of Modern Western Art, the new distribution evened things out: both museums had three Sisleys, while the Gauguins were almost evenly shared – fifteen in the Hermitage and fourteen in the Pushkin Museum (although it is true that the artist's major works stayed at the latter museum). More often the numbers were weighted in favour of the Moscow museum, even taking into account transfers carried out in the 1930s: Monet, eleven against eight; Cézanne, fourteen against eleven; Signac, three against one; Henri Rousseau, four against three.

The situation regarding the work of Matisse, Derain and Picasso was very different: to these the Moscow museum made no particular claim. Shchukin's collection of Cubist works by Picasso was handed over to the Hermitage without a tear shed. The Pushkin Museum had far more severe problems in terms of both exhibition and storage space.[122] Clearly it was more difficult to find room for the larger canvases, particularly when such pictures were accompanied by the risk of 'ideological decadence'. Orbeli, meanwhile, paid some attention to the opinions of experts, and did not hesitate to secure for his museum pictures that, while out of step with Socialist Realism, played a fundamental role in the history of twentieth-century art: Matisse's *Red Room*, *Dance*, *Music* and *Family Portrait*; Picasso's *Two Sisters*, *Dance with Veils* and *Three Women*; Derain's *Portrait of an Unknown Man Reading a Newspaper*; and Bonnard's triptych, *On the Mediterranean*.

While the transfers of the early thirties had brought 93 pictures to the Hermitage, following the post-war exchanges the museum now had more than 150. Among them were canvases that were already recognised by authorities in the art world, albeit not by the Soviet leadership, as classics of nineteenth-century painting: Monet's *Corner of the Garden at Montgeron*, Renoir's *Portrait of Jeanne Samary*, Van Gogh's *Memory of the Garden at Etten*, Gauguin's *Woman Holding a Fruit*, and two works by Cézanne – *Large Pine near Aix* and *Mont Sainte-Victoire*. By this time the collection of late nineteenth- and early twentieth-century French art had reached such proportions that it bore comparison to the art of the Old Masters, acquired by the museum long before. In 1948, as well as the pictures from the Shchukin and Morozov collections, the Hermitage also obtained from the Museum of Modern Western Art[123] works from the 1920s by such artists as Léger, Lhote, Ozenfant, Survage, Favory and Alix. These works, of course, are vastly inferior when compared to the paintings of the previous period; nevertheless, they provide an unbroken line running through the development of French art.

Now enriched beyond imagination, the Hermitage was unable to display a single one of the paintings it had received from the Museum of Modern Western Art. For a long time they were kept in Storeroom 'A', where they could be viewed only by a few artists who were able to pull strings, or occasional Western experts with special permission.

Overleaf: **View of Palace Square and the General Staff Building** (Rossi, 1819–29) from the Winter Palace. Before the Revolution, the Ministry of Foreign Affairs and the Ministry of Finance occupied the wing to the left of the arch of the General Staff building. A few years ago this wing was handed over to the Hermitage. Restoration work is currently being undertaken inside, with the intention of transferring the gallery of nineteenth- and twentieth-century French art from its present location in the Winter Palace to this building.

55

After Zhdanov's cultural pogroms, it was virtually an act of suicide to exhibit new Western art. It was only after Stalin's death – from the mid-1950s – that little by little this art became accessible to the public. First it was the Impressionists, followed by Cézanne, Van Gogh and Gauguin. At the end of the 1950s many of Matisse and Picasso's works were still languishing in storage. At the beginning of the next decade the majority of 'new Western' works – which by then were hardly new – were displayed in the museum's galleries.[124] Since then the pictures that once belonged to Shchukin and Morozov have been sent more and more frequently to overseas exhibitions. Their life in the Hermitage has taken on a new meaning. For in a museum of world art, these canvases, hanging alongside the most exalted works of antiquity, provide a link in the chain of world culture.

It should be noted that additions to the collection did not cease after 1948. However, the quality of the new acquisitions could hardly be expected to match those astonishing 150 works. Resources for purchases on the internal art market were and remain severely limited, particularly with regard to new Western art. And, indeed, where was the Soviet Union to find such resources, particularly during the decades in which it was separated by an iron curtain from the rest of the world? On the rare occasions that Western paintings did turn up in the hands of collectors, they were insufficient to form the basis of a collection with a clearly identified context, and would normally be sold on the open market or offered to museums. The Purchasing Committee of the Hermitage did manage to buy pictures by Eugène Isabey, Harpignies, Troyon, Winterhalter, Carolus-Duran, De Neuville and Friant, as well as a particularly fine late work by Millet, *Landscape with Two Peasant Women*.[125] Of works from the turn of the century, the most notable were Redon's pastel *Woman with Wild Flowers*, and a rare early work by Dufy, *Portrait of Susanne, the Artist's Sister*. Later works of importance included the watercolour book by Blaise Cendrars and Sonia Delaunay-Terk entitled *The Poem of the Trans-Siberian and of Little Jehanne of France*. One special success was the purchase of three marvellous sculptures by Bourdelle from the artist's daughter (at a time when it was extremely difficult to get money from the Ministry of Culture); hitherto this artist's work had not been displayed in the museum.

A significant role in these additions was played by donations. A drawing by Marquet was presented by his widow, while the family of Maurice Denis gave studies for *Sacred Grove* and a wonderful early drawing for the first panel of the *Story of Psyche*. The Hermitage also received Picasso's drawing, *Scenes from the Ballet 'La Boutique Fantasque'*, presented to St Petersburg by the dancer Mikhail Baryshnikov. Although not often recognised, an important contribution was made by gifts from Lydia Nikolaevna Delektorskaya, who was Matisse's secretary and assistant for many years. Matisse's late painting was at last represented in the museum thanks to two of her portraits. The same can be said for the sculptures and perfect drawings by Matisse that Lydia Delektorskaya also gave to the museum, part of his oeuvre previously unrepresented at the museum. With these additions the Matisse collection is now unparalleled in its breadth.

In more recent times some extremely important steps have been taken to add to the Hermitage's collection. However perspicacious Morozov and Shchukin may have been, they were unable – indeed, did not try – to collect everything. As time leaves its mark, we not only come to appreciate the marvellous achievements of these collectors, but also feel more sharply what their collections lacked. Filling in the gaps in such a collection is a complex task; any new work must be treated with extreme scrupulousness. Sadly items worthy of the Hermitage, which in Shchukin's time might have been relatively inexpensive, are now too costly. Money is always the issue. The importance, therefore, of the initiative of Boris Yeltsin in 1997 should not be underestimated: the president of Russia assigned special funds to the museum for broadening its collection. The initial funds were directed at strengthening the new French art collection, with the aim of correcting some of the most obvious omissions. The first purchase was of Boudin's *Beach at Trouville*,[126] a picture that places the artist on a level with his great student Claude Monet. Another landscape, *Rue Custine in Montmartre*, is the first work by Utrillo in the Hermitage collection, where it takes its proper place alongside a painting with which it demands comparison: Pissarro's *Boulevard Montmartre*. Pissarro's work combines the liveliness of a momentary impression with the fleeting splendour of the *belle époque*; alongside it, the gloomy foreboding of Utrillo's treatment of the same subject is all the more strongly felt.

The acquisition of Soutine's *Self-portrait* was not just a first for the museum: the painting is also one of the most significant creations of European Expressionism, and the only work by Soutine in Russia. That this should be the case is something of a paradox, since Soutine was an émigré from the Russian Empire. Rouault's *Head of Christ* has enabled the Hermitage to display a worthy example of the creative processes of the thirties, even if it only partially fills one of the gaps in the collection of French painting. Another major addition has been Dufy's *Sailing Boats in Deauville Harbour*, which has at last enabled the museum to fulfil Shchukin's 'final wish'. Finally Maillol's *Spring Without Arms*, a large work and one of his finest achievements, complements his small-scale sculptures, of which there were already examples in the Hermitage. It is now possible to compare Maillol and Bourdelle, two of the greatest French sculptors of the twentieth century. Maillol's *Spring* also reminds us of his work on the sculptures in Morozov's Psyche Hall,[127] bringing us back once more to one of the collectors who promoted French art so memorably.

In spite of the serious financial difficulties in today's Russia, the Hermitage continues to carry out a project of expansion. Directly opposite the Winter Palace, to the left of the mighty arch of the General Staff building, stands the former Ministry of Foreign Affairs. This building, which has been handed over to the museum by the city, will at last provide an exhibition hall for the Hermitage's unique collection of seventeenth- to early twentieth-century decorative ensembles, currently held in storage. These will include Bonnard's triptych *On the Mediterranean*, and Denis's ensemble, the *Story of Psyche*. Here, too, Maillol's statue will surely find its rightful setting.

Idols of the Salon and the Impressionists

At which particular moment did the age of modern French art begin? Indeed, is there a specific date on which everyone might agree? Probably not. Any precisely defined date is bound to give rise to numerous disagreements and uncertainties, if only because aesthetic development is always part of a continuous process, with no absolute beginning and no clear end. One period flows into the next, and no interruption is ever more than temporary. Society's aesthetic notions do not suddenly change: they evolve gradually as new qualities are assimilated, and it is impossible to say when changes become irreversible.

The starting point for this book – 1860 – is therefore inevitably somewhat arbitrary, and does not preclude other possibilities. Why not, for example, 1863, the year of the first Salon des Refusés, or 1867, the year of the Exposition Universelle in Paris, with its pavilions dedicated to Courbet and Manet? Why not 1870, when the Franco-Prussian War began, or even 1871, the year of the events of the Paris Commune, adopted as a landmark date by Soviet historiography?[1]

Ever since human beings have considered themselves in an historical context, there have been constant attempts to partition the past in order to improve our understanding of it. In modern history we are quite prepared to consider the years 1800 and 1900 as watersheds, even though these were hardly moments of global change in the history of humankind; today, indeed, we find ourselves obsessed by the significance of the new millennium. As with history itself, clearly art does not divide up into periods conveniently corresponding to round numbers. Nevertheless, it would be wrong to say that 1860 is an entirely arbitrary

date. For if we ignore political events – the revolutions of 1830 and 1848, say, or the Franco-Prussian War and the fall of the Second Empire – and instead base our definition of artistic periods on movements within the art world itself, then a boundary between the 1850s and the 1860s emerges and deserves special attention.

For this was the time when several young artists emerged onto the art scene in France, who within fourteen years would become known as the Impressionists. They were destined to bring about a revolution that would influence the course of world art.

What was happening in Paris in 1860? The eighty-year-old Ingres, generally recognised as the guardian of the tenets of Classicism, was reworking his *Turkish Bath* (1862; Paris, Louvre), a picture at once sensual and wilful, that showed a radical departure from the canons of Classicism. Delacroix, the chief revolutionary of French art in the first half of the nineteenth century, was completing his murals in the Church of St Sulpice, one of the masterpieces of Romanticism. Manet painted his first masterpiece, *The Spanish Singer* (*Guitarrero*) (1860; New York, Metropolitan Museum of Art), which was displayed at the Salon of the following year, where it earned the painter a special commendation and heralded him as the most promising of the new generation of artists. Degas was working on his *Young Spartans* (*c.* 1860–2; London, National Gallery), *Semiramis Building Babylon* (1860–1; Paris, Musée d'Orsay), and the *Bellelli Family* (1858–67; Paris, Musée d'Orsay) – the finest group portrait of the century. Under Degas's brush the emotionalism of the historical composition gave way to the sober pursuit of reality. At this stage both Manet and Degas were far ahead of Monet, Renoir

and Cézanne; they were, of course, older, and a difference of five or ten years is significant at that age. In 1860 the nineteen-year-old Renoir, who in the previous year had given up decorating porcelain, took the decision to devote himself full-time to art, and applied for permission to make copies of paintings in the Louvre. Claude Monet, unaware that he was to become the greatest landscape painter of the age, had registered at the Académie Suisse in order to improve his life drawing. It was here, in this inexpensive 'school', which had no teachers but which offered the opportunity to paint live models, that he first met Pissarro. Cézanne also met Pissarro there in the following year, when he was still trying to persuade his father to allow him to become a professional artist.

In 1860 the followers of Ingres and Delacroix were still jousting over Classicism and Romanticism, over traditional and new approaches to art, and over the role of drawing and colour in art. Courbet and Millet were at the very height of their powers, and unlike their predecessors were striving to get as close as possible to representations of reality. They were ahead of the drive for a new naturalism or Realism, viewed by many as movements capable of offering an alternative to Classicism and Romanticism. Realism, indeed, was beginning to gain ground over both of these movements, although a rigid hierarchy still dominated society's perception of art, which strictly limited the rise of those genres most suited to Realism: landscape, still life and genre painting. For, according to the criteria of the time, these latter were considered among the lowest forms of art. History painting was the genre most highly rated, although perceptions of historical art changed considerably throughout the nineteenth century. At the beginning of the century German aesthetes argued against the portrayal of real historical events; instead they insisted that history painting should elevate the factual to a higher plain of more general moral significance. This approach was also prevalent in French art, but Gros, Géricault, Delacroix and Horace Vernet countered it, striving instead for the emotional and factual reproduction of events; they in turn created their own, strictly historical, form of art. Nevertheless the attempts of the official art establishments (such as the annual Salons, the Institut de France and the Ecoles des Beaux-Arts) were still directed at encouraging pictures with legendary subject matter, and particularly pictures on Old and New Testament themes.

Masters of History Painting

At the beginning of the 1860s, the truest exponent of the highest form of history painting – that is, compositions on a biblical theme – was generally recognised to be William Bouguereau. The Parisian art establishment valued this relatively young artist particularly highly, and his works were correspondingly expensive. The best known Russian art collector of the time was N. A. Kushelev-Bezborodko. Paying close attention to the opinions of the Parisian orthodoxy, he managed to acquire Bouguereau's *Tobias Receives His Father's Blessing* soon after the painting was completed. The draughtsmanship and the knowledge of chiaroscuro demonstrated by Bouguereau in this relief-like composition, based on his study of the canvases of the Old Masters, is truly flawless. A meticulous study of the art of antiquity and the Renaissance shines

through in every fold of clothing, and the whole composition, not without the cold grandiosity of Byzantinism, is a rarity indeed. Such a picture is Academism of an almost chemically pure sort – an example of technical skill that is also cold and lifeless.

Matisse, who some three decades later found himself in Bouguereau's studio, remembered the lessons of this sterile master with particular abhorrence. In front of this eminent coryphaeus, a member of the Institut de France, stood his well-known picture *The Wasp's Nest* (1892; private collection). Alongside was a finished and absolutely exact copy of the picture, and on the easel was another canvas, primed for the next copy. 'Bouguereau was literally recreating his picture for the third time. His friends exclaimed: "O Monsieur, how conscientious you are, what a labourer!" "Indeed," responded Bouguereau, "I am a labourer, for art itself is a labour." I realised then that these people, who bore the imprint of the Institut, understood nothing (for they were indeed sincere), and I quickly realised that I could learn nothing from them.'[2]

Cézanne, whom Matisse called 'a kind of benevolent god of painting',[3] always regarded Bouguereau as the personification of the Salon. 'He would often say, "How I would like to have my works accepted by Bouguereau's salon".'[4] Emile Bernard, who recorded these words of Cézanne's, added, 'Clearly he could not but dislike this master of the fashionable Salons. Nevertheless, the idea that he expressed was entirely correct: it is not lack of originality that prevents the comprehension of an artist but the imperfection of his work.'[5] 'Perfection' without originality is a certain guarantee of success, as is so brilliantly shown by the career of Bouguereau. Taken to its logical conclusion, however, it leads art into a creative cul-de-sac. Photographic precision in the representation of ancient subjects, be they biblical or classical, did not create the effect of genuine antiquity. Indeed, quite the contrary: for by imposing on bygone eras the prosaic bourgeois values predominant in the third quarter of the nineteenth century, it had the effect of distancing the spectator from the past.

Nonetheless, history paintings were frequently taken as metaphors for the time in which they were painted, and as such – insofar as their effect was quite the contrary to that intended – they were often considered failures. This is particularly true of compositions based on the Gospels. The end of the century saw two distinct approaches to the recreation of scenes from the Gospels. The first was expressed in a striving for historical accuracy; in the second, ancient motifs gave way to the deliberate inclusion of features quite inconsistent with the era portrayed. The 'modernisation' of Old and New Testament themes had long been a feature of works of the Old Masters and had not met with any objections; in the second half of the nineteenth century, however, an entirely different attitude came about. Educated people based their opinions of recreations of past events on the search for historical truth prevalent at the time. In response to this, several artists set off for Palestine in an attempt to immerse themselves in the place to be portrayed in their Gospel canvases; their pictures were then peopled with characters carefully drawn from life.

morning mist: the attempt to use the 'everyday' to highlight the miraculous, without recourse to the traditional symbolic use of the halo, is characteristic of the new era. Christ is not a vision and is portrayed as no less real than the other characters. Moreover, in a foreshadowing of the Symbolist era, Tissot does not encourage a single 'reading' of the picture. What, indeed, is it about? Is it about the miracle of the appearance of Christ the Omnipresent, or does it represent some contemporary martyr–preacher, unidentified and even unspecified? Does the picture elicit the thought that were Christ to appear on earth today, no one would recognise him? Do the ruins of the cathedral represent the desperate situation of the Catholic Church at the time? In any event Tissot has travelled far from the canon, as witnessed not only by the general crisis of the Church, but also by the attempt to overcome the undoubted decline in religious art.

Alongside the Realists, who shunned religious motifs, were the traditionalists of Salon–Academic art, who treated them with excessive respect. Neither group, however, could fail to recognise the overriding lack of spirituality in their work. The conception of ideal, 'pure' form, supported by all the European academies, fatally restricted the real living energy of artists. Many talented and industrious artists, who spent years in the pursuit of excellence, were prisoners of various stereotypes of form. Hundreds of pictures, hanging row upon row in the annual Parisian Salons, were most professionally executed. Their very competence, however, so universally banal, gave the impression that most of the canvases were the work of a single brush. In such general conditions of impersonality and formality the subject gains exclusive significance. Thus it was that recognition came principally to the painters of new subjects. Alternatively, success could be achieved by anyone canny enough to turn old motifs inside out. In this sense, everything that went on in the Paris Salons of the second half of the nineteenth century is reminiscent of the situation in the modern film industry, with its feverish pursuit of original subjects, all the while exploiting the same old 'box-office' plots, with remakes and far-fetched situations, always aimed at terrifying or titillating the viewers. In essence, Salon art fulfilled much the same role as that of modern-day Hollywood, with its all-powerful influences.

Few indeed were the subjects not covered by the Paris Salons, the principal exhibition opportunities of the time. With each Salon the themes presented to the world became ever more resourceful. This was most easily achieved in genre painting, but the history genre, too, produced some interesting results, where subjects included little-known episodes from ancient chronicles as well as more recent topical events. But what was to be done with New and Old Testament 'history', which for so long had occupied the highest place in the genre hierarchy? Of course, anywhere other than Paris, attempts to destroy the canon would have been immediately aborted, but here the opportunity remained for artists to draw attention to themselves with 'special effects'.

Most notable among those who were able to present traditional subjects in an inventive and even paradoxical way was Jules Lefebvre. Were it not for the label on the painting, who would ever have thought that the

One such artist was James Tissot. Even before his first trip to the Holy Land he had painted *Ruins (Voices Within)*, a picture which was quite unlike the traditional type of biblical composition. The painting shows two wanderers, not the characters from the meeting on the road to Emmaus, but hapless contemporaries of the artist, seeking shelter in the ruins of a cathedral. The emaciated figure of Christ, with terrible stigmata on his hands and feet, presses close to one of the travellers. The gentle glow behind him is like the luminescent haze of an early

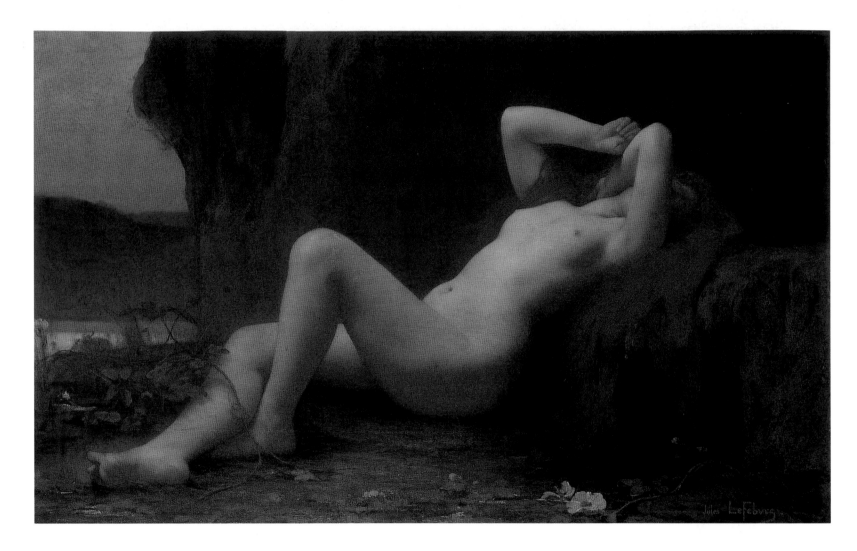

nude woman, shown entirely in accordance with the latest Parisian fashions (for which her shock of wavy red hair is sole but sufficient evidence), and reclining lazily on the rocks, is none other than an exhausted *Mary Magdalene in the Cave*?[6] It is not known whether Alexandre Dumas *fils* guessed what this picture represented, but in any event the author of *La Dame aux Camélias* acquired this extraordinary portrayal of the sleeping or dreaming patron saint of camellias for his collection. The famous writer, along with other eminent connoisseurs, was struck not only by Lefebvre's skill, but also by the *risqué* allusions to the art of the Old Masters. The pose of Mary Magdalene, with minor adjustments, echoes the pose of the sleeping Bacchante in Titian's famous *Bacchanal* (1518; Madrid, Prado), but the Salon artist made his heroine so refined and delicate that her image conformed fully to the current ideals of feminine beauty.

Jean-Jacques Henner dedicated a whole series of compositions to Mary Magdalene. Contemporaries of the artist found a reflection of her even in such canvases as *Study of a Woman in Red*, seeing in this work a continuation of the Venetian Renaissance tradition. Nowadays, however, hard as we may try, it is difficult to find in Henner's languorous profiles any trace of Titian's golden-haired Magdalene. Nevertheless, it is worth

remembering that even Van Gogh – admittedly at a time when he knew of the Impressionists only by hearsay – saw the merits of Henner and Lefebvre in that they imparted 'modernity' to classical figures.

However unexpected Lefebvre's Magdalene may appear, she is but one of numerous examples of Salon characters of that type: nymphs, shepherdesses, noblewomen and even saints. It is no accident that the 'sleeping beauty' was a favourite image in the art, poetry and music of the second half of the nineteenth century. The state of sleep in portrayals of nude women, suggesting a kind of unworried innocence, satisfied the rules of propriety of the age, as well as meeting the connoisseur's delicate demands for voyeurism. Thus the religious subject, originally intended as a means of taming the flesh, in a strange way ended up as a source of carefully calculated eroticism.

From today's point of view, Jean-Léon Gérôme's *Sale of a Slave-girl in Rome* is much more worthy of the description 'history painting' than Lefebvre's composition. However, if we discount the secondary details, such as the costumes of the Romans or the brick façade of the auction house, Gérôme's work is no more historically accurate than Lefebvre's. In fact, slave auctions were never conducted in the way portrayed by

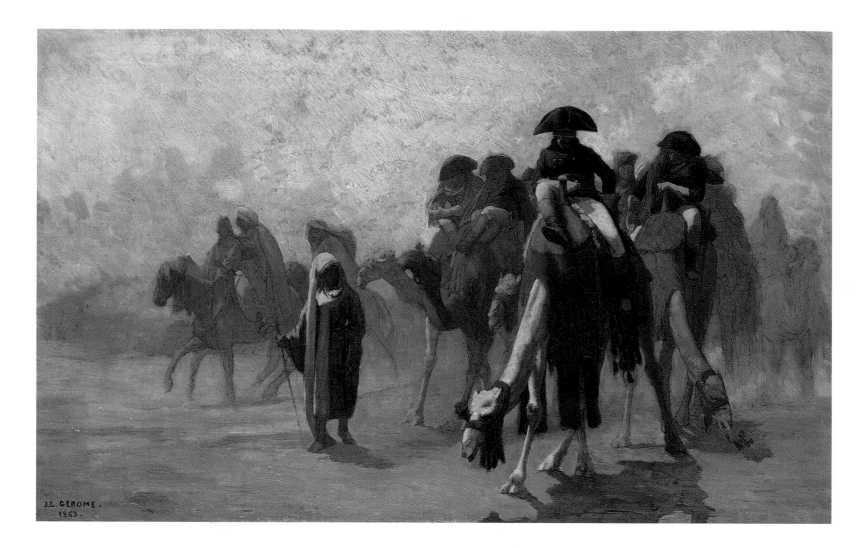

Gérôme. As was quite common in Salon art, this picture ends up as a kind of flawed hybrid of genres, not unlike the way in which modern cinema produces not only dramas and thrillers, but also, for example, erotic thrillers. The Salons of the 1870s and 1880s included numerous portrayals of the nude female form. But however enticing their poses (obviously within the realms of propriety of the age), they did little to excite the public. Nudes in a historical context, however, were another thing altogether. When G. I. Semiradsky showed his *Phryne on the Feast-day of Poseidon in Eleusis* (1889; St Petersburg, State Russian Museum) in St Petersburg, the response was remarkable.[7] Gérôme created his *tour de force* with Phryne much earlier, and his only worry was whether the sight of a naked beauty being devoured by the stares of a crowd of men could comply with the ethical demands of the time and still create a sufficiently theatrical effect. He skilfully composed his spectacle in accordance with all the rules of theatrical *mise-en-scène*. In the centre is the beautiful slave-girl. Her clothing has been torn off, so that both the greedy buyers of antiquity and, at the same time, the visitors to the Paris Salon can assess her bodily attributes. The viewers of the Salon were readily convinced of the verisimilitude of this spectacle of pseudo-antiquity. They were not in the least bothered by such an

absurd historical detail as the garland on the slave-girl's head, as if indicating that she is the main subject of the trade. The other naked girls, sisters of the garlanded slave-girl, and the woman with a child, have presumably already been sold, and they are faced with the prospect of eternal separation from the young girl as the excited buyers stretch out their hands. Here also are the impassive scribes and officials alongside the experienced auctioneer, giving his usual cry of 'what am I bid?'

Sale of a Slave-Girl became the outstanding creation of Salon Realism with historical overtones. Gérôme here was following the tradition of Ingres, and in particular *The Spring* (1856; Paris, Musée d'Orsay), but it is characteristic that having borrowed Ingres's pose for his heroine, he placed her in a genre setting. The motif of the beautiful slave-girl is not unusual for the nineteenth century, since an emotional tension is provided by the juxtaposition of beauty and bondage. A statue by Hiram Powers entitled *Greek Slave-girl* (1843; Washington, DC, Corcoran Gallery of Art) was enormously popular in the middle of the century. It was displayed in triumph at the Great Exhibition in London in 1851, and may have encouraged Gérôme towards depicting the slave markets.

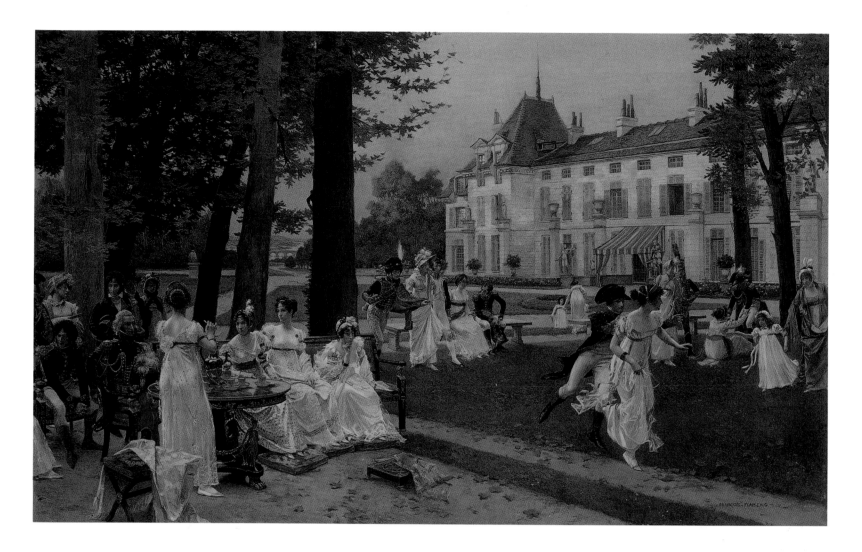

Gérôme justified his impressive reputation as a history painter in several works dedicated to his own times and, specifically, the era of Napoleon. He remained a Bonapartist all his life, and portrayed his hero not only on canvas but also in sculpture; most notably, he was responsible for the design of the Monument to the Glory of General Bonaparte. Alongside Meissonier, Gérôme made a significant contribution to the new Bonapartiana, encouraged by Napoleon III. It is a feature of the work of both artists that they avoided portraying Napoleon as the apotheosis of brilliant heroism; in this they differed greatly from the masters of the Empire style – David, Gros and Ingres. Gérôme's Bonaparte, like that of Meissonier's picture *1814*, is a man who has struggled to cross the desert, and is retreating with his troops along the road – not a demigod, but a mere mortal fated to undergo heavy trials alongside those around him. It was precisely this 'human' Bonaparte that appealed to the citizens of the Second Empire.

When at the beginning of the century David, the first portraitist of the Emperor, was commissioned to paint *The Coronation of Napoleon*, he used the style, composition and even the dimensions of a vast canvas to illustrate an event of supreme national importance. However, in subsequent treatments of the Napoleonic theme towards the end of the century, France's hero unexpectedly began to be portrayed more informally. Thus, for example, in François Flameng's series bought by Nicholas II for the Winter Palace, Napoleon is seen engaged in hunting, or rocking his child, the king of Rome, or even light-heartedly playing tag with a court lady, as here in *Reception at Malmaison in 1802*. And it was in such illustrations of great historical personages at play that the devaluation of the history genre was most noticeable. This type of painting became increasingly common towards the end of the century, notwithstanding the risk of tastelessness that is often characteristic of such subjects.

The evolution of history painting into this more intimate subject matter was already evident by the middle of the century in the pictures of Ernest Meissonier, dedicated principally to the seventeenth century. This self-taught artist's interest in characters of the period is explained above all by the fact that he mastered his craft by studying the art of the minor Hollanders. Meissonier's route to success was largely paved by the novels of Alexandre Dumas *père* describing the adventures of the musketeers, but the artist would not have achieved worldwide renown

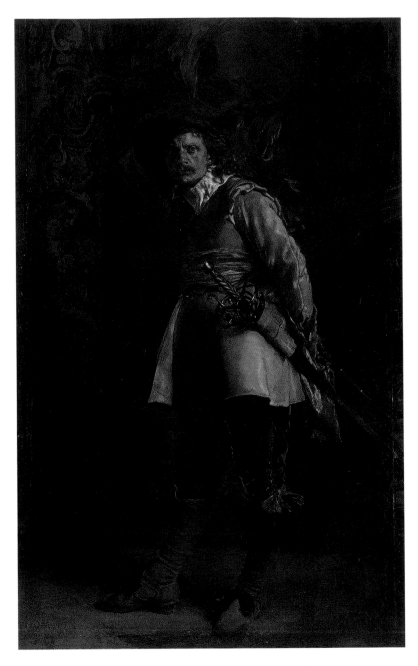

had he not impressed the public with the evident virtuosity of his brushwork. Few could fail to be impressed by his famously expensive miniatures, where the slightest details are painted so skilfully that they can be viewed through a magnifying glass. The musketeers and cavaliers of old are reminiscent of photographs of actors posing in the striking costumes of that glittering period. Certainly photography began to have a marked effect on art from the middle of the century. Meissonier, of course, was not so bold in his use of photography's advances as Courbet, Degas or Cézanne. It would be unfair, however, to see in Meissonier's works little more than a reworking of the mechanical possibilities of the camera. As was the case with other luminaries of the Salon, the public's enthusiasm for this artist's techniques was not shared

in artistic circles; far from it. For it was precisely Meissonier's technique of reproducing nature that became the main area of contention in the struggle for the new art, and not just between Academicians and Impressionists, but ultimately between Academicians and everyone else. V. I. Surikov's opinion of Meissonier was typical. Russia's finest historical painter wrote to P. P. Chistyakov: 'His pictures throng with people. You know his paintings well. These new ones are no different from the others: the same meticulous attention to detail, which is no doubt the reason why the public likes them so much. How can this be, when you could examine his canvas under a microscope and not find a single brushstroke? It seems to me that Meissonier has progressed no further than the minor Dutch like Van der Helst and Netscher. It smacks of photography and is insufferable. I reckon that he must have spent a year and a half working on the lace of one miniature.'[8] It is a judgement that is worth considering. Certainly Van der Helst and Netscher are no Rembrandt or Vermeer, but this does not mean that they did not have style. And the same is true of Meissonier: he undoubtedly had his own style, albeit more dazzling than profound.

It was precisely this style that the Impressionists could not accept, and later they rejected the genre character of his works. The very term 'history painter' became a source of ridicule, and Meissonier was the genre's most significant practitioner. Art historians of some twenty years ago dismissed Meissonier as a skilful but retrograde craftsman, who stood in the way of the real innovators. But is it really as simple as that? Did they not recall the words of Delacroix: 'Good, like everything he does.'[9] And why did they ignore the constant interest of Van Gogh, who completely disagreed with Rodin's assertion that Meissonier was an empty vessel? 'Now you could look at a Meissonier for a year,' Van Gogh wrote to his brother, 'and there would still be something in it to look at next year, you may be sure of that. Not to mention his lucky days, when he had perfect flashes of genius. Certainly I know that Daumier, Millet and Delacroix painted quite differently – but there is something essentially French in Meissonier's workmanship, which even the old Dutch masters could not have objected to, although it is quite different to them and entirely modern.'[10] Meissonier was not a rival of Delacroix, nor of Van Gogh, but to the Impressionists he always stood for the worst traits of the opposing camp.

In the 1860s a new figure appeared on the scene of history painting, Jean-Paul Laurens, most notable for his interest in tragic and sombre subjects. Initially these came from ancient history: *The Death of Cato* (1863; Toulouse, Musée Augustins) and *The Death of Tiberius* (1864). Later he turned to the Middle Ages and the Renaissance: *Francesco Borgia Before the Open Tomb of Isabella of Portugal* (1876), *Interrogation at the Tribunal of the Inquisition* (late 1880s; Hermitage) and others. It was Laurens whom S. M. Tretyakov singled out as France's finest historical painter when he purchased *Interrogation* and *The Last Moments of Maximilian*. Surikov noted, not without envy, 'Here come the French with their Laurens, though as a historical artist he is weak. There is no sense of period in his pictures. They are just illustrations on a historical theme.'[11] It is difficult to argue with such a judgement, for it is easy enough to treat any historical painting

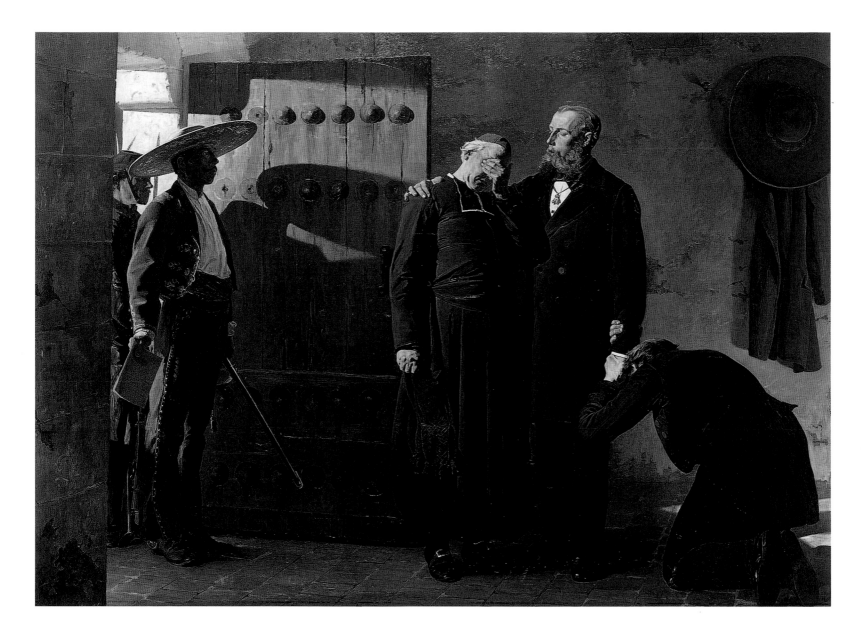

as an illustration or theatrical *mise-en-scène*. It is perhaps more appropriate to consider the extent to which the illustration conveys the spirit of the period. And, of course, this principal aim is more easily achieved when the artist deals with events from the recent past.

Edouard Manet had portrayed the execution of the Austrian Archduke in pictures painted shortly after his death (*The Execution of Emperor Maximilian*, 1867, Boston, Museum of Fine Arts; 1868, Mannheim, Kunsthalle). These pictures were actually a veiled attack on Napoleon III, whose foreign policy brought about Maximilian's tragic demise. Laurens, however, as if to spite his predecessor, and, surprisingly, going against his own republican convictions, expressed complete empathy with the hapless claimant to the imperial throne of Mexico. He shows how calmly, even imperturbably, Maximilian greets the representative of Juárez who, verdict in hand, enters the cell in one

of the fortified chambers of Querétaro. Maximilian comforts the weeping priest and the servant who is on his knees before him. Laurens's picture is not devoid of melodrama, but this is bound to be the case with such subject matter. In any event, the canvas was highly praised by Rodin, who befriended Laurens: 'I read in the papers that your wonderful picture of Maximilian has been bought in Russia, a country where tastes are a little less dull than in France.'[12]

In the field of historical compositions that portrayed contemporary events, the artists most highly rated by French society in the 1870s and 1880s were Alphonse de Neuville and Edouard Detaille who were both battle painters. Their popularity may be ascribed to a wounded national consciousness after defeat in the Franco-Prussian war. Their works were endlessly reproduced, even beyond the borders of France, and made these *peintres militaires* extremely popular.[13]

De Neuville was blessed with an extraordinary talent. Qualified as a lawyer, he rejected a career at the Bar in order to become a battle painter. The Crimean War, the Garibaldi Uprising, battles in far-off Mexico – De Neuville fed on an almost childish fascination for anything to do with battles and armies. The Franco-Prussian war, which he witnessed, always defined the direction of his art. Despite the actual outcome of this ill-fated campaign, De Neuville's brush was constantly drawn to depictions of national heroism. The subjects of his previous battle compositions, however, which tended to show the commander giving timely orders to his troops, or a hero sacrificing himself to decide the outcome of a battle, would not do here at all. Napoleon III's commanders were talentless. The outcome of the war was decided by the inequality of the forces and the poor preparation of the French army. But De Neuville was still able to find an approach that gained the grateful attention of his fellow countrymen: he concentrated on the heroism of the anonymous foot soldiers. Besieged by the superior forces of the Germans, without cartridges to defend themselves, they remain standing to the end. *Attack on a Barricaded House at Villersexel* (1874; purchased

by the State for the Musée du Luxembourg) immediately preceded *Episode from the Franco-Prussian War*, which was a modified version of the popular canvas *The Last Rounds*. The very titles of De Neuville's pictures – *Skirmish on the Roofs*, *Battle on the Rail Tracks* – gratified the national feelings of the French, who wanted to believe in the steadfastness of their resistance.

Episode from the Franco-Prussian War tells a story full of details that could not fail to move the artist's contemporaries. The mansard roof of a house is being fired upon by the enemy's artillery: the roof is pitted with the direct hits of shells. Six defenders of the house are huddled together in this last 'bastion'. A seventh, clutching at a wound in his stomach, struggles to clamber up to join them. Another body lies dead and stiffening in the foreground, a gun with a bent bayonet lying discarded nearby. Of course, a century and a quarter later, we view such pictures quite differently, less as an image of conflict than as an artistic creation. Perhaps it is stifled by detail, but that it is well composed and expressively coloured is undeniable. Most striking of all is the treatment

of light. When we consider advances in this field, we think first and foremost of the Impressionists, and this is as it should be. Nevertheless, this does not tell the whole story. De Neuville may not have had Claude Monet's audacity, but the precision and virtuosity of his brushwork is self-evident. The sun's rays light up the smoke and dust, still hanging in the air from the artillery fire, the shaded areas are illuminated with great skill. Without doubt this play of light not only animates, but also brings the whole picture together. Whether De Neuville was employing techniques discovered by the Impressionists, or whether by studying nature and using the experience of his predecessors he was following a parallel path, is difficult to say. It is a question that can only be answered by the study and impartial evaluation of pictures that have for too long languished in obscurity.

Much the same can be said of *The Commander's Feast*. If this small country *bistrot* had been portrayed by De Neuville empty of people, and if the view that opens out before us were a straightforward landscape, the picture would not only be much more appealing to our modern tastes, but it would also demand comparison with the works of the Impressionists. In fact, the background compares well to Pissarro's Pontoise landscapes of 1872–3, for example, although De Neuville's work is notable for its more painstaking finish. For De Neuville the landscape in *The Commander's Feast* is incidental, simply a view from a restaurant where the main attractions are the excellent lunch and agreeable atmosphere. The scene of refreshment itself can be compared to the motifs of such innovators as Manet or Degas, who between 1876 and 1878 painted their famous pictures of cafés. But De Neuville appealed more to the connoisseurs of his own age, for his painting also contains an entertaining narrative. And here, perhaps, lies the major difference between the unofficial and official artists. For the former a narrative was not necessary – undesirable, even – since it all too easily became a light-hearted anecdote, as De Neuville's picture shows. *The Commander's Feast* is hardly the definitive example of the artist's work, just as a light musical piece does not exemplify the work of a serious composer.[14] Nevertheless it is notable that even in a playful mood the military artist is meticulous in his depiction of the uniforms.

De Neuville's renown in his own lifetime was based on the large battle panoramas of Champigny and Rezonville from the Franco-Prussian War that he painted in the early 1880s with Edouard Detaille. A pupil of Meissonier, Detaille was able to fulfil complex commissions quickly and with virtuosity, accurately reproducing, for example, the finest details of military uniform. In *Chorus of the Fourth Infantry Battalion at Tsarskoe Selo*, Detaille examines a scene that was for him both foreign and exotic, with its massive Orthodox cathedral and thatched cottages. The squatting Russian dance and the bottles of wine in the foreground would suggest some kind of regimental celebration. However, there is no real feeling of festivity, and the portrayal of this meaningless gathering, illustrated with such formulaic detail, is ultimately dry and uninspiring. It would be difficult to imagine a more damning indictment of history painting than works such as this, where socially significant events were ever more frequently replaced by depictions of everyday trivialities.

The outcome of the Franco-Prussian War, which so deeply affected the French sense of national worth, played an important role in establishing the popularity of battle compositions of a kind that differed significantly from the earlier style of Gros and Horace Vernet. The techniques of artistic Realism were allied with attempts to depict characters, and sometimes even to convey the prosaic nature of war. To a great extent battle paintings replaced other kinds of historical painting, and Meissonier, De Neuville and Detaille achieved popularity throughout Europe.[15] It is worth noting that the pictures of troubadours of the French army – even in Detaille's dry, photographic works – were greatly admired outside France; not, of course, for their nationalistic content, but for the relatively high quality of their execution.

In the Footsteps of the Romantics: Illustrators and Orientalists

In the second half of the nineteenth century pictures based on literary
fiction became increasingly popular. Many of them, in fact, were simply
a variation on historical painting. Thus Edouard Dubufe's painting of a
cavalier courting a young lady is, in its own way, a piece of retro or
pastiche art, recalling Watteau and his followers. Devoid of the excesses
of Rococo, artificial and refined, it satisfied the tastes of the court of
Napoleon III, where Dubufe, whether painting the Empress's ladies-in-
waiting or the Empress's rooms, enjoyed a brilliant reputation. His
canvases were the fruit of historicism, born out of an admiration for
the era that preceded the revolution of 1789. *Lovelace's Kidnapping of
Clarissa Harlowe* portrays one of the key moments in Richardson's
famous novel *Clarissa*. It is true that at the time the picture was painted
the novel was losing popularity, but it was not without its admirers.[16]
The painting is illustrative, although it would be wrong to see it simply
as an illustration. *Clarissa* is thought to be the longest novel in English,
and could be described as the direct forerunner of the modern soap

opera. In the book, interwoven plots are gradually revealed by letters
between the characters. In the painting, however, such measured
intricacy gives way to the energetic action that the Romantic era had
taught the public to enjoy. A single movement reveals both Clarissa's
desire to escape from the prison of her parental home and her dual atti-
tude to Lovelace: revolted by his vanity and frivolity, she is also attracted
to his lack of pettiness and malice, so prevalent in her own family.

The influence of literature was particularly pervasive in art of the
Romantic era, as is shown by Delacroix's *Journal*, containing lists of
subjects that he wanted to paint. Literary motifs even appeared in a
genre as apparently unsuitable as still life. For example, Philippe
Rousseau, in his precise portrayal of the corner of a kitchen, has
created an entire scene based on La Fontaine's fable *The Hermit-Rat*,
in which a rodent rejects the calls of his fellows to join the general
struggle. There could hardly be more social a motif than that, and yet
Rousseau's still lifes on themes from La Fontaine were particularly
popular at the court of Napoleon III, where he also worked for such

classical art. Thus, for example, we look at Doré's *Illustration for Charles Perrault's 'Bluebeard'* and are reminded of similarities with Dürer's iconographic wood-carving *St Christopher* (1525). But Doré was also able to introduce originality into the composition. The motif of a winding staircase, encircling Bluebeard, lends the picture a dynamism that befits its subject.

Doré's remarkable productivity often meant that his work lacked variety. But in his greatest works, which certainly include *Tavern in Whitechapel*, the results are magnificent. The gouache preserves the impetuous course of his brushstrokes as they pick out various infernal figures in the semi-gloom. Doré's *London: A Pilgrimage* pictures have been compared with depictions of the Descent into Hell. Indeed, in 1861 Dante's *Inferno* was published with illustrations by Doré, and the references to his Dante pictures lent a special sharpness to his scenes of contemporary London low-life. This entire series reflects the dark side of human nature, and in works such as *Tavern at Whitechapel* there is also a characteristic sense of ominous mystery. Some time afterwards, when Van Gogh used one of Doré's London series (*Newgate – Exercise Yard*) as the basis for his *Prisoners' Round* (1890; Moscow, Pushkin Museum), it was precisely this element of mystery that he preserved.

Compositions like *Tavern at Whitechapel*, which can be formally labelled 'genre painting', are in fact only superficially concerned with the portrayal of everyday life. The same can be said of many pictures where the subject matter is set in the East. The French campaigns in North Africa drew attention to that region, and created a whole new style in the repertoire of the Salon, where ethnographic sketches alternated with exotic fantasies. It also seemed that an element of Romantic pathos was more acceptable in everyday subjects if transferred to a different continent. With the decline in religious and historical art in the latter years of the Second Empire, subjects that had been thought to be not sufficiently elevated or of secondary importance suddenly came to the fore, thereby further blurring the definition of genre painting. Now, the portrayal of everyday life had to be attractive, bright and unusual. The French Romantics had already addressed this problem of depicting reality long before by turning to Oriental subject matter. This source of material was constantly reworked, until eventually it was exhausted in the Rococo period. Now, however, motifs from the Near East were adopted in place of chinoiserie. Delacroix's last paintings, for example, dating from the beginning of the 1860s, celebrated the world of the Arabs: their battles, their hunts, their horses. Alongside Horace Vernet, Decamps and Marilhat, Delacroix inspired a new fashion for Oriental art that also became popular outside France.

Gérôme, whom Baudelaire criticised for his 'typically French attempts to find success beyond the boundaries of painting',[17] while not breaking with ancient motifs, easily adapted to the popularity of the Orient without changing the essence of his art. Every aspect of his *Pool in a Harem* – the carpet on the marble floor, the painted tiles, the carved, inlaid table next to the carpet – so accurately reproduced, is designed to draw the spectator into one of the most secret and closely guarded places in the Eastern world: the sheikh's seraglio. The inhabitants of the harem,

patrons as Princess Mathilde and Baron Rothschild. The secret of this artist's success, despite his working in the unprestigious genre of still life, lay less in the precision of his compositions, or in his ability to portray real objects accurately, than in the special refinement of his chiaroscuro, which he had learnt from the old Dutch masters of still life.

No century has seen such a flourishing of illustration as the nineteenth, and the most famous name in this field was Gustave Doré. A child prodigy, at the age of eleven he was already using such complex techniques as lithography. While still a young boy, Doré had been widely acclaimed for his ability to reproduce any subject creatively and quickly. With his astonishing productivity he soon captured the book market. Having taken his first artistic steps during the heyday of Romanticism, Doré remained faithful to its tenets. He had no need of models, painting always from memory and imagination. When Van Gogh admitted that he much admired Doré's words 'Je me souviens', he was referring to the master's principal method of working from memory, from the subconscious which at the required moment would offer up distant echoes of

however, are clearly Western women, even if one or two of them are shown in specifically Eastern poses. This is shown less by the actual features of the women in the foreground – both based on the same Parisian artist's model, with only the colour of the hair changed – than by the fact that all the nude figures are painted in complete conformity with Western academic norms. The reclining woman on the right is strongly reminiscent of Ingres's *Grande Odalisque* (1814; Paris, Louvre), while the whole picture recalls the same artist's *Turkish Bath* (1862; Paris, Louvre). However, Gérôme, who considered himself the guardian of Ingres's legacy, was quite unable to reproduce the lively, flowing lines of his forebear. In place of the *horror vacui* of *Turkish Bath* and the excess of naked bodies, the smooth alternation of foreground and background is the dominant feature of *Pool in a Harem*. The absence of any sensuality in a motif where it might be expected is the result of this smooth, impersonal technique, which Baudelaire saw as Gérôme's weakness, but which in modern times has surprisingly found new popularity.

Ferdinand Roybet's *Odalisque* was an 'Oriental' reinterpretation of one of Courbet's most famous portrayals of the female nude. Roybet recalled Courbet's *Woman with a Parrot* (1866; New York, Metropolitan Museum of Art) from the Salon of 1866, when this enormous canvas had enjoyed a notable success.[18] Courbet's picture was itself a response to the scandal caused by the appearance of Manet's *Olympia* (1863; Paris, Musée d'Orsay)[19] in the Salon of the preceding year. A Salon artist himself, Roybet was little interested in the implications of this rivalry or in the subtext of these two earlier paintings. It was enough for him that a decade previously 'le tout Paris' had been talking about them. By combining features of both pictures, Roybet perhaps hoped to repeat their success, particularly since he had smoothed out their 'rough edges'. Thus his Odalisque, rather than causing general dismay like Olympia with her shameful pose and look, is gently playing with a bird. But Roybet does bring to the picture something of his own: that skill in the depiction of detail that was so admired by visitors to the Salon. It can be seen in the finish of all the luxurious details: the fan of the black slave-girl, the silver censer, the rich materials covering the

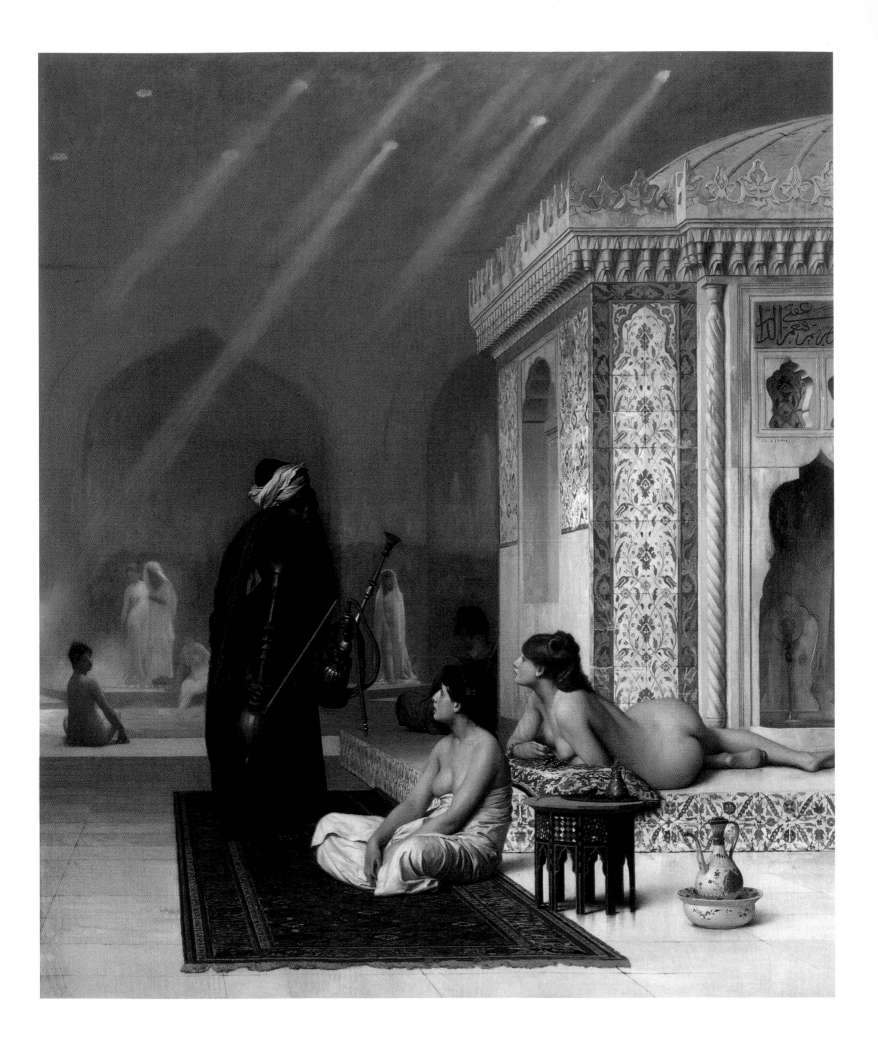

Left: **Pool in a Harem**, *c.* 1876, by Jean-Léon Gérôme
Below: **Odalisque (La Sultane)**, mid-1870s, by Ferdinand Roybet

Overleaf (top): **Harbour in Constantinople**, 1880s, by Félix Ziem
Overleaf (bottom): **Arab Encampment**, 1872, by Victor Huguet

77

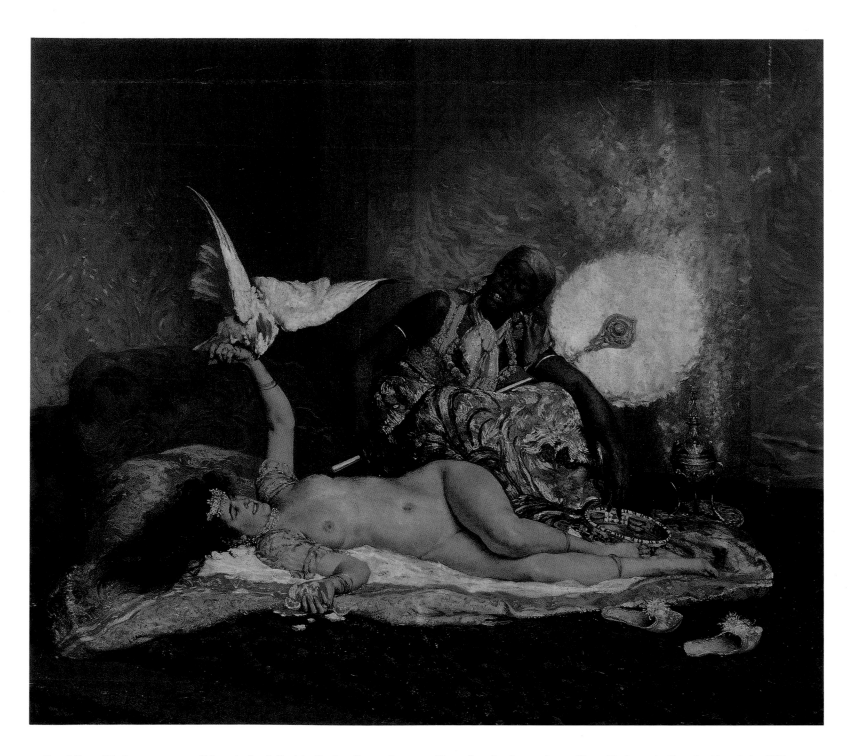

walls of the gilded room – everything, indeed, that indicates the rank of the concubine. This picture, which hung in Tsar Alexander III's study, was also known as *La Sultane*.

Orientalism began to influence a number of genres that until then had existed quite happily without it: history painting (of which Gérôme's *General Bonaparte with His Military Staff in Egypt* is a typical example), nudes, and even as traditional a form of French landscape (since Joseph Vernet) as harbour views. Thus *Harbour in Constantinople* by Félix Ziem, a specialist in this area of painting, shows sailing ships and a vast galley in the foreground that would seem more suited to Turkey, than Marseilles or Le Havre. Indeed, these very details define the spirit of the seascape. Delacroix, too, found in the Near East those elements of antiquity that European civilisation had obliterated. Was not Ziem's Constantinopolitan galley based on the rowing boats of the ancient world? Like the majority of French paintings on Oriental themes in

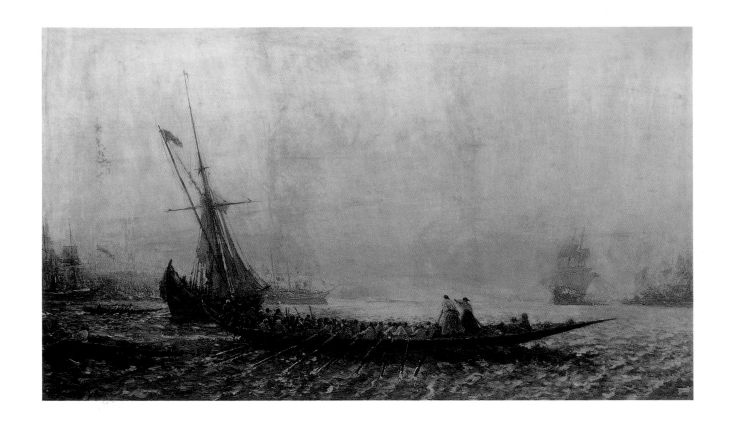

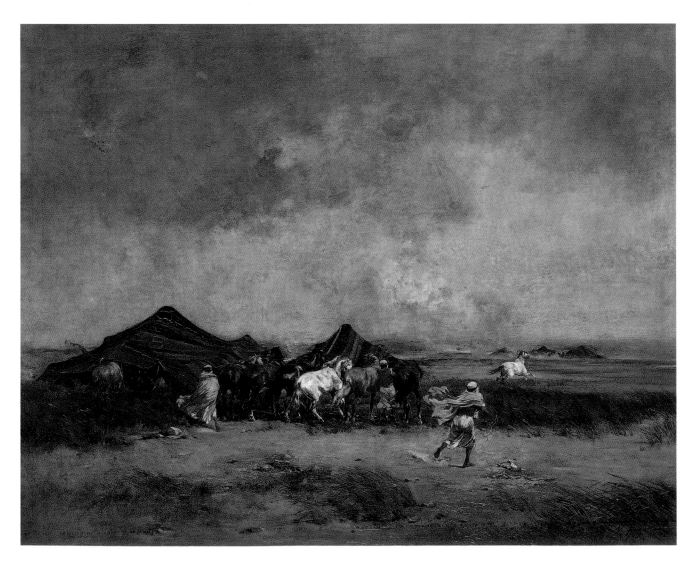

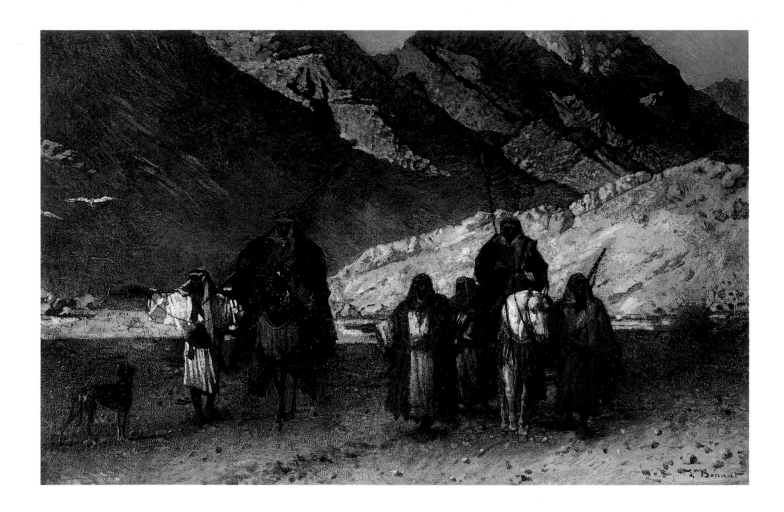

Previous page (top): **In the Mountains**, 1870s, by Léon Bonnat
Previous page (bottom): **Night Robbers**, 1868, by Eugène Fromentin

Below (left): **Fountain by the Cathedral of St Peter in Rome**, 1868, by Léon Bonnat
Below (right): **Young Watercolourist in the Louvre**, *c.* 1891, by Pascal-Adolphe-Jean Dagnan-Bouveret

the Hermitage collection, *Harbour in Constantinople* belonged to Alexander III, and is indicative of his general tastes. The Russian Emperor was also very taken with *Arab Encampment* by Victor Huguet, perhaps because it reminded him of the southern steppes and tents of Asia. This is a typical example of the Oriental pictures that became so popular in the 1860s and 1870s. The most important requirement of such compositions was the ability to draw horses. A spirited Romanticism and the constant search for compositional originality were also characteristic of artists of this genre. In this they differed from the more formulaic approach of the sporting genre in England which gained enormous popularity as early as the middle of the eighteenth century. *Night Robbers*, one of the best canvases in the Hermitage by Eugène Fromentin, a teacher of Huguet, is effectively a portrait of splendid stallions, apparently much more spirited than the naked Arabs who have stolen up to them under cover of night. The grey stallion is particularly fine: the precise depiction of the horse is combined with a wonderfully expressive sense of movement that Fromentin learnt from Delacroix.

The Orient, which introduced the finest French Romantics to a new sense of colour, also unexpectedly became a source of inspiration for

an artist such as Léon Bonnat. The lush tones of his picture *In the Mountains* are striking precisely because they come from an artist of known academic inclinations, at a time when the Impressionists had only just begun to advocate the use of pure colour. The restrained 'museum' colouring of Gérôme, Fromentin and Bonnat himself, who normally painted his Oriental compositions from photographs in his studio in St Jean-de-Luz (he even tried to reconstruct a real desert on the beach of this small town) suddenly gave way to a forceful use of colour born of the imagination.

Genre Painters

It is difficult to believe that *In the Mountains* and *Fountain by the Cathedral of St Peter in Rome* are the work of the same hand. The earlier *Fountain*, in fact, is more characteristic of Bonnat's creative output as a whole. Although it shows little concern for what might be termed purely artistic problems, the painting does reveal Bonnat as a colourist of some skill. One need only look at the figures on the right: the dresses of both Italian girls create a beautiful combination of white, yellow, red and dark-olive colours. However, Bonnat, as a faithful student of the Ecole des Beaux-Arts, considered drawing the most important skill, and here

Below (right): **Young Girl with a Nest**, late 1860s, by Charles Chaplin

Overleaf (top): **After the Storm**, 1869, by Eugène Isabey
Overleaf (bottom): **Oyster Catching**, 1884, by Pierre Billet

81

he must be given his due: he was a true master. For Bonnat the merits
of drawing lay not simply in the accuracy of the proportions and the
definition of the spatial relationship between all the elements. His lines
are able to link the various parts of the composition, so that the stone
statues and the living characters are joined in a satisfying whole. The
entire scene was painted in the studio, probably from a photograph of
the Roman fountain, but creates the impression of having been drawn
from life. Having spent several years in Rome, Bonnat would have
witnessed many such scenes, where young Italian girls would come
to St Peter's to pray at this fountain for protection from infertility.

Pleasing and uncomplicated, such openly attractive scenes as Bonnat's
Fountain near St Peter's in Rome or *Young Watercolourist in the Louvre*
by Dagnan-Bouveret were universally successful, even in the courts
of Europe (both pictures at one stage adorned the Tsar's palace at
Gatchina). Dagnan-Bouveret, an artist with inclinations towards
Realism, concentrated mainly on peasant themes, even long after
they had become outdated. He was seduced by the example of Charles
Chaplin, who had much earlier given up the serious pursuit of painting
from life in favour of portrayals of charming coquettish girls. Chaplin
was one of the first artists to pick up on the fashion for Rococo art in
the Second Empire, and, following the example of Boucher and Greuze,
took to producing portraits of delightful little heads and attractive
figures. His *Young Girl with a Nest* stands alongside such other
paintings as *Girl Blowing Bubbles* (1864),[20] *House of Cards* (1865) or
Girl with a Cat (Paris, Musée d'Orsay). It would seem that Chaplin was
in the same tradition as Chardin, who depicted games with soap bubbles,
card houses and other such innocent pursuits, although Chaplin
updated his characters somewhat. However, it was with good reason that
his works soon became mockingly known as the 'boudoir genre'. It is not
that they were technically inferior to the works of Boucher and Chardin,
but they exhibited none of the playfulness that was so representative of
the spirit and philosophy of the 'age of courtesy'; these gracious figures
in coquettish poses gave the impression of having been produced to
order. And indeed Chaplin was one of those who unintentionally created
an artistic fashion adopted by Parisian commerce for their advertising.
The heads and figures on cosmetic goods and other mass-produced items
could not but devalue the genre in which Chaplin specialised.

With the approach of the twentieth century such pictures became
completely overshadowed. Nowadays, true, enlightened art-lovers view
them with renewed interest; not through a lack of appreciation for the
Impressionists (to whom such paintings were anathema), but precisely
because it is impossible to appreciate the full impact of the Impressionist
revolution without considering its context. A full understanding of the
significance of Impressionism in the history of art is incomplete without
consideration of the works of Chaplin, Dagnan-Bouveret, Bouguereau,
Gérôme and hundreds of other artists who upheld the ideal of beauty
sanctioned by the Salon. It is unfortunate that the vast majority of
museum exhibitions, as well as courses in the history of art, continue
to ignore them to this day.

Bastien-Lepage, Dagnan-Bouveret, Lhermitte and a host of other artists
with an excellent academic education, who did not want to be left behind
by the advances of their age, quickly exchanged antiquated subjects for
scenes from everyday life and, what is more, turned to the methods of
Realism in their work. Their lack of discrimination could hardly fail
to annoy the Impressionists and their followers, particularly since by
imitating the innovations of the Impressionists the very same Dagnan-
Bouveret succeeded in surpassing the Academicians and earning a
number of awards, of which the Impressionists could only dream. As
early as 1878 this young artist (who was in fact much younger than

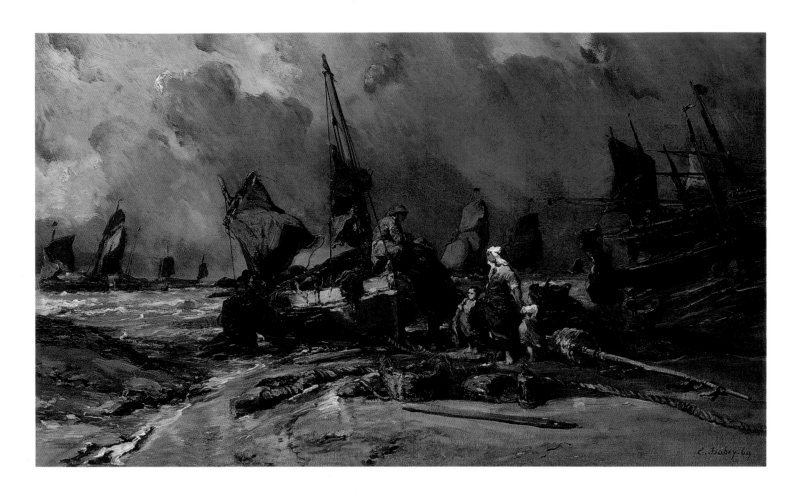

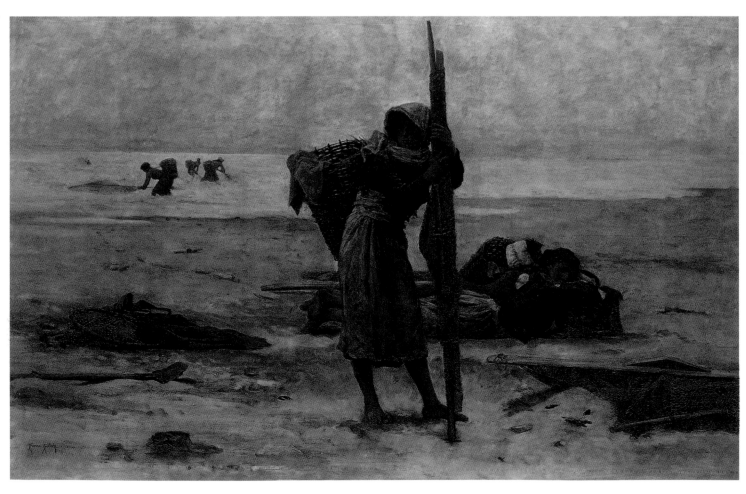

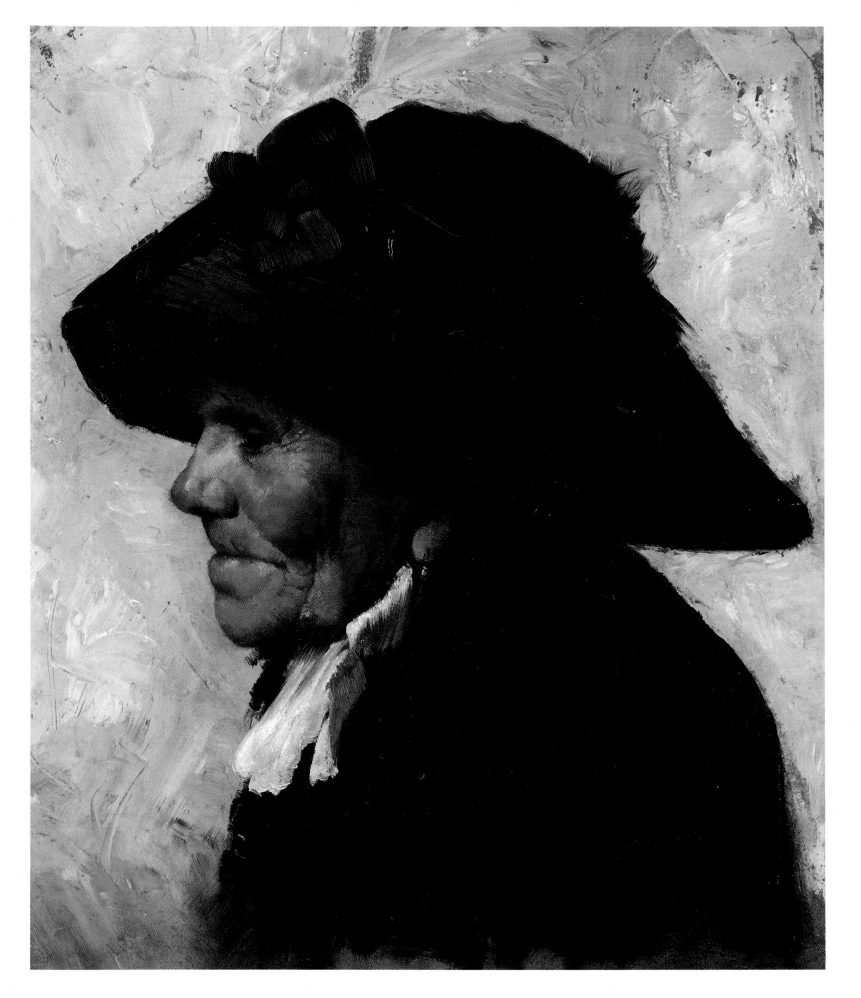

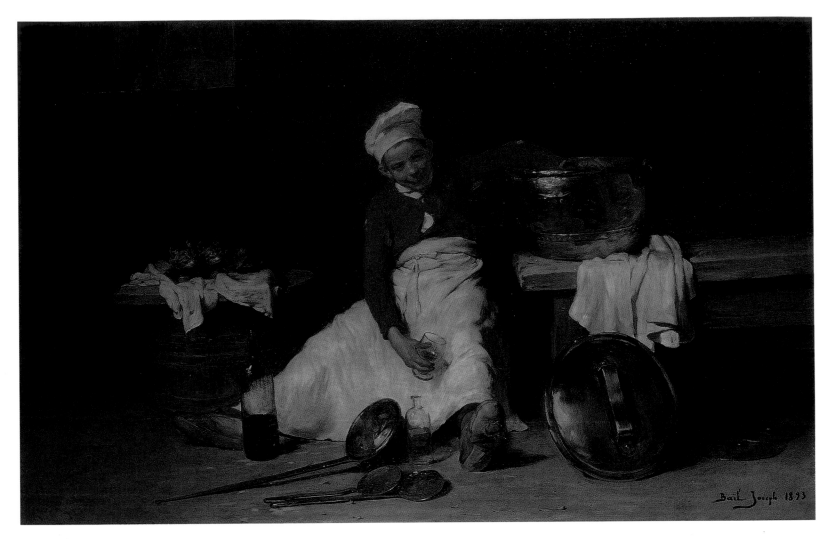

the founders of Impressionism) was awarded a medal by the Salon.
It should be mentioned that Dagnan-Bouveret hardly deserves censure
for the brightness of palette and liveliness of brushstroke that are
characteristic of his work, since the same qualities were not criticised
among the German and American Impressionists who followed in the
footsteps of the French innovators. In fact nothing is ever that simple,
and the curse 'peintres maudits' continues to this day. However, the
true study of the history of art can only be effected if we acknowledge
its complexity. The greatness of Degas and Cézanne is in no way
diminished if alongside them we recall the belated Realists of the end
of the nineteenth century.[21]

What is most striking about pictures such as Dagnan-Bouveret's
Young Watercolourist in the Louvre or *Kitchen-Boy* by Joseph Bail is
the remarkable disparity between the skilled execution and the openly
superficial, entertaining subject matter. In other countries an artist so
obviously gifted in the techniques of his craft would have chosen themes
of greater import. And while it is right to assume that artists like Bail
shunned serious and momentous themes simply because they were not
to their taste, at the same time, Paris offered such varied opportunities

for mastering this or that artistic skill, and acceptance by the Salon
demanded such a high level of professionalism, that it was often these
lesser masters who achieved success by demonstrating their wonderful
technique. Incapable, perhaps, of deep thought or flights of fantasy,
they nonetheless often impressed with the precision of their execution,
particularly when combined with amusing subject matter. Paris, where
dozens of humorous journals were published, and where all too often a
sharp wit meant more than genuine intelligence, could appreciate a joke.

In other countries it would have been considered ridiculous to waste
paint and canvas on the portrayal of a boy merrily emptying a bottle
of wine under the reproachful gaze of some kittens, but not in France.
Regular visitors to the Salon might also have gleaned further interest
from this simple little joke, seeing in it a parody of the elevated history
genre. The apron of the kitchen-boy seems to parody the toga in Salon
representations of ancient Roman life. It is quite possible, indeed, that
Bail was making a reference to a picture by Jean-Paul Laurens entitled
The Late-Roman Empire: Honorius (1880; Norfolk, VA, Chrysler
Museum), which had attracted public interest a few years earlier. In that
picture the boy Emperor is shown on his throne in a similar fashion, his

Overleaf (top left): **Portrait of Prince K. A. Gorchakov**, 1868, by Alexandre Cabanel
Overleaf (bottom left): **Portrait of Mme M. S. Derviz**, c. 1899, by Jean-Joseph Benjamin Constant

Overleaf (top right): **Portrait of P. A. Chikhachev**, 1864, by Paul Baudry
Overleaf (bottom right): **Portrait of Princess O. V. Paley (Countess Hohenfelsen)**, 1902–4, by Pascal-Adolphe-Jean Dagnan-Bouveret

85

legs wide apart, failing to reach the ground. His left hand rests on an enormous sparkling golden orb, which in Bail's picture is exchanged for a brass cauldron. The 'sword' of the kitchen-boy is the ladle at his feet. Even when it first appeared, Laurens's melancholy seriousness was the object of much ironic commentary in Paris.

Artistic creation is always characterised to an extent by specialisation. Nowhere is the superficiality of Salon art more apparent than in the annals of genre painting, where it was extremely important to 'mark out' one's territory. The niche of each artist might be a tiny one, but at least it was his own. Bail's niche, for example, consisted of humorous little tales concerning apprentices and housewives, while Chaplin concentrated on variations of 'pretty young things'; Geoffroy, by contrast, specialised in people who had fallen on hard times. The title of one of his apparently dramatic scenes is entirely characteristic: *The Resigned* (1901; Paris, Musée d'Orsay), a work peopled with characters similar to that in the Hermitage's *Study of the Head of an Old Woman*.

Even during the age of Realism, one of the preconditions for having a work depicting real life accepted by the Salon was a technique capable of raising the subject matter beyond the commonplace. Thus, for example, in his picture *After the Storm*, which shows a fishing vessel flung onto the shore, Eugène Isabey wanted to distance his viewers from the characters in the scene. This artist, who had passed through the Romantic school and had painted a number of sea battles and colourful seascapes, did not have the modern desire to create a human drama based on mutual experience. Even at the end of the 1860s he preferred to create an elegant, stylised scene.

The life of seamen, precisely because it satisfied the desire for spectacle, was for a long time an attractive subject for those seeking recognition by the Salon. The sea was an effective background, and had only to be made to reflect the activities of the 'characters'. Where in Isabey's picture the sea foams, indicating the recent storm, in *Oyster Catching* by Pierre Billet, it has receded at low tide, and, like the resting fishermen, is calm. French artists, such as Courbet, Millet and Breton, who had started to depict scenes of manual labour from the middle of the century, originally drew their subject matter almost exclusively from the countryside and only later turned their attention to the seashore. None of these sea compositions, however, comes close to the conviction demonstrated in Millet's best works. *Oyster catching* requires constant movement along the bared sea floor as the tide ebbs. But in Billet's picture the figures are lifeless. They correspond less to the reality of life on the seashore than to the standards and principles of academic art, the picture being composed in the studio with a model adopting various attractive poses. The contrivance of such compositions forced the Impressionists to avoid the pitfalls of genre art, and to concentrate on unpeopled landscapes.

Society Portraitists

French Salon art in the Hermitage is represented above all by portraits: they were acquired from the properties of the St Petersburg nobility that were nationalised after the October Revolution. From the moment Russia began to imitate Western-European culture, portraits became an integral part of the decoration of court palaces and country houses. The reign of Catherine the Great saw the emergence of numerous artists of this genre, like Levitsky, Rokotov and Borovikovsky. At their best, these artists achieved the standards of Western-European art, although in most cases their technique remained somewhat unsophisticated. After them came the age of the Parisian celebrity-artists. At the end of the eighteenth century Elizabeth Vigée-Lebrun came to work at the Russian court. A few years later, at the beginning of the nineteenth century, Russian aristocrats travelling abroad began to commission portraits by François Gérard and even Ingres. By the middle of the century Winterhalter had become their idol, and people literally queued up at the door of the German master,[22] who had first served as court painter to Louis-Philippe, and later under Napoleon III. Nevertheless it is worth noting that however expensive portraits became, they continued to occupy a fairly lowly position in the hierarchy of genres.

Of course, throughout the last third of the nineteenth century the importance of portraits in the overall Salon-Academic system of values did not remain unchanged. If at the beginning of the 1870s the Musée du Luxembourg, the citadel of official art, hardly contained any portraits,[23] by the beginning of the twentieth century its galleries displayed nearly three dozen such pictures. It was, however, the late 1860s and early 1870s in particular that saw a flourishing of the portrait genre. This was for entirely understandable reasons of social prestige, since portraits were required by those who held positions of influence in society, and who desired to display an *image présentable* to their peers. As a result, portrait painting could not fail to attract any artist of repute. Portraits provided a stable income even for those who were principally known for different types of painting. Thus, for example, Baudry and Cabanel, who at the beginning of their careers gained considerable reputations for their female nudes, did not avoid portraits. Indeed, Alexandre Cabanel's early portraits quickly earned him recognition. Russian aristocrats, at the same time, were well aware of trends in French fashion. While occasionally they commissioned works from Russian painters like S. K. Zarianko or I. E. Repin, for the most part they turned to recognised Parisian masters. It was only later, in the 1890s and early 1900s, that they made an exception by commissioning works from V. A. Serov.

However, the seasoned leading lights of the Salon did not generally undertake complex commissions or tasks that required creativity, since they viewed portrait painting as a swift means of lining their own pockets. Prince Konstantin Gorchakov, while in Paris, commissioned a portrait of himself from Cabanel, who had already painted Napoleon III and some of his ministers. 'In his youth,' wrote the biographer of the Gorchakov family, 'he was considered in the Russian capital a *magister elegantiarum*.'[24] But in *Portrait of Prince K. A. Gorchakov*, this eminent

amongst the refined circles of Parisian high society, although not in artistic circles. In reality he was not a great draughtsman. While free and easy, and at the same time fairly accurate, his parallel brushstrokes reveal a lack of the strength and conviction which distinguish the drawings of a Manet or a Degas.

Helleu was one of those who defined the way women were depicted at the end of the century: elegant, both strong-willed and fatalistic, at once real and artificial. A variation on this image can be found in François Flameng's *Portrait of Princess Z. N. Yusupova with her Two Sons at Arkhangelskoe*, with the carefully drawn but essentially doll-like figure of the heroine. A few years later Zinaida Yusupova was painted by the finest Russian portraitist of the turn of the century, V. S. Serov (1902; St Petersburg, State Russian Museum). This later portrait reveals the personality behind the society beauty, with her own – albeit none too profound – inner world. It is unsurprising that Serov's portrait provoked considerable scorn from Russian critics for its crudeness and lack of completion, for this was a society that still preferred the technique of such an artist as Flameng.[26]

The Landscapes of the Barbizon Group

No other period in the history of art has produced conditions quite so favourable to landscape painting as the 1800s, a time that has quite rightly been called the landscape century.[27] It was a significant period indeed; long-held ideological, religious and aesthetic conceptions were under review, and genres came to the fore that were based on direct recreations from nature rather than on aesthetic doctrines attempting to interpret social or confessional concepts. The landscape, like the portrait and the still life, soon became one of the most significant forms in art.

The new importance of landscapes was connected to fundamental developments in the European social consciousness. With the end of the anthropocentric Age of Enlightenment, man's belief in himself was shaken. The self-fulfilment of the individual had little attraction for the Romantics, who were more inclined to regard man as a drop in the ocean than as master of the universe; it is hardly surprising, therefore, that the arguments of the Enlightenment lost all appeal for them. Instead they were left to pour their energies into an instinctive

explosion of feeling, a thirst for the storm, a longing for the impossible, a search for other worlds or for what was absorbing and miraculous in the world around them. Thus the dawn of the nineteenth century saw the rediscovery of landscape as a genre.

The Romantics used the depiction of nature to express their spiritual unease, their dreams and feelings. Such paintings were not always of nature alone, but often included easily accessible natural scenes such as walks or outings from the home. It is easy to see why the Romantics returned again and again to the same motifs: they gradually became an integral part of their spiritual world. For the most sensitive artists, this

led to ever more involved research into these motifs. And thus in their hands Romanticism slowly merged into Realism.

By the middle of the century in Europe – and considerably earlier in England – the landscape in art had secured itself a lasting reputation. In the decades that followed it was landscape that became the focus for art's most significant quests and discoveries: principally with French Impressionism, but later in similar, albeit less notable, movements – German Impressionism, the art of the Italian Macchiaioli, and the work of various European artists gathered under the banner of Realism. By the end of the century there was not a single truly important artist

Landscape with a Ploughman, early 1860s, by Théodore Rousseau

in France who did not paint landscapes. How different it had been at the beginning of the century. One need only recall David or Ingres, whose occasional attempts hardly earn them the description of landscape artists.

In one way or another all the major achievements in European landscape painting in the first half of the nineteenth century are connected with Romanticism: the work of Friedrich in Germany, Turner and Constable in England, and Corot on the other side of the Channel. It is true that, with the exception of Corot, the French Romantics remained indifferent to depictions of nature. However expressive the backgrounds of Delacroix's late canvases may be, their only function is to provide the setting for a *mise-en-scène*. Mimicking the emotions of the characters, they are less the expression of the outer world than a reflection of the artist's feelings. Thus, for example, in the compositions portraying

Christ on the lake of Gethsemane, nature, 'aroused' in full sympathy with the energetic conduct of the biblical characters, is used to reflect the artist's state of mind.

There are a small number of 'pure' landscapes by the French Romantics in which the nature portrayed does not stem from the artist's imagination, as with Delacroix, but is real and observed in all its details. Nonetheless these scenes are also transformed into a reflection of the artist's spiritual unrest. Thus in Gustave Doré's *Gorge in the Mountains* the rushing stream, mountain precipices and scudding clouds are all subjugated to the intensity of feeling projected onto the depiction of this Scottish highland plain, painted as it was from memory. The painting becomes a universal image of mysterious, animated nature, and is the creation of a fervent Romantic. In essence the very motif of a mountainous landscape remained the province of Romanticism.

At the end of the 1870s, however, as Impressionism reached maturity, Doré's work gave little promise of discovering new horizons. Colour, which by then was becoming the central challenge in French art, is almost totally lifeless in this painting, which lacks the simplicity and brevity that at the beginning of the century distinguished the works of Friedrich, the finest mountain landscape artist of the Romantic era. The work of Camille Corot reveals a seamless merging of Romantic, Classical and pre-Impressionist tendencies. The treatment of space in Landscape with a Lake, with its shaded foreground, or repoussoir, and the coulisses of trees along the sides, has its roots in the techniques of the Old Masters. However, the presence here of elements from the 'historical landscapes' of Classicism should not be taken as a tribute to antiquity, for such elements are reinterpreted in a truly Romantic way. From out of the gloom of the trees and the mysterious dark glade suddenly emerges the tranquil but radiant view of the sparkling lake

in the distance, with a boat by the shore and a glowing sky above. The light shines through the mist on the lake, gilds the foliage and does not fade completely even in the thicket of trees. Such careful attention to the play of light and air makes Corot a direct forebear of the Impressionists, although Landscape with a Lake, a late work, was painted when Impressionism's techniques were already established. Instead of heavy physicality and precise draughtsmanship, Corot preferred shading, an atmospheric modulation of tones and lack of definition.

On the eve of the appearance of the Impressionists, French landscape painting owed its most significant developments to Corot and the Barbizon group, artists who depicted their environment in the village of Barbizon and the forest of Fontainebleau. The classifications 'Barbizon group' and 'Barbizon style' are not entirely consistent. Many of the paintings of Théodore Rousseau, Dupré, Daubigny, Troyon, Jacque,

and Diaz de la Peña – including some now in the Hermitage – were not painted in Barbizon; while Rousseau and Millet lived there almost constantly, many of the others were just visitors. The leader of the group was Rousseau, whom Corot described as a revolutionary because of his bold techniques. His best works, from 1830 to 1840, did indeed break commonly held perceptions of what landscape painting should be about. Rousseau, in his own words, wanted to be 'an artist of his own country'; he travelled widely in France, striving for the realistic, accurate reproduction of any subject, however unprepossessing it might appear to be. An ever more realistic portrayal of nature became one of the defining features of French landscapes, with which Rousseau is rightly credited. By the beginning of the 1860s, there was, it is true, a marked falling-off in his work, but even in his final years he was still producing strong works of considerable originality, including his romantically striking *Landscape with a Ploughman*. In many of his paintings Rousseau used bitumen, a paint that was fashionable in the middle of the century, and which imparted a green-brown tone to the details of paintings. This use of bitumen reveals the half-hearted attitude of Rousseau and others of the Barbizon group towards colour. Rousseau said that in extreme cases it was even possible to do without colour, but that nothing could be achieved without harmony.

The Dutch artists of the seventeenth century, whom Rousseau, Dupré, Troyon and Jacque invoked in their struggle against the stifling dictates of the Classical landscape, were poor models in terms of brightness and purity of colour; nevertheless, they showed how to paint nature without unnecessary adornment. The Barbizon group, however, did not simply recreate the techniques and motifs of their distant forebears, for Rousseau, Dupré and others soon surpassed them with the dynamism and Realism of their works. In Troyon's *Path in a Small Wood*, Diaz de la Peña's *Landscape with a Pine Tree* and, particularly, Dupré's *Landscape with Cows*, the construction of each tree or branch, and the slightest shade of foliage, are all conveyed with remarkable attention to detail. In historical terms such realistic details were essential to art, as people began to learn to view nature in a new way. However, while the Barbizon

Below (top): **Landscape with a Flock of Sheep**, 1872, by Charles-Emile Jacque
Below (bottom): **Landscape with a Pine Tree**, 1864, by Narcisse-Virgile Diaz de la Peña

group surpassed the old Dutch landscapes in terms of tangibility, their works were quite inferior from the point of view of profound conceptual content. In their symphonic polyphony, the richness of their temporal and spatial continuum and the perfect harmony of all their elements, the greyish Dutch views of the Golden Age are far superior to the Barbizon works. In the Barbizon landscapes the effect of concrete reality is achieved largely at the expense of greatness and polyphony. This is even more the case with an artist like Harpignies, who was not a member of the Barbizon group, but who shared their approach to landscape painting.

Like their Dutch predecessors, each member of the Barbizon group ploughed his own furrow. Narrow specialisation ultimately helped them not only to break into the Paris Salon, but also to establish themselves on the European and North American art markets. The growing popularity of the Barbizon group soon attracted a talented if shallow artist called Constant Troyon. He had won medals at the Salon, and, following the example of Rousseau and Daubigny, headed off into the forest at Fontainebleau to paint studies. After a journey to Holland he became a follower of Paulus Potter, and finally found his leitmotif in the realistic portrayal of cows set in a Barbizon landscape. The demand for his pictures was so great that he was scarcely able to fulfil his

commissions. Troyon's paintings of herds of cows ambling along the road, like Charles Jacque's flocks of sheep, were equally successful in St Petersburg and New York: in both cities the works of the Dutch masters were revered, and thus collectors had developed a taste for these contemporary treatments of familiar motifs. In the works of both painters Realism includes an element of idealisation; it was this that allowed pictures of the 'peasant genre' to adorn respectable drawing-rooms, including that of Alexander III in the Anichkov Palace.

Barbizon painting gradually evolved from its semi-Romantic, semi-Realist beginnings to an ever increasing accumulation of realistic elements. The Realism of the Barbizon group, however, proved to have fragile foundations. No sooner had they achieved recognition in the middle of the century than they began – some more so, some less – to repeat themselves or to give in to the temptation of superficial prettiness. Whereas previously artists of the Barbizon group had the greatest difficulty having works accepted by the Salon, during the Second Empire they became pillars of the establishment.

Compared to the canvases of Rousseau and Dupré, the landscapes of Charles Daubigny appear less energetic and more contemplative: they were the result of the study of nature rather than of real experience.

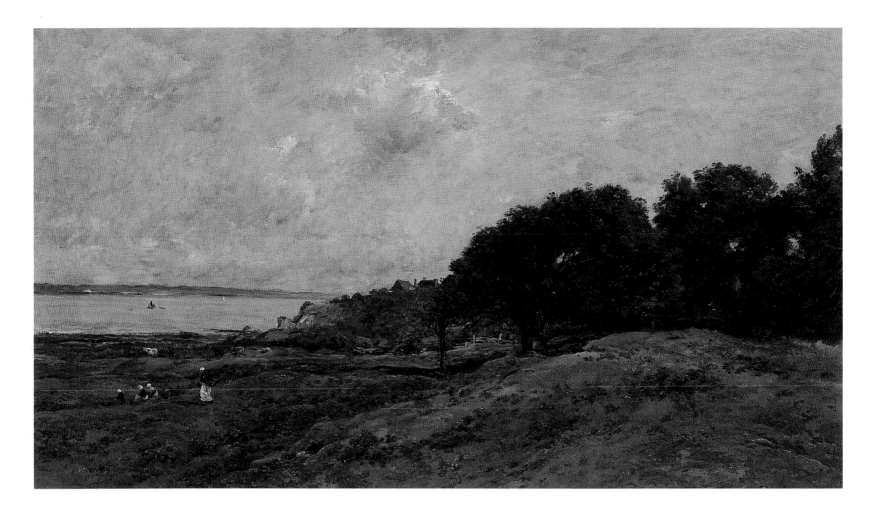

The artist's four works in the Hermitage show a gradual breaking-down of the boundaries between studies and actual pictures, and reveal an increased attention to the play of light. Daubigny was particularly successful in his studies painted in the open air. One of these, *Banks of the Loing* (a popular painting, also incorrectly known as *Banks of the Oise*), was obviously painted from the middle of the river, from the small boat where Daubigny spent much of his time. The sense of a boat smoothly floating along the river bank is clearly felt, while the horizontal line of the bank defines the entire structure of this small canvas. It is a painting that conveys not only outward reality but also the very spirit of the French landscape. The village in the distance is an integral part of nature, existing in unity with it. Daubigny was one of a very small number of artists with an established reputation who supported the Impressionists at the beginning of their creative journey. He had come to painting *en plein air* before them, and this work in the open air lightened his palette and brought it to life, lending greater flexibility to his colour schemes. It is easy to feel how quickly the strokes have been brushed onto the canvas, creating an almost impressionistic surface, particularly in the upper sky section. It is significant that in 1868, at roughly the time that *Banks of the Loing* was painted, and some years before the Impressionists' first exhibition, the young Odilon Redon described Daubigny as an artist of note, and

particularly remarked upon the beauty of colour in his pictures. 'Monsieur Daubigny's great quality will always be the harmony – that is, the completeness – of his colour. It is impossible to mistake the hour at which Monsieur Daubigny paints. He is the painter of a moment, of an impression.'[28] Even before that, the word 'impression' was used by Théophile Gautier in reference to Daubigny – albeit in a somewhat derogatory sense. The artist himself was not sufficiently aware of what he had achieved in terms of the comprehension of reality through art. His early views and studies of the shore at Villerville made a strong impression on the young Monet, who wrote to Boudin that Daubigny was an artist who understood nature.[29] Daubigny himself, however, was more drawn to large-scale canvases. And when he turned to such works as *The Coast at Villerville*, he in fact took a step backwards. For when he worked in his studio he did not simply create a composition based on a study painted in the open air, with a few necessary minor adjustments. Instead, the range of colour became ponderous; the freshness of his painting was sacrificed to outdated principles of what was picturesque.

Also connected with Barbizon were the works of Jean-François Millet, who spent the last years of his life in the village. The forest at Fontainebleau inspired in him impressions entirely different to those of Rousseau, Troyon or Diaz. Less a landscape artist than a poet of

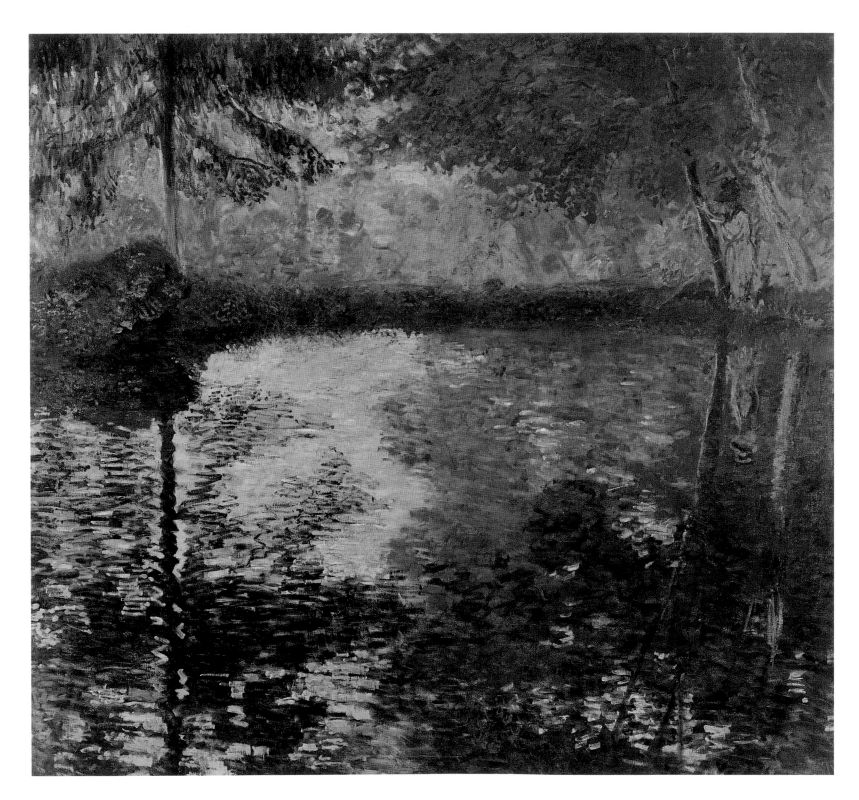

The tree and bushes in *Corner of the Garden at Montgeron* are not cut short to make them more attractive. It is simply that a fragment is enough to show the most important element, at least, for the Impressionist: the stirring of nature and the remarkable picturesque qualities it evokes, which would pass unnoticed by those concentrating on great views or magnificent effects. The pictorial elements are not ranked according to first or second importance, nor can they be examined in isolation; they rise up before our eyes in one artistic whole. In the play of patches of colour in *Pond*, it is not immediately apparent that the painting includes figures: a lady with a fishing-rod and a man

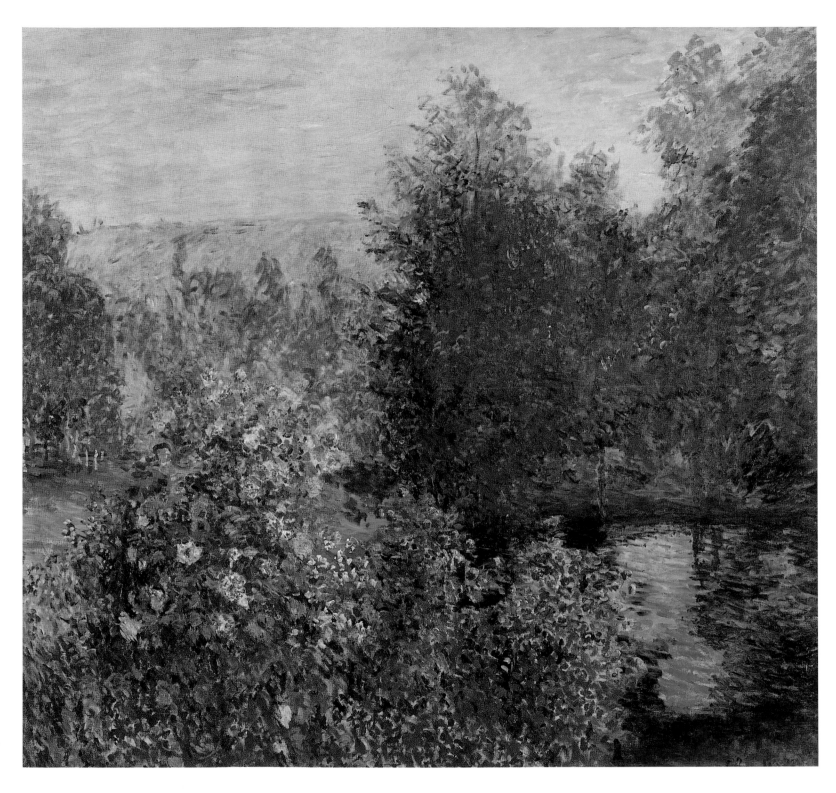

lying on the bank. Monet's contemporaries often turned such scenes into entertaining vignettes, but he views them with equanimity. The moment does not accommodate precise outlines or delicate details. Thus the man is barely discernible, although he is lying not far from where the artist is sitting. But the momentary impression creates a perception of colour of astonishing beauty, and becomes the basis for a piece of rare artistic unity. In order to achieve this, Monet, who was convinced that the first view of a subject was the truest and least prejudiced, was prepared to sacrifice other techniques.

The *Parisiennes* of Renoir and Degas

Through the efforts of Monet, Sisley and Pissarro, the landscape became the principal genre of the Impressionists. Degas and Renoir, too, paid tribute to landscape painting, but their primary interest was in the portrayal of the human body, or, more precisely, the female form. It was the work of these two artists that provided the most lively and striking images of Frenchwomen of the final decades of the nineteenth century.

Of course, Edouard Manet should not be forgotten. His creative spirit is superbly conveyed in the *Portrait of Mme Jules Guillemet* – one of the true masterpieces of drawing of the time, and the quintessence of French drawing in general. When we look at the lines of this quick sketch, drawn with wonderful clarity and sureness of touch, we can imagine the pencil moving over the page; in other words, this is an occasion where we can reconstruct the creative process. The drawing

did not present Manet with a complex task and it is hardly surprising that such portrait studies are often attempted by artistic dilettantes. But when an artist uncovers a simple, striking and original approach to a banal *métier* or tired theme he is all the more worthy of praise. It is tempting to see greater merit in the sketch of Mme Guillemet's profile than in many of the artist's finished paintings and portraits. Not only has Manet caught the likeness, capturing in a fleeting expression the subject's character and mood, he has also created a universal image – the image of the *Parisienne*. Not surprisingly, a second portrait of Mme Guillemet (1880; near Copenhagen, Ordrupgaardsamlingen), is entitled *La Parisienne*.[37]

Mme Guillemet was generally considered to be the true embodiment of Parisian elegance, and few knew of her American origins. She was one of the charming society ladies with whom Manet loved to conduct light conversations – *causerie* – verging on flirtation. Even when incurably ill, Manet remained true to form, decorating letters to his *Parisienne* with sketches of her profile, or one of her legs peeking out from beneath a skirt hitched a little higher under the table than was quite proper. 'Madness it may be,' he wrote in the margin of one such sketch, 'but a pleasant madness, which allows me to pass my time most agreeably.'[38] What are the characteristic features of the *Portrait of Mme Jules Guillemet*? A slightly playful touch, a well-developed sense of self-irony, the unconstrained and almost careless movement of the pencil, and the result – a delightful, timeless lightness of touch.

Lightness in this context does not suggest superficiality, but rather that sense of *joie de vivre*, without which it is impossible to present the art of the Rococo, and which above all was the essence of Renoir, the Rococo's rightful heir. Lack of constraint, the absence of all affectation, a noble naturalness – these are the qualities that distinguish his heroines. Their lives were almost always connected with Paris. Thus *La Parisienne* was the title of the most representative of Renoir's paintings at the first exhibition of the Impressionists. The women Renoir chose to paint almost all belonged to one social circle. Although he occasionally painted society ladies, on the whole his subjects were not so high up the social ladder: actresses, maids, milliners, seamstresses, workers met by chance on the street, models, usually not professional but 'les grenouilles', as women of a certain loose conduct were called – those emancipated young women who lived through love, rather than earned their living by it.

It is possible that one of these 'grenouilles' posed for *Head of a Woman*. We are unlikely ever to find out who the model was. She is a *Parisienne* – real, alive, natural and not the idealised, entirely artificial creation of a Lefebvre. Renoir was not attracted to intellectual or strong-minded women, but to those who reminded him of cats. 'Cats are the only women it is worth talking about. They are the most enjoyable to paint' – such were the words of the artist, recorded by his son.[39] Paintings like *Head of a Woman* were neither commissioned nor intended for display at exhibition. They were usually painted at one sitting, the surface of the canvas being quickly covered with diluted paint, as if the brushstrokes were attempting to keep up with the immediate impression of the artist. Renoir valued naturalness above all, and experienced genuine pleasure

Head of a Woman, *c.* 1876, by Pierre-Auguste Renoir **Woman in Black**, 1876, by Pierre-Auguste Renoir

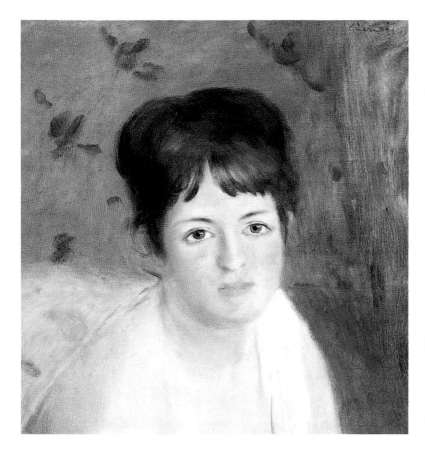

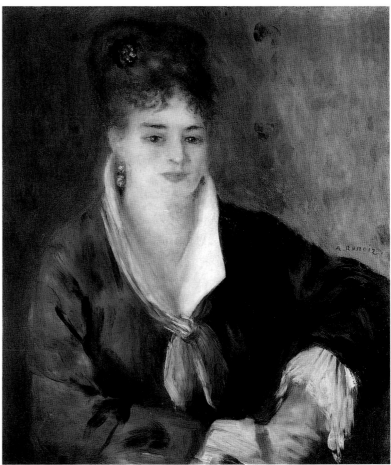

when he painted young women, particularly when he was able to work with models whom today we would call 'Renoiresque'. 'Even before I could walk,' the artist once said, 'I loved to paint women.'[40]

Head of a Woman, Woman in Black, which was painted at the same time, and *Girl with a Fan* – the very names of these works reveal a tendency which, to paraphrase one of Renoir's friends, sometimes represented a desire to treat a subject purely in terms of its pictorial tone.[41] This is why there is no need to make laboured attempts at identifying the Woman in Black. Her portrayal is not physiognomical, and even less is it a psychological study; rather it is an artistic experiment in praise of the beauty of the colour black. The black dress of the lady is notable for the wonderful richness of nuances; only the shades are pure black, and everything else is a blending of the subtlest shades of grey, from black to silver.

In order to achieve the extreme intensity of black in *Girl with a Fan*, Renoir turned to mixing the most delicate dark blue and dark red paints. Nothing sets off the charm of her youthful skin so well as the young girl's blue-grey eyes, her hair and her enormous bow. And what would the *Portrait of the Actress Jeanne Samary* be without the unique artistic effect of her frothy pink dress against a dark background? This effect somehow creates a sense of harmony in the pose and smile of this enchanting star of the Comédie Française. Her red hair seems to

sparkle, not just because the tone has been faithfully captured, but also because of the golden streaks of paint that almost imperceptibly merge with the background, where there is not a single delineated outline. Could Renoir have hoped for success when he painted *Woman in Black*? By no means. Success could only be guaranteed to a picture like Carolus-Duran's *Portrait of Mme N. M. Polovtsova*, painted in the same year. The comparison is particularly apt, since both subjects are presented in the same pose. Renoir would not have seen Carolus-Duran's St Petersburg canvas, but he would have been very familiar with its style. The two artists had earlier been competitors. 'Since the portraitist's craft was a profitable one,' wrote Jacques-Emile Blanche, 'a young Renoir, a young Bonnat or a young Carolus would have been searching for commissions from the same clientele.'[42] While Carolus-Duran went from success to success, however, Renoir, who had no intention of tailoring his art either to the tastes of clients or to the demands of the Salon, found himself at a difficult stage in his life. From 1872 the Salon jury rejected his pictures. Nor did the hopes for the Impressionists' exhibition prove justified. Renoir took part in the first three exhibitions, showing fifteen pictures in 1876 and twenty-one in 1877. He refused to participate in the fourth, having decided in 1879 to strive once again for recognition from the Salon.

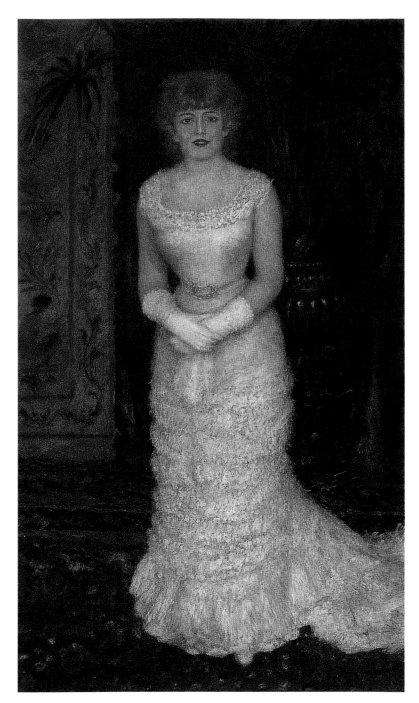

'There are scarcely fifteen art-lovers in Paris', Renoir wrote a little later to Durand-Ruel, 'who are able to appreciate an artist without the Salon's approval. And there are about 80,000 who will not buy a painting unless the artist has been admitted to the Salon… I don't want to waste my time doing battle with the Salon, and I don't even want to give the impression of so doing… My participation in the Salon is purely a business under-taking. In any event it will be like certain medicines: even if they don't actually do any good, at least they cannot do any harm.'[43] Renoir pinned his hopes on two paintings: *Portrait of Mme Georges Charpentier with*

her Children (1878; New York, Metropolitan Museum of Art), and *Portrait of the Actress Jeanne Samary*. The success of the former finally brought about a turning point in his career. Few, however, noticed *Jeanne Samary*, which was badly presented, high up and poorly lit. In his review of the Salon, Huysmans wrote, 'The never-ending insufferable smile of this actress is well caught. We find her again here, smiling as always, but this time in a pink dress in M. Renoir's canvas. It is so strangely positioned, right up high in one of the Salon's dumping grounds, that it is quite impossible to tell exactly what effect the artist hoped to create. They might as well have attached pictures to the ceiling since it's virtually there in any case.'[44]

The Hermitage portrait of Jeanne Samary is more conventional than the artist's earlier paintings, including earlier portrayals of the same actress, particularly the famous picture in the Pushkin Museum in Moscow (1877). This is shown principally in the use of formulae employed in court portraits. Remarkably, however, Renoir has managed to avoid the mannered, pompous and artificial style so characteristic of Salon paintings. Who else but Renoir could have countered the heavy luxury of the bourgeois drawing-room with the bright smile of his subject? For some reason we do not notice the tastelessness of the ornate vase that provides such a wonderful contrast to the figure of the actress. There are similarities in the discreet staccato design of the carpet and the elusive, undefined nuances of the dress. Even the winding ornament on the screen has its own special effect, for without it we would perceive Jeanne Samary quite differently, a woman in whom Parisian taste is combined with a sweet spontaneity. Was this how Samary really was? From contemporary descriptions and from photographs that have been preserved it can be suggested that Renoir's pictures do not entirely reflect reality. But so what? This is how Renoir saw her; in essence, he was creating an ideal image, and not a copy from nature. Jeanne Samary's features were expressive but heavy, something that is not evident in Renoir's portraits; for he did not so much paint the actress as she was, as illustrate his admiration for her. In fact her mouth was wider, her teeth more prominent and her lower jaw heavier. It is said that Samary herself preferred Renoir's portraits to all others, although her likeness was better caught by other artists, such as Carolus-Duran (*c.* 1885; Paris, collection of the Comédie Française) or Louise Abbeme, whose portrait of Samary was also shown at the Salon of 1879.

It is timely to remember that for decades historians of art have praised the veracity of the Impressionists' art, and have marked this as the cause for their ostracism by the Salon. And as for the pillars of Academic art, in the art historians' eyes their only contribution has been to over-embellish reality, for which they merit if not eternal oblivion, at least whole-hearted censure. According to such an evaluation scheme, Renoir should be reproached for the 'Salon-ness' of his *Portrait of the Actress Jeanne Samary* or Monet condemned for the excessive dec-orativeness of his late landscapes. Such attitudes are now only partially justified. The problem is not idealisation in itself, for art cannot do with-out it, and thus one form of idealisation will always replace another like the seasons of the year. It is simply that the idealisation used by the Salon artists was outdated, or becoming so, and in their hands became

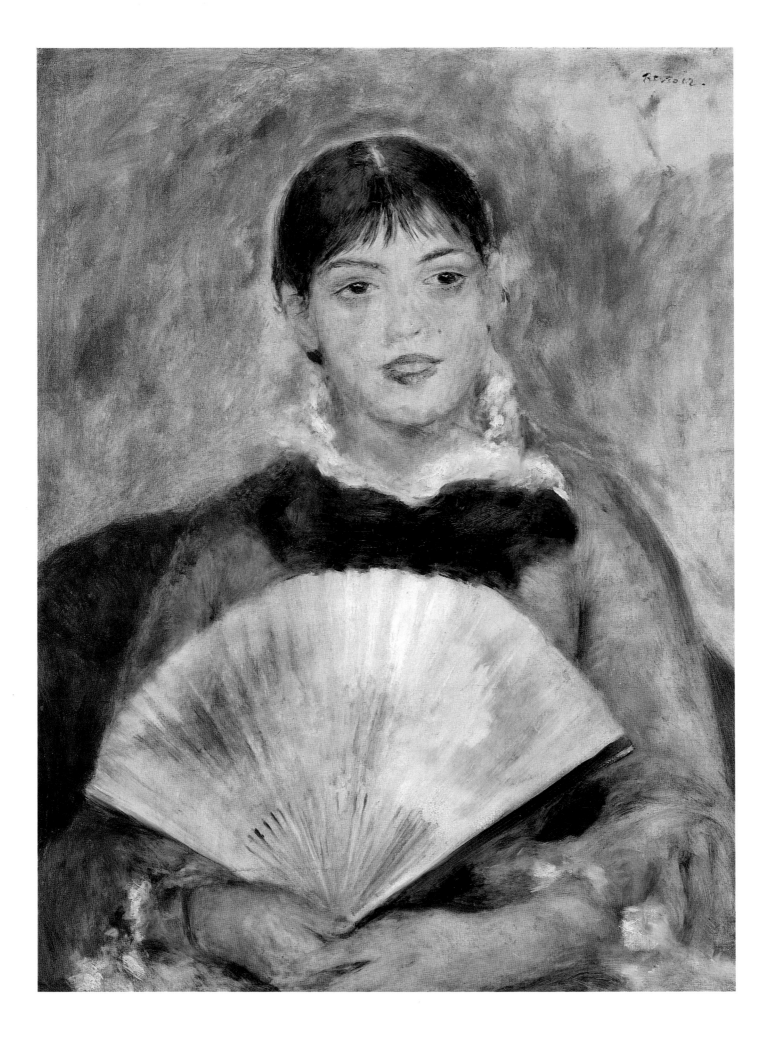

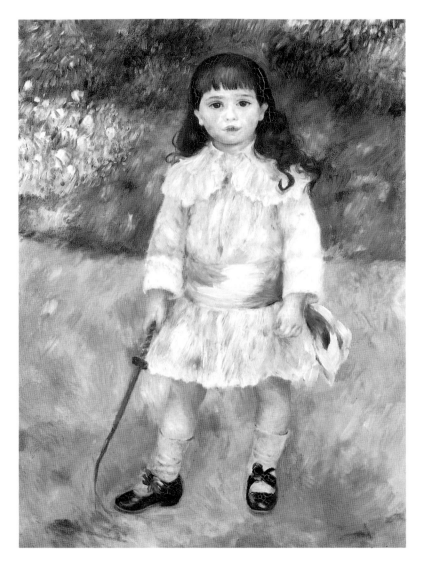

key into the colouristic ensemble. One of the problems Renoir faced in this portrait was how to show a fairly light subject against a similarly light background. Here, as always with the Impressionists, the palette, so much lighter than that of their predecessors, was dictated by the inner meaning of the painting. Thus a bright, sunny background adds exuberance and freshness, and is inextricably intertwined with youth. And how young and pure is the girl's oval face! The whole picture is deliberately based on the melodic cadence of recurring curves: the perfect egg-shape of the head, Angèle's sloping shoulders, the outline of the red armchair and finally, of course, the fan itself, which defines the whole tone of the painting. Thus the entire artistic structure perfectly matches the form and character of Angèle – this dreamer, with fire in her eyes, the ultimate cat-woman, the embodiment of softness with hidden claws. The picture attracted great interest at the seventh Impressionist exhibition in 1882, where Huysmans preferred it to *Luncheon of the Boating Party* (1880–1; Washington, DC, Phillips Collection), saying that the model was 'entrancing, with her great sparkling black eyes'.[45]

No one but Renoir was truly able to convey the refinement of the *Parisienne* with such sincerity and warmth. 'What does he do', wrote the artist's brother, the critic Edmond Renoir, 'when he starts on a portrait? He asks the model to behave as normal, to sit in her usual pose, and wear her everyday dress, so that nothing in the picture should display tension or preparation.'[46] Pictures like *Girl with a Fan* occupy a special place in Renoir's oeuvre. The drawing of Angèle's face already reveals the search for a purity of line that led the artist to his so-called linear or Ingresque style. Renoir had always loved Ingres, and his journey to Italy in the year following *Girl with a Fan* provoked a particularly strong admiration for Raphael. He became convinced that it was essential to go back to the draughtsmanship of Raphael and Ingres. Renoir had never shared his friends' antipathy towards the Salon. While they were preoccupied with their struggle for recognition, and with the problem of subject matter, Renoir diverged from them, and turned to the question of form.

entirely lifeless. Monet and Renoir, on the other hand, were interested in real life and wanted to find a new beauty in it; and so when they portrayed nature, at the same time they idealised it.

In their society portraits Cabanel, Baudry and Carolus-Duran had no need for new techniques. Any pursuit so fraught with deviations from their well-proven path to success could only harm their reputation. The background in their portraits is always painted uniformly, its sole purpose to set off the figure of the subject and to fill the space between subject and frame. These empty backgrounds, sometimes occupying half of the canvas, clearly show that it was not principally artistic problems that preoccupied the Salon artists. For the Impressionists, though, every little part of the painting was important, every area of the canvas an integral detail of a unified artistic whole.

In *Girl with a Fan*, for which the model was Angèle, one of the artist's favourites, the background is not as complex as that of *Portrait of the Actress Jeanne Samary*; but it is no less important as a means of revealing the subject. Every brushstroke introduces an indispensable major

Renoir's pictures of the 1880s show a certain compromise. Thus *Child with a Whip* is a stylistic hybrid of elements of Impressionist painting (the background and the dress) and clean lines (the boy's face), that were quite uncharacteristic of Impressionism. It is known that the child is four-year-old Etienne, son of the senator Etienne Goujon. In commissioning the painting, Goujon did not wish to tie Renoir to the stylistic norms of the Salon;[47] nevertheless, it is possible that the swimming patches of colour in the background, here representing the free play of sunlight, did not entirely appeal to him. In any event, in comparison to *Child with a Whip*, the portraits of the senator's two elder sons, which were probably painted after this, conform more markedly to the standards expected by society – and are consequently far less interesting in artistic terms. It is surely also significant that Renoir particularly enjoyed painting young children. He was attracted to these natural subjects: round-faced, healthy children with beautiful hair. He particularly loved long locks in boys, and for a long time did not allow his own children to have their hair cut short.

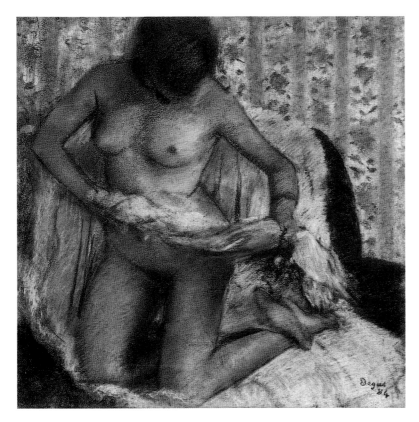

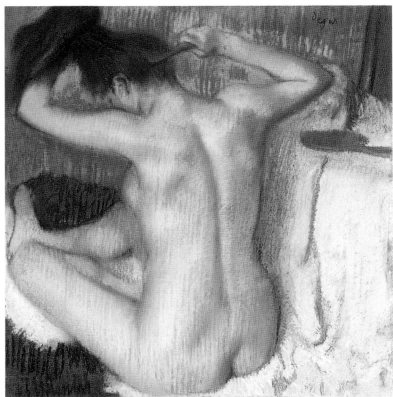

It is hardly surprising that people who did not know the circumstances of the commission took the model to be a girl. It is also unsurprising that to this day people prefer to call the picture *Child*, without referring to the boy's name. This does not mean that the portrait is inexpressive. Quite the contrary: the wilful nature of the boy is clearly revealed. By all accounts he was a capricious child, and the whip in his hand is therefore a significant detail. At the same time, however, generic characteristics in Renoir's portraits are always conveyed more distinctly than individual ones. There is much in common between all the children that he painted. This was particularly well expressed by the artist's son Jean, portraits of whom bear a remarkable resemblance to *Child with a Whip:* 'He had already painted our portraits hundreds of times before we were even born, as well as all the other children, all the girls with whom the artist peopled the world created by his genius... Parents often stop me and say, indicating their child, "Don't you think that he's a little Renoir?" And the most amazing thing is that they are right.'[48]

Among the founders of the Impressionist movement a special position is occupied by Edgar Degas. He, with good reason, preferred to talk about 'independents' rather than 'Impressionists'. Despite his extraordinary gifts, this man, with his difficult character and sharp tongue, was not fated to be the leader of the group. But for all his disagreements with other members, he shared their general conviction that art must be insolubly bound to modern life, and should reproduce it in a lively and direct way. Degas began with Academic pictures and portraits in the style of Ingres, who always remained his idol. Blessed with an astonishing sense of colour, Degas nevertheless considered

drawing to be the foundation of all art. His understanding of the possibilities of line was far more profound than that of the other Impressionists, even of Renoir during the period of his linear style. Degas said that he was always trying to incite his colleagues to search for new approaches to drawing, since he considered this a more productive field of activity than colour. He never, however, neglected colour, but remained, in his own words, 'a colourist through line'.

The desire to paint by drawing gradually led Degas to reject oils altogether and to concentrate on pastels. No one before him had ever shown such mastery of this medium, no one had imbued it with such energy. The Impressionists, as a rule, only painted with the subject before their eyes. Degas was able to do without this. He never forgot the words of Ingres, who as an old man gave the following reaction to Degas's studies: 'It is good, young man. Never paint from life. Always from memory and from prints of the Old Masters'.[49]

Monet or Sisley, who were more preoccupied with conveying immediate visual impressions, had to start a new canvas if the weather changed, or had to wait until the lighting returned to what it was before. For Degas questions of light and atmosphere were of secondary importance. At any time he might return to the same picture. Always dissatisfied, his was an endless search for a kind of perfection that no one apart from him, perhaps, would even have recognised. The unalterable communion of composition and drawing was his principal, persistent concern. It explains many aspects of his work, even, for example, such an apparent peculiarity as his love for working on paper; in this medium it is easier

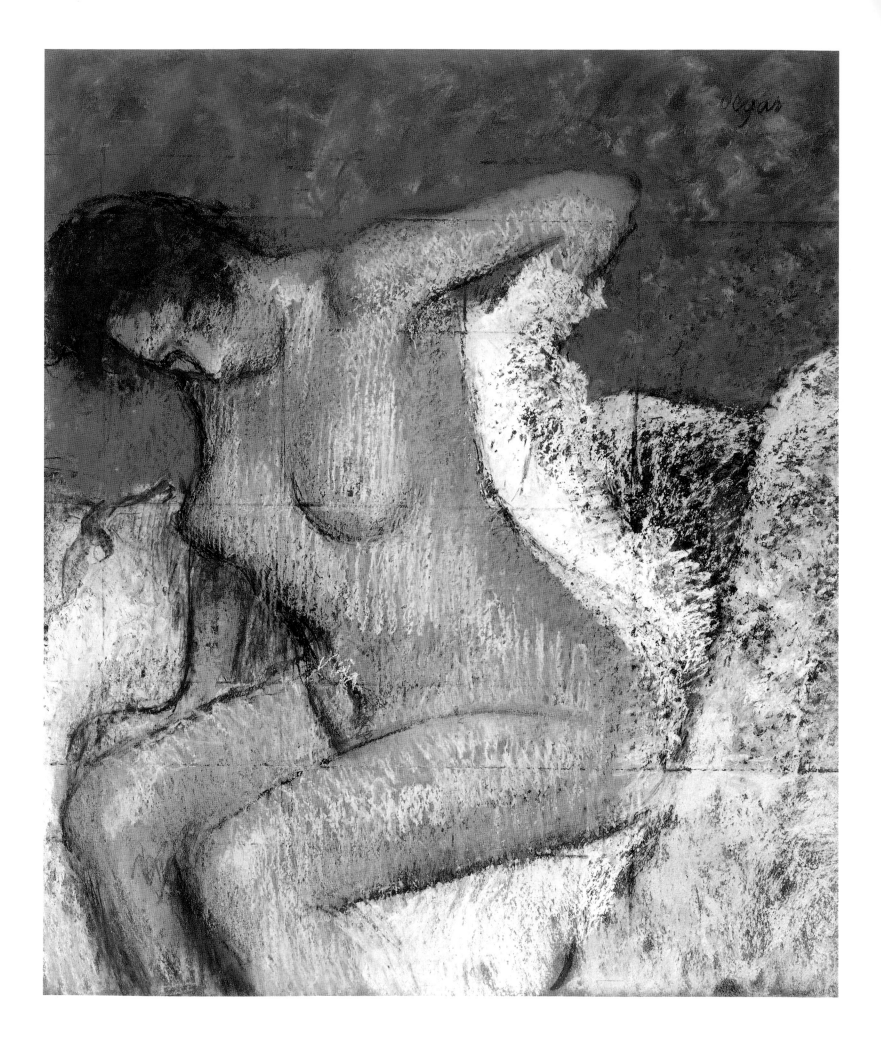

to carry out compositional studies, since it is always possible to cut out or add a piece. Degas was more strongly linked with centuries-old traditions than Monet, Sisley or Pissarro, but this link was internal and hidden, based not on imitation but on a close understanding of the creative process.

Degas's contemporaries greeted his nudes with indignation, and not just because the Salon portrayed nudity of an entirely different sort. The Old Masters, too, struggled with rather carefully defined prescriptions for the portrayal of nudity. Rembrandt alone was not afraid to show completely real, unadorned nakedness. Degas was even more merciless. 'Just think,' he admitted to his friend Daniel Halévy, 'in another age I could have painted Susanna bathing.'[50] Now, however, as the struggle for truth in the representation of real life reached its peak, he had no place for Susanna in his art: mythological subjects were not needed. Degas's nudes were his own contemporaries; their proportions did not correspond to any ancient template. In his pictures they never pose, but are always engrossed in their own simple occupations: they wash, dry themselves, do their hair. So preoccupied are they that they have no vain desire to appear more attractive. Degas was not exaggerating when he said that his characters were viewed as if through a keyhole – an admission that goes some way towards revealing one of the most important psychological aspects of his lonely life. Van Gogh, who was first to recognise this trait, wrote to Emile Bernard, 'Degas's painting is at once virile and impersonal, precisely because in his private life he is happy to be just a minor civil servant terrified of living it up. He looks at his fellow humans, stronger than he, who screw around and screw around, and he paints them so well precisely because he has no desire to screw around himself.'[51]

Degas strongly preferred movement and gesture that had neither emotional nor psychological motivation, as is well illustrated by the fact that he never tried to depart from the field of pure plastic arts. He particularly loved professional movement – dancers, jockeys, women ironing – and constantly returned to these themes. If the artist found similarities between the carefully controlled gestures of ballerinas and the movements of women absorbed in washing and dressing, then it is because both were sincere and devoid of affectation. It is true that in his old age Degas was to say with bitterness that he had too often considered women as animals. And while undoubtedly his approach did suffer from lack of variety, it kept him from the kind of external prettiness and convention that had for so long hindered the artist's view of reality.

Degas never allowed himself to exaggerate the refinement of his models' proportions. Naturalism, however, was anathema to him. His aim was the eternal search for beauty, which could be attained neither through copying nature, nor through 'correcting' it. For Degas, the secret of creation lay in animating line and colour, so that they obtain independent value and expressiveness. The beauty of *After the Bath* (1884) is achieved through the soft silver lighting, the glimmer of the colour reflections and the alternation of shade and semi-shade – all of which combine to produce an organic balance between warm and cold

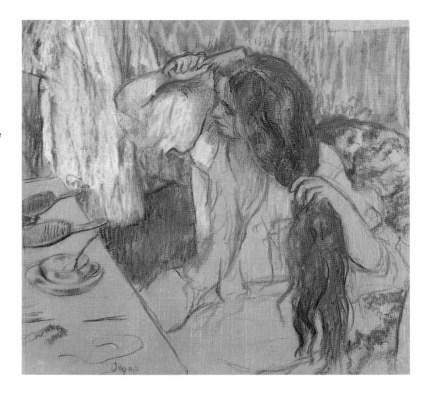

tones. This picture, with its fully defined background, differs from his later pastels: the action takes place alongside a wall covered in paper fashionable for the early 1880s. The pattern, however, is not illusory, but serves to highlight the main subject. The alternation of vertical stripes on the paper at the borders interacts quite beautifully with the pose of the model, and introduces an additional note of dynamism. Among the numerous portrayals of women drying themselves, this comparatively early example of the motif is unique: in later works the artist did not return to this composition. Degas's heroine does not pose like Lefebvre's Magdalene: she is not used to elevated suffering, nor, indeed, to strong emotions of any kind. The subject – whether historical or not – had ceased to be an integral part of artistic design. Any kind of pretext was enough to paint a nude body; all that mattered was that it must not be contrived, for a contrived picture cannot be convincing. After a bath a woman dries her hair and then combs it, and for Degas either action was enough to form the basis of a composition. The artist memorises the pose of the model in its natural, unpremeditated totality, and details are invented or adapted to create an artistic whole. The model kneels on the sofa, covered by a sheet. It is a natural, momentarily glimpsed pose, which will change in the next second. There is a slight awkwardness about it, but the outline of the figure is fluid, and there are no sharp contours even at the elbows or the bent knees. The delicately outlined protuberances of the breast and hip and the smooth contour of the shoulders are in harmony with the folds of the sheet, while the patterned stripes of the wallpaper, defined but not at all harsh, accentuate the fluidity of the outline of the model's body. The woman's red hair and the colour of the sofa cover have a 'common denominator', while the sheet remains just a sheet, and seems to hint at a *mandorla*, the almond-shaped light which from ancient times served

Dancer, 1885–6, by Jean-Louis Forain

Gatefold: Dancers, c. 1896–8, by Edgar Degas
Reverse of gatefold: Seated Dancer Adjusting Her Shoes, c. 1880, by Edgar Degas

as a frame for portrayals of a deity. For the Impressionists, however, art was focused not on the heavens but on earth. This composition, apparently so spontaneously achieved, is in fact carefully thought out and well organised. In its construction Degas, more than the other Impressionists, revealed his links with tradition. The figure is drawn in a square with such skill that it bears comparison with the finest examples of ancient Greek vase-painting, where the geometry of limited space, the beauty of outline, the lack of constraint and the truthfulness in the portrayal of the nude form were for the first time brought into unified harmony.

Possessed by the desire to convey movement as authentically as possible, Degas tirelessly returned to the same situation over and over again. The very same gesture of a raised hand passing a comb through

the hair was examined down to the minutest detail, and each time appeared anew. The Hermitage canvas *Woman Combing Her Hair* has two variations in American collections, where the same motif has undergone a total compositional reworking. Having changed the position of the leg into a more Oriental style, Degas had to reposition the figure to the right, to free up space for new details in the background. In all three variations he preferred to look from behind, and slightly to one side, a viewpoint that makes the mechanics of the pose all the more strongly defined. The selection of such a viewpoint reveals not only Degas's own preferences, but also reflects Japanese prints, in which similar compositions were widely known. In order to convey movement, here it was necessary not only to decide the position of the arms, legs and body, but also to feel the complex interrelation between all the parts of the body. The musculature of the spine and the alternation of grooves and ridges are explored with astonishing insight, and yet this picture is nothing like an anatomical illustration. Degas shows a figure that is far from the ideas of perfection of the time, but this commonplace body is painted in such a way that it is impossible not to feel that the transformation of everyday reality is taking place before our eyes. It is achieved through the accumulation of various artistic techniques: by the soft tones of the pastels, but most of all by the qualities of the drawing, where the contours of the figure become first delicate and precise, then thicker and less defined, then finally disappear altogether. Drawing of this kind is not learnt in art schools. It was a new style of drawing, capable of capturing movement. The background is particularly effective: the blue drape to the right repeats the outline of the body and the raised arm, while the position of the legs, forming almost a right angle, seems to control the lines that indicate where the two walls meet. Just as in the pastel *Woman at Her Toilet*, which is based on the same motif of combing the hair, the table is orientated in accordance with the gesture of the arms, while the armchair in which the woman is sitting somehow slows down the movement, confining it to the square defined by the composition.

As time passed, a tendency towards generalisation became more and more apparent in Degas's art. This is well illustrated by a comparison between two works on an analogous theme, painted ten years apart. In *After the Bath* (1884) the space within which the figure is enclosed is drawn in fairly concrete fashion. However, in the pastel *After the Bath* (c. 1895), the background has turned into an abstraction, and the relationship between colours has become simpler and more decisive. This is a work of rare refinement. It is possible that the artist himself was so taken with the scene that he has not bothered about the significance of the patches of colour – the white, for example, is more akin to foam than to the sheet with which the subject is drying herself. But with Degas, of course, it could not be any other way. The artistic structure of the pastel and the artist's intuition forced him to make the edge of the white area irregular, for any other way would be inorganic. The brushstroke is now quicker than before. The painting process has become more complex and more energetic. Striving for a particular colour effect, the artist has not hesitated to combine techniques, adding tempera and possibly gouache to the pastel and charcoal. At the same time, he has mastered new techniques, splashing the pastel with boiling

water or working with steam to enable the layer of colour to coalesce, thereby allowing him to go over the same area more than once. It is likely that as a result of such a procedure he probably used a network to transfer the figure from a sketch; a tool which, of course, he did not think to preserve.

'Throughout his life,' wrote Paul Valéry, 'Degas has painted Nudity in all its different forms, in an unbelievable number of poses, and at the most striking moment of movement. And all the time he has been searching for a system of lines that is able to *formulate* the given state of the body with the utmost delicacy and at the same time with extreme generality. Neither grace nor visible poetry attracts him. His works hardly sing at

all. Artistic creation must always leave some place to chance, so that certain charms can emerge that excite the artist, take control of his palette and lead his hand… But he, strong-willed by nature, never satisfied with anything achieved immediately, with a mind that was terribly critical and over-educated in the Old Masters – he never trusted straightforward enjoyment in work. I love this severity. He is one of those people who never feel that they are working or achieving anything unless they do so in spite of themselves. This, perhaps, is the secret of the truly virtuous man.'[52] Neither Renoir nor the other Impressionists exhibited such all-consuming, uncompromising severity. Only Cézanne and Seurat possessed it. Monet and, in particular, Renoir were uneven artists, and alongside works of true genius are sometimes limp, casual paintings (of which, fortunately, there are none in the Hermitage collection). But with Degas, any sketch, even the most unfinished, has the incontrovertible logic of a single possible resolution.

His *Dancers* [gatefold] is a case in point. Its bold composition – in essence a sketch – is magnificent: each turn of the head is caught so sharply and precisely that it is impossible not to feel the essence of movement of each dancer and of the group as a whole. Degas turned to the theme of ballet dancers more often than to any other,[53] and this is why his name is so often associated with it. However, he did not want to be known simply as a painter of ballerinas, saying that the dancers were principally a pretext for portraying movement and painting beautiful fabrics.

Nothing provides a clearer proof of Degas's genius than comparison. Forain's *Dancer* is notable for its economy of artistic means and the absence of ill-conceived prettiness that distinguished practically every work on a theatrical theme shown in the Salon. But its effectiveness immediately pales against Degas's pastels, with their conviction and energy – and this despite the fact that Forain openly admitted that he owed everything to Degas. Lacking his teacher's extreme self-criticism, he was normally quite satisfied with what he achieved at the first attempt. Much of what Forain painted hardly reaches beyond the boundaries of illustrative journalism, to which he paid too much attention. He introduced elements of narrative into some of his pictures, something that had long since been abandoned by Degas and which was rejected outright by mature Impressionism.

By the 1870s Degas had already discovered the theme of the café-concert, soon to become the province of illustrators of entertaining periodicals. By painting the café-concert, and then the fashionable music-halls of the 1890s, they were able to juxtapose the stage and the auditorium, thus depicting contemporary figures who would normally have no place in official art. For in fact the music-hall and, before it, the café-concert were not just performance venues, they also provided a place for rendez-vous and brief acquaintances, where ladies of lax morals found themselves an occupation. By the end of the century Parisian humorists and caricaturists had already begun to turn to various themes that were based on the activities of the music-hall.

For all his indebtedness to Degas, Forain remained interested in entertaining subject matter. In his *Music-Hall* some kind of intrigue is taking place, although it is not entirely clear what, for the conventionality of the painting leaves no place for details: the crowd dispersing after the show is represented by an almost undivided patch of colour, painted with rapid strokes. The most striking aspect of the picture is the woman in a white blouse. She and her husband in his fur coat – perhaps he is a Russian[54] – are the main characters in the scene, and where their gazes meet is the focal point of the whole composition. Others have also turned their heads towards the woman, although the reason for their attention can only be surmised. Why, unlike everyone else in the scene, is she standing by the exit, without a coat or a cloak? Is there some secret drama concealed here, or, more likely, has the artist simply portrayed a gentle but fallen creature?

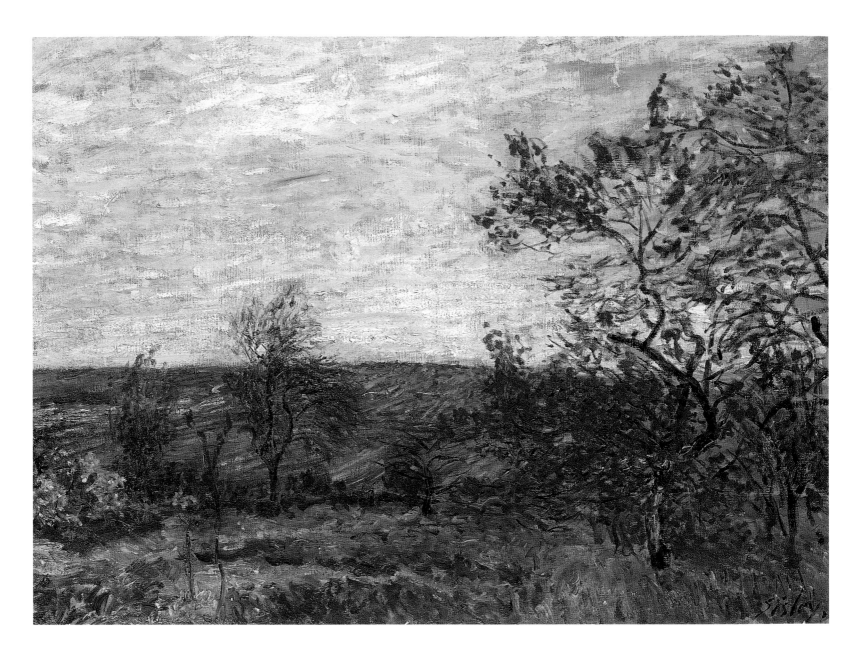

The Landscapes of Mature Impressionism: Sisley, Pissarro and Monet

By 1880 serious disagreements had emerged between the Impressionists. The long struggle of the 'irreconcilables' for recognition had still not produced the desired result. After Renoir's success in the Salon of the previous year, Monet and Sisley decided to follow suit, while Degas opposed such a move completely. It is worth noting that it was considerably easier for Degas to abide by his principles since, unlike the other 'renegades', he was not wholly dependent on selling pictures as a source of income. The Salon jury, however, rejected Sisley's work, and accepted only one of Monet's more traditional paintings. The financial support both artists received from Durand-Ruel meant they were able to stick to their chosen path, but recognition still awaited them; for Sisley, indeed, it came only after his death.

Sisley based himself far from Paris, in Veneux and then later at Moret, at the confluence of the rivers Seine and Loing. Life in the provinces was much cheaper, and nature – so necessary to the Impressionist – was close at hand. The landscape itself was entirely unremarkable, without grandiose effects or illustrious buildings. The details of *Windy Day at Veneux* – sickly saplings, a ploughed field extending as far as the horizon and a light grey sky – are hardly designed to create a striking, joyful impression. What makes the picture a remarkable work of art is the visible sense of nature's inner life, the harmonious pulsation of all its elements. The movement of cold air and the unique light of the Ile-de-France seem to penetrate the landscape. In his explorations of landscape, Sisley went hand in hand with Claude Monet, and it was to Monet that he constantly looked in both the selection and the treatment of motifs. From the very beginning both artists shared much in

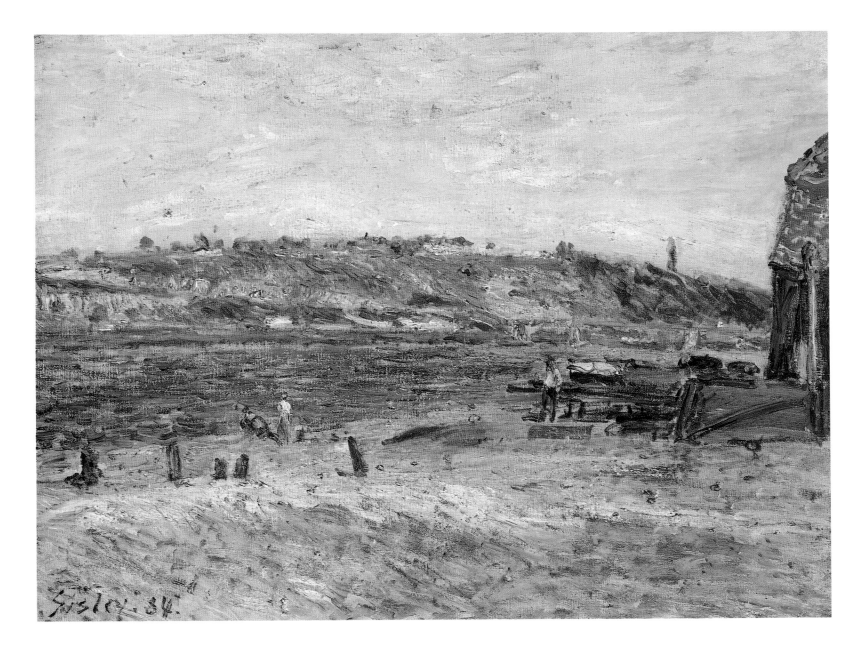

common. Even then, however, some critics were able to identify the characteristics of each. In 1873 Armand Silvestre wrote: 'At first sight it is difficult to spot the difference between the works of M. Monet and M. Sisley… Look a little deeper, however, and you will soon notice that while M. Monet is the most adept and daring, M. Sisley is the most harmonious and hesitant.'[55]

The slow-moving waters of the river Loing, with its undemanding charm, corresponded to the artist's nature. Here, in Saint-Mammès and the surrounding area, Sisley painted about sixty pictures. 'And here are the banks of the river Loing', wrote the critic Gustave Geffroy. 'Willows, poplars, mornings as beautiful as the dawn of time, a dew that evaporates and then turns into a pale halo above the hills, the blue shade of a tree, the barges on the river bank, the huts, glimmering like the

castles of legend, white and lilac glades…'[56] And again: 'He strove to express the harmony that exists between the foliage, the water and the sky in all weather and at all times, and in this he was successful.'[57] In his picture *The River Bank at Saint-Mammès*, the sky, the river Loing, the gently sloping near bank and the high bank opposite are painted in bold, but at the same time delicate, broken strokes. They capture the vibration of the air, the flow of the water and the overall organic rhythm of nature.

It can be argued that the Impressionists arrived at a system of creative techniques that expressed their pantheism in the most direct way possible. This applies equally to pictures as varied as *View of the Town of Pont-du-Château* by Albert Lebourg, who emulated Monet in his treatment of light, and *Landscape* by the ageing Renoir, who had turned

Boulevard Montmartre, 1897, by Camille Pissarro

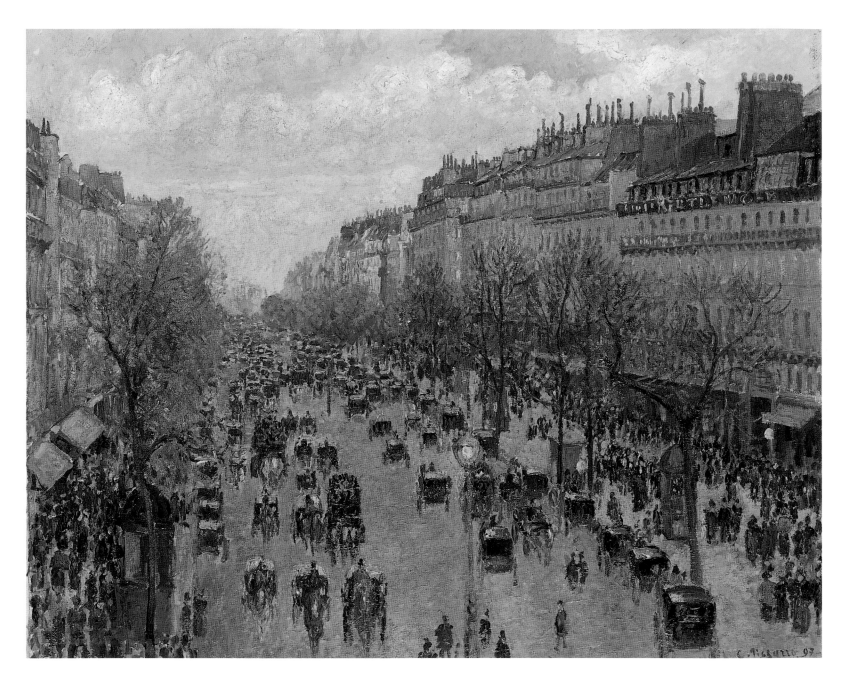

to a style that was far more fluid and free than before. Now the thick brushstrokes are used less as a means of conveying details of the landscape, and have instead become signs of the vital energy of nature.

There is no doubt that for the Impressionists the world of the big city – above all, Paris, with which they were all closely connected in their youth – had no less vitality than nature itself. Camille Pissarro played a particularly important role in the portrayal of the French capital. He stood out from his contemporaries in his love of rural themes. He also painted many pictures in the small towns of Auvers and Pontoise, where he lived due to the cost of life in the capital. He turned to paintings of Paris much later than Monet and Renoir,

but having become absorbed in the theme, went on to paint more views of the capital than any other Impressionist. Pissarro captures Paris with its never-ending movement – the walk of passers-by, the passage of carriages, the flow of air and the play of light. His city is not a list of sights, but an architectural environment of a style that most would not even stop to consider. This is not a city of jaded structures, but a living, thriving organism. Caught up in this movement, we do not notice the banality of the buildings that line the Boulevard Montmartre, in whose indefatigability the artist found a unique charm. Pissarro painted the Boulevard Montmartre in the morning and afternoon, in the evening and at night, in bright sunlight and in the gloom, and he always viewed it from the same window. *Boulevard Montmartre*

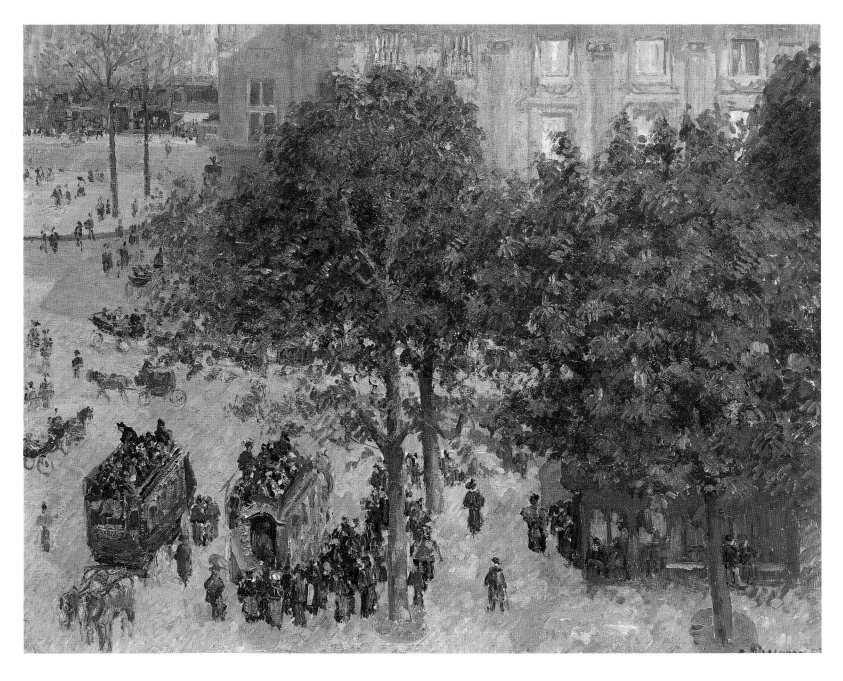

in the Hermitage is one of the finest examples of the series and, indeed, of the whole Parisian cycle. It has the explanatory subtitle *Afternoon Sun*. Changes in the weather and lighting always forced the artist to 'catch' the necessary moment: 'Each morning,' he admitted to his doctor, 'I sit at my look-out post until midday, sometimes until half past twelve, and then in the afternoon from two until half past five.'[58] The simple motif of the street stretching into the distance created a precise compositional foundation, which remained unchanged from picture to picture. His series of the following year, painted in a room in the Hôtel du Louvre, was constructed quite differently. This time the chosen subject was the Place du Théâtre Français. The terminus for several omnibus lines, the square was constantly criss-crossed by pedestrians and carriages in every possible direction, while the axis of the streets remained the focus for most of the movement. Instead of a wide open, airy panorama, the viewer is drawn to an enclosed space in the foreground; as with *Boulevard Montmartre*, however, every detail denotes a concern with compositional harmony. Thus in order to offset the splendid crown of the chestnut tree in the right of the picture, Pissarro opens out a small part of the square on the left. Here he has placed two crowded omnibuses, a long queue of passengers, and then, submitting to the rhythm created by the wild blossoming of the spring trees, he has scattered carriages and passers-by here and there. The fresh greenery and delicate morning light thus define both the colour and the composition of the picture.

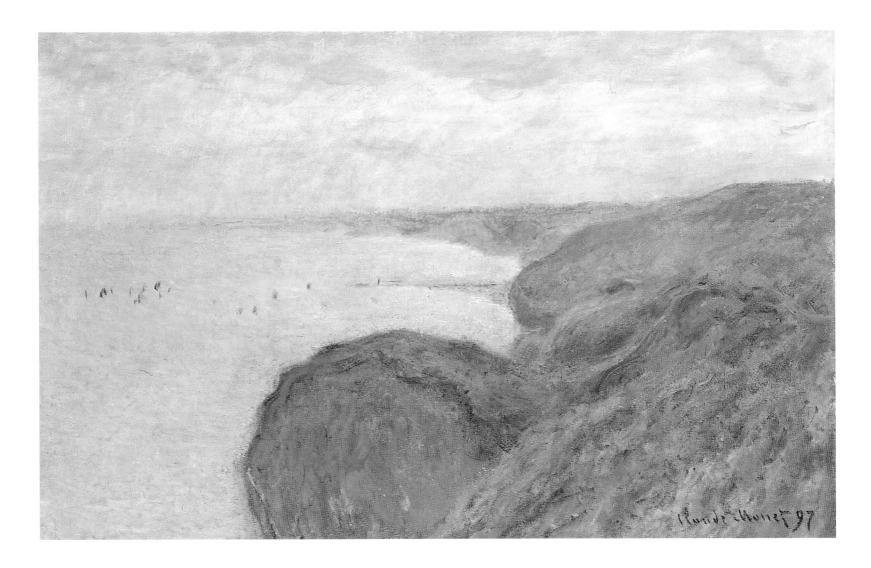

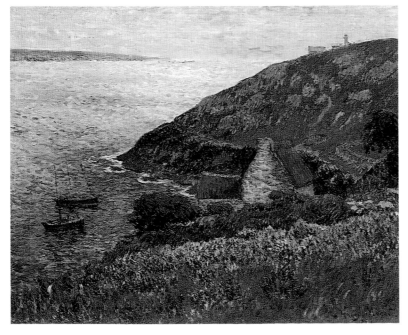

The London cycle was completed in 1904 and was then shown by Durand-Ruel. In the foreword to the catalogue for this exhibition the writer Octave Mirbeau wrote: 'The constant theme of these canvases, constant and yet at the same time changing, is the river Thames. The smoke and fog, the forms, the architectural shapes, the perspective, the whole city deaf and echoing in the fog, the fog itself, the struggle for light and all the stages of this struggle; the sun held captive by the gloom or with dissipated rays piercing the gleaming coloured depths of the atmosphere; the endless drama of reflections on the waters of the Thames, a gloomy, magical, miserable, joyous, florid, terrible drama, the drama of a nightmare, a dream, a secret, a fire, a furnace, of chaos, of floating gardens, of the invisible and the unreal, and at the same time of nature itself, this particular nature created by this wonderful city that artists up until M. Claude Monet have not known how to see, have not known how to express, and who have only seen in it a trivial picturesque accident, an anecdote cut short but not the ensemble, not the magnificent and striking whole that now opens up before our eyes.'[63]

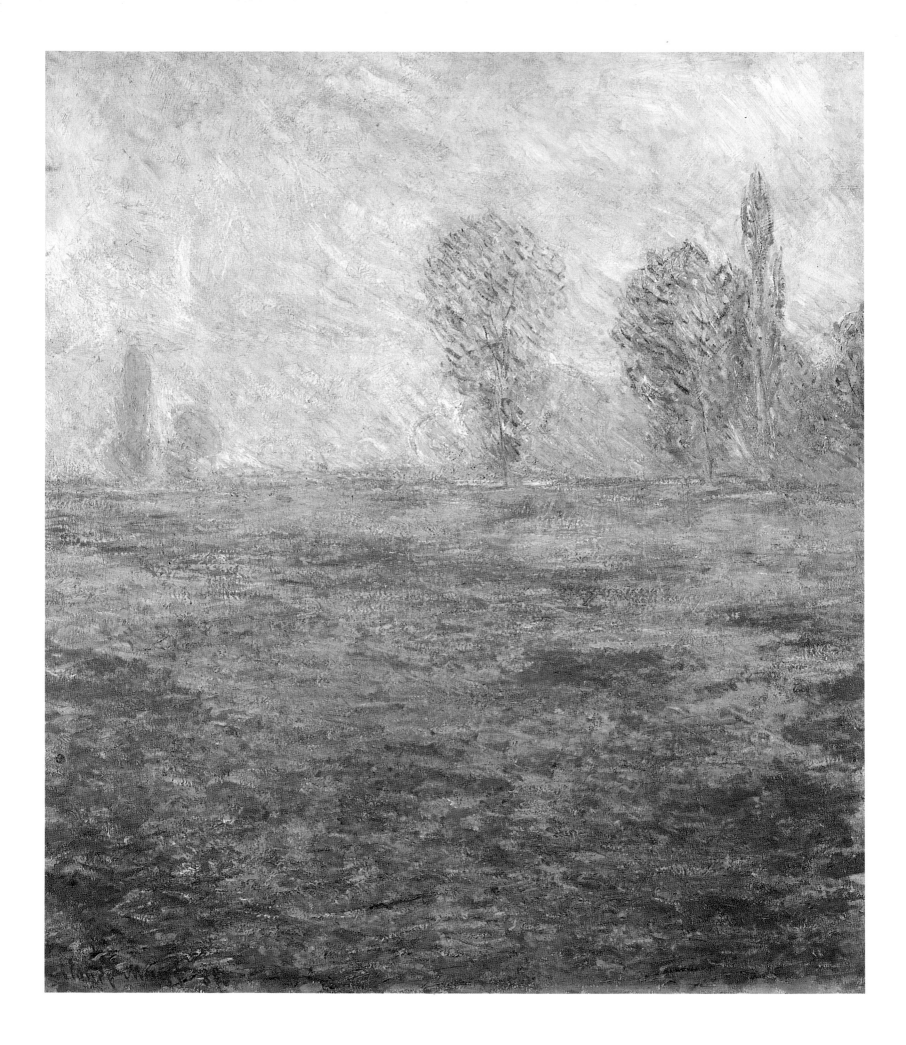

Sculpture at the time of the Impressionists: Auguste Rodin

Throughout the nineteenth century French sculpture lagged noticeably behind painting, although to contemporaries quite the opposite seemed to be the case. The weight of Classical traditions was overcome with far greater difficulty. Academism, the true heir to Classicism, proclaimed the immutability of 'eternal' principles, and dictated a fairly narrow selection of images for imitation. Initially such an aesthetic foundation was quite sufficient both for official requirements and for the demands of the public. Statues and statuettes at the Salons were not noted for their variety. With such a limited range of genres it was more difficult for sculptors than for painters to overcome the prevalent clichés, and the vast majority, indeed, did not even attempt to do so. The nature of the medium led them to 'human' themes, to anthropomorphic characters, more often mythological or mythologised than real.

The creative path that stretches from Latin to French traditions of myth always had a strong preference for depictions of nudity. The real Napoleon, as soon as he became the hero of myth, could be stripped of his clothes in a sculptured image, and people of the early nineteenth century saw nothing strange in this. But it was in the portrayal of the nude that the dictates of Salon–Academic sculpture were at their most pernicious. For exhibitors at the Salon, in order to avoid monotony, were constantly thinking up new subjects and unheard-of poses.

The figures in Albert-Ernest Carrier-Belleuse's *Satyr and Bacchante* are rendered in such contorted poses that they would seem more suited to an acrobatic performance in the circus. This, however, did not trouble art-lovers of the day. By contrast with the cold rigour of Classicism, the decorative allure that dictated the poses of Carrier-Belleuse's characters was warmly received. The sculptor's influence was notable: both Dalou and Rodin worked under his direction in their early years. He had an excellent grasp of the basics of the craft, and the details of his terracotta statuettes show lively and assured modelling. The whole effect, however, is altogether too contrived: a kind of plait, woven out of two separate parts, forms the bodies. In the first half of the century such a configuration would have been completely impossible. Now, however, the strict Classical canons were overturned, not just because their routine nature had begun to cause dissatisfaction even in academic circles. Other circumstances also played their part. Empress Eugénie, an ardent admirer of Marie Antoinette, tried to resurrect the images and techniques of eighteenth-century art, promoting the 'second Rococo', which had none of the stylistic unity of genuine Rococo. The era of historicism began, distinguished by an indulgent and eclectic fascination with the stylistic features of previous eras. Carrier-Belleuse, nicknamed 'the Claudion of the nineteenth century', was able to exploit the new fashions. Thus, after the success of his *Triton Carrying a Nymph*, he was able, without changing the composition or its dimensions, to introduce new figures and create the group *Satyr and Bacchante*.

The Salon made great demands on the technical mastery of sculptors – greater, perhaps, even than those made on painters. In the eyes of connoisseurs and the general public, the ability to work in such materials as bronze and marble was in itself proof enough of the artistic achievements of a sculptor. Huysmans' words of 1879 are revealing: 'It is high time we revised that old cliché that has been with us all these years: that sculpture is the glory of France, that painting has hardly moved on, but sculpture – well! No, a thousand times no. Of course, from the bottom of my heart I loathe the majority of pictures on display in the annual Salon, I hate the art of Bonnat and his contemporaries, I hate these crude imitations of great art, these pygmies that the ignorance of the public and press would accept as giants; but how much more – if that is possible – do I despise those other pygmies that call themselves modern sculptors. Painters are simply geniuses alongside these official plasterers.'[64]

Nowadays, even if as art-lovers we are able to overcome our complete indifference to the statues of Salon laureates, it is still hard to understand why they were so universally acclaimed by the most demanding and enlightened critics of the 1870s. For them, sculpture upheld the 'honour of French art', being devoid of 'ostentatious individualism'. Even such a serious defender of Realism as the critic Castagnary declared that sculpture remained a powerful element of national art.[65]

It is easy to imagine the admiration of visitors to the Salon before a sculpture like Prosper d'Epinay's *Beggar-Cupid*. It is also easy to understand why his works should have been so popular at the Russian court. His life-size statue *Awakening* decorated the study of Alexander III, and the Empress posed for a portrait. In *Beggar-Cupid* the figure of the charming boy-cupid is remarkable for the controlled elegance of its proportions. Marble is a medium that does not forgive errors. In painting it is always possible to go over an unsuccessful stroke, but how do you correct a mistaken blow of the chisel, plunged too deep into the stone? Clearly works like *Beggar-Cupid* demanded time-consuming and highly professional work. The overwhelming majority of the public at the time of the Impressionist exhibitions would not have hesitated to say which was the superior artist – d'Epinay or Claude Monet. The very idea of such a comparison would have seemed absurd. On the one hand, here was a man whose pictures were painted at one sitting, pictures that even with the best will in the world could only be described as sketches, and that to exhibit was akin to publishing a draft or outline instead of a completed literary work. And on the other hand, the public would have recognised immediately that d'Epinay was an artist whose works demanded months of dedicated toil. The quality of the craft is persuasive

from the very first glance: to convey the transparency of fabric in a medium such as marble is scarcely an easy task. But, with tremendous virtuosity, d'Epinay overcomes the hardness of his material to create the effect of the light cloth.

Salon sculpture of the 1870s and 1880s borrowed the theme of charming cupids, sometimes mischievous, sometimes well-behaved, from the Rococo. But it also introduced its own clearly audible note of bourgeois modernity. At the end of the first half of the century the minor Biedermeier Romantics and, a little later, the Realists, who also turned to social motifs, produced a number of sentimental portrayals of young beggars, intended to provoke compassion and sympathy.[66] Their time, however, soon passed. D'Epinay, by juggling with a motif that had already fallen out of use, found a new socially inoffensive application for it. How could one fail to admire a beggar like d'Epinay's, as long as it is standing in the drawing-room at the Anichkov Palace?

While, by the middle of the century, clear Realist tendencies had appeared in painting, in sculpture they were later and less well-marked. Often they were combined with Romantic refrains.

work are of secondary importance. The hint at a balustrade in *Romeo and Juliet* is a reference to the Renaissance. By contrast, in another of the artist's embraces, *Eternal Spring*, all historical elements are removed, and the theme of the work is the universality of love. The young pair seem to rise out of the rocks. Rodin borrowed the technique of juxtaposing finished and unfinished surfaces from Michelangelo, but here the technique has a symbolic weight which Renaissance sculptors could not have imagined. The rock represents nature, virginal and primordial, and it is less a setting for the action than a spatial and temporal environment, without beginning or end. Eternity itself, however, is not in the rock, but in the ceaseless rhythm of life, in the inspired plasticity of the human body.

Rodin's love scenes are often endowed with an energetic or even dramatic content. They are the essential symbol of life as the artist and his sensual ego understood it. As a result, in the duets in the Hermitage the male dominates, representing the active instigation of love. Only the composition of *Poet and Muse* is resolved differently, where Rodin expresses an idea prevalent at the end of the nineteenth century, that of woman as the inspiration of art. Art not inspired by woman was doomed to sterility. Rodin undoubtedly believed in this idea, which is why the poet, clinging to his muse-woman, does not just dream – he actively seizes his creative force from her.

Rodin's late works show a marked divergence, particularly in his portraits. The small mask which comprises the Portrait of the Japanese Dancer Hanako (a name that means child-flower), and the insight with which the momentary psychological state is captured, is reminiscent of Manet's sketches. Rodin was himself an exceptional draughtsman. And the fact that different moods are revealed in the various sculpted and drawn portraits of Hanako show that Rodin's Realism did not diminish with age.

The bust *Portrait of V. S. Eliseyeva* dates from the same period. It is a society portrait, quite unexpected from the creator of *Man with a Broken Nose*; such, however, was the evolution of the artist, as he became a portraitist of rich foreigners. The smoothness and airiness, quite unlike anything by the Old Masters, and the fashionable lack of definition are undoubtedly a tribute to Symbolism and Art Nouveau. The taste for refinement and abstraction that colours the artist's late works was not, of course, characteristic of Rodin alone. The bust of Eliseyeva was carved from marble not by Rodin himself (although all the work would certainly have been carried out under his guidance), but by Charles Despiau. Working as Rodin's assistant at that time, translating the master's designs into material, Despiau was later to become one of the most gifted exponents of European poetic Realism. Like Bourdelle, when he achieved independence he strove to repudiate his teacher, who by then had descended into prettiness and effects ill-suited to sculpture; Despiau, however, remained indebted to his mentor's creative work.

before, a work was completed. And even where a title had been chosen in advance, it was often subject to change. The author's title for the work displayed in the Hermitage under the name *Poet and Muse* was *Reverie*; it had yet another name – probably the artist's, too – *Awakening*. Rodin's dissatisfaction with his choice of names should not be taken as a weakness. On the contrary, it shows that the frequent criticism that he was too literary was often exaggerated. Rodin never began with an *a priori* formulated theme, but with the requirements of the plastic arts, the necessity of embodying feeling, since for him 'art is nothing other than feeling'.[72] The sculptures themselves do not gain a great deal from their references to the world of mythology (*Cupid and Psyche*), or literature (*Romeo and Juliet*). Concrete details in Rodin's

Portrait of V. S. Eliseyeva, 1906, by Auguste Rodin

Post-Impressionism

At the end of the nineteenth century, it would have been inconceivable that later generations would refer to the age as the era of Post-Impressionism. Indeed, the idea of being post-anything would have surprised them, for it was only the most enlightened art-lovers who had heard of Impressionism – and even they considered the movement at best marginal. For Impressionism was a relatively small detail in the overall picture of art and culture of the period. Nevertheless, this small group of '*refusés*' achieved the impossible: they breached the stronghold of the academic Salon, and left supporters of academism without a future. The onslaught was so swift and precipitous that those in the anti-academic camp were unable to consolidate their position. Before Impressionism had assumed its final form, conflicts began to break out within the movement, and there were also attempts to overturn its most important tenets. The varied and sometimes contradictory artistic tendencies that emerged in the last quarter of the nineteenth century were aiming to bring Impressionism to completion, and although they were not all leading in the same direction, they came to be known collectively as Post-Impressionism. It is, however, a term that should not be taken literally, for the artists of this group were already working at the same time as Pissarro, Monet, Renoir and Degas.

Paul Cézanne

Paul Cézanne emerged at the same time as the Impressionists; he was their friend and contemporary, and learned a great deal from them. It is revealing, however, that Pissarro, whom Cézanne recognised as his teacher, did not consider Cézanne an Impressionist. 'What is an Impressionist?' the young Matisse asked the elderly Pissarro. 'He is a painter who never paints the same picture twice. All his pictures are different. An example? – Sisley. Cézanne is not an Impressionist. He is a classical painter, because with his bathers, his *Mont Sainte-Victoire* and other such paintings, he has painted the same picture all his life. Cézanne never painted the sun; his weather is always grey.'[1]

But for many young artists of the beginning of the twentieth century who decided to go further than the majority of the Impressionists, it was Cézanne who served as their principal model. 'Cézanne is a teacher for all of us,'[2] said Matisse. 'He was my one and only master', echoed Picasso. 'Don't you think I looked at his pictures? I spent years studying them... Cézanne! It was the same with all of us – he was like our father. It was he who protected us'.[3]

Cézanne's great ambition was to develop from Impressionism an art that was solid and eternal, like museum art. This did not mean that he wanted to reconcile Impressionism with museum painting, or somehow to efface the fundamental differences between the two. Such an attempt at compromise was the guiding force of the Salon at the turn of the century. Cézanne, however – for all his admiration of the Old Masters – felt strongly that the conception of space and the plastic arts that had been created by the Renaissance, and which had survived so successfully to the end of the nineteenth century, was no longer in tune with the development of European thought and could not lead to a deeper understanding of the world. He therefore began to lay the foundations of a new way of thinking, using as his building blocks the elements of a new plastic language that had been discovered by the Impressionists.

From the very beginning Cézanne was out of step with Impressionism, if we understand the term to mean an artistic method of capturing fleeting impressions. Even an early work such as *Girl at the Piano*, with its classically strong architectonics, provides a clear demonstration of the qualities that prevented Cézanne from siding unconditionally with Impressionism. The tightly applied dark colours have a clearly defined material and static quality that is in marked contrast to Monet's *Lady in the Garden*, a work painted at the same time. The compositional structure of Cézanne's work has baroque and romantic overtones that are a clear reminder of the artist's admiration for Rubens; these elements also explain the painting's other title – *Overture to Tannhäuser* – with its reference to Wagner's opera.

'Tannhäuser', wrote the artist's favourite critic Charles Baudelaire, 'represents the struggle between two principles that have chosen the human heart as their main battleground; in other words, the conflict between the flesh and the spirit, heaven and hell, Satan and God. And this duality is conveyed immediately in the overture, with incomparable mastery.'[4] Baudelaire's words were undoubtedly lodged in Cézanne's mind, and provide the best possible description of the dramatic qualities

in Cézanne's own work. They may also help us to understand why the artist spent three years grappling with this idea in his painting, and why, despite investing all his creative effort in his work, he remained dissatisfied, rejecting one version after another. In his struggle to express artistic principles, Cézanne may also have found some comfort in Baudelaire's assertion that the material success or failure of *Tannhäuser* proved nothing. The opera was greeted with derision in Paris. Cézanne felt a strong affinity with Baudelaire's comment, written in response to this reception, that no great work of art can fail to inspire argument; equally, Baudelaire's summation of the opera must have resonated with the artist: 'A method of perfect construction, a sense of order and division that recalls the architecture of the ancient tragedies.'[5]

The composition of *Girl at the Piano* is both simple and carefully conceived. Cézanne's sisters are depicted in the drawing-room at Le Jas de Bouffan, positioned at an equal distance from the left edge of the sofa, which the artist uses as the central vertical in the painting; the piano is counterbalanced by the armchair. What is most remarkable is the complete lack of monotony in such a deliberately measured and carefully executed *mise-en-scène*. An astonishing energy is achieved through the

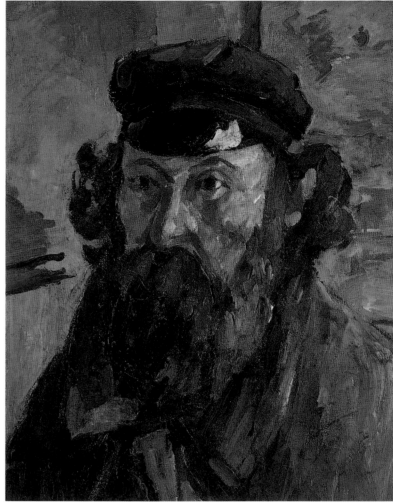

colour contrasts and the touch of the brush on canvas, while the decoration on the wall is painted with a vigour that would seem more appropriate to a battle-scene in the spirit of Delacroix. The ornamental flourishes seem to represent something more than just the pattern of the wallpaper, as if engendered by the energy of Wagner's music itself. The ornamental backdrop provides a dynamic and fluid element in the construction of the painting as a whole, and serves to bring the figures and objects together within the composition. The picture is not a copy from life so typical of the overwhelming majority of interior compositions of the middle of the nineteenth century. Nor is there any attempt to explore the psychology of the characters. The portrayal of young women in a banal setting, playing the piano and knitting, is reminiscent of similar motifs employed by the Realists of the second half of the nineteenth century, but Cézanne is quite unconcerned with producing a mirror image of nature: his brushstrokes are not smooth; minute details are unimportant. Here is an example of the kind of refined awkwardness that is so typical of his compositions.

'Through drawing and colour,' Cézanne wrote later, 'the artist clearly conveys his feelings, his perceptions. He cannot be too scrupulous, too sincere or too humble before nature. But to some extent he must have mastery of his model, and, above all, of his means of expression. He must penetrate what he sees before him, and strive to express it in the most logical way possible.'[6] The strength and unquestionable logic of *Girl at the Piano* was not the work of a moment, but the result of sustained effort and numerous compositional variations. Cézanne was capable of working endlessly on his canvases. His lack of compromise had no equal. The realisation of his impressions of the world was, for Cézanne, a work of great responsibility and complexity, and there were few who understood him. Even his childhood friend Emile Zola believed him to be a failure, someone who had lost his way. It was only in his later years that Cézanne saw how young artists were striving to emulate him. In his Hermitage *Self-Portrait in a Cap* he appears at least ten years older than he actually was – not so much because of his beard, but because the loneliness of his struggle really did age him prematurely.

The composition of *Self-Portrait* shows clear traces of the influence of Camille Pissarro, with whom Cézanne often worked side by side. It was through Pissarro above all that Cézanne absorbed the influences of the Impressionists. In his *Bouquet of Flowers in a Vase*, painted later, the

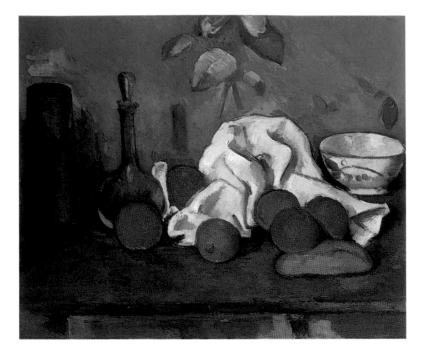

Fruits, 1879–80, by Paul Cézanne

palette is noticeably brighter, but still not to the extent that the work could be taken as an example of Impressionism. Cézanne did not want to sacrifice the material solidity of his subject for transience and effect: he saw Impressionism not as an end in itself, but only a means to an end. Atmosphere, which played such an important role in the creative consciousness of Monet and Pissarro, is not absent from Cézanne's still life, just as it is not absent from his landscapes; but here, it is somehow thickened and condensed.

Fruits shows a further lightening of the palette: here the colours are more resonant and more clearly defined. The guileless details of the still life – the carafe, the cup, the folded napkin, the fruit and the roll – are more than just everyday objects; they represent the very substance of art, evoking the spirit of antiquity and recalling the words of the artist: 'solid, eternal, like museum art'. This painting is indeed worthy of comparison with museum canvases, but how close is Cézanne's painting to the classical works of *nature morte*? Alongside the Dutch still lifes of the seventeenth century, *Fruits* might appear a little clumsy. For example, if a painter two centuries earlier had included a lemon in his composition, he would undoubtedly have peeled it, showing its skin winding into a spiral, while the cut would sparkle with drops of juice, clearly conveying the structure of the fruit. Such a lemon, or any other similar detail, would be instantly recognisable, being painted according to the principle of creating a mirror image – a principle to which Cézanne's objects did not always adhere. It simply did not occur to Cézanne to paint nuances such as the detailed representation of the baked crust of bread or wine sparkling in the carafe. Even the glass of his carafe is rendered in such a way that it is impossible to tell if it is transparent. As with other works by the artist, the verisimilitude of the objects in *Fruits* is relative; there is no sense of the fabric of the napkin, for example – it is more an artistic conception of a napkin than its literal portrayal.

'This is the thesis: whatever may be our temperament, whatever our abilities when we stand before nature, we must convey the image of what we see, forgetting everything that has gone before us. This, I believe, allows the artist to express his whole personality, great or small.'[7] Cézanne's words underline at once the necessity of creative independence and the need for a figurative approach in painting from life. Never tiring of painting the same subjects, he strove persistently to reveal their figurative essence. Cézanne was a painter to the core of his being; the goal he sought was to convey the painterly quality of objects – not the literary, symbolic, psychological or gastronomic quality, or, indeed, any other kind of quality.

Cézanne constructed his still life quite deliberately, like an independent plastic construction. He crumpled the napkin and placed it roughly in the centre, since the logic of the composition demanded a dynamic detail designed to 'hold' the space – just like a rock or a bush in his landscapes. An Old Master would not have allowed himself anything of the sort. His decorously laid out tablecloth would, of course, have been part of an elegant banquet, while its virgin whiteness would have revealed the origins of the still life in religious paintings, where objects were endowed with symbolic significance. The bread and wine were traditional symbols of Christ, although it is true that by the time of the Baroque their symbolism had already been watered down. Cézanne, for all his Catholicism, never even attempted to impart an allegorical meaning to his depiction of objects.

Each object in *Fruits* is coloured with extraordinary intensity, but these colours do not result from attempting to match every brushstroke with nature. For Cézanne, the most difficult thing was to ensure that none of the dynamism of the colour was lost through the rendition of the third dimension; at the same time he strove to retain the depth of the space and the volume of the objects (a tendency towards two-dimensionality was certainly a characteristic of Impressionism). This task was so difficult that Cézanne had to concentrate on the depiction of objects with the simplest geometrical forms: spherical fruits, a carafe combining a sphere and a cylinder, a vessel in the shape of a truncated cone, and hemispherical porcelain cups. The still life is composed in the following way: first, each object is made to be clearly visible from any distance without disrupting the overall composition; and second, the artist displays the full range of colour juxtapositions. The orange, for example, contains colour elements of the carafe, the napkin, the lemon and the other orange. Still life, by its very nature, was a genre ill-suited to the Impressionists. Cézanne embraced it with particular enthusiasm because in its 'single combat' with inanimate objects the most complex problems it posed found their simplest resolution.

If we compare *Fruits* to the later *Still Life with Drapery*, with its more complicated, more baroque composition, it becomes clear that Cézanne was resolving the range of spatial and artistic difficulties with increasing assurance. *Still Life with Drapery* is a work of remarkable control. Nevertheless, it is completely free of cold rationality, for Cézanne's powerful temperament shines through every brushstroke – in the energy of the three-dimensional fruits, in the folds of the napkins and in the

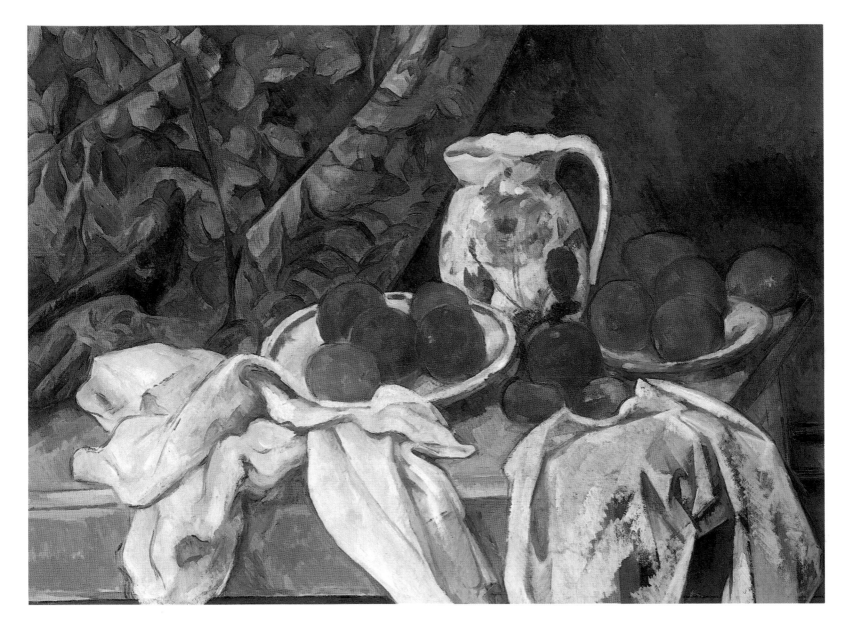

vibrant designs of the drapery. As before, the fruits are completely devoid of any gastronomic attraction and are stripped bare of everything unrelated to the aesthetic notion of form. Different details have varying degrees of finish: thus while the napkin in the bottom right-hand corner of the picture is unfinished, the fruits themselves provide a perfect example of Cézanne's combination of colour and form. In order to create the impression of volume, the artist added neither black nor white. Instead, borrowing the Impressionists' device of pure colour, he constructed the form of the orange by applying yellow, orange, red and violet strokes in such a sequence that they combined to form a sphere, which is not a simple copy or imitation of any particular orange but becomes in itself a precious daub of artistic material. Nor does Cézanne allow it to become lost in the overall colour scheme: one orange is separated from the next by a bluish edge. Neither Pissarro nor Monet would have attempted such an outline. Degas used it, but in a totally different

way. In Cézanne's picture the outline appears from a distance to be a kind of membrane of air encasing the fruit, while the general bluish-grey patina of the still life is the nearest thing to an embodiment of the air around us, one of the elements that constitute the world.

Cézanne lends the same clarity and conviction to his depictions of the human figure that he applies to objects in his still lifes. The pose is always one of great steadfastness. Whether painting his *Smoker* or his *Lady in Blue*, Cézanne's characters always impart a sense of solidity and longevity, as if they have eternity at their command. *Smoker* is like a block of stone, utterly immovable. Although Cézanne's paintings of smokers have their roots in the seventeenth century, they are entirely different from the characters that inhabit these Dutch and Flemish genre paintings. The theme of smokers frequently appeared in French art of the nineteenth century as well, for example in the work of

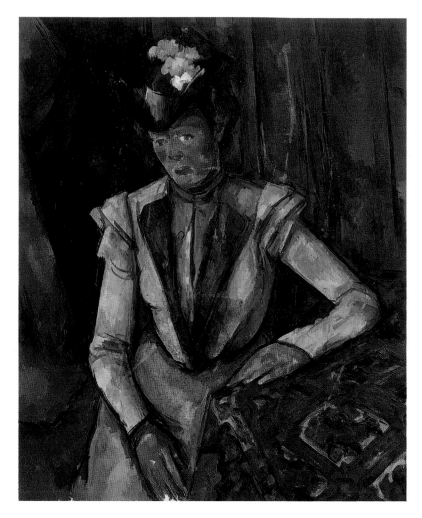

is, its primacy and its codification involve a change in the role of human subject. The lady's face appears transfixed, emptied of personal or expressive character. The features themselves and the red triangle of the cheek are isolated in the mask, like a pattern, as remote from any function or purpose as the red bouquet on the table-cloth.'[8] These words, however, tell only part of the truth. It would be equally possible to describe Rembrandt's faces of old men as masks, where everything that is individual or specific to the portrait is subjugated to a higher order, to that self-immersion which is the means through which the spirituality of the subject is expressed.

Cézanne's strictly formalised approach to art, which governed his work over several decades, found its rightful place with the appearance of abstract art and, in particular, Cubism. The Cubists certainly learnt their structural approach from Cézanne; moving away from his techniques of generalisation, they created their own system of geometric simplifications. But Cézanne himself had no desire to deprive painting of its figurative origins; and this, allied to his desire to comprehend the formal basis of the art of the Old Masters, was one of the reasons for his constant references to classic works in the Louvre. When the young Cézanne, searching for his own artistic path, copied Rembrandt's *Bathsheba* (Paris, Louvre), there can be no doubt that what attracted him was not just the beauty of the great Dutch artist's painting, but also the drama of the heroine sunk deep in troubled thought. Both *Smoker* and *Lady in Blue* are anti-Impressionist not only in terms of form – more like tangible constructions compared to Impressionism's fleeting visions – but also in terms of content. The philosophical seriousness and lofty intent that Cézanne noted to be sadly lacking in Courbet's work is certainly present here.

The same can be said of Cézanne's landscapes, which are notable, above all, for their painterly architectonics. Their careful structure leads to an interaction between the various elements of the composition that have echoes in the complex and profound harmony of nature itself. After his Impressionistic period, Cézanne, without forgoing the achievements of Impressionism in terms of colour, found himself at odds with the movement. The cold range of pure colours of *Banks of the Marne* would have been unthinkable without the artistic revolution in painting carried out by Monet and Pissarro. But the transience, fluidity and changeability that the Impressionists saw in nature irritated an artist who sought what was imperishable and eternal. In *Banks of the Marne*, Cézanne turned to a motif which was most naturally suited to the methods of the Impressionists: for them, water, with its moving reflections, became an essential symbol for the prevailing mutability of nature. For Cézanne, however, the river had to be entirely smooth: it is a mirror; the leaves of its trees shimmer unseen. Everything is still, submissive to a kind of supernatural crystalline structure reflecting the essential design of nature. Cézanne did not subject nature to an *a priori* construction. The structural approach of his mature works has its foundation in nature and is born of it. To convey the constancy of the landscape, whatever may be the changes taking place within it, was one of Cézanne's greatest aims. The spirit of his painting was given over to preserving and immortalising the majesty of nature.

Meissonier. Cézanne, however, bypasses the anecdotal elements of the subject, imbuing it instead with a kind of detachment from everyday life. It is hard to imagine anything less designed to entertain the viewer than Cézanne's portrayal of a man with a pipe. His face is untouched by expression or grimace. Psychological interpretation, as it was understood by the artist's contemporaries, has no place in Cézanne's work. He does not even paint in the eyes, revealing instead dark black cavities. But for all that, Cézanne had a deep understanding of the peasant character, their inextricable link to the land and their ancestors. Cézanne himself said that he was most attracted to the appearance of people who had grown old without changing their habits, submitting to the laws of time. Renoir, in order to paint his model successfully, had to succumb to her charms (and, of course, the majority of his models were beautiful young women), while Cézanne's approach reveals a certain lack of sympathy or a fear of sensual temptation. This reflected the artist's character and his particular religiosity, as well as his more philosophical and profound view of the world.

Some art historians have felt that for Cézanne there was little difference between still life and portrait painting. Gowing, in particular, characterised *Lady in Blue* as follows: 'Far from systematic though the colour

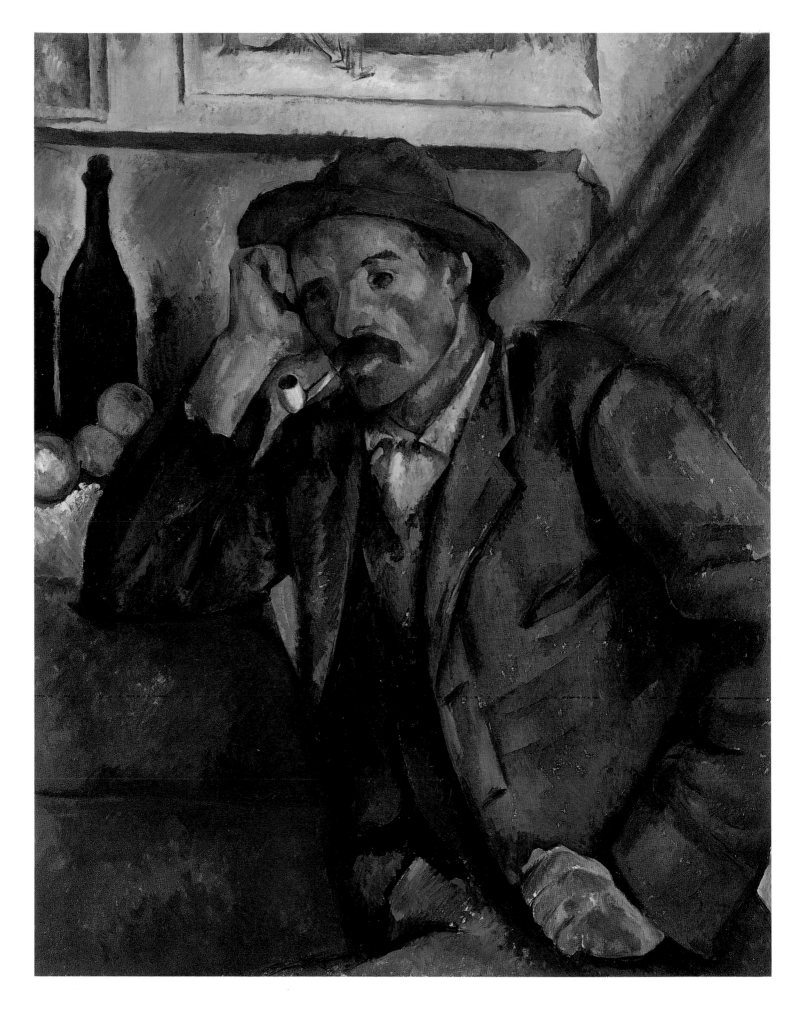

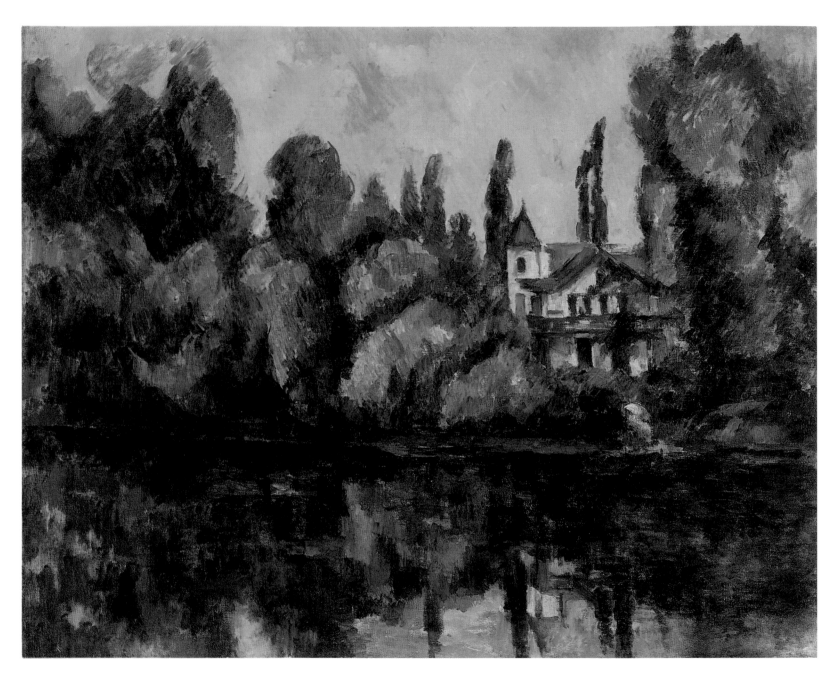

The critic Georges Rivière, who supported the Impressionists from the time of their first exhibitions, had already referred to Cézanne in 1877 as 'a man born of giants.'[9] And when Cézanne paints a pine he does so as though he were himself gigantic, the notion of differentiating minor details seeming absurd, irrelevant, and even impossible. The pine is minted, carved out with mighty blows, and the whole picture, while preserving the bright colours of the Provençal landscape, is executed with a severe spirituality. For all that, *Large Pine near Aix* remains one of the artist's most constructional works. It is built out of separate blocks of resonant colour, while the application is akin to ancient mosaics – albeit with far more complex aims. Mosaics are generally two-dimensional, whereas for Cézanne it was essential to maintain the depth of the land-

scape, even in a picture where its role is secondary – for the perspective here is to a large extent hidden by the branches of the pine. By using thick strokes, and not attempting to smooth them over, the artist strives to convey the complex and unrestrained variety of the natural world. The 'mosaic' of his brushstrokes is free of mechanistic predetermination or even self-conscious virtuosity. Cézanne, with good reason, described the realisation of his sensations as an agonising process. Relying on intuition, he seems to grope for form in an amorphous environment; he is persistent, sometimes impatient, but always concerned with imparting the maximum solidity to the overall construction. Cézanne's task was to ensure that the composition of his work should not be contrived: from the very outset it had to remain a depiction of a specific tree.

Large Pine near Aix, *c.* 1895–7, by Paul Cézanne

Nikolai Punin, one of the first Russian promoters of new French painting, used *Large Pine near Aix* as an example to explain the spatial foundations of Cézanne's art. He compared Cézanne's painting to a realistic work by Ivan Shishkin (for whom pine trees had become a recurring motif), suggesting that if you imagined pulling sharply on the branches of Shishkin's pine, the tree would be torn out of the ground with roots and earth attached. Pull on a branch of Cézanne's pine, however, and a piece of sky would come with it. The wholeness in Cézanne's painting was an expression of the holistic nature of the universe.

For Cézanne, however, the most complete representation of the greatness of simplicity and of the immutability of nature was Mont Sainte-Victoire.

Cézanne's well-known 'pursuit of the motif' was most often expressed in his pilgrimages to this mountain. Cézanne sought certainty in his motifs, and what could be more certain than Sainte-Victoire, where the artist lived and worked? In the Hermitage *Mont Sainte-Victoire*, the mountain is such a mighty piece of sculptured dominance that everything around seems to swell and rise up in response to its rhythm. There is little point in discussing how accurately visual perception is conveyed here, but it is evident that the mountain is too much in relief and is moved too far into the foreground, with the result that the spatial and linear perspective is destroyed. Furthermore, minor details have been omitted. The relief of the real mountain is thus turned into the plastic relief of the picture.

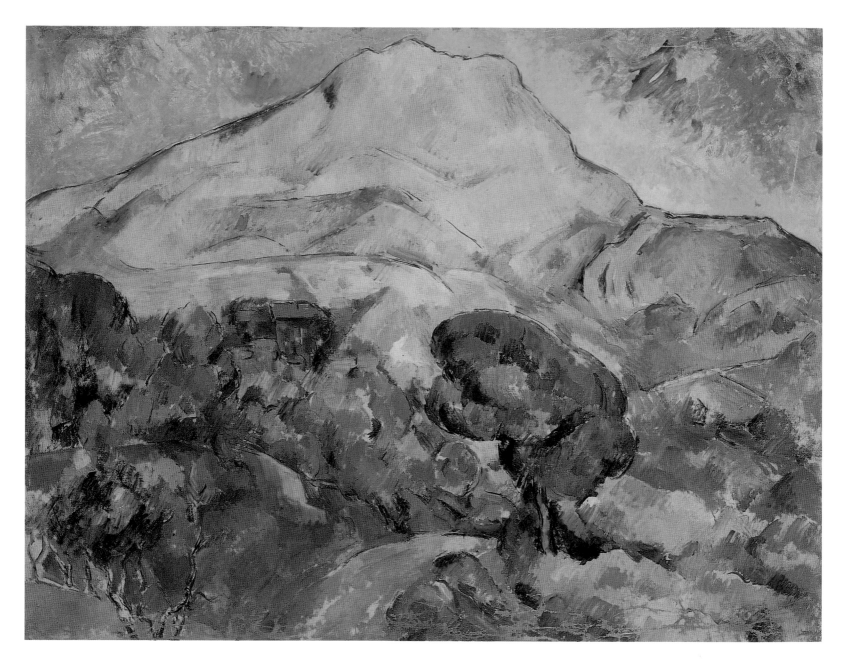

The eminent German collector Karl Ernst Osthaus visited Cézanne in April 1906. By this time Vollard had gradually taken most of the artist's canvases to Paris. Those that remained were predominantly mountain landscapes, and Cézanne used them to explain the essence of his approach to the problems of perspective. 'The most important thing in a picture is to find the right distance. Colour must express all the breaks in depth. It is in this that the true talent of an artist is seen.'[10] The colours of *Mont Sainte-Victoire* are defined by nature: the bare rocky summit is grey, beneath it the green pastures and groves open up, while the foreground is a reddish colour. The natural division of tones of colour – warm shades in the foreground and cold tones in the background – are designed to help convey a sense of depth. The Old Masters, who were concerned with reconstructing space, normally divided their paintings into three planes, with a foreground that was warmer and darker, and a background achieved by using colder, brighter colours. Cézanne, however, for all his respect for his predecessors, was not interested in such a prescribed formula. His favourite mountain was more than a simple view that needed to be conveyed as authentically as possible. And if the massive bulk of Sainte-Victoire seems to be placed too much in the foreground, then Cézanne actually forces this impression upon us by introducing warm tones into the depiction of the mountain and cold tones into the lower part of the painting. In this way colour not only expresses breaks in the depth of the scene; by destroying the old three-plane formula it also creates a new and unified artistic structure, characterised by a dynamism that had never before existed in painting.

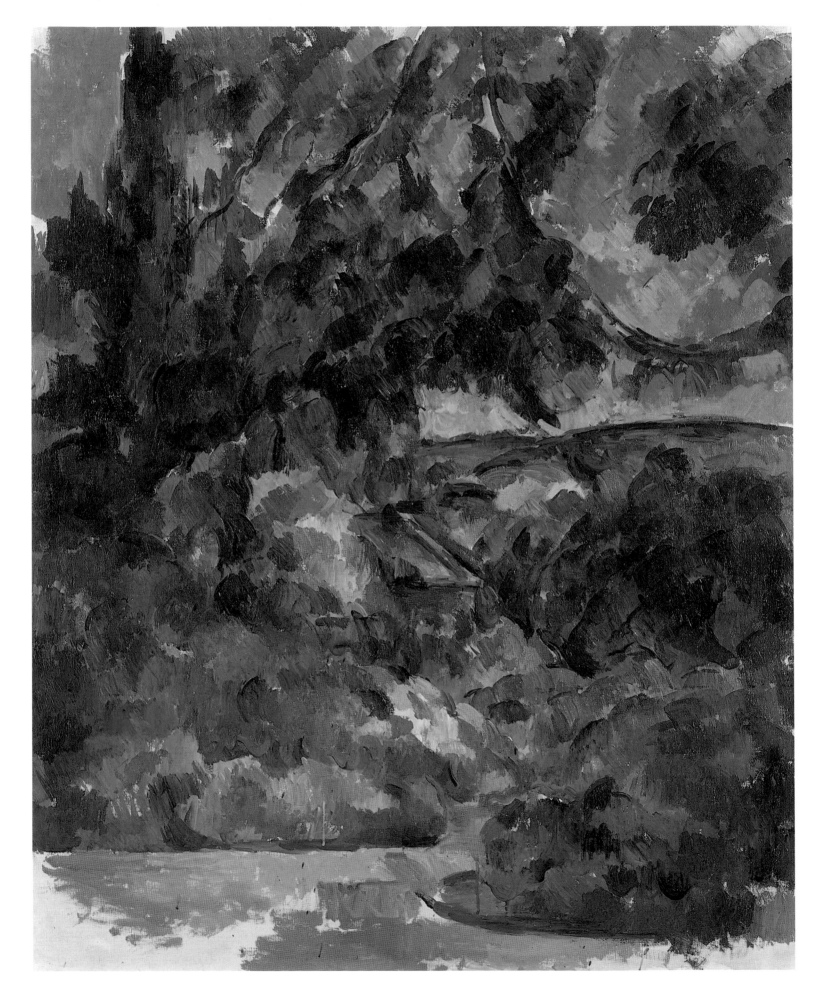

Sometimes – as is apparent in *Blue Landscape*, the latest of Cézanne's works in the Hermitage – the artist literally fought with the canvas in his attempts to convey his view of nature. Such was the internal tension of this struggle that Cézanne ended up on the threshold of Expressionism. The motif of a turn in the road hidden among the thickets was one that attracted Cézanne on several occasions during the last years of his life. This can hardly have been a coincidence. The motif does not simply record Cézanne's impressions from walks around Aix; it also expresses his contemplation of the turn that was to conclude his life's journey.

The Neo-Impressionists

Cézanne was not the only artist whose work was marked by a pursuit of content and the consequent search for form. Both elements are clearly recognisable in the works of various artists who, having passed through Impressionism, ended up adapting or even rejecting the movement. In Germany such artists predominantly embraced Neo-Classicism. In France, however, where the Neo-Classical movement – long since defunct – was finally laid to rest by struggles with Romanticism and Realism, attempts to assert the principles of a strong pictorial 'architecture' inevitably used the advances of Impressionism. Cézanne on one level, Van Gogh and Gauguin on another, and the Neo-Impressionists on a third – while all in their own way refuting Impressionism – relied on the very elements of painting to which Monet and his friends had attached the greatest artistic importance. Of course, there were other reactions against Impressionism, in particular a return to literary themes, expression of emotions, use of symbols, and so forth.

The last Impressionist exhibition took place in 1886. Neither Monet, nor Renoir, nor Sisley took part in it. Even Pissarro, who by then was affiliated to his new friends Georges Seurat and Paul Signac, showed pictures in a style that came to be known as Neo-Impressionism, Divisionism, Pointillism or Chromo-Luminarism. This new form of Impressionism conveyed art through coloured dots (hence Pointillism, from the French *point*, 'dot'), the resulting optical blending of tones (Chromo-Luminarism) arising from the dots' separate, disjointed existence on the canvas (hence Divisionism, from the French *division*).

Signac, who led the movement after the early death of Seurat and became its chief theorist, made clear his debt to the Impressionists when he wrote that the techniques which the Impressionists had used 'instinctively' were employed by him and his fellow artists scientifically, in accordance with strict calculations. 'The Neo-Impressionists, like the Impressionists, use only pure colour. But they absolutely reject any mixing of colours on the palette, except for those colours that are adjacent on the chromatic register. These colours – the one merging into the next and brightened by the addition of white – convey the variety of shades and all the tones of the solar spectrum. Orange mixed with yellow or red, violet going from red to blue, green going from blue to yellow – the Neo-Impressionists use no other elements. But through the optical blending of these colours taken in different proportions, they attain an infinite variety of tints from the most intense to the most grey.

Not only do they banish from their palettes all mixtures that diminish the strength of colour; they also refrain from sullying their colours by juxtaposing contrasting elements on the canvas. Each brushstroke, taken as pure colour from the palette, remains pure on the canvas.'[11] Signac's *Port of Marseille* is one of the most characteristic examples of Neo-Impressionism. Claude Monet – whom Signac had admired greatly – was also drawn to such landscape motifs. However, the Impressionists would never have employed such a regulated mosaic technique nor have submitted to the total rejection of colours not in the spectrum. They were more interested in painting from nature than following principles.

Henri Edmond Cross's *View of the Church of Santa Maria degli Angeli near Assisi* is another example of the Divisionist technique. Cross, an ally of Signac and former pupil of Carolus-Duran, was blessed with an extraordinary gift for colour. While Signac's painting is almost entirely occupied by the water and sky – and hence the use of pure colour is entirely justified – Cross has chosen a motif that includes tree trunks, which would suggest the inevitable inclusion of some non-spectrum, grey tones. And yet Cross uses only pure blue, green and violet for the tree-trunks. The technique that Monet used when painting his haystacks is here employed in an immeasurably more methodical way.

Both Cross and Signac constantly emphasised the importance of the painting's arrangement over momentary optical impression. In their mosaic-like brushstrokes, their return to traditional compositional techniques (such as the staging of a scene with clearly defined wings and centre) and the carefully calculated balance of cold and warm tones, these artists were not simply striving for a decorative effect or the greatest possible sonority of colour. They wanted to ensure that they were creating more than simple sketches, that they had at their command the precisely defined 'logic and grammar' of painting. A comparison between Cross's *View* and Sisley's *Villeneuve-la-Garenne* is inevitable, for both landscapes are similarly constructed. Cross's knowledge of these pictorial rules enabled him to paint a brighter, more dazzling picture. But alongside Sisley's work the overall artistic effect of Cross's *View* seems forced. There is no poetry in the landscape, and even the strictly artistic aspects of the work are somehow narrow. The systematic optical blending of tones demanded a careful and lengthy 'separation' of each pair of adjacent brushstrokes.

Of course, this technique was not suitable for work in the open air. Both Signac's and Cross's pictures were painted in the studio. Furthermore, the Neo-Impressionists, as true children of their time, had little faith in the power of the imagination. To convey everyday objective reality, Signac and Cross chose to employ techniques which were used by mosaicists in the Middle Ages to depict not the everyday world but another world entirely – the Kingdom of God. Not all motifs of Impressionist art were suited to this technique – far from it. As a result their thematic repertoire was markedly reduced. Neo-Impressionism, in essence, did not survive beyond the nineteenth century, although a number of works were painted in this style in the first years of the twentieth century. Young artists, dissatisfied with their academic training, turned to Neo-Impressionism as a new and progressive artistic system.

However, the movement promised more than it actually yielded. For a century enthralled by science, the seductive idea of giving art a strictly scientific basis ultimately proved misleading, and Neo-Impressionism itself played a dual role in the history of European art. Although the blind faith in the technique of separate brushstrokes soon acquired a doctrinaire aspect, the new discoveries made in the field of colour were of great future significance. In the work of Signac and Cross, colour – even when subjugated to the optical blending of tones – was given proper emphasis. And although Matisse would later accuse the Neo-Impressionists of having the pedantry of provincial housewives (and indeed the structure of Cross's painting is reminiscent of a cross-stitched embroidery), in his use of pure colour he took on from where their experiments left off. The same can be said – even before Matisse – of Vincent Van Gogh.

Vincent Van Gogh: The South of France

Van Gogh was an artist of Dutch origins, and he remains the pride of Dutch national art. The French, however, consider him their own. Having moved to France, Van Gogh corresponded with his brother in French, and his finest works were painted in France. His so-called 'second' style blossomed under the influence of the Impressionists and it is this, rather than his earlier style connected with his time in Holland, that is represented in the Hermitage. At first sight the two styles are quite different. The early pictures tend to be darkly coloured paintings of Dutch and Belgian labourers in northern landscapes, while the French period is characterised by bright, colourful and incomparably more expressive paintings. In both form and theme the differences are clear. The pathos of art with a social message, which lay at the heart of many of the works of the Dutch period, becomes increasingly rare in the later works, although a certain kinship can be seen – on careful study – between, for example, the woman bending over the flowers in *Memory of the Garden at Etten* and the peasant women in Van Gogh's early drawings. This picture is a special case however, since, as its name suggests, it was conceived through nostalgia for the artist's homeland. The most important single element in Van Gogh's work – of whatever period and under whatever conditions – is the profound internal sense of drama.

Van Gogh arrived in Provence at the beginning of 1888, and it was the setting for his best paintings. These reveal a countryside quite different from that painted by Cézanne. Van Gogh's Provence is a region seen through the wide-open eyes of an ardent romantic, intoxicated by the sun and by the profusion of colours. He reacted to this southern colourfulness with the enthusiasm of the northerner. For Van Gogh it was not enough to use pure, predominantly unmixed colours in *Memory of the Garden at Etten* – one of the most successful works of his Arles period. In order to emphasise the sonority of the colours still further, he brought together contrasting tones: green and reddish-orange in the dress of the woman on the left, yellow flowers burning on the red-blue cloth, and red flowers aflame on the green flower-bed. 'Pissarro is right', Van Gogh reflected, 'when he says that you must boldly exaggerate the effects created by the discord or harmony that colours produce.'[12] Pissarro himself would never have gone as far as Van Gogh's thickly

juxtaposed tones. His own use of exaggerated colour was still based on the comparative objectivity of the optical impression. Van Gogh in this instance was closer to Signac, although he did not in any sense attempt to paint according to the rules of Neo-Impressionism. The deliberate juxtaposition of highly contrasting tones is not used to create an optical illusion from a certain distance, but instead aims for a general chromatic effect. Van Gogh explained this use of exaggerated colour characteristic of his Arles period in a letter to his brother Theo: 'It is only that what I learned in Paris is leaving me, and I am returning to the ideas I had in the country before I knew the Impressionists. And I should not be surprised if the Impressionists soon find fault with my way of working, for it has been fertilised by Delacroix's ideas rather than by theirs. Because instead of trying to reproduce exactly what I have before my eyes, I use colour more arbitrarily, in order to express myself forcibly.'[13]

In *Memory of the Garden at Etten* there is a sense that the artist is driven by powerful emotions that force him to disregard the most essential precautions of technique. The canvas is thick with colours, as if thrown at the surface in a passionate explosion. The picture was not painted from life, but from the artist's imagination and vivid memories of Holland. Van Gogh had developed the habit of painting from the imagination, working on cold November days in the studio rather than in the open air; he was persuaded to do this by Gauguin, with whom he shared lodgings at Arles. Gauguin in turn painted his *Women in the Garden* (Chicago, Art Institute, W.G. 300; also known as *In the Garden of the Hospital at Arles*). It is not known who first had the idea for this composition used in both canvases, but they bear witness to an unusual creative dialogue between the two artists. The paintings share two basic elements of construction: the winding path on the right-hand side and the depiction of two women from Arles on the left. But where Gauguin's path is crossed by the straight lines of the fence and the pyramid-shaped bushes, Van Gogh's work has no place for such details. His lines and brushstrokes are endowed with a truly flame-like character. In contrast with the smooth tranquillity of Gauguin's canvas, the entire surface of Van Gogh's painting seems to stand out in relief. The garden path is like a river in full spate. With remarkable boldness Van Gogh wilfully constricts the space: the traditional division between figure and background is absent – everything is subordinated on an equal level to a single impassioned rhythm.

It is difficult to believe that two paintings as different as *Memory of the Garden at Etten* and *Arena at Arles* – with its more clearly defined linearity and absence of thickly layered texture – could have been painted by Van Gogh at almost the same time. Gauguin's stay at Arles forced Van Gogh to pay particular attention to his painting, for Gauguin, like Van Gogh, had passed through Impressionism and rejected it. It was Van Gogh's hope that by allying his work to a synthesis of Gauguin and Bernard he could pinpoint general principles of creativity. Suggesting that Gauguin should head the Atelier du Sud, and hoping, too, that Emile Bernard would join them, Van Gogh continued to dream of this creative partnership, making real efforts to assimilate the style of his two friends. However, his proposed interpretation of this synthesis

differed radically from what Gauguin and Bernard were doing. In *Arena at Arles*, Van Gogh did not so much construct a theoretical composition as convey what was for him a real and vivid impression of the noisy southern crowd; he intuitively went beyond Gauguin's placid style, introducing an unprecedented number of people into his picture. In his depiction of the spectators, Van Gogh almost seems to be unaware of the remarkable piece of historical architecture that faces him. He is almost equally uninterested in the spectacle of the *corrida* itself, which is only hinted at by the clouds of dust. The arena is nothing more than a pretext for depicting the crowd. As early as the spring of 1888, Van Gogh wrote to his brother of the uniquely beautiful spectacle presented by the excited crowd in Arles.[14] It is likely that the most important aspect of the picture was to find a general tone that would neutralise the

variety of colours in the many-faced crowd. Van Gogh brings this vast array of characters together in an almost Impressionistic way, employing a generalised blue-grey tone which creates the sense of air and shade falling on the circle row of the amphitheatre.

The picture's basis in reality does not preclude a symbolic interpretation. While the ochre-yellow of the arena evokes its sandy surface in daylight, for Van Gogh yellow also signified the sun and the southern hemisphere, where he had travelled in search of brilliant colours. The circle, as a symbol of the sun, had an overriding attraction for Van Gogh, and in his consciousness the yellow arena became a metaphor for the sun. Here, however, the metaphor is altered by the allusion to a foreshortened, distorted sun, no doubt because the arena represented a scene of

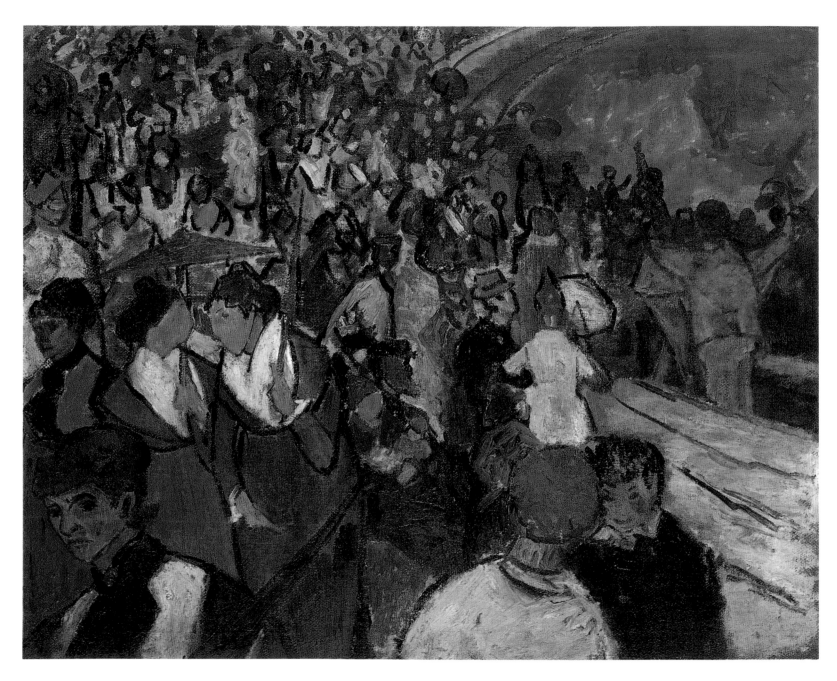

torment and slaughter of the bull, something Van Gogh could not have condoned. The bull, for all its understatement, is the most noticeable detail in the picture. When *Arena at Arles* was being painted, Van Gogh regarded the bull as more than a dumb animal. 'As you know, the symbol of St Luke, the patron saint of painters, is an ox',[15] he wrote to Bernard in June 1888, and in his next letter he returned to the theme: 'The patron saint of painters – St Luke, physician, painter, evangelist – whose symbol is, alas, nothing but an ox, is there to give us hope.'[16] These words indirectly recall Van Gogh's persistent efforts to establish the Atelier du Sud, his dream of a new kind of Guild of St Luke. It is no coincidence that the words are directed at Bernard, whom Van Gogh wished to see as one of the founding members of the community.

The interplay between the yellow arena and the yellow head in the foreground also suggests a more than purely visual significance. The yellow-headed man viewed from behind 'leads' the viewer into the picture space, echoing the motif of the sun. A redhead, like the artist himself, it is hard to resist seeing him as a coded self-portrait. He is in conversation with a man in black. The aesthetic reasons for such a juxtaposition are self-evident: the contrast creates a warmer yellow. However, these two figures are also reminiscent of a well-known photograph of Van Gogh and Bernard, taken two years earlier, in which Van Gogh is also shown from behind. The man in black looks like Bernard, although Bernard did not have brown hair. While it cannot be said with certainty that this is indeed Bernard, we cannot ignore Van Gogh's tendency

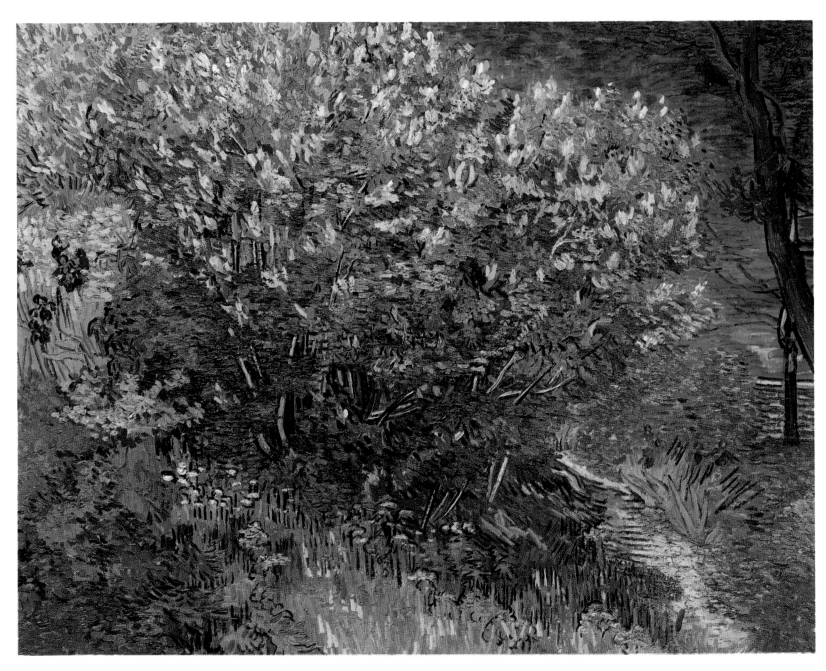

towards Synthetist portraits at the time (we need only think of the young woman in *Memory of the Garden at Etten*). The woman in the bottom left-hand corner of *Arena* is clearly a portrait, although she cannot be identified with anyone else in Van Gogh's work. Her gaze is one of guarded alienation, but it is apparent that she is somehow connected to the artist: she occupies the most prominent position despite the presence of others to whom the artist is not indifferent. It is surprising that Van Gogh did not once refer to this composition in any of his letters, for it is arguably the most complex of all his works in terms of design.

Arena at Arles is unusual because it combines three separate approaches to art. The first is purely pictorial: a crowd scene drawn from life, as if

captured at a specific moment. The second – one of personal recollection. The third is symbolic and indirect, but nonetheless significant: the artist's world of ideas opens up before us, his sense of loneliness in a crowd, his dreams of creating a community, his almost obsessive preoccupation with the sun as the embodiment of light and life. *Arena at Arles* is an allusive painting that creates a number of different impressions, largely because it is unfinished.

By contrast, *Lilac Bush*, one of the artist's supreme achievements, is a remarkable example of organic wholeness and transcendent harmony. In the landscapes of his Dutch period, Van Gogh frequently applied a symbolic subtext to his depiction of trees, hinting at his fate and his

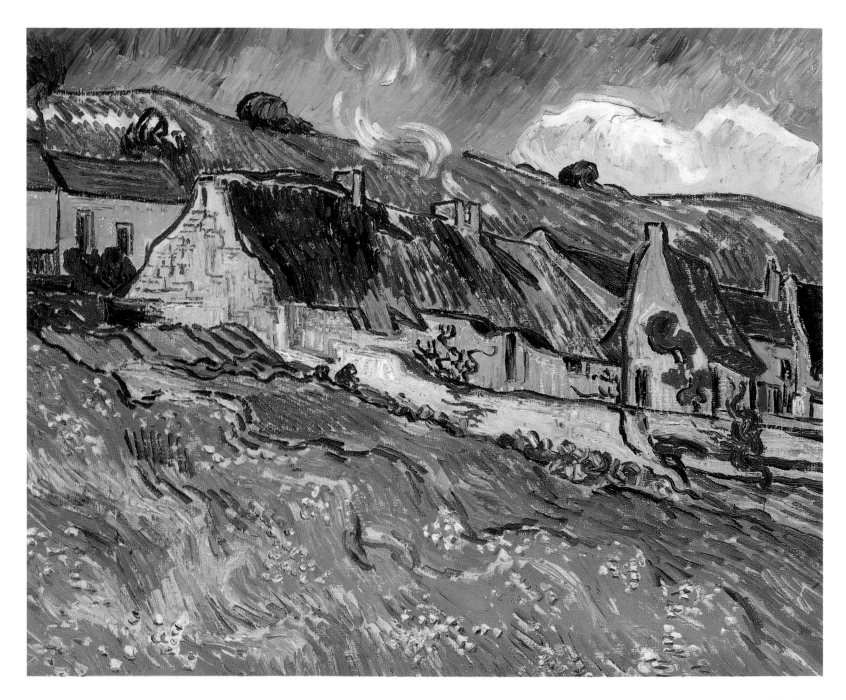

relationships with those close to him. This lilac bush in the garden of the hospital at Arles, shown reaching for the sun and growing, so it seems, before our very eyes, is not just a part of nature; it is a motif that strikingly reflects the artist's state of mind.

In depicting nature, precision inevitably takes second place to self-expression; what the eye beholds is not transferred exactly to canvas. There is always an element of deviation from nature, but how extreme can this deviation be? Each era provides its own answer to this question. But every great artist resolves it in accordance with the basic aesthetic laws, which dictate the unity of a work and an internal consistency in

the fusion of all its elements. Why is the sky in this picture too blue? It can be interpreted as water, an inversion that was characteristic of Van Gogh. The area of deep blue is essential as a counterbalance to the numerous shades of green: without it, the bush would lose its focus. The colour of the sky also evokes an intensity of emotion. At one with nature, the artist is thus entitled to such licence, or, in Van Gogh's own words, to this 'lie which has greater truth than the literal truth'. The blue of the sky in *Lilac Bush* is so intense that it immediately recalls the rich colours of the south; it tells of the troubled artist, striving for the extreme saturation of colour and for its supreme significance – elements that convey the essence of Van Gogh's universe.

Through colour Van Gogh achieved a powerful and complete mode of self-expression, which did not alienate him from the outer world, but led him towards a passionately lyrical sympathy with the organic rhythms of nature. The joyful and at the same time dramatic riot of green so absorbed the artist that when we glance at the picture the bush seems somehow to burst out from the upper edge of the frame. There is not one superfluous or indifferent stroke. Van Gogh learnt his brushstrokes from the Impressionists, but their painting techniques, when compared with a work like *Lilac Bush*, seem chaotic and wilful. Van Gogh's brushstrokes have the discipline of a single burst of expression.

In *Cottages*, the mass of brushstrokes depicting the hillside are painted in one direction, from the bottom right of the picture to the top left. They meet another wave – the strokes of the sky – at right angles. This struggle between two elements – earth and sky – gives rise to a mighty internal tension, which is further strengthened by the colour contrasts. We see here a motif discovered by the Impressionists (we need only compare *Cottages* with Monet's *Haystack* and other views of Giverny), taken by Van Gogh to new extremes of dynamism. The artist was immediately drawn to Auvers, with its 'real country scenery', and the already rare thatched roofs, which reminded him of his native Brabant. It is easy to understand why Van Gogh was drawn to the motif of thatched roofs almost merging with the field: they seem to represent humankind's organic origins – a theme in nature from which he drew inspiration.

The Tahitian Paradise of Paul Gauguin

Paul Gauguin stands alongside Cézanne and Van Gogh at the source of contemporary art. These three played the decisive role in taking painting beyond the strictly representational. All three were loners, misunderstood by society; their fates helped to engender the widely-held belief that the true artist of the modern era was doomed to be an outsider. Their individual relationships with society, however, were very different from one another. Cézanne, whose work entirely undermined the basis of official academic art, which he felt served as an adornment of the bourgeois state, became in later years a well-to-do man who led a generally bourgeois life, tainted by many of the prejudices of that class. Van Gogh and Gauguin, however, despised society's conventionality. The critic Albert Aurier described Van Gogh, in an article which appeared during the artist's lifetime and was characteristically entitled 'The Loners: Vincent Van Gogh',[17] as an enemy of bourgeois moderation and small-mindedness.

As for Gauguin, his very life became a challenge to the whole of bourgeois civilisation. Van Gogh and Gauguin, of course, proved to be too different in character to sustain a long friendship, but we should not dismiss their similarities. Both artists were essentially self-taught, and both were romantics in their relationships with the world. Gauguin's attempt to fight against contemporary European civilisation by fleeing to a kind of 'primitive golden age' was romantic and, of course, utopian. As with Van Gogh, Gauguin's unconventional and extraordinarily romantic life has become the stuff of legend.

Like Cézanne and Van Gogh, Gauguin also passed through an Impressionist phase. He took part in the Impressionists' exhibitions on three occasions (Cézanne did this only twice, whereas Van Gogh never had the opportunity). But it was Gauguin who moved the furthest away from Impressionism, and this is evident in the marked two-dimensionality of his work, and, more importantly, in his mature works, the finest of which were painted on Tahiti. In these, he moved away from a direct engagement with nature, which Van Gogh and Cézanne never did. In his Tahitian canvases Gauguin does not so much depict directly perceived objects, as portray a synthesis of images and memories. Thus the details of one picture pass freely into the next, and then into a third, sometimes even without any fundamental changes. If Gauguin's style was nothing more than this simplification of motifs – as was the case with some of his followers – then his painting would be doomed to superficiality. What was important for Gauguin, however, was not how to simplify nature, but how to enable every form to 'emerge from the consciousness' of the creator.

Gauguin and his followers gave various names to their methods, but most frequently they called it Synthetism or Symbolism. Gauguin's work is by no means devoid of symbols, but the content is never given over to them entirely. For all their allegorical nature, his paintings are closely linked with reality and with actual circumstances in the artist's life, vividly reflecting his impressions – although not to the extent of making him a genre painter of daily life. Leaving Europe behind, he went in search of poetry rather than simply the exotic. He wanted to discover eternal truths in everyday life, and so the apparently trivial became imbued with truly monumental greatness and significance. The spirit and way of life of the Tahitians, their sincerity and simplicity, their particular gracefulness, all found expression in his compositions. And of course Gauguin could not fail to be entranced by the landscape of the Pacific, its mountains, unusual trees and tropical skies.

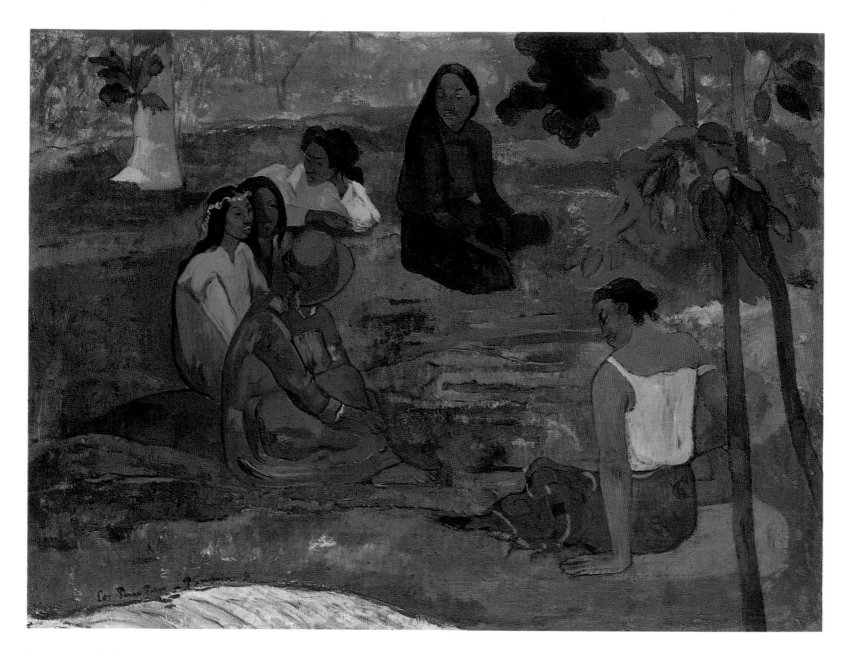

Landscape painting, which had been the main feature of Gauguin's work during his Impressionist period, was already beginning to fade in importance during his time in Arles and Brittany, and with his move to Tahiti it clearly became secondary. The Tahitian pictures very rarely show 'pure' unpopulated landscapes. Gauguin depicts nature not simply in terms of its beauty but as a means of connection. One of the most expressive landscapes of his first visit to Tahiti is *Fatata te Mouà (At the Foot of the Mountain)*. In the centre is an enormous mango tree, a unique sight in the place where Gauguin settled. On the right is the artist's hut. It should not, incidentally, be thought that the picture is topographically accurate. Gauguin later introduced his beloved tree with its great golden crown into entirely different settings, most notably in the background of *Nave Nave Moe (Sacred Spring)* (page 171). The depiction of the horseman rushing through the red wasteland past the

mighty trees introduces a romantic – albeit *piano* – note. As has been shown by the Swedish anthropologist Bengt Danielsson, an expert in Tahitian history, at that time 'the population had decreased so much that cottages were rarely to be seen. And, as in this picture, it would have been rare indeed to see more than one horseman or passer-by.'[18] The initially unnoticed figures of the horseman and the solitary traveller are principally necessary to convey the scale and grandeur of nature, but at the same time these characters seem to contain a reference to the subject at which Gauguin only hinted.[19]

Les Parau Parau shows a group of women gossiping amongst themselves. The artist is indifferent to the subject of the conversation, for this has no bearing on his art, and the picture does not attempt to divert or to intrigue. The figure of each Tahitian woman is caught in

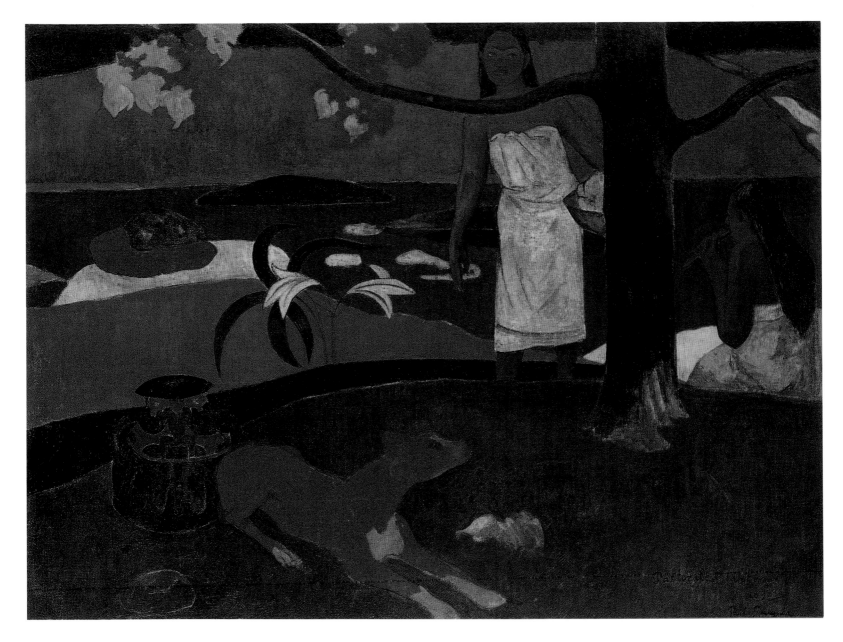

marvellously complete outline. The soft contours of their bodies reflect and react with the lines that mark the landscape. Gauguin did not see his strength as depicting the expression on his characters' faces, but in the harmony of all the moving elements in the picture: the smooth contours and colours of gold, emerald, blue and red. The line of the horizon is raised so high that the two-dimensionality of the ground on which the women are sitting is almost at one with the two-dimensionality of the canvas. This was extremely important for Gauguin, who did not like to 'spray' his paints, preferring instead to apply them in a broad expanse.

The most important elements of Gauguin's style – the flat areas of colour and the outlines that frame them – are even more marked in a picture such as *Pastorales Tahitiennes*, where the colour is divided up into large-scale sonorous zones, and takes on an almost independent

character. Gauguin was ready to sacrifice much in the interests of pure colour. Here, as in other pictures, he has no time for shade. Like one of the masters of the Middle Ages, from whom he learnt much, Gauguin knew the strength of the effect of pure colour. Following in the tradition of creators of tapestries, stained-glass windows and enamels, he wanted to create 'music in pictures', achieving this 'through the application of colours and lines in symphonic harmony.' He was particularly preoccupied with the similarities between music and art. It is no coincidence that in *Pastorales Tahitiennes*, where the subject is music, the colour should ring out with a special clarity and autonomy. This is particularly true of the landscape, which is constructed out of distinct planes of colour, reminiscent of the partitioned enamels of the Middle Ages. The landscape does not simply occupy a large area of the canvas: imbued with more vivid tones than the figures, it becomes an artistic

representation of Tahitian music. The woman emerging from the river stops and listens to the melody produced by the other Tahitian woman. The predominance of softly curving horizontal lines and the overall tonality of the work corresponds to the bewitching calm of this Tahitian paradise, lulled by the sounds of the reed-pipe. By introducing pure colours the artist intuitively avoids a harsh juxtaposition of colours and does not allow contact between blue and red or yellow and dark cherry.

'I have just completed three canvases,' wrote Gauguin in one of his letters from Tahiti. 'I think they are my best, and since it will be January 1 in a few days I have dated one of them – the finest – 1893. As an exception I have given it a French title, *Pastorales Tahitiennes*, since I cannot find a suitable name in Kanak.[20] I don't know why, but by using a Veronese pure green and a pure vermilion, it takes on the appearance for me of an old Dutch painting or an old tapestry. To what can I attribute this? Alongside it, all my other canvases seem to lack colour.'[21] In the finest Tahitian pictures, among which all the Hermitage canvases can be counted, the wonderfully pure and yet muted colours, the melodious contours and the unhurried, measured rhythms convey precisely what the artist was striving for in Oceania: concord between the human and the organic, the secure union of humankind and nature. This was despite the fact that civilisation, from which the artist was fleeing, had already reached Tahiti, and the union that his paintings embody was more a reflection of his dreams than of reality.

In *Eü haere ia oe (Woman Holding a Fruit)*, the fruit itself is the compositional and thematic centre of the work, which repeats the rounded contours throughout. Rhythmical echoes pervade the entire picture: the structure of the branches is thematically related to the lines of the head and shoulders, while the pattern on the skirts of the Tahitian girls 'returns' to the earth in the form of mysterious patches of colour. The outline of the silhouette of the woman carrying a fruit achieves a rare clarity. The drawing in Gauguin's Tahitian canvases reveals clearly how concerned the artist was with the creation of rhythmically organised painting, where – as in music and poetry – contrast and repetitions are constantly used. Although they used it differently, Cézanne and Van Gogh also sought repetition in the composition of their paintings. The dynamic brushstroke which becomes a leaf or a blade of grass in Van Gogh's *Lilac Bush* finds its partner in the next leaf-stroke. *Large Pine near Aix* – or, indeed, any other composition by Cézanne – is formed from the same structural elements as the next picture, and these elements are carried on from one to the next, whatever the actual motif. Gauguin's contrasts and returns, however, always arise from the motif itself; thus they fulfil a role similar to that of rhyme in a work of poetry. In *Nave Nave Moe (Sacred Spring)* the red skirts of the Tahitian girls 'rhyme' with the red area of reflection in the spring, while their white shirts find their reflection in the lilies.

It is worth noting that a detail such as the skirt in *Woman Holding a Fruit* is rather more than just a piece of clothing. It is an artistic sign, a symbol of island life. In the early Tahitian works the appearance of a red skirt with yellow flowers was brought about by the strictly aesthetic necessity of introducing patches of each of these colours. For all the

highly delicate artistic instrumentation of the later *Nave Nave Moe*, symbols play the more important role. Our understanding of them is guided by the interrelation between the patches of red, divided up in the manner of a *cloisonné* work – the water, the fruit as it is raised to the mouth, and the clothing of the main characters. One significant detail in *Nave Nave Moe* gives a wonderfully expressive indication of the aims of Gauguin's Symbolism: the identical red skirts with a gold floral pattern, worn by the Virgin Mary and Eve as they sit side by side like sisters. It is a simple and effective method of giving both characters a 'common denominator'.

At the same time, however, Gauguin was well aware of the danger of becoming too preoccupied with symbols, and he had no desire to turn his pictures into coded messages. And although he attached perhaps too much importance to the expressive possibilities of colour, he did not want his painting to become little more than decorative linear patterns. Every technique, including the search for contrasting echoes, was determined by the necessity of revealing the content of the picture. Nowhere is this better demonstrated than in *Woman Holding a Fruit*, a canvas that Gauguin himself called somewhat mysteriously *Eü haere ia oe* – 'Where are you going?' In this majestic representation of Eve, the idealised beauties of European painting have been replaced by a native girl with heavy features and a clumsy figure – someone who could in no sense be described as seductive. The words of the artist in his book *Noa-Noa*, describing a neighbour who posed for him, might easily apply to her: 'Overall, in terms of European aesthetics, she was not very attractive. But she was beautiful. The fusion of curved lines that made up her features had a kind of Raphaelian harmony, while her mouth was as if modelled by a sculptor who spoke the language of thought, of the kiss, of joy and suffering. And I saw in her a fear of the unknown, the melancholy of bitterness mixed with pleasure, and that special passivity when a woman seems to give way to everything and yet remains in control.'[22] *Woman Holding a Fruit* brings to mind Gauguin's words from his letter to August Strindberg: 'The Eve that I painted (she alone) could logically remain unclothed before our eyes. Yours would not have known how to take a single step in this simple state without appearing shameless, and, too beautiful (perhaps), would have evoked evil and suffering.'[23]

The most important place in the picture is given to the fruit, which occupies a strong central position. It is a pumpkin, used for various purposes in Tahiti, as in other tropical countries, but above all as a water-carrier. If we look carefully, we can even make out the thread by which the vessel is carried. It is apparently the simplest everyday scene imaginable, and with this central detail the artist provides a response to the question posed in the title of the picture. However, the self-evident reply to 'Where are you going?' – to get water, of course – is not the true meaning of the work. Its content is multi-layered: the easily accessible gives way to layers of profound meaning, rich in personal motifs that are not easily decipherable. It was no accident that for a long time the vessel was thought to be some obscure tropical fruit. The traditional title of the painting, *Woman Holding a Fruit*, with the fruit unspecified, is indicative of how people first reacted to the painting, and to this day the name may be seen to be justified by the green colour of the vessel,

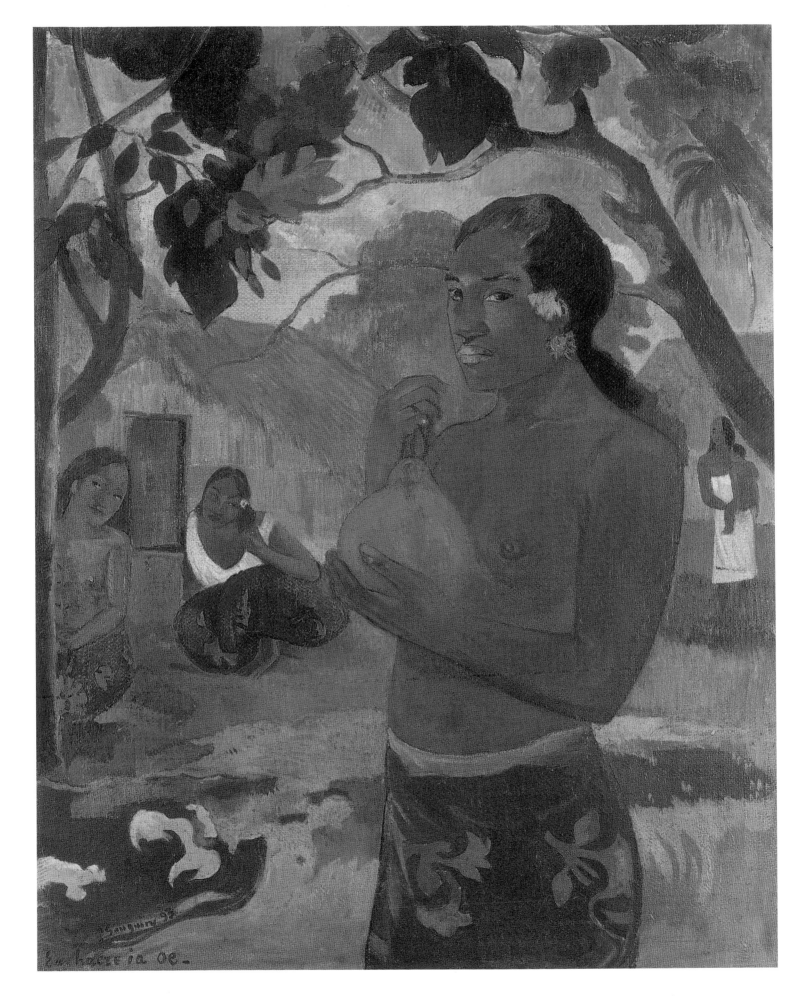

associated with a recently plucked tropical fruit. The water which the vessel contains has a multitude of symbolic meanings, Christian, Oriental and Pagan, but always vital. To the Indians, for example – in whose mythology Gauguin had a lively interest – water is the beginning and end of existence. Various cultures throughout history have attached symbolic significance to the image of the pumpkin. The Chinese, for example, treat it as a symbol of the connection between two worlds, the earthly and the celestial. The symbolism of life and its genesis, embodied through the motif of the water vessel, runs throughout the whole picture, and this is complemented by the energetic echoes of the contours: the pumpkin, the bare breast, the outline of the strong young female body, the clump of trees in the centre, the figures of Tahitian women in the background, as well as the vessel's thread, the fingers of the hand and the branches of the trees. The same can be said of the colour repetitions: the green of the pumpkin is transferred to the tree in the background, to the foliage of the nearest tree and the grass of the glade.

The features of the main character in the picture are recognisable as those of Teha'amana or Tehura, Gauguin's *vahiné* [Tahitian wife]. The arrival of this thirteen-year-old girl at Gauguin's house inspired the artist to produce a whole series of outstanding works. In *Woman Holding a Fruit* Teha'amana appears older than in the other pictures, and it is possible that this was by design: here Gauguin needed to portray a mature woman and not someone who was almost still a child. A comparison between the various portrayals of Teha'amana shows that in each case the artist explored questions of symbolic imagery, rather than those of portraiture. The depiction of the fruit vessel is clearly ambivalent. An apparently living, newly plucked fruit is in fact portrayed as a dried-up lifeless casing. It is conceivable that elements of hidden dark irony are at play here, where the biblical first mother at the tree of knowledge is replaced by the native Eve at the tree without fruit.

Evidently the pumpkin is somehow linked to the hidden motif of motherhood. The Tahitian girl with a child in the background clearly has some relevance to Teha'amana. The following lines appear in a letter from Gauguin to Daniel de Monfreid, written in August or September 1892. 'Here, in Oceania, I am soon to be a father again. Damn it all! It seems I must sow my seed wherever I go. It is true that here it is not a problem. Children are always welcome and all the relatives are ready to take them in. As you know, on Tahiti the greatest gift you can give is a child. So I shall not be worried for the child's future.'[24] What happened to the child? The answer to this question is evidently provided by the woman with a child in her arms in the background of *Woman Holding a Fruit*. Her white dress is a clue, for on Tahiti white symbolised mourning. It is probable that the new-born child lived only a short time, and Teha'amana went out of the artist's life even before he departed for Paris. It would have been strange to portray a dead child as Gauguin does here – held in his mother's arms. At the end of December 1892 Gauguin was working on his *Pastorales Tahitiennes*, a picture which with some justification is interpreted nowadays as a requiem, for both figures are presented in white dresses.[25] What prompted him to paint this picture, which he considered at the time to be his best? A clue to the answer may be found if

we reconsider *Woman Holding a Fruit*. The lush colours of this painting are notable for a greater softness than those in other paintings by Gauguin. This is the world of paradise, of nature in harmony. But it is only necessary to look into the face of the Eve of this paradise to understand that this utopian setting does not preclude drama. Taking this into consideration, the question in the title does have another direct meaning. Where can this Eve go? Where can the artist go? By posing a question in his title, which in the surroundings of Tahiti does not seem to require an answer, and by replying as if accidentally with the whole iconographic structure of the picture, Gauguin has created a work full of genuine wisdom within an everyday scene. The cycle which began with a naïve dream of a paradise overseas ends with a profound reflection on the meaning of life.

Nave Nave Moe (*Sacred Spring*) represents the culmination of Gauguin's first Tahitian journey. Painted from memory in Paris, it is the embodiment of the legend of paradise on earth. It is one of the artist's most contradictory works. The upper and lower sections of the painting are stylistically quite different: the former is softer and more plastic, the latter has a criss-crossing of lines in the style of *cloisonné*. The forced conventionality of the lower part or foreground is explained by the fact that it contains the majority of the symbolic content of the work. The symbols in *Nave Nave Moe*, however, are unusually varied. The spring is richly allusive in all religions; in Christianity it is connected with salvation and spiritual life. The lilies represent purity and chastity, while the apple in the hand of the Tahitian Eve signifies original sin. However, the Christian ideas represented by the characters in the foreground are arranged in a quite specific and unusual manner. Mary and Eve, sitting near to the spring, are presented in the Eastern style, deep in meditation. At the same time they seem to represent youth, in contrast to the more mature women in the middle ground, for whom the time of daydreams has already passed. These older women are gossiping about something, and their conduct highlights the utterly everyday, worldly aspect of life, set against the elevated and the spiritual. There is another significant juxtaposition in the painting: the immobile figures of the foreground and middle ground set against the group of natives who are dancing in the approaching twilight before a double statue. Gauguin was inspired by illustrations in a book by a Frenchman travelling through Oceania, which described the ancient cults of the islanders.[26] The whole construction is crowned by the vast tree, already familiar from *Fatata te Mouà*, a Tahitian totem connected with Hina, the Goddess of the Moon. Yet however much we may try to interpret the symbols and allusions of this strange vision of the 'Promised Land', it is not this that initially draws us to the picture, but its formal, aesthetic structure, the delicate drawing and the captivating range of colours that so wonderfully convey the golden evening light of the tropical island.

Despite going through an Impressionist phase, Gauguin had no desire to remain part of Impressionism, believing it to be too artistically restrictive. Gauguin always strove to broaden his sphere of activity, not only by returning constantly to his European heritage, in particular with themes relating to the Middle Ages, but also by embracing aspects of non-European art. Gauguin's views of culture were at once universal

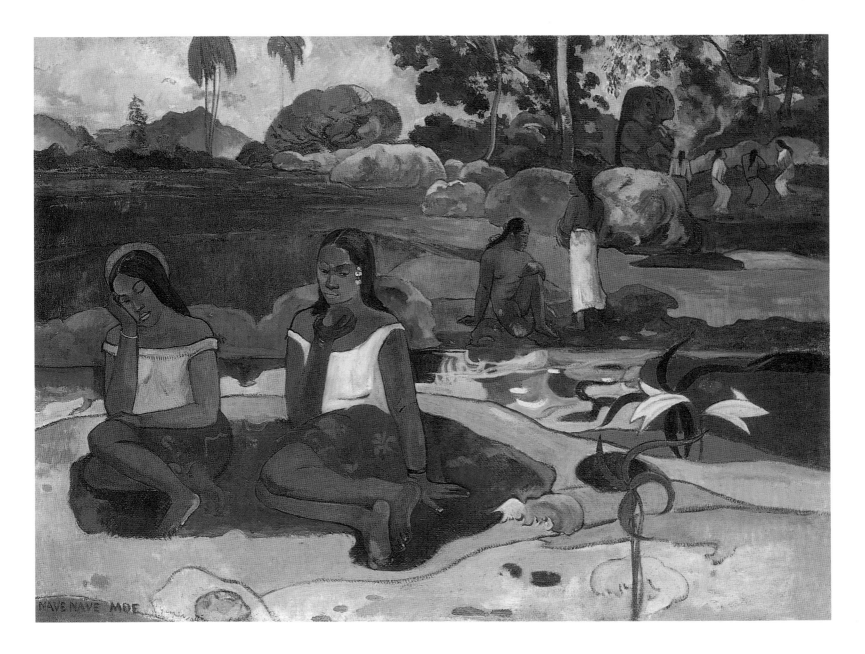

and inclusive. He was extremely interested in folk art, whether in Brittany or Tahiti, and was particularly drawn to those eras when artists remained anonymous masters while pursuing an elevated spirituality, beauty and expressiveness. Gauguin played an important role in overcoming the Eurocentric limitations placed on our approach to culture – limitations which remain to this day. Before the 1860s, European art took little or no consideration of what was going on in other continents. Manet, Degas and Monet appreciated and benefited from the lessons of Japanese woodcuts. But Gauguin went considerably further. He studied the art of the Near and Far East, Ancient America and Oceania. All that remained for him to discover was African sculpture. With this knowledge he would have acquired a cross-section of all the main artistic currents, hitherto unknown or ignored, that were to exert a powerful influence on the development of twentieth-century art.

Gauguin was not afraid of borrowing, for anything he borrowed was adapted to the spirit of his creativity. It might be argued, for example, that the concept of the frieze-painting *Scene from the Life of Tahitians*, where the movement of the characters passes along the breadth of the canvas, was suggested to the artist by Ancient Egyptian sculpture and art of the Classical world, in particular the friezes on the Parthenon. Similarly, the fisherman in *Te Vaa (Canoe)* is reminiscent of images from Ancient Egyptian painting; his pose is similar to that of people feasting, painted on Theban Old Kingdom tombs, while the technique of portraying the body in profile with the shoulders face-on is typical of Ancient Egyptian artists. At the same time, the overall design of *Te Vaa* echoes *The Poor Fisherman* by Puvis de Chavannes (1881; Paris, Musée d'Orsay), which at the turn of the century became a cult picture in non-Academy artistic circles.[27] *Te Vaa* is the largest-scale of all the Gauguin

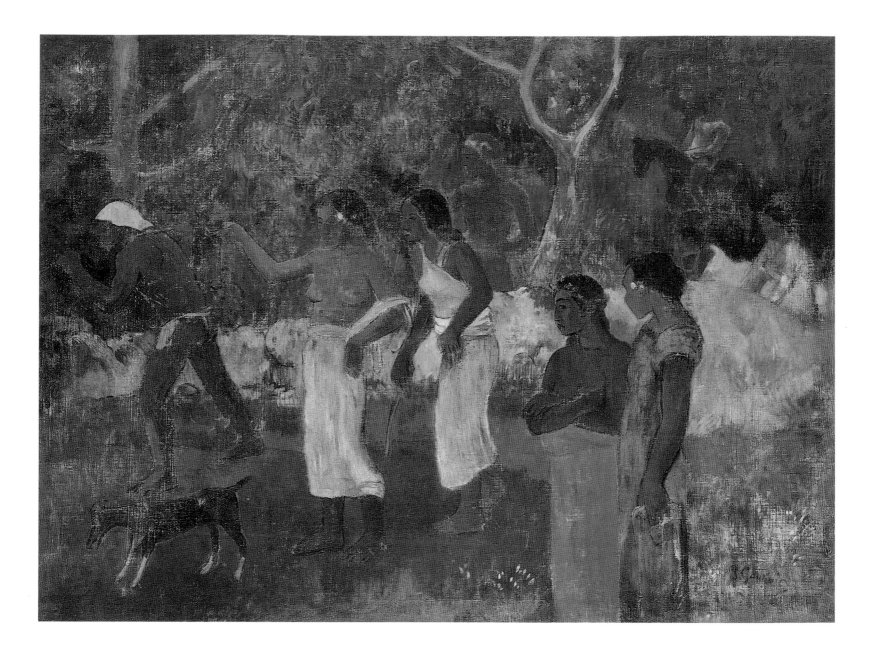

canvases in the extensive Hermitage collection. Here the artist was particularly concerned with achieving a monumental effect and overall balance. The composition is based on the intersection of two diagonals: the first, and most important, follows the outline of the stern of the boat, while the second follows the contour of the body of the Tahitian girl. A mountain crowns the upper part of the picture: its mysterious silhouette is essential not just because it bridges the two central characters and represents an important mark of the Tahitian landscape, but also because it has its own symbolic significance. In both Oriental and Western religions the mountain is connected with spiritual elevation and meditation. Similarly, the gesture of the fisherman – at first an apparently everyday one, as he drinks from the shell of a coconut – is full of hieratic meaning. The choice of the time of day, as the sun sinks down into the sea beyond the horizon, is probably also significant. The

gold of the evening Oceanian light and the almost equally intense blue colour was a contrast that continually struck the artist in Tahitian nature, and defined the colouring of *Te Vaa*. It is likely that in his attempts to capture this special tropical light at dusk Gauguin took some experimental risks with paint; this, along with his use of a jute canvas, is responsible for the painting's poor condition.

The conscious primitivism combined with an attempt to convey the magical qualities of light – or, more precisely, of light and colour – stems from Gauguin's desire to paint pictures that were to a large extent religious in their internal meaning. There was much that connected Gauguin to Christian art, although not one of his pictures could be used as an illustration to the gospels. Just as in Brittany he wanted to delve into the beliefs of the local peasants, on Tahiti he was intent on

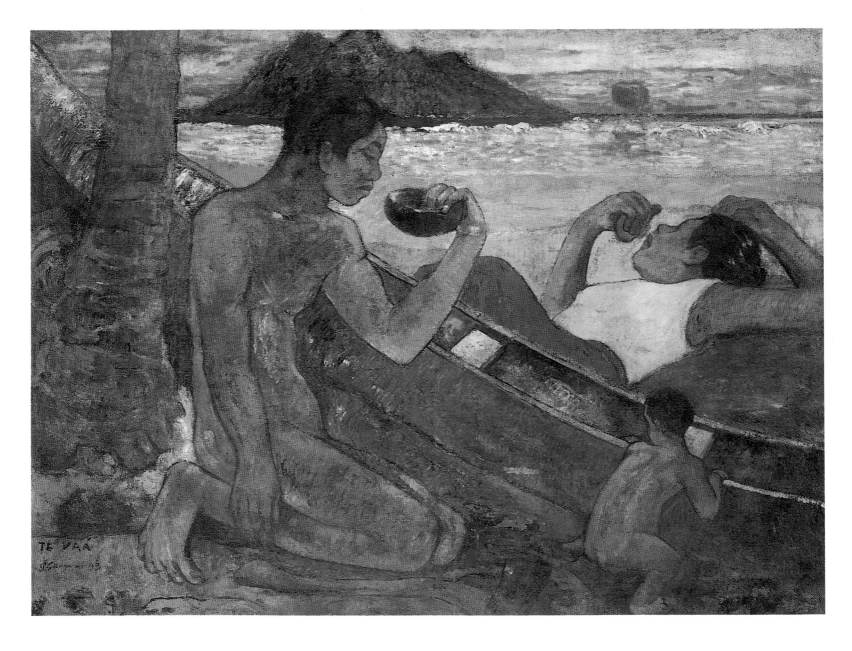

getting to know the islanders who had only recently converted to
Christianity. Christian ritual was alien to Gauguin; he regarded it as
a form of idolatry. In his picture *Infant (Nativity)*, the artist presents a
heretical reinterpretation of the central moment of the gospel story. The
woman with the infant in her arms, whom we can recognise as Pau'ura,
the artist's second Tahitian wife, is an embodiment not of the Virgin
Mary, but of Tupapao, the Spirit of the Dead. The dead infant, of course,
is not Christ (Gauguin on more than one occasion compared himself
with Christ), but the artist's daughter, who died within a few days of
birth. Nevertheless, in painting this requiem for the little girl, the artist
deliberately and insistently introduced motifs from the gospels. There
is, incidentally, another possible explanation for this syncretism: it is
possible that Gauguin started the picture on the eve of the child's birth,
and then repainted it after her death.[28] If the painting was originally

conceived as the Annunciation, it is difficult to imagine how it could
have been transformed into the scene shown here, where motifs from
the Nativity, such as the infant in its mother's arms, are combined with
a parody – from a European point of view – of the Annunciation.

Gauguin wanted to see in his art the reflection of a superior wisdom,
a kind of all-inclusive religious philosophy. *Where Are We From?
Who Are We? Where Are We Going?* he asked in the title of his most
programmatic work (1897; Boston, Museum of Fine Arts), a painting
which is directly linked to the genesis of *Man Picking Fruit from a Tree*
(page 178) and the mysterious *Tarari Maruru* (page 178). With his
portrayal of natives dancing in front of idols alongside Eve and Mary
in *Nave Nave Moe (Sacred Spring)*, Gauguin was trying to say that their
primordial religion was in no way inferior to Christianity. The very title

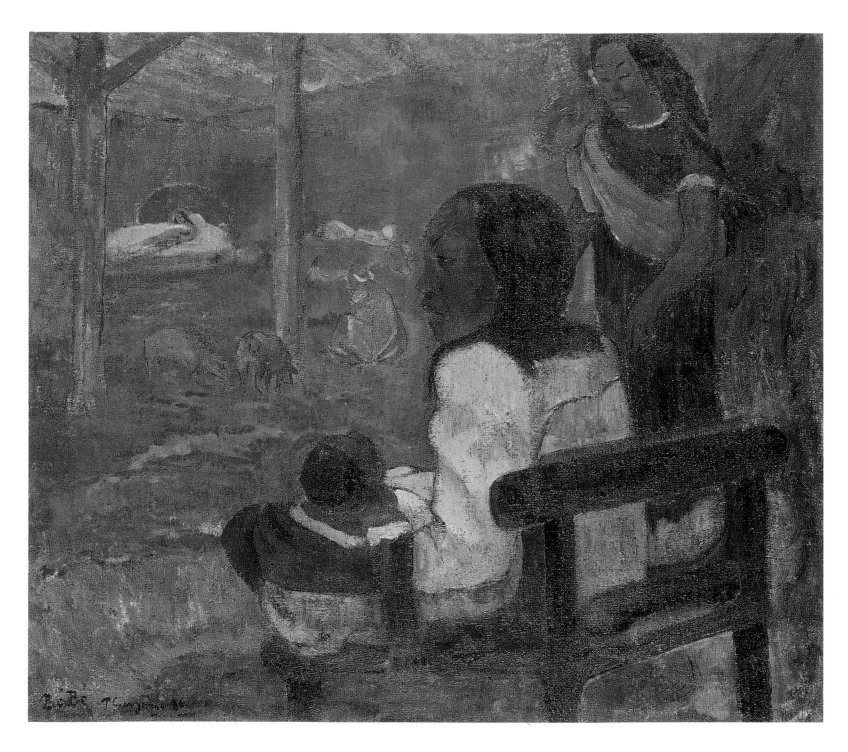

of *Te Avae No Maria* (*The Month of Mary*) (page 176) – in other words, May – and, more importantly, the picture's theme, reveal Gauguin's attempts to combine traditional Christian motifs with the pagan delight of his own Tahitian mythology.

Gauguin sincerely wanted to explore the Tahitians' beliefs, and in pictures such as *Idol* he was successful. The picture was painted a few months after the Boston canvas *Where Are We From? Who Are We?*

Where Are We Going?, which also portrays a graven image. *Idol* is one of Gauguin's most disturbing and mysterious works. The echo between the outline of the graven image and the contours of the trees emphasises to an almost obsessive degree the presence of the idol, which is referred to in the work's Tahitian title (one of the translations of *Rave te hiti aamu* is *The Presence of an Evil Monster*). The idol here is much more than the creation of native sculptors; it is a living being, and it is difficult to tell from what material it is fashioned. Gauguin's description of

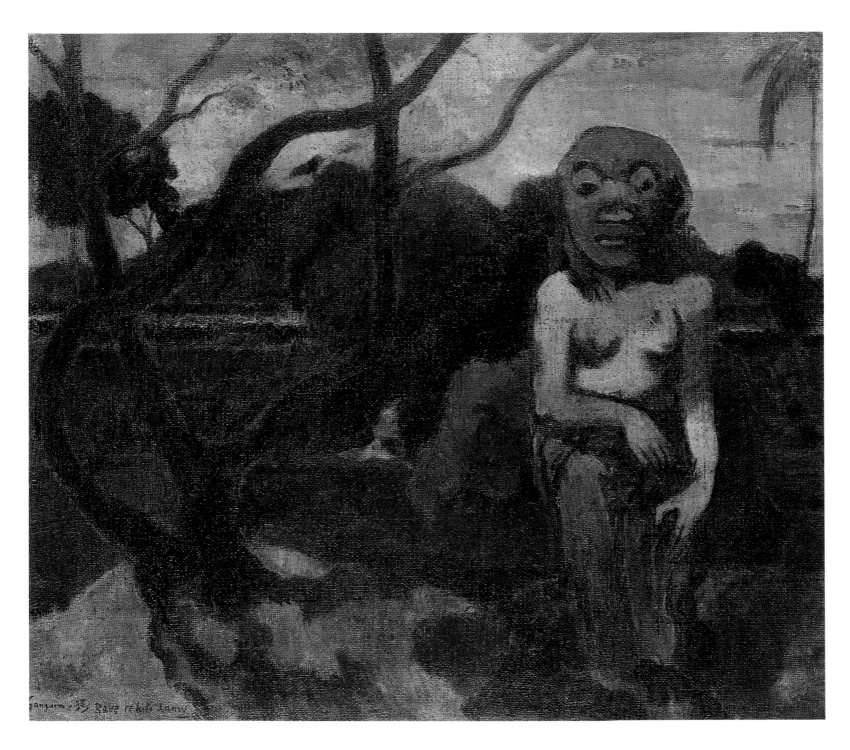

the Boston canvas in a letter to the critic Fontainas could just as easily have applied to *Idol*: 'The idol is placed here not for any literary interpretation; it is just a statue, perhaps less statuesque than the living figures that surround it... When I think of it in my hut, it seems to merge into a unified whole with all of nature, ruling in our primitive souls, like an imaginary consolation in the face of the suffering that is aroused by what is most ill-defined and misunderstood in the mystery of our origin and our future.'[29]

It is likely that it was precisely his desire to evoke in his paintings the experiences of the soul, inseparable from the mystery of spirituality, that led Gauguin time and again to turn to the depiction of evenings in nature. This also corresponded to his colour preferences: as dusk approaches nature takes on new and highly expressive tones. *Nave Nave Moe, Scene from the Life of Tahitians, Te Vaa, Tarari Maruru, Idol, Te Avae No Maria, Three Tahitian Women against a Yellow Background* and, finally, *Maternity (Women by the Sea)* (page 179) – the action of

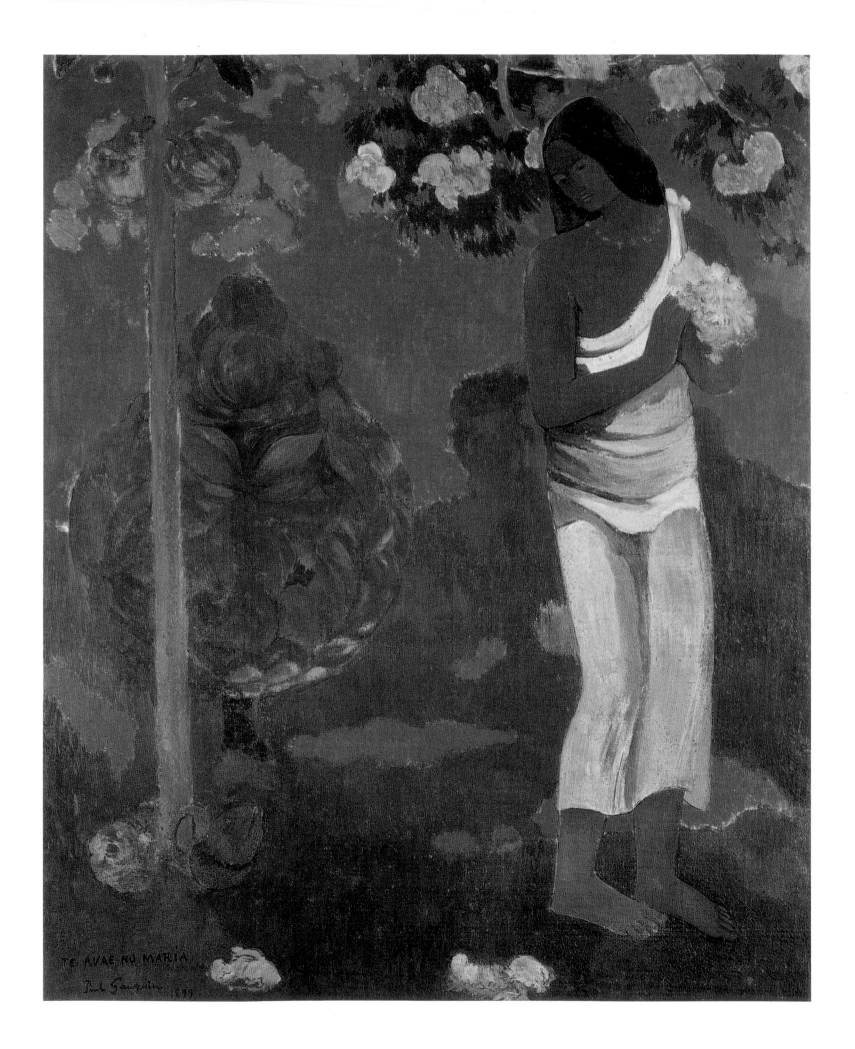

Left: **Te Avae No Maria (The Month of Mary)**, 1899, by Paul Gauguin
Below: **Three Tahitian Women against a Yellow Background**, 1899, by Paul Gauguin

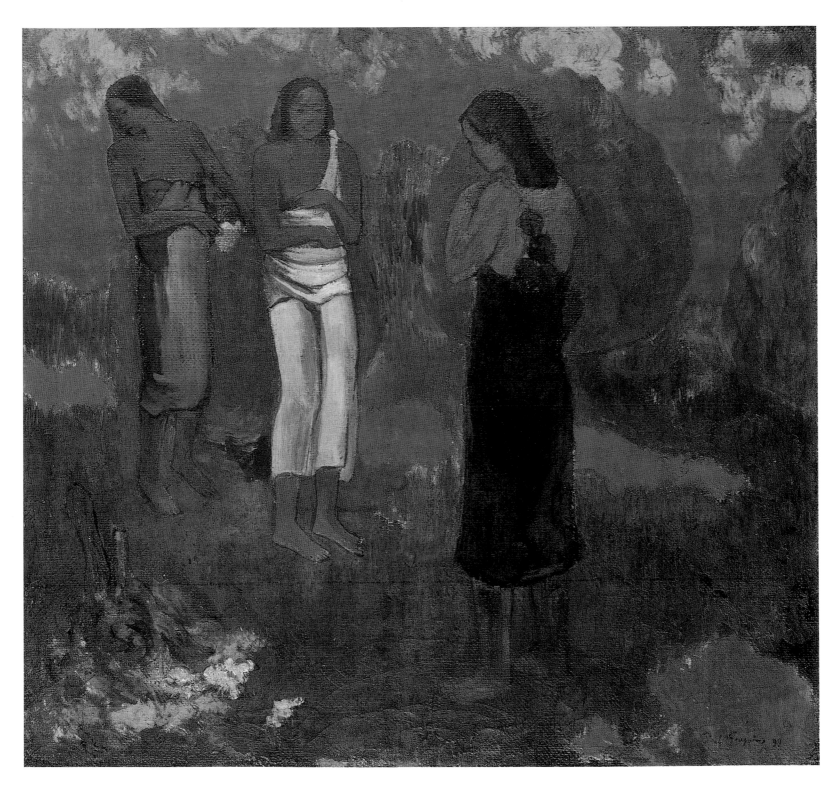

each of these paintings takes place in the evening, at the hour when the sun's rays begin to glow with gold and dusk. The most glowing and harmonious evening of all is probably depicted in *Maternity*, a picture which bears comparison with the finest representations of peace and harmony in the art of the Renaissance. The painting is thought to be dedicated to the birth of the artist's son. If that is indeed true, Gauguin did not attempt to make his work the portrayal of a real situation. The Tahitian woman breast-feeding the infant is not Pau'ura, but a generalised and elevated image similar to an icon of the Madonna. In spirit the whole scene is reminiscent of the Adoration of the Magi

Tarari Maruru (Tahitian Landscape with Two Goats), 1897, by Paul Gauguin

Below: **Man Picking Fruit from a Tree**, 1897, by Paul Gauguin
Right: **Maternity (Women by the Sea)**, 1899, by Paul Gauguin

in the art of the Old Masters, although here the role of the adorers is played by young women. Comparisons have also been made between the characters in the picture and the three graces.[30] As is characteristic of all truly great creations, the content of this modern-day 'icon' is multifaceted: not only does it introduce us to the reality of the artist's life on Tahiti, it also serves as a link between the different iconographic images of East and West.

Even when he turned to still life, Gauguin did not produce a dry rendition of objects. *Sunflowers*, the latest of Gauguin's canvases in the Hermitage collection, is a picture redolent with mystery. The motif, borrowed from Van Gogh, is here treated quite differently and evokes an entirely different emotion, not only through the colouring of the picture, but also through the juxtaposition of the still life with the head of a woman at the window, whose immobile features recall the face of Buddha (Gauguin turned to images of Buddha on more than one occasion). The mystery deepens as an eye seems to stare out from the centre of the upper sunflower. This probably reveals the influence of Odilon Redon, with his fantastic visions that resemble eyes swaying on stalks. At the same time, an eye encircled by the sun's rays – the

all-seeing eye – is a common decorative feature in Christian churches, while the sunflower is a traditional symbol for the sun. The symbolism of the whole picture, however, is expressed through little more than hints – indeed, the work is intriguing precisely because of its under-statement. For it was precisely at the time he was creating this picture that Gauguin wrote: 'In art we must look for an allusion rather than a description, as is the case with music.'[31]

On the Fringes of Symbolism

Gauguin's creative work had a strong influence on the development of Symbolism. This movement, which might more accurately be described as a general tendency, gathered strength in France in the 1880s, and by the end of the century had taken root in various European countries. Originating in literature, which remained its main field of application, Symbolism soon became a feature of painting and other graphic arts. It left its mark on such great artists as Van Gogh, Rodin, Monet and Bonnard, although none of these could actually be termed Symbolists.

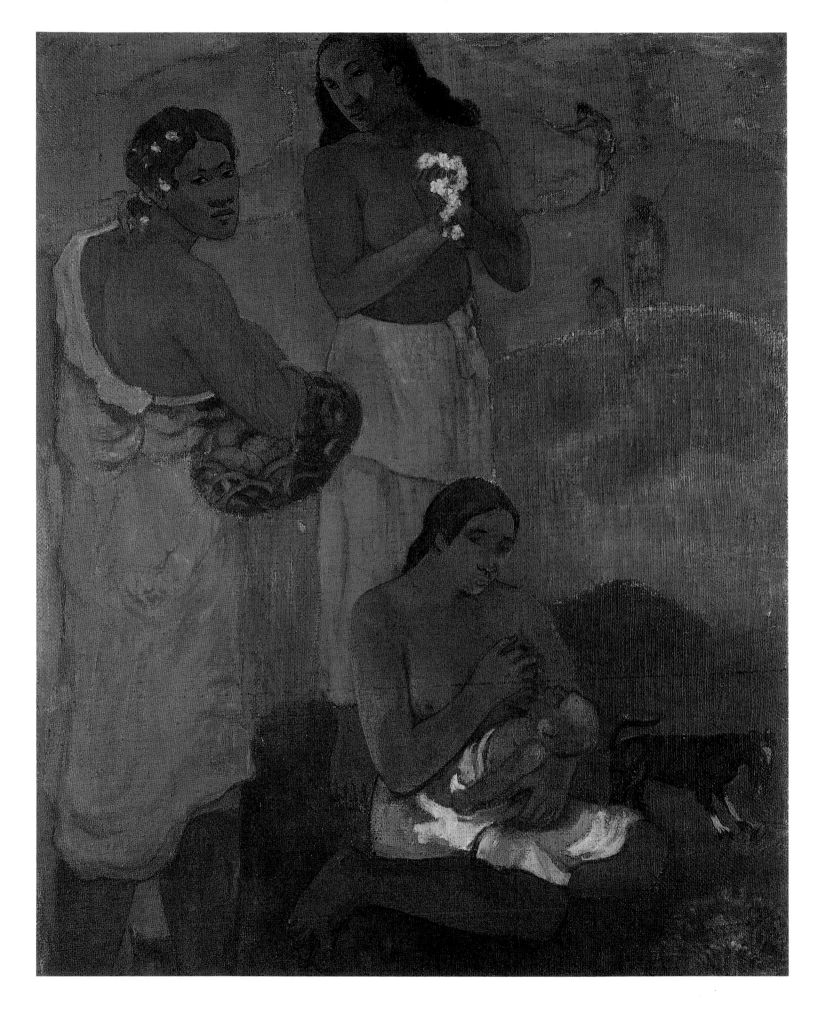

The etymology of the word Symbolism provides few clues to the nature of this widespread tendency, since all art throughout history has made wide use of symbols. At the end of the nineteenth century a group of writers and artists emerged who professed adherence to Symbolism. By contrast with their immediate forebears – for example Zola and his naturalist school in literature – they created and used symbols much more intensively than ever before. Born out of the prevalent anti-naturalist and anti-positivist tendencies in Western creative thought, Symbolism reacted against literal interpretation. Its aesthetic became inseparable from the struggle for individual freedom in art, and this alone gave rise to a vast and multifaceted array of artistic impulses. Thus some representatives of the movement were prone to mysticism,

while others avoided it altogether; all, however, no longer constrained by existing norms, were able to reveal a multitude of hitherto unrealised nuances. Thus, in his *Art Poétique* (1874), a poem that became a kind of Symbolist manifesto, Verlaine called for the pursuit of shades, of nuance, not colours or paint; the poem expresses the need for allusiveness, understatement, suggestion and musicality:

De la musique avant toute chose,
Et pour cela préfère l'Impair
Plus vague et plus soluble dans l'air,
Sans rien en lui qui pèse ou qui pose...
Car nous voulons la nuance encor'

Right (top): **Woman by the Sea**, 1887, by Pierre Puvis de Chavannes
Right (bottom): **Naïade**, *c.* 1896, by Henri Fantin-Latour

181

Pas la Couleur, rien que la nuance!
Oh! La nuance seule fiance
Le rêve au rêve et la flûte au cor!

[Music above everything else,
And for that prefer the uneven,
Vaguer and more soluble in the air,
Without anything heavy or definite...
Because still we desire nuance.
Not colour, only nuance!
Ah! Only nuance can link
Dream to dream, and flute to horn!]

The poet Jean Moréas, who published his *Symbolism – A Literary Manifesto* in 1886, not only brought the word into wide usage, but also set out the tenets of a method that applied equally to literature and art: 'Symbolist poetry, the enemy of "instruction, declamation, false sensibility and objective description", seeks to clothe the Idea in a tangible form which will not be an end in itself but which, while serving to express the Idea, will remain subordinate... In this art, neither scenes from nature nor human actions nor any other physical phenomena can be present in themselves: what we have instead are perceptible appearances designed to represent their esoteric affinities with primordial Ideas.'[32]

The most highly regarded artist in Symbolist circles was Pierre Puvis de Chavannes, whose renown reached its peak in the second half of the 1880s. Since he was much older than the Impressionists, Puvis escaped their influence, but later he himself became a luminary for artists of the Post-Impressionist movement. He was admired by such varied and gifted artists as Renoir, Monet, Seurat, Van Gogh and Gauguin. Théophile Gautier, Baudelaire and Leconte de Lisle found a great deal of poetry in his compositions. The twentieth century, however, has been much more reticent in its appraisal. For all their undoubted compositional harmony and balance, Puvis de Chavannes' pictures are characterised by their rather anaemic colouring and forced literary allusions. The academic genesis of Puvis' painting is well demonstrated in his archetypal early work *Village Firemen* (1857; Hermitage). Nevertheless, even in the outward appearances of his art, Puvis' painting was markedly different from that of the Academicians and the Realists. He was quite uninterested in the overall finish that was so beloved of the Salon; nor was he preoccupied with the materiality of his figures or the depth of his landscapes. Thus a work such as *Woman by the Sea*, even from today's point of view, can be considered a sketch. The picture recalls the admission that the artist himself once made: 'I have a weakness to which I am loath to admit. It is that I prefer all views that are slightly melancholic: a low sky, deserted plains in a restrained tone, where each blade of grass makes its music with the gentle breath of the southern wind.'[33] *Woman by the Sea* is characteristic of the artist's mature works, to which he imparts a certain fresco-like quality, even with works painted on the easel. Indeed, Puvis' large canvases in oil, which were fixed to the wall, were known as frescoes by his contemporaries. Such paintings played a significant role in the development of French monumental decorative art of the turn of the twentieth century.

The development of French art during the nineteenth century is normally presented as a series of movements: Classicism, Romanticism, Realism and Impressionism; and this scheme is essentially correct. But alongside these main movements ran several other trends, and it is the work of such artists as Puvis de Chavannes and Fantin-Latour that

confirms their importance within artistic development as a whole. As each movement was replaced by its 'younger' antagonist, it did not simply disappear the next day, but lived on in the shade. Puvis de Chavannes not only used elements of Classicism and Romanticism; he gave them a freshness, when they were already 'out of season'.

Henri Fantin-Latour, who throughout his life admired the works of Delacroix and Corot, but also tried to learn from Courbet, combined in his own way the techniques of Realism and Romanticism. His constant fascination with the music of the German Romantics led him to paint pictures like *Naïade*, in which he attempted to convey an impression of waves of sound through visual waves. If we compare his treatment of water with the works of other marine artists, its illusory, unworldly

nature becomes more evident. 'This artist', wrote Odilon Redon, 'has striven long and hard to interpret music through art, forgetting that no colour is able to convey the world of music, which will always remain entirely an inner world with no equivalent in real nature.'[34] For all his Symbolist inclinations, Fantin-Latour did not restrict himself purely to 'musical' fantasies, spending much more time on still lifes, a genre essentially alien to Symbolism. One might wonder what connection there could be between his fantastical compositions and the still lifes so grounded in real life. Fantin-Latour's flowers – be they roses, nasturtiums or pansies – are always rendered with precise botanical accuracy allied to extraordinary delicacy. The composition of his still lifes is generally undemanding. A follower of Edouard Manet, and a frequent visitor to the Café Guerbois, where the Impressionists

gathered, Fantin-Latour nonetheless diverged from them, keeping faith in more traditional techniques, and in particular the use of dark-brown background. Unlike the Impressionists and the artists of the next generation like Signac or Van Gogh – Fantin-Latour did not try to achieve extreme richness of colour, and his flower still lifes conformed fully to the norms of poetic Realism. However, there is undoubtedly something magical about the colours with which he painted his flowers: they are suggestive and allusive. The artist treated his colours as living entities, endowed with 'soul', and in this he stood alongside the Symbolists.

The most significant practitioner of Symbolist painting is generally recognised to be Odilon Redon. A contemporary of the Impressionists, Redon even exhibited at their last exhibition, although by then the limitations of their art seemed to him too restrictive. He started to gain attention during the Post-Impressionist era, particularly from the literary Symbolists, who saw in his art the clearest expression of the movement's tenets. While Gauguin, who admired Redon and called him a dreamer and seer, sought refuge from civilisation in the exotic world of Polynesia, Redon chose a different form of 'salvation': he buried himself in his own inner world, the rarefied dream-world of the recluse.

Woman with Wild Flowers belongs to this dream-world. The lingering gaze of the woman's black eyes is a look within, a descent into the secret depths of her own soul. The wide-open and yet unseeing eyes are a sign of immersion in a sleep-like dream. There is no subject here; just a scarcely caught allusion to a motif. *Woman Sleeping under a Tree* is no

Left: **Woman with Wild Flowers**, *c.* 1895–8, by Odilon Redon
Below: **Woman Sleeping under a Tree**, 1900–1, by Odilon Redon

185

less mysterious. This small picture conveys not so much the physical presence of the character referred to in the title, but rather a dream or vision. And the vision does not conform to the usual norms of objective reproduction with respect to the application of perspective, the use of light and shade and the depiction of the physical qualities of objects. The astonishing shades of dark blue, of course, indicate a particular time of day, but above all they express the incomparable sense of mystery that night alone can summon. Redon's images, themselves born of fantasy, serve as a kind of wake-up call to the imagination of the viewer. 'My drawings', the artist wrote, '*inspire*; they do not define. They do not determine anything. Like music, they place us in the ambiguous world of the indeterminate.'[35] 'For myself, I believe I have created an expressive, suggestive, indeterminate art. Suggestive art is the irradiation of divine plastic elements converging and combining to produce dreams which enlighten and inspire by provoking thought.'[36]

In order to achieve this 'irradiation', Redon departed from standard methods, turning instead to unorthodox techniques. In *Woman Sleeping under a Tree* he used tempera instead of oils. He literally rubbed the paint into the unprimed and only weakly glued canvas. In this way the 'grain' of the canvas was preserved. The canvas itself thus became an integral part of the whole artistic construction, creating a sense of vibration in the picture and enabling the colours to 'radiate' in a unique way. In his pastels, to which he turned more and more frequently from the second half of the 1890s, Redon, just like Degas, departed from traditional methods. His bold use of colour was evident

not only in his deep, unmuddied tones, but also in his treatment of black, for which he earned the admiration of Matisse. The shadings of Redon's coloured chalks and the vibrations and modulations of his softly sparkling hues are beautiful and decorative, but, more importantly, they are wonderfully expressive. 'I am capricious,' the artist said, 'I float along on the infinite combinations of the materials I touch. I believe that the artist yields to the stimulus of materials that will transport his spirit. I am sure of what I will not do, but not of what my art will bring about. I await joyous surprises while working, an awakening of the materials that I put to work and that my spirit develops. A good work of art, made in one burst with tenacity, determination, passion as much as reason, should surpass the goal the artist has set for himself.'[37]

Only the era of Symbolism could have given rise to the art of Eugène Carrière. Today it is difficult to understand why his dull and gloomy pictures should have so delighted even the finest artists of the time. Rodin, for example, considered him a genius. But the caustic Degas once expressed himself thus about Carrière's work: 'Someone has filled the nursery with smoke.' In *Mother and Child*, *Woman Leaning on a Table*, and *Woman with a Child* – as in the vast majority of his other works – Carrière shrouds his characters in a brown haze. The mystery created

by this technique is scarcely profound, but such paintings were successful with the public at the turn of the century, if only because their accessibility made them particularly well-suited to literary allusion. Carrière's lack of definition has nothing in common with Redon's understatement. While Redon was liberated by the limitless possibilities of artistic transformation, the play of fantasy and poetic allusion, Carrière's lack of definition, by contrast, remains an obtrusive mannerism, so that its principal achievement is to acquaint us better with the tastes of the turn of the century. Nevertheless, the problems of creativity addressed by Carrière are not completely meaningless. The dramatic element he developed in the theme of motherhood is significant, if only because he was one of the artists on whom Picasso based his works from the blue period, and in particular *Two Sisters*.

The pursuit of mysticism that touched even those with academic leanings also helped to strengthen Symbolism. Such artists usually 'measured out' doses of mystery in relation to the theme they chose. Gaston La Touche, for example, first achieved renown for his pictures of ladies and knights, executed in the style of the 'second rococo' with references to Watteau and Lancret. Later he turned to religious subjects (*The Last Supper* and *The Relics*), where he became excessively pious

and persistently made use of an effect of light that was supposed to represent the divine. The image of the halo in the form of a conventional circle had become unacceptable in an era where the supernatural had to seem 'natural', as a kind of emanation of light or energy. The figure of Christ gives off a glow as if from some electric source. In *The Relics* the luminescence emanates from the figures of the priests: it is also designed to supply the best proof of the miracle.

Symbolism sometimes even touched such an apparently alien genre as landscape. Jean-Francis Auburtin's *Landscape with Overgrown Pond* (page 190) bears no relation to the techniques of Monet, but the picture contains elements of tonal reticence and balanced construction which this pupil of Puvis de Chavannes learnt from his mentor.

Symbolist understatement is also apparent in the youthful *Green Landscape* (page 190) by Auguste Herbin. By contrast, every detail of Charles Lacoste's *Small House in a Garden* (page 191) is precisely drawn, but this only serves to strengthen the mystery of the picture. Lacoste, who at one time was close to the Neo-Impressionists, paid particular attention to light, although in *Small House in a Garden* he does not go as far as the optical blending of tones, since concerns about colour were for him clearly of secondary importance. The light of Monet and Signac has been turned into a substance of an entirely different nature: a light able to awaken the instinct of fear that lies in the depths of the human psyche. The early works of Herbin or Lacoste also, to a greater or lesser extent, contain elements of compromise and repetition. They belong neither to Impressionism nor to Symbolism, although they owe a whole

Below: **The Relics**, 1899, by Gaston La Touche
Right: **The Last Supper**, 1897, by Gaston La Touche

Overleaf (top): **Landscape with Overgrown Pond**, *c.* 1900, by Jean-Francis Auburtin
Overleaf (bottom): **Green Landscape**, *c.* 1901, by Auguste Herbin

range of their artistic features to both movements. The works of both these artists are essentially decorative. When we look at Lacoste's *Landscape of the South of France* (page 191), for example, we can understand why in later life the artist spent much of his time on wallpaper and theatre decorations. A talented artist from the provinces, who encountered the dazzling innovations of new art on his arrival in Paris, Lacoste tried to keep up with the times, particularly since he had himself intuitively been moving in the same direction. 'When I arrived in Paris in 1899,' Lacoste wrote, 'I was struck by how, although isolated in Bordeaux and ignorant of all the movements in art of my time, I was

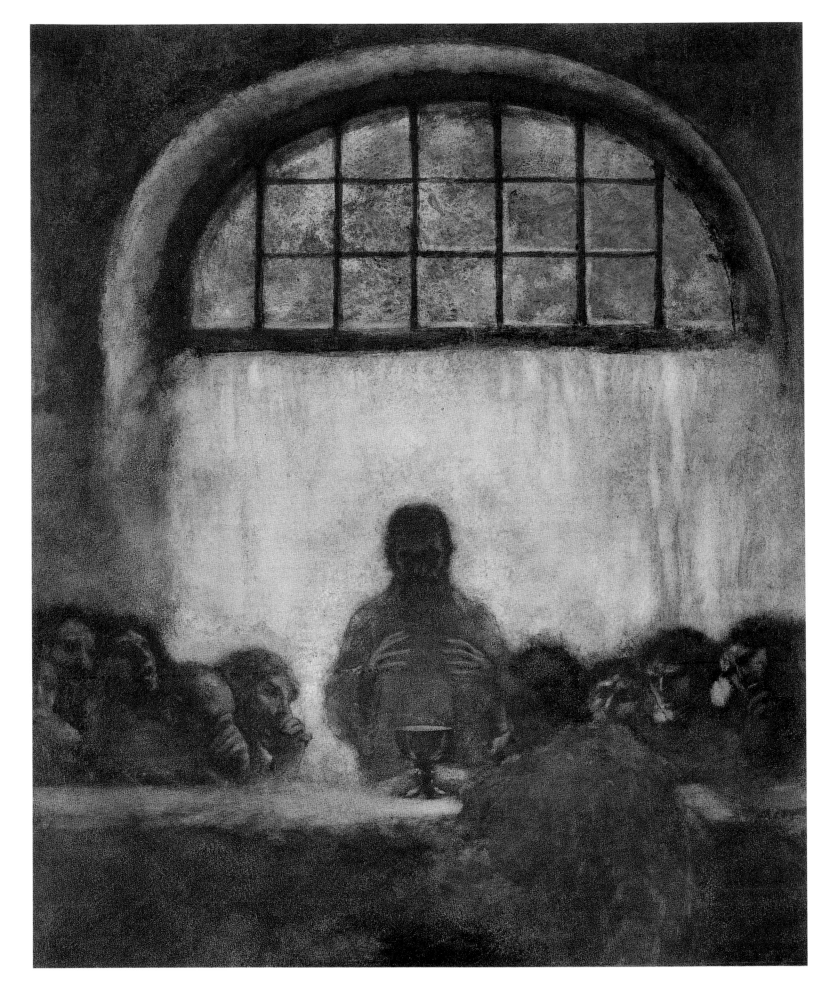

Previous page (top): **Landscape of the South of France**, 1912, by Charles Lacoste
Previous page (bottom): **Small House in a Garden**, 1905, by Charles Lacoste

Below: **Wedding Procession**, _c._ 1892, by Maurice Denis
Right: **Mother and Child**, 1895, by Maurice Denis

involved in the same pursuits as my contemporaries, the "young ones"
of the age – Denis, Marquet, Guérin, Dufrenoy, d'Espagnat, Lehmann –
whom I only met when I was thirty... Without having exchanged a
single word, we were working, each in our own way, in the same
"climate", pursuing variously the same discoveries which our age
undoubtedly called for.[38]

Nabis aux belles icônes

Denis, Bonnard, Vuillard, Roussel and Vallotton have gone down
in art history as members of a single group; and yet, for all their
similarities, there was still a great deal that separated them. In their
youth they were bound by membership of a circle of artists with the
unusual name 'Nabis' (from the Hebrew _nabbi_, meaning 'prophets').
Since they had all placed their work under the general heading of
Post-Impressionism, they were familiar with the convention of titles.
The word 'Nabis' is far from revealing about the nature of these
artists' aims. It is likely, how-ever, that it was their very lack of
unity that prevented the emergence of a different label that would
have applied to them collectively.

The Nabis appeared at the end of the 1880s under the influence of
the Impressionists on the one hand, and Gauguin and the Symbolists
on the other. They were bound more by friendship than by creative
or ideological ties. Denis, Roussel and Vuillard had all been to school
together, while Denis, Bonnard and Vuillard had at one stage com-
bined their meagre resources to rent a communal studio. The latter
two shared a particularly deep personal friendship. In the overall
history of art, the Nabis did not play as significant a role as such
artists as Degas, Monet, Cézanne, Van Gogh or Gauguin. Theirs
were not revolutionary pursuits: they saw their main aim as the

development of the achievements of their illustrious predecessors.
From the very beginning two distinct trends emerged within the
Nabis group. The first contained Sérusier and Maurice Denis, who
enthusiastically painted religious pictures and might be said to have
lived up to their self-given sobriquet of 'prophets'. The artists in the
second group were not noted for their evangelical zeal. But there was
always an element of friendly humour in this small group's use of the
word 'Nabis'. They referred to Denis as the 'Nabis aux belles icônes'.

Denis was deeply religious from childhood. At the age of fifteen
he wrote in his diary: 'Yes, I must be a Christian painter, so that I
can glorify all the miracles of Christianity.'[39] The foundation of the
Ateliers d'Art Sacré in 1919, together with Denis joining the order of
the Franciscans, was the logical conclusion to his attempt to combine
religion and art, which had first emerged as a preoccupation in the
Nabis period. However, given the climate at the end of the nineteenth
century, Denis was too much of an artist to have remained simply
a servant of the Church. For it was the twenty-year-old Denis who,
writing under the pseudonym Pierre Louis in the journal _Art et
Critique_, coined the following pithy phrase, which would be quoted
decades later by artists of the avant-garde: 'Remember that a picture,
before it becomes a horse in battle, a nude or an anecdote of some
kind, is simply a flat surface covered with paints applied in a parti-
cular order.'[40] Later this thesis would be reformulated to reflect the
aesthetic programme of the whole Symbolist movement: 'Sounds,
colours and words have a wonderfully expressive value beyond any
representation, beyond even the literal meaning of words.'[41] When, at
the age of seventeen, he visited an exhibition of Puvis de Chavannes,
Denis was struck by 'the wonderful, calm and simple decorativeness
of his pictures' and the compositional techniques that 'produced a
sweet and mysterious impression on the soul'.[42] Puvis de Chavannes,

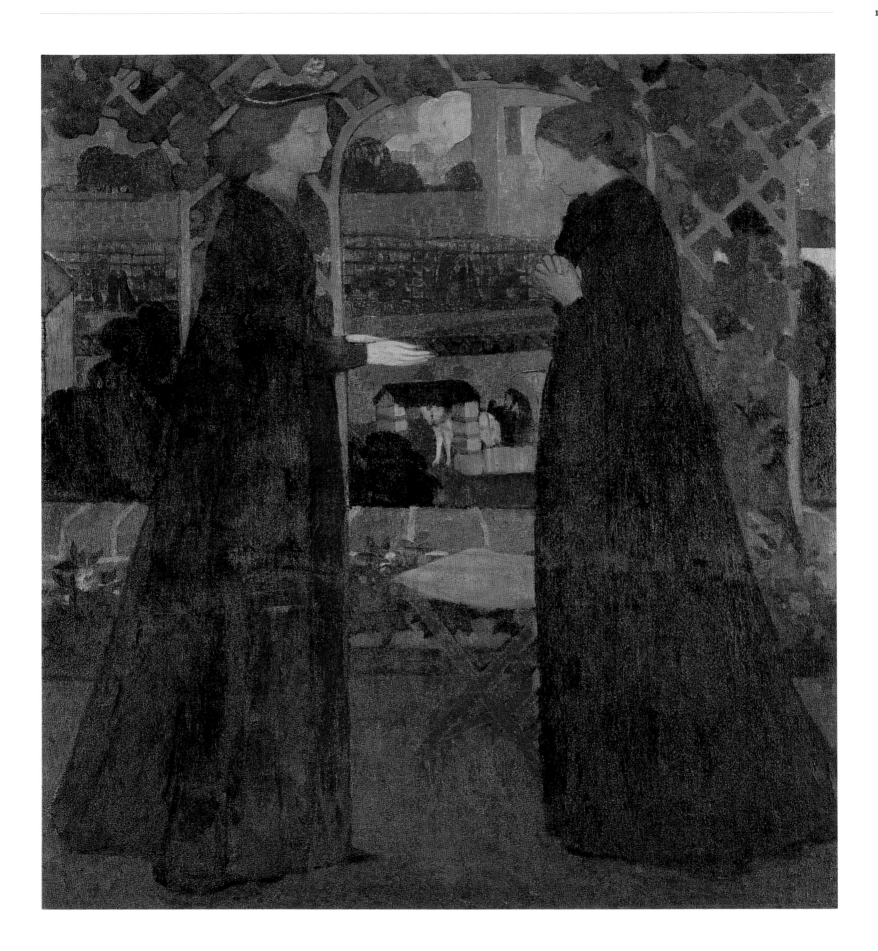

The Visitation, 1894, by Maurice Denis

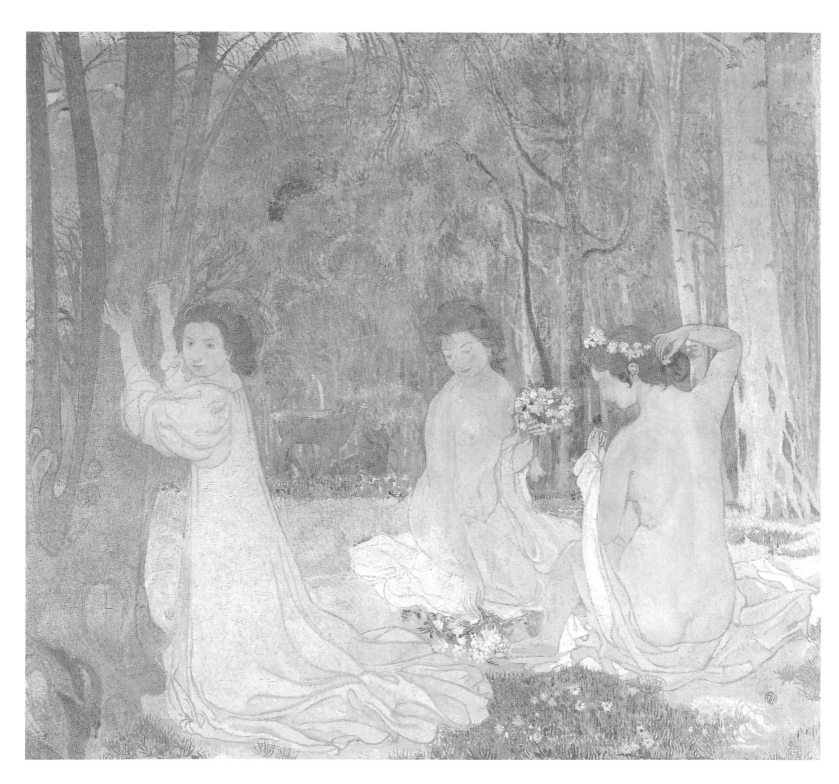

how Denis's remarkable talent for colour might have developed had he not subordinated it to theories of neo-traditionalism and rules governing the composition of pictures.

Denis's *Figures in a Spring Landscape (Sacred Grove)* became one of the most significant pictures to emerge in the Symbolist canon.

Its allegory, its elegantly mannered style and its intertwining of allusions puts it on a level with the poetry of the Symbolists. Although the painting contains much that is personal, the composition is governed by the Symbolist approach, which demands erudition and a willingness on the part of the reader to delve into nuances. In iconographic terms it is connected with the theme of

Right (top): **Study for Figures in a Spring Landscape (Sacred Grove)**, 1897, by Maurice Denis
Right (bottom): **Holy Spring at Guidel**, *c.* 1905, by Maurice Denis

199

the three graces, although the theme itself is resolved in a highly unusual way. Two of the women are presented naked, while the third, dressed in white, is separated from them. Paying no attention to her friends, she is carving the artist's signature on the tree – a feature which, of course, contains a playful element. Denis is presumably referring to the ancient custom of guessing the name of one's intended and carving it on a tree. The camomile flowers are also relevant to this guessing-game, while in ceremonies the wreath is often a symbol of fate. In several regions in France and Germany the approach of spring has, since ancient times, been symbolised by a girl in white – the 'May Rose'. The composition thus provides an intricate combination of motifs of spring, love and future blossoming. The pair of deer in the background is an embodiment of spring, renewal and growth (because of the yearly re-growing of the horns). The deer is a messenger of the gods and the sacred beast of Diana, while in ancient times Diana was considered the patron of girls preparing for marriage. The deer is also a symbol for hearing. In pagan times people would come to sacred groves to converse with the gods, hoping to hear the voice from on high; in this picture all three women seem to be listening out closely for something.

In comparison to *Wedding Procession* (page 192) or *The Visitation*, *Figures in a Spring Landscape* marks a departure from Denis's early, more two-dimensional style. This change was provoked by travels in Italy, when he began to feel the influence of Renaissance art. It is striking how many different influences are combined in *Figures in a Spring Landscape*: here you will find ancient tapestries, the Neo-Impressionists, Raphael and Puvis de Chavannes. The 'common denominator' in the canvas is the outline of the naked girls, echoed and repeated in the girl in the luxuriant dress, the white fabric with its intricate folds, and the outline of the trees. But the Gauguinesque technique of rhythmic repetition is here used with some adjustments. By simplifying his art, Denis was searching for a system of lines which would not simply outline areas of colour, but would themselves act in harmony with such colour, playing as it were in the same key. Thus the delicate intertwining of the fluid lines corresponds precisely to the colouring of the work with its pre-dominance of pinkish tones. Gauguin had no desire to please. Denis undoubtedly did have this desire, and here, once again, is revealed the feminine nature of his art. There was a difference between the Symbolist wing of the Nabis, to which Denis belonged along with Sérusier and Ranson, and the group containing Bonnard, Vuillard and Roussel, in that the former gave greater significance to the human figure and therefore attached more importance to drawing. With the onset of the twentieth century Denis became less and less successful in maintaining a balance between drawing and colour. His drawing was often stiff, while the colouring was 'raw' and florid.

In comparison to the best works of the 1890s or even *Holy Spring at Guidel*, Denis's picture *Bacchus and Ariadne* is much less organic. The nudes here are drawn in three dimensions, with well-defined musculature; this gives voice to the characteristic desire of the Nabis to instil new life into ancient legends and to modernise myth (a

similar aim can be seen in Bonnard's *Early Spring*). This time, however, Denis's attempt at modernisation appears a little mechanical. Ariadne lying on the rock is an echo of ancient museum sculptures, but the male and female bathers belong to an entirely different world, a world defined by the fashions of bourgeois society, which have nothing whatever to do with legend.

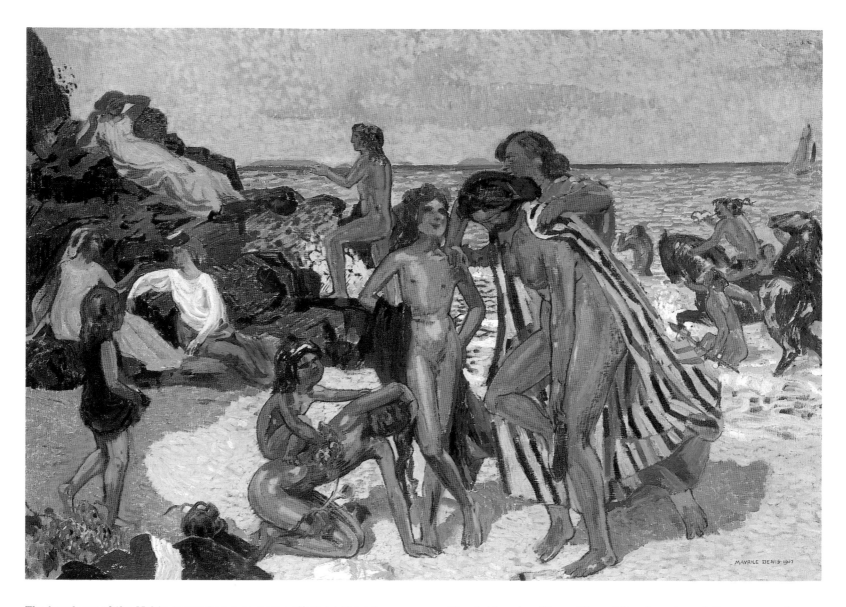

The break-up of the Nabis group had a negative effect on the art of the majority of its members. It is notable that the crisis first of all affected the Symbolist wing of the group. The artists who had concentrated on filling their works with symbols and metaphors, Christian teaching, the doctrine of theosophy or literary story-telling were poorly equipped to cope with working in a strictly pictorial sphere. This was not a question of lack of talent. Denis was highly gifted, but his stylistic meandering in the 1890s gave rise to doubts as to whether he had successfully chosen his artistic direction. Denis's pictures and murals create the impression less of painting than of colouring. His monumental decorative works for private residences, theatres, churches and public buildings, created over a period of almost fifty years, are many in number. But only rarely do they reach the heights of his finest easel works.

One that does is the *Story of Psyche*. This ensemble portrays several episodes from one of the stories in Apuleius's book *Metamorphoses*,

or *The Golden Ass*. The outline of the story is as follows: general admiration for the beautiful young Psyche has aroused the anger of Venus. Cupid, sent by Venus to make the young girl fall in love with a man of humble origins, is himself captivated by Psyche. With the help of Zephyr he hides Psyche in his palace. Goaded on by her evil elder sisters, Psyche breaks her promise never to look on the face of her secret lover and lights a lamp, accidentally pouring drops of burning oil on Cupid's shoulder. Doomed to wander after Cupid's disappearance, Psyche is set various trials to overcome. When she receives a box from Proserpina as a gift for Venus, she disobeys her and opens it, only to become a victim of the subterranean sleep that escapes from the box. The story ends happily: Cupid hurries to help her, brings Psyche out of her sleep and, having received Jupiter's consent, marries her.

Apuleius's tale is as much a fairy-story as it is an allegory about how the soul (Psyche) strives to be united with love (Cupid). It is this

Cupid in Flight is Struck by the Beauty of Psyche (first panel of the *Story of Psyche*), 1908, by Maurice Denis

Below: **Zephyr Carries Psyche to the Island of Bliss** (second panel of the *Story of Psyche*), 1908, by Maurice Denis; right: **Psyche Discovers that Her Secret Lover is Cupid** (third panel of the *Story of Psyche*), 1908, by Maurice Denis

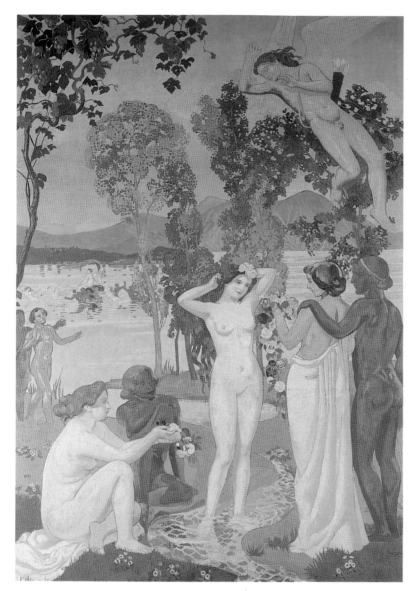

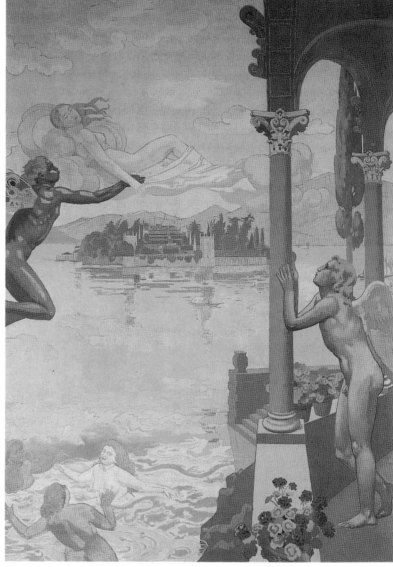

second aspect, already portrayed by the humanists of the Renaissance, which attracted Denis. For it was the personification of the human soul, as presented by the Ancient Greeks, rather than the sensual temptations of the subject matter, which the artist saw in Psyche. Quite consciously, he set his interpretation alongside the older treatments of the theme (Raphael, Giulio Romano, Rubens). He avoided the story's more dramatic moments, leaving out the episodes with the sisters and Psyche's trials that followed the night when she first recognised Cupid.

The *Story of Psyche* became an eloquent expression of the aims of Art Nouveau. This style, which began to flourish at the turn of the century, pursued the ideals explored in this monumental decorative ensemble. It appeared that everything – from architecture to jewellery – could be expressed through the serpentine lines of a style that embodied the dream of synthesis and, at the same time, aspired

tenaciously to the ideal of elegance. The thirteen panels and the elegant ceramic vases and furniture based upon the same principles and designed from sketches by Denis complemented each other magnificently in the Moscow mansion of Ivan Morozov.

The most important elements in the ensemble – in terms of both meaning and artistic merit – were the five large-scale panels that revealed the subject of the work. Unity of format, figures on the same scale, an identical degree of two-dimensionality as well as areas of colour echoing one another – all these simple but effective methods were employed by the artist to unify the different parts of the series. However, in Denis's decorative painting there are still moments of weakness, such as the stereotypical expressions on the characters' faces, the unremarkable garlands, bouquets of flowers and clouds. The combination of areas of blue and pink reveal as much about the scenes portrayed as they do of the decorative techniques typical of

The Vengeance of Venus: Psyche, Opening the Box of Dreams of the Underworld, Sinks into Sleep (fourth panel of the *Story of Psyche*), 1908, by Maurice Denis

In the Presence of the Gods, Jupiter Grants Psyche Immortality and Celebrates Her Marriage with Cupid (fifth panel of the *Story of Psyche*), 1908, by Maurice Denis

Art Nouveau as a whole. Denis worked according to established norms, and similar decorative elements can be seen in advertising posters and labels of the time, as well as in mass-printed art, where individuality was not an issue. The third panel, *Psyche Discovers that Her Secret Lover is Cupid*, is the most impressive. Here the bright pink colour of the naked body is transformed into the pinkish-ochre colour of the light of the lamp, and the whole composition achieves a unity, thanks to its dark background. The isolation of the centre makes the subject even more striking. The panel was done in the style of easel painting, proving once again that Denis's main achievements were in this field.

The idealised heavenly backgrounds in these panels of the *Story of Psyche* conjure up the Italy of tourists' dreams, seasoned with architectural fantasies. In a case such as this, where a concrete

motif is included in the picture alongside imaginary details, both are subordinated to the norms of decorative generalisation. Thus the cypresses lining the garden path in the fourth panel (the garden is actually the Giusti garden in Verona) are fused into an undispersed, two-dimensional area of colour. Any other resolution would ruin the flatness of the composition. Denis did not feel limited by the need to resolve purely decorative tasks, because he also wanted to introduce a symbolic content to the picture; nevertheless, the symbolic significance is primarily dictated by the success with which he was able to marry art and architecture.

Top: **Psyche's Parents Abandon Her on the Summit of the Mountain** (sixth panel of the *Story of Psyche*, commissioned by Ivan Morozov as an addition to the original five panels), 1909, by Maurice Denis

Bottom: **Cupid Carries Psyche to the Heavens** (seventh panel of the *Story of Psyche*, commissioned by Ivan Morozov as an addition to the original five panels), 1909, by Maurice Denis

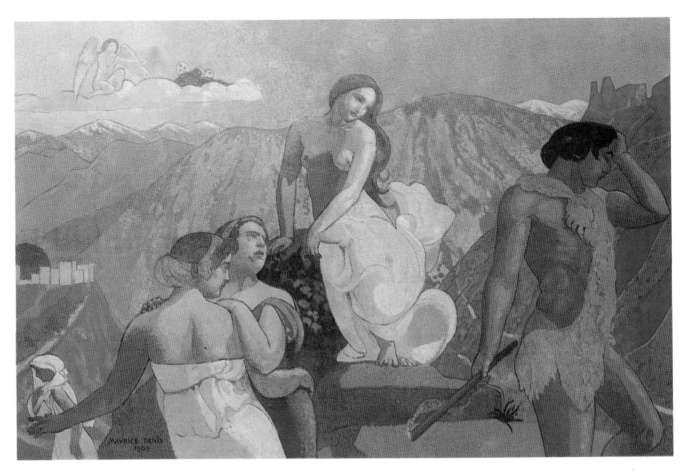

Pierre Bonnard: The Gift of Charm

The Nabis as a group did not outlive the nineteenth century, although most of them continued to work for another four decades. Between the nineteenth and twentieth centuries, their art underwent a number of relatively significant changes, not all of which could be considered positive. For the majority, their best years remained those when they had functioned as a group and attended regular meetings. Even as rare a talent as Vuillard's showed little development after 1900. Only Pierre Bonnard, indisputably the most talented artist among them, was successful in keeping pace with the times. He was to be among the small number of artists whose work provided a bridge from the nineteenth century to the twentieth. In character and in his art Bonnard was not the most flamboyant of artists. In a century of unrestrained innovation, his painting can sometimes seem too closely linked to tradition; but it would be quite wrong to talk of him simply as an imitator. Everything that Bonnard assimilated from his predecessors was absolutely appropriate to his character and gifts – his understated irony and rare sense of colour and arabesque.

Bonnard took his first independent steps in art at a time when a new wave of interest in Japanese art was sweeping through France. By comparing the pictures of Monet and Degas, Redon and Gauguin, or Seurat and Signac with prints from the land of the rising sun, art historians have discovered that frequently it was Japanese art that inspired developments in new French art. The techniques used in Japanese woodcuts were used to a greater or lesser extent by the entire Nabis group. Only one of them, however, was nicknamed the *Nabi Japonard* (sometimes even the *Nabi Très Japonard*), and that was Pierre Bonnard.

The Nabis movement began as an expression of Post-Impressionist reaction against Impressionism, and this is reflected in Bonnard's early career. In his early works, such as the small picture *Behind the Fence*, with its marked two-dimensionality and intricate interweaving of lines, he had absolutely no concern for the play of light, sense of airiness or the momentary impression. Deprived of all bright accents of colour, the picture is nevertheless extremely decorative. The effect is above all created by the diagonal transoms of the fence. As early as the beginning of the 1890s Bonnard often strove to include in his compositions right-angled intersections and checked patterns: normally this would be in a woman's dress, a scarf or a table-cloth. The talent of a natural decorator in a picture like *Behind the Fence* is revealed in the awareness with which the artist controls the tension of graphic flatness, skilfully alternating patches of checked design with calm, empty areas of the picture. Art historians sometimes see the checked patterns of Bonnard's early work as the early indications of Japanese influence, and certainly something similar can be found in Japanese prints. This artist, however, was not concerned with mechanical imitation; he came alight whenever he found a motif in nature that pleased him.

What is so remarkable about this image of a small corner of a Parisian suburb? The subject is not particularly diverting, nor is the draughtsmanship delicate. There are some banal brown houses, the black trunks of winter trees, a monotonous fence almost hiding the solitary figure of a woman. Only the white patches of freshly fallen but already melting snow bring a touch of life to this unremarkable landscape. Has the woman come out to call in her playing child as dusk falls? Her dress is hardly suitable for a long walk in such weather. But as you look at the picture, you do not really notice the subject. The painting is too generalised, too imprecise, for us to read anything into the face of the woman. More importantly, the artist does not even insist on the subject of the scene. The composition of the picture is immediately perceived as a unified pattern, where the details, as they become part of the design, seem somehow to break up and fade away, like the feathers of a quail.

Bonnard soon changed his reference points, gradually drifting towards the Impressionists. He became very close to Degas. In 1898 he received this letter from Renoir: 'You have the gift of charm. Do not neglect it. You will meet artists stronger than you, but your gift is precious.'[44] Having settled in Vernon, Bonnard befriended Claude Monet, for only a few kilometres separated his house from Monet's residence at Giverny. At the turn of the century, not only did Bonnard cease to reject Impressionism; he began to embrace its techniques and apply them more and more widely. It was to Impressionism that Bonnard owed the themes of his canvases, their pictorial freedom, the absence once and for all of any elements of forced composition and the spirit of a joyful and brilliant perception of nature. He was indeed quite justified in calling himself, in a conversation with Matisse, the last Impressionist.

In comparison to the early works, *Landscape in Dauphiné* is not so preoccupied with decorative effects. There is none of the former two-dimensionality. The space in the picture is given considerable depth, while the foreground is Impressionist in style, although the work is

not a hymn to colour in the manner of a painting by Monet or Pissarro. Alongside their landscapes, this picture looks extremely subdued. It does not immediately attract the attention and might well have hung unnoticed at an exhibition. It takes time to appreciate the beauty of these muddy-green colours. The precisely captured tones convey a somewhat prosaic view of nature, almost as if seen through the eyes of a peasant. Here we are not talking of a kind of peasant aesthetic norm – for such a landscape could hardly have held any attraction for local peasants – but of a psychological sense of place. In a distinct way Bonnard conveys a perception of the landscape through the characters in his picture, as they make their way to work on a foul autumn day. Similarly, in the

painting *A Corner of Paris* the centre of the composition is occupied by a group of children, and through the multi-coloured posters on the wall the artist brings to this corner of a major city something of the spontaneity of the inquisitive children being led out for their walk. The notes of humour evident in such pictures disappear in the unpopulated landscapes, like *The Seine near Vernon*. Bonnard's pure landscapes are not only more lyrical; they are also less decorative.

The years that separated *A Corner of Paris* and *The Seine near Vernon* were marked by the emergence of the Fauves. Amidst their trumpet calls to the public and critics alike it became difficult for the softer melodies

Right (top): **The Seine near Vernon**, *c.* 1911, by Pierre Bonnard
Right (bottom): **Study of a Nude**, *c.* 1906, by Pierre Bonnard

209

of Bonnard's art to be heard. Bonnard, however, did not remain
untouched by the influence of the bright colours of Matisse and the
artists of his circle. In comparison to *A Corner of Paris*, the Parisian
compositions executed for Ivan Morozov in 1911 revealed a different,
heightened colour register. Despite these influences, though, Bonnard
could never have become a follower of Matisse: his temperament was
different, and his talent had been nurtured under different conditions.
In order to resist the laconicism of Matisse and Picasso, who forced the
art world to recognise them as the arbiters of taste, Bonnard needed
more than just his characteristic inclination towards intimacy. He did
not believe that Impressionism had had its day. 'When my friends and I',
the artist said, 'decided to follow the Impressionists, trying to develop
their achievements, we endeavoured to overcome their naturalistic ideas
of colour. Art is not nature. We were more preoccupied with composition.
There was also much more that could be made of colour as a means of
expression. But the pace of change sped up and society was ready to
welcome Cubism and Surrealism before we had achieved our stated aims.
We were somehow left suspended in the air.'[45]

The problem at the heart of Bonnard's art is his relationship to
Impressionism, and this is most clearly revealed when he adopts the
same themes and compositions as his predecessors. Above all this applies
to landscapes in big cities. And for Bonnard the big city was always
Paris. In comparison to his early depictions of the French capital, like *A
Corner of Paris*, the paintings of the Morozov suite are notable for their
far more complex composition: they contain more people and are more
spacious; they are brighter and richer in colour. All these qualities bring
works like *Morning in Paris* and *Evening in Paris* close to the creations
of Monet, Renoir and Pissarro. Following in their footsteps, Bonnard
presents the streets of Paris as though each scene is an unexpectedly
observed spectacle, although of course this spontaneity is far more artful
than it would at first appear. Turning to motifs that were waiting for
him on his doorstep, the artist did not in fact paint the scenes immedi-
ately, but only after they had settled in his consciousness, having
filtered through his memory. And, of course, it should not be forgotten
that this was the memory of an artist. Having no aims to achieve a
literal recreation of the scenes, he discarded everything that was not
consonant with his own particular aesthetic, thus every single part of
the canvas became rich in terms of both composition and the wide range
of colouristic consonance. Both parts of the Morozov suite clearly reveal
a remarkable concern with composition, and in this Bonnard was closer
to Degas than to Monet or Pissarro. Furthermore he avoided precise
details in his depiction of the characters, rejecting sharp focus in favour
of a softer range of colour. The result is that the colours produce an
effect even before the viewer is aware of what specific 'object' is identi-
fied by a specific area of colour.

Bonnard's orchestration of colour is not arbitrary. In *Morning in
Paris* the blue and pink tones in the sky and the cold shades of the fore-
ground are caught with such precision that, even before the eye can
make out the early-morning bustle of the passers-by and the coal carts
making their daily dawn delivery, we can say exactly what hour of day
the artist is portraying. But when we are able to identify precisely what

the shades depict, they do not lose their charm; on the contrary, their charm only grows. The areas of colour only identify the objects – they do not belong to them completely. The different colours are quite autonomous, but their independence is justified by the beauty of the image they produce when brought together. And yet for all that, Bonnard's brushstrokes and use of colour are expressive and neat. Understatement does not harm the precision of the work, but helps it. The brushstroke that identifies the body and tail of the dog in *Morning in Paris* – not even the whole animal – is enough to convey its habits, as is also the case with the coalman's donkey, struggling to move its sliding legs forward as quickly as possible. The new century knew no animal painter who understood the character of creatures as well as Bonnard. And he also catches the movement of humans, their way of behaving, with astonishing insight. The old flower-seller in *Evening in Paris* moves as only she, an old flower-seller, could possibly move – unhurriedly counting each step, and the youth and spontaneity of the children playing around her are exquisitely captured. The details combine to give a sense of Paris's way of life. In *Morning in Paris* the foreground is given over to those who have to rise early: the old coalman, the girls hurrying to work, the small schoolboy who is not hurrying at all. In *Evening in Paris* there is a quite different, more

strolling rhythm to the movement. The first picture portrays a square, the crossing-point of several different journeys, while the second depicts a boulevard. One requires an openness of space, the other is more closed-in. For the morning picture it is important to show the dawn sky and the walls of houses lit by the first rays of the sun; when dusk descends, different details are required. 'What is beautiful in nature', said the artist, 'is not always what is beautiful in art, especially in reduction. For example: the effects of evening, of night.'[46]

The secret of Bonnard's pictures does not just lie in their depiction of people and objects in their most picturesque aspects; the harmonies of colour become a kind of hidden metaphor and are endowed with a more general significance. This is why Bonnard returned time and again to the same motifs, although of course he never straightforwardly repeated himself. For Bonnard, the path to beauty that 'can be found in every-thing' was a question of valuing the precious, and for Bonnard the most precious thing was colour with its own significant degree of autonomy. 'A picture', the artist believed, 'is an alternation of areas [of colour] which combine one with another and ultimately create an object in such a way that the eye glides over it without meeting any obstacles.'[47]

Bonnard liked to blur the boundaries between the conventionally decorative and the strictly representational. Thus, for example, in *Train and Barges*, individual details taken out of context might not enlighten us a great deal: the tree in the bottom right-hand corner is not immediately recognisable, nor is the vineyard. Recognition only comes when you have seen enough of the whole picture. The pictorial ensemble of tones somehow controls all the separate elements of the picture, and this is why Bonnard's art naturally led to understatement. Occasionally, this understatement can be explained by fleeting sensations received during a walk along a village footpath. You do not immediately notice the amusing little girl, and such a feature is entirely characteristic of Bonnard's work: he avoids looking at his characters straight on. The whole picture leads us into a system of parallels. Both pictorially and in terms of some inner meaning the little girl's head, the crowns of the trees, the smoke of the steamer and barges and the clouds are all united in a single chain. For all the convention of a quick sketch – indeed, perhaps because of it – the artist compels us to feel that we are part of what is going on. He does not look on from one side, but seems himself to be in the centre of the scene. This is also why the foreground appears more indistinct than what is behind it. Even here, in a panoramic landscape, Bonnard does not abandon his habitual sense of intimacy.

Bonnard's Parisian paintings bear the unmistakable stamp of his personality. There is even intimacy in his portrayals of the capital's bustling boulevards. The choice of motifs for the Morozov suite is particularly revealing. The artist is not attracted to a dazzling midday nor a human anthill, but to early morning and dusk with their particular lyricism. In both parts of the Parisian suite, in *Train and Barges* and in the triptych *On the Mediterranean*, the faces of the characters are portrayed a little out of focus. Bonnard admitted that he never allowed himself to become submerged entirely in reality. His paintings never became an illusion of an actual landscape; they never undergo that metamorphosis evident in the pictures of the Impressionists, when a precisely located, often distant viewing-point turns rapid and apparently carelessly applied brush-strokes into foliage rustling in the wind or a woman's luminous skin. However far away we move from one of Bonnard's pictures, the sense of the paint remains. The element of conventionality is retained in every situation, because it expresses the essence of the artist, his intellect and his mood. The imprecise outlines, floating texture and brushstrokes which can be explained neither by the vibration of air nor by an attempt to portray the outward appearance of an object – all these gain true meaning only as the constituent elements of an overall artistic structure, of a small independent world saturated in colour. For Bonnard colour

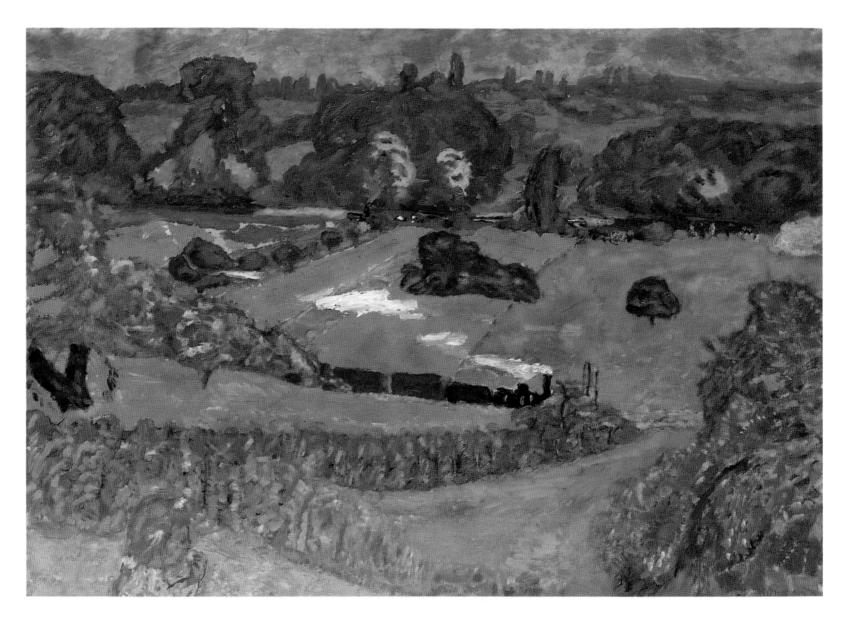

was more important than light. With his wonderful ability to capture the special light of Parisian evenings and the no less extraordinary light of early mornings, he was absolutely convinced that paint was in itself such a valuable material that it should never be used simply as a support, as a resource, even where the reproduction of light was concerned. The autonomy of paint that has become such a characteristic feature of twentieth-century art links Bonnard to Matisse, to Picasso and to Léger.

Because colour was so autonomous in Bonnard's painting, the problems of composition became extremely important for him. Monet and Pissarro were able to paint one and the same motif over and over again, without even changing the viewpoint. This method did not suit Bonnard. Among the approximately 2,000 pictures that he painted no two are identical. The compositional foundations of his art are perhaps less obvious than those of Vuillard, but they are no less strong. This is revealed by a consideration of the two parts of the Parisian suite, at first separately and

then together. Although *Evening in Paris* lacks the depth of spatial structure of *Morning*, each composition provides a wonderful counterbalance to the other. Thus the woman in the right part of *Morning* corresponds to the old flower-seller in *Evening*, while the girls moving straight towards the viewer in one correspond to the children in the other. The sense of movement across the surface of the canvas also serves as a unifying factor between the two pictures.

Train and Barges, *Early Spring (Little Fauns)*, *Morning in Paris* and other paintings by Bonnard convey the artist's quiet voice, his unique lyricism and his seductive mischievousness. With typical spontaneity Bonnard introduces little fauns into *Early Spring* – characters which would have been unthinkable for the Impressionists. These little creatures are enchanting, with their cheeks swelling as they play on the reed pipes. We do not immediately notice their goats' legs, but as soon as we do, we quickly accept them as part of this real, contemporary

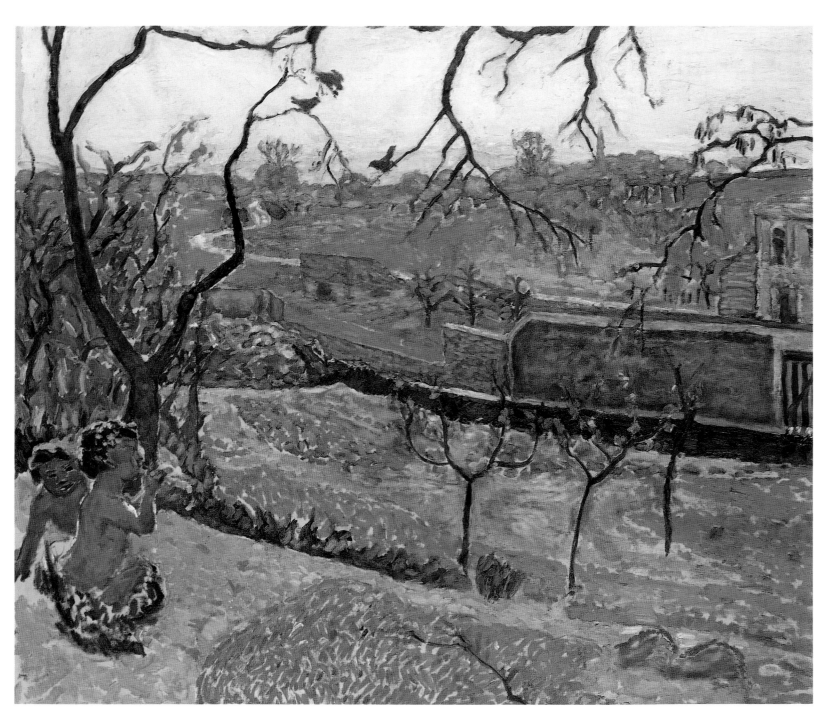

Early Spring (Little Fauns), 1909, by Pierre Bonnard

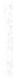

corner of the Ile-de-France. It is not a scene of unbounded beauty, but a pleasant landscape, conveyed as if to the accompaniment of the silvery, caressing sound of music. A friend and schoolfellow of the Symbolists, Bonnard used the techniques of their poetic style, but at the same time he liked to mock them gently. Here, he imparts a dual meaning to the fauns; it is difficult to say whether in this painting there is more humour or joy at the awakening of nature. But this is precisely why, with its blend of poetic joy and an ironic humour, this picture of the outskirts of Paris becomes an embodiment of the mythical 'Golden Age'.

Although Bonnard's paintings always had a structural 'carcass' (the artist's own word) and a truly harmonic balance, the chance nature of momentarily snatched compositions and the liveliness of texture are characteristic features of Bonnard's easel works. It might seem that he lacked the necessary qualities of the large-scale artist, although his efforts in monumental decorative art are amongst the greatest achievements in the field. All the Nabis paid particular attention to this area of activity, but it was Bonnard – whose painting was free of that deliberate solemnity which mural paintings generally seem to require, and whose

Left: **The Triumph of Bacchus (Fête Champêtre)**, 1911–13, by Ker-Xavier Roussel
Right: **Mythological Subject**, c. 1903, by Ker-Xavier Roussel

217

Roussel and Vuillard

The two school friends Ker-Xavier Roussel and Edouard Vuillard began their careers in art in a similar fashion. Later, although they maintained the close ties of friendship, their views of painting came to differ radically. Both studied under the academician Diogène Maillart, laureate of the Prix de Rome. After the divorce of his parents, Roussel took refuge with Vuillard's family, and later married his sister. In comparison to Vuillard, Roussel was more susceptible to outside influences, and his work clearly owes much to the Japanese and to Puvis de Chavannes. The first years of the twentieth century were the defining moments in the development of his style. The artist's literary interests played a decisive role in establishing his thematic repertoire. In his youth he was rarely without his copy of Virgil, and many of his canvases appear to be based on the Ancient Roman poet's *Bucolics*. Among his contemporaries he admired Mallarmé most of all, particularly *L'Après-Midi d'un Faune*. When Roussel was teaching at the Académie Ranson he would read Mallarmé's verses during lessons, believing that they would stimulate the imagination better than any debates or lectures. Nymphs, fauns, Bacchanalian revels, pastoral idylls – these are the principal motifs in Roussel's art.

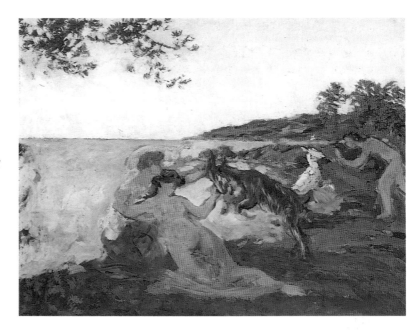

Roussel strove to create a modern equivalent of the historical landscape; not lifeless and sickly-sweet like the attempts by Salon artists, but energetic and truly artistic. In this respect he shared Cézanne's admiration for Poussin. The heady combination of mythology and modernity that he found in Cross's works also appealed to him. In March 1898 Denis wrote in his diary: 'Roussel says that it would be interesting to know what led Poussin to modify his sketches, which are very beautiful, into pictures that are quite unlike the sketches.'[49] The main reason for such modification was that the idea behind each work did not find its ideal expression immediately, but only after the final 'minting', when the sketch was turned into a painting. Unlike the pioneers of new art, who despised the viewing public, the Old Masters based their creations on the need to be understood by people who commissioned art and by their fellow artists. For Poussin, however, true spontaneity of drawing and colour was not just crucial; it was the sole condition of the artistic act.

The spontaneity of the sketch was important to artists at the end of the nineteenth century: Roussel's *Mythological Subject* is notable for its sketch-like technique. It is true that when he turned to large-scale compositions, in particular monumental decorative works, he had to come to terms with the postulates of the art of the Old Masters; however, he never fully embraced them. The need for creative spontaneity explains Roussel's tendency to repaint his finished works, something that certainly did not always improve them. At the same time, however, it may be that it was precisely Roussel's individualism and his fiery nature (in his political views he leant towards anarchism) that saved him from becoming stiltedly stylised, something he never succumbed to, even in his compositions based on antiquity. By the 1890s he was already painting landscapes with half-nude and nude figures, where the boundary between contemporary rural idylls and mythical idylls is almost imperceptible. Roussel's pastorals are not incorporeal fantasies. The landscape of France is revealed in them; they are real and contain notes of humour.

Edouard Vuillard's creative wisdom consisted in an awareness of his own limitations: he concentrated on a grasp of nature, on those little noticed, intimate examples of nature to which he was always strongly attached. The joy of the family home, the unhurried flow of domestic life – his art was satisfied by this alone. Vuillard's work was always dedicated to tranquillity, but the perceptive Signac saw in him 'a delicate and intelligent boy, and a nervous and enquiring artist'. 'He showed me his works from various periods, the explorations he had made. There was a great deal of charm in his small sketches of interiors. He has a wonderful grasp of the voice of things. His pictures are the work of a good painter, and in their muffled polychromy there is always a splash of bright colour which establishes the harmony of the work. The contrast of tones and the skilfully distributed chiaroscuro balance variations in colour, which, for all their dullness and greyness, are always so refined as to be almost painful.'[50]

At the very time these lines were written, Vuillard himself wrote to Maurice Denis: 'I have a fear, or rather an absolute horror, of general ideas which are not my own; although I do not deny their worth, I would rather an act of humility than to ape comprehension.'[51] With his mistrust of current tenets and fashionable theories, Vuillard recognised only those ideas which he personally had conceived. In the same letter he writes that if a work brought him pleasure it was only because it contained an idea in which he himself believed. However, he never made declarations concerning his own ideas. Like Bonnard, he had no love of publicity and on more than one occasion said 'silence protects me'.[52]

A descendant of the Impressionists with their pursuit of painting *en plein air*, Vuillard, on the contrary, preferred the limited space of rooms. He had a rare gift for colour, which led him to rich and untapped resources in areas where they had often hitherto been ignored – in measured, unpretentious everyday life, in the trivialities of existence.

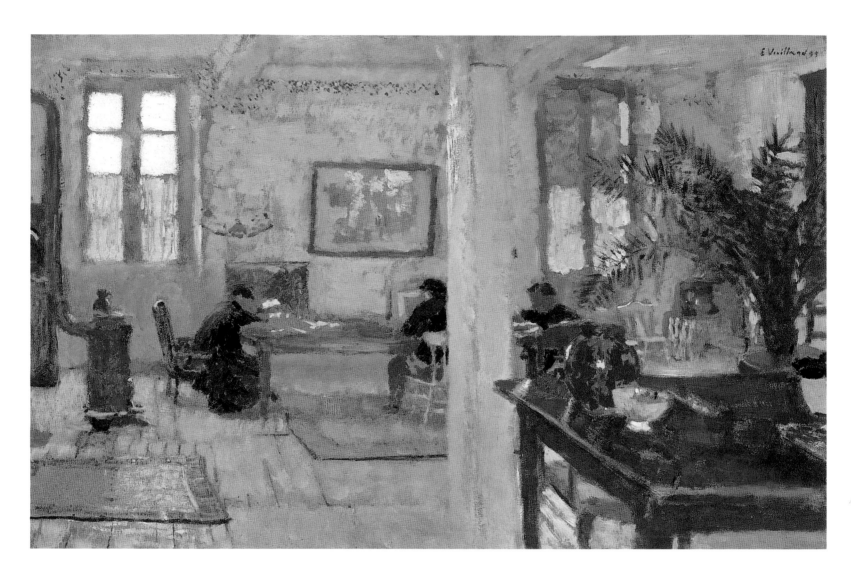

The interior, however, did not in itself engage the artist, but held an attraction because it was a setting for human life. At the same time, the people that appear in his pictures and introduce a lively note into the compositions are rarely actual characters.

Thus in the picture *In the Room*, the human figures are inextricably linked with their surroundings, with the background, and almost blend into it. The artist has not omitted a single detail, and as we look closely we see not just tables and chairs, but also more insignificant objects like vases. We can imagine that Vuillard has simply included everything within his field of vision, quite unembarrassed by the lack of beauty or artistic merit of the objects that make up the scene, like the black iron stove with its pipe. The 'inelegance' of the wastepaper basket is irrelevant, because the materiality of the objects has been erased and is entirely subjugated to the artistic aim. Objects almost seem to dissolve, turning into patches of deadened colour, and yet they still do not disappear from view. Vuillard, like no one else, felt the beauty of muffled tones, which corresponded perfectly to the silence of his interiors. Like all the Nabis, Vuillard attached enormous importance to the decorative

qualities of colour, and like Bonnard he was able to combine them with a special intimacy of construction. Even their contemporaries noticed the similarities between their gentle colours and the music of Debussy. Their interest in subtle nuances and melting half-tones combined an Impressionist love of real motifs with a fascination with the mysterious, which became a marked feature of end-of-the-century art. Most evident in Symbolism, it also touched artists to whom Symbolism was alien.

For all the softness and delicacy of his art, Vuillard did not for a minute ignore the architectonics of his compositions, and in this he differed from the other Nabis. In *Children*, the structural basis of the work – the carcass – is clearly revealed, formed out of the combination of the straight lines of the architecture and furniture. Here the artist has chosen a viewpoint such that the screen, balcony, door and carpet form a kind of geometrical structure, encasing and connecting the areas of colour. And it is all done with such a lack of affectation that the thought of any special compositional re-arranging simply does not arise. Such a picture, in Jacques-Emile Blanche's apt phrase, reveals a 'gourmand turned ascetic'.[53] Vuillard boldly introduced empty spaces into the

Children, *c.* 1909, by Edouard Vuillard

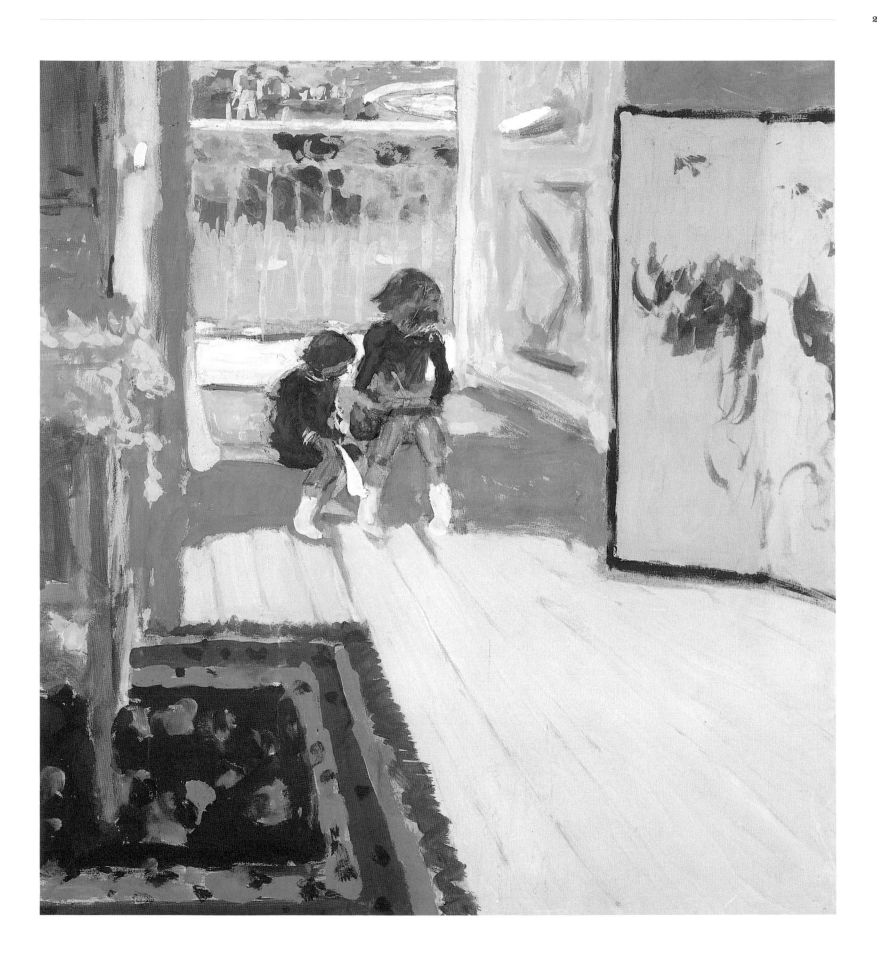

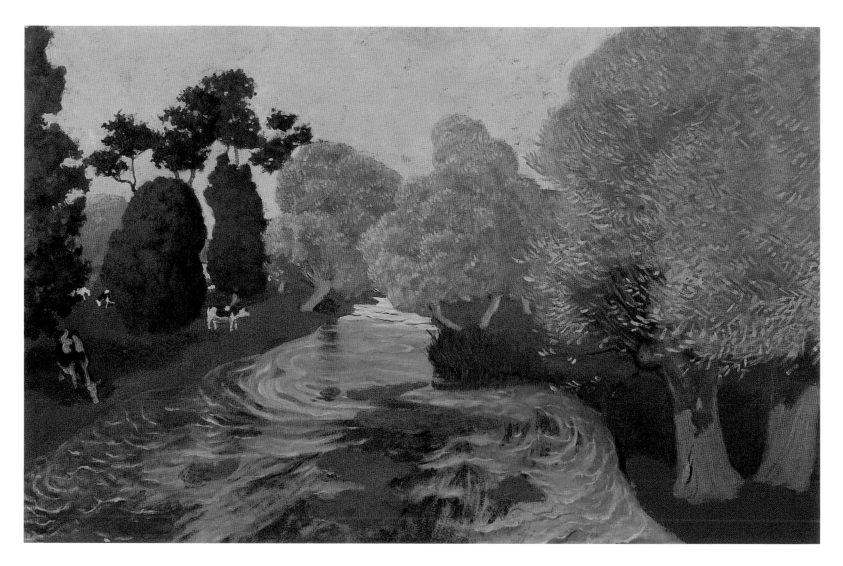

composition, making them an essential condition of the structural soundness of the work. Nearly a third of the whole picture, and almost the entire foreground, is given over to the pale area of the floor. By using to such good effect the contrast between empty, light spaces and details rich in colour and tone, Vuillard was able to give his art an inner significance. In order to create a rich decorative whole, he had no need of special or exotic themes. His theme was always before his very eyes – usually in the life of his family or those close to him.

Félix Vallotton: 'Nabi Etranger'

A native of Lausanne, nicknamed the 'Nabi Etranger' by the other members of the group, Félix Vallotton differed from the other Nabis not only because of his foreign origins, but also because stylistically he was quite unlike them, to the extent that some art historians consider him to have been only a nominal member of the group.[54] Nevertheless, the fact that the Nabis themselves – albeit not immediately – allowed him to join their circle means that there must have been some grounds for his inclusion.

Vallotton's art has an inherent intimacy of its own, although it has none of the sentimental tenderness of Denis or the joyful poetry of Bonnard. Both the formal qualities of his pictures and their construction, their harshness and astringent aridity – almost always a feature of his work – make Vallotton a special case not only in the context of the Nabis, but also amongst his other contemporaries. His marked objectivity, the concentrated impartiality of his view, expressed in scrupulously exact, almost academic drawing and an impersonal style, are characteristics that link him not only to the naturalists of the nineteenth century, but also to movements in the following century.

All the Nabis were noted for the artistic maturity of their works, even the earlier ones. Vallotton's style established itself very early on and changed little thereafter. When he moved to Paris at the age of seventeen, he had to pursue other work: in restoration, in print reproduction, drawing for fashion magazines and various types of humorous publications. He gained recognition for his woodcuts, carried out in a bold and generalised manner, without any half-tones. At the age of twenty his paintings, exhibited in the Salon, began to attract attention. Not

only then, however, but later, too, the more advanced artists who were struggling for the emancipation of colour and brushstroke considered his style retrogressive. 'Vallotton's pictures are as anti-painting as could be,' wrote Signac in his diary. 'He thinks that he is following Holbein and Ingres by being dry and precise, but in fact he is only reminiscent of the worst pupils of Bouguereau. It is ugly and stupid. And yet Vallotton certainly has a sense of what is beautiful and he is intelligent, too: his engravings on wood prove it.'[55]

On first inspection, Vallotton's paintings and woodcuts appear to be the work of two different artists. The paintings are more detailed. Only the essential features remain in the woodcuts, and everything that is secondary is swallowed up in blackness. The two media do, however, have some things in common. There is the uncompromising precision of the drawing. There are also the decorative and generalising qualities of line, which, in the words of the eminent critic of the turn of the century, Jacques Rivière, 'lasso' the form. Furthermore, the colour, like the black areas of the woodcuts, is divided up across the painting in broad zones, while at the edge of these zones the brushstroke – the basic measure and unit of artistic activity – is weakly expressed. For Signac, who had no time for smooth planes and whose surfaces 'erupted' with separate brushstrokes, Vallotton's work seemed entirely in opposition to his own style and to everything that stemmed from the Impressionists. But the young Swiss, arriving in Paris when the Impressionists were still struggling for recognition, did not know them or did not want to. And it was not because he was in thrall to the lessons of Jules Lefebvre or William Bouguereau at the Académie Julian; it was because he preferred to go to the Louvre, where he copied the works of Antonello da Messina, Leonardo or Dürer.

The basis of Vallotton's painting is most clearly revealed in his interiors, which are pure, rigid still lifes in the strict sense of the term. The people who inhabit these still life interiors are portrayed with the same impartiality as are objects like cupboards or beds. Behind the hypnotic list of objects, this inventory of life at the beginning of the twentieth century, lies a hidden melancholy which verges on the indifference of the fatalist. And it is clear that rather than portraying the lives of unknown people, Vallotton is depicting his own, as well as those of his friends and acquaintances. The series of interiors of the artist's Parisian flat was conceived as a contemporary version of the compositions of de Hooch or Janssens. Authorial irony, however, prevents the glow that warmed the Dutch pictures of the seventeenth century from penetrating here. Jean Cassou saw one of the main features of Vallotton's personality as his 'bourgeois anarchism', which was most clearly and harshly expressed in his literary works. What Cassou wrote about Vallotton's novels applies equally well to his interiors and to many of his other compositions: 'The novels certainly give us the key. We sense an ambivalent attitude: on the one hand, a caustic and querulous fury against the miserable, ridiculous and reactionary bourgeois society, and on the other a no less reactionary satisfaction at being part of it.'[56]

Sarcasm is most usually allied to the human. In his pictures of nature Vallotton is revealed in a different light. Here he is more recognisably

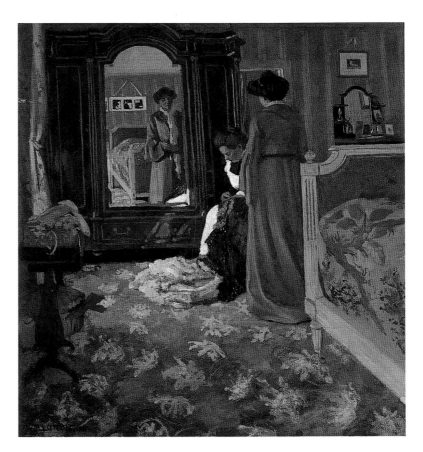

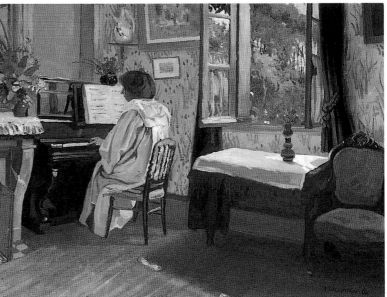

a Nabi, coming close to the other members of the group in terms of both decorativeness and stylistic allusion. Even in this genre, however, Vallotton preserves a certain sense of looking in from the outside. There is something playful in his Normandy landscape *Arcques-la-Bataille*, one of the artist's finest works of the genre; the style almost suggests that the artist approached it as a game. It is as if Vallotton

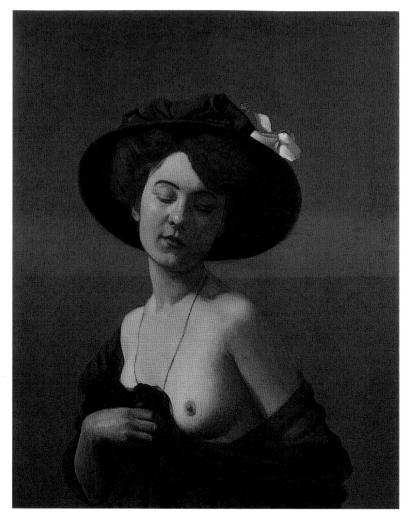

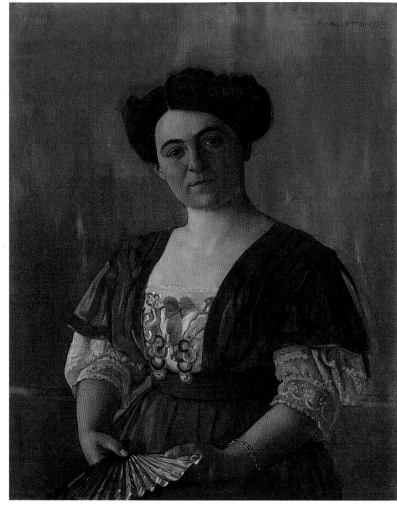

remembers that he knows Japanese art but, stylising, he prefers to remain a European, simply adding a certain Japanese flavouring. Here it is worth recalling Gauguin, whom all the Nabis admired. His *Wave* (1888; W.G. 286) was very popular among them and gave rise to several imitations. Vallotton, what is more, made use of Cézanne's *perspective plongeante*, where the foreground, as opposed to the background, is dramatically foreshortened; the spirit of Cézanne's landscapes, however, remained alien to him. Vallotton's diminutive cows could not have grazed there; they needed comfortable, cultivated nature. Amongst representatives of professional, but not Salon, art, Vallotton was that rare example of an artist who did not shun well-worn, almost peasant, motifs, although it is true that he managed to dispense with the shepherds beloved of tradition. He avoided neither consciously 'poetic' scenes, like the rosy dawn, nor old-fashioned compositional schemes with a separate middle ground; in this respect *Arcques-la-Bataille* is closer to the work of the Barbizon artists.

From a young age Vallotton was a frequent visitor to museums and exhibitions, and he was able to borrow an intonation heard here, a gesture seen there, a word or a technique. This was not for pure

imitation – for otherwise there would not be the note of parody in his canvases and engravings – but as a means of self-expression. When he played with a borrowed technique, Vallotton was not afraid to appear backward and thus amusing. A sharp sense of modernity could transform an outdated technique. *Young Woman in a Black Hat* is undoubtedly a parody, with its fusion of the apparently incompatible: the effective turn of the body of a half-naked figure, the elegant hat with flowers – and the dull everyday face. The view of the artist appears to be dispassionate, and yet something personal seems to shine through in his relations with the woman. Annette Vaillant recalled how beneath his Calvinist exterior Vallotton concealed a strange, Ingresque sensuality.[57] Intimacy, however, is extinguished by an ironic smile. This is noticeable even in the palette, which is limited and obviously making fun of the colour range of the hack-portraitists of the Salon.

In his portraits of M. and Mme Haasen, Vallotton himself becomes a society, even official, portraitist, proving himself well capable of fulfilling that role. The dispassionate approach of the artist is almost akin to that of the photographer. Is it because the portraits were

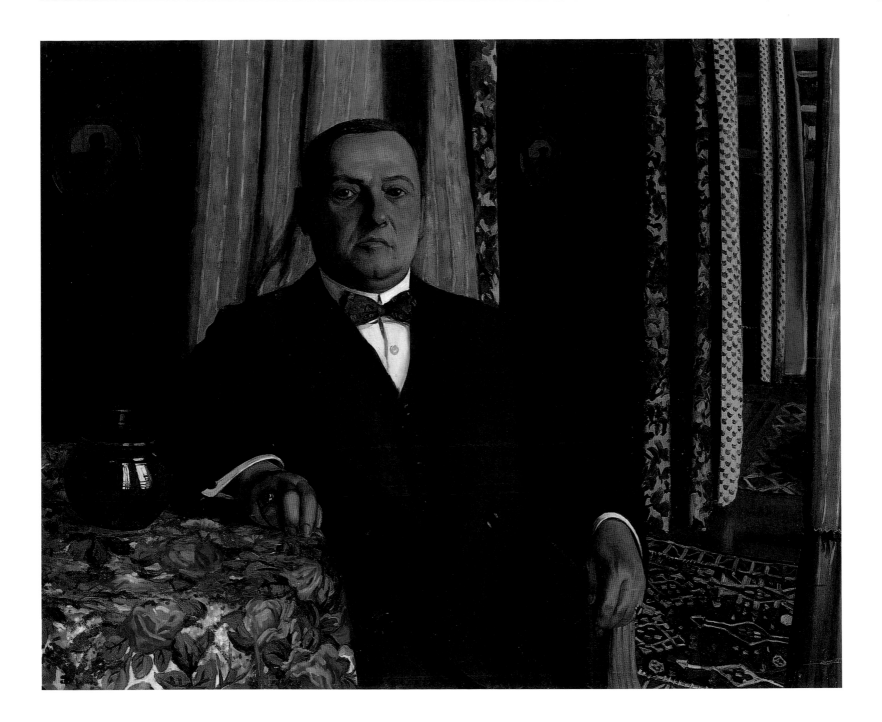

commissioned? It seems that Vallotton seeks nothing more than the achievement of a superficial likeness, and he does not allow a single movement of his brush to express his attitude towards the model. With good reason, therefore, from an artistic point of view, the background details to the Haasen portrait are more interesting than the subject himself.

Nevertheless, these commissioned portraits are not quite as simple as they might appear. When Vallotton painted a portrait of Gertrude Stein in 1907 (Baltimore, Museum of Art), Vuillard could not resist joking:

'Yes, it's Madame Bertin all right', suggesting that the 'Nabi Etranger' had used Ingres's *Portrait of Louis-François Bertin* as a model (1832; Paris, Louvre). Vallotton also used the formula of Ingres's celebrated picture in his *Portrait of G. E. Haasen*, and, with a few adjustments, in *Portrait of Mme Haasen*. The disarming directness of style and the lack of restraint, unusual for the Nabis, compels us to look for other parallels. One of these was identified by Apollinaire, who wrote that Vallotton 'pretends to draw his inspiration from Ingres, while, in fact, he imitates one of the most astonishing of modern painters... the Douanier Rousseau.'[58]

Bust of a Man (Self-Portrait), *c.* 1905, by Louis Anquetin

Louis Anquetin was one of those artists of the middle ground, having
no desire to be conscripted forever into one particular movement. He
was blessed with an enviable sureness of touch. Van Gogh constantly
enquired in his letters after what this artist was doing, and consciously
compared his own work with Anquetin's. It might appear that the
admiration of Van Gogh and Toulouse-Lautrec would be enough to
ensure Anquetin an honoured place in the history of art, but this has
not been the case. Signac, perhaps, was right when he observed that a
truly original artist would have created miracles with one tenth of
Anquetin's talent.[61] At the end of the 1890s Anquetin was on the crest
of a wave, having become, with Emile Bernard, one of the founders of
Cloisonnism. He crossed so easily from style to style, however – from
Impressionism to Divisionism and then Synthetism, from an interest in
Delacroix to Japanese art and thence to Edouard Manet and later the Old
Masters – that he did not really leave his mark anywhere. If Anquetin's
life had ended in the early 1890s, then he might perhaps have been
remembered as a talented and promising artist. Instead he lost faith in

Impressionism and Symbolism, and turned to the Old Masters for
inspiration. As a result he withdrew from the battle of ideas that
defined the perceptions of life of the Parisian art-going public, and
consigned himself to oblivion.

The middle ground was particularly heavily populated at the turn of
the century. Salon–Academic art no longer enjoyed the popularity of
two or three decades earlier, nor the advantages of repressive measures,
since it had lost its monopoly over the right to exhibit works. It should
be remembered that it was precisely this struggle against the monopoly
of the Salon that gave rise to the Impressionist movement. One of the
reasons that their exhibitions came to an end was the emergence of new,
more liberal salons.[62] And those who inhabited the middle ground were
thus able to choose not only their style, but also their exhibition space.
Their paths sometimes crossed the followers of Puvis de Chavannes or
Gauguin, and sometimes artists who were searching for contemporary
democratic themes. In the main, however, the artists of the middle
ground sought acceptance by the enlightened art-going public; as a
result they turned not to the Salon des Artistes Français, where the
academicians still held sway, but to the newly re-established Société
Nationale des Beaux-Arts. These artists were constantly trying to keep
abreast of new movements, but while allowing themselves a measure
of extravagance from time to time, they had a tendency to avoid too
much experimentation.

In the middle of the 1890s a number of artists emerged from this group,
descendants of the Realists and the Naturalists, who strove to broaden
the boundaries of their creativity by the introduction of decorative
elements. It was at this time that Charles Cottet came to general notice
for his social topicality and dramatic intonation, which can be seen even
in his views of Venice. Strictly speaking these are not views at all: the
city's celebrated architectural wonders can only just be distinguished,
becoming secondary topographical marks in the context of the natural
elements. Cottet's landscapes are in their own way theatrical decorations.
When painting these works, Cottet was sometimes better known than
the Nabis, who rated his decorative skills very highly. In Vallotton's
large canvas *Five Painters* (1902–3; Winterthur, Kunstmuseum), the
artist portrays Bonnard, Vuillard and Roussel alongside himself, while
the place of honour in the centre of the picture is given to their esteemed
guest, Cottet. Of course, this was partly explained by Vallotton's
attempts to disassociate himself from the Idealist–Symbolist wing of the
Nabis, whose representatives he quite deliberately excluded from this
group portrait; nevertheless, the inclusion of Cottet in the company of
the leading artists of the Nabis group and the designation of this picture
as 'decorative' by the artist himself indicates that Vallotton felt he had
much in common with Cottet.

Along with Cottet, Lucien Simon was a member of the so-called Bande
Noire, a group of artists preoccupied with dark tones. Of course, not
every work of Simon's is executed in sombre tones; far from it. In his
watercolour *The Artist's Children*, the black and dark grey tones are
introduced only to highlight the bravura of the bright colours in the
work. Benois, who called Cottet and Simon two of the most prominent

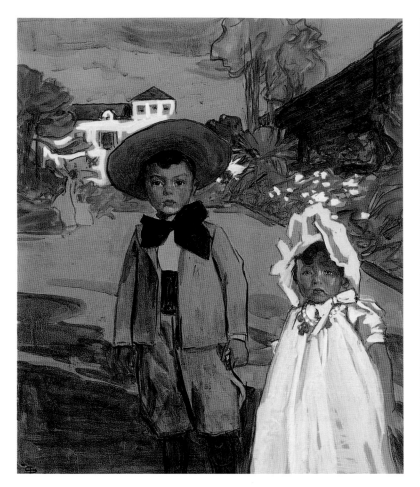

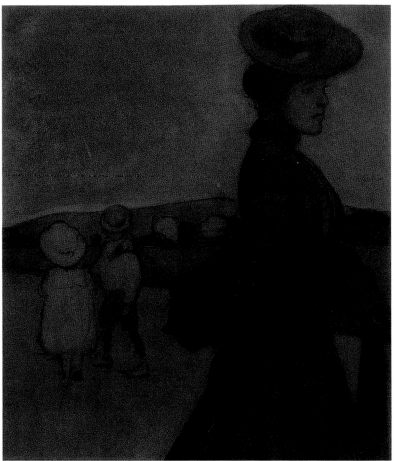

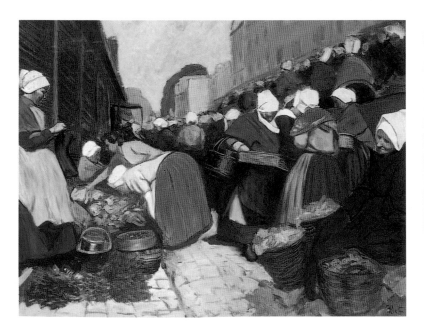

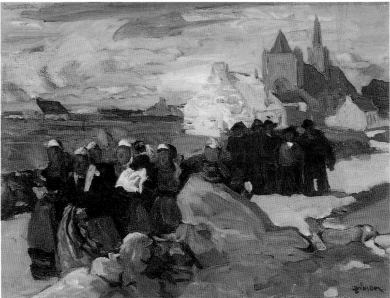

Below: **Reclining Nude**, *c.* 1906, by Maxime Déthomas
Overleaf: **Zebras at the Watering-Hole**, *c.* 1906, by Georges Manzana-Pissarro

Parisian artists of the end of the nineteenth century, nevertheless noted their superficiality. 'Simon was satisfied with conveying the purely exterior view alone – something which, incidentally, he did with considerable skill. I like his large, spontaneous watercolour studies most of all, as well as his "initial ideas" for pictures, which in their final versions always seemed to take on a measure of academic correction.'[63] *Breton Men and Women* can be considered just such an 'initial idea', the sketch for a future composition. Along with Cottet and another artist who stood to one side of the Bande Noire, Carrière's pupil Fernand Piet, Simon often drew inspiration from Breton motifs. But in contrast to Gauguin and the Pont-Aven School, in their depictions of Brittany these artists were not concerned with the beliefs of the local peasants; indeed, they had little interest in local folklore and were content instead with capturing the ethnography of Brittany, which was relatively exotic for the Parisian.

Maxime Déthomas stood close to Cottet and Simon. More a draughtsman than a painter, Déthomas cultivated the style of complete, generalising outlines, the mastery of which was considered to be the artist's supreme skill at end of the nineteenth century. It is worth remembering that this style was also a feature of the work of the young Picasso on the threshold of his blue period.

Georges Manzana-Pissarro, the son of Camille Pissarro, also showed a considerable affinity with this kind of linearity. He moved far beyond the Impressionism of his father, and in *Zebras at the Watering-Hole* he was clearly following the example of Gauguin, both in his choice of an exotic subject and in his two-dimensional treatment of all the details, united by the technique of artistic repetition: the stripes on the zebras' hides, the radiating circles in the water, the contours of the body of the African woman, the stone on which she sits, and so on.

Previous page: **Masquerade**, early 1890s, by Jules Chéret
Below: **Ball in a Paris Suburb**, *c.* 1892, by Théophile-Alexandre Steinlen

Right: **Cholera's Coming**, 1898, by Théophile-Alexandre Steinlen

The decorative refinement of this work clearly heralds the stylistics of Art Nouveau, one of the forebears of which was Jules Chéret. His posters, as charming as they are frivolous, were all over the streets of Paris throughout the last third of the nineteenth century, and were the inspiration for Toulouse-Lautrec, as well as Bonnard and other artists of the Nabis group. Not only in his posters, but in his pastels, too, Chéret constantly returned to the same image, as if making a cliché of it, thus, in the French way, symbolising his *joie de vivre*. Chéret, Manzana-Pissarro, Déthomas and Steinlen sometimes turned to painting, but their creative output, always recognisable for its applied character, was not confined to painting alone. Chéret's posters and tapestries, Manzana-Pissarro's tapestries, screens and painting on glass, the stage decorations and book designs of Déthomas, and the sketches and illustrations for magazines by Steinlen were not the full extent of their activities, only the main areas. The essential feature of all their applied work was its link to the growing medium of mass culture.

Of the artists listed above Steinlen was closest of all to mass culture. It was not just that his works were primarily executed in print form; from the beginning of his career they also possessed a measure of

adaptability. Thus Steinlen's *Ball in a Paris Suburb* translates Renoir's *Le Moulin de la Galette* (1876; Paris, Musée d'Orsay) into a language more accessible to mass consciousness. He replaces Renoir's artistic audacity with a skilful tracing of details, and converts a single bright moment into a full account of the circumstances and the nature of each of the characters. With its literary feel, *Ball in a Paris Suburb* could just as easily have been a story illustration. Steinlen's gift meant that he always remained an illustrator. He even began by illustrating songs of the Parisian suburbs, and was most famous for his illustrations accompanying the publication of the songs of Aristide Bruant, a popular singer of the late 1880s and 1890s. Steinlen's pictures were intended for reproduction, and were based on his numerous sketches of street scenes: he literally never left home without his sketchbook. In 1904, in an article dedicated to an exhibition of the artist's work, Anatole France called Steinlen 'famous' and his work 'epic' – little knowing, of course, that Steinlen's fame would soon wane.[64] This clear miscomprehension was the result of a mutual sympathy for socialist ideas. Steinlen's co-operation with leftist periodicals at the turn of the century as well as the social clarity of his compositions ensured the artist a brief popularity in France, and a rather more lingering fame in the Soviet Union – albeit

V'là l'choléra qu'arrive

Paraît qu'on attend l'choléra,
La chose est positive.
On n'sait pas quand il arriv'ra,
Mais on sait qu'il arrive.

V'là l'choléra! V'là l'choléra!
V'là l'choléra qu'arrive!
De l'une à l'autre rive
Tout le monde en crèv'ra!

Aristide Bruant
1884.

Dessin original de Steinlen. — "Le Mirliton. — n° 117. Juillet, 1893.

artificially sustained.[65] Devoid of true originality and depth, however, such art too easily degenerates into the field of illustrated journalism.

A sudden rise and subsequent neglect was also the fate of Charles Guérin, although for entirely different reasons. Sergei Shchukin became interested in his work very early on, and hung a large canvas by Guérin in the place of honour in his music-room. Guérin also remained one of Ivan Morozov's favourite artists. Unlike his former classmates at the Ecole des Beaux-Arts – Matisse and Rouault – Guérin was not noted for his forceful temperament, nor for his tireless pursuit of new directions; nevertheless, he was clearly talented. His *Lady with a Rose* reveals a subtle mastery of the decorative potential of colour, something that Gustave Moreau developed successfully in his students. Guérin's experiments with colour, however, are the result not so much of direct experience of the motif, like Matisse, as the stylised reworking of it. Furthermore, he clearly lacked conviction, and his creations are more subject to prevarication than to the logic of development.

Girl Reading a Book is quite unlike *Lady with a Rose*; here the muffled tones and delicate nuances of the grey colour range are reminiscent of Bonnard's painting at the time. Later on Guérin either returned to his earlier decorative style – although this more and more frequently gave way to the formulaic – or he turned to painting from life, always worrying about how to make his subject as attractive as possible. His models are beautiful, their poses refined, and the range of colours is often pleasing to the eye. Occasionally he adds a piquant, but of course decorous, detail. In *Nude*, the extravagant, highly fashionable hat that adorns the model's head – without which no self-respecting lady would dream of appearing on the streets of Paris – adds a sexual note to the composition. What prevented Guérin's extraordinary gift from shining more brightly? Why did he fail to prevent himself succumbing to banality? It was probably a fear of the unexplored, a desire to occupy his own niche on the already inhabited middle ground, where artistic conformity promised limited but guaranteed success.

Maillol and Bourdelle

Compared to painting, the situation in sculpture at the turn of the century was rather less complicated. Sculptors of the academic school, whose position had weakened considerably, partly because of the activities of Rodin, were still erecting conventional monuments, and were obliged to mimic, particularly when creating sculptures linked with architecture or funerary memorials. The growing demand for decorativeness and emotion compelled artists with the correct academic education to adopt some of the features of Art Nouveau. If at the end of the nineteenth century Art Nouveau left its mark on the work of Dalou and Rodin, then with less gifted artists like Albert Bartholomé, its infectious influence was felt in a more standard, albeit less precise, way. In Bartholomé's refined sculptures of weeping girls, the marble block is worked in such a way that each detail seduces with the beauty of the rounded forms of the young naked body. Their attraction is accentuated by the flowing folds of fabric, for the artist allows himself openly to 'play' with elements of Art Nouveau. From its thematic content *Weeping Girl* might be thought to evoke a minor key; this is not the case, however, for we admire the figure of Bartholomé's heroine rather more than we sympathise with her plight.

Just as Impressionism provoked a reaction against itself, expressed in the various branches of Post-Impressionist art, so too the sculpture of Rodin gave birth not only to numerous imitations, but also to the strongest possible opposition, the main representatives of which were Maillol and Bourdelle.

Although Maillol did sculpt relatively early, when he took lessons from a sculptor in Perpignan, he only seriously engaged with sculpture at the age of thirty-six. When he first moved to Paris, Maillol concentrated on painting and tapestries. His interest in applied arts brought him close to the Nabis, and particularly to Maurice Denis. His first efforts in sculpture were small terracottas. Vollard (whom Maillol had met through Vuillard) made copies of these works in bronze without informing the sculptor and with little regard for copyright rules. It was in this form that they became known throughout the world.[66] Maillol's small, extremely delicate sculptures were executed in the same key as his later monumental works. They all speak of calm, grace and dignity. In comparison to Bartholomé, and, even more so, Rodin, the movement of his figures is more restrained, the forms more generalised. At first sight Maillol's sculptures convey the impression of extreme and natural simplicity. The attainment of such simplicity might appear to be an uncomplicated affair, but in fact it rarely came easily to him. The artist always avoided unusual elements, the extravagant or the contrived. His girls stand, sit, adjust their hair. Maillol himself said 'I do not invent anything, just as an apple tree cannot pretend to have invented its apples.'[67] The simplicity of his work is expressed in everything: in the fact that he normally portrays solitary figures, and in the fact that his subjects are usually country girls. In the artist's own words, 'Our time has no more need of gods; we only have to follow nature.' Maillol's characters are themselves part of nature. There is nothing mannered or artificial in them, and their nudity is the purest possible expression

of their naturalness. For Maillol the theme of the naked body was even more important than for Rodin. Even his memorial to the revolutionary Louis-Auguste Blanqui is conceived in the form of a naked woman. The naked female form offered the artist means that were sufficient for him to express the most profound aspects of his world view.

Maillol greatly admired Cézanne, an artist whom he described as having the secret of grandeur. Both men rejected detail in the search for an overall idea, and both were attracted to people who lived in harmony with nature. There remained, however, a considerable difference between them. Maillol's art is inseparable from the concept of grace, which was alien to Cézanne. This was the extremely rare, innate understanding of

grace related to Ancient Greek art. Maurice Denis, who influenced Maillol even before he turned to sculpture, also recognised this aspect of grace, but the results achieved by the two artists could not have been more different. Denis admitted: 'This simplicity, this grand style that we were seeking amongst the paradoxes and which we could only find through using systems – Maillol discovered it all almost without effort, in himself.'[68] Maillol's *Standing Bather Adjusting her Hair* stands in a pose similar to that of Psyche in the first panel of the *Story of Psyche*. And yet alongside the statuette Denis's heroine seems almost like a magazine illustration, her dimensions out of proportion to her significance. The small statuette, however, is genuinely significant and monumental; its secret doubtless lies in its authentic and natural structure.

It was Rodin who often referred to Phidias, but in fact Maillol, an artist of the next generation, was closer to Phidias and the fifth-century BC Greek sculptors. 'What I am striving for', he explained, 'is architecture and volume. Sculpture is architecture, it is the equilibrium of masses, it is composition with taste. This architectural aspect is extremely diffi-cult to achieve. I try to attain it like Polyclitus. My starting-point is always some kind of geometrical figure – a square, a rhomboid or a triangle – because such figures hold their form best in space. I am not a mathematician. If I wanted to achieve a result through geometry, I would only end up with lifelessness. I construct my figures according to a geometrical plan, but I choose the plan myself.'[69]

Woman Covering Her Face with Her Hand describes a triangle, her pose is balanced, her outline simple, precise and expressive, but who could say that this is the fruit of sterile rationality? Maillol's harmony is the result of a wonderful synthesis of the general and the particular. He rarely worked from life, and although he could have done without models altogether, he never forgot them. In his native Banyuls-sur-Mer he simply would not have been able to find women who were prepared to pose naked. His model was thus primarily his wife Clotilde, who is recognisable in *Crouching Woman*, but is quite unlike the subject of *Woman Covering Her Face with Her Hand*. Maillol admitted that although he learnt nothing from his time at the Ecole des Beaux-Arts, he remembered some of the models very well, saying 'I knew her off by heart.'[70] 'I did them all without models', the artist said of his early works. 'All my statuettes were done without models, even without sketches. That was how I did them: I just invented them completely. That is why they look genuine.'[71]

One of the turning points in Maillol's creative life was his work on the ensemble *The Seasons*. The first sculpture of the ensemble was *Pomona*, which met with success at the Salon d'Automne of 1910. The work was bought by Ivan Morozov, who then commissioned three more statues from the artist which he intended to place in his music-room, already decorated with Maurice Denis's series of panels, the *Story of Psyche*. *Flora* followed *Pomona*, and then came *Spring* and *Summer* (cast together in 1911). Strictly speaking, the title of the ensemble – *The Seasons* – is not without a certain conventionality. According to Rewald,

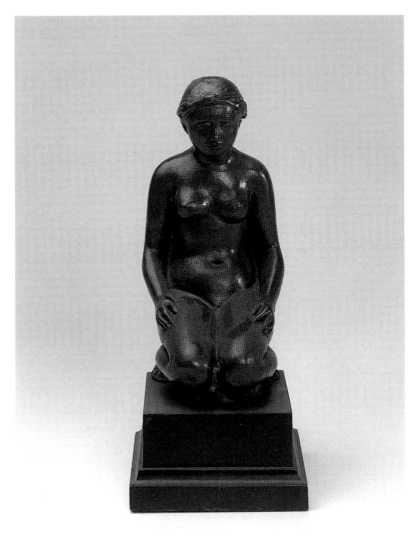

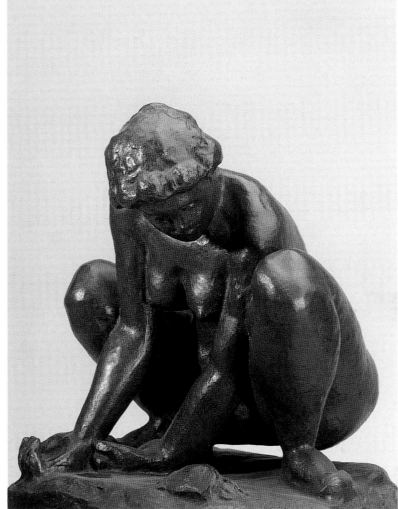

the titles of Maillol's works were normally thought up by his literary friends. In Morozov's music-room *Spring* and *Summer* formed a pair. Both pairs were positioned at opposite ends of the room. In *Spring* and *Summer* Maillol presented two different types of woman. *Spring*, otherwise known as *Woman Holding Flowers*, is refinement personified: a well-proportioned figure appearing to reach forward and even upwards. In contrast to this young, not yet fully formed creature, *Summer* presents a mature woman, wide-hipped and with a more developed breast. *Spring* stands out from the artist's other statues in her elongated proportions. Maillol's heroines are normally short-legged and somewhat portly. They reflect the type of woman his wife Clotilde was, and her jealousy combined with straitened material circumstances prevented the artist from working with other models. Did he have a different model for *Spring*, with a more fashionable figure, or did he – as is more likely – simply work from his imagination? We know that *Flora* was executed without a model, since the artist himself said so, and the genesis of *Spring* suggests that the same was true of this later work. Initially the torso appeared, entitled *Spring, Without Arms and Head* (1910), the plaster cast of which was presented by Maillol to the Museum of Modern

Art in New York. Later the figure received a head, and this Hermitage sculpture is still without arms or a garland of flowers. In the final version the woman leans her head slightly forward, as if looking into a mirror, as she tries on her necklace of flowers. In comparison to the other statues in the Morozov ensemble, *Spring* is remarkable for its extreme modernity, evident in every aspect of the work: in the proportions of the body, in the movement of the head – which differentiates the figure from the artist's sculptures based on antiquity – and even in the type of face.

Evidently the artist was consciously trying to create a statue that corresponded to the spirit of the times even in the choice of female type. In his monument to Cézanne, which Maillol planned to execute at about the same time, the artist intended to create a supine figure of a well-proportioned, long-legged woman, and he even suggested to Misia Edwards that she might pose for him. This woman (also called Nathanson and Misia Sert) was a muse of the 1890s, whom Renoir, Bonnard and the other Nabis all painted. Misia declined: 'Maillol, I love your sculpture but I cannot bear your women, your fat women.'[72]

Standing Nude, 1900, by Aristide Maillol

Right: **Spring without Arms**, 1910–11, by Aristide Maillol
Below: **Spring without Arms** (detail), 1910–11, by Aristide Maillol

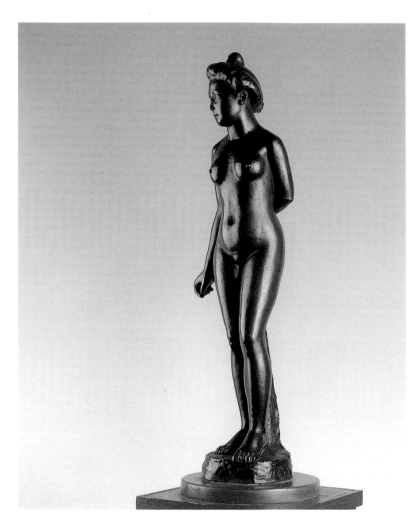

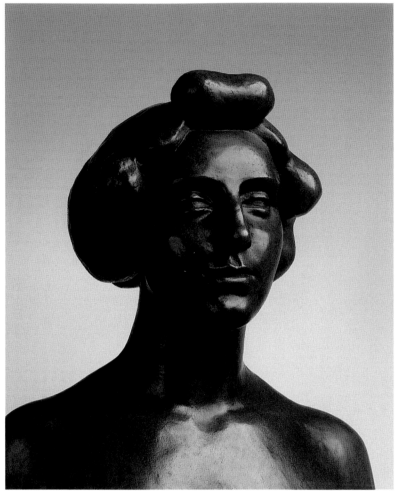

By contrast, Maillol's patron Count Kessler found *Spring* 'unpleasantly skinny.'[73] What would Maillol's contemporaries have said of our modern standards of beauty, when alongside today's top models the armless *Spring* appears quite well fed? Leaving such comparisons aside, however, this wonderfully articulated figure is a magnificent embodiment of the principle of harmony.

Maillol said that he sought not character but beauty – a remarkable admission, which could be said to draw a line under the aesthetics of the nineteenth century. Rodin might also have uttered such words, but he would have meant something quite different. His great works were created when beauty emanated from character, but when his faith in character began to wane, Rodin yielded to the temptations of Symbolism and Art Nouveau. Rodin, who paved the way for the next generation of sculptors, served as their main point of reference until he provoked opposition on the part of the most talented of his successors. Some of them were in favour of a return to the principles and techniques that had held sway in Ancient Greece during the Early Classical period (later this interest was to turn into archaism). Such views spread across all Europe. They were shared by the Spaniard Manolo, the Swede Milles, the Croat Meštrović and, to a certain extent, even by Bourdelle. Maillol

alone was happy to avoid stylisation and archaism. An inheritor of the thousand-year-old traditions of Mediterranean culture, with their cult of the harmonious man, Maillol continued to create art that was as full-blooded as it was ideal – a unique combination for the time. He consciously placed his art in opposition to 'life's abominations', for he believed in humankind's abilities to overcome them, and believed that art 'brings us close to the eternal'.

Emile-Antoine Bourdelle, who was the same age as Maillol and, like him, a southerner, was also a monumental artist. Both men fought for the rebirth of classical traditions, although Bourdelle's attitude to antiquity was more multifaceted and contradictory; his art did not so much resist his age as reflect it. Vera Mukhina, the sculptor who was once his pupil, said that his creations were always full of tension, like the strings of a bow. The son of a Montauban joiner, Bourdelle was sent to the Ecole des Beaux-Arts in Toulouse at the age of fifteen. Even at this early stage his audacity shocked his teachers. He arrived in Paris and took second place in the entrance examinations to the Ecole des Beaux-Arts. Bored with the routine of academic life, however, he left the school early. Already a fully formed artist by this time, Bourdelle joined Rodin's workshop, where he spent five years working as a marble-cutter.

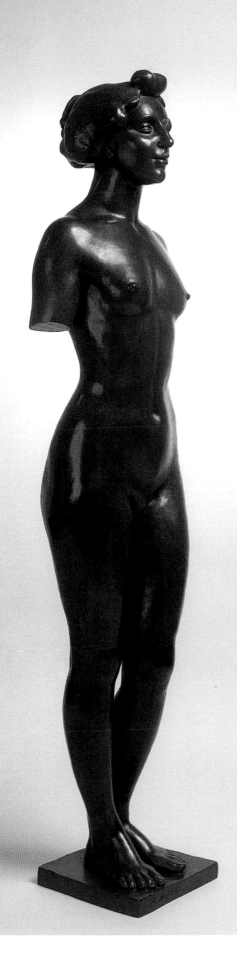

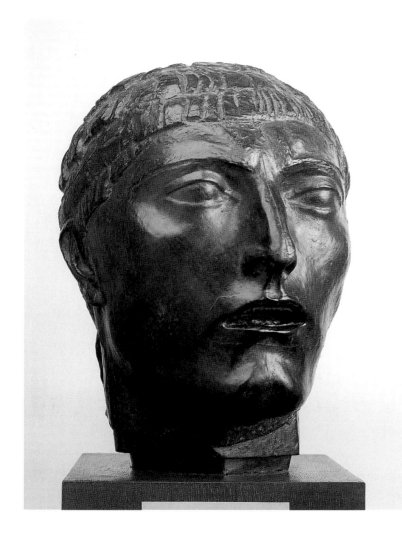

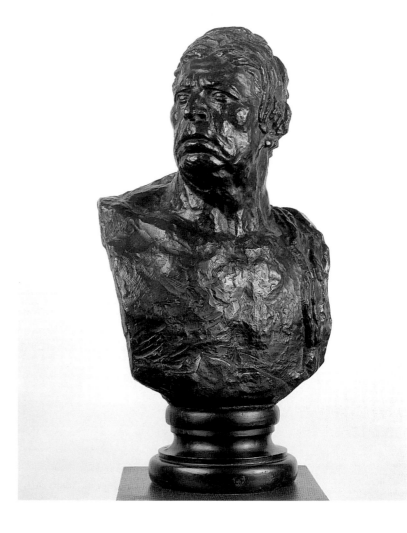

Bourdelle would always admire Rodin, although he could not help but voice some of his objections to his master's art – if only because of his fiery temperament. Rodin considered this ebullience to be an excellent character trait in his young helper. Bourdelle disagreed with Rodin because he felt that the latter's architectural qualities had been sacrificed to an excess of plasticity, and he wanted to see sculpture return to its monumental origins.

Large Tragic Mask of Beethoven was cast by Bourdelle when he was still working for Rodin. It is strongly reminiscent of *Man with a Broken Nose*, only Bourdelle does not simply copy nature; he has deformed the face with the decisiveness of Daumier's caricatured sculptures – although of course his technique is not actually caricature. There is a tremendous contrast between this portrait of Beethoven and Rodin's late works. If the latter's bust of Eliseyeva is comparable to a luminescent cloud, then the metaphor of a cliff is more appropriate for Bourdelle's sculpture. We see here not just a difference in temperament, but also a conflict of conception. In Rodin's portraits people are isolated from the world, at the mercy of their emotions. His portrayals, even those as apparently posed as Eliseyeva's, are intimate. The same cannot be said

of Bourdelle's heroes. They are usually part of this world. This is perhaps less apparent in *Large Tragic Mask of Beethoven*, because, as well as being a portrait, it is a thematic sculpture on the drama of music, of an autonomous world whose boundaries are set by the closed eyes and the tragic mask of the face. For Bourdelle, however, the world of music does not contradict real life – it reveals it, and is full of the same dramatic tension. 'The call of Bach or Beethoven is the voice of the Universe, which finds echoes all around, for they speak in a universal language' – this was the sculptor's conviction. Beethoven's music, the image of the composer – or, more accurately, the image of Beethoven's music – had a powerful attraction for the artist throughout his creative life. While still a young man, Bourdelle saw a portrait of Beethoven in a shop window in Montauban, and was immediately struck by it, particularly as he saw similarities between himself and the composer. His first attempt at capturing Beethoven's face was probably therefore the result of a fairly superficial attempt at self-identification. The earliest sculptural portrait of Beethoven dates from when Bourdelle was seventeen; in total he created more than forty portraits, not one of which repeats another. The artist's fascinated portrayals of the great musician could not be further away from commissioned copies of an approved image.

The most powerful motif in the Beethoven cycle is that of the tragic solitude of the genius. And in order to convey this, Bourdelle required a ferocious expressiveness which, while standing at the very limits of expressionism, never crosses into it. Soon after the appearance of *Large Tragic Mask of Beethoven* Mecislas Golberg wrote perceptively: 'The forehead is the eye of the storm. The lips are distorted, the wide-open eyes blaze and overwhelm, the nose, ferocious and awesome, quivers while the chin seems to tremble. This is live energy, a strength that sweeps all before it, a storm that deforms. Having achieved such a level of analytic expression, the sculptor has only two possible paths to follow: he can make the forces unleashed submit to his laws or he can give up the struggle. There are only two possible outcomes beyond this mask: chaos or order. The master sculptor has chosen the latter, and has discovered a new type of sculpture that throws down a challenge to the fierce analytical style of Michelangelo and makes the grace of Donatello more austere.'[74]

The extreme energy of Bourdelle's modelling and the intensity of his style are all the more remarkable in his *Portrait of Ingres*, where such an approach might seem to be less justified. In our consciousness, drama is inseparable from Beethoven, but it is far harder to say the same of Ingres's art. If we try to imagine Ingres on the basis of his paintings and drawings, then we are unlikely to conjure up hot temper and obstinacy. But Bourdelle knew immeasurably more about his fellow-countryman than we do. Ingres's harshness and intransigence impressed him, and he discovered more in Ingres's art than we can. Bourdelle saw in Ingres's drawings, which he called the drawings of a bull, the suppressed fury and madness of a genius made aware of his power. Bourdelle based his intensity in his modelling partly on Rodin and partly on Barye, whom he referred to as one of his teachers on several occasions. However, he went considerably further than his fore-bears. The tension of the musculature, which naturally arises in Barye's wild animal scenes or in the convulsive movements of Rodin's sinners, here becomes the tension of a plastic, rather than a physical, process. It was important to Bourdelle to achieve a unified surface in plastic terms. For this reason there is little difference between his treatment of skin and hair, while the pupils of his eyes are completely unidentified. Quite consciously Bourdelle avoided the complex and ingenious techniques employed by Houdon, for example, who made his eyes sparkle as if alive. In short, this sculptor of the beginning of the twentieth century strove for Cézanne's artistic creation, whose dynamic architectonics left an ineradicable impression on him. He declared that it was Cézanne to whom he felt closest of all.

The three bronzes in the Hermitage collection are enough to make apparent the variety of Bourdelle's creative work. Unlike his portraits of Ingres and Beethoven, *Eloquence* is characterised by unified and generalised surfaces, while the head is modelled with truly classical clarity. The open mouth and the strong features of the face call to mind theatrical masks of antiquity and examples of Ancient Greek monumental sculpture, such as the head of Aphaia from the temple in Aegina (Paris, Louvre). The history of oratory begins in Ancient Greece, and the theme led Bourdelle to the art of that time. It would be quite wrong,

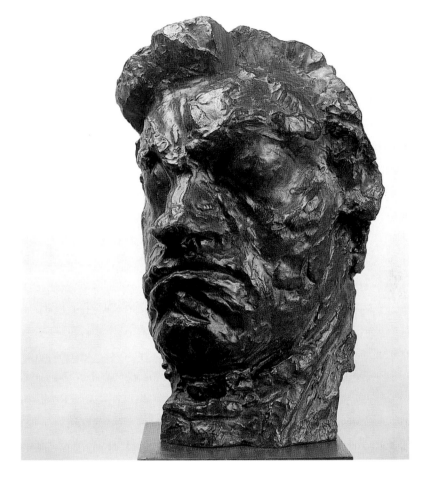

however, to see *Eloquence* as an example of stylisation, for the sense of internal tension is overtly modern.

Eloquence is a simply allegory. The young man is apparently in mid-speech – his mouth open. But this is not an ostentatious eloquence, delighting in its own elegant turns of phrase, but a profound eloquence grounded in sincerity and conviction. The bronze head is a study for a four-metre-high statue of the same name, which decorated the pedestal of a monument to General Alvear in Buenos Aires. In creating a massive equestrian statue, Bourdelle was following a centuries-old tradition, but he needed to resolve the spatial and plastic problems posed by the work in a new way, and they were problems of remarkable complexity. Because of the difficulties involved, each of the allegories was reworked several times. A study like *Eloquence* is great in itself, irrespective of the role it was to play in the overall composition of the statue. Its most important characteristic is its genuinely monumental aspect, the peculiar density of its inner meaning. Such a sculpture feels cramped inside a room, where, by contrast, the statues of Rodin are seen to their very best effect. It needs air, a sense of space, and not the interior chamber setting of former times.

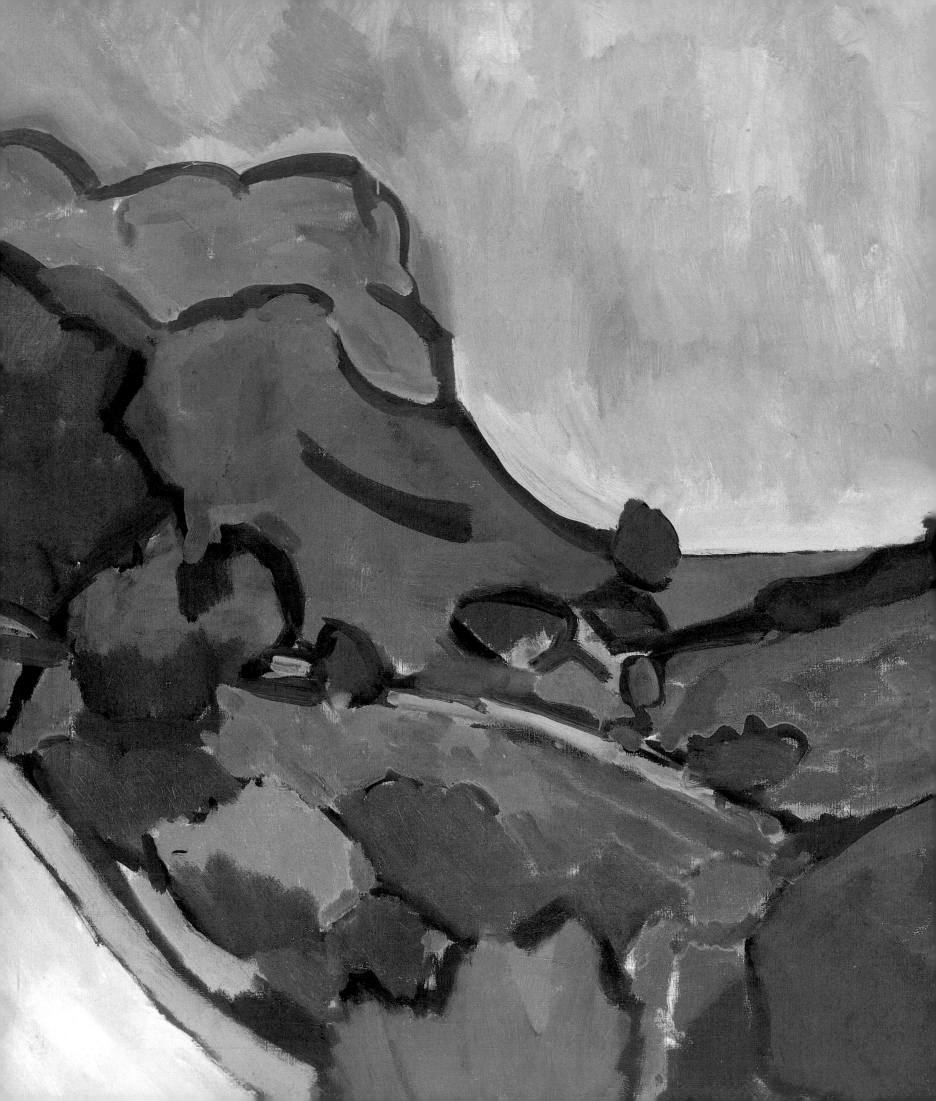

The Twentieth Century:
Insight and Hyperbole

The turn of the twentieth century was a time of unshakeable faith in progress, when society lived in expectation of a better future. Young Parisian artists had little time for either the traditions of the Salon or the innovations of the Impressionists: they were consumed with a desire to cross new frontiers. In this atmosphere of feverish anticipation, it was hardly surprising that the art world should find its champions in Matisse and Picasso. The Fauvist and Cubist movements were largely founded upon their efforts. And while both movements were short-lived, and did not represent the full scope of either Matisse's or Picasso's activities, it would be wrong to underestimate their importance. For together these two movements defined the principal directions in which Western art was to develop through the twentieth century.

Louis Valtat: On the Threshold of Fauvism

The Fauves emerged onto the Parisian art scene immediately after the Nabis, and the gap between these two groups marks a watershed between two eras. The Nabis continued to paint into the first four decades of the 1900s. While they had largely remained faithful to the tenets of Impressionism, the Fauves, by contrast, had no interest in neo-traditionalism or in perfecting the advances of their predecessors. The bright colours of Matisse, Derain and Vlaminck erupted onto the art scene in violent contrast to the gentle half-tones of painters such as Bonnard, Denis and Vuillard. Matisse and his contemporaries were clearly reacting against the methods of the Nabis, just as Fauvism was to provoke the emergence of Cubism, in turn to be replaced by neo-classicism. It is obviously too simplistic to suggest that each of these movements developed solely as a rejection of the past; there was, of course, a degree of interplay between various groups usually regarded as 'distinct'. Although they were misunderstood and often neglected, there were those innovative artists who straddled more than one of these movements.

One of these 'intermediary prophets' at the turn of the century was Louis Valtat. An artist valued by Bonnard, Maillol and Toulouse-Lautrec, and whose pictures were collected by Signac and Renoir, can hardly be said to have been entirely misunderstood. Nevertheless, the majority of art lovers and dealers failed to recognise him, something that irritated Renoir, who painted Valtat's portrait and posed for the artist himself.[1] Ivan Morozov was one of very few collectors who rated Valtat's talent highly; for the wider public he never became a truly popular figure.

Valtat was essentially a contemporary of the Nabis: he was only a year younger than Vuillard, two years younger than Bonnard, and a year older than Denis. He maintained friendly relations with the Nabis, and it is not difficult to find similarities between their themes and colour schemes and his own. Valtat's *Young Women in the Garden* was based on Vuillard's *Public Gardens*, along with various other depictions of park promenades by Denis, Bonnard and Roussel from the first half of the 1890s. A subject first explored by Edouard Manet and the Impressionists is treated by Valtat in a stylised and deliberately decorative manner, the artist boldly omitting details that would have interfered with the smooth distribution of colour. With an understatement worthy of Vuillard, he distils the subject to a decorative whole based on autumn foliage, while the silhouettes of the women echo the rounded outlines of the leaves.

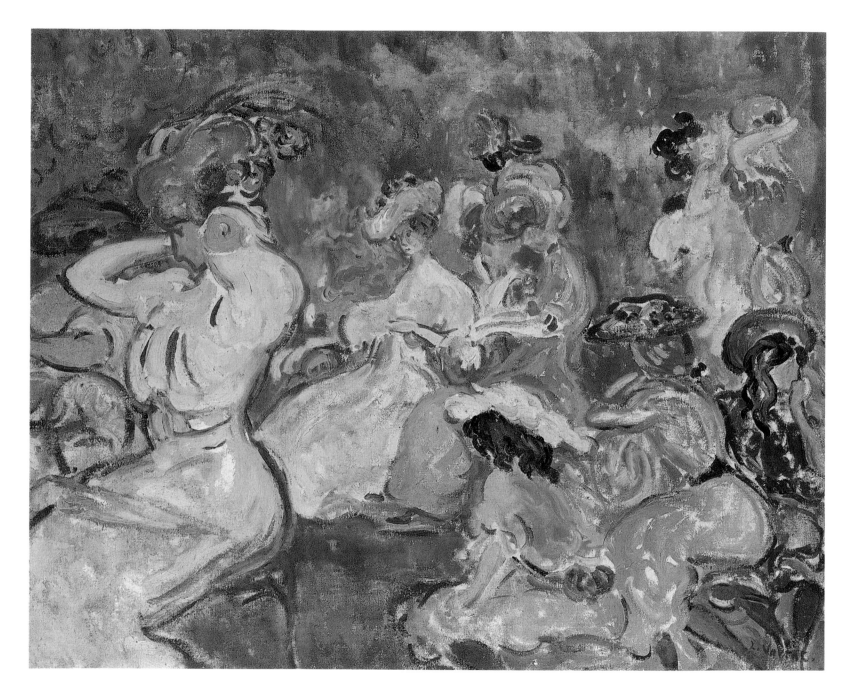

The problems of colour were so important to Valtat that they affected his depiction of details. Thus in his early work *The Boat*, the children in the bottom left-hand corner almost merge with the sand, while the woman on the right blends with the shade of the boat. For whatever Valtat portrays – be it the slope in the background overgrown with grass and shrubbery, or the boat in the foreground – each movement of his brush attempts to preserve the liveliest possible technique. The surface of the picture is reminiscent of loosened soil. For the most part, the brushstrokes do not blend into each other, but maintain their own independence; Signac's homogeneity, for instance, is quite alien to this technique. The comparison with Van Gogh is perhaps more appropriate

– although, of course, Valtat did not share the Dutchman's irrepressible temperament. He was consumed by a desire to paint with absolutely unmixed, bright colours. At the same time as *The Boat*, he painted a much more resonant variation on the same theme entitled *Woman with Children by a Boat* (*c.* 1899; Bordeaux, Musée des Beaux-Arts). Here the sand is conveyed by a lemon-yellow paint, the dark blue shade of the boat by pure ultramarine, and the woman's dress by a bright red cinnabar. There is little that differentiates this canvas from the standard examples of Fauvism created by Matisse and Derain in 1905–6, but for Valtat it was probably no more than a study. For when he moved on to larger-scale works, a balanced relationship between colours became an

The Boat, 1899, by Louis Valtat

Overleaf (top): **Violet Cliffs**, 1900, by Louis Valtat
Overleaf (bottom): **Bay of Anthéor**, *c.* 1906–7, by Louis Valtat

249

essential feature of his finished paintings: explosive brightness gave way to colouristic harmony. An interest in pure colour, which was already clearly evident in Valtat's pictures from the 1890s and which increased when he became acquainted with the works of Van Gogh, helped the artist to develop a style that anticipated Fauvism. The liberation of colour, which was to form the vanguard of the movement, was the culmination of developments in all of French art at the turn of the century. Valtat began to explore the expressive potential of pure colour long before the famous Salon d'Automne of 1905, when the word 'Fauvism' was first coined; essentially, however, he was more a herald of the movement headed by Matisse than an actual participant in it. The

term 'proto-Fauvism', which has recently been applied to the art of Valtat and René Seyssaud, is therefore quite apt. One of the most scandalous exhibits at the Salon d'Automne of 1905 was Valtat's *Seascape*, a kind of postscript to *Violet Cliffs*, which is the most obviously Fauvist of Valtat's works in the Hermitage, despite being painted five years before the movement emerged. Several remarkable pictures from the Salon caused a great stir when they were subsequently published in *L'Illustration*. *Seascape* was accompanied by a commentary on the exhibition by Gustave Geffroy, which is equally applicable to *Violet Cliffs*: 'Louis Valtat shows real power in his evocation of cliffs, either red or violet, depending on the time of day, and the blue sea, either clear or shaded.'[2]

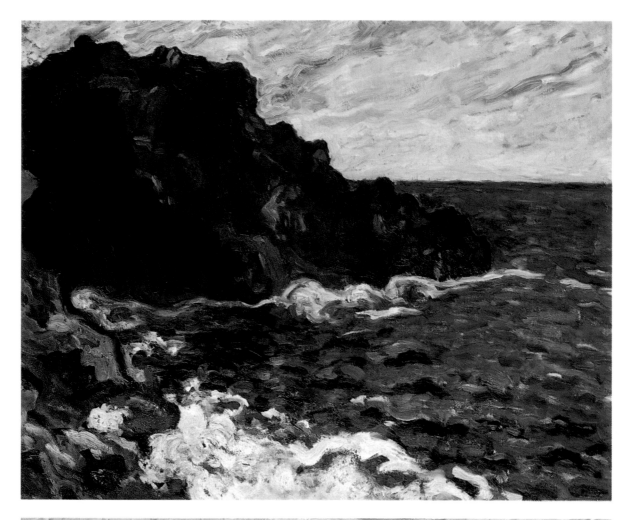

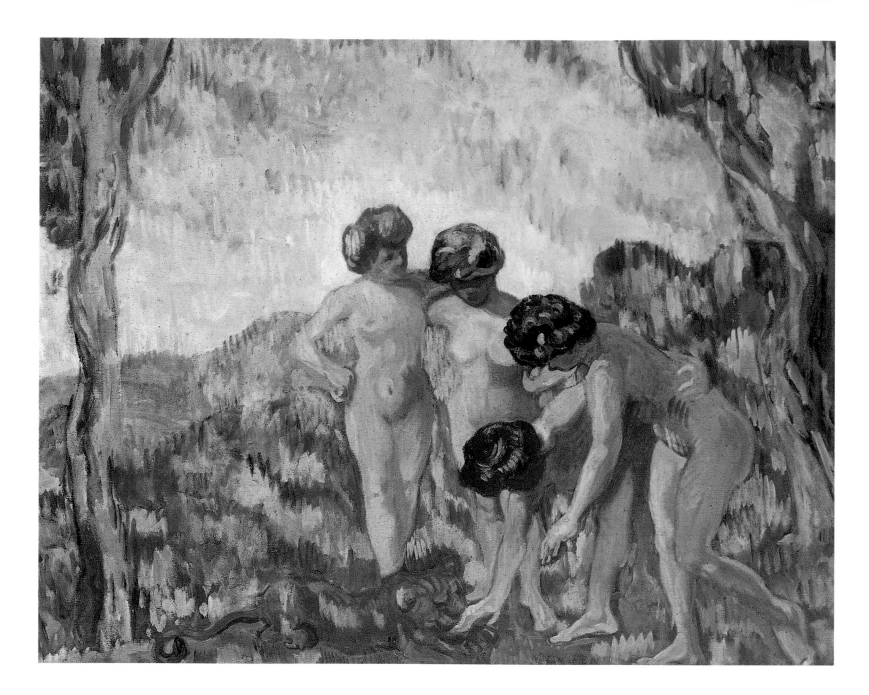

Later on in his career, Valtat did not try to force his colours to new extremes, as did Matisse and Derain, fearing for the completeness of his overall artistic structure. In pictures such as *Bay of Anthéor* and *Sun through the Trees* there is less energy, less tension, but a more carefree style. Valtat had achieved a kind of Fauvist Neo-Baroque, submitting every element of his composition to the assured and elegant movements of his dancing brushwork.

At the turn of the century René Seyssaud attracted some attention for his proto-Fauvist explorations. His narrow and sometimes even outdated themes, together with the hermit's life that he led (he left the Paris scene three years before the first Fauvist exhibition), prevented him from play-ing a significant role in French art. Both *The Road* and *Ploughing* are bold contemporary re-workings of the art of Millet and the Barbizon group. They are remarkably expressive: notable for the energetic spon-taneity of the brushstrokes, and testifying to the freedom in creativity. In comparison to Matisse and Derain, however, Seyssaud, later nick-named the 'Black Fauve', lacked colouristic imagination.

Sweeping spontaneity of brushwork was characteristic of Pierre Laprade, who earned far greater fame. The carefree nature of his brush-strokes, his lively technique, as well as an individual understanding of colour, were all typical of his art. Laprade often translated the motifs of the Rococo into the language of contemporary art. There was a time

when he was even known as the Watteau of the twentieth century, although a comparison with Fragonard might be more appropriate. Laprade spent a great deal of time copying paintings in the Louvre, although he was far from being stylised in his approach, preferring instead to view the works of the Old Masters through the prism of Renoir and Cézanne's late works. 'An examination of Cézanne's works', he later said, 'provoked the first anxiety in my art; it posed problems that I had not hitherto considered and which continue to require resolution even today.'[3] Laprade liked to paint garden and park land-scapes, flowers, and interiors with female figures. His motifs were often inspired by his estate in Fontenay-aux-Roses, where the artist spent most of his time. Like Manet and Renoir, he was said to have created his own particular type of female character. Certainly, his heroines are unmistakable, although they are often portrayed in the same summary way as his gardens or interiors: these are clearly middle-class women from a particular section of society. They have the leisure for agreeable

pastimes, whether examining lace or gathering flowers. Laprade's portrayals of such women are not without a certain intimacy, although paradoxically there is also an element of display, even a kind of bravura about the painting technique.

At a time when Fauvism had already unfurled its banners, Charles Picart Le Doux painted his *Landscape at Saint-Denis*. The painting may appear measured alongside the works of Matisse or Vlaminck, but the areas of colour and the delicate nuances of the colour relationships undoubtedly reflect the landscape compositions of artists close to Fauvism, such as Marquet, Manguin and Puy. Picart Le Doux was also allied to Marquet in his poetic approach to nature. 'It seems to me', the artist said, 'that we need to raise ourselves up by gradually overcoming the artistic order, by unconsciously achieving emotion and ultimately touching on lyricism.'[4]

him. His Fauvist experiments, however, did accelerate the develop-
ment of his own style, the essence of which was an attempt to sub-
ordinate a real landscape to a system of simplified areas of colour.
The artist's inclinations towards Realism were too strong to allow
him to subordinate nature to experiments with lineal, spatial or
colour distortions, in the manner of Matisse or Derain.

The most attractive examples of Marquet's painting are his town-
scapes, and above all the Parisian scenes. Like the Impressionists he
constantly painted the same view, although varying the composition
each time. He loved the Seine most of all, and became masterful at
capturing the river's essence through simple applications of patches
of white and light blue. In Marquet's landscape *Quai du Louvre and*

the Pont Neuf the river is almost hidden. The Palais de Justice is seen
in the background, and the spire of Sainte-Chapelle peeks out from
behind it; as the central vertical in the painting, it represents the
focus of the artist's viewpoint. The Seine is scarcely visible behind
the luxuriant treetops, which magnificently accentuate the Pont Neuf
sparkling beneath the bright sun. Nevertheless, the main element in
the painting remains the river, its powerful diagonals defining the
strength of the whole composition.

In 1908 Marquet moved to a studio on the Quai Saint-Michel, formerly
occupied by Matisse. From here he was close to Notre-Dame, which he
had occasionally painted before then, setting his easel up on the para-
pet. Now, however, he had constant access to a wonderful perspective

Page 263 (top): **Port of Hamburg**, 1909, by Albert Marquet
Page 263 (bottom): **View of the Environs of Rouen**, 1927, by Albert Marquet

Quai Notre-Dame, Le Havre, 1908, by Georges Dupuis

265

with the mighty cathedral in the background, and he created a whole
series of landscapes, the finest of which was *Rainy Day in Paris*
(page 260). When he bought a large flat, despite being short of money,
Marquet justified the purchase by saying it was 'because of the win-
dows'. The studio on the sixth floor ensured the artist would have
his favoured elevated viewpoint and the necessary distance from his
subject. As with the Impressionists, Marquet's views of Paris were not
merely accurate representations of architectural landmarks. In *Rainy
Day in Paris*, the cathedral appears as an indistinct silhouette, where
the architectural features can only be guessed at. Whereas an artist
like Pissarro brought out dozens of details in his street scenes, this
artist of the next generation, in search of certainty and stability, con-
centrated on colour correlation, which led him to use a small number
of tones. The overall tonality and incorruptible calm of Marquet's
picture is reminiscent of early landscapes by Corot.[6]

Marquet was one of the most observant draughtsmen French art
has ever known. In two or three brushstrokes a human figure comes
alive, taking on an individual way of walking, even a personality. For
example, the combined patches of black in *Rainy Day in Paris* convey
with astonishing precision the poses of the passers-by in the rain.
However, despite this gift, Marquet included far fewer people in his
pictures than Pissarro in his depictions of Parisian boulevards and
squares. Marquet's city is not an embodiment of noisy movement, but
rather the combination of immovable masses of stone, which capture
the serene certainties and gentle nostalgia of the artist.

The mood of hidden melancholy that runs through Marquet's art
after the death of his beloved mother in 1907 can be sensed in *Rainy
Day in Paris*, but is even more strongly felt in *Place de la Trinité in
Paris* (page 261). Here, too, the artist remained faithful to his Realist
inclinations, but he wanted to produce more than just a literal recre-
ation of the scene from the window of a flat, which a friend had put
at his disposal for a whole series of canvases. His acute observation
of the mood of the city enabled him to explore the changing life of
its streets and squares: dark areas of paint capture the passers-by,
omnibuses and cars, while other dark brushstrokes convey the win-
dows of houses and the church. The colour areas and lines combine to
form the skeletal outline of the painting, based on a generally unified
and restrained palette, which in turn ensures a particularly expres-
sive sonority.

A student of the Impressionists, Marquet imbued each of his paintings
with luminous air, but he achieved this effect through incomparably
simpler means: by a small number of patches of carefully chosen
tones. In *Bay of Naples*, white, blue and black paint is enough to
make the painting 'breathe' with fresh sea air, at once wonderfully
transparent and luminescent. Here, however, there is absolutely no
sense of the vibration of the atmosphere. Marquet's nature is clear
and calm; alongside it the nature of the Impressionists can seem
excessively lively. This overall sense of clarity is strengthened in
the painting by the interplay of the various different planes in the
landscape. In the second, or more often the third, plane, Marquet

establishes a barrier beyond which the view cannot extend. In *Port
of Hamburg* and *Port of Menton* it is the rows of houses; in *Saint-
Jean-de-Luz* and *Bay of Naples*, the line of the shore. Nonetheless,
as far as the eye can wander, it does so without hindrance. Marquet
was not interested in pursuing mystery. The depths of his landscapes
attract like the promise of a delightful stroll; they open up immediate-
ly and without constraint. Only the boats on the surface of the water
in *Bay of Naples* give a sense of how the alternation of planes is
achieved. Planes merge one into another with a smoothness and
ease on the eye that is rare.

Bay of Naples is undoubtedly a masterpiece, standing out from
Marquet's many other wonderful portrayals of the harbours of
Europe. While still a child in Bordeaux, Marquet used to go to the
port whenever he could, admiring the play of light on the water and
watching the barges and vessels pass by. When he became an artist
he never missed the chance to visit ports in any of the countries he
went to, with the result that he was jokingly called the 'régisseur
des ports'.[7] The finest works of this set, painted before the start of
the First World War, convey a poetic, pure and almost childlike
wonder before the beauty of the Mediterranean ports and gulfs.

The Fauvist Generation

Marquet's Fauvist experiments were only a small part of his creative output, and not even the most important. For the other artists with whom he was friendly and alongside whom he exhibited at the beginning of the twentieth century – Manguin, Dufy, Puy, Friesz – participation in the Fauvist movement was much more marked, although in each case it lasted for only a limited period. Fauvism was a complete artistic movement, although short-lived. First emerging in 1905, by 1907 it had already begun to lose some of its followers. This was not entirely the result of the increased speed with which developments in art occurred.

Fauvism was a movement that stressed the individual feelings of artists, and it inevitably encouraged the swift expression of differences between temperaments; this in turn quickly led to their moving apart in different directions. Nevertheless, it is impossible to exaggerate the role played by Fauvism in the history of Western-European art. It united an abundance of artists blessed with a powerful gift for colour, and enabled this gift to find expression in the most unexpected ways.

Matisse, the undisputed leader of the movement and its most gifted exponent, was the only one of the Fauves whose art did not suffer when he began to depart from Fauvism. For artists as important as Derain,

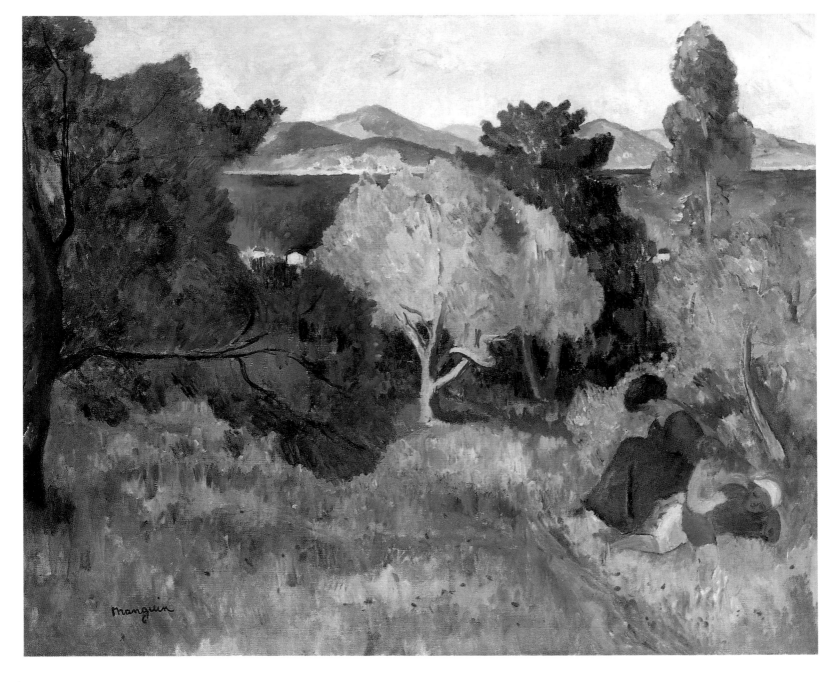

Vlaminck and Van Dongen, however, the most productive years were those dedicated to the movement. Even more remarkable was the example of less gifted artists such as Manguin, Puy, Friesz and Chabaud. All were talented artists, of course, but they painted their finest works during the Fauvist period when, caught up in the eye of the storm, they rejected 'scholastic' conventions in favour of creative experimentation. The same can be said of such little-known artists as Georges Dupuis, whose art was, for a short time, affected by the colouristic innovations of Matisse, Derain and Dufy. The innovations of Fauvism, above all in the sphere of colour, were extremely important. They provided a basis for the Expressionists from various European countries, as well as representatives of other movements. Fauvism redefined many aspects of the approach to art. As the first significant movement of the twentieth century, it effectively defined many of the most important features of subsequent movements: the striking forcefulness of artistic means and an increased attention to certain highly valued formal aspects of art. This was not the result of a deliberate pursuit of sensational innovation; rather, it grew from the very nature of the Fauves' art. By continuing the work of the Impressionists and Post-Impressionists in the liberation of colour, Matisse, Derain, Vlaminck, Van Dongen, Dufy, Manguin and other artists of the group discovered that the entire effect of a picture could be based on the simplest, most dynamic colour combinations.

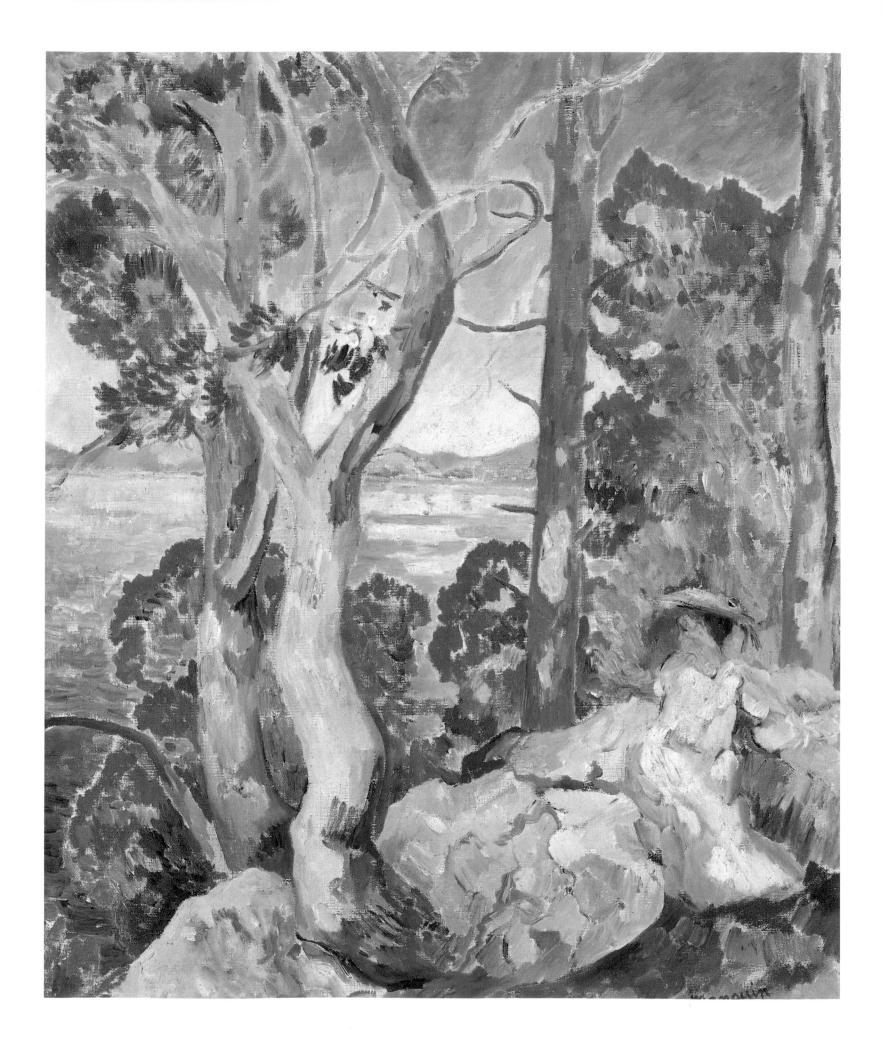

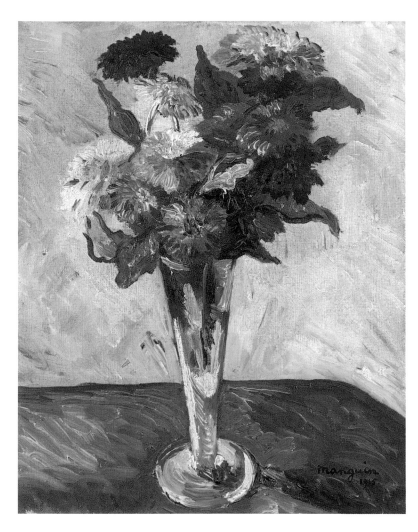

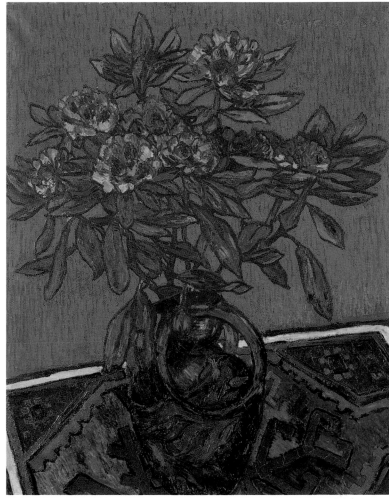

'Fauvism', Matisse was to say, 'was for me a test of means: to apply blue, red and green alongside each other and to combine them in an expressive and structured way. This was born of an internal necessity in me, and not a reasoned intention.'[8] Thus Matisse underlined the intuitive rather than the rational nature of Fauvist art. Its colouristic simplifications were dictated by a desire to express emotion directly and powerfully. Matisse and some of the other artists of his circle had studied under Gustave Moreau, who told his students that the more strongly emotions were expressed in art, the simpler the means (although this was not a maxim he followed in his own art).

Henri Manguin, another of Moreau's students, was not nearly as radical in his use of colour as Matisse, and occupied a similar position to Marquet's in the Fauvist movement. He also preferred landscape to all other genres, and, like Marquet, did not allow himself to distort nature. As Apollinaire noted, he had the ability to saturate his colours with light, sustaining the radiation of the Mediterranean sun in his tonal contrasts. Manguin discovered a nature that was most in keeping with his temperament and attitude to life – the lush and welcoming resort of Cythère. From the beginning of his Fauvist period he spent every

summer on the Côte d'Azure and, intoxicated with 'ce beau pays de Saint-Tropez', he painted picture after picture as he tried to express his admiration for the Mediterranean landscape. In June 1905 he wrote to Matisse: 'I am full of enthusiasm for this country and, in particular, for where we are at present. It is absolutely magnificent and I want to use it because I feel that I shall never find anything like it again.'[9]

'I must tell you how happy I am here,' Manguin wrote in another of his letters, 'in this wonderful region where we have the sea, the plains and the mountains, all combined and infinitely varied in a completely restricted space – not to mention the sun, which has shone now steadily for nearly two months.'[10] Manguin thus used celebratory colour combinations, lightening and intensifying tones. His colours are generally brighter than Marquet's, his paints less subject to optical illusion. The majority of the canvases from his Fauvist period are executed in a single range of colour consisting of shades of scarlet, light blue, light violet and various greens. The predominant tonality is always in the major key and it is fruitless to look for dramatic or even disquieting notes in Manguin's art. There is nothing discordant in his paintings, even though they predominantly employ pure colours of the spectrum. In

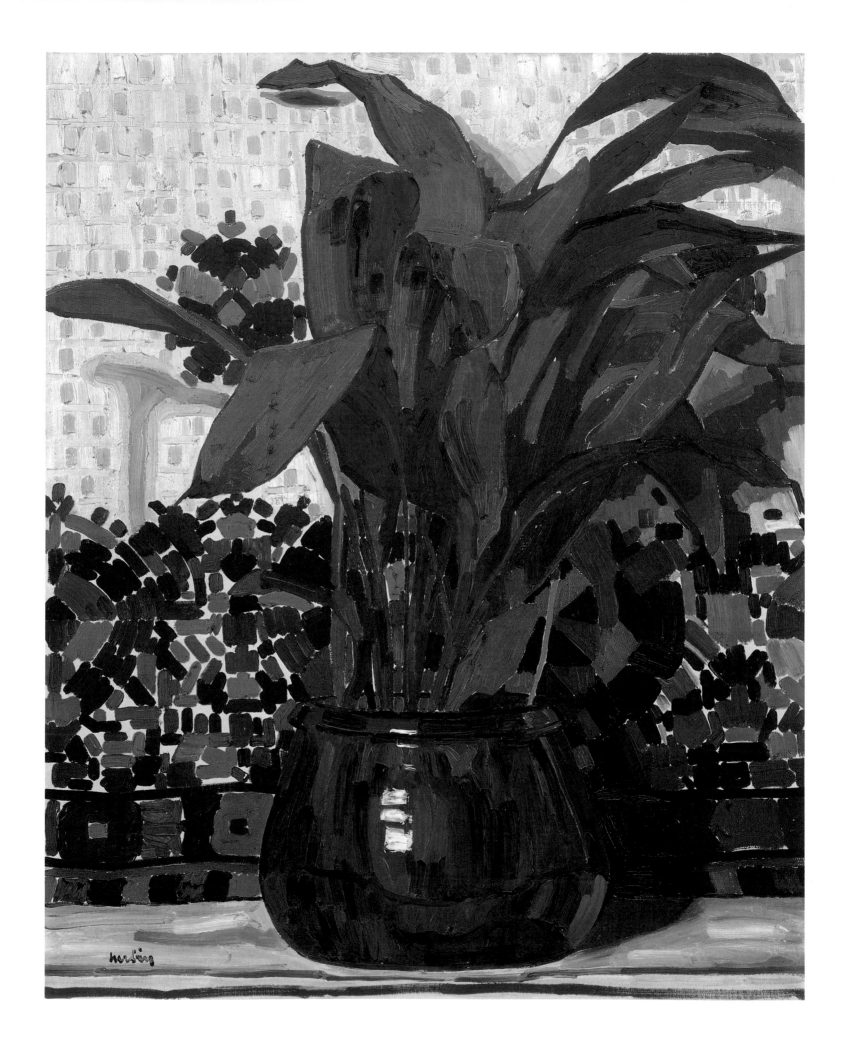

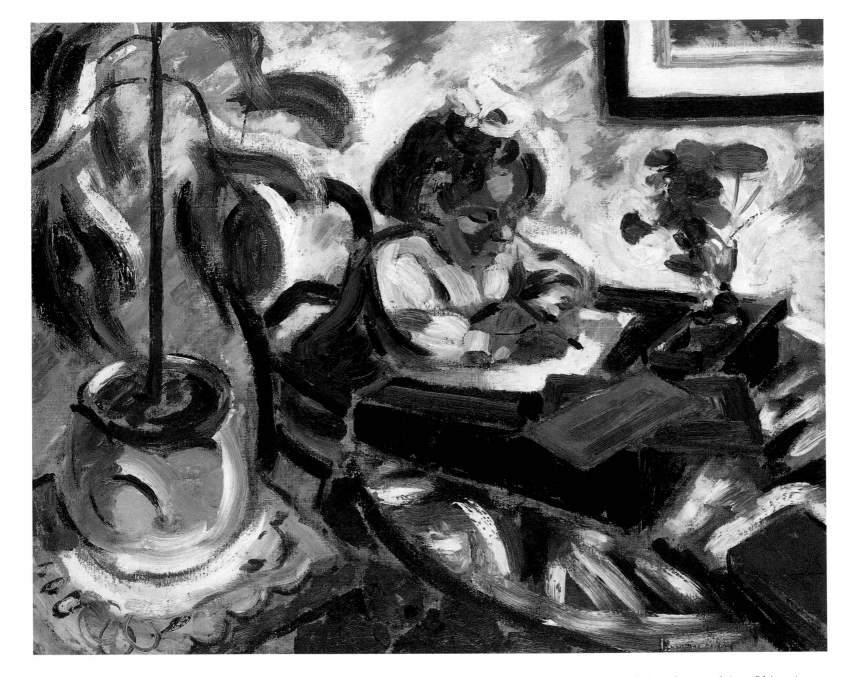

Landscape in Saint-Tropez and *Path in Saint-Tropez* the artist avoids juxtaposing contrasting tones where possible; he also declines to accentuate areas of colour by using outlines.

In July 1906 Matisse wrote to Manguin from Collioure: 'I expect that you have been completely caught up in your work and that Cavalière has finally revealed its rich possibilities. Cross has written to me that you are doing some stunning things. Happy man!'[11] Indeed, Manguin's work in the Bay of Cavalière led to some of his greatest successes. Cross was full of admiration for Manguin's Cavalière canvases, because he saw in them an extension of his own ideas. However, although he learnt from Signac and Cross in his adoption

of pure tones and in the elevation of the colour register of his art, Manguin avoided their mosaicism. He followed his own emotions, not the rules of Chromo-luminarism, and through his experience of working in watercolours turned to 'filling in' with bright, unmixed paints. The use of repoussoir in *Morning in Cavalière*, and the reddish earth in the foreground that turns into a large area of scarlet, set the mood for all the other colour combinations. It is colour that is triumphant, and the subject itself – a woman resting on the shore of the bay – becomes an entirely secondary detail. Although the woman (who is in fact the artist's wife) is positioned in the foreground, we do not notice her immediately: she almost merges into the surrounding countryside.

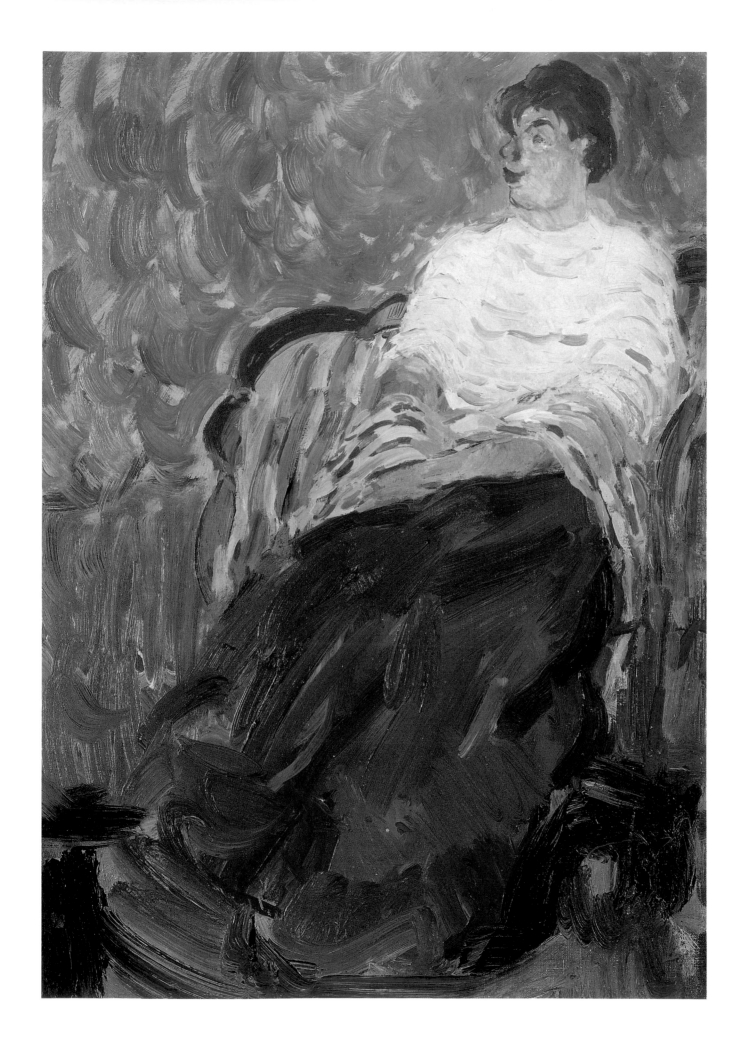

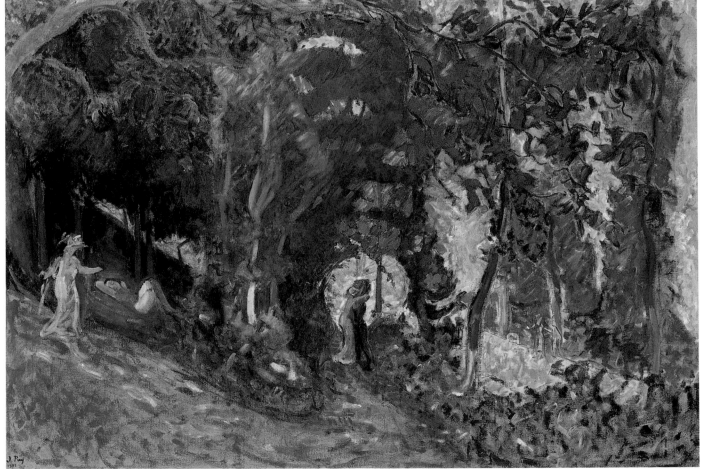

The influence of Fauvism spread like a forest fire, and affected a number of artists who were not directly connected to Matisse, Manguin, Derain and Dufy. It was this influence that explained the adoption of brighter colours by Dufrenoy's friend Pierre Girieud, an artist who was too much a follower of Gauguin to adopt Fauvism definitively. The younger Auguste Herbin, who was not yet prepared to reject the precise draughtsmanship and chiaroscuro of academic art, nevertheless experimented boldly with colour. The background of his *Flowers* (page 270) uses various patches of primary colour – yellow, blue and most of all red – to bring out the green of the wide leaves with the maximum intensity.

Fauvist art, and principally that of Matisse, also served for a time as an example to Henri Le Fauconnier, who adopted broad sweeps of the brush and striking colour contrasts in his *Little Schoolgirl* (page 271). The application of such techniques to a subject that had hitherto been the sole province of Salon artists, with their sentimental portrayals of well brought-up girls, caused quite a stir in the Salon d'Automne of 1907, and at the subsequent Golden Fleece exhibition in Moscow the following year. The Fauvism of *Little Schoolgirl* is, however, essentially superficial. A genre that is fundamentally alien to Fauvism is treated in a Fauvist manner: a realistic genre composition with details such as the expression of effort on the girl's face as she writes on her piece of paper.

By this time the founders of Fauvism had a sure grasp of the new dialectics of art. In his early, proto-Fauvist *Portrait of Suzanne Dufy* (page 272), Raoul Dufy achieved extreme expressiveness of brushstroke combined with a total lack of constraint. A few sweeps of his brush were enough to convey precisely his sister's face with her retroussé nose and red hair, shown to best effect against the blue background. A redhead himself, Dufy liked to use this technique in his self-portraits. Early on, he learnt how to achieve freshness in his use of blue, and each time applied other colours to provide the necessary support: in this case, red. The scarlet modulations of the woman's dress combine with the blue background to produce a harmony of such sonority that the formulaic nature of this small picture is forgotten. The painting must indeed have seemed a negation of pictorial conventions at the turn of the century.

However, not all the Fauves or 'savages' were revolutionaries and out-spoken pioneers in proclaiming new principles in art. Puy and Friesz, for example, were far more moderate, while they contributed to the achievements of Fauvism with their pursuit of bright and lush colour resolutions. Apollinaire, who noted Jean Puy's talent and originality, remarked that 'Puy's paintings are completely devoid of sadness and imbued with a witty and voluptuous grace that is rare today.'[12] The words of the poet are particularly appropriate when we consider *Summer* (page 273), a picture notable for its freshness of tone and unconstrained decorativeness. It would be quite possible to use it as a design for a theatre set, with its enlivening *mises-en-scène*. However,

the theatre at the turn of the century had no need for Puy's gifts, and the artist himself was most of all attracted to easel painting. From the outset Puy's Fauvism was determined by his admiration for Cézanne, in whose creations Puy saw a renaissance of classical French traditions. In a picture such as *Landscape*, the compositional equilibrium and rich-ness of colour which co-exist with the material aspects of the landscape owe a great deal to Cézanne. In Puy's *Portrait of the Artist's Wife*[13] the psychological and other aspects of portrait painting are clearly sec-ondary to the attempt to compose a durable and structural picture in the manner of Cézanne. Thus the figure of the woman, who occupies a strictly central position, has most importantly a structural function.

Still Life with a Statuette of Buddha, 1909, by Othon Friesz

Below: The Temptation (Adam and Eve), c. 1910, by Othon Friesz
Right: Roofs and the Cathedral in Rouen, 1908, by Othon Friesz

Othon Friesz was also influenced by Cézanne. When Friesz's *Autumn Work* first appeared, Charles Morice pointed out 'la grande leçon de Cézanne'. Apollinaire's description of an identically titled painting by Friesz (now in the National Gallery in Oslo) can be applied equally to the Hermitage study: 'In the background the immobile mass of the forest and the houses, and in the foreground, the mobile group of figures gathering wood and fruit while a mother lies nursing her child – all this forms a composition full of emotion and grandeur. Perhaps the only thing lacking to make this painting a masterpiece is for the artist to have been the simple interpreter of a universal doctrine in the age of religious beliefs.'[14]

Autumn Work, a picture in which Friesz had still not rejected the bright colours of Fauvism, came as an unexpected signal of change for young artists in Paris. Alongside the works of innovators who had encroached on the classical foundations of art, it signalled a return to classicism: not simply an imitation of the various techniques against which Fauvism had rebelled, but a return to tradition strengthened by the emancipation of the artist's own emotions. Roger Brielle, in an extension of Apollinaire's ideas, analysed the picture thus: 'Everywhere, from the central character whose arms are raised to form the summit of a pyram-

idal equilibrium, all the lines attain harmony in the movement of the surrounding bodies and in the sense of movement that drives the land-scape, the mass of leaves and the sky. The figure on the left, whose form reflects the overall form of the canvas, responds to this movement like a small, finite universe that is identical to the universal system within which it exists.'[15]

In the pictures painted after *Autumn Work* – *Hill* and, to an even greater degree, *Roofs and the Cathedral in Rouen* – the noticeable imposition of order and the simplification of the natural motif together with the 'calming' of the palette reflect those processes that were soon to define the creative pursuits of the Parisian avant-garde. It is worth remember-ing, however, that this was the time when another native of Le Havre, Friesz's young friend Georges Braque, was painting his first Cubist landscapes, using Cézanne's postulates to reach considerably more radical conclusions.

Friesz was too faithful to nature simply to turn it into an abstract plastic composition. His youthful admiration for Boudin and Monet was influential, and later he worked with Pissarro shortly before the latter's death. For Friesz, unlike Matisse and Derain, the atmospheric

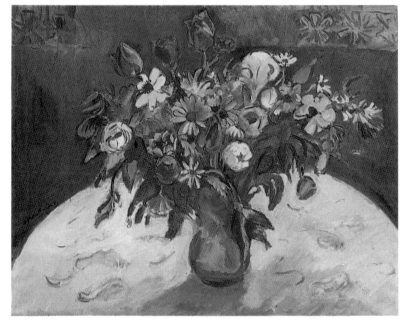

considerable stir[16] It was remarked upon, for example, by the eminent critic A. Hepp: 'Is it the lessons of Cézanne or the demands of his own temperament that have suddenly made M. Friesz at peace with himself? The fact is that his *Rouen Cathedral* is one of the most successful products of the movement of which he is a part, and which is now bearing the whole future of art forwards. M. Friesz's picture, with its solid construction, upholds volume and sonorous tones; it rehabilitates that internal life whose demise we have long been expecting. What an indication M. Friesz's *Rouen Cathedral* is! Fifteen years ago he would have felt obliged to paint twenty hourly views of the same sight.'[17]

However, at such a critical period in French art, the problems resolved by such a landscape were soon to seem unimportant. At the same time, Friesz himself lost his way after the collapse of Fauvism and the emergence of Cubism. It is no coincidence that his still lifes from 1909 to 1910 produce a dual impression. In *Tulips and Marguerites*, it appears that the artist is either trying to return to the lusher colours of the Fauvist period – as a floral still life ought to allow – or else he is attempting to move ahead by means of the careful detailing of form. *Still Life with a Statuette of Buddha* is a rather more complete work, but its reference to Oriental motifs is already outdated in the context of Parisian art of the time. All of this indicates that the artist was attempting to resolve the crisis through broadening his range of themes in an essentially haphazard way.

Friesz's reworkings of motifs from the Middle Ages and the Renaissance, as in *The Temptation (Adam and Eve)*, were fairly superficial in character. Nevertheless, his attempt to instil new life into 'Cézannesque' art through the use of overtly decorative techniques indicated that Friesz had not exhausted his potential. Later, critics were surprised that the director of the Gobelins factory failed to appreciate that *Adam and Eve* was in its way an application to undertake a similar composition in the form of a tapestry, but Friesz never received such a commission.

The Chatou School: Vlaminck and Derain

A meeting between Derain and Vlaminck in 1900 was to be the event that marked the origins of Fauvism. As they left the Parisian suburban train at Chatou, where they both lived, the two fell into conversation and realised that they shared an interest in art. They agreed to meet the next day under the bridge over the Seine to paint from nature. Thus was born the Chatou School, a name coined – either ironically or proudly – by Vlaminck. Derain and Vlaminck often set up their easels side by side, and later rented a cheap studio on the island of Chatou, but neither wished to dominate, and so they supported each other in their quests for the most dynamic artistic resolutions possible.

Maurice de Vlaminck's *View of the Seine* is a wonderful example of daring dynamism. Included in the background are two of the most important places in the history of the Fauvist movement: the bridge and the island at Chatou. Of all the pictures in the Hermitage, this one perhaps most warrants the title of Fauvist. The chosen means of expression are the simplest and most energetic imaginable: intense

concerns of the Impressionists remained relevant even when he embraced Fauvism. When he turned to depicting Rouen Cathedral, he did not use the same viewpoints as Claude Monet. The name *Rouen Cathedral*, under which the work appeared at the Salon d'Automne of 1908, is somewhat misleading, since the famous edifice is removed far into the background, and its towers are likened to the roofs of the unremarkable houses in the foreground. Indeed, the building simply provides the opportunity for the creation of a composition with its own sense of movement. By avoiding bright colours, to which he had previously been committed, Friesz concentrated on the relationships between three-dimensional objects. When it first appeared the picture caused a

View of the Seine, c. 1906, by Maurice de Vlaminck

colours and bold brushstrokes. The whole is a kind of elemental explosion reminiscent of Van Gogh. Vlaminck himself acknowledged the revelatory impression Van Gogh's paintings had made on him at an exhibition in 1901. He learnt from Van Gogh how to work with the directness of a child, to reject the rules inculcated at art school, and to do away with the palette. 'Straight from the tubes, dammit! In order to paint, we need buckets of colour.'[18] If, however, we look at Vlaminck's works from an emotional rather than a formal point of view, it is clear that Van Gogh's paintings arose from very different emotional impulses. In their world view, the two artists were as much in opposition as faith and the loss of faith.

Vlaminck and Derain remained close for a considerable time. They shared a belief in the freedom and spontaneity of the creative act, and easily found artistic means that satisfied the temperament of each. However, if we compare Vlaminck's *View of the Seine* with Derain's *Harbour*, pictures that are thematically similar and painted around the same time, we can quickly appreciate the differences between the two artists. Both were among the first in European culture to appreciate the originality of children's creativity. But while Vlaminck's words, 'I always look at things through the eyes of a child',[19] need to be taken with a pinch of salt, with Derain – at least, at the beginning of the Fauvist movement – the situation was rather different. His *Harbour*

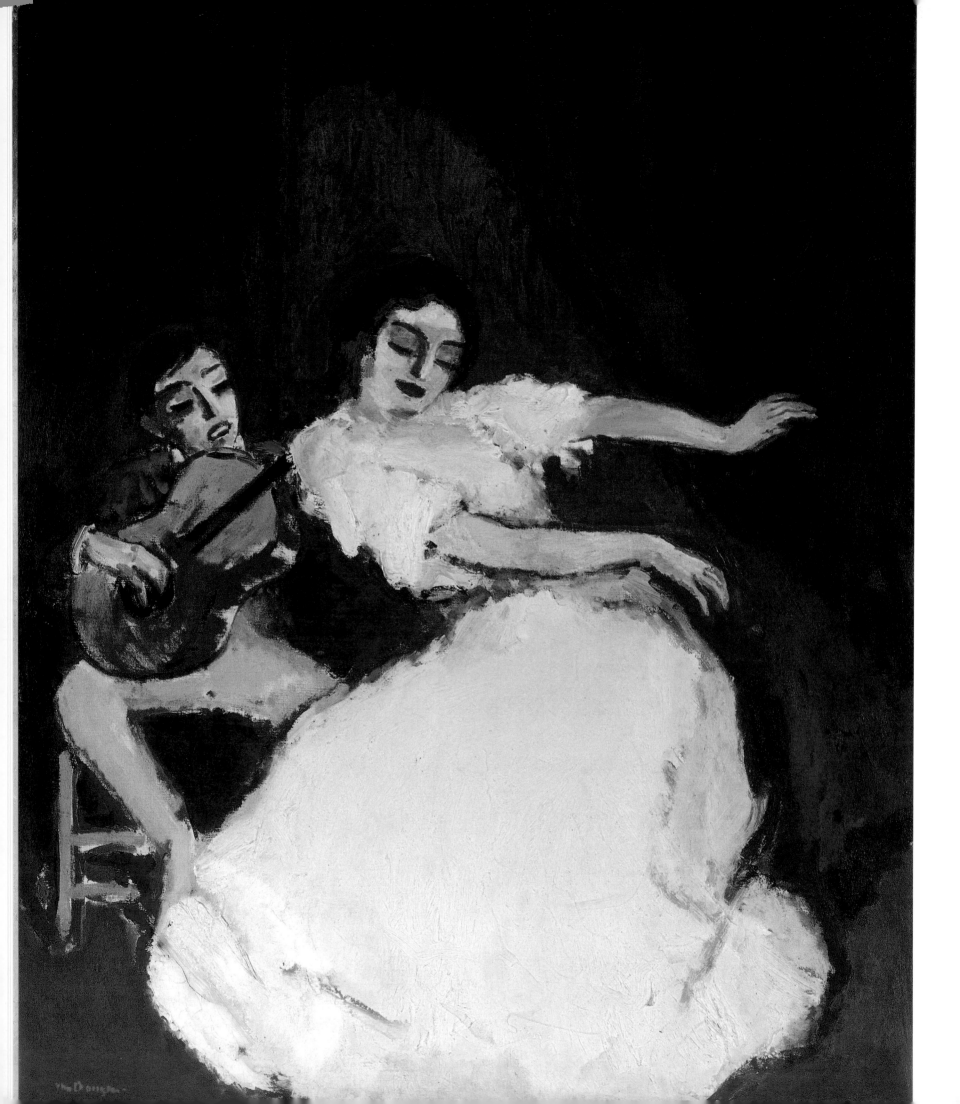

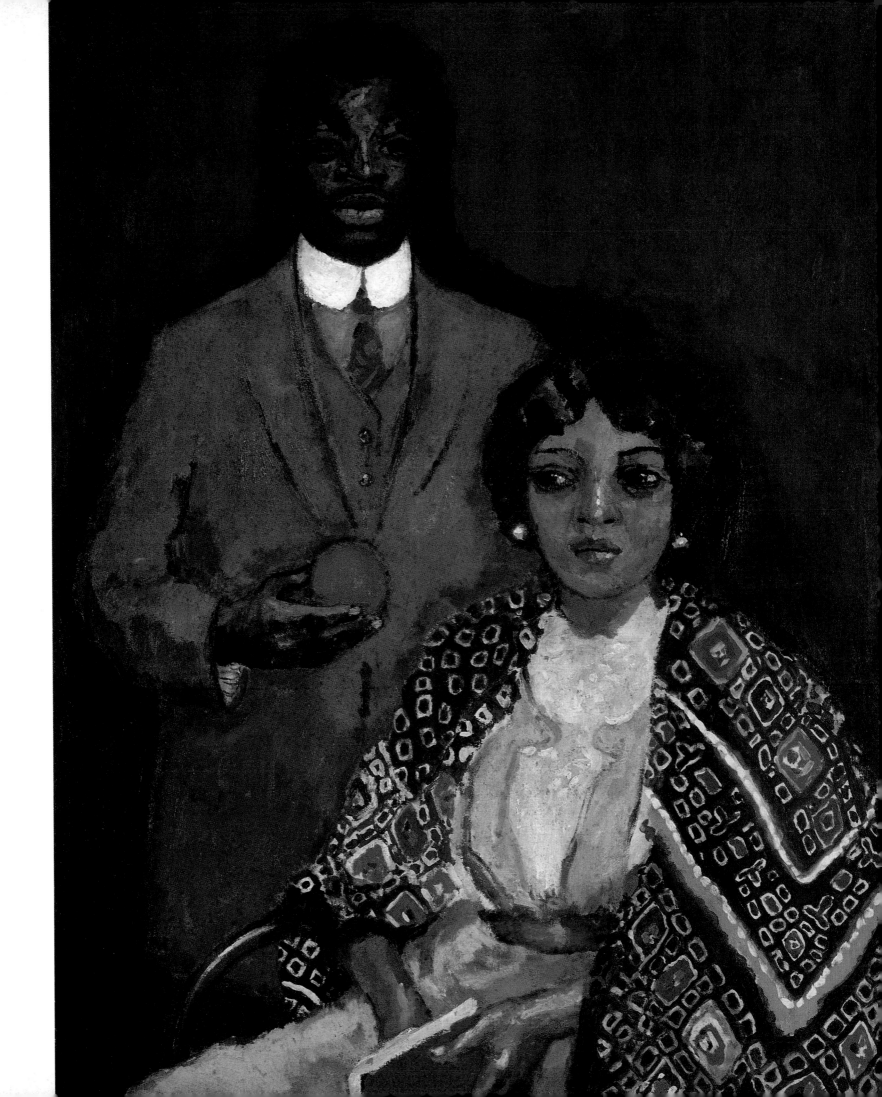

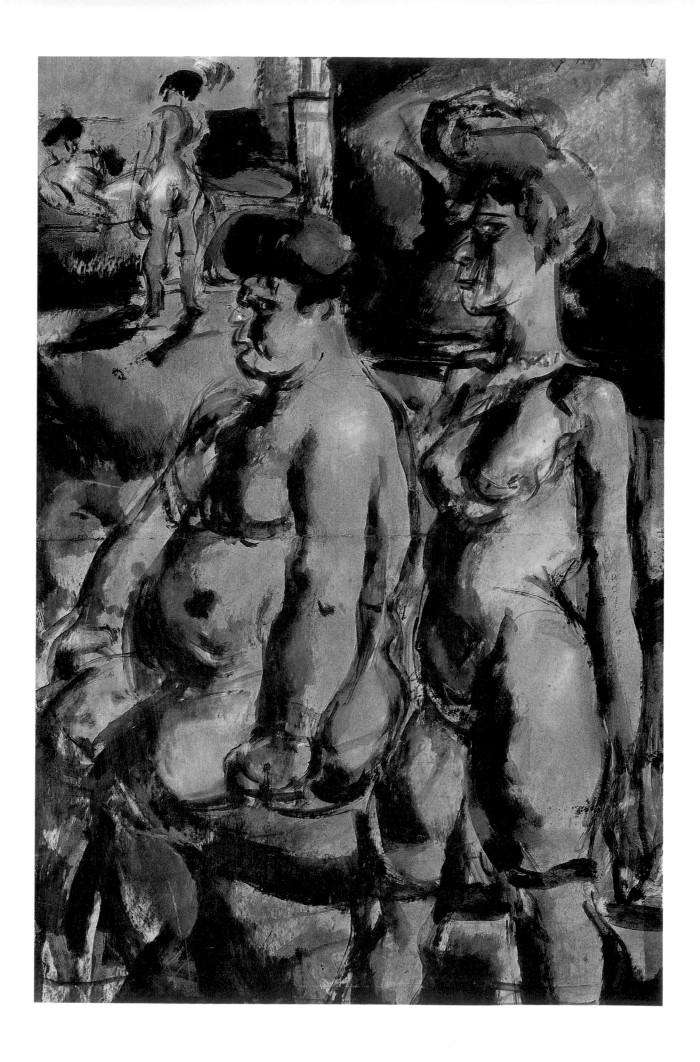

Page 288: **Antonia La Coquinera**, 1906–10, by Kees van Dongen
Page 289: **Lucie and Her Partner**, 1911, by Kees van Dongen
Left: **Girls**, 1907, by Georges Rouault

Sketch of a Vase, c. 1910–11, by Georges Rouault

291

The Tragic Art of Georges Rouault

Georges Rouault was Gustave Moreau's favourite student in a class which included Matisse, Marquet and Manguin. He exhibited at the Salon d'Automne of 1905, and one of his pictures caused a great scandal when it appeared in the magazine *L'Illustration*, an event which essentially marked the beginning of the Fauvist movement. From then on critics bracketed Rouault with the Fauves, although the artist himself always rejected this definition. The similarities between Rouault and the Fauves are purely external and do not extend to the content of his paintings. He rarely painted from nature, constantly immersing himself in his own world peopled by characters who were alien to the Fauves. Rouault's creations are inseparable from Symbolism, which he employed in its religious and social aspects.

The images of prostitutes in his painting *Girls*, a theme to which Rouault often turned at the beginning of the twentieth century, can only really be understood within the context of his depiction of saints and clowns, of Christ and corrupt judges. For Rouault the prostitute was the most evil embodiment of humankind's depravity, an inevitable progeny of ugly reality. He viewed reality as the satanic kingdom of the forces of evil, where a woman for sale was both victim and the supreme vice. *Girls*, like other paintings on a similar theme, depicts two bodies, one fat, the other emaciated. The juxtaposition and contrast create a symbol for a universal corruption. But disgust was not the only emotion to overcome him: his fury was combined with sympathy, and it caused him to blame society for leading people into abject degradation.

Rouault was not afraid of using the grotesque to make his point, boldly coarsening the features of his subjects and thickening his paints. In a formal sense he was close to Matisse and Derain. The initiators of Fauvism, however, were predominantly artists of the midday sun, while Rouault was a painter of the night. His nights throng with characters that sometimes hint at caricature, although never entirely belong to that category. Caricature is an attack against a specific evil, with ridicule as its strongest weapon. For Rouault, however, evil is eternal, and laughter has no place in it whatsoever. In all his art Rouault was a tragedian, one of the most powerful tragedians European art has produced. Even when he depicts nature, he is unable to be a serene lyricist. Rouault's landscapes are inextricably linked with the tension of expectation and anguish, and in order to convey these emotions, the artist sacrifices verisimilitude.

In *Spring* (page 292), which in its composition and colour scheme is reminiscent of a stained-glass window, it is difficult to distinguish where the shore ends and the reflections in the water begin. The theme of a spring flood is addressed principally through the use of flowing and surging outlines, all contained within an oval. It is believed that *Spring* was painted in Versailles, but there is not the slightest hint of Versailles's famous sights. Rouault declared with good reason that he was interested not in beauty but in expressiveness, which is achieved in *Spring* through the watered-down blue

set off against thick bands of black, which at first sight resemble a kind of complex hieroglyph. The blue of the landscape – like in Vlaminck's small town compositions – testifies to the influence not so much of Cézanne as of medieval stained-glass windows. Rouault was deeply affected by such windows from an early age, when he worked as an apprentice to a stained-glass restorer. The stained-glass artists of the Middle Ages did not aim to remind parishioners of their daily cares – for these were to be left on the threshold of the church; rather, they spoke of the summits of the soul. Rouault also spoke to the soul through the medium of modern art. As André Malraux wrote: 'For [Rouault], the model does not exist: it is only a possibility, it is what Rouault's painting makes of it – sometimes dense and solid, sometimes flattened out like the stained-glass windows of Chartres.'[24]

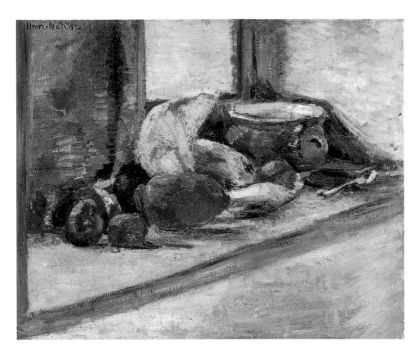

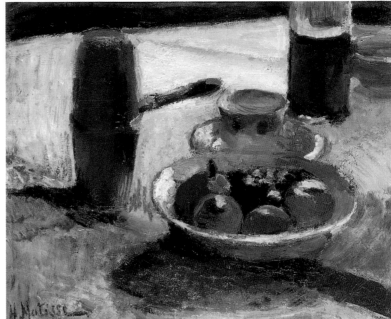

Matisse: On the Threshold of Fauvism

Fauvism would not have been such a powerful and influential move-
ment had not Matisse stood at its head. Like Derain, Dufy, Friesz and
his other contemporaries, Matisse did not see Fauvism as the ultimate
expression in his art, and his Fauvist period only lasted a relatively
short time. But, in his own words, Matisse was 'testing the means at
his disposal' and this period was to be a turning point in his creativity.
The Hermitage collection, like no other, shows Matisse's gradual and
measured movement towards Fauvism and how, having left Fauvism
behind, he achieved new artistic discoveries.

The earliest canvases in the collection, the still lifes from 1897 to 1901,
reveal Matisse's gradual departure from three-dimensionality and the
chiaroscuro treatment of objects. In *Blue Pot and Lemon*, light is no
longer used to bring out the materiality of objects; it becomes a subject
in its own right. The brushstrokes are not so much dictated by the form
of a given object as by the rhythm that arises from the artist's attempt to
keep pace with the flow of light. In *Fruit and Coffee Pot* Matisse is again
preoccupied with the problem of light, which is deliberately caught in its
most difficult form: objects shown against the light. The picture seems
to be painted in order to demonstrate the play of specks and reflexes of
light, and the penetration of light into the shade, although colour does
not play a subordinate role.

The three years that separate *Blue Pot and Lemon* from *Dishes on a
Table* were marked by a persistent struggle for mastery of colour,
something that would have been unthinkable without the achievements
of the Impressionists and their followers. In 1897 Matisse met the
patriarch of Impressionism, Camille Pissarro, from whom he received
some important advice. It was probably Pissarro who drew the attention

of the young artist to Cézanne. Matisse's admiration for the Master from
Aix is clearly visible, without any element of imitation, in *Dishes on a
Table*. The picture is notable for the lack of definition in the details and
the strong colouring. Matisse recalled that Sergei Shchukin, having
chosen this still life when he first came to visit the artist's studio, insist-
ed that before closing the deal he should be allowed to keep the painting
for a short time so as to get used to it. 'I was fortunate that he passed
this first test without difficulty, and that the still life did not weary
him.'[25] Shchukin did indeed settle on the picture. The contemplative
element evident in this painting was already integral to Matisse's work.
It reflected not just the pursuit of a new style, but also a sound know-
ledge of the Louvre collection. Encouraged by Gustave Moreau,[26] Matisse
copied canvases by Poussin, Watteau, Fragonard, Chardin, Raphael and
De Heem. Reworking their paintings, he made discoveries that he could
never have found in the official art of the Salon.

Two distinct tendencies emerged in Matisse's art from 1898 to 1900:
a tendency towards calm and contemplation, and, at the same time,
a clear emotional agitation, expressed through the stirring-up of the
paint surface – bright colours, sharply separated brushstrokes and a
deliberate sketch-like quality. This unfettered agitation, which Matisse
later learnt to control, may be seen as evidence of youthful impatience
and tension, *Sturm und Drang*. This impetuous creativity would have
been unthinkable from a recent graduate of the Ecole des Beaux-Arts
before the example set by Van Gogh and Gauguin.

In the summer of 1897 Matisse acquired a sketch by Van Gogh.[27] In
1898, when he set off for Corsica for several months, Matisse was still
strongly under his influence. Contemporary critics have often pointed
out that Corsica had the same effect on Matisse as Arles did on Van
Gogh. It is even possible that the very idea of working in the south

was inspired by Van Gogh, and Matisse reacted to the light and colour of the south, just as Van Gogh had ten years earlier. A concern for the intensity of colour persuaded Matisse to turn to painting at speed in *Sunflowers in a Vase*; as might easily be imagined, this led him to try out new paint combinations, which resulted in a darkening of the colours. For Van Gogh the sunflower was an embodiment of the sun, and although the same idea is not entirely absent from Matisse's work, an attempt to resolve purely artistic problems is the real point of this variation of the sunflowers.

By this time Matisse already considered himself a representative of the overall Post-Impressionist movement, which was leading towards pure colour. However, notwithstanding the fact that several of his predecessors had already travelled this route, Matisse was unable to take a shortcut and emerge immediately at his final destination. His art started with the restrained half-tones of everyday reality in the still lifes of 1890. This was the year of Van Gogh's death, an artist who had already achieved astonishingly intense colouristic sonorities. Matisse, however, did not attempt to jump immediately from his early Realism to another, more brightly coloured, reality. Like Vincent Van Gogh himself, Matisse needed to develop his own sense of colour, a process that was to take several years.

One of the earliest and most wonderful examples of the way in which he transformed nature through the use of pure colour was the small still life *Dishes and Fruit*, which is one of Matisse's key early works. There is no doubt that he was under the influence of Van Gogh and Cézanne, and by adopting the colouristic intensity of the former and the spatial and plastic generalisations and *perspective plongeante* of the latter, it could be said that Matisse was competing with both. In comparison to Van Gogh and Cézanne, Matisse was less concerned with defining the nature of objects. For example, it is difficult to say exactly which red fruit is portrayed in the right side of the picture. Is it an apple? A pepper? The same can be said of the light green fruit in front of it – either an apple or a quince. The viewer is presented not with a mirror image of objects so much as their terse and sonorous representation in colour. This picture was truly ahead of its time, and has aptly been called proto-Fauvist.

Jardin du Luxembourg and the other Parisian landscapes of the same period reveal features that bring Matisse's art close to that of Gauguin, another important influence for Matisse. His sympathies were even evident in his choice of canvas, always coarse-grained, like the jute hessian favoured by Gauguin. The influence can now be seen not only in the disregard for minor details, but also in the overall calmness of

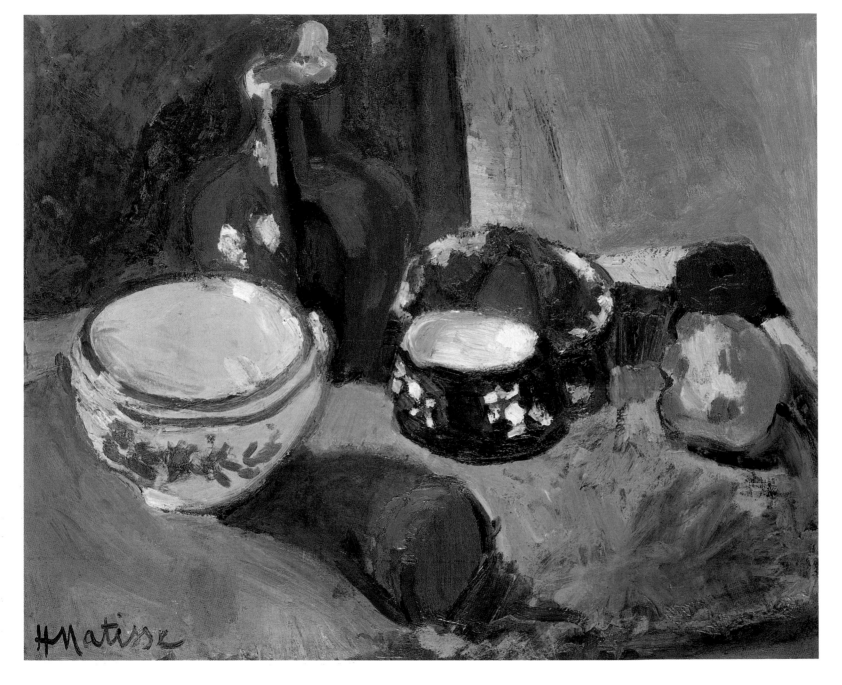

the surface of the picture: the Corsican agitation has been overcome. The whole composition is constructed out of a small number of large, active zones of colour. And although Matisse was not inspired by the colours of the tropics, the colour in his picture is brighter than in Gauguin's. If we compare Matisse's *Jardin du Luxembourg* with Gauguin's *Fatata te Mouà (At the Foot of the Mountain)* (page 165),[28] we can see that both were striving for decorativeness and generalisation through strengthening the role of colour, but for Matisse the reproduction of light remained the most important element, and the alternation of areas of cold and warm tones in Matisse's picture means that the depth of space is conveyed in greater relief.

The tonality of *Jardin du Luxembourg* is calm and restrained. Having risen at dawn and set off on foot for the garden from the Quai Saint-Michel, where he was living at the time, Matisse set up his easel in a deserted alley, still sunk in long, dark shades. But where the sun comes through the foliage, the colour bursts through in vivid tones. With this work, we are given a hint of the artist who would, in a few years' time, be accused of 'throwing a bucket of paint in the face of the public'.

L'Exaltation de la Couleur

It was in Collioure in 1905, and in the spring and summer of 1906, that Matisse's liberation of colour really came to fruition. Matisse could not fail to learn from the Neo-Impressionists, and it was their influence that led to the use of separate brushstrokes and distinct patches of colour in *View of Collioure*. These were the two techniques that formed the basis for Matisse's new art. The separation of brushstrokes in *View of Collioure*, however, is not applied with the same methodical precision of Signac or Cross, nor is it aimed at creating the effect of luminescence through the optical blending of colours. Above all, the technique has an expressive function: to convey the roof tiles sparkling in the sun and the play of light on the sea, while the walls of the houses and the mountains are portrayed through even patches of colour. Furthermore, the brush-strokes are applied on such a large scale that the Neo-Impressionists' theories of light become irrelevant. As with Derain, who worked along-side Matisse in Collioure at the time, each brushstroke attains autonomy, partly due to the lack of shading in the treatment of individual objects – a lack of shade that was to some extent dictated by the dazzling southern sun.

'The means of expression', Matisse was to write three years later in his *Notes of a Painter*, 'must almost inevitably flow from the temperament of the artist. He must have the simplicity of soul that allows him to believe that he has painted only what he has seen. People who conscious-ly stylise and knowingly depart from nature must inevitably depart from truth itself. When he reasons, the artist must of course realise that his picture is an artifice, but when he paints, he must have the feeling that he is copying from nature. And even when he departs from nature, he must remain convinced that he is doing so to convey nature more completely.'[29] Matisse's bright paints and their method of applica-tion to the canvas served to convey a simple, even naïve impression of nature. The complete liberation of colour, however, did not solve all of his problems. The colours had to be brought into harmony with each

other, without 'levelling' or muddying them. It was in the summer of 1905 that Matisse made progress with this difficulty: 'During one season in Collioure,' he later said, 'I began with the idea of a theory or obsession that I heard expressed by Vuillard, who spoke of the "definitive touch". This helped me enormously, because it gave me the sensation of the coloration of the object: I applied the relevant colour, and this was the first colour on my canvas. Then I would add a second colour, and since this colour would not accord with the first, I would apply a third to reconcile them. I would then continue in this vein until I had the sense that I had a canvas in complete harmony, and that I had given vent to the emotion that had driven me to paint the picture in the first place.'[30]

In *View of Collioure*, the first two colours were the reddish-orange of the roofs and the blue of the sea. The conciliatory role of the third colour is the green, while the other conciliatory colour is the pink.

In his Collioure landscapes of 1905 Matisse took a major step forward as a colourist, even in comparison to a radical work such as *Dishes and Fruit*. In that earlier work, objects are conveyed through pure, unmixed colours, but the artist was already struggling with the fact that they did not always sit easily side by side. He was thus concerned that the fruit and cups in the still life should, where possible, be distinguished by a light violet outline. This harmonising outline was chosen to ensure that

the patches of colour on the canvas should be expressive, without losing any of their intensity. Nevertheless, this technique led to an inevitable compromising of the brightness of the colour.

The fiery colours of the Collioure landscapes, reflecting the feverish and rebellious energy at the turn of the century, would seem to have little in common with the structural sketched basis of the work of Cézanne, the artist whom Matisse admired above all others. However, the impression of paints slapped on the canvas spontaneously and without prior preparation is misleading. Certainly the paints are applied to the canvas with considerable urgency. The painting process, however, was preceded by a

period of consideration, when, pencil in hand, each detail was precisely defined in delicate contours, now almost buried beneath the avalanche of colour. Following on from Van Gogh and Gauguin in his search for the greatest possible dynamism, Matisse turned to the juxtaposition of contrasting tones. He went further in giving autonomy to his colours, but even his most experimental works are based on an examination of nature, on which he relied more than either Van Gogh or Gauguin, as is evident in the use of brushstrokes in *View of Collioure*. While Gauguin sacrifices individual brushstrokes in favour of broad zones of colour, and Van Gogh employs urgent strokes that express emotional turmoil, Matisse's technique lies somewhere between the two: he com-

bines areas of flat colour with separated brushstrokes, although he is closer to Van Gogh in his tendency towards extreme colouristic intensity. The paints used in *View of Collioure* are condensed and purified to reflect the concentrated emotion of the artist. The Mediterranean midday colours are, in reality, different, since under the blazing sun they tend to lose their strength and become whitened. Matisse could not allow this in his art – indeed, it did not even occur to him to pursue the illusion of true light, since this would have entailed giving colour a secondary role. Matisse believed that colour was sufficient in itself to convey everything the artist could want. And indeed his colours convey the intense, luxurious heat of the south wonderfully well – not literally, of course, but metaphorically.

If *View of Collioure* belongs to Matisse's early Fauvism, then *Lady on a Terrace*, also painted in Collioure two years later, is another step in the direction of decisive simplification. The picture is notable for the persistent use of coloured outlines, only hinted at previously. The emergence of outlines brought the artist's thoughts back to the organisational role of drawing, which for a time had been submerged beneath the avalanche of colour; it was to herald the swift end of Fauvism. It is true that the outlines in *Lady on a Terrace* introduce their own tones in relation to the areas of colour they surround. Not only do they differentiate and heighten the dynamism of each colour zone, they also bring neighbouring colours into harmony with each other. Matisse deliberately forces this technique, already adopted by Van Gogh. Even more so than Van Gogh's canvases, however, this picture is reminiscent of children's drawings: in the recklessly thick contours, the overall two-dimensionality, and in the selection of details – the bright green hills, the house on the shore, the sail. It is possible that Matisse was attracted to and amused by his own young sons' drawings of their mother, for it is Amélie, the artist's wife, who is shown in the picture.

One of the driving forces behind the aesthetic of Fauvism was the desire to return to first principles. 'When the means become so refined, so delicate, that their expressive force is exhausted, we need to return once more to the essential principles that form the human language. These are the principles that resurrect, that return us to life. Pictures of refinement, of subtle gradations and lifeless blends – these are what drive us towards beautiful blues, beautiful reds and beautiful yellows, colours that stir the depths of the human soul. This is the point of departure for Fauvism: the courage to return to the purity of means.'[31]

The Fauvist stage of Matisse's still lifes is clearly visible in *Vase, Bottle and Fruit*. In terms of colour it is radically, even conceptually, different from his previous paintings in the genre. Its very construction – it was painted over a previous composition – heralds a new era in art. The dark shade of the original painting is half-covered in rapid, diluted whitening strokes, which, together with the bright patches of the fruits and the designs on the tablecloth, create the impression of an almost pastel-like sonority. However, the artist had absolutely no intention of turning to the tender, soft intonations of pastel. His brushstrokes are aggressively applied to the canvas, in one burst, heralding the 'art of action'. And yet, as always with Matisse, the impetuous is tempered with reason. The magical colours have a solid structure, recalling the artist's classical studies, in particular his Louvre copies of Chardin's *Pyramid of Fruits* and De Heem's *Still Life*. The composition is considered and deliberate. The sparkling apex of the milk jug defines the centre of the work. The vases and vessels, apparently placed at random, in fact counterbalance each other, while the table covered in *toile de Jouy* provides an elegant and sturdy pediment to the pyramid of fruits.

In his Fauvist years, Matisse did not always approach different genres in the same way. He was most radical in his treatment of landscapes and

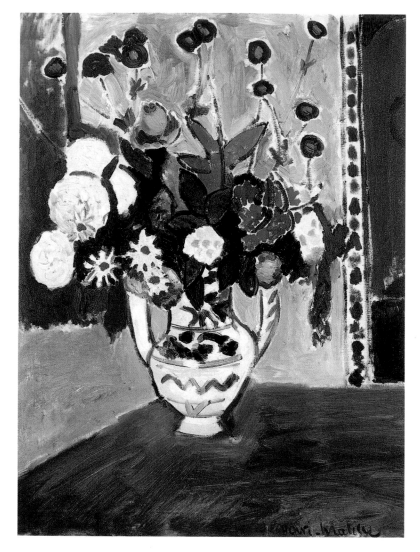

figured compositions. In still lifes, as a rule, he was more dependent on nature. His landscapes tend to be relatively loosely structured. In their overall composition they might appear to have been painted by one of the Impressionists: a piece of space is plucked almost as if at random from a panorama, and it is then extended in any direction at the whim of the artist. Only occasionally does Matisse turn to identifiable landmarks, such as in *View of Collioure*, where the bell-tower of the church of St Vincent is given the role of a central axis. In the still lifes, however, everything is carefully considered in advance.

In *Dishes and Fruit on a Red and Black Carpet* the spatial scheme is undoubtedly in the manner of Cézanne, but the picture, with its wide zones of colour, is structured in the spirit of Gauguin. In the first place, the subject is an Eastern artefact, for it is the carpet, not the fruits, that is central to the work. The deep red of the carpet is the dominant colour of the work, and dictates the inclusion of additional emerald-green tones, for which the artist required lemons and a banana, as well as the *porrón* of green glass. This exotic Spanish vessel superbly complements the Eastern ceramics and fabric. It also plays a vital compositional and spatial role: its neck establishes the middle ground of the picture and provides a vertical element which stabilises the whole structure, while the spout echoes the shortening perspective of the carpet. Like Delacroix before him, Matisse pursues a red and green key; however, he now takes the colours to their extremes of intensity, and in order to achieve harmony, requires the addition of a third colour. This colour is already contained in the carpet, the centre of which is coloured black. The sprinkling of lemon-yellow in turn imparts depth and strength to the black. In this way the carpet assumes overriding importance in the colouristic structure of the picture, and is not a mere background for the other items. On the contrary, the objects are designed to bring out the exultant, luxurious beauty of the carpet. When Matisse first visited North Africa he brought this prayer-mat back from Biskra, as well as the two-handled vase shown in *Bouquet*. These items were not simply attractive details; they provided the 'touchstone' for each of these works.

The Shchukin Commissions

Matisse's most powerful innovations in colour were carried out in his commissions for Sergei Shchukin, in the programmatic works *Red Room*, *Dance* (page 306) and *Music* (page 307). *Red Room* was to become one of the turning points in the history of European art. Matisse was pursuing a harmonious balance in this painting despite the unprecedented dominance of the red colour. He was testing his colours' expressive potential by pushing them to their optimum intensities.

Red Room was originally quite different in tone, and was entitled *Harmony in Blue*. After a radical reworking it appeared at the Salon d'Automne of 1908 under the name *Decorative Panel for a Dining-Room*. The picture did not last long as *Harmony in Blue* – probably not more than two months – and then an unexpected impulse prompted the artist to repaint it. Matisse was in a somewhat difficult position at the time, because *Harmony in Blue* had been commissioned by Shchukin, who had evidently had reservations about its tone, but the reworking had

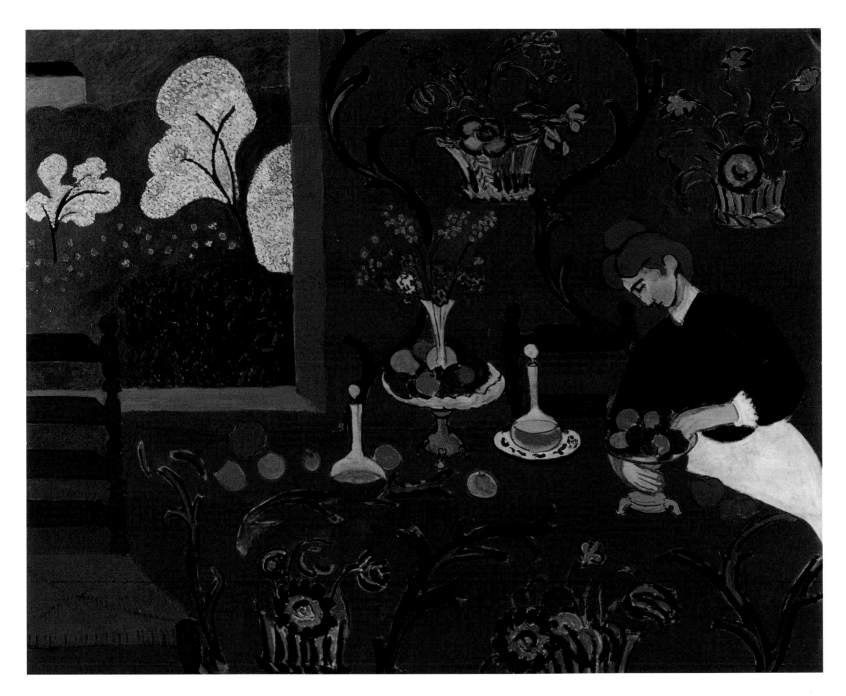

not been discussed with him. Matisse was rather embarrassed by this lack of consultation, though it is true that some of the most successful pieces of contemporary art have resulted from unexpected transformations. Although a blue picture would have been more decoratively suited to the large dining-room of the Shchukin mansion, the owner was not dissatisfied when he received *Red Room*. He quickly realised what a step forward the new 'Harmony' represented, and what a stir it would cause in the contemporary art world, and soon informed Matisse that the *Red Room* pleased him greatly.[32] The history of this remarkable work shows that there are countless ways of achieving harmony, and that one and the same composition can achieve entirely different symphonic results.

The starting point for *Harmony in Blue* had been the decorative *toile de Jouy* that Matisse painted on numerous occasions. The finest representation of the fabric remains *Still Life with Blue Tablecloth*, which serves as a kind of postscript to *Red Room*. After the Salon d'Automne of 1908, once more inspired by the *toile de Jouy*, Matisse laid the cloth out on a table, giving it the role of both tablecloth and richly figured background, reminiscent of Early Renaissance pictures. The trio of objects, introduced into such a non-domestic setting, take on qualities unconnected to their everyday use. The objects do not cast any shadow, and are assigned a subordinate role to the powerful arabesque, so that the fabric, in the words of Louis Aragon, 'poses, becomes the model'.[33]

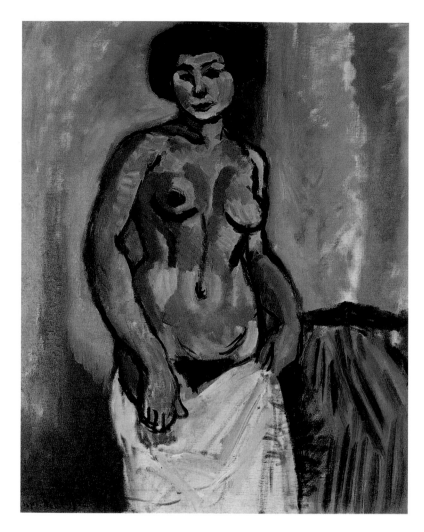

As in *Red Room*, the floral garlands of the *toile de Jouy* become mighty arches forming the rhythmic basis of the entire picture. In order to achieve this effect, the artist uses a dual viewpoint: while the objects are viewed from the side, the fabric is viewed as if from above. But although Matisse combines the flatness of the canvas with the two-dimensionality of the cloth-covered table, he does not lose all sense of depth. The elements in the painting hover between two-dimensionality and three-dimensionality since Matisse does not include any shading.

In both variations of the *Decorative Panel for a Dining-Room* (*Harmony in Blue* and *Red Room*) every detail is subordinate to the S-shape of the fabric's design. As in medieval or Oriental painting, the concept of a third dimension is entirely absent. Matisse's earlier, more represen-tational paintings allowed the viewer to imagine himself a participant in the scene portrayed. The *Decorative Panel* is already a 'thing in itself', a fusion of the real and the entirely artificial, heralding the innovations of the twentieth century.

The first striking feature of *Red Room* is its deliberately poster-like clarity and simplicity. However, while the information in a poster is

designed to catch the attention immediately, Matisse's panel demands that we study it closely and submit to the influence of its powerful rhythmic structure. This structure controls every detail, from the trees in the garden to the carafes on the table or the servant girl placing a bowl of fruits on the table. The arabesque absorbs everything that falls within the artist's field of vision, so that the picture becomes not a mirror of nature but an independent organism, a self-sufficient world. *Harmony in Blue* and its subsequent manifestation, *Red Room*, were conceived as a still life panel. The panel was not painted from nature, but born almost entirely of the imagination. Several years later, Matisse told Aragon of his still life painting when he was studying under Gustave Moreau: 'I thought that I should never paint human figures, but then I began to include them in my still lifes... My figures are alive for the same reason that my still lifes are alive... A loving union, a sense that gives my objects their quality.'[34]

In addition to the overall tone, one detail in the picture was changed. When Matisse was working on the painting in the Hôtel Byron in spring 1908, the trees in the garden were already in bloom, and there was a late snowfall, rare for Paris, which made the trees even whiter. The tops of the trees were transformed into completely white crowns. The garden viewed through the window in the left of *Red Room*, a green counterbalance to the predominant red, has an Oriental feel reminiscent of a Persian miniature. The very treatment of this segment of garden – a rectangle within a rectangle – has an Oriental feel. The Western tradition of the open window implies a spatial depth; by contrast, the Persian miniature avoids this depth and often denotes apparently distant elements of landscape with precise horizontal or vertical geometric borders.

In 1908, Matisse said, 'what interests me most is not still life, not landscape, but the human figure',[35] and this signalled a new stage in the artist's creativity. The figurative composition – the portrait, the nude – now took on considerably more importance. *Nude (Black and Gold)* stands out among works of this latest genre. Matisse's intoxication with colour gradually gave way to the realisation that richness and strength depended not on the uncontrolled forcing of various undiluted colours, but, on the contrary, on the economic use of colour. In *Nude (Black and Gold)*, the artist essentially juxtaposes two dominant colours. They are only modulated and supported by one or two additional secondary colours. The gold tones of the nude body were not Matisse's innovation: we need only think of Gauguin's canvas with nude Tahitian girls *And the Gold of Their Bodies* (1901; Paris, Musée d'Orsay). The difference is that Matisse had no need for the exotic, and arrived at terser conclusions. Ochre and black are enough for Matisse to paint the body convincingly. His habitual ochre takes on jewel-like qualities, while the black forces the ochre to be shot with gold. The black in turn has the depth of a gemstone. It is difficult to think of any other artist for whom black was so expressive and bold. The frame itself, with its gold flourish-es and black background, is so integral to the painting that Matisse must have commissioned it or owned it prior to painting. Its energetic design serves not just as a border to the picture, but also modulates it so that the two elements make a unified whole. The possibilities of a style

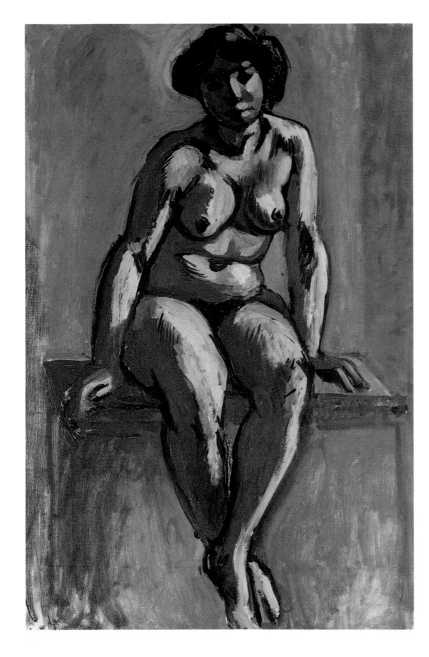

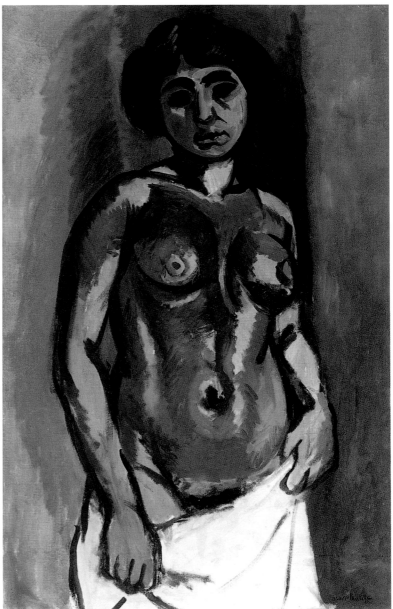

which is representational while simultaneously subordinating the 'real' to its own internal aesthetic are revealed when we compare *Nude (Black and Gold)* with the preliminary *Study of a Nude* which has none of the final work's energy and liveliness.

Matisse deliberately chose *Nude (Black and Gold)* and *Seated Nude* as illustrations for his manifesto of new French art, *Notes of a Painter*. The choice was not arbitrary: his all-consuming work on this motif had led him to a newly expressive range of colour and powerful architectonics in his drawing. Here, the portrayal of a professional model posing for money, elevated to a kind of idealised status, becomes an object of unknown, inspirational respect, an earthly cult figure. In *Notes of a Painter*, Matisse wrote: 'I need to paint the body of a woman. Initially

I give it grace and charm, but then I have to give it something more. I shall try hard to reinforce the significance of the body by highlighting its most essential lines. At first glance the charm may then be less noticeable, but ultimately it will re-emerge in a new form, which I shall create and which will now receive a wider and more fully human meaning. The charm may be less alluring because it is no longer the sole characteristic of the body, but nevertheless it lives on, contained in my overall conception of the human figure.'[36]

Nude (Black and Gold), with its sculptured three-dimensionality, was painted in the same year as the more two-dimensional *Game of Bowls*, where the nude body is depicted in a generalised rather than realistic way. The two works contrast sharply, and not only in terms of style;

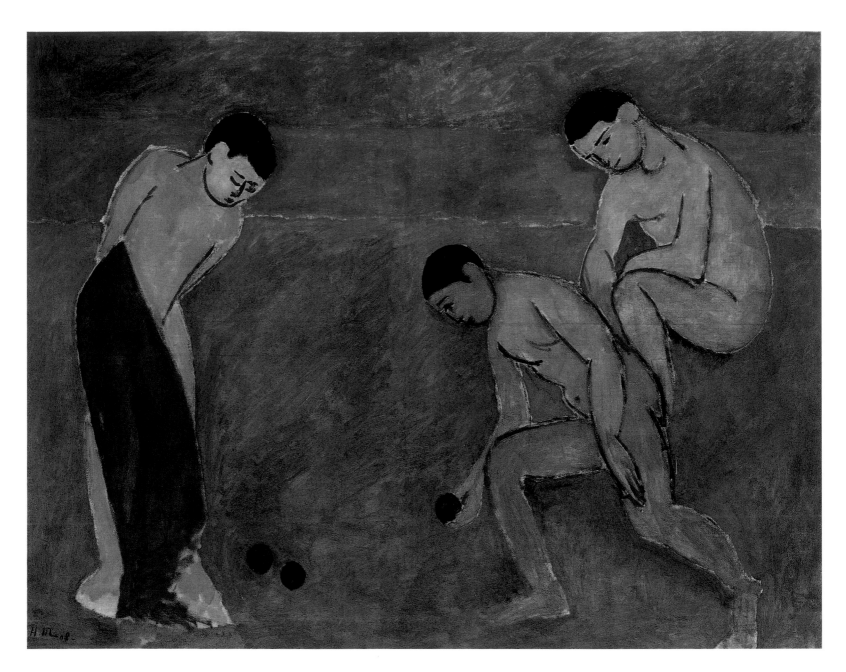

Game of Bowls, 1908, by Henri Matisse

the first is inextricably linked with nature and strives to recreate it, while the second is an unambiguous expression of primitivism (in the broad sense of the word). At that time Matisse was deeply interested in art from outside the usual sphere of European culture, which started with the Renaissance and which by the end of the nineteenth century seemed to have exhausted its resources. Many years later he visited the Barnes Collection in Merion, Pennsylvania, where the paintings of the Douanier Rousseau, for example, were hung alongside works of the late Middle Ages. Matisse commented that such juxtapositions helped us to understand many things that could not be learnt in academies.[37]

Matisse's 'primitivism' is principally connected with humankind's primordial past, to that mythical time when art itself was only begin-

ning. *Game of Bowls* belongs to the Golden Age cycle; it is not remotely idyllic, unlike most paintings on similar themes. The figures in *Game of Bowls*, like those in the later *Dance* and *Music*, are at once like and unlike real people. The youths are obviously enjoying playing *pétanque*, a game popular in the South of France; at the same time, however, their gestures and poses are almost ritualistic. Matisse's characters are not simply enjoying themselves; they are caught up in the 'game of life'. The highly abstracted landscape becomes the only conceivable setting for such an activity, and it contributes to the painting's severe and mysterious symbolism. The watery surface on the horizon – either a river or the sea – is not so much a feature of a country landscape as a symbolic environment, for both river and sea have, since time immemorial, served as a metaphor for the dialectics of life and death. The more symbolic

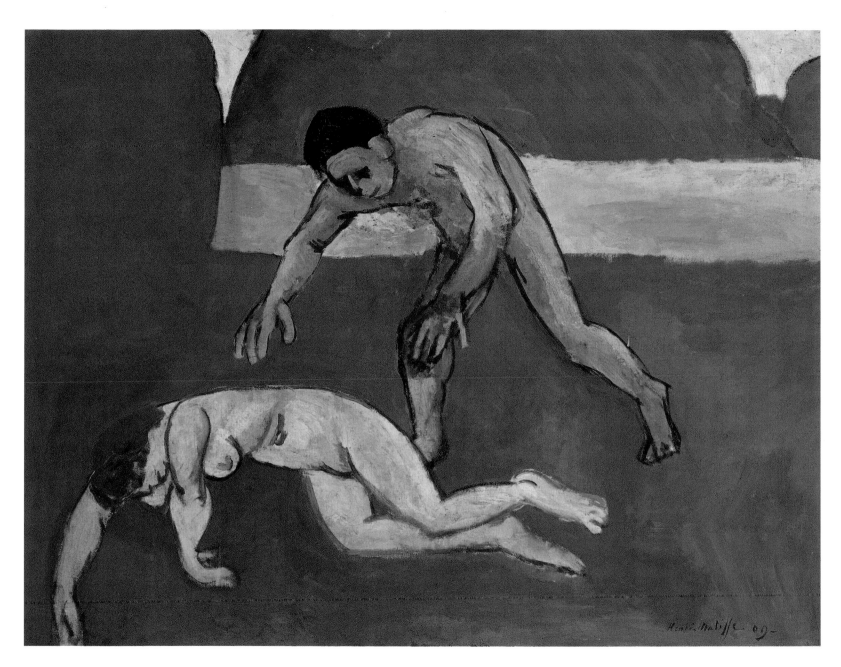

such art becomes, the more it is seized by primitivism, where stylistic aspects of a picture are dictated by its content. In the absence of psychological background or explanatory details, and in the overall simplicity of artistic method, the painting takes on the appearance of an allegory. The number of characters is symbolic: three, a recurring number in folklore. There are, significantly, the same number of bowls as people. The whole scene comes across as a kind of ritualised recognition of fate. The apparently light-hearted theme is developed in a solemn, even dramatic way. The range of colour, contrary to what we might expect, is not joyous at all. The green of the meadow is an embodiment of life born out of the earth, and the Egyptians used green to paint the figure of Osiris, god of nature's reproductive forces and ruler of the underworld. The symbolism of the colours is an intuitive rather than literary device.

The broad and contradictory nature of Matisse's Golden Age series is illustrated by a comparison between *Game of Bowls* and another work from the cycle, *Nymph and Satyr*, which was based on a ceramic panel composition Matisse had worked on almost two years before. But whereas the ceramic triptych is purely decorative, with a contrived border of clusters of grapes instead of the picture's landscape background, the painting commissioned by Shchukin dispenses with all such mythological tokens. The scene is imbued with abstracted, symbolic meaning concerning fate, life and gender, which puts it on a par with *Game of Bowls*, *Dance* and *Music*.

Dance and *Music* represent the most powerful and complete expression of Fauvism – not just of Matisse's Fauvism, but of Fauvism in general.

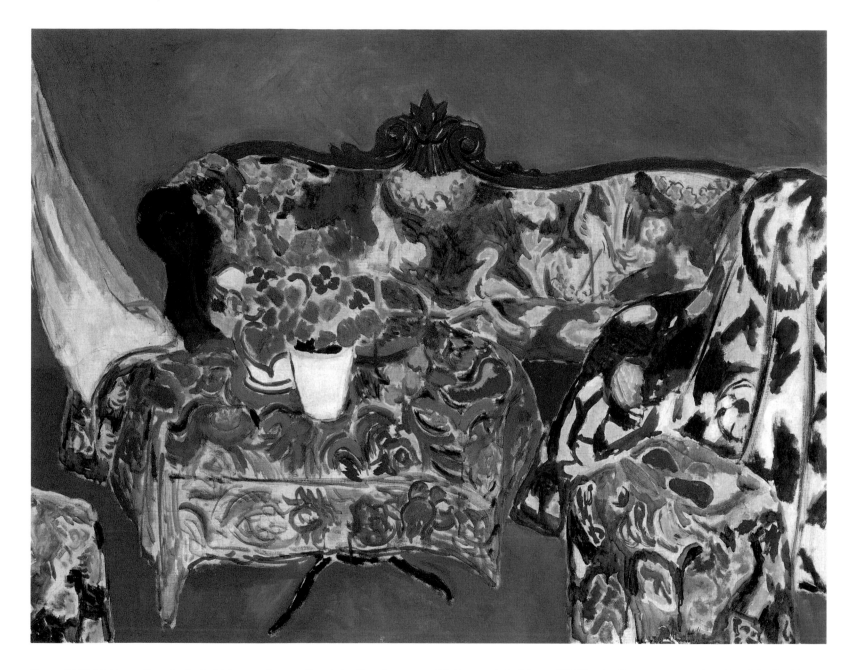

From 1907 Matisse often included his own terracotta statuette of a reclining nude in his still lifes – more often than any other object. Each time, the other objects in the painting gain additional meaning by being placed alongside the statuette. In *Pink Statuette and Pitcher on a Red Chest of Drawers*, which shows a corner of the artist's studio in Issy-le-Moulineaux, the figurine is not immediately recognisable: its outline is less well defined than those of the vessels that surround it. But wherever the eye rests, whether on the bronze decoration on the commode, the jugs or the winding plants, the same motif is echoed again and again – the languid and captivating curves of the body of the nymph, eternal symbol of an ideal world. Whereas earlier Matisse concentrated on the reconciliation of saturated colour, now he was no less interested in the possibilities of the arabesque.

Matisse painted two still lifes in the same room in a hotel in Seville. These were *Spanish Still Life* and *Seville Still Life*, both of which reveal the enthusiasm with which Matisse collected Spanish shawls when he crossed the Pyrenees. The floral designs on the fabric, whether used as a tablecloth or thrown carelessly over the back of a sofa, interact with each other and with the design of the sofa's upholstery, creating a complex and intricate arabesque, now an increasingly important feature of Matisse's work. The same objects are differently portrayed in each canvas, so that when we look from one to the next it initially appears as though we are looking at different objects. This is because the ensemble of objects provoked contrasting emotions in the artist at different times. In comparison to *Seville Still Life*, *Spanish Still Life* has a more emphatic emotional

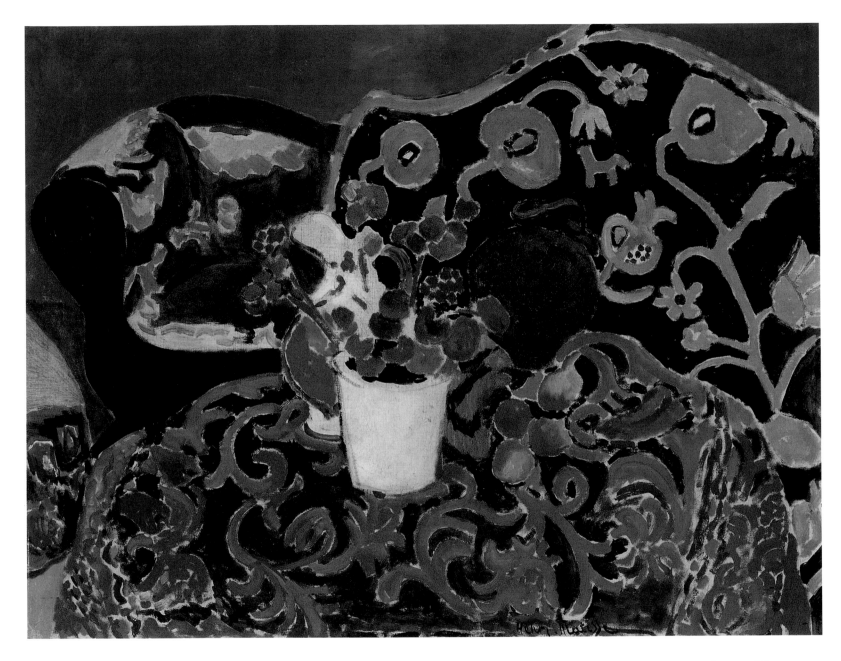

key; it is terser in terms of drawing and stronger in colour. The arabesques of the decorative fabrics in these two paintings represent a step towards Matisse's *Family Portrait* and other large-scale interiors.

At the end of his Fauvist period Matisse concentrated on achieving harmonic balance between decoratively treated details. In works such as *Lady in Green* and *Girl with Tulips*, the psychology of the model, as it was understood in the nineteenth century, is of little interest to the artist. Instead, Matisse tries to use new decorative means to reveal the human 'essence' of his model. In *Lady in Green*, the range of colour is based on the simple, soothing tonal combinations. He places the brightest patch of colour and the woman's sole adornment – the red carnation – in the centre of the composition,

at the intersection of the diagonals. The traditional pose of the portrait-sitter is extremely calm. But despite the old, even outdated outlines, the artist has managed to breathe new life into them, and filled them with a new and entirely contemporary content. Both pictures belong to a genre that was widespread in France in the Romantic era. These are not portraits of particularised individuals. For both Matisse and the collectors they remained unnamed 'ladies' or 'women'. Such works were normally exhibited as 'figures' and they usually portrayed paid, but not professional, models; the studied poses of the latter held absolutely no attraction for Matisse.

Matisse instinctively combined the specific (that is, a portrait, an interior or a landscape) with the abstract and even the philosophical.

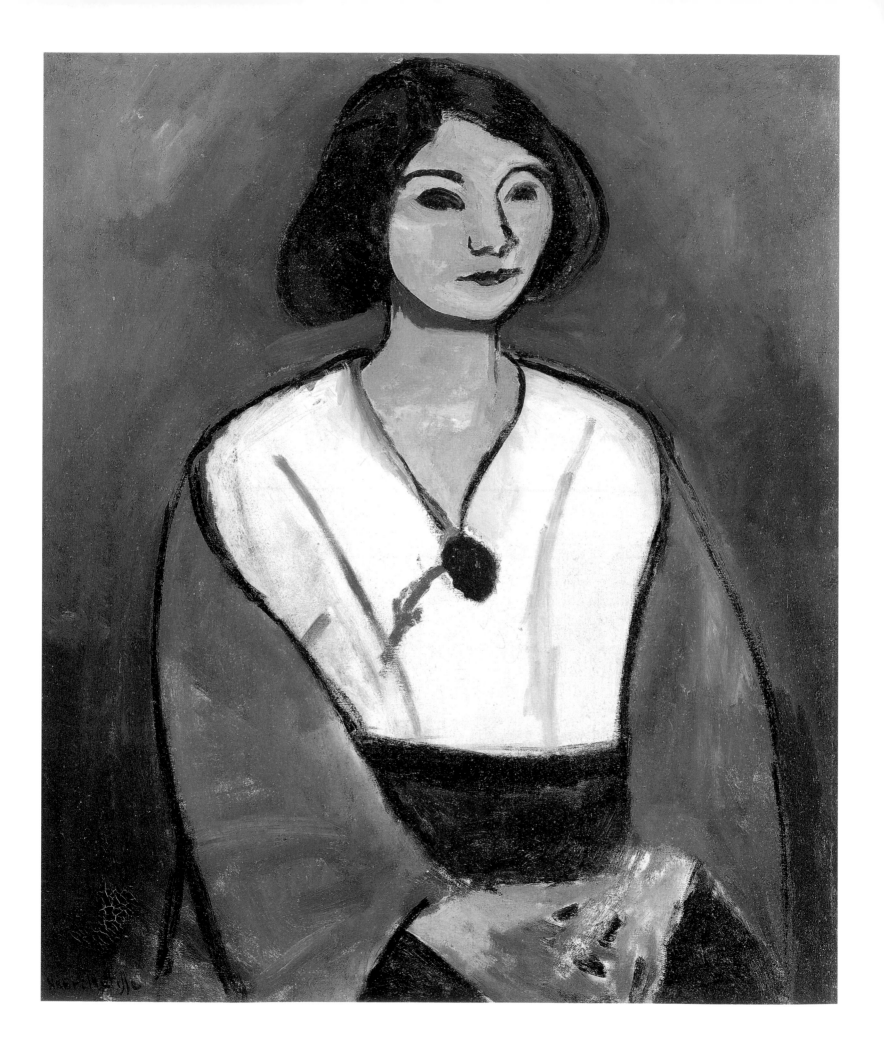

This is magnificently illustrated in *Conversation*, one of the pinnacles of Matisse's achievement. Having transformed *Harmony in Blue* into *Red Room*, Matisse nonetheless did not abandon the idea of a monumental composition with blue as the dominant colour. Like *Red Room* before it, *Conversation* introduced a hitherto unseen concentration of a single colour into European art, although this time the colour was blue. It surrounds the figures and is at once a kind of ideal substance, an embodiment of concentrated thought, and a more concrete depiction of the shading of the room. The Impressionists, who were the first to uncover the blue nature of shade, would have been quite astonished to see their innovation taken to such lengths. Van Gogh had already imparted an absolute and timeless quality to details that the Impressionists had caught in their momentary, fleeting state. Matisse went much further. The blue in *Conversation* cannot be understood simply as shade, for it relates not only to the physical world, where any object can have a shadow if it is lit, but also to the spiritual world of the artist's emotions. Matisse was concerned not so much with objects in themselves as with – in his own words – their 'interrelation'. For this reason he retains the shading of objects in order to recreate the illusion of real space. At the same time, however, he based his art on the idea that the canvas is a two-dimensional space, the sense of which must always be conveyed.

The beauty of inspired colour, operating above or in addition to what was dictated by strictly illustrative imperatives, arose because Matisse moved far beyond verisimilitude, and worked in an abstract sphere. In *Conversation*, even the aperture of the window into the garden does not disrupt the two-dimensionality of the work. In order to achieve this effect Matisse painted the glade in a single green tone, interrupting it with dashes of blue, which reconcile the view through the window with the overriding colour. The remarkably minimal drawing allows the autonomy of colour. For centuries art throughout the world had sought inspiration in the juxtaposition of the masculine and the feminine. Matisse did the same in an almost schematic manner, through lines and primary symbols. The black railing serves as a bridge between the two figures, between the persistently repeated verticals and the tensed curves. The railing has a concrete role as part of the building at Issy-les Moulineaux, and an abstract one as a kind of code for the whole picture. It represents the juncture of two starting-points, separately identified by the figures of the man and the woman. The former is depicted using straight lines, and the latter through more curving lines. The two origins are brought to life by their union. The tree, which stands between the two main characters and combines the straight and rounded forms, is both the tree in the garden at Issy, and also an ancient symbol – the tree of life. The meaning of such detail is more complex, more multifaceted than, for example, in *Red Room*. There, the whole composition is determined by its decorative nature, whereas here the decorative is only one of many aspects of the painting.

The composition juxtaposing a man and a woman – a motif to which Matisse never again returned – is bathed in blue, which becomes an indissoluble substance representing quiet, purity and mystery. It is a

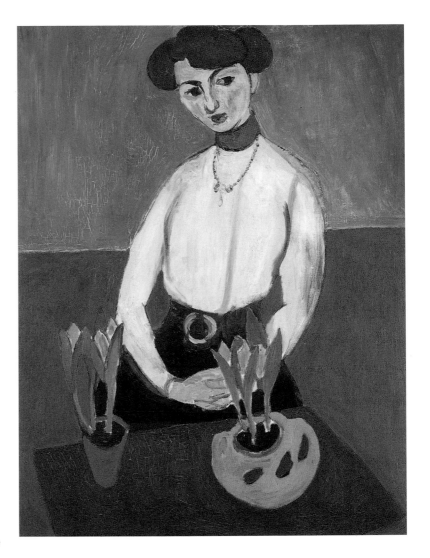

motif much more common in literature than in painting, where it first left its mark in the 1890s (Munch's *Eye to Eye*, 1894, Munch Museum, Oslo; Bonnard's *Man and Woman*, 1900, Musée d'Orsay, Paris). With Matisse the theme retains its existential origins, and in his hands it finds a truly profound resolution for the last time in European art. This is all the more striking because the picture is almost anecdotal and includes a note of self-irony; the couple portrayed are Matisse himself and his wife Amélie. It is morning. The wife is either asking or explaining something to her husband, recently woken and still in his pyjamas. A comparison of the man in *Conversation* with photographs and self-portraits reveals that Matisse has caught his own pose with great perception. But even more remarkably, these particular details are combined with the abstract, where the characters operate on an almost mythological level. We are reminded of the Annunciation and various 'foretellings' in the art of the Ancient East. It is ultimately of little importance exactly which of the variations of ancient myth the artist refers to – what is important is that his work tells of the ancient, sacred motif of the heavenly news, the *message du ciel*.

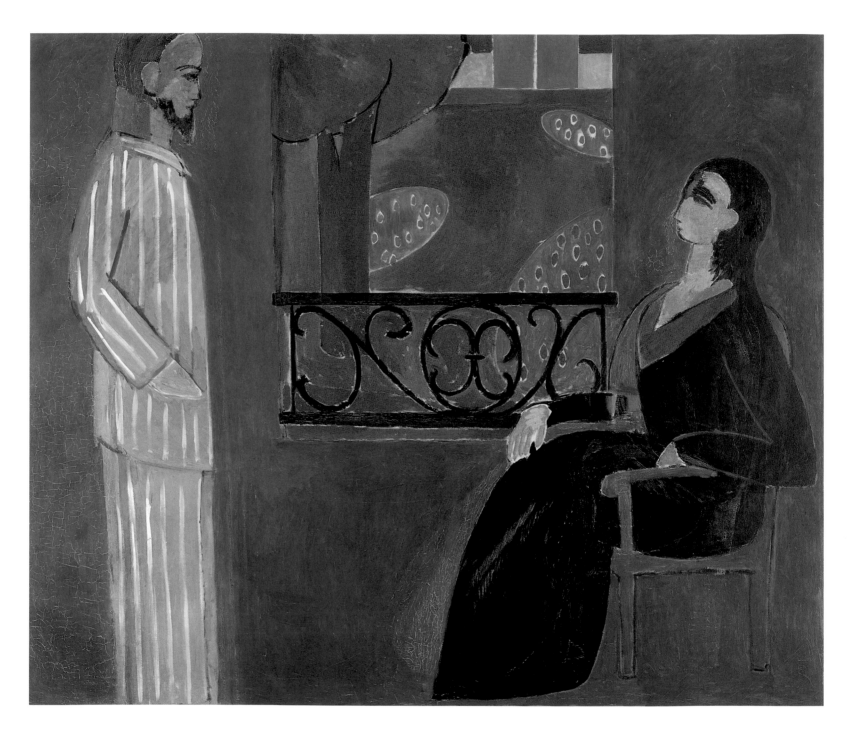

In old age the artist was asked whether or not religious art still existed. He replied: 'All art worthy of the name is religious in itself. Whether created by line or by colour, if it is not religious, it does not exist. If a work is not religious, it can only be anecdotal or documentary, and then it is not art.'[41] *Conversation* is obviously a religious painting, both in its formal construction and in its artistic and historical allusions. The blue is reminiscent of Giotto, who was always Matisse's favourite artist. Shchukin, who immediately understood the spiritual import of the canvas, saw in it different associations: 'I often

think of your blue picture (with two figures)', he wrote to Matisse. 'It seems to me like Byzantine enamel, so rich and deep is it in colour. This is one of the most beautiful pictures that I now remember.'[42]

Family Portrait stands in complete contrast to *Conversation*. Two types of composition are combined here: elements of monumental art come to life alongside intricate decorative design. The theme of the group portrait now finds an infinitely more complex resolution than before. The wife engaged in embroidery, the daughter, and the

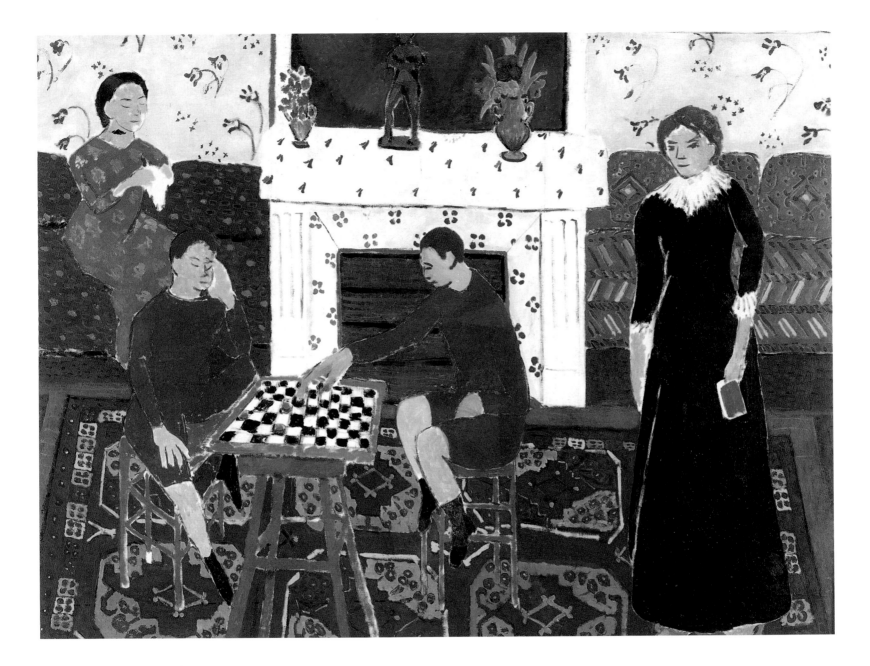

two sons playing draughts are presented as an everyday domestic episode. The motif of the checked pattern on the draughts board in the centre unites the Oriental carpet, the sofa, and the ornamentation on the walls and fireplace. The most important features, however, are the resonant patches of colour in the family's clothing: the scarlet shirts of the boys and black dress of the girl. The dense area of black, which plays a more active role here than in *Conversation*, is one of the boldest innovations of early twentieth-century art. Only the dress of the mistress of the house is not as dynamic. The logic of the colouristic composition of the work forced the artist to ignore a fully realistic representation. Gertrude Stein recalled that Madame Matisse usually wore a black dress, but, in the interests of colour harmony, she is here dressed differently and placed in the background.

The characters' faces are formulaic and lack distinguishing features; only the most strained interpretation could see them as portraits. Portraiture is entirely secondary to colouristic concerns, and indeed the picture is essentially a debunking of the traditional idea of the group portrait and of portraits in general. It is no coincidence that three decades later Matisse was to say: 'As for the portrait painters – they are being outdone by the good photographers.' And in response to the question 'So why then do we need artists? What use are they?' he replied: 'They are useful because they can augment colour and design through the richness of their imagination, intensified by their emotion and their reflection of the beauty of nature, just as poets or musicians do.'[43]

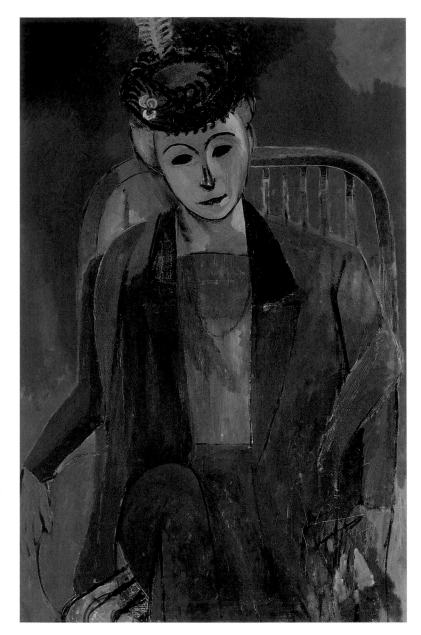

Much earlier, Matisse had noticed that the expressiveness of Eastern carpets was often based on the juxtaposition of comparatively large areas of pure colour – black, for example, in Arabian prayer mats – with sections of ornamental design. In *Family Portrait* this technique has a very particular purpose. While the figure of Madame Matisse almost blends into the background, perhaps suggesting that she is the soul of the house, Matisse's daughter Marguerite, who was a woman of considerable independence, stands out in her black dress, which is reminiscent of the ceremonial robes of Emperor Justinian in the Ravenna mosaic of San Vitale (*c.* 547). It was only six months after painting *Family Portrait* that the artist remarked in Moscow: 'The Byzantine style impresses with its monumental qualities.'[44] The women are positioned on different sides of the picture, as though to

mark the complex relationship between Madame Matisse and her step-daughter. Finally, the red shirts of the boys are not just patches of red, organising the central part of the composition; they are symbolic of energy and competition, and it is entirely appropriate that the artist's sons should be playing a game. With colour and its organising rhythms the artist has created a work where the mundane becomes ceremonial, almost hieratic; the picture thus becomes a solemn portrayal of the finest and most elevated features of human nature.

It is interesting that in creating such a large-scale painting Matisse was inspired by art that is far from monumental: 'Persian miniatures showed me the full possibility of my sensations. Through its details, this art suggests a wider space, a truly plastic space. It helped me to overcome the limitations of intimate art.'[45] At the very time that traditional Europeanism was leading art into a cul-de-sac, Matisse sought refuge in the art of the Orient. Vanderpyl, who witnessed the Salon d'Automne of 1913, and who was no great admirer of Matisse, noted the effect of this 'Orientalism': 'I remember as if it was yesterday the success that M. Henri Matisse achieved at the Salon d'Automne, the last before the war, with his portrait of Mme. H. M. "It is more powerful than Chinese art", one of my colleagues confided in me ecstatically. Yes, yes, Matisse has managed quite superbly to learn from the lessons of the East, both Near and Far.'[46]

The Hermitage portrait rightly has pride of place in the magnificent cycle of portrayals of Amélie Matisse. The changing details of these pictures – whether the dress of the subject or any of the objects surrounding her – were important to Matisse, since they led him to look at a familiar face in a new way. In *Portrait of the Artist's Wife*, Amélie Matisse is presented not as the mistress of the house, as in *Family Portrait*, but as an elegant *dame*. For all their schematic nature, examples of the latest fashion – the hat with a feather, the cut of the jacket, the scarf carelessly thrown over the shoulder – are conveyed with extreme precision, although of course these were not for Matisse the most interesting elements in the painting. The picture is unusual because it combines elements of portraiture with decorative qualities. Shortly before he started work on the picture, Matisse told Clara MacChesney, 'I seldom paint portraits, and if I do, only in a decorative manner. I can see them in no other way.'[47] The woman's face is like a mask, reminiscent of the theatrical masks of antiquity with their mysterious symbolism, or the masks of Western Africa that exist to this day and the bleached mask-like faces of Japanese *myiki*.

Matisse in Morocco

Matisse's fascination with North Africa was most markedly expressed in his two journeys to Morocco in 1912–13. He was persuaded to go there by Marquet, and hoped that the southern lighting, even more intense than in Collioure, would stimulate new developments in his art. Until very recently it had been Matisse whose work represented the latest word in art for the Parisian avant-garde. Now, however, Cubism offered young artists different and, as they saw it, more revolutionary and thus more seductive artistic principles. It was therefore necessary for Matisse

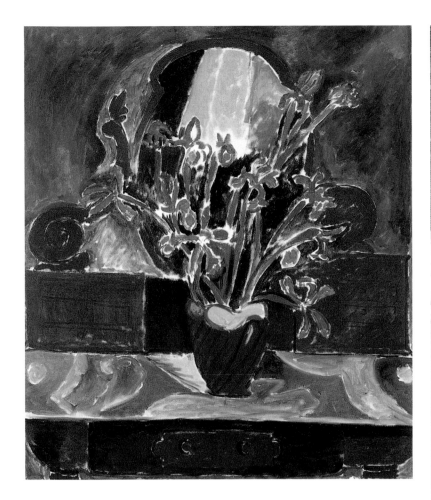

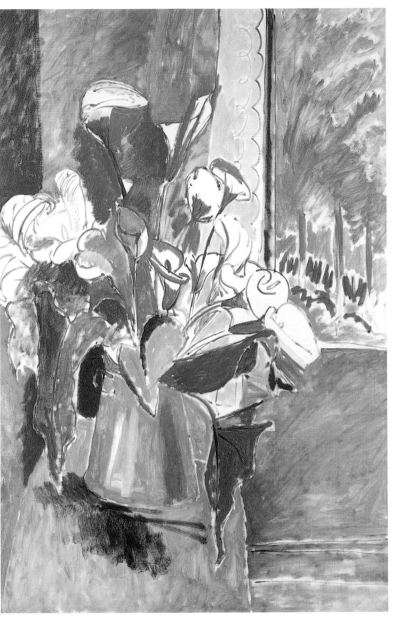

to prove once again that the path chosen by him – and from which he had no intention of departing – could lead to new horizons. His very first Moroccan picture, *Vase of Irises*, became one of the artist's most unusual still lifes, both in terms of colour relationships and in the choice of objects portrayed. The mirror plays a crucial role here, although not for the outdated effect of the juxtaposition of an object and its reflection. Rather, it serves as a kind of 'tuning fork' for the whole work: by containing the brightest and darkest colours in the picture, the mirror sets the tonal scale. At this stage in his career Matisse frequently depicted pot plants; it enabled him to include the black colour of the earth, essential for contrast with the other brighter colours. This was the effect he created with the geraniums in his Seville still lifes. In *Vase of Irises* the viewpoint is such that the earth is not visible, but the essential black colour is provided by the mirror. Its mysterious dark recesses contrast wonderfully with the stems of the irises as they reach up from the vase. In his depiction of the thoroughly provincial neo-Rococo dressing-table and mirror, Matisse does not seek refinement; rather, he uses the piece of furniture as a point of contact with the other objects in the picture. His penetrating eye opens up the unexpected parallel between the petals of the flowers, the frame of the mirror, the stems and the simple designs on the vase. In this way he underlines the unity of all the elements in the still life; an object that is clearly inanimate comes to life as it is likened to the flowers.

Matisse painted two more floral still lifes in Morocco, *Bouquet (Arum Lilies)* and *Light-Blue Vase with Flowers on a Blue Tablecloth* (Moscow, Pushkin Museum). Both pictures compare living flowers with fabric, but while the first is a celebration of drawing, the second is a celebration of colour. In *Bouquet* the tendrils of the arum lilies find an echo in the wavy ornament of the curtain. Equally, the movement of the windswept trees seen through the window reflects that of the lilies on the table. The rhythmic echoes are muffled and gentle in tone. *Light-Blue Vase*, by contrast, is a crescendo of colourfulness. Everything in the picture is precise and grandiose: it is a celebration of what has passed, of what is complete, whereas *Bouquet* is a picture of process, a poem of early morning, where there is much yet to be defined and everything breathes of an unrealised potential.

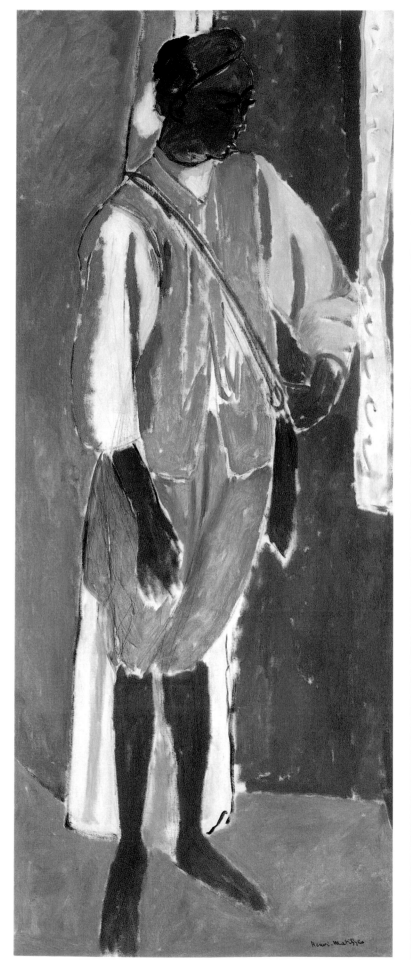
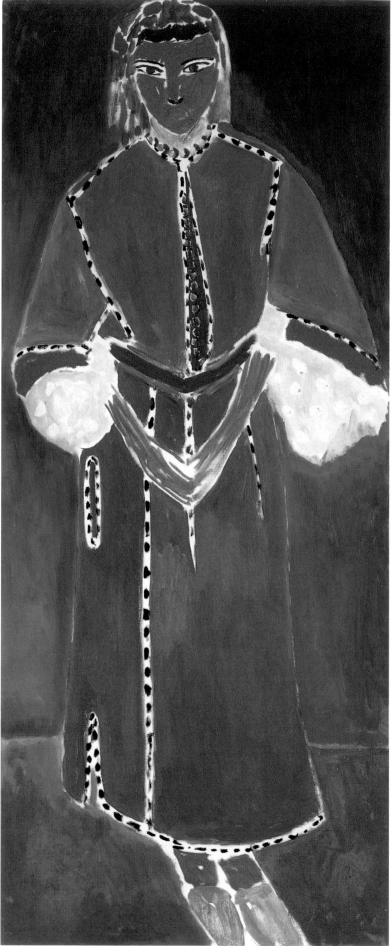

In his Moroccan period Matisse turned as never before to ensemble works, creating actual or hypothetical triptychs and two-part suites. *The Moroccan Amido* and *Zorah Standing* offset each other wonderfully. Both are life-size portraits, but they are executed with a remarkable simplicity and freedom that could only normally be expected of a water-colour sketch. Lightness is the key to everything here: the application of the paint, the light tonality, the absence of shade, the stretched perspective and, in particular, the fluid pose of the young man.

Of all the Moroccans whom Matisse met, Zorah left the strongest mark in his art. He liked to draw her, although he did have to be careful working this way in a Muslim country. When he returned to Tangiers in the autumn of 1912, for some time he was unable to find her until he discovered that she lived in a brothel. Matisse managed to persuade Zorah to pose for him once again, even though she occasionally annoyed him. The celebratory, hieratic nature of the picture is unconcerned with these details; the interweaving of the everyday with the highly poetic reality of a work of art was now Matisse's principal concern. In *Standing Moroccan in Green* the predominant malachite tone is not only the colour of the Moroccan's outer garment; it is itself an embodiment of energy. The subject of the picture is a Riffian. Up until the early years of the twentieth century, the Riffians were reputed to be fearless warriors, who would defend their liberty at all costs and were even known to kidnap visiting Europeans. We see in these paintings Matisse's ability to convey psychological characteristics through his use of colour. Whereas Amido, used to being in service, looks away, the Riffian does not avert his gaze. There is even something aggressive in the way he moves forward. 'Can you look at this magnificent barbarian', wrote Marcel Sembat when he visited Matisse's Moroccan exhibition in 1913, 'without thinking of the warriors of old? The Moors of the *Chanson de Roland* had this same severe expression.'[48]

Standing Moroccan in Green and *Arab Café* represent the two extremes of Matisse's Moroccan art. The colouristic forte of the first picture stands in contrast to the placid piano of the second. For all its generalisation, the portrayal of the face and clothes of the Riffian is representational, while *Arab Café* tends towards abstraction. This painting can be better understood when considered alongside Camoin's *Moroccans in a Café* (1912–13; private collection), a painting that possibly shows a similar custom of old friends strolling along the streets of Tangiers. Camoin's scene is executed in a far more realistic manner, with depth conveyed through both foreground and background. In the foreground, which is shaded, an Arab prepares to enter the café. In the background are customers in white clothes which, in Matisse's work, are transformed into a light grey. Camoin tried to recreate his Tangiers café with great precision; for Matisse, however, this was unimportant. In his work the details so important for Camoin are secondary to the seductive predominance of the gentle blue-green tone.

Black, white, yellow-ochre and elements of red are all essential contrasts to the pale greenish-blue colour. Even in *Conversation* there was not such a predominance of one single colour; Matisse used only as much blue as was necessary to counterbalance the other colours. The light

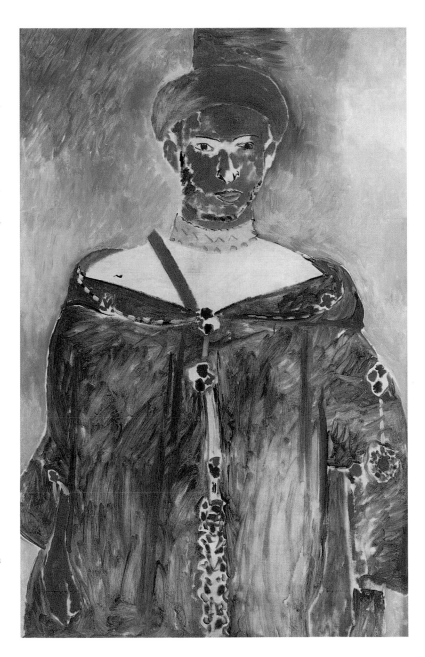

grey tone of the clothes in *Arab Café* is introduced to echo the principal colour. The pale ochre is used with relative freedom to delineate the dark skin of the Moroccans, and extends into the border surrounding the composition. This technique of framing the scene is borrowed from Eastern miniatures, and without it the whole composition would lose the logic of organisation that is an essential ingredient of Western art. Matisse certainly considered *Arab Café* to be one of the finest of his Moroccan canvases;[49] initially, however, the painting had very few admirers. The cool reaction of even so bold and insightful a critic as Apollinaire is notable: during the exhibition held at the Bernheim-Jeune Gallery he said, '*The Turkish Café* [as he called it] and *Entrance to the Casbah* are amongst the bearable works inspired by modern North Africa.'[50]

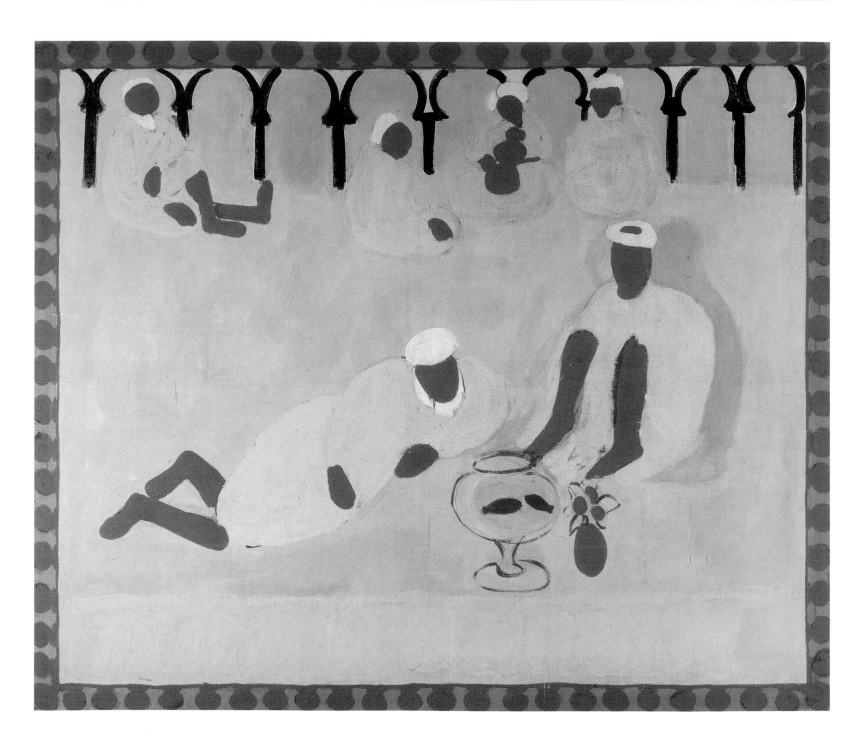

The extreme sparseness of the means of expression might appear severe, but in Matisse's hands it is combined with great insight and, one might even say, tenderness. Matisse's striving for simplification while retaining a natural delicacy is characteristic of *Arab Café* as a whole, but most particularly of his depiction of the fishbowl. If we recall Matisse's other 'aquariums' the comparison becomes clear. Through his persistent reworking of the picture he aimed to achieve the ultimate artistic terseness. Even now we can tell that the position of the figures in the foreground was changed twice. The colouristic structure of the canvas

was also changed. Sembat described this in the spring of 1913: 'The character in the top left was in red, the one next to him in blue and the third in yellow. It was possible to distinguish four faces with eyes and mouths. The uppermost figure was smoking a pipe.'[51] Sembat also quoted Matisse, revealing the artistic logic behind *Arab Café*: 'I have my fishbowl and my pink flower. Excellent! If I make them red, then this vermilion will turn my flower violet. So what? I want my flower pink! Otherwise it's no use to me! Instead my fish will have to be yellow – but I don't mind, let them be yellow.'[52]

Right (top): **Rocks**, 1912, by André Derain
Right (centre): **Houses by the Water**, 1910, by André Derain
Right (bottom): **Mill on the Marne (Créteil)**, c. 1911, by Auguste Herbin

321

Between Cézanne and the Cubists

It is difficult to believe that *Houses by the Water* is the work of the artist who painted *Harbour* and *Mountain Road* (pages 280–1). One of the most gifted colourists of his generation, Derain suddenly rejected the colours of the spectrum, sharply limiting his palette to earthy grey-greens and browns. His compositions had always been notable for their balance, but with his emergence from the Fauvist period he began to show a special interest in structural elements. Now every detail created the effect of a structure that was unshakeable – the only structure possible. The lessons learnt from the Cézanne retrospective at the Salon d'Automne of 1907 fell on fertile soil, although Derain later tried to underplay the extent of Cézanne's influence. His assertion that Cézanne's 'concern for perfection is incompatible with the free play of human thought'[53] could be understood as a comment on his own years of stubborn struggle for 'perfection'. Derain destroyed almost all his works dating from the last few months of 1907 to early 1908, but those that remain provide the purest demonstration of his debt to Cézanne.

'It is impossible to reduce everything to straight lines. Look at Picasso! – nothing but straight lines! Cézanne's straight lines led us to Cubism.'[54] But what is Derain's *Houses by the Water* if not a creation from straight lines? And, in any case, did straight lines really play such an important part in Cézanne's art? We need only compare *Houses by the Water* with any of Cézanne's compositions on a similar theme – *Banks of the Marne* (page 154), for example – to see that there are very few lines in his painting. Through his endless sittings Cézanne used to 'extract' from nature what was most important, its unchanging essence. Derain, it might seem, was following a similar path, although nature had considerably less significance for him: the finished construction is not so much extracted from as forced by nature.

In *Houses by the Water* the very choice of motif is characteristic: the simple little cubic buildings, which create the effect of an imperfect crystal. This impression is strengthened by the reflections in the water, where the repeated right angles of the houses make the overall land-scape less immediately recognisable. Through relatively minor simpli-fications – that is, through a geometrised 'finish' – this crystalline structure almost becomes an autonomous three-dimensional structure reminiscent of Cubism. Derain, however, like a number of his contempo-raries, was either unable or unwilling to cross the line beyond which Cubism began. A quasi-Cubist treatment can also be seen in three slightly later paintings: Auguste Herbin's *Mill on the Marne*, and Henri Le Fauconnier's *The Lake* and *Village in the Mountains*. The term 'pre-Cubist' would be appropriate were it not for the fact that chronologically these paintings coincided with Picasso's Cubism. It is hardly surprising that Le Fauconnier's works, which made a strong impression when they first appeared, should have lost their appeal for later generations, who placed too high a priority on formal innovation.

The term Cubism was first used in 1908. As a movement it did not out-last the First World War, although it was longer-lived than Fauvism. Cubism emerged in part from the recent revelries of colour, but its

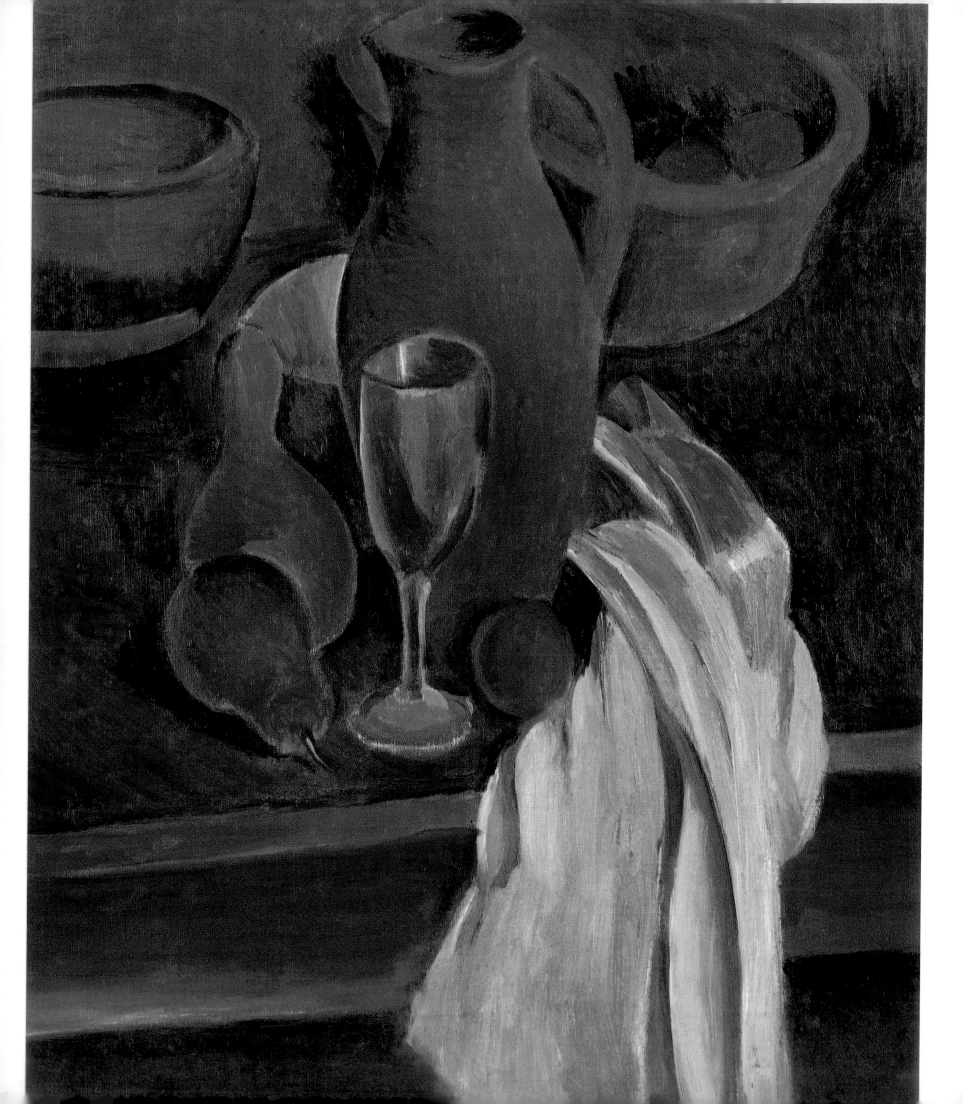

Left: **Still Life with Earthenware Jug, White Napkin and Fruit**, *c.* 1912, by André Derain
Below: **Table and Chairs**, 1912, by André Derain

Overleaf (top): **Still Life with Breadbasket, Jug and Wineglass**, *c.* 1913, by André Derain
Overleaf (bottom): **Still Life with Skull**, 1912, by André Derain

327

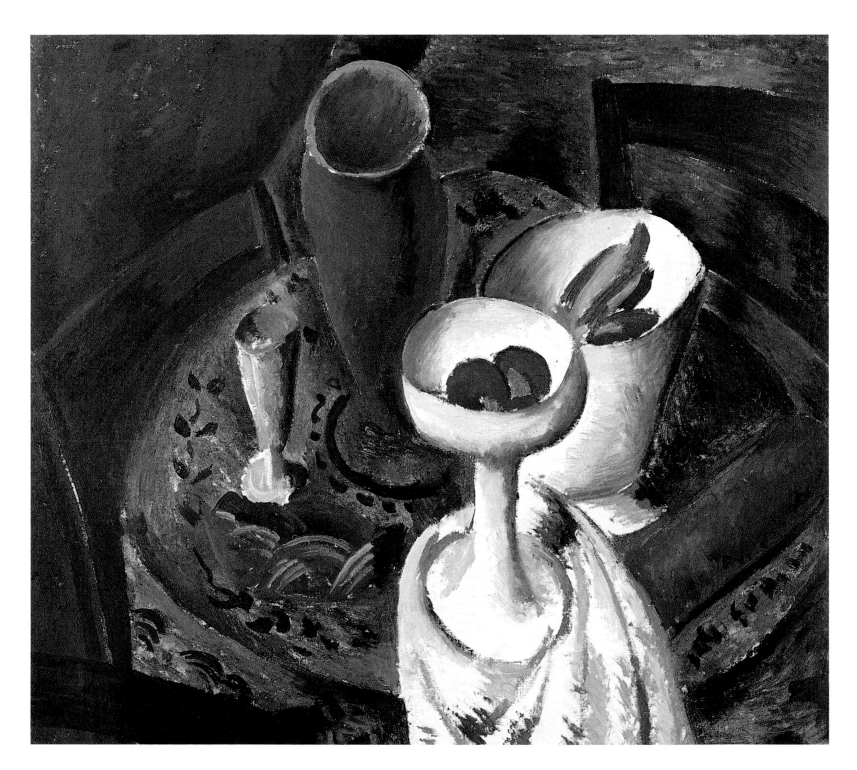

look at them we realise that they express the artist's own spiritual confusion, which always hoped to find stability in the chaos of life in the city. In his search for spirituality Derain turned to extreme monochrome generalisation in one of his most successful still lifes, *Still Life with Breadbasket, Jug and Wineglass*. This picture explains the name given to this period of Derain's work – the 'Gothic period'. The folds of the fabric are suggestive of columns of a medieval cathedral, while the bread, wine and fish are recognisable more as Christian symbols than as everyday objects.

In the Hermitage still lifes the simplification of detail gives rise to an extremely complex interweaving of meanings and associations. Derain evoked this juxtaposition of the apparently simple (the humble fruit dish, *compotier*) with the significant in the following lines:

In fact Derain had already set out in a new direction before the War, as can be seen most clearly in his portraits. Both the Hermitage canvases of the *Young Girl in Black* mark the beginning of the importance of portraiture in Derain's work. Both pictures show a tendency to go back to nature, which was to dominate Derain's painting over the following years, and which led to a fairly naïve kind of precision in his work, normally characteristic of self-taught artists.

This is more the case with the finished *Portrait of a Young Girl in Black* than with the study for the painting. The treatment of space in the two works is diametrically opposed. In the study hardly any space is left for the background. The picture is notable for its truth to life and the boldness of its drawing: the few, predominantly circular, lines echo each other with great expressiveness. Paradoxically, the rounded back of the armchair becomes an everyday equivalent of a halo. At the same time, since it is the most active colour element in the work and it contrasts with the pale face of the girl, this detail underlines the subject's fragility.

In *Portrait of a Young Girl in Black*, unlike the preparatory work, there is none of the directness of initial observation. Stiffness and a 'Fayum-like' torpor predominates. The majority of the canvas is given over to an empty background. Derain does not try to explore his subject's inner world, preferring instead to portray a face-mask. What is more important is that his character is facing the unfathomable and eternal nature of the world. The monotone, self-sufficient blue that surrounds the girl is not simply a background or painted wall: it is an embodiment of the limitless nature of space, which in turn becomes the infinity of time.

During his Gothic period Derain began one of his most important works, *Portrait of an Unknown Man Reading a Newspaper (Chevalier X)*. Here the distortion of reality is taken to grotesque extremes. The painting is reminiscent of the early experiments of the Cubists, the naïve creations of the primitive autodidacts, as well as the art of the primitives – that is, the founders of modern European art. It is known that by the age of eighteen, Derain was already familiar with the works of famous artists through reproductions. He was also a collector of puppets, and his hero, the pointedly titled 'Chevalier X', is little more than an enormous puppet. What could be more banal than a picture of a man with a newspaper in his hands? And what could be simpler than the techniques used by the artist to recreate this man-doll? There is something mysterious and even magical in the simplicity of Derain's painting. It is worth remembering that André Breton, one of the founders of Surrealism, praised in this painting 'the strange equilibrium of a character between a drawn curtain and the crumpled newspaper he holds in his hands.'[60]

Old Masters, so that in its composition *Martigues* is reminiscent of fifteenth-century landscape backgrounds. Derain, however, was no styliser of antiquity. He genuinely wanted to follow the primitives, and sometimes, in works such as *The Wood*, *Landscape with a Boat* and, especially, *Martigues*, he was successful. It was, however, impossible for Derain to sustain his identification with unknown painters of the Gothic era, simply because an artist of the twentieth century could not be the child of a different age – a fact bitterly borne out by the beginning of the First World War, which signalled the end of his Gothic period.

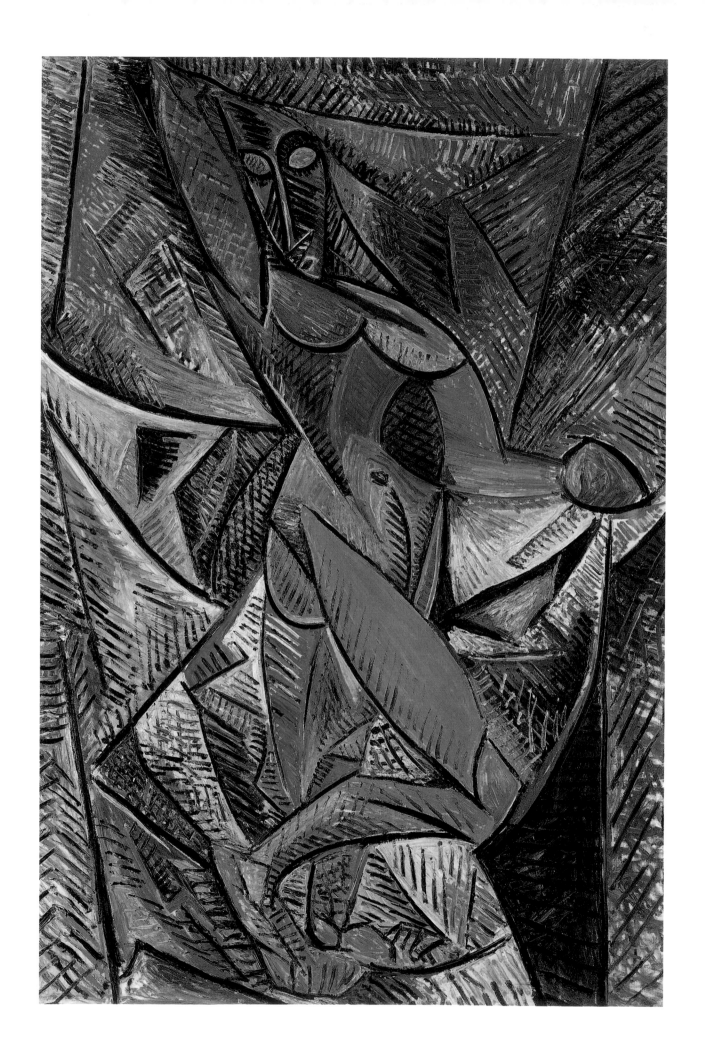

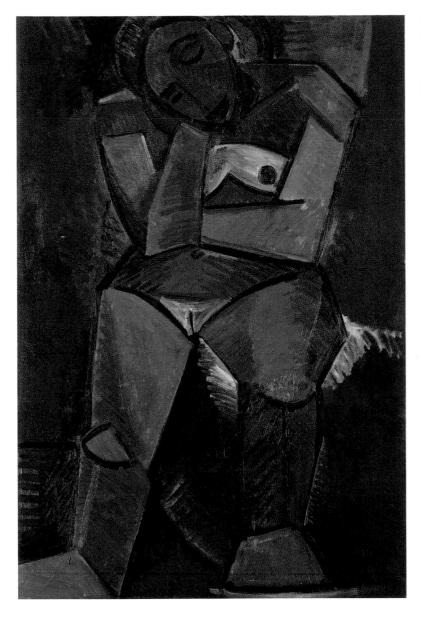

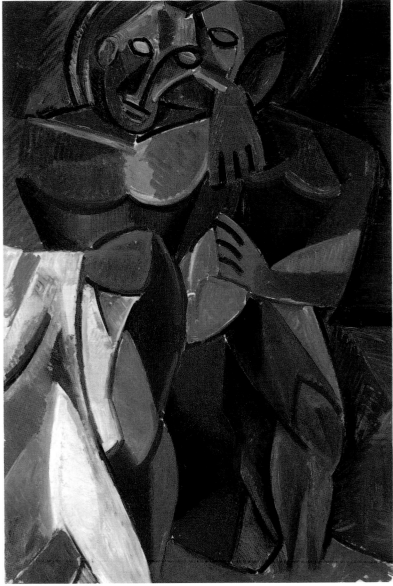

ing and fragmentation, were prompted by the sculpture of Gabon. The picture, however, is not a portrayal of an African idol. It tells of the tension that the artist perceived in European society of his time. *Dance with Veils* is thus not so much the illustration of a woman dancing to music as a spontaneous embodiment of music itself, which overrides everything that surrounds it – both the figure and the space. 'I work like the Chinese and the Mexicans; not after nature, but like nature,'[68] Picasso was later to say.

In this picture, bathed in electric yellow light, sharp angles and diagonals predominate, although not one of the lines crosses the whole expanse of the canvas – they collide with each other, breaking each other up. The whole composition is divided up into edges like sharp splinters, which move with a nervous, pulsating rhythm. Painting of this level of heightened intensity had never existed before *Dance with Veils*. Picasso

used his own self-awareness to capture the dawning tensions of the age. He understood the energy that gripped an era on the brink of collapse; in short, he has painted a visionary picture.

Dance with Veils can also be seen as a challenge to Cézanne, whose late canvases portray bathers in similar poses, demonstrating the architectonic unity of the artist's perceptions. A little later, however, Picasso began reworking Cézanne's ideas. But the development of Cubism was far from simple, and it would be naïve to try to explain it only in terms of the influence of African art or of Cézanne. What is more, it was not simply a question of reworking abstract plastic compositions. *Dance with Veils* and other works can be linked directly with events in Picasso's life. The whole of Paris at that time was talking about Richard Strauss's opera *Salome*, which premièred in the city in May 1907. Its success brought about a revival of an earlier dance version of

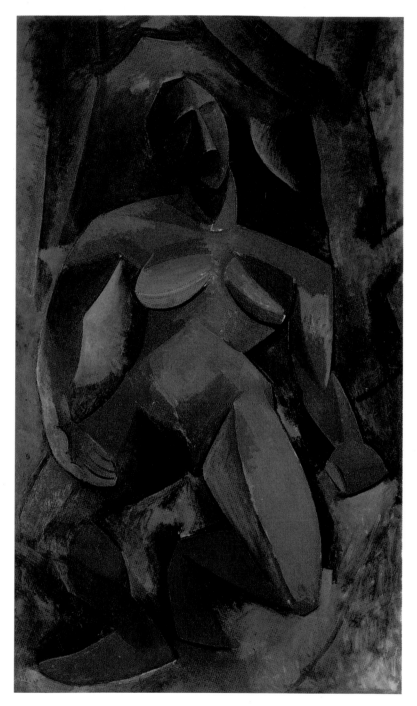

make his art readily accessible, believing that the artist should translate nature into art through symbols. The essential lesson he learned from African sculpture was that art could openly become a system of signs or symbols. The symbolism of his pre-Cubist works was limited to a particular artistic tradition and is consequently simpler to understand. But when the depiction of outward reality ceased to satisfy Picasso, he concentrated exclusively on inner meanings and mystery, which could only be transmitted through symbols. The artist acknowledged that during this period he and his friends liked to talk about 'squaring the circle'. Even to this day there are those who understand Cubism as a series of experiments carried out for the benefit of future artistic developments. Picasso responded that 'Cubism is neither a seed nor a foetus, but an art dealing primarily with forms, and when a form is realised it is there to live its own life.'[70]

Considerable effort is required to interpret the subject of a painting like *Friendship*. The canvas's level of abstraction can best be ascertained by looking at the lower half of the work. As in *Bathing*, the human body, along with the rest of the composition, is translated into a series of straight lines and arcs, which attain a kind of universal significance. The arc could equally signify the leg, the breast, or the nose and eyebrows. Parts of the human body are transformed into elements of artistic structure, with unexpected results. Picasso explained the mechanics of such metamorphoses thus: 'The secret of many of my distortions – which many people do not understand – is that there is an interaction, an inter-effect between the lines in a painting; one line attracts the other and at the point of maximum attraction the lines curve in towards the attracting point and form is altered.'[71] At the same time, the distortions accumulate into the dramatic tension that always gripped the artist, whichever painting he was working on.

With each major canvas of 1908 that followed *Friendship* – *Seated Woman*, *Dryad*, *Three Women* – Picasso addressed new and essentially three-dimensional problems. The naked female form was always a favourite theme of Picasso, the only exception being the Cubist period from 1910 to 1914. It was through this motif that Picasso was able to be most polemical, for no other subject had been so exhausted and vulgarised by Salon art, which was far from being a spent force in 1908.

Both *Seated Woman* and *Dryad* are similar in method to the youthful sketches Picasso made in Barcelona in 1899. The fundamental articulation of lines is immediately established; secondary details are omitted, and the sketching is swift and spontaneous. The line of such a drawing is clearly more energetic than in nature itself; more energetic, too, than can be fixed in a photograph.

In *Seated Woman* this method achieves the ultimate celebration of drawing. Straight lines play the decisive role, while circular lines are secondary, and are only allowed to indicate the bend of the knees or the oval of the face. *Seated Woman* is 'pinned together' so firmly that it demands to be seen as a carefully thought-out construction, where the verticals and horizontals are ideally and soundly balanced, the various levels are not repeated and the base is more solid than the apex. One of

Salome choreographed by Lois Fuller, in which the dancers had used veils to emphasise their movements to great effect.[69] Furthermore, Picasso's work on this large-scale, provocative composition was prompted by his rivalry with Matisse, whose *Blue Nude* had just met with scandalous success at the Salon des Indépendants.

Cubism signalled a decisive shift from the Realism and Romanticism of previous years. Picasso's perception of the world around him became more profound as his works became more esoteric: he had no desire to

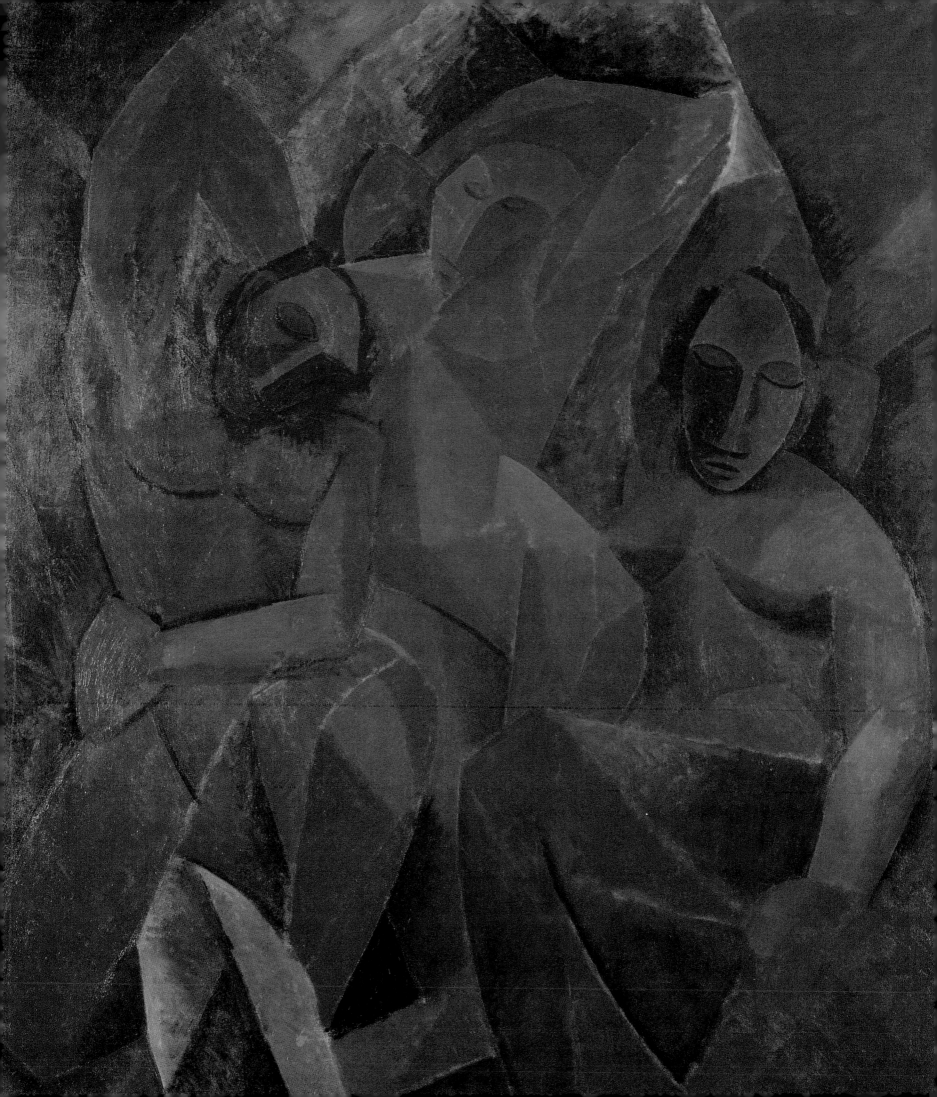

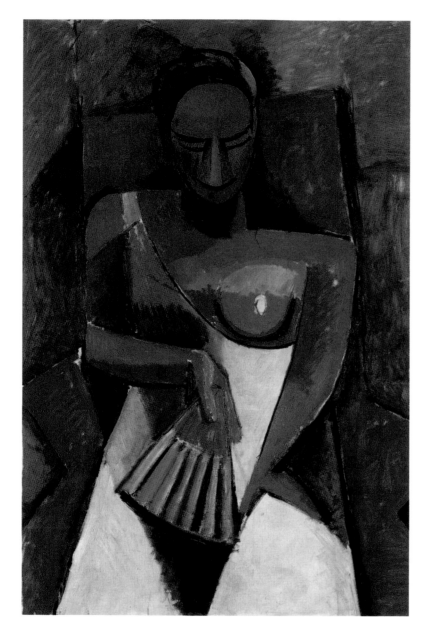

precisely the Cubists' formal aims. In *Woman with a Fan* every detail of the picture plays a part in this process of equation: the arms, the nose, the forehead, the breast, parts of the armchair. Disparate elements in the work are tied together: the head and the breast, the fan and the pyramidal base of the figure, the dress divided up into triangles, and so on. The armchair combines with the woman to create a unified whole. Its arms are subject to the same configuration as the fan, which is the central detail of the whole painting. Whereas in portraits by earlier artists – Goya, for example – the fan served purely as a social indicator, in Picasso's Cubist compositions it serves an entirely different purpose. In *Fan* (1905; Washington, National Gallery of Art; Z.1.308) the dynamics of the composition are defined by a gesticulation that imitates the opening of a fan. In the Hermitage *Woman with a Fan* the fan's interrelation with the human figure is much more complex. The woman's gesture reflects the mechanical movement of an inanimate object, like a kind of clockwork toy, a gesture that is underlined by one shoulder being sharply lower than the other. Why did Picasso paint the picture in this way? Was it the strictly formal exchange between the fan and the figure, or the desire to parody Salon beauty, or perhaps some episode with *la belle* Fernande? (We can imagine her, in her camisole, pretending, with her fan, to be the queen of the ball. In the unusually hot summer of 1908, Picasso apparently worked naked, while Fernande wore only a camisole.)[72] By then it seems that little remained of the artist's former love for his muse. And ultimately the human mechanism he has constructed seems all the more grotesque precisely because of the fan. But however monstrous the woman may appear, Picasso was least interested in parody or mockery, for his picture represents something altogether more important: an image of the cruel mechanical gods of an incomprehensible age.

Dryad is even more grotesque, although it would be quite wrong to take it as a caricature. Laughter, always directed at a specific object, is the weapon of the caricaturist, and this was completely alien to Picasso's painting. He did not consider himself superior to the subjects of his pictures, and consequently was in no position to mock them. When he was working on this picture he believed in the dryad no less than a Cycladic sculptor would have done. Within *Dryad* there is the sense of primordial fears being awakened. But is the modern artist capable of sharing the feelings of another world and another era? Unquestionably he is, so long as the society in which he lives seems to him as incomprehensible and harmful as wild nature would have appeared to his distant forebears.

We can also detect this apprehension of chaos in *Three Women*, which expresses an extraordinary thirst for harmony in a world full of discord and disarray. This thirst was always alive within the artist, even when it was difficult for him to uncover it. Picasso said: 'I consider a work of art as the product of calculations that are frequently unknown to the author himself. It is exactly like the carrier-pigeon, calculating his return to the loft. The calculation that precedes intelligence. Since then we have invented the compass and radar, which enable even fools to return to their starting-point... Or else we must suppose, as Rimbaud said, that it is the other self inside us who calculates.'[73]

the techniques of traditional architecture was that of lending weight to the base through rustication and through the use of large windows. Something similar can be seen in Picasso's picture, where the function of rustication is fulfilled by the parallel hatching. The work's merit lies not only in its solid structure, but also in its sense of dynamism. In *Seated Woman* the high relief of the contours, the peculiarities of the 'sliding' pose, at once uncomfortable and full of tension, the figure's superhuman dimensions, her compression and the lack of surrounding space – all contribute to this sense of dynamism. For Picasso the struggle for intensity of expression was inseparable from harshness, even coarseness, and he once admitted that in creating things he needed to make them coarse.

'The picture as equation' was how André Salmon summed up the views of the artists and poets who surrounded Picasso. These words capture

According to the artist's original design *Three Women* was to be a Cézannesque scene with bathers; the women washing their backs, their arms raised with the elbows uppermost. Later, following his intuition, Picasso brought the figures so close together that they became a triune. The subject could now only be made out with difficulty, but the composition became better organised and more powerful. The movement of the figures, reaching upwards and united in a single burst, was something that Picasso found in his favourite painter, El Greco.[74] Here, however, Picasso has imparted so new and unexpected a resonance to the movement of the outlines that to this day the source of his inspiration remains a mystery. In *Three Women* Picasso paradoxically combines the sense of movement with a pyramidal structure – a tried and tested formula for stability. This combination of movement and stasis is finely balanced; the fragmented forms do not conflict as in *Dance with Veils*, and the whole picture has the form of a unified, complex crystal, which obeys a certain logic of growth. The homogeneity of this massive group is underlined by the predominance of red-brown tones, which in their materiality restrain the explosion at the centre of the picture. Having started with a paraphrase of Cézanne's bathers, Picasso's strong inclination towards associations and 'recollections' has led him to the archetypal motif of the three graces, the embodiment since Hellenic times of harmony and feminine beauty. His very treatment of such a theme is challenging, for it is impossible to apply any normative understanding of beauty to a Cubist painting, where visual attractiveness is sacrificed to the overall sense of movement. It is as if Picasso has cut across millennia to those mythical times when bare stones represented the three charities, who only much later became the three graces, and later still a symbol of refinement. These figures, with their arms behind their heads and 'sleeping' faces, indifferent to everyday existence, live in a magical world created by the artist's imagination. Antiquity and contemporaneity are unexpectedly combined by an artist who has penetrated to the very heart of matter and phenomena.

This unexpected juxtaposition of different meanings is common in Picasso's work. *Composition with a Skull*, which occupies a unique place in Cubist art, is a variation on the *Vanitas*, a variety of still life that served as an allegory of human vanity and mortality in the seventeenth century. The choice of objects in Picasso's picture are part of a traditional symbolism: the palette representing art; the books – knowledge; and the pipe – life's pleasures. Significantly, the linear construction of the work leads the viewer towards the skull – the symbol of death – finding resolution in its curves and edges. The overall artistic structure of the work, however, is thoroughly anti-traditional.

For many years *Composition with a Skull* remained a riddle for art historians. Its bright colours made it tempting to view the work as a link between Fauvism and Cubism, and thus it was dated to 1907. Such easy links, however, are not found in Picasso's work, and the colours, although bright, are by no means Fauvist. The theme of death, which explains the colouring of Picasso's memento mori, was always alien to the Fauves. A painting such as this can only have resulted from a spiritual trauma, not from artistic evolution. The artist himself never spoke of the emotions that gave rise to *Composition with a Skull*. The

suicide of his neighbour at the Bateau-Lavoir provides a more convincing explanation of the drama of the work than Matisse's possible influence – for at this time Picasso was certainly not inclined to pay homage to Fauvism.

From the beginning of the summer of 1908 the number of still lifes in Picasso's work increased noticeably. While still in Gosol two years earlier, the artist found his artistic direction in the clear geometry of simple objects. In pictures such as *Pot, Wine-Glass and Book* and *Green Bowl and Black Bottle*, the classical sense of harmony is no longer present, although the objects remain ordinary as before. Picasso had painted this kind of still life while still a student, and even as a young man he drew with the conviction of Raphael. In these pictures he is revisiting, and attempting to master, the study of decorative art.

What of Cézanne's influence? The posthumous exhibition of Cézanne's work in the autumn of 1908 and the publication of his famous letter to Bernard, in which he asserted that nature should be treated through a cylinder, a sphere and a cone, provoked a tendency to geometrisation in the work of a number of artists. But Picasso chose objects whose cylindrical or conical nature was plainly evident from their very shape. The wineglass, for example, combines all three elements of Cézanne's formula; and all three are again present in the carafe in *Carafe and Three Bowls*. Is this Cézannism? Certainly Picasso's persistence borders on parody, but as with his figurative compositions there is no question here of mockery, and not only because we know Picasso held Cézanne in high esteem. In fact the sense of Picasso's extreme seriousness is strongly felt. His still lifes are an act of the deepest faith. When we contemplate them we find ourselves contemplating the solemn preordained nature of things. Worthless everyday objects are here imbued with almost hieratic significance.

Impressionism was the culmination of artistic developments of the nineteenth century, and even after he had distanced himself from the movement, Cézanne's paintings retained common ground with some of its techniques. By contrast Picasso, with his still lifes of 1908, did not modify Impressionism, as Cézanne had done; he refuted it. For this reason we should talk of Cézanne's influence on Picasso with considerable reservations. The atmosphere, the sparkle of light, the complex modulations of colour – all are decisively repudiated. The break with the nineteenth century is clear in the distortions, which in Picasso's work are much more radical and deliberate than in Cézanne's. In *Green Bowl and Black Bottle* the mouth of the bowl is unnaturally pointed. The softness of a more accurate oval shape would have gone against the spirit of the picture, and not interacted so successfully with the contours of the bottle and the other lines. 'Of course,' Picasso explained to Kahnweiler, 'when I want to make a cup, I'll show you that it is round, but the overall rhythm of the painting, the structure, may force me to show this roundness as a square.'[75]

The structure also controls the lighting of the picture, and for this reason the objects are portrayed as if each has its own source of light. The shadows thrown by the carafe and bowls are dictated not by the

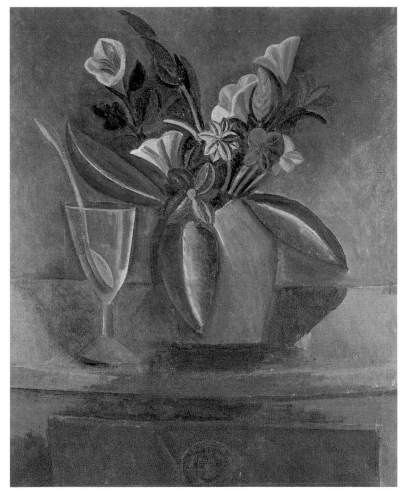
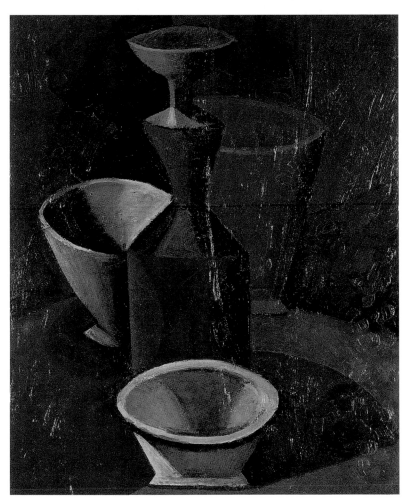

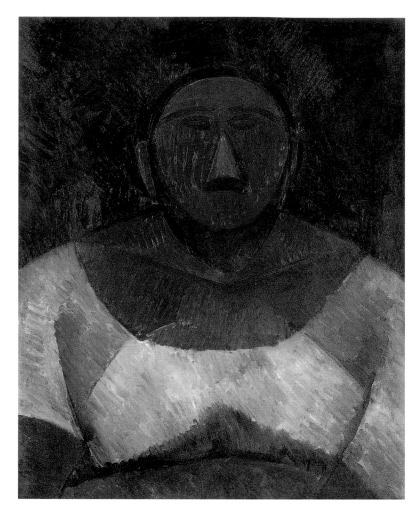

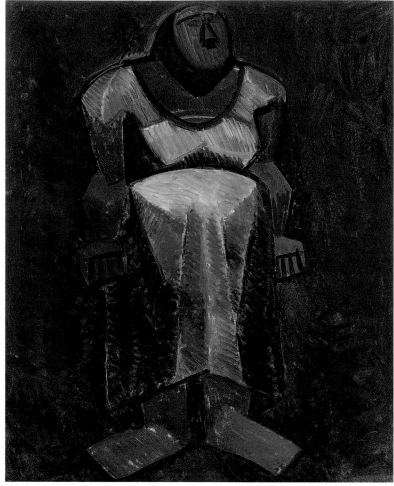

positioning of the lamp, but by the rhythm of the ovals and semi-ovals. The pursuit of echoes and of a unified whole leads to the eradication of material differences between the objects. Thus while in *Pot, Wineglass and Book* the ceramic of the pot and the glass of the wineglass are discernible – the refractions in the glass reminding us of the falsity of outward impressions – in *Carafe and Three Bowls* the material properties of the objects are left undefined. It is simply matter: stony-hard, primary and, apparently, unaffected by time. So primordial, so eternal are the forms of the objects, that they are perhaps better described as 'primary forms'. These are not the real objects of Cézanne's painting, where the geometric basis shows through, but instead, the concept of the simplest, eternal shape, ever immutable. It is not surprising that this small still life creates the effect of extreme monumentality, such as had never been seen in the previous century, and which harks back to Cycladic or ancient Mexican sculpture. The striking monumentality of the work is combined with a sense of inscrutable mystery, created by Picasso's primitive objects, in particular his vessels with their disturbing, enigmatic orifices.

Carafe and Three Bowls has much in common with sculptured relief. Within a limited depth the moulding of the objects is highly energetic.

The treatment of the third dimension is not subjected to the rules of linear perspective. Picasso's primary forms are placed in their space with greater autonomy than is evident in the works of generations of his predecessors. Space itself is radically condensed, and this is no longer the mathematically precise space limited by its frame, which had formed the basis of the spatial perceptions of Americans and Europeans since the Renaissance. This is space created by the artist, constructed intuitively and not in accordance with general, impersonal principles of order.

The landscapes of La Rue-des-Bois are painted in the same spirit. In August 1908 Picasso moved to this small village, taking refuge from the heat and nervous stress brought about by his work in the city. It is difficult to believe that *Small House in a Garden* depicts the natural environment of the Ile-de-France, the cradle of Impressionism. Picasso, of course, did not paint from nature and, in general, stated that he did not paint natural landscapes; nevertheless *Small House* provides a fairly concrete representation of the place where he was living. The artistic generalisations do not conceal essential features of the landscape, such as the type of trees, and the greenness of the land (indeed, several similar works have given rise to the idea of Picasso's 'Green Period'). Other features are also retained, such as the small houses of the white village.

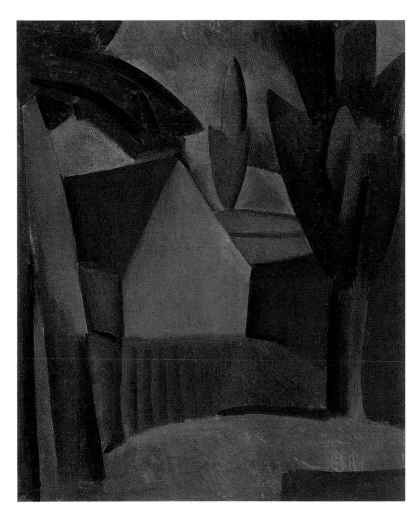

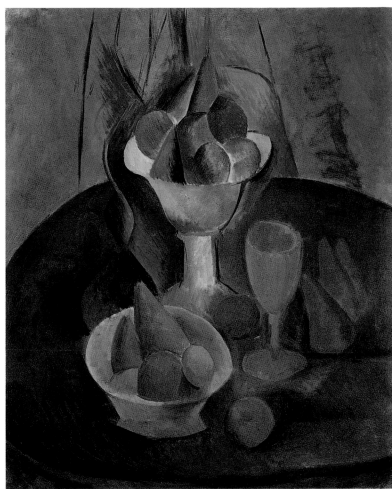

However, while we can say that the landscapes of the Impressionists could conceivably be 'real' places, Picasso's own work in this genre is clearly not, in his own words, 'art dependent on nature'.

In *Bouquet of Flowers in a Grey Jug* (page 351) even organic nature is sharply reduced to simple and extremely precise outlines. It is normally said that while Picasso was in La Rue-des-Bois, the 'African' tendency in his work was replaced by the Cézannesque. The emblematic nature of *Bouquet of Flowers*, along with the anti-naturalistic finish and decorativeness, are also reminiscent of Henri Rousseau's work. Picasso was impressed by Rousseau's sincerity, without which he felt art would lose its power and liveliness; Picasso's own sincerity, however, was of an entirely different nature and had nothing to do with naivety. Cézanne's work was a more fruitful source of inspiration, and a better guide to future development. But while Cézanne's techniques were being copied and his motifs reworked, Picasso uncovered in his work not so much models of composition as a kinship of spirit. It can hardly have been a coincidence that, like Cézanne, Picasso kept in his mind the image of Frenhofer (the painter hero of Balzac's *Chef d'oeuvre inconnu*) frenziedly, almost insanely, forcing his way to the heart of the mystery of creation. 'What attracts us to Cézanne is his anxiety – that is Cézanne's lesson.'[76]

The relationship between the Cubists and their predecessors is clearly evident in their use of analogous motifs. A comparison between Cézanne's peasants, including his 'smokers', and Picasso's *Woman Farmer* pictures is revealing. In the treatment of both artists the subject has withdrawn into herself; Picasso's *Woman Farmer*, however, has none of the smokers' contemplation; rather, she appears on the defensive. A hypertrophied power emanates from this Scythian-like sculpture. In both pictures of *Woman Farmer*, the subject is shown front-on, so that the figure seems to reach out to us from the frame with all her impressive might. This front-on view enables the artist to explore her inner world. But can we talk of an inner world, of a psychology, if the head is a stump, a block, and there is not even a line for the mouth? Certainly, because this extremely simplified sphere contains a vital internal energy; within it reigns the dense, earthy, stubborn anima. Most remarkable of all, the excessively terse style of this portrayal of Marie-Louise Putman does not in any sense affect the picture's likeness to its subject. Whatever may have inspired the artist to create these embodiments of 'mother earth', they remain portraits[77] – albeit grotesque portraits, presenting an environment entirely alien to creativity. Such grotesque elements are not found in Cézanne's peasants.

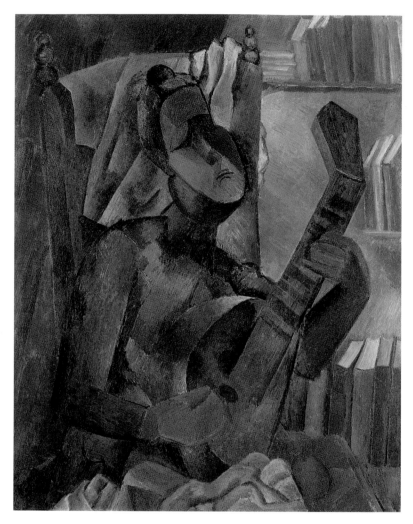

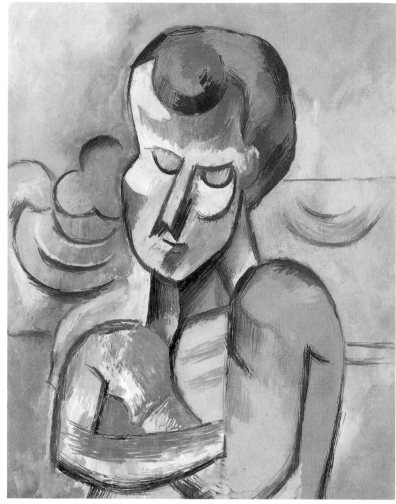

The influence of Cézanne's painting in terms of its internal discipline is clearly evident in Picasso's works of the winter of 1908 to 1909. *Vase with Fruit*, unlike the still lifes painted in the summer of that year, has a softness of intonation and a balanced construction. The objects are pictured from various, but close, viewpoints, and the drawing itself is less harsh. They exist in an environment of compressed air. The overall sonority of the work is more polyphonic, although, as before, the material qualities of the objects – the glass of the goblet or the fleshy pulp of the fruits – are barely distinguishable. The composition is extremely carefully thought out: the large fruit vase is positioned precisely in the centre, while the pears, apples and pumpkin stand respectfully to one side; each object is positioned so that other details do not interfere with it or destroy the general sense of balance.

In Picasso's *Woman Playing the Mandolin*, the napkin thrown over the back of the armchair and the crumpled napkin in the foreground are deliberate references to Cézanne's work. It is thought that Corot's *Gypsy-girl with a Mandolin* (São Paolo, Museu de Arte) was the inspiration for this picture, or perhaps similar compositions by Corot from the mid-1860s, such as *Italian Girl Playing a Mandolin* (Winterthur, Oscar

Reinhardt Museum), or *Young Woman in a Red Blouse* (Paris, Musée d'Orsay). It is also possible, however, that Picasso was inspired by portraits of girls with lutes, popular in seventeenth century art. Cézanne had only painted a musical instrument once, in *Girl at the Piano*, while Picasso had painted musical themes from his early years (*Old Guitar-Player*, 1904, Chicago, Art Institute; *Organ-Grinder*, 1905, Zurich, Kunsthaus). Of course, in the Cubist work, the mandolin does not provide the thematic foundation of the work, as it does in *Old Guitar-Player*; however, it should not be seen as an incidental detail. For Picasso the mandolin was a metaphor for the feminine; it 'grows into' the overall geometrical structure of the painting, so that ultimately the mandolin's body and the woman's breast become a unified whole. Cézanne did not normally place anything in his subjects' hands. In his later works the model occasionally holds a book, a detail that was used as an adhesive element, a keystone for the architecture of the picture. Picasso's mandolin, by contrast, is here an expressive element. The books standing upright on the shelf, portrayed with an almost aggressive authenticity for a Cubist work, together with the vertical back of the armchair, are elements the artist uses to underline the energy of the diagonals, and in particular the deliberately expanded diagonal of the mandolin's neck.

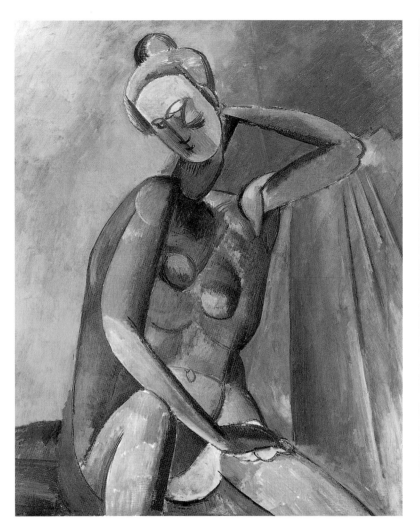

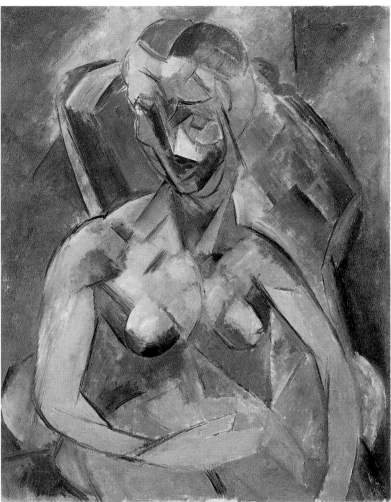

Nude, which also shows Cézanne's influence, is remarkable for an ideal balance between space and figure. Picasso is fairly free in his treatment of the figure, rejecting a single viewpoint in his portrayal of the various parts of the body. Thus something that Cézanne had only hinted at is here realised in full. Later Picasso was to say: 'I don't want to do a nude as a nude. I only want to say breast, say hand or belly. To find the way to say it – that's enough.'[78] In *Nude*, the back, both sides, breast and stomach are revealed simultaneously; it is as if the figure is viewed not at an angle of 90 degrees or even 180 degrees, but 240. In order to provide the fullest depiction of each arm and leg, Picasso painted them by changing his perspectives.

A Young Lady (as Shchukin called this nude to avoid accusations of indecency) is remarkable for its even more decisive geometrisation. This beautiful naked body is demarcated by powerful edges, a technique that challenged all previous concepts of aesthetics. Even a motif as traditional as echoing the outlines of the female form and the curve of an armchair is here almost entirely subjected to the play of crystalline formations. It was essential for Picasso to convey that a painting is first of all a painting, and only then a portrayal of something or some-

one. By extension, a new understanding of light plays a special role in imparting autonomy to the picture. Whereas early Cubism had followed the traditional rules of chiaroscuro, different principles now controlled light. Bursting out here and there, light is no longer solely concerned with illuminating objects, and instead its dynamic play alone provides sufficient basis for the picture. The light in *A Young Lady* does not play a role in conveying verisimilitude; instead it is an emanation from the artist's own consciousness and bathes the picture in an 'inner light'. Picasso's trip to Horta de Ebro in the summer of 1909 was the inspiration for compositions such as these, most apparent in the landscapes of that time.

These landscapes, in comparison to those painted at La Rue-des-Bois, are more open, and are notable for a markedly crystalline articulation, which in *Brick Factory at Tortosa* even applies to the sky. The grammar of Cubism is here expressed with remarkable clarity. *Brick Factory* repudiates all former ideas of landscape art. It is impossible to approach this painting by degrees, starting from the foreground, through the middle and then to the background of the horizon; this was the Old Masters' approach, and that of many of Picasso's contemporaries. The sense of

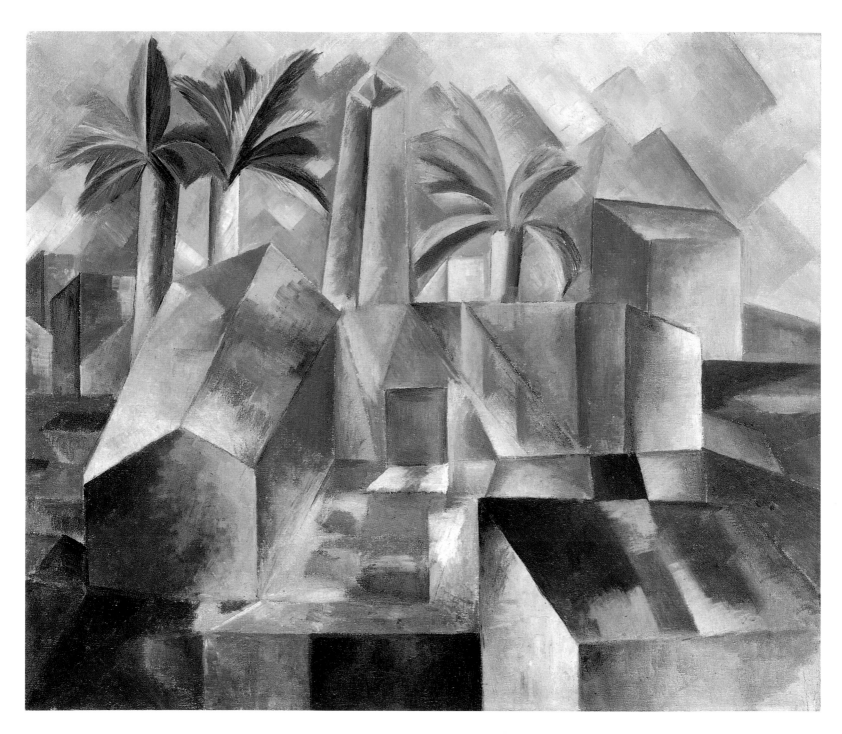

distance, essential to those paintings, is here meaningless, redundant. Now the landscape is perceived immediately and in its entirety, and every detail is part of the overall geometric structure. The objects are not defined in detail, but are stamped with edges and planes – these alone provide the definition. The houses are viewed from several points; they turn and move, subject to the will of the crystalline structure. When we compare the painting to photographs of the small, unremarkable brick factories of Tortosa that have survived to this day, the phantasmagorical nature of the picture becomes clear. By equating these small stuccoed

buildings with a precious crystal, the artist underlines the beauty and grandeur of simple things.

Picasso himself compared the works of his next period to cracked mirrors. The impossibility of presenting reality in harmonious images gives rise to the fragmentary nature of the works. This 'depopulated' world is entirely under the spell of the geometrician, and if the artist had submitted himself completely to this world, he would have achieved abstract art. Picasso, however, although he reached the threshold of

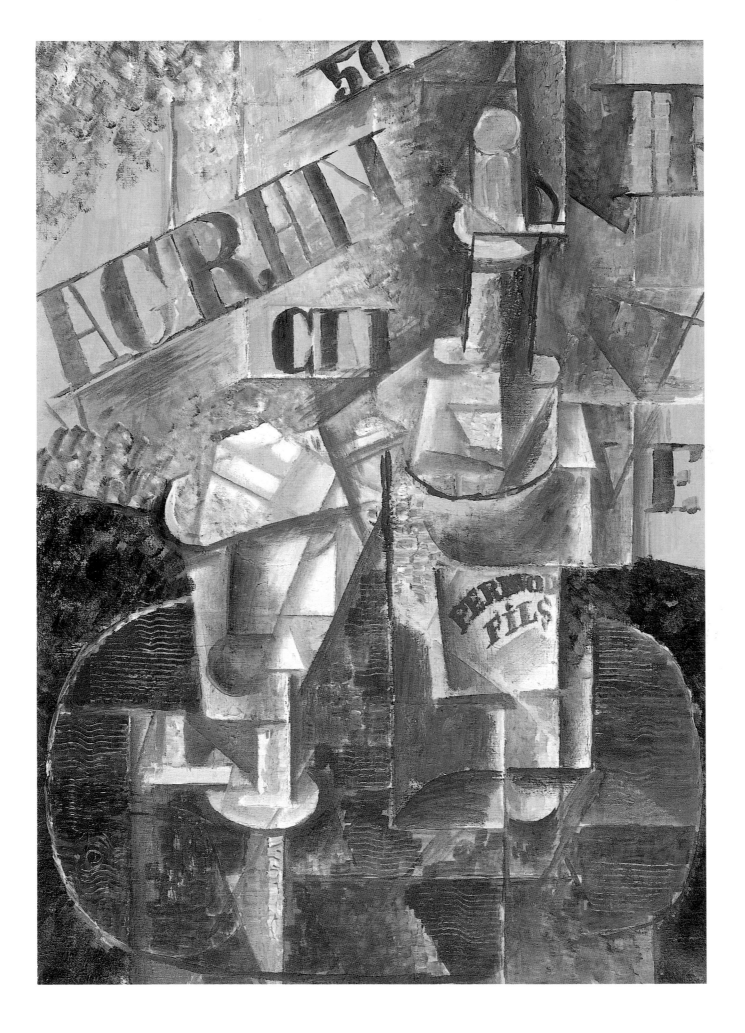

abstraction, never took the final step. 'Where is the drama?' he used to ask of art reduced solely to the combination of patches of colour. The drama of life was never absent from Picasso's art, whatever he painted.

The tension in a picture like *Table in a Café* is the result of a kaleidoscope of impressions, all of which change so rapidly that none of them ever takes final shape. The consciousness of the artist, battling against the speed of such changes, clutches at details, at the precision of a letter or the materiality of style. Picasso's everyday impressions are reflected as much in the scraps of words as in the objects, of which only traces remain in the picture. Sometimes these words can be deciphered; often, however, they remain unintelligible. But this does not mean that this art is a mere riddle. As he covered the canvas with paint, Picasso found himself in the power of rhythms, of the eternally pulsating life of forms. Many years later, he admitted that he was himself unable to explain some details, even at the very moment of painting such pictures. 'All the forms cannot be rationalised. At the time, everyone talked about how much reality there was in Cubism. But they didn't really understand. It's not a reality you can take in your hand. It's more like a fragrance – in front of you, behind you, to the sides. The scent is everywhere, but you don't quite know where it comes from.'[79]

With *Table in a Café* the process of departure from the artist's previous sculptural style – a process that had developed over three years – takes on a truly ambiguous character. Picasso's painting is here even flatter. The objects do not appear monolithic at all, and seem to be in the process of being perceived. They lack the precision that would be provided by a silhouette. Indeed, were it not for the table with its woody texture, which sets off the glass and bottle, they would be almost unrecognisable. The colouring becomes more complex: grey-green and lilac tones quite foreign to the severe style of early Cubism begin to appear. In Picasso's own words, an 'intellectual game' is under way, arising from the collision of words, snatches of words and figures, and unexpected anthropomorphic juxtapositions (glass/head and bottle/male figure). The game is played using material reflecting the circumstances of the artist's life. 'Others have asked me why I paint pipes, guitars or packages of tobacco and why these objects keep appearing in the canvases of contemporary painters. If Chardin, for instance, painted onions and peaches, it's because he painted in the country, near his kitchen, and onions and peaches were familiar sights to him. So, what could be more familiar to a painter, or painters of Montmartre or Montparnasse, than their pipe, their tobacco, the guitar hung over the couch, or the soda bottle on the café table?'[80]

The developments in Picasso's art of the spring and summer of 1912 led to a new stage in Cubism, traditionally called 'Synthetic'; it has perhaps more accurately been described by one historian as the 'Cubism of Recreation'. In *Table in a Café* the motif taken from life is transformed in accordance with the rhythms and intuitive responses of the intellectual game, but it nevertheless remains rooted in reality. In the compositions that followed, the motifs become entirely imaginative.

In *Guitar and Violin* the conventional form of the instruments is entirely subverted, so that a seemingly arbitrary composition is constructed out of their elements. The positioning of these elements, however, is subject to a unified and complex rhythm, created by the artist's intuition, which governs the architectonics of the canvas. We can imagine how the pendulum movement suggested by the position of the guitar and violin hanging on the wall may have affected this rhythm. In addition to the details of the instruments, the designs on the wallpaper play an important role. These designs are reproduced almost naturalistically – and could have been replaced by pieces of actual wallpaper, as was sometimes done – since their ornament is in itself relatively abstract. The creation of a system of contrasts and correspondences thus becomes the ultimate aim of the three-dimensional construction and is obvious in the juxtaposition of the flourishes of the wallpaper border with the fingerboard and the *f*-shaped sound holes of the violin.

Musical Instruments is made up of parts of a guitar, a violin and a mandolin. While the title of the picture is clearly conventional, a new 'architecture' is created out of disparate elements of the instruments, so that it is no longer possible to make out any real object in its entirety. Details of the guitar, violin and mandolin, along with musical notes and wallpaper, are brought together to create an abstract, music-like composition that no longer has any connection with reality. Such a composition has its own set of values, is self-sufficient, with no need for associations with external realities; it appeals to the inner reality of the artist's thoughts and emotions. In the black areas of the picture we can even discern hidden associations with the crucifixion, a motif to which Picasso was always strongly attracted. The composition of *Musical Instruments* is enclosed in an oval. It is likely that in using this format Picasso was following the example of Braque, who said that the oval helped him to concentrate on artistic structure, and removed the 'problem of corners' – the recreation of space is always complicated by corners. The whole development of Picasso's Cubism, however, led the artist immanently to the oval. In addition to Braque's example, there were other, less obvious, reasons for Picasso's use of the oval in 1912.

Picasso's life changed with the appearance of Eva Gouel. This delicate, refined woman was as different from the large and somewhat ungainly Fernande as the 'Cubism of Recreation' was from early Cubism. Picasso avoided direct portrayals of Eva, but in the summer of 1912 he wrote to Kahnweiler, 'I love her very much and will show this in my pictures.'[81] Eva's name is shown in the picture *Tenora and Violin*, although it is so microscopic that until recently it remained undetected.[82] 'Eva' is written on the violin, an instrument that always attracted Picasso through its

anthropomorphic associations with the female figure. He might equally have identified his lover with the tenora (a feminine word in Spanish) – a Catalonian musical pipe, which seems to prop up the violin. Furthermore, its refined, elongated shape is ambivalent, and could be interpreted as an embodiment of the masculine juxtaposed with the feminine represented in the curves of the violin. It would be naïve to reduce the essence of such a work to a coded portrayal of the features of a real person. Nevertheless, Eva Gouel undoubtedly stimulated the development of qualities such as delicacy and agility in Picasso's paint-

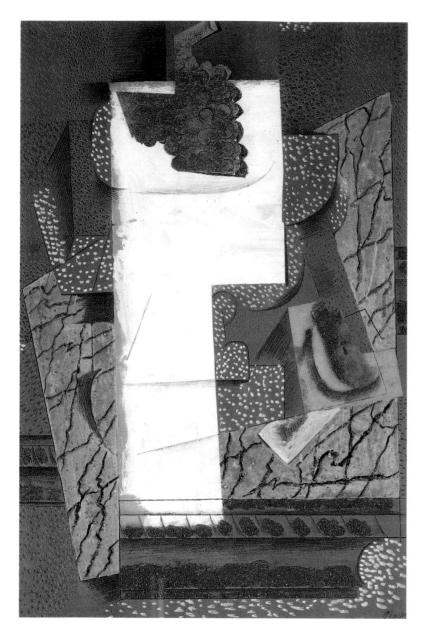

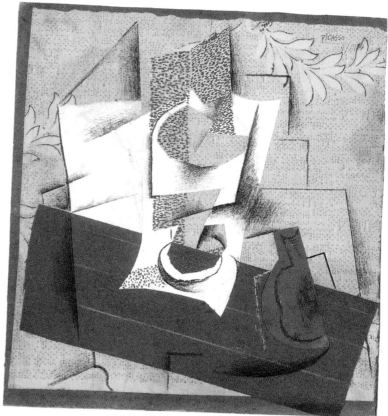

The playful and symbolic meanings of the paintings of 1912 to 1914 herald the most important developments in artistic consciousness of the second half of the twentieth century. Interestingly, a decade and a half after his first treatment of the café motif, Picasso returned to the same theme on the eve of the First World War. A change of genre took place. Whereas in his pre-Cubist and early Cubist years Picasso had painted few still lifes, from the autumn of 1910 Picasso's treatment of the genre took on a particular meaning. By creating dynamic compositions in a genre that European languages generally designate as 'quiet' (still life, Still-Leben, stilleven, etc.) he was perhaps seeking a kind of guarantee against a complete departure from the material nature of things. The inherent anti-dynamism of the still life genre was in Picasso's hands one of the most dynamic periods of his creative life. And just as every artist requires a certain recalcitrance in the material, which the art always strives to overcome, so Picasso required the resistance of genre. Without this, the inner tension of his art would have been impossible.

At least half of all Picasso's Cubist still lifes contain representations of tables. The psychological weight that defined his pre-Cubist work on the café theme has now disappeared completely. With the absence of human figures, the pictures now include a far greater number of material details than in the Blue Period. At that stage of his development the attraction of objects consisted in their ability to reveal the subject and explain the status of the character portrayed. It was entirely sufficient to denote bare walls and the surface of a table and

ing, and in this sense she was no less influential than his other companions at different stages of his creative life.

Gradually, Rococo elements began to appear in Picasso's art. The rhythmic systems of his compositions became more simple, staccato and capricious. The term 'Rococo Cubism' refers to a kind of analogous adoption of formal elements. The outlines of a cut pear or musical instrument chosen by Picasso are associated with the forms of the female body, and the motifs of the violin and guitar are used even more frequently. The theme of music is directly linked with the image of Eva, and it is known that some of Picasso's 'musical' compositions contain direct references to her. More importantly, however, music is an example of an art which does not reflect the literal impressions of the external world, but creates its own integral artistic environment.

Right (top): **The Tavern**, *c.* 1914, by Pablo Picasso
Right (bottom): **Scenes from the Ballet** *La Boutique Fantasque*, 1919, by Pablo Picasso

361

to reproduce a glass of absinthe. When they developed into strictly
formalised still lifes or still-life interiors, the pictures of the café became
less intelligible but more dynamic. They are composed of fragments of
momentarily caught objects, which combine to form a rhythmical struc-
ture abstract in organisation, akin to a musical composition.

The Tavern, as the choice of objects and fragments of words indicate,
is one of Picasso's last treatments of the theme. The truncated *REST*
[restaurant] is executed in a decoratively refined script, and the work
doubtless contains an element of humour, as was noted by Shchukin
who called it *The Tavern*. The details in this picture are extremely com-
pressed: there are no pauses or empty spaces. The anti-spatial structure
of such a work is in direct proportion to its forced materiality. It is true
that the material basis of some of the details can only be identified with
extreme difficulty, but this may simply be because our own everyday
reality is so different to that of the artist. The words of Picasso's friend
Ilya Ehrenburg provide a better understanding of this picture: 'I
remember a wonderful night shortly before the war… We went to
a small restaurant opposite Montparnasse station called "The Cabby's
Rendez-vous" – it was open all night. I called two friends. The names
of the dishes were written in chalk on a blackboard, and we managed
to try each one – of course we had to stay there until morning.'[83] *The
Tavern* was painted at the very time Ehrenburg was describing, and it
is possible that the picture portrays the same all-night bistrot.

However great the materiality – the *Sachlichkeit* – of the objects in
The Tavern, they appear in the painting as symbols, and in a symbolic
context. The objects that are most clearly defined and which immediately
catch the eye are the knife and fork. Pictures of a knife and fork were
often used as signs for public eating-places. In this capacity it is appro-
priate to compare Picasso's late Cubist compositions with signboards.[84]
The origins of the café theme stretch back to the Dutch and Flemish
'inns' of the seventeenth century; everyday scenes that were themselves
descended from allegorical compositions of the preceding age. The
theme's potential for a certain kind of realism ensured its survival up
until the turn of the twentieth century. From then on, however, this
everyday subject lost its interest. It only remained for the theme to be
returned to abstract ideas, emblems and symbols, as is shown by the
Cubism of Picasso in his pre-War period.

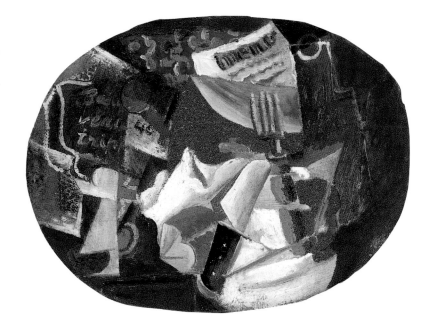

The Ebb-tide: Departure from Cubism

From the beginning Cubism was marked by two opposing tendencies; the constructionalist and the dynamic. The first dominated the movement's early stages, the second came to the fore in the latter stages. The dynamic tendency was later reborn as Futurism and Abstraction, and ultimately even led to a repudiation of art. It was a powerfully destructive force, for as soon as it began to gather strength, artists like Derain decided to curtail their involvement with Cubism. The dynamic tendency quickly came to dominate, finding support not only within France, but also far beyond its borders. This dynamic phase of Cubism was doubtless more in tune with this restless era.

By 1913–14 Cubism had become the universal language of the Parisian avant-garde; it was adopted in Italy, Russia, Britain and the United States. From its origins under the roof of the Bateau-Lavoir, Cubism had been an essentially inaccessible and secretive movement. Now, however, it promised to evolve into an artistic style that, if not popular with the masses, at least had a significant number of followers. The appearance of picture-poems was entirely symptomatic of this evolution, as exemplified by Blaise Cendrars and Sonia Delaunay-Terk's fold-out book *The Poem of the Trans-Siberian and Little Jehanne of France*. Although only a limited number of copies were printed, this first *livre simultané* reached a fairly wide circle in contemporary art. The book was the product of a new-found faith in artistic synthesis, a desire to establish new links between different fields of art – in this case literature and painting.

Although Sonia Delaunay-Terk later maintained that she devised the style of the book completely independently, in her partnership with Robert Delaunay her role was always secondary. She turned her husband's innovations into works that had more relevance to everyday life: advertisements, costume designs, fabrics, book covers, plates, theatre sets and so on. She borrowed the motif of the Eiffel Tower from Robert, and it became a symbol of modernity for both of them.[85] Everything she turned her hand to bears the unmistakable mark of artistic gift and a genuine sense of colour.

Pure colours, which had only recently been rejected by Cubism, began to be used again; not with the freedom of the Fauves, but in a more regulated fashion, subject to geometric rules. Apollinaire, a friend of Robert Delaunay, made a distinction between 'New Painting' and early Cubism: he underlined the new art's more lyrical character and what he called its 'musicalisation'. Apollinaire termed this new art 'Orphism', after the mythical Greek musician and poet Orpheus; he described Orphism as 'pure art'.[86] Delaunay, who had come to Cubism after experiments in Neo-Impressionism, tried to reintroduce spectral tones to painting, although he subjected them to clearly defined rules. He insisted on 'simultaneous contrasts' of colour. Simultaneity became a key word for the Orphists, amongst whom Apollinaire included the Delaunays, Léger, Picabia and Duchamp. Sonia Delaunay-Terk defined the main tenet of the Orphists' programme as, 'pure colours becoming flat and opposing one another through *contrastes simultanés*, which for the first time create a new form built not on chiaroscuro but on the depth of the relationships

between the colours themselves'.[87] Guillaume Apollinaire's commentary
on *The Poem of the Trans-Siberian* is also revealing: 'Blaise Cendrars
and Mme Delaunay-Terk have made the first attempt at simultaneity
of the written word and the contrast between colours. They aim to teach
the eye to read the ensemble of a poem at one glance, just as the conduc-
tor of an orchestra reads all the notes of a score at once; just as we see
all the plastic and textual elements of a poster with one look.'[88]

Neither Orphism nor Cubism survived the First World War as a move-
ment. When war broke out, half the city's artists left Paris. Some, like
Derain, Friesz, Léger and Alix, joined the army. Others remained, but
the number of exhibitions reduced dramatically, as did the activities
of art dealers. Overall, there was a marked decline in creative activity;
among the works of the war years reflecting the terrible events that
shook Europe, only a few reveal true artistic qualities. These include
The Signal by Le Fauconnier who, cut off from Paris, ended up in
Holland. Along with Chagall, Le Fauconnier was associated for some
time with the Orphists, and it is worth noting that Chagall's *Sacred
Coachman* (1911; Crefeld, private collection) is compositionally close
to *The Signal*. Le Fauconnier did not share Chagall's tendency towards
fantasy, nor Delaunay's abstract impulses. However, using the same

techniques as the Orphists, he began to treat perspective with far
greater freedom after 1911, as is apparent from *The Signal*. When
this picture was exhibited in Amsterdam in 1916 along with several
other new works by Le Fauconnier, the distinguished Dutch artist Jan
Toorop wrote: 'He often gives his works a decorative character, painting
them without symmetry but with broad strokes full of conscious virtu-
osity. He owes this conscious force to his ingenuity, which matured so
quickly from his early Cubist experiments and his universal formulae.
This is a psychological quality – not a Dutch one, but one born of
ancient Gallic-pagan traditions and nurtured by the early Christian
primitive tradition in France.'[89]

In *The Signal*, the psychological symbolism noted by Toorop unites the
figure of the engine-driver, the railway points, the puffs of steam and

the locomotive emerging from the tunnel. There is no need for a specific subject in a painting where the colour red, a symbol for calamity, is so predominant. The time at which the canvas was painted – the First World War and, in particular, the recent bloody battles on the Marne – urges us to consider it as a warning and a cry of despair from the artist.

A period of consolidation in art took place in the years immediately following the end of the First World War. Léger, Survage, Ozenfant, Lhote, Favory and Alix, who had all spent time painting Cubist pictures, did not resume where they had left off in August 1914; instead each drew his own conclusions from pre-War Cubism. In André Lhote's *Green Landscape*, only the roofs of the houses in the foreground give a hint of the artist's former interest in Cubism. Striving for a more precise reproduction of nature, the artist adopted a position that brought him closer

to an updated type of Neo-Classicism, adopted by a number of former Cubists. Yves Alix, who had also felt the influence of Cubism, eventually rejected Cubist abstraction. His *Court Scene* is not in fact set in a courtroom but in the corridors of the Palais de Justice. Alix illustrates the way lawyers continue their play-acting outside the court – a habit mercilessly ridiculed by Daumier, whose example inspired Alix. The prosecutor, judges and attorneys are all cast from the same mould, as is apparent in the identical, highly expressive, construction of their faces.

Léopold Survage's work evolved from Cézannism to Cubism and then Abstractionism; at the beginning of the 1920s he had perfected a style that combined invention, elegance, delicacy of colour and refinement of drawing. His *Landscape* reflects his experiments with multiple perspectives, viewed as if through a prism, as well as his work in the theatre.

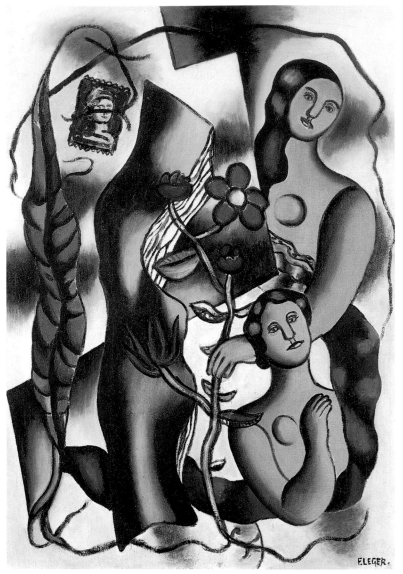

Survage's style was marked by a balletic lightness, and it was this that led Diaghilev to commission his theatrical decorations. This lightness reflects the mood of *la folle époque*, the decade that followed the end of the First World War. A number of elements in Survage's *Landscape* reveal the influence of the advent of Surrealism: the deliberate interplay of foreground and background, the psychological rather than material mystery of the details, and the use of surreal chiaroscuro.

Ozenfant, who was also alienated from Cubism, stands at the opposite extreme to Survage. He never indulged in mystification or any kind of wilfulness. Ozenfant was strongly opposed to the distortion and dispersion of the object in pre-War Cubism, and was against the rejection of formal disciplines. Nevertheless, Purism, the movement he headed along with Le Corbusier and of which he considered himself the chief theoretician, was a legitimate (if unintended) offshoot of Cubism. Like Cubism, it was based on a respect for simplified geometry. Unlike the founders of Cubism, however, Ozenfant was strongly attracted to mass-produced industrial products with their clear, precisely defined forms. Precision was the aesthetic discipline of the industrial age, and this was what fascinated Ozenfant as he strove for an entirely rational art. Le Corbusier, too, was later to define architecture as a machine to be inhabited.

The emergence of Purism had been heralded by Juan Gris, who considered painting to be 'architecture, flat and coloured'.[90] Ozenfant strove for even greater simplifications. In 1920 the founders of Purism met Fernand Léger and began to publish the journal *L'Esprit Nouveau*. By this time Ozenfant's art had achieved a purity of style expressed in *Still Life with Dishes* and other still lifes of the same series, made up of identical elements. Bottles and glasses are typically the objects selected, and thematically these pictures are descended from the Cubist canvases of Picasso. But the impassive evenness of the flat areas, the restricted, precisely defined outlines of these paintings are very different from paintings such as *Table in a Café*. These are still lifes in the literal sense of the term.

In his enthusiasm for the precision inspired by the machine age, and in his understanding of the rhythmical organisation of a painting's two-dimensionality, Amédée Ozenfant had much in common with the

Composition, 1924, by Fernand Léger

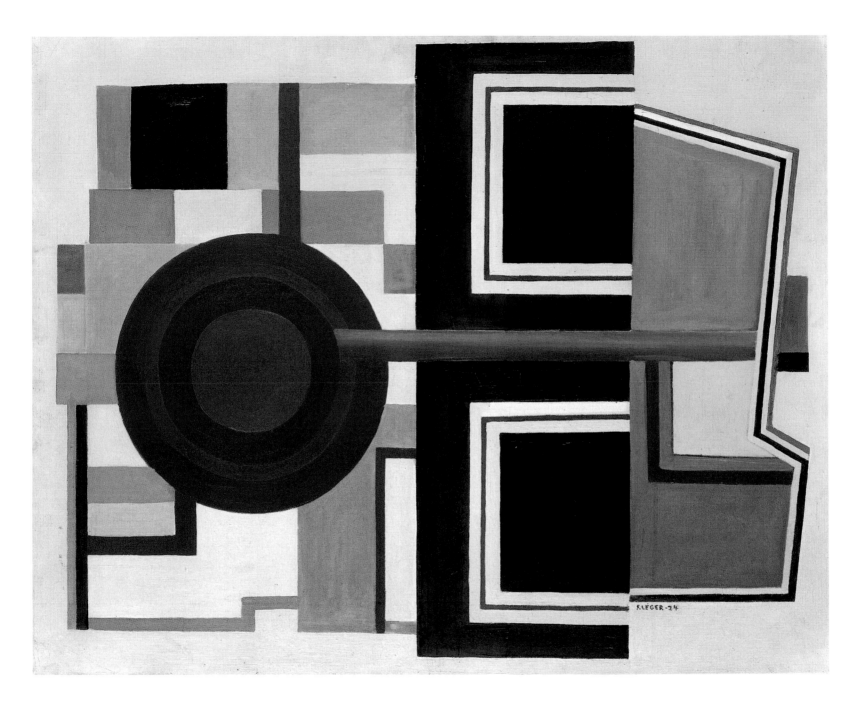

considerably more talented Fernand Léger. When he was painting *Composition*, Léger declared that he conceived machine images as others imagine a landscape. By conceiving such images he arrived at non-objective art, but even his abstract paintings, made up of rectangles and circles, were the apotheosis of modern technology and the machine age. As early as February 1912 the first exhibition of the Italian Futurists had opened in Paris, and had received a fairly cool reception. Léger and Delaunay, however, discovered parallels between these paintings and their own experiments. They were strongly attracted to the possibility of conveying movement, and in order to do this they discovered a number of surprising techniques. The geometrical elements in

Composition, although they do not portray any particular mechanism, provoke associations with connecting rods, slide-blocks, pistons and crankshafts, all prepared for rotary movement, drawing us into persistent rhythms. The meaning is thus not reduced to a decorative arrangement of patches of colour – it consists in the creation of a 'machine image'. While he was painting this picture, Léger published a lecture, floridly entitled 'The Aesthetic of the Machine, Geometric Order and the Truth', in which he maintained: 'Pure tone implies absolute frankness and sincerity. You cannot play around with it. What is more, if in one of my canvases a neutral tone sits alongside a pure tone, it will come alive under the influence of the pure tone.

Since I am striving to create the impression of movement in my works, I place three-dimensional objects in opposition to flat surfaces, thus bringing the flat areas to life. In works of this nature it is not a question of hypnosis through colour, but of the ennoblement of surfaces – I aim to give a building or a town the physiognomy of joy.'[91] In this way Léger viewed easel painting as a step on the road towards genuinely decorative monumental art, such as might be painted on the walls of buildings.

Even the people in Léger's paintings seem to be the creations of a machine. In *Postcard* parts of the body are unmistakably similar to the parts of a machine or architectural models. Everything is monumental

and breathes of an unshakeable faith in the present and the future. Throughout his life Léger was somehow able to retain an unaffected admiration for the construction of machines and the sweep of the great city. 'For me', the artist said, 'the human face and the human body have no more importance than a key or a bicycle. These are objects of plastic value, which I can use as I wish. The object has replaced the subject and abstract art has arrived at total liberation; now we are able to consider a human face not from the point of view of sentimental value, but purely as an object of plastic value. This is why in the evolution of my art the human face has remained consciously devoid of expression.'[92] In the painting *Postcard*, the various features of Léger's work of the early

1930s – the vertical leaf on the left, the young women, smoothly and powerfully outlined, the flower – combine to form a series of comparisons: the lips and the leaves, the breast and the centre of the flower, the hair and the trunk of the tree. As the artist himself explained, 'I dispersed my objects in space, forcing them to support one another and to shine out in front of the canvas. The colours of the background and the surface, the leading lines, the distances and the oppositions all combine to create a light play of rhythms and harmonies.'[93]

The Road to Expressionism

Expressionism represented the main antithesis to Cubism in early twentieth-century European art. Perhaps for reasons of national character, it was markedly more present in the countries of Northern Europe and Scandinavia, particularly Germany where it became the most significant movement in modern art. In France, Expressionism never really took root as a movement; at least half of the artists who practised Expressionism in France were originally from other countries. Nevertheless, the most striking developments in Expressionism throughout Europe were driven by artists working in France, largely because of the influence of Gauguin and Van Gogh.

German Expressionism owed a great deal to Fauvism. However, although both movements struggled for unrestrained creative emotions, the character of these emotions were far from identical. For example, the cheerful *joie de vivre* that is inseparable from the Fauvist works of Matisse, Derain, Dufy and Manguin was quite alien to the art of 'The Bridge' group (*Die Brücke*), regarded as the standard-bearers of Expressionism. It is revealing that the German Expressionist artists were particularly interested in Vlaminck and Van Dongen, artists who had already journeyed halfway towards Expressionism. Vlaminck, in fact, always considered himself a North European, as some of his ancestors were Flemish. For all his impassioned approach, however, he – like the other painters of the French avant-garde – could not help but look back towards Cézanne, although his Cézannism was of a much more nervous, disturbed kind than that of his friend Derain. Vlaminck's *Cézannesque* period did not last long, and he returned to his original rather sombre emotiveness and spontaneity, which was accompanied by a rejection of aesthetic theory. During his work on *Landscape with a House on a Hill* Vlaminck said that theories in art were as useful as doctors' prescriptions: in order to believe in them first you had to be ill.[94] Compared to his early Fauvist works, Vlaminck's post-War canvases show a greater restraint of colour, and a swiftness of drawing reminiscent of Courbet's late landscapes. The small patch of red for the roof, contrasting with the stormy autumn greens, is a technique of contrast used on several occasions by Corot to convey colouristic liveliness. Vlaminck, having tried fervently to persuade everyone that he had no respect for museum art, nevertheless found his foundations in such art, maintaining his former faith in a primitive, harsh romanticism.

The painting of Chaïm Soutine, a brilliant artist of the Paris School, represents the greatest achievements of Expressionism. The term 'Paris School' can be misleading. As used by art historians it does not include all artists who were working in Paris; nor does it necessarily refer to artists born in the French capital. Indeed, it is most useful to indicate that Paris was the capital of all western art, for it included artists from Spain, Germany, Italy, Poland, Russia and the United States. The majority of these were Europeans, and they were quick to befriend each other and promote each other's work. In this way Chagall, Modigliani and Soutine attained international popularity, providing a wonderful combination of original national self-expression and a willingness to learn from the discoveries of French artists at the turn of the century.

Soutine was one of a several children born to a penniless tailor from the Belorussian village of Smilovichi. His childhood was hard – it is said that he tried white bread for the first time when he was fifteen – and yet Soutine emerged from a place which had not even the faintest understanding of art to become one of the most original artists of the century. As a boy he went to Minsk and Vilno without a penny to his name, and managed to take some lessons at the local art schools. He lived in extreme poverty: his rations consisted of the cheapest black bread and salted cucumbers, which probably caused the stomach ulcer that eventually led to his death. In Paris he stayed at La Ruche (' The Beehive'), a strange jumble of tiny rooms and studios in Montparnasse that was home to Léger, Archipenko, Zadkine, Lipchitz, Modigliani, Chagall and Cendrars. Here, at the very heart of the avant-garde, he quickly felt himself at home.

A fellow-inhabitant of this bizarre commune described his impression of Soutine: '[He] brought to La Ruche a spirit that was wild, stormy and full of extravagance. But sometimes he was essentially quiet, humble and almost painfully shy.'[95] This strange conflict in his character is evident in Soutine's *Self-Portrait*, which was probably painted after he had left La Ruche and moved into a studio with Modigliani, who also painted several portraits of Soutine. 'Soutine has the tragic expression of incomprehension, a constant longing for suicide',[96] was how Ilya Ehrenburg described the portraits. In fact these words are not true of Modigliani's paintings, which, as a tribute from one friend to another, are at most imbued with melancholy and are devoid of the drama inherent in Ehrenburg's description. Ehrenburg was describing the Soutine he had known in Paris and his account is therefore far more appropriate to the Hermitage *Self-Portrait*.

The style of Soutine's picture is exceptionally bold, as if painted in a single burst of energy; at first glance it even resembles a malign caricature. However, it is clear from photographs that the artist has accurately captured his most distinct features, without a hint of self-pity. He is just as precise in his depiction of his clothing: numerous memoirs mention Soutine's 'down-and-out's' attire. Later, when he achieved success and dressed in exquisitely tailored suits, it was said that he still looked like a beaten dog. Nonetheless, Soutine was not without a certain arrogance and knew the worth of his own talent. *Self-Portrait* is aggressively anti-academistic, and in the urgent brushwork, undiluted by half-tones, we hear the sound of dumb despair. The style addresses the complex problems that only portraiture can resolve – the depiction of the psychology of someone who has been 'flayed'.

Of all twentieth-century artists Rouault was perhaps the only one whose paintings on themes from the gospels matched the works of Old Masters in terms of spiritual depth. His early Christian canvases coincided with the Symbolists' inclination for religious and mystical motifs (we need only think of La Touche, for example). Rouault, however, quickly parted company with the Symbolists, and his religious art belongs to a genre all of its own. His Christian compositions were never straightforwardly consonant with the views of the established Church. Instead, his is a very individualised Christianity, a mixture of humility and anarchism. We do not find scenes like the Annunciation or the Presentation at the Temple in Rouault's art. He painted only those scenes from the gospels that struck him as reflections of his own era. The majority of Rouault's religious paintings are devoted to the theme of Christ's Passion. His *Miserere* series of engravings, brought about by the events of the First World War, also inspired various works in oil over a number of years. Religious painting had become something of a rarity in the twentieth century. A number of new churches had been built, some of which were strikingly original in architectural terms; painting, however, seemed unable to go beyond the level of banality. When Rouault's contemporaries treated themes from the Gospels they generally adopted a kind of formulaic spirituality, or else they turned to illustration. The artists may have been devout believers, but their works were often insincere.

When he was working on *Head of Christ*, Rouault wrote: 'It is not enough to pray before you paint in order to equal Fra Angelico; nor is it enough to believe in only spiritual means in order to bring a work to life. In the first place a strong and vigorous inclination is required.'[97] Much was written about the need for a revival of religious painting, and many attempts were made, generally with lamentable results. 'Shall we introduce contemporary art into the churches?' asked Rouault, before providing his own response: 'This cannot be done simply by waving a magic wand. We must begin by loving painting, and then, once we love painting, we shall become clear-sighted... I have known many erudite people who are completely insensitive to form, colour and harmony, and other less cultivated people who are sensible of these things. These are the ones who, like a good hunting dog, have a nose for the art of the Old Masters and some of the moderns.'[98]

In his emotional perception of the world Raoul Dufy could not have been more different to Soutine or Rouault. Nevertheless, Dufy believed that Rouault's religious works provided the finest embodiment of the supernatural in all contemporary art; he was also on friendly terms with Soutine. Dufy's own gifts, however, had nothing to do with the tragic. Recalling Fragonard, he asked himself why joyful art could not exist in the modern age, as it had in the Rococo era? The question, of course, was rhetorical, but it is true that the twentieth century has produced relatively few celebratory works of true artistic merit.

The post-war *folle époque* valued Dufy especially highly. Lightness, elegance, true French *chic* – these were not the qualities of the Expressionists, the Cubists, or indeed of the majority of avant-garde artists, who considered such attributes the province of the Salon *charmeurs*. However, Dufy combined *chic* and refinement with a

The name of Georges Rouault is often linked with Expressionism, although his methods were not entirely compatible with the postulates of the movement. Rouault spent years, even decades, working on the same compositions, achieving a perfection and supreme spirituality which only he was fully able to comprehend. This was not entirely consistent with the Expressionist practice of spontaneous execution.

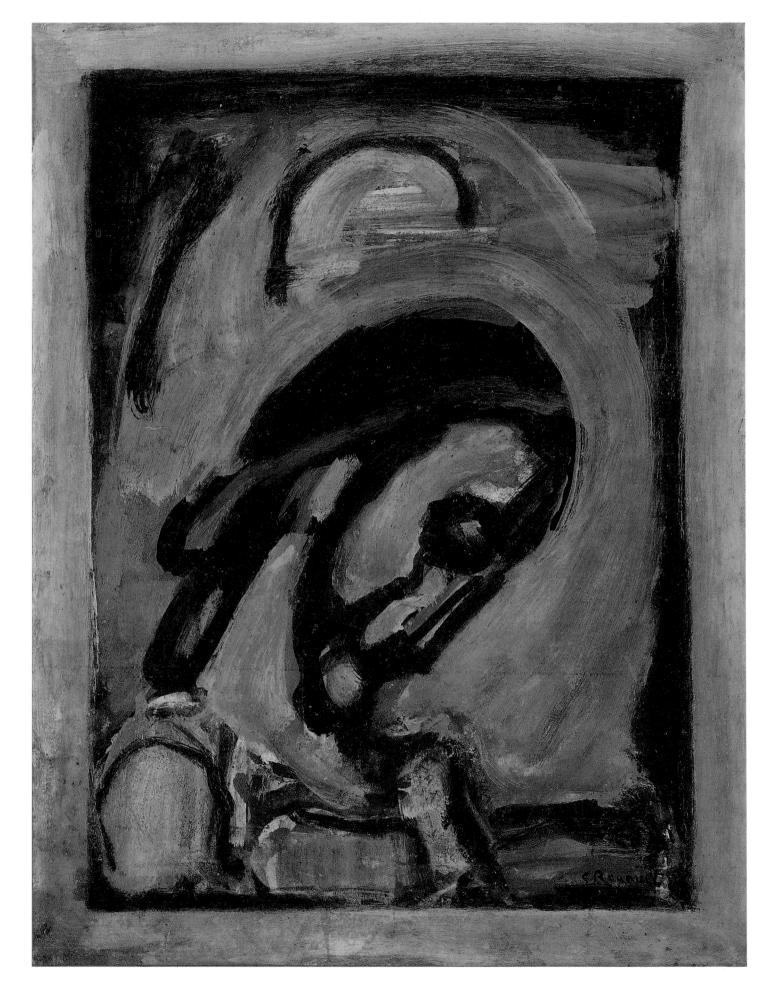

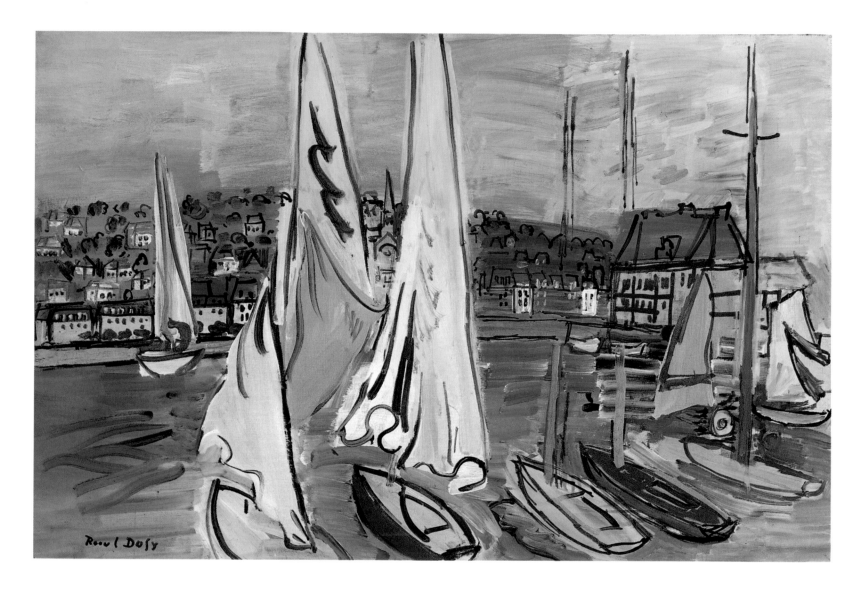

measure of laconicism and simplicity that could only have come from
an artist who had emerged from the avant-garde.

Sailing-Boats in Deauville Harbour has a lightness of draughtsmanship
reminiscent of a watercolour. The greyish sky and water, the blueish
mass of the hills and the white and pale yellow of the sails – these are
the basis of the work. The houses on the rugged coastline are defined by
a few jerky strokes, while each sail consists of three or four brief sweeps
of the brush. The drawing is applied on top of the coloured background,
a technique which Dufy returned to in his numerous sketches for deco-
rative fabrics and cloths, and which he used unconstrainedly in his art.

The harbour at Deauville had changed a great deal since it was painted
by Boudin. This small fashionable town on the coast of the English
Channel, with its casino, horse racing, polo championships and regattas,
became a favourite haunt of Dufy's. However, not a single one of his
depictions of the town could be called naturalistic. They are fantasies on
a theme prompted by nature. 'Today landscape painting teaches people

how to see a landscape,' Dufy once confided to Courton. 'The ancients
painted landscapes from nature. Now there are many things that lie
between these two extremes. We make an intellectual interpretation
from nature; we are forced to paint what has already been painted,
and we must arrive at the quintessence.'[99]

Having chosen the path of the modern artist in the first years of the
century Dufy, like Matisse, stood for an unaffected view of things. The
spontaneity of the execution of *Sailing-Boats in Deauville Harbour* might
remind us of a child's drawing. Dufy, however, was not inclined to over-
estimate the value of childish creativity. 'Of course,' the artist said, 'the
freshness of innocence is always attractive, but there is something else.
In children's drawings there is something very important – if only in its
earliest form – which must reappear with the experience of knowledge.
You see, this is why – whatever people may say – school is necessary.'[100]

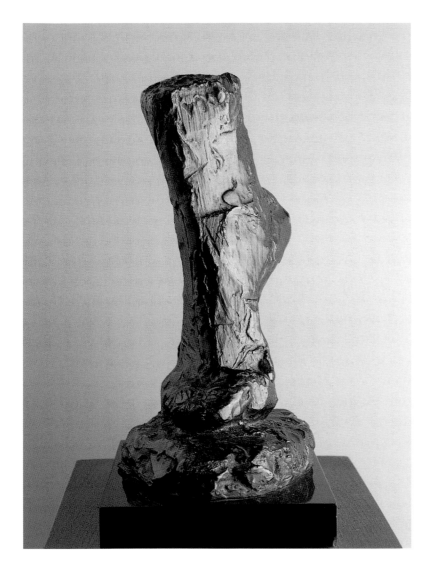

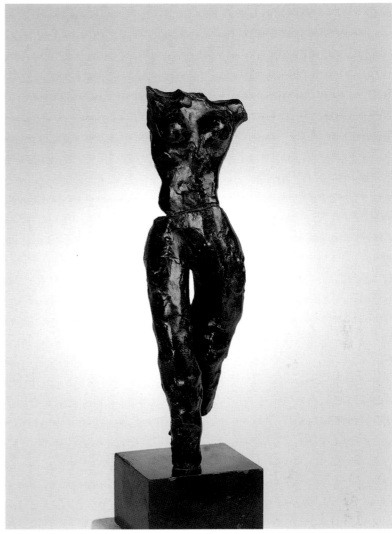

The Statuettes of Matisse

So immense was Matisse's gift for painting that sometimes his
sculptures are paid less attention than they deserve. His small-scale
statuettes, relatively few in number, are often overshadowed by the
brilliance of his canvases. However, Matisse himself always recognised
their importance. He returned to sculpture throughout his creative life,
and his work on the statuettes was assiduous and sometimes lengthy.
A drawing or even a painting could be created quickly, in one sitting,
when he wanted 'a release of emotion'. But both his large-scale relief
works and his small-scale statuettes required a different approach. Here
he had to think ahead about the constructional considerations in joining
together various parts of the human body. The human form was always
the subject of Matisse's sculptures. He used to say that the human figure
enabled him more fully to express his religious feelings: 'I do not try to
detail all the features of a face, recreating them one after the other with
anatomical accuracy. If I have an Italian model before me, who at first
glance strikes me as a purely animal existence, then in the process of

my work I uncover her most significant features, and through the
lines of her face I penetrate the lofty gravity that exists in every human
being.'[101] 'Gravity' implies both significance and weightiness, and this
word alone serves as a key to Matisse's sculptural aims. Matisse main-
tained that sculpture and painting were two parallel directions in art,
which should never be muddled. He admitted that he turned to sculpture
when he was tired of painting, but at the same time he worked in
sculpture as a painter. Often the same model or the same pose is
portrayed both on the canvas and in bronze. On more than one occasion
Matisse portrayed his own sculptures in his paintings. In his picture
Pink Statuette and Pitcher on a Red Chest of Drawers (page 309), for
example, Matisse's own sculpture is depicted in the centre of the work.

Not once, however, did Matisse use sculpture as a support for his paint-
ing. Experts may argue whether *Study of a Foot* is a study for *Dance* or,
indeed, a study at all, but there is no doubt that this work has its own
structure. It possesses an immanent energy and three-dimensional
perfection that could only come from sculpture and which should not

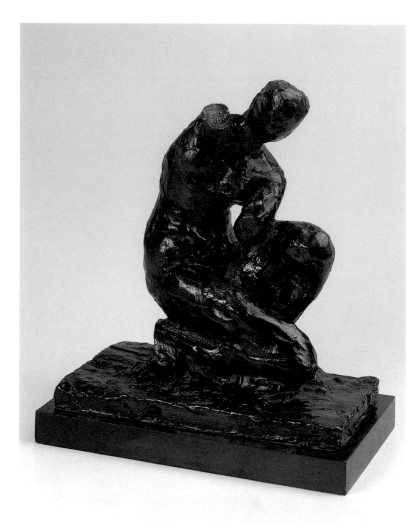

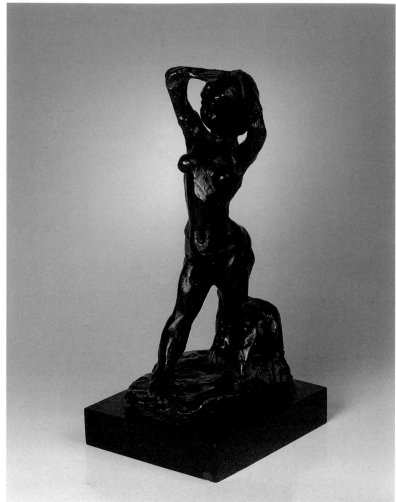

be confused with an accurate representation of anatomical details. Some of Matisse's predecessors would prepare for a picture by moulding their figures. They would then use these to create a setting from which they could work out the best possible composition for their painting. Matisse never followed these methods: for him, sculpture could never have a subordinate role. While Matisse's paintings are openly two-dimensional, his sculptures are emphatically three-dimensional. Matisse used to say that 'in sculpture form needs to be expressed more definitely, for it needs to be viewed from a greater distance'.[102] If we compare Matisse's sculptures to the other artistic media within which he worked, they appear more expressive and less subject to creative evolution. Matisse's sculptural style was developed under the influence of Barye, Rodin and Bourdelle. He turned to Bourdelle for advice, visiting his workshop in 1900. He then spent sitting after sitting working on a free version of Barye's *Jaguar Devouring a Hare*. Matisse was also friends with Maillol, although he later recalled that they never discussed sculpture. 'We never spoke on the subject. For we would not have understood one another. Maillol worked through mass, like the Ancients, while I worked through the arabesque, like Renaissance artists. Maillol did not like taking risks, while I was always attracted to them.'[103]

Matisse's statuettes were modelled in clay and then cast in bronze in limited numbers (usually ten copies). The clay was used not so much for recreating real flesh as for the creation of three-dimensional volume. In *Standing Nude* the artist turns to distortions of anatomical accuracy in order to express purely sculptural rhythms. Beauty in its normal everyday sense is irrelevant to this or other statuettes by Matisse, just as it would have been inapplicable to the artist's Celtic forebears, whose bronze figurines were the inspiration for the movement of *Torso*, which was also conceived as a variation on the Nike of Samothrace. 'Your imagination', Matisse explained to his students, 'is thus stimulated to help the plastic conception of the model before you begin. This leg, but for the accident of the curve of the calf, would describe a longer, more slender ovoid form; and this latter form must be insisted upon, as with the Ancients, to aid the unity of the figure. Put in no holes that hurt the ensemble, as between thumb and fingers lying at the side. Express by masses in relation to one another, and large sweeps of line in inter-relation. One must determine the characteristic form of the different parts of the body and the direction of the contours which will give this form. In a man standing erect all the parts must go in a direction to aid this sensation... One can divide one's work by opposing lines (axes)

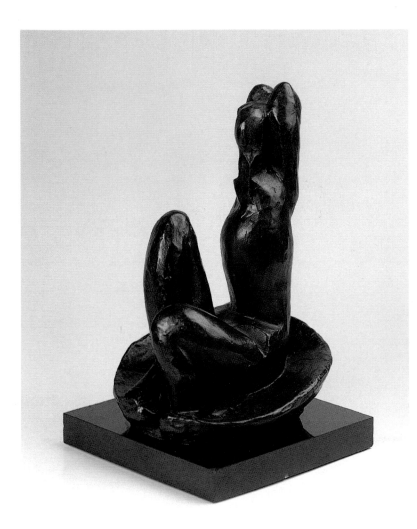

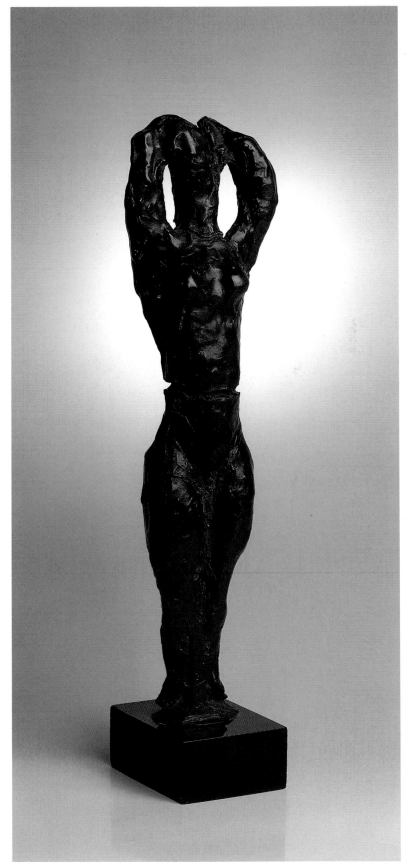

which give the direction of the parts and thus build up the body in a manner that at once suggests its general character and movement.'[104]

The essence of Matisse's sculptural techniques is most strongly felt in his variations on themes from antiquity. *Crouching Venus* recreates the pose of the so-called *Doidals Aphrodite*: Matisse was well-acquainted with a Roman copy of this Hellenistic statue in the Louvre. The Ancient Greek original of the statue has not survived, but its Roman copies were often imitated in the nineteenth century.[105] With his *Crouching Venus*, Matisse conducts a polemic discourse with both the ancient sculptors and their imitators. The name itself contains a paradox. The features of the face of the goddess of beauty are not delineated, while the body is proportionally inaccurate. The only indication that this is Venus is the absence of arms: Matisse's statue is without arms in precisely the same way as the *Venus of Milo*. Had he so desired, Matisse could easily have referred to the Vatican copy in order to see the ancient genuflecting Venus with arms. However, arms would have hindered the plastic accents of the sculpture and were thus unnecessary. For the same reasons Matisse did not develop the bathing theme, which was used by the ancient masters – it is clear that the plastic aspects of the image rather

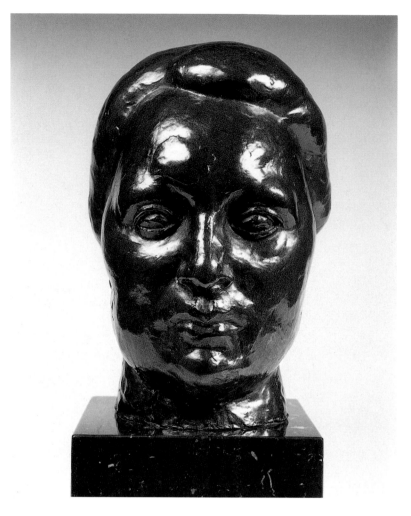

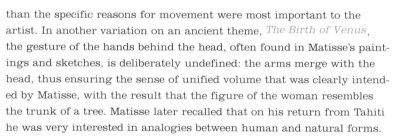

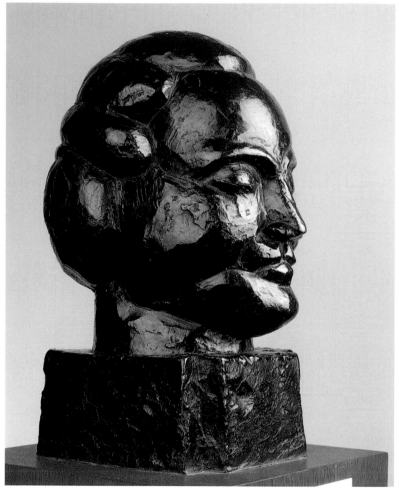

than the specific reasons for movement were most important to the artist. In another variation on an ancient theme, *The Birth of Venus*, the gesture of the hands behind the head, often found in Matisse's paintings and sketches, is deliberately undefined: the arms merge with the head, thus ensuring the sense of unified volume that was clearly intended by Matisse, with the result that the figure of the woman resembles the trunk of a tree. Matisse later recalled that on his return from Tahiti he was very interested in analogies between human and natural forms.

The most significant of Matisse's sculptures in the Hermitage collection is surely *Henriette III*, the last of a series of three heads posed by the professional model Henriette Darricarrère. In this work nothing remains of Henriette's beauty, of the refinement and sensitivity that Matisse captured in his odalisques portraying Henriette in the mid-1920s. It is possible that the artist was struck by changes in her face. Even if that were so, however, the coarsening and ageing of Henriette's features are so pronounced that there is no question of a portrait likeness. The entire series of heads shows with unique clarity Matisse's development from the concrete to the more abstract, to a structure of profound plasticity that begins to take on its own life, regardless of the model on which it is based.

Matisse: The Magic of Line

Matisse left a vast number of drawings. When they serve as sketches and studies for other works, their main interest lies in the extent to which they reveal the creative process. The drawings which from the outset were intended as independent works of art are significantly more important. Whenever he turned to paper, pencil and charcoal, Matisse was aware of the special properties of his chosen materials. He always began by 'collaborating' with his material. In sculpture he tried to make use of the pliancy and plasticity of clay. In the same way, in his drawings the nature of the representation and the method were defined not only by the medium, but also by the size, whiteness and texture of the paper, as well as the potential for interplay between the white background and the pencil or pen lines. In all his drawings Matisse's main aim was to achieve the utmost simplicity.

All the works in the Hermitage collection, which were created over two decades, are striking for a special expressiveness attainable only through drawing. The earliest was executed in 1933, when Matisse was already sixty-three years old. The thirties and forties were the period of Matisse's finest achievements in graphic art, and he began to

turn to drawing with increasing frequency as one of the highest forms
of art. By treating the same motifs with only limited technical resources,
portraying the same model again and again, he strove not only to
sustain the creative impulse the model inspired, but also to find the
sharpest possible expression of this impulse. In this sense his aim in
graphic art was the same as in painting. Matisse managed to avoid
monotonous repetition while treating the same subject. This was not just
because there was something new, some previously unseen arabesque or
movement of line. Formal innovation arose as a natural consequence of
fluctuating emotions. It is as though Matisse knew everything about his
model, but was caught up in an endless game, where he always strove –
and, indeed, managed – to uncover a new expressive or inspired nuance.
Matisse's drawings are immediately arresting both through their
bewitching simplicity, and the virtuosity and conviction with which the
lines control the white rectangle of the paper. They are also striking in
that we can discern not only the result of the artist's work, but also the
process that has led to that result. The line on the paper is the trace of a
pencil or pen. When we approach Matisse's work we have a strong sense
of the swiftness of his movement, and we can even guess the order in
which the lines have been committed to paper. We can sense the creation
of the drawing, for each feature retains the energy of the creative
gesture. If there has been a moment of hesitation, we feel this too.

The attraction of *Portrait of a Young Woman with Her Hair Down* lies
in the precision and swiftness of the pencil lines. The pencil scarcely
pauses. Here and there some barely noticeable shading is added to the
lines, along with some deliberate, light hatching. This hint of shading
creates the effect of soft velvety skin, while the hatching brings out the
hair's silky texture. Like most of Matisse's drawings in the Hermitage
collection, *Portrait of a Young Woman* portrays Lydia Nikolaevna
Delektorskaya. Delektorskaya, who was constantly at Matisse's side
for the last twenty years of his life, was not only his model but also his
friend, secretary and part-time nurse. After Matisse's death she worked
as a literary translator, but the main part of her life was spent in the
service of Matisse's art. She was born in Siberia, and at a very young age
had lived among émigrés in the Chinese city of Harbin. She arrived in
Paris at the age of nineteen, with no job and not a word of French.
This was a time of general economic crisis, and her first three years in
France were spent in the constant search for employment, which was
always low-paid and temporary.

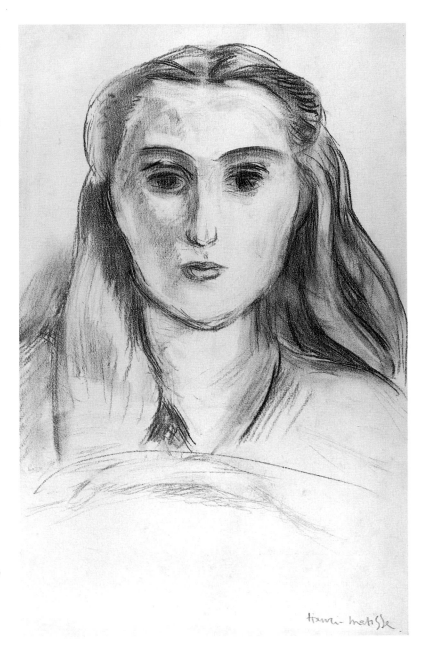

'In October 1932,' Lydia Delektorskaya later recalled, 'at a time of great
personal financial difficulty, I happened to find some work with Henri
Matisse. At this time he was working on his enormous *Dance* panel for
the Barnes Foundation in Philadelphia, and he needed an assistant in
his studio. After six months the panel was complete and he returned
to easel painting, and then he no longer had need of an assistant. But
four or five months later his wife, who by then had been incapacitated
for several years, was looking for a new girl to work as nurse and com-
panion. They remembered me and sought me out. At first I worked in
the position by the day, then they offered me monthly work, and invited
me to live with them, which I accepted. So it was that I found myself
alongside Matisse... for 22 years. During the first year I was with them,

Henri Matisse scarcely paid any attention to me. He lived immersed in
his work; I was someone who helped around the house and that was all.
Sometimes it appeared that he was a little perplexed by the presence in
this very French family of an example of the notorious 'Slavic soul'. He
would spend all day working in his studio, but during breaks would
come without fail into the living quarters of the appartment to spend a
few minutes with Mme Matisse, who spent much of the day lying down.
I would sit in silence while they chatted about one thing or another,
though it was clear that Matisse's thoughts were still fixed on his work.
A few months or perhaps a year later, Matisse's severe and penetrating
gaze began to fix itself on me, and I paid no attention to this. Although
he had made three or four sketches of me when I had first worked as
his assistant, it did not even occur to me that I might pose for him

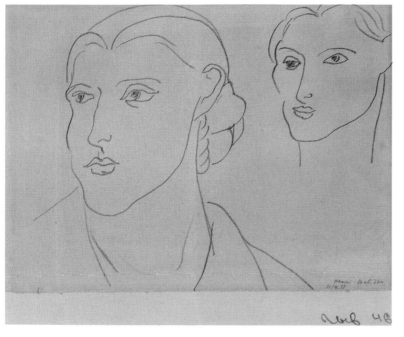

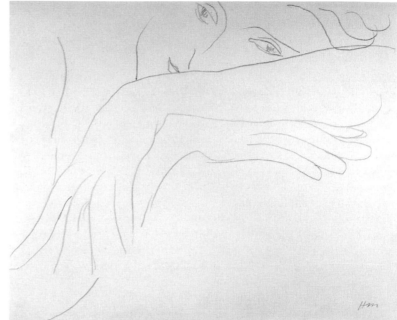

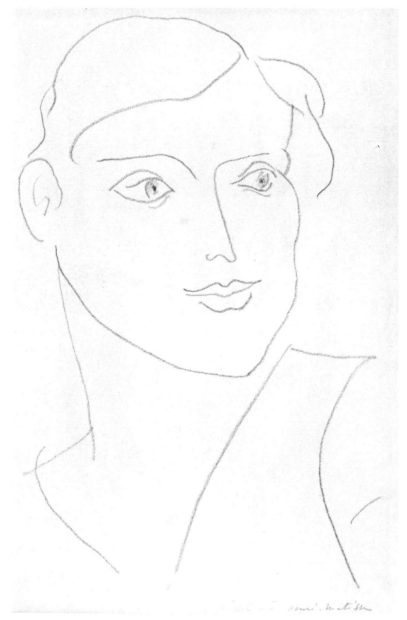

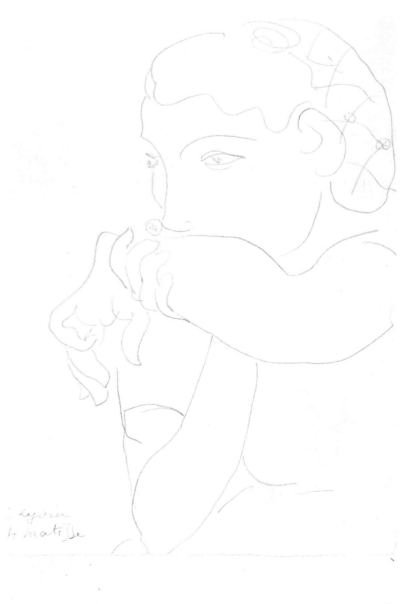

Opposite (top left): **Two Studies of a Woman's Head**, 1935, by Henri Matisse
Opposite (top right): **Study of a Model Leaning on the Back of a Chair**, 1934, by Henri Matisse
Opposite (bottom left): **Portrait of a Woman**, 1935, by Henri Matisse

Opposite (bottom right): **Portrait of a Woman**, *c.* 1939, by Henri Matisse
Below (top): **Female Profile (to the left)**, 1935, by Henri Matisse
Below (bottom): **Portrait of a Woman**, 1944, by Henri Matisse

379

again. There were two reasons for this. When I had first come to him in search of work I belonged to the category of émigrés who, under French law, had no rights to paid work, with the exception of one or two temporary jobs: cinema extra, mannequin, temporary nanny and so on. Since I was in a state of extreme penury and still spoke very poor French, I decided to make ends meet by working as a model. Before coming across Matisse's address by pure chance – I knew nothing of him! – I had found work in three other studios. But I found the work, which required me to simulate self-assurance, a terrible burden. So as soon as I found myself constant employment as a nurse and companion, I hoped that I would never have to return to the profession of model, which I had found so detestable. Furthermore, since Henri Matisse had not wanted to work with me any more after the first three or four sketches, I decided that as a model I was simply not suited to him, and that was that… There was another thing, too: I was not his 'type'. Apart from his daughter, the models that inspired him were principally Southerners. But I was a very pale blonde. No doubt this was why, when from time to time he showed interest in me, he gave me such a deep and thoughtful look.'[106]

According to Lydia Delektorskaya, after *Study of a Model Leaning on the Back of a Chair*, Matisse began to draw her regularly. He may have been attracted by 'this pose, which was unusual for him, perhaps because it was a little bold coming from an employee'.[107] The pose was later to be transformed into the painting *Blue Eyes*, and it is likely that it forced the artist to pay more attention to someone whom he had hitherto viewed as only a chance presence in his house. Matisse felt the utter naturalness of the pose, which was an extremely important condition of all his work. 'It was what he was always looked for in his work, as he would watch his models at rest. He even admitted that an affected or strained pose tired him and made him feel unwell.'[108]

'My models', Matisse said, 'are human figures, who are never simply figures in some kind of interior scene. They are the principal theme of my work. I depend on my model entirely, and this is why I watch her at rest and only then decide on the pose that I think best conveys her naturalness.'[109] Matisse could not work without models, but it usually took some time before he established a rapport with them, even if they were well suited to him. Later this rapport would become a kind of dialogue. It was as if each turn of the figure required a renewal of the acquaintance, which would begin by detecting the point of contact, highlighting some particular details that would later become secondary. Then the nature of the rapport would change, becoming increasingly dynamic. Matisse's first drafts were often realistic studies of details. Later drafts tended towards an almost formulaic laconicism. By returning to his model again and again, Matisse would begin to understand her character and habits and would bring out her most important features. The end result would combine careful forethought with the completely free and natural movements of pencil or pen. In his final drawings Matisse achieved a wonderful lightness, where the pencil seems almost autonomous, and the drawings to have been created blindfold. At the critical moment the artist's eye was always fixed on his model and not on the paper, while his pen would move over the paper without detaching itself from the surface.'[110] 'In order to liberate the

grace and naturalness of my model I do many exercises before committing pen to paper. I never strive for vigour; on the contrary, I am like a dancer or a tightrope-walker who begins his day with long hours of loosening-up exercises, so that every part of his body is under his control when he wants to convey his emotions to the public through a series of slow or fast dance movements or through an elegant pirouette.'[111] He also warned: 'I have never treated drawing as an exercise in some particular skill, but as a means of expression of intimate feelings or a state of mind. For drawing is a simplified means, able to express my feelings with simplicity and spontaneity, so that the viewer can gain access to them without difficulty.'[112]

In *Female Profile (to the left)*, a masterpiece of outline drawing, the young woman's hair is conveyed through a few flourishes of the pencil;

this is work which could only have taken a few seconds. Single delicate and classically clear lines delineate the strong features with naturalness and skill, while the outline of the profile is achieved in a single movement. Each line – the nose, the chin, the ear, the locks of hair, the edge of the dress at the base of the neck – is marked by the same quality of musicality and a light, waltzing rhythm.

It is worth comparing the wonderfully simple *Female Profile (to the left)* with such a complex composition as *Reclining Nude (Artist and Model)* to appreciate that for Matisse nothing was impossible in graphic art. In *Reclining Nude* the woman, drawn in clear, sensual outlines, almost occupies the whole page, so that her head is even slightly cut-off. The strong young body, carelessly sprawled, concentrates the light of the drawing into herself, as if pushing everything else to the edge of the

painting. At the same time, however, the other details – the patterns on the carpet, the tiles on the wall, the mirror, and the artist's table in the foreground – all combine to form a wonderful setting for the nude woman. It seems that she is not so much posing as gaily playing around. But significantly the drawing is subtitled *Artist and Model*, and the presence of the artist is emphasised in a variety of ways: from his hand holding the pen, with which the viewer enters the space of the drawing, to the small caricatured image of the artist, staring tensely out of the mirror onto the pure and sensual outlines of his young model-goddess. In his later years Matisse turned away from colour in his drawings; he worked predominantly in pencil, and occasionally in ink or chalk. He ultimately realised the supremacy of line drawing over all other forms of graphic art, maintaining that 'these drawings are far richer in content than mere sketches, which is how many people see them. They are a source of light; when we look at them in the evening light, or lit indirectly, we can see that they contain light and differences in value which correspond to colour, as well as the knowledge and sensitivity of line. This is achieved because line drawings are always preceded by studies drawn with less rigorous materials such as charcoal or shading. This enables us to consider at the same time the character of the model, her human expression, the quality of the light that surrounds her, her environment and everything which can only be expressed through drawing.'[113]

On the evening of 28 August 1939, Matisse set off for Switzerland to see an exhibition of masterpieces from the Prado. When he arrived in Geneva he learnt of the declaration of war with Germany, and immediately returned to Paris. However, believing his presence in the disturbed capital to be useless, but not wanting to be too distant, he stopped for a short time in Rochefort-en-Iveline. Here he tried to find distraction from his worries by immersing himself in his work. The drawing *Portrait of a Woman in a Hood* (page 384) and the painting *Young Woman in a Blue Blouse*, both of which were executed in Rochefort, are variations on the same theme. Both works depict the contemplative face of the artist's assistant, Lydia Delektorskaya; however, they create an image that is so generalised that in each case the likeness is of secondary importance,

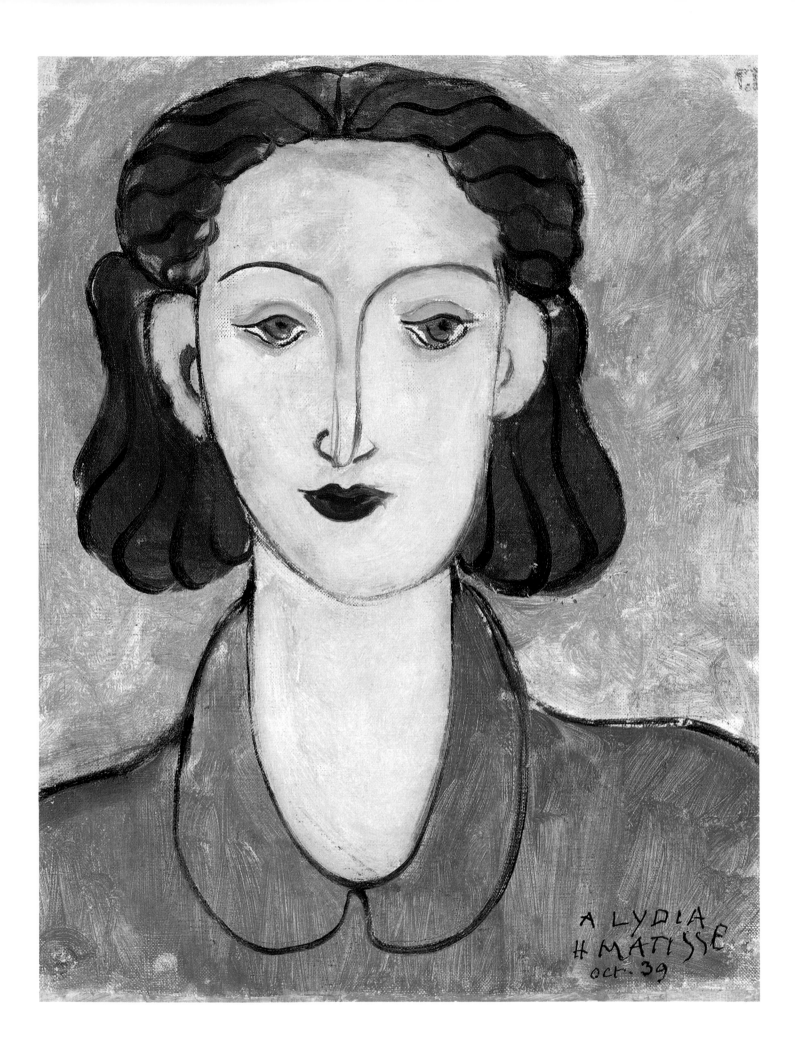

A LYDIA
H MATISSE
oct. 39

Left: **Young Woman in a Blue Blouse (Portrait of L. N. Delektorskaya)**, 1939, by Henri Matisse
Below: **Still Life with Jug and Peaches**, 1940, by Henri Matisse

Still LIfe with Two Vases, 1940, by Henri Matisse

383

and the anonymous titles of the works seem justified. Fascinated by the classical strength of the young woman's features, Matisse concentrated on achieving a simplicity of 'subliminated' lines. In each picture he found additional means of capturing the features: in the drawing the outline of the hood echoes the terse expressiveness of the face, and it becomes the only appropriate frame; in the painting, by contrast, the face is framed by the apparently complex and decoratively rich golden locks of hair. *Young Woman in a Blue Blouse* is unexpectedly reminiscent of ancient works of art such as the statues of *kouroi*, and in particular a *kouros* on the Athenian Acropolis. Both have strong facial features consisting of a single arc for the nose and eyebrows, wide-open unseeing eyes, coloured lips, an elongated neck and, most importantly, conventionally ornamental hair in individual locks. In both *Portrait of a Woman in a Hood* and *Young Woman in a Blue Blouse* the model pays no attention to the viewer, there is no sense of communication. In *Young Woman* her eyes are wide open, but her gaze is not directed at the artist or the viewer; rather, she seems to look in on herself. Matisse, who openly admired Lydia's blue eyes, made them the key to the meaning of this

composition. It is irrelevant whether or not he asked her to pose in blue, corresponding to the tone of her eyes, or whether he settled on the colour during the creative process. The blue basis of the picture, which forces itself upon us after we have already viewed the whole picture, somehow brings all our attention back to the face.

Female Profile (page 386) belongs to the series *Themes and Variations*, which is one of the greatest achievements of twentieth-century graphic art. All the drawings in the series are divided into groups. Each group consists of one charcoal drawing dedicated to the theme, with thick lines and shadings. Just as in a set of musical variations, the theme is then treated using different instruments – pencil or pen. It is as if the sky, recently clouded over, has cleared to let the light through, and each drawing in the group shines with the whiteness of the paper, leaving only the contours of the object or the human figure behind. These drawings are the very embodiment of lightness. 'When I draw my *Variations*, the path that my pencil traces across the page has something in common with the gesture of a man who is feeling his way

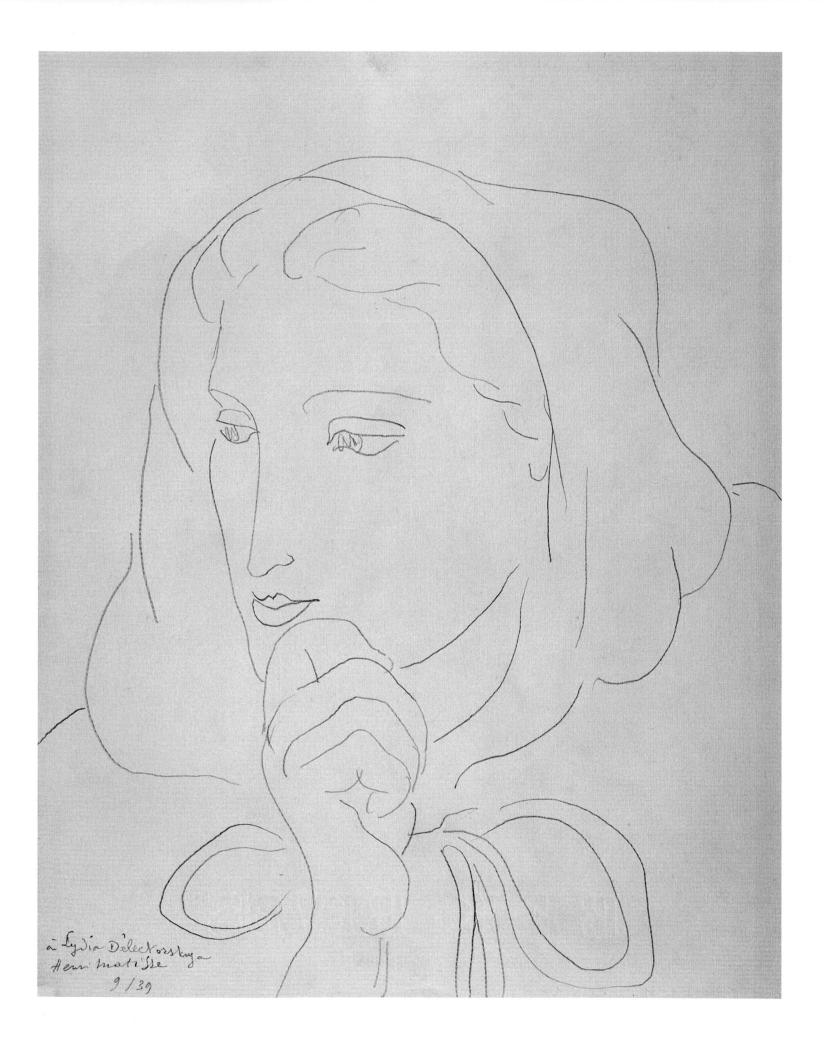

à Lydia Délectorskaya
Henri Matisse
9/39

Left: **Portrait of a Woman in a Hood**, 1939, by Henri Matisse
Below (right): **Woman with Bare Breasts**, 1948, by Henri Matisse

Overleaf (page 386): **Female Profile**, 1942, by Henri Matisse
Overleaf (page 387): **Portrait of L. N. Delektorskaya**, 1947, by Henri Matisse

385

through the darkness. I mean that my path has nothing preordained in it: I am led, I do not lead. I pass from one point of my model to the next, and I see each in absolute isolation, independent of the other points towards which my pen leads me.'[114] Remarkable for the unique style that reveals the personality of the artist, these works are also notable for the organic way in which real facts are translated into the world of art. The lines are precisely arranged so that we both recognise the objects portrayed and respond to their expressiveness. They are autonomous features, and they express more than they portray. Just as in Matisse's still lifes we uncover more than simple objects, in his portraits we see more than just faces. We uncover a unique, harmonious world of lines, in which what is extracted from reality is truly valuable and captivating.

It is appropriate to pass from the drawing, *Female Profile*, to the painted *Portrait of L. N. Delektorskaya* (page 387). For despite the obvious difference in techniques, the different times they were created and the contrasting points of view, it is clear that in both works the artist is moving towards a single aim: the revelation of one particular female face, conveyed with the concision of a great artist. In the painting, unlike the drawing, the model is shown face-on. This distinctive face-on posture, dissected by a vertical line, actually creates an effect one would normally expect from portraits in profile. The details of the face – in particular the silhouetted outline, the straight nose and the sharp, slightly exaggerated prominence of the chin – are viewed as if from the side; they are therefore quite unexpected in a work where the artist has looked at his model straight-on. Three or four decades earlier, Matisse had deliberately forced the decorative qualities of his portraits as an antidote to naturalism, which was especially difficult to avoid in the portrait genre. In his late canvases he went even further. In comparison to *Lady in Green* or even *Zorah Standing*, the pictorial structure of *Portrait of L. N. Delektorskaya* is markedly more abstract. A portrait of this kind verges on the symbolic; it is almost a hieroglyph. The colour structure attains a level of autonomy never seen before, so that the hair of the model is conveyed in green. What is more, going against the logic of chiaroscuro, the lighter green shade is shown on the left, where the blue of the left-hand side of the face would seem to indicate shadow; the dark-green, by contrast, is on the right, the same side as the yellow which undoubtedly indicates the lit side of the face. The division of colours overall can be described as zonal: the green zone, the yellow zone, the grey zone and so on. The borders of the zones are clearly defined by the simplest of black lines.

The linearity and two-dimensionality of the picture is largely due to the fact that Matisse's final creative period was dedicated to cut-outs. Scissors became his main instrument, and he used them to cut figures or ornamental details from sheets of paper previously painted with gouache; these were then stuck onto a paper foundation. The year in which he painted *Portrait of L. N. Delektorskaya*, Matisse published *Jazz*, a selection of compositions for which the originals had been executed using the technique of *découpage*. In the text that accompanied the illustrations, Matisse wrote: 'To draw with scissors. To cut immediately into colour reminds me of the direct approach of sculptors in stone. That is the spirit in which this book has been conceived.'[115]

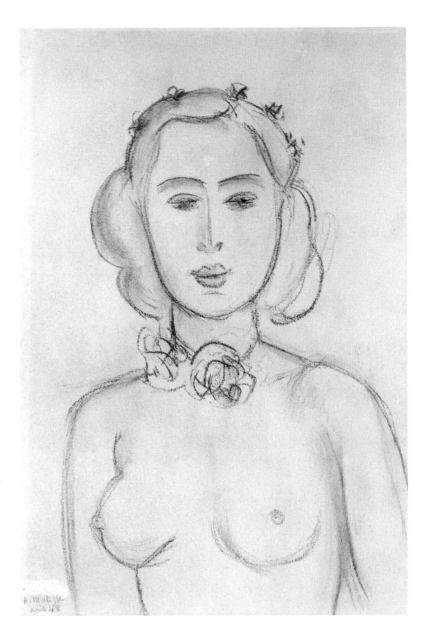

Matisse compared the draughtsman's work with that of the sculptor on more than one occasion. Depending on what he intended to portray, the sculptor always chose clay or stone. Stone, in turn, could be of different hardness. The choice of materials in drawing was dictated by the feelings of the artist. Charcoal was suitable for the soft expression of three-dimensionality through shading. But in *Woman with Bare Breasts* the unshaded background was so important that Matisse limited himself to hints of shading. Charcoal was no doubt used here because its softness corresponded superbly to the image of the young woman. The techniques are very simple: an oval delineates the shape of the face, the combination of a few curved lines conveys the hair. Matisse's mastery of three-dimensionality, and the understated conviction and delicacy in his work, all testify to a vision of clarity and harmony based on a complex understanding of the world around him.

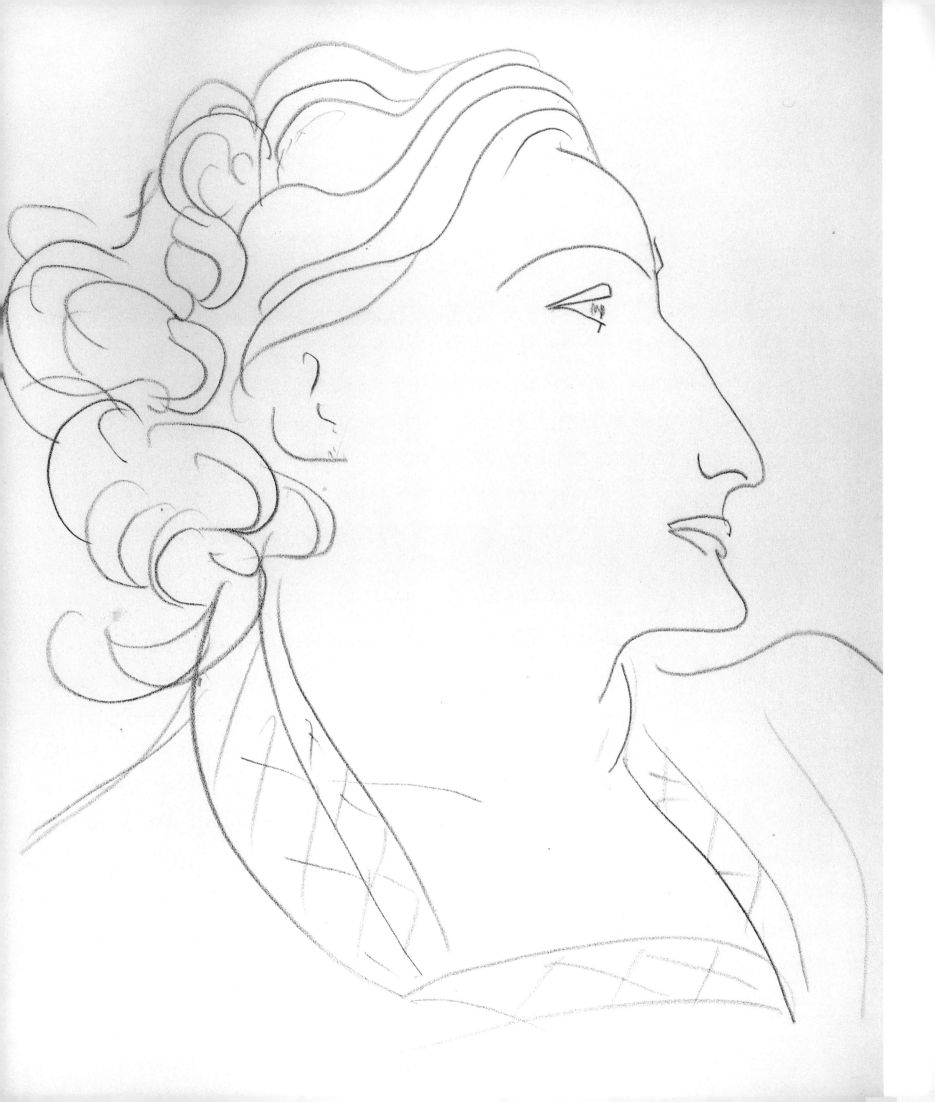

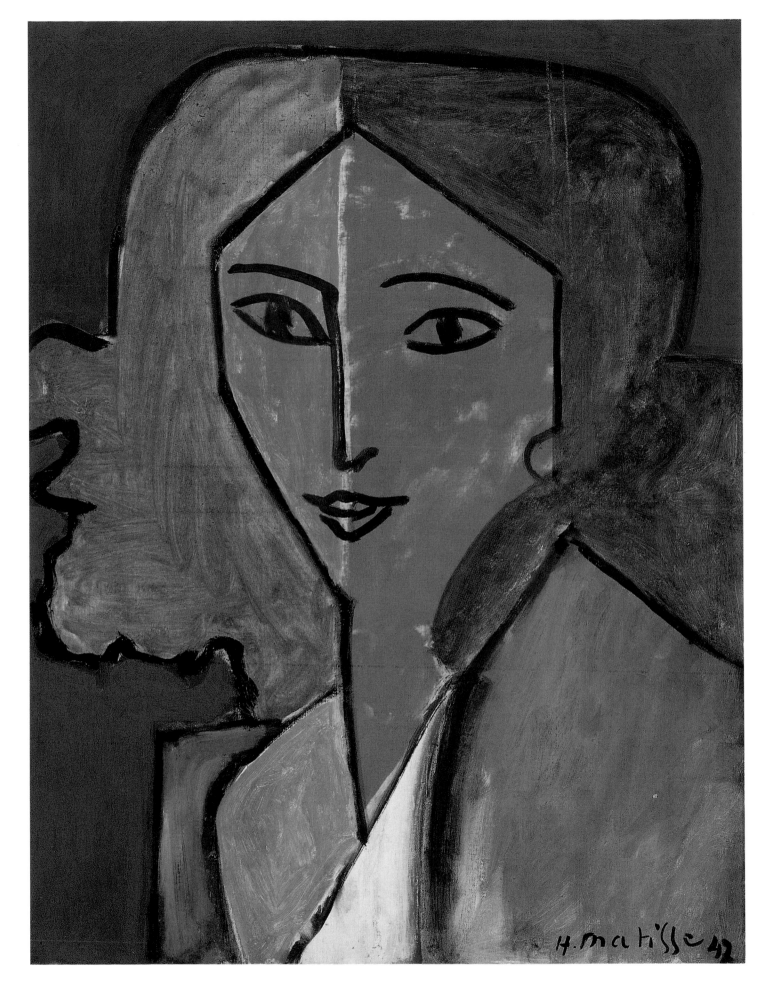

Notes

The Story of the Collection

1. This is particularly true of American institutions, whether it be the Metropolitan Museum of Art in New York, the National Gallery in Washington, the Art Institute of Chigaco or the Philadelphia Museum of Art. In the great European centres (Paris, London, Munich), the collections are – for historical reasons – more specialised; thus in Paris, for example, European art is divided between several museums: the Louvre (from the Renaissance to the 1840s); the Musée d'Orsay (mainly showing the development of art in the second half of the nineteenth century); and the Centre Georges Pompidou (twentieth-century works). To these three national museums should also be added several municipal galleries: the Petit-Palais, the City Museum of Contemporary Art, and others.

2. Brockhaus and Efron, *Encyclopaedic Dictionary* (St Petersburg, 1904), vol. 81, pp. 38–9. It is worth mentioning that Somov, although he disregarded Impressionism and any of the 'extremes' of the new art, was an extremely erudite man who wrote many articles about nineteenth-century artists for the same encyclopaedia.

3. Before the Revolution the Hermitage comprised the Picture Gallery, the Department of Antiquities and the Numismatic Collection, and as such could hardly be regarded as a museum of world culture. It became so only in the Soviet era – with the creation of new departments and the expansion of the existing ones – when the idea of including contemporary works of art within a wider framework began to be implemented.

4. Such was the fate, in particular, of the collections of G. E. Haasen in Petrograd, and N. P. Ryabushinsky in Moscow. Certain works that were exhibited in Russia in the years leading up to the First World War disappeared after the Revolution.

5. The aim was to implement the slogan 'Art Belongs to the People' as quickly as possible. However, very often problems such as a lack of qualified personnel or difficulties with heating meant that within a few years the museums simply ceased to exist. Their liquidation can also be blamed, in part, on the Soviet regime's policy of selling off works of art abroad at the end of the 1920s.

6. They were not transferred to the museum immediately. Although the Winter Palace (where the Gallery of French Nineteenth- and Twentieth-Century Art is housed) is today an integral part of the Hermitage, straight after the October Revolution it was renamed the Palace of Arts and turned into an independent museum. In 1922 most of the rooms in the Winter Palace were made available to the Hermitage, while the rest were occupied for a further four years by the Museum of the Revolution.

7. The Russian Museum of Emperor Alexander III, the largest museum of Russian art in the country, only opened after Alexander's death, in 1898, but the tsar was already discussing it in the mid-1880s. At Alexander III's behest, the Hermitage acquired the unique collections of Basilevsky and Golitsyn, the former at a cost of five and a half million francs.

8. A. Prakhov, 'Emperor Alexander III's work in Russian artistic education', *Art Treasures of Russia* (St Petersburg, 1903), vol. iii, pp. 154–6.

9. *Ibid.*, p. 148.

10. *Ibid.*, p. 142. On this trip to Paris paintings by Repin, Vasnetsov, Savitsky and Kharlamov were acquired and subsequently donated to the Russian Museum.

11. B. K. Veselovsky, 'The Picture Gallery of the Imperial Academy of Arts, III', *Catalogue of the Gallery of Count N. A. Kushelev-Bezborodko* (St Petersburg, 1886), p. iii.

12. *Ibid.*, p. iv.

13. Will of P. M. Tretyakov, 17 [29] May 1860, State Tretyakov Gallery; published in *State Tretyakov Gallery: Studies in History, 1856–1917* (Leningrad, 1981), p. 301.

14. *Ibid.*, p. 302.

15. In 1921 sixteen of Haasen's paintings entered the Hermitage collection, and the museum thus reflected, if inadequately, the art of the first decade of the twentieth century. The catalogue of Haasen's collection has not survived, but it was undoubtedly more comprehensive. At the exhibition *One Hundred Years of French Painting: 1812–1912* several of his paintings were shown (including works by Bonnard and Vuillard) which later disappeared, probably between 1917 and 1921.

16. The first transfer of paintings to Moscow occurred as early as 1862, when 200 works were removed from the Hermitage to form the basis for the collection of Western painting at the Rumyantsev Museum, which in turn became the nucleus of the picture gallery at the Museum of Fine Arts (later the A. S. Pushkin State Museum of Fine Arts). In 1924 around 200 paintings from the Shuvalov and Yusupov palace-museums, as well as a significant number of works from the Hermitage, were sent to the capital. In 1927 a further 66 paintings from the Hermitage and the affiliated Yusupov collection were despatched to Moscow, and another consignment the following year. Among the paintings which the Pushkin Museum acquired from the Hermitage in 1927–8 were works by Botticelli, Lotto, Sebastiano del Piombo, Guido Reni, Ostade, Steen, Claude and Watteau. Finally, at the beginning of 1930 the Pushkin Museum received another 73 masterpieces, including Cranach's *Virgin and Child*, paintings of the Madonna by Perugino and Luini, Veronese's *Minerva*, Rubens's *Bacchanal* and *Portrait of a Woman*, portraits by Van Dyck, four paintings by Rembrandt, Poussin's *Rinaldo and Armida*, and many other outstanding works.

17. Shchukin's house was targeted by high-ranking 'comrades' at the People's Commissariat of Military Affairs, located nearby. Trotsky used to drop in here when he was still head of the Red Army. The merger of the two collections, a decision of the People's Commissariat for Enlightenment, was officially presented – as was customary – as a progressive step. The director of the Museum of Modern Western Art, B. N. Ternovets, was made to write that the merger was dictated 'by a desire to systematically display the history of new Western art' (B. N. Ternovets, 'Fifteen Years' Work', *The History of the State Museum of Modern Western Art*; see B. N. Ternovets, *Letters, Diaries, Articles* (Moscow, 1977), p. 139). However, it is evident that the merger resulted in a vastly reduced display area, so that a proposal was put forward to add a third floor to Morozov's house, which would have utterly ruined this superb work of architecture.

18. 'In accordance with the expressed will of its owner S. I. Shchukin,' wrote the famous Russian critic Muratov, '[the collection] is intended to be donated to the city's Tretyakov Gallery where it will supplement and carry forward S. M. Tretyakov's collection of foreign painting.' P. P. Muratov, 'The Shchukin Gallery', *Russkaya Mysl* [*Russian Thought*] 8 (1908), p. 116.

19. For further information on S. I. Shchukin and other great Russian collectors of the beginning of the century, see A. Kostenevich, 'Morozov and Shchukin – the Russian Collectors', *Russian Collectors of French Painting* (ex. cat.: Folkwang Museum, Essen; Pushkin Museum of Fine Arts, Moscow; Hermitage Museum, St Petersburg (Cologne, 1993), pp. 37–137).

20. P. A. Buryshkin, *Mercantile Moscow* (Moscow, 1991), p. 145.

21. Much of his collection eventually ended up in the Hermitage.

22. The paintings were later sold by his sons, and the collection ceased to exist.

23. P. B. [P. D. Boborykin], 'Letters about Moscow', *Vestnik Evropy* [*European Herald*] 3 (1881), p. 378.

24. In 1878 Ivan Vasilievich's three eldest sons, Nikolai, Piotr and Sergei, became joint owners of the firm I. V. Shchukin and Sons, and thus acquired the means to purchase works of art.

25. *The Shchukin Museum Over its Eighteen-Year Existence (1892–1910)* (Moscow, 1910), p. 1.

26. With the onset of Soviet rule the Shchukin Museum was abolished. The buildings, which had been specially constructed by Piotr Ivanovich for his collection (where the spirit of Ancient Russia had predominated), were handed over to the K. A. Timiryazev Biological Museum – an absurd use of such a building, but the new museum had influential patrons since it was affiliated to the biology faculty of the Sverdlov Communist University. Piotr Shchukin's exhibits were transferred to the storerooms of the Historical Museum where they remain to this day.

27. Letter of A. P. Chekhov to O. L. Knipper, 23 January 1902: A. P. Chekhov, *Collected Works* (Moscow, 1950), vol. xix, p. 230.

28. *Katalog der Sammlung Iwan Stchoukin, Paris. Gemälde alter Meister. Auktion bei Keller und Reiner* (Berlin, 9 April 1907).

29. A testament to their friendship is the portrait Zuloaga painted of Ivan Shchukin, which is now in the Hermitage. Shchukin is shown as a society dandy (no doubt how he wished to be portrayed), not on a Parisian boulevard but against a stony Spanish landscape.

30. Ivan Shchukin owned several paintings by El Greco which have since been confirmed as original; a canvas such as *The Repentance of Saint Peter* (now in the Phillips Collection, Washington) is undoubtedly one of the artist's masterpieces. Even if some of his paintings were more accurately attributed to the artist's circle rather than his own hand, this was no reason to dismiss them as fakes. It was hardly likely that a successful forgery would have been attempted at the beginning of the twentieth century, when El Greco was only just being rediscovered after long neglect, and both Shchukin and Zuloaga would have easily identified a recent forgery.

31. M. Denis, *Journal* (Paris, 1957), vol. ii, p. 108.

32. Y. Tugendkhold, *The First Museum of Modern Western Painting* (Moscow, 1923), p. 12.

33. Related literature has often repeated Tugendkhold's claim that the first Impressionist painting acquired by S. I. Shchukin was Monet's *Lilacs at Argenteuil* (1873; Moscow, Pushkin Museum). 'In 1897 F. Botkin, long-term resident of Paris, turned his attention to the work of Claude Monet in the private gallery of Durand-Ruel. Shchukin immediately acquired his *Lilacs at Argenteuil*, which was the first of Monet's works to enter Russia' (Y. Tugendkhold, *op. cit.*, p. 13). It is more likely, however, that this painting came a year later. Ivan Shchukin, Sergei Ivanovich's son, referred to *Rocks at Belle-Ile* as the first painting by Monet to appear in their house (letter from I. S. Shchukin to A. A. Demskaya, 3 December 1972, Archive of the Pushkin Museum of Fine Arts). This would accord more readily with the information in Wildenstein's catalogue, which gives 1898 as the year of its sale (D. Wildenstein, *Claude Monet: Biographie et catalogue raisonné* (1084), Lausanne, 1974–1991).

34. V. V. Perepletchikov, *Journal Entries*, Moscow (Central State Archive of Literature and Art: F. 824, Op. 1, Ed. Khr. 14, p. 170).

35. Monthly literary supplements to the magazine *Niva* (January/February 1897).

36. A. Benois, *Memoirs* (Moscow, 1990), vol. i, pp. 490–1.

37. Y. Tugendkhold, 'The French Collection of S. I. Shchukin', *Apollon* 1–2 (1914), p. 6.

38. P. P. Muratov, 'The Shchukin Gallery', *Russkaya Mysl* [*Russian Thought*] 8 (1908), p. 129.

39. J. Flam, *Matisse on Art* (Berkeley/Los Angeles, 1995), p. 203.

40. Y. Tugendkhold, 'The French Collection of S. I. Shchukin', *Apollon* 1–2 (1914), p. 18.

41. P. P. Muratov, 'The Shchukin Gallery', *Russkaya Mysl* [*Russian Thought*] 8 (1908), p. 116.

42. J. Freeman, *The Fauve Landscape* (Los Angeles, 1990), p. 83.

43. *Ibid.*, p. 92.

44. B. W. Kean, *French Painters, Russian Collectors: The Merchant Patrons of Modern Art in Pre-Revolutionary Russia* (London, 1994), p. 161.

45. He kept it in a prominent place in his New York house.

46. A. H. Barr, *Matisse: His Art and His Public* (New York, 1951), p. 147.
47. Letter of 20 December 1910. See A. Kostenevich, 'La correspondance de Matisse avec les collectionneurs russes', *Matisse et la Russie* (Moscow/Paris, 1993), p. 168.
48. Tugendkhold, 'The French Collection of S. I. Shchukin', *Apollon* 1–2 (1914), p. 6.
49. S. D. Miloradovich, 'Meetings in the School of Painting, Sculpture and Architecture', *Valentin Serov in the Memoirs, Diaries and Correspondence of his Contemporaries* (Leningrad, 1971), vol. ii, p. 86.
50. K. S. Petrov-Vodkin, *Khlynovsk; The Space of Euclid; Samarkand* (Leningrad, 1970), p. 361.
51. Piotr Pertsov, for example, thought that the gallery contained too many paintings by Henri Rousseau and André Derain (P. Pertsov, 'The Shchukin Gallery of French Painting', *The Museum of Modern Western Painting* (Moscow, 1922), p. 86).
52. F. Olivier, *Picasso et ses amis* (Paris, 1933), pp. 118–19.
53. W. Rubin, *Picasso and Braque: Pioneering Cubism* (Museum of Modern Art, New York, 1989), p. 363.
54. Tugendkhold, 'The French Collection of S. I. Shchukin', *Apollon* 1–2 (1914), p. 30.
55. *Catalogue of Paintings in the Collection of S. I. Shchukin* (Moscow, 1913). The catalogue was published in two languages and contains 225 entries. In Shchukin's personal copy, which is kept in the archive of the Pushkin Museum of Fine Arts, there are handwritten additions at the end.
56. N. Preobrazhensky, 'In the Gallery of S. I. Shchukin in Moscow', *Patrons and Collectors: Almanac of the All-Russia Society for the Protection of Monuments of History and Culture* (Moscow, 1995), p. 49.
57. P. Pertsov, 'The Shchukin Gallery of French Painting', *The Museum of Modern Western Painting* (Moscow, 1922), p. 92.
58. *Ibid.*, pp. 92–3. Pertsov's reference to S. N. Bulgakov is entirely characteristic. The paintings by Picasso belonging to S. I. Shchukin on the eve of, and during, the First World War had a strong effect on Russian philosophical and poetic thinking. See N. Berdyaev, 'Picasso', *Sofiya* (1914); G. Chulkov, 'Demons and the present', *Apollon* 1–2 (1914); S. N. Bulgakov, 'The Corpse of Beauty', *Russkaya Mysl* [*Russian Thought*] 8 (1915).
59. B. N. Ternovets, 'New Acquisitions in the Second Museum of Modern Western Painting in Moscow', *Sredi Kollektsionerov* [*Among the Collectors*] 5–6 (1922), p. 27.
60. Archive of the State Historical Museum, Moscow (Op. I; F. 265; D. 9).
61. *Ibid.*
62. Exact information as to when M. A. Morozov started to collect paintings is not available.
63. P. A. Buryshkin, *Mercantile Moscow* (Moscow, 1991), p. 130.
64. M. K. Morozova, 'Memoirs', *Nashe Nasledie* [*Our Heritage*] 6 (1991), p. 99.
65. *Ibid.*, p. 97.
66. 'The Gentleman', *Collected Works of Prince A. I. Sumbatov* (Moscow, 1901), vol. iii, p. 398.
67. 'Memoirs of M. K. Mamontova-Morozova', *Kuranty: Local Lore, History and Economy Almanac* (Moscow, 1983), pp. 348–9.
68. *Recollections of Konstantin Korovin* (Moscow, 1971), p. 604.
69. S. Diaghilev, 'M. A. Morozov', *Mir Iskusstva* 9 (1903), p. 141.
70. B. N. Ternovets, 'The Museum of Modern Western Art (Morozov department)', *Letters, Diaries, Articles* (Moscow, 1977), p. 107.
71. S. Diaghilev, 'M. A. Morozov', *Mir Iskusstva* 9 (1903), p. 141.
72. *Recollections of Konstantin Korovin* (Moscow, 1971), p. 606.
73. A. Bely, *The Beginning of the Century* (Moscow/Leningrad, 1933), pp. 460–2.
74. P. A. Buryshkin, *Mercantile Moscow* (Moscow, 1991), p. 133.
75. Official publications of the Tretyakov Gallery refer to a legacy rather than a gift, which of course is not correct. See *The State Tretyakov Gallery: Studies in its History 1856–1917* (Leningrad, 1981), p. 212; also *The State Tretyakov Gallery: Catalogue of Eighteenth- to Early Twentieth-Century Painting* (Moscow, 1984).

76. M. K. Morozova, 'Memoirs', *Nashe Nasledie* [*Our Heritage*] 6 (1991), p. 97.
77. These figures were given by Ternovets, who was responsible for nationalising the Morozov collection – see B. N. Ternovets, 'The Museum of Modern Western Art (Morozov department)', *Letters, Diaries, Articles* (Moscow, 1977), p. 108. I. A. Morozov himself referred to a larger number (430) of works of Russian art (F. Fénéon, 'Les Grands Collectionneurs: Ivan Morosoff', *Bulletin de la vie artistique* (1920), p. 355), but possibly this figure included drawings as well.
78. F. Fénéon, 'Les Grands Collectionneurs: Ivan Morosoff', *Bulletin de la vie artistique* (1920), p. 355.
79. Later Alfred Barr, the founder of the New York Museum of Contemporary Art, who was well acquainted with both the Shchukin and Morozov galleries in Moscow, even gave preference to the Morozov Gauguins. See A. Barr, *Russian Diary; Defining Modern Art: Selected Writings of Alfred H. Barr, Jr.* (New York, 1986), p. 116.
80. In the Pushkin Museum's archive is a copy of the exhibition catalogue annotated by I. A. Morozov.
81. S. Makovsky, 'French Artists from the Collection of I. A. Morozov', *Apollon* 3–4 (1912), p. 11.
82. *Ibid.*, pp. 5–6.
83. J. Flam, *Matisse on Art* (Berkeley/Los Angeles, 1995), p. 204.
84. F. Fénéon, 'Les Grands Collectionneurs: Ivan Morosoff', *Bulletin de la vie artistique* (1920), p. 356.
85. Just before this exhibition, in an essay on Edouard Manet, Tugendkhold referred to *Bar at the Folies-Bergère* as 'by no means his strongest' (Y. Tugendkhold, *French Art and its Representatives* (St Petersburg, 1911), p. 29).
86. Letter from V. A. Serov to I. A. Morozov of 10 December 1909. See B. N. Ternovets, 'The Museum of Modern Western Art (Morozov department)', *Letters, Diaries, Articles* (Moscow, 1977), p. 116.
87. Marguerite Duthuit, Matisse's daughter, recalled that I. A. Morozov was 'bluff, genial and kindly', while – in her own words – Shchukin was characterised by Matisse as 'a shrewd, refined and very serious man'. (B. W. Kean, *French Painters, Russian Collectors: The Merchant Patrons of Modern Art in Pre-Revolutionary Russia* (London, 1994), p. 102.)
88. B. N. Ternovets, 'The Museum of Modern Western Art (Morozov department)', *Letters, Diaries, Articles* (Moscow, 1977), p. 119.
89. B. N. Ternovets, 'Collectors and antiquaries of the past: I. A. Morozov', *Sredi Kollektsionerov* [*Among the Collectors*] 10 (1921), p. 41.
90. A. Efros. 'The Man with the Amendment: Memories of I. A. Morozov', *Sredi Kollektsionerov* [*Among the Collectors*] 10 (1921), pp. 3–4.
91. M. Denis, *Journal: 1884-1943*, vol. iii (Paris, 1959), p. 214.
92. Letter from V. A. Serov of 12 July 1910. (B. N. Ternovets, *Letters, Diaries, Articles* (Moscow, 1977), pp. 106–7.)
93. The commission for the new Bonnard panels was conducted through Félix Fénéon, who sent I. A. Morozov a letter from the artist expressing satisfaction that the collector was pleased with the triptych. He asked if he could have a small photograph showing how the triptych was hung, so that he could work on the next two parts. A slight delay resulted from Bonnard's insistence that he would not lower the price, asking 25,000 francs for both panels, as well as for the triptych *On the Mediterranean*. Morozov in the end agreed to Bonnard's terms. Bonnard's letter to Fénéon and Morozov is kept in the archive of the Pushkin Museum of Fine Arts.
94. Letter from S. I. Shchukin to Matisse, 10 December 1913 (Kostenevich, *Ibid.*, p. 173). The panel Shchukin is referring to is *Summer, Dance* (1912; Moscow, Pushkin Museum).
95. Letter from Matisse to I. A. Morozov, 19 September 1911 (Kostenevich, *Ibid.*, p. 181).
96. Letter from Matisse to I. A. Morozov, 29 September 1912 (Kostenevich, *Ibid.*, p. 182).

97. Y. N. Zhukov, *Preserved by the Revolution: The Protection of Monuments of History and Culture in Moscow in 1917–21* (Moscow, 1985), p. 67.
98. F. Fénéon, 'Les Grands Collectionneurs: Ivan Morosoff', *Bulletin de la vie artistique* (1920), p. 357.
99. This proximity was ultimately fatal for the Shchukin residence. Its occupants after the Revolutionary Military Council were first the People's Commissariat and then the Ministry of Defence, which took over the surrounding area and erected ugly buildings for its administration and Military Academy. Fortunately the Shchukin residence was not demolished; instead it was taken over for departmental purposes. Access is strictly forbidden.
100. Y. Annenkov, *Diary of My Encounters* (Leningrad, 1991), vol. ii, p. 275.
101. It is clear that before leaving the country S. I. Shchukin must have given all his papers to someone for safekeeping, in particular his correspondence with dealers and artists. Judging by his letters kept in Matisse's Paris archive, Shchukin would also have possessed a significant number of communications from Matisse. Numerous attempts to trace the Shchukin archive have proved fruitless. It can only be assumed that the person to whom Sergei Ivanovich entrusted his papers destroyed them during the years of general repression. To have kept correspondence belonging to a White Russian émigré, as well as numerous documents not written in Russian, would have carried great personal risk.
102. *Decrees of Soviet Rule* (Moscow, 1964), vol. iii, pp. 399–400.
103. S. T. Konenkov, *My Century* (Moscow, 1971), p. 209.
104. *Decrees of Soviet Rule* (Moscow, 1964), vol. iii, p. 460.
105. *Decrees of Soviet Rule* (Moscow, 1968), vol. iv, p. 240.
106. Central State Archive of the RSFSR (F. 2306, Op. 28, Ed. Khr. 84, L. 2). It is not clear exactly who was this Denisov, appointed to keep check of Ternovets and Morozov; doubtless he was connected to the Cheka.
107. P. A. Buryshkin, *Mercantile Moscow* (Moscow, 1991), p. 148. It may be suggested that Shchukin's opinion was influenced by the fact that at that time – 1920 – the Galerie Bernheim-Jeune, while trying to interest Shchukin in collaboration, had concluded a contract with Dufy.
108. The Dufy paintings and the drawing by Picasso were later sold by Shchukin's daughter, while the canvases by Le Fauconnier are still owned by the collector's grandson, André-Marc Deloque-Fourcaud, who showed them to the author. By comparison to *Village in the Mountains* in Shchukin's Moscow collection, the Paris works are much more expressionistic and sombre. These four individual depictions of women created for Sergei Ivanovich were deeply personal, and portrayed members of his family.
109. Sales of works of art began in 1928, two years after A. I. Mikoyan was made People's Commissar for Foreign Trade. Mikoyan played a particularly sinister role in the squandering of Russia's art treasures. The Antiquariat was created – an organisation that was invested with the highest authority to sell works from state museums abroad, the museums being powerless to countermand it. It quite soon became clear that the most convenient place to carry out these sales was Germany, since the Rapallo Treaty had formally recognised the Soviet government and, by extension, its nationalised possessions. If at the first auctions in November 1928 the works sold were of varying merit, the artistic standard at later sales became increasingly high. The Hermitage and the palaces within and around Leningrad suffered particularly badly from these sales.
110. P. A. Buryshkin, *Mercantile Moscow* (Moscow, 1991), p. 148.
111. The collection of Albert Barnes at Merion, Pennsylvania, remains one of the best in the world, with more than 100 works by Renoir and over 60 by Cézanne. However, Barnes was not overly fastidious or infallible in his artistic judgement, and he acquired a very large number of works known to be of secondary importance. Morozov's paintings by Cézanne, for example, although significantly fewer in number, are undoubtedly of a higher quality.

112. R. C. Williams, *Russian Art and American Money: 1900–1940* (Cambridge, MA, and London, 1980), p. 34.

113. Among the paintings from the Museum of Modern Western Art bought by Clark were Cézanne's *Portrait of Madame Cézanne in the Conservatory*, which belonged to I. A. Morozov, Renoir's *Waitress at the Restaurant Duval*, from the collection of S. A. Shcherbatov, and Degas's *Singer in Green*, from the collection of M. P. Ryabushinsky (all three are now in the Metropolitan Museum of Art, New York), as well as Van Gogh's *Night Café*, from the collection of I. A. Morozov (now in the Yale University Art Gallery, New Haven).

114. A sign of the approaching changes was the dismissal, without any explanation, of B. N. Ternovets – the first and only director of the Museum of Modern Art.

115. A high-ranking official of the Arts Committee of the USSR, and, from the 1950s to the 1980s, of the RSFSR Ministry of Culture.

116. N. V. Yavorskaya, 'Eyewitness Account of How the Museum of Modern Western Art was Closed', *Dekorativnoye Iskusstvo SSSR* [*Decorative Art in the USSR*] 7 (1988), p. 13.

117. *Ibid.*

118. *Ibid*. The destruction of works of art was perhaps to be expected from the zealous bureaucrats on the Arts Committee, just as the Nazis did with the works of *entartete Kunst* ('degenerate art') not sold at auctions in Lucerne in 1939.

119. Senior members of the Arts Committee. Lebedev later became director of the Tretyakov Gallery, while Sysoev, renowned for his officious and narrow-minded dedication to the implementation of 'cultural' prohibitions, was for many years secretary of the presidium of the Academy of Arts.

120. Resolution of the USSR Council of Ministers No. 672, of 6 March 1948: State Archive of the Russian Federation (R. 5446, Op. 1, D. 327). Published in an article by M. Aksenenko, 'How Cézanne and Matisse were Closed Down', *Mir Muzeya* [*Museum World*] 6–7 (November/December 1998), pp. 47–8.

121. I. A. Orbeli, a generally assiduous director who was not inclined to turn anything down, was aided by N. V. Yavorskaya, who was anxious as to the fate of the paintings and wanted to make sure they ended up in a secure place. Furthermore, Orbeli had been given instructions by his wife, A. N. Izergina, who was the Hermitage curator of nineteenth- and twentieth-century painting at the time.

122. The storerooms of the Pushkin Museum were filled to overflowing. To celebrate the dictator's seventieth birthday, a long-running exhibition was held of gifts received by Stalin; the exhibition was as pompous as it was absurd. The entire museum was filled for several years with these exhibits, which meant that there was no room for Old Master paintings from the permanent collection. Also destined for the storerooms was the entire Dresden Picture Gallery, brought over from Germany in 1945. The issue of its return had still not been raised at that time.

123. The Museum of Modern Western Art's acquisitions in the second half of the 1920s owe a great deal to the initiative of B. N. Ternovets, who succeeded in forging direct contacts with a whole range of artists.

124. However, even in 1962 the Hermitage had to withstand strong pressure from the presidium of the Academy of Arts, headed by Vladimir Serov, once more striving to 'restrain' the type of work on show by excluding the bolder works of Matisse and Picasso. During one discussion about what should be exhibited, the then president of the Academy of Arts was forced to back down after a gentle rebuff from A. N. Izergina, who quoted the following words from the original decree (which had been found, forgotten, in the archive) nationalising the Shchukin collection: 'its high artistic value gives it state-wide significance in terms of public education'. Serov fulminated: 'Who wrote this nonsense?' When he heard that it was signed 'Ulyanov' [Lenin], he was forced to back down, but made no attempt to hide his extreme irritation.

125. The painting was held at the Soviet–Finnish border in 1980 after an illegal attempt to take it out of the country; it was then handed over to the Hermitage.

126. The importance of buying the Boudin landscape was further dictated by serious doubts over the authenticity of the only other work by Boudin owned by the Hermitage – *On the Beach*. This came from the collection of the artist Natan Altman and was acquired in 1968. The museum now tries to be absolutely sure in all its attributions, relying not only on art-historical and technical analysis, but also on impeccable documentary evidence of provenance.

127. With the division of the Museum of Modern Western Art's collection in 1948, the entire *Story of Psyche* ensemble by Denis went to the Hermitage, while the four statues by Maillol, created to complement the series of paintings, remained in Moscow at the Pushkin Museum of Fine Arts.

Idols of the Salon and the Impressionists

1. Rosenblum and Janson consider 1815, 1848 and 1870 the principal milestones of the nineteenth century, although it is true that they apply these dates not just to French art but to Western art as a whole; see R. Rosenblum and H. W. Janson, *19th Century Art* (New York, 1984). Rewald begins his history of Impressionism from the World Exhibition of 1855 and the appearance of Pissarro in France; see J. Rewald, *The History of Impressionism* (New York, 1973).

2. 'Matisse Speaks', *Art News Annual* 21 (1952); J. Flam, *Matisse on Art* (Berkeley/Los Angeles, 1995), p. 200.

3. 'Matisse: Entretien avec Jacques Guenne', *L'Art vivant* 18 (15 September 1925); quoted in *Henri Matisse: écrits et propos sur l'art* (Paris, 1972), p. 84.

4. E. Bernard, 'Souvenirs sur Paul Cézanne', *Conversations avec Cézanne* (Paris, 1978), p. 57.

5. *Ibid.*, pp. 57–8.

6. It is indicative that when the picture first arrived from the Winter Palace, where it did not have a label, even employees of the Hermitage could not guess what the subject was, and entered it in the catalogue of Western European Art of 1958 as *Reclining Nymph*. Only later was an engraving with the original title found quite by chance.

7. A. P. Chekhov wrote at the time, half in jest, half seriously: 'There are now two heroes of the day in St Petersburg: Semiradsky's nude *Phryne* and a fully-clothed me. We are both causing a stir' (letter to M. V. Kisseleva: A. P. Chekhov, *Collected Works* (Moscow, 1949), vol. xiv, p. 312).

8. Letter from V. I. Surikov to P. P. Chistyakov (Paris, late December 1883): V. I. Surikov, *Letters: Recollections of an Artist* (Leningrad, 1977), p. 61.

9. *Journal of Delacroix* (Moscow, 1961), vol. i, p. 379; entry for 10 June 1853.

10. Letter from Van Gogh to his brother (August 1889; *The Complete Letters of Vincent Van Gogh* (New York/Boston, 1988), T602).

11. V. I. Surikov, *Letters: Recollections of an Artist* (Leningrad, 1977), p. 244.

12. Undated letter from Auguste Rodin to Laurens, private collection. See *Jean-Paul Laurens: Peintre d'histoire 1838–1921* (Paris, Musée d'Orsay, 1997), p. 110.

13. The death of Alphonse de Neuville was mourned throughout France, and a bronze statue in his honour was erected on the Place de Wagram. His and Detaille's fame was truly pan-European. It is revealing, for example, that in the main Russian encyclopaedia of the turn of the century, edited by Brockhaus and Efron, the article on De Neuville is longer than those on Courbet, Millet and Manet. De Neuville's and Detaille's paintings adorned the Palais du Luxembourg. After its disbandment in 1937, the Louvre refused to take any of them.

14. S. M. Tretyakov acquired it because it offered a Western parallel with the social works of the Wanderers, which his brother, the founder of the Tretyakov Gallery, was collecting.

15. 'The pictures of Meissonier, Detaille and de Neuville were an essential part of all French exhibitions organised in Russia at that time, and if for some reason they were missing from an exhibition, the fact would inevitably be commented on by the press as a major lapse by the organisers.' G. U. Sternin, *Russian Artistic Culture in the Late Nineteenth – Early Twentieth Centuries* (Moscow, 1984), p. 95.

16. *Clarissa* was very highly rated by Balzac and Musset; the latter called it his favourite novel.

17. C. Baudelaire, 'The Salon of 1859', *On Art* (Moscow, 1986), p. 208.

18. Roybet's work was praised at the time by Cabanel and Baudry, but was viewed with hostility by Zola and the Goncourt brothers, who usually supported Courbet; they saw in *Woman with a Parrot* a concession to Academism.

19. Courbet did not want to cede his pre-eminent position to his young rival and decided to fight him on his own territory. Manet in turn took up the challenge, painting his own *Woman with a Parrot* (1866; New York, Metropolitan Museum of Art), only this time fully clothed. The appearance of a parrot in both these paintings was interpreted as an indiscreet hint at a confidant, the parrot being witness to the dressing of the naked woman.

20. This picture was acquired by the government of Napoleon III for the Musée du Luxembourg; it was destroyed during the Second World War.

21. 'History is written by the victors, and the history of art is no exception. This is why Impressionism and its offshoots have always dominated the established views of artistic development of the last years of the nineteenth century, while Realism – which remained a powerful force at the time – has receded into the background.' S. Ringbom, 'Nordiskt 80-tal', *Verklighet, luft och ljus. 1880-arene i nordisk maleri* (Oslo, 1985), p. 7.

22. As a result there are around fifteen of his paintings in the Hermitage.

23. In the catalogue of the reconstructed Musée du Luxembourg of 1874 only two portraits are listed; neither of them, however, was acquired by the state, which only bought works higher up the hierarchy of genres. See *Le Musée du Luxembourg en 1874: Peintures*, ex. cat. edited by Geneviève Lacambre and Jacqueline de Rohan-Chabot (Paris, Grand Palais, 1974).

24. Epée, 'The Residence of Prince K. A. Gorchakov', *Zhurnal krasivoy zhizni* [*Journal of Fine Living*] 62–3 (1 August 1916), p. 7.

25. Princess M. K. Tenisheva, *Impressions From My Life* (Leningrad, 1991), p. 110.

26. A. N. Benois mentions a typical episode in his memoirs. Serov painted a portrait of Nicholas II in a double-breasted jacket (the portrait was destroyed by soldiers during the storming of the Winter Palace on 25 October 1917), which the Tsar decided to show to the Empress. 'But she, however, was used to the smooth finish of modish foreign artists like F. A. Kaulbach and F. Flameng. When she saw the picture for the first time, she announced in English in the presence of the artist: "But the portrait is not finished!". This cut our friend to the quick, and since he still had his palette and brush in his hands, he offered them to the Empress with the words: "Then finish it yourself".' (A. N. Benois, *Memoirs* (1990), book 4, vol. ii, p. 373.)

27. K. Clark, *Landscape into Art* (London, 1949).

28. M. Fidell-Beaufort and J. Bailly-Herzberg, *Daubigny* (Paris, 1975), p. 60.

29. G. Geffroy, *Claude Monet: Sa vie, son temps, son oeuvre* (Paris, 1922), p. 28.

30. L. C. Perry, 'Reminiscences of Claude Monet: 1889–1909', *American Magazine of Art* (March 1927), p. 120.

31. In particular, Louis Leroy, who wrote one of the most scandalous accounts of the exhibition, described Lépine's painting as quite delicate in tone. See L. Leroy, 'L'Exposition des Impressionistes', *Le Charivari* (25 April 1874).

32. A. Proust, *Edouard Manet: Souvenirs* (Paris, 1897), p. 2.

33. It is characteristic that it was under this name that a weekly journal appeared from 1879, published by Georges Charpentier, a supporter of Renoir and Monet.

34. However, Sisley could have seen Corot's *Memory of Mortefontaine* (1864; Paris, Louvre) with its line of a shaded bank and *coulisses* of trees. The picture was kept in the Château de Fontainebleau and was publicly accessible.

35. A. Wolff, *Le Figaro* (3 April 1876); quoted in John Rewald, *Histoire de l'Impressionisme* (Paris, 1986), p. 232.

36. Letter to De Bellio (25 July 1876); quoted in *Claude Monet par lui-même* (Paris/Brussels, 1989), p. 29 (paintings, drawings, pastels and correspondence collected by Richard Kendall).

37. It was under this title that the painting was shown at Manet's posthumous exhibition of 1884, which suggests that it was the artist's own title for the work.

38. D. Rouart and D. Wildenstein, *Edouard Manet: Catalogue Raisonné* (Lausanne, 1975), vol. ii, no. 580.

39. J. Renoir, *Auguste Renoir* (Paris, 1962).

40. *Ibid.*

41. 'The creation of a subject through tones, and not through the subject itself – this is the distinctive feature of the Impressionists, this is what distinguishes them from other artists.' G. Rivière, 'Exhibition of the Impressionists', *L'Impressioniste* (14 April 1877) (taken from: L. Venturi, *Les Archives de l'impressionisme* (Paris/New York, 1939), vol. ii).

42. J.-E. Blanche, 'Renoir portraitiste', *L'Art Vivant* (July 1933), p. 292.

43. Letter from March 1881 (L. Venturi, *Les Archives de l'impressionisme* (Paris/New York, 1939), vol. i, p. 115).

44. J.-K. Huysmans, *L'Art Moderne* (Paris, 1911), pp. 69–70.

45. *Ibid.*, p. 290.

46. E. Renoir, Fifth Exhibition of the Journal *La Vie Moderne*, vol. 11 (19 June 1879) (taken from: L. Venturi, *Les Archives de l'impressionisme* (Paris/New York, 1939), vol. ii).

47. It is very likely that Renoir was introduced to Etienne Goujon by Antonin Proust. Proust was a friend of Manet and a connoisseur of new painting, being head of the Ministère des Beaux-Arts in Gambetta's government. Goujon no doubt took such a recommendation into consideration.

48. J. Renoir, *Auguste Renoir* (Paris, 1962).

49. P. Valéry, *Degas: Danse, Dessin* (Paris, 1965), p. 68.

50. D. Halévy, *Degas parle* (Paris, 1960); H. Loyrette, *Degas: Je voudrais être illustre et inconnu* (Paris, 1988), p. 125.

51. Letter to Emile Bernard from Arles, early August 1888 (*The Complete Letters of Vincent Van Gogh* (New York/Boston, 1988), B14).

52. P. Valéry, *Degas: Danse, Dessin* (Paris, 1965), pp. 105, 107.

53. Shackelford, saying that at least half of Degas's mature and late works are devoted to ballet, counts around 1,500 paintings, pastels, drawings and engravings on this theme. See *Degas: The Dancers*, ex. cat. by G. Shackelford (Washington, DC, National Gallery of Art, 1984).

54. Evidently this circumstance enticed P. I. Shchukin to acquire the picture; his younger brother Sergei, however, in choosing the best French paintings for his collection, ignored *Music-Hall*.

55. A. Silvestre, *Galerie Durand-Ruel: Recueil d'estampes gravées à l'eau forte* (Paris, 1873); quoted in D. Riout, *Les Ecrivains devant l'Impressionisme* (Paris, 1989), p. 16.

56. G. Geffroy, 'Sisley', *Les Cahiers d'aujourd'hui* (1923), p. 16.

57. *Ibid.*, p. 20.

58. J. Bailly-Herzberg, ed: *Correspondance de Camille Pissarro* (Paris, 1989), vol. iv, p. 327.

59. G. Clemenceau, *Claude Monet: Les Nymphéas* (Paris, 1928), p. 85.

60. D. Wildenstein, *Claude Monet: Biographie et catalogue raisonné* (Lausanne, 1974–91), vol. ii, letter 352.

61. *Ibid.*, vol. iii, p. 65.

62. Letter to Durand-Ruel, 23 March 1903: *Claude Monet par lui-même* (Paris/Brussels, 1989), p. 193 (paintings, drawings, pastels and correspondence collected by Richard Kendall).

63. O. Mirbeau, *Catalogue des Vues de la Tamise à Londres* (Paris, Durand-Ruel, 1904).

64. J.-K. Huysmans, *L'Art Moderne* (Paris, 1911), pp. 91–2.

65. J.-A. Castagnary, 'The Salon of 1873', *Salons*, vol. ii (Paris, 1892). For views of the French press on sculpture of the 1870s, see R. Butler, 'Rodin and the Paris Salon', *Rodin Rediscovered*, ex. cat. (Washington, DC, National Gallery of Art, 1981).

66. The Hermitage, for example, possesses the paintings *Beggar-Boy on a Bridge in Vienna* by the Austrian artist Ferdinand Georg Waldmüller and *Sleeping Savoyard Boy* by the German Wilhelm Leibl.

67. T. H. Bartlett, 'Auguste Rodin: Sculptor', *American Architect and Building News* 25 (19 January 1889), p. 28.

68. R. M. Rilke, *Auguste Rodin* (Leipzig, 1913), pp. 23–5.

69. P. Gsell, *Auguste Rodin: L'Art* (Lausanne, 1953).

70. R. M. Rilke, *Auguste Rodin* (Leipzig, 1913), pp. 23–5.

71. E.-A. Bourdelle, *La Sculpture et Rodin* (Paris, 1978), p. 20.

72. From Rodin's will, published in P. Gsell, *Auguste Rodin: L'Art* (Lausanne, 1953).

Post-Impressionism

1. Recorded by Georges Duthuit in *Henri Matisse: écrits et propos sur l'art* (Paris, 1972), p. 44.

2. 'Matisse: Entretien avec Jacques Guenne', *L'Art Vivant* 18 (15 September 1925), quoted in *Henri Matisse: écrits et propos sur l'art* (Paris, 1972), p. 84.

3. G. Brassaï, *Picasso and Company* (New York, 1966), p. 79.

4. C. Baudelaire, 'Richard Wagner et *Tannhäuser*', *L'Art Romantique* (Paris, 1968), p. 280.

5. *Ibid.*, p. 277.

6. Letter from Cézanne to Emile Bernard of 26 May 1904: *Paul Cézanne, Correspondance* (Paris, 1978), p. 303.

7. Letter from Cézanne to Emile Bernard of 23 October 1905: *ibid.*, pp. 314–15.

8. L. Gowing, 'The Logic of Organised Sensations', *Cézanne: The Late Work* (New York, Museum of Modern Art, 1992), p. 64.

9. G. Rivière, 'Exposition des Impressionistes', *L'Impressioniste* 2 (14 April 1877) (taken from L. Venturi, *Les Archives de l'Impressionisme* (Paris, 1939), vol. ii).

10. K.-E. Osthaus, 'Une Visite à Paul Cézanne', *Conversations avec Cézanne* (Paris, 1978), p. 97.

11. P. Signac, *D'Eugène Delacroix au Néo-Impressionisme* (Paris, 1964), p. 86. Signac's book was originally published in 1899.

12. Undated letter from Van Gogh to his brother Theo: *The Complete Letters of Vincent Van Gogh* (New York/Boston, 1988), T500.

13. Undated letter from Van Gogh to his brother Theo: *The Complete Letters of Vincent Van Gogh* (New York/Boston, 1988), T520.

14. Undated letter from Van Gogh to his brother Theo: *The Complete Letters of Vincent Van Gogh* (New York/Boston, 1988), T469.

15. Letter from Van Gogh to Emile Bernard (second half of June 1888): *The Complete Letters of Vincent Van Gogh* (New York/Boston, 1988), B8.

16. Letter from Van Gogh to Emile Bernard (late June 1888): *The Complete Letters of Vincent Van Gogh* (New York/Boston, 1988), B8.

17. A. Aurier, 'Les Isolés: Vincent Van Gogh', *Mercure de France* (January 1890).

18. B. Danielsson, *Gauguin in Polynesia* (Moscow, 1960), vol. 13.

19. In his recent biography of Gauguin (*Paul Gauguin: A Life* (New York, 1995), p. 338), David Sweetman suggested that the two figures represent Jotefa, the androgynous Tahitian youth, depicted as a horseman and woodcutter – which could express the artist's interest in this subject, as attested to in *Noa-Noa* (Berlin, 1926). If the horseman can be accepted as a representation of Jotefa, it is more likely that the figure on the right is a self-portrait of the artist.

20. Sweetman (*ibid.*, p. 339) believes that the picture's title has an ironic meaning.

21. Letter from Gauguin in Tahiti to Daniel de Monfreid (late December 1892): *Lettres de Paul Gauguin à Georges-Daniel de Monfreid* (Paris, 1950), p. 64.

22. P. Gauguin, *Noa-Noa* (Berlin, 1926).

23. Letter from Gauguin to Strindberg of 5 February 1895, published in M. Malingue, *Lettres de Gauguin à sa femme et à ses amis* (Paris, 1946), p. 197.

24. *Lettres de Paul Gauguin à Georges-Daniel de Monfreid* (Paris, 1950), vol. xii. Taking this letter in conjunction with the painting completed in April 1892, *Vahiné no te vi* (or *Woman with a Mango*) (Baltimore, Museum of Art; W.G. 449), in which Teha'amana is shown about five months pregnant, leads to the conclusion that the birth must have taken place in September or October. However, this event – and in fact everything concerning Teha'amana – is shrouded in mystery. If a child had existed, it would surely have been known about. The reference in the letter to de Monfreid – 'I am soon to be a father again' – would seem to contradict Danielsson's theory of an abortion. It is likely that the birth took place, but that either the child was stillborn or died soon after birth. John Rewald quotes from this letter and makes the following comment: 'Apparently no child was born; Bengt Danielsson was unable to unearth any birth record on Tahiti, nor does the local tradition mention that Tehura had any offspring by Gauguin.' J. Rewald, *Post-Impressionism: From Van Gogh to Gauguin* (New York, Museum of Modern Art, 1978), p. 499.

25. C. Stuckey, *Tahitian Pastorals: The Art of Paul Gauguin* (Washington, 1988), pp. 283–4.

26. J.-A. Moerenhout, *Voyages aux Iles du Grand Océan* (Paris, 1837). Moerenhout was a diplomat and amateur anthropologist whose book inspired many of Gauguin's images and theories on Polynesian religion.

27. The Russian sculptor Anna Golubkina, outlining for an artist friend a short trip to see the main European attractions (Paris, London, Berlin), listed the Mona Lisa, the Venus de Milo, Titian, Van Dyck, Michelangelo and Carpeaux, and went on: 'Do not forget Puvis de Chavannes's *Poor Fisherman* in Luxembourg' (letter to L. A. Gubina of 1909, published in A. S. Golubkina, *Letters; A few words on the Sculptor's Art; Contemporaries' Reminiscences* (Moscow, 1983), p. 79).

28. Such is the opinion of Richard Brettell in his analysis of the Munich 'double' of the Hermitage painting. R. Brettell, 'Te tamari no atua', *The Art of Paul Gauguin*, p. 410.

29. Letter from Gauguin in Tahiti to André Fontainas, March 1899. *Lettres de Gauguin à André Fontainas* (Paris, 1946), pp. 288–9.

30. W. Andersen, *Gauguin's Paradise Lost* (New York, 1971), p. 248.

31. Letter from Gauguin to Daniel de Monfreid, August 1901. *Lettres de Paul Gauguin à Georges-Daniel de Monfreid* (Paris, 1950).

32. J. Moréas, 'Un Manifeste Littéraire – Le Symbolisme', *Le Figaro* (18 September 1886).

33. M. and J. Laran, *Puvis de Chavannes* (Paris, 1911), p. 42.

34. O. Redon, 'Fantin-Latour' (November 1882), published in O. Redon, *A Soi-Même: Journal 1867–1915. Notes sur la vie, l'art et les artistes* (Paris, 1989), pp. 156–7.

35. *Ibid.*, pp. 26–7.

36. From the introduction to an exhibition catalogue, July 1910; *ibid.*, p. 116.

37. From a letter to Charles Morice from Redon, September 1911: *Odilon Redon: Prince of Dreams 1840–1916* (Art Institute of Chicago, 1994), p. 431.

38. Letter from Lacoste to his granddaughter Irène, 11 February 1957: *Charles Lacoste: 1870–1959* (Paris, 1985), pp. 23–4.

39. M. Denis, *Journal: 1884–1943* (Paris, 1957), vol. i, p. 59.

40. M. Denis, *Theories: 1890–1910* (Paris, 1913), p. 1.

41. M. Denis, *Serusier: Sa Vie, Son Oeuvre* (Paris, 1943), p. 64.

42. *Ibid.*, p. 67.

43. M. Denis, *Theories: 1890–1910* (Paris, 1913), p. 251.

44. C. Terrasse, *Bonnard* (Geneva, 1964), p. 40.

45. C. Terrasse, *Pierre Bonnard* (Paris, 1967), p. 94.

46. *Ibid.*

47. *Ibid.*, p. 11.

48. *Bonnard and His Environment*, ex. cat. (New York, Museum of Modern Art, 1966), p. 11.
49. M. Denis, *Journal: 1884–1943* (Paris, 1957), vol. i, p. 143.
50. Signac's diary entry for 16 February 1898: 'Extraits du journal inédit de Paul Signac: 1897–1898', *Gazette des Beaux-Arts* (April 1952), pp. 276–7.
51. Letter from Vuillard to Maurice Denis, 19 February 1898. M. Denis, *Journal: 1884–1943* (Paris, 1957), vol. i, p. 137.
52. *Edouard Vuillard, K.-X. Roussel*, ex. cat. (Paris, Orangerie des Tuileries, 1968), p. 23.
53. *Les Mardis: Stephane Mallarmé and the Artists of his Circle*, ex. cat. (University of Kansas Museum of Art, 1966), p. 44.
54. Thus Charles Chassé, in his book about the Nabis published in the artist's homeland, only mentions him in passing, while devoting whole chapters to artists who were not part of the circle and generally played a minor role in art of the end of the nineteenth century. C. Chassé, *Les Nabis et Leur Temps* (Lausanne and Paris, 1960).
55. Signac's diary entry for April 1898. 'Extraits du journal inédit de Paul Signac: 1897–1898', *Gazette des Beaux-Arts* (April 1952), p. 280.
56. J. Cassou, *Panorama des arts plastiques contemporains* (Paris, 1960), p. 65.
57. A. Vaillant, *Bonnard* (London, 1966), p. 109.
58. G. Apollinaire, *Apollinaire on Art: Essays and Reviews 1902–1918* (New York, 1972), p. 194.
59. Review of the Salon des Indépendants of 1891, published by Vallotton in Lausanne. F. Vallotton, *Journal de Suisse* (1891), quoted in *Le Douanier Rousseau* (Paris, 1984), p. 102.
60. E. Bernard, *L'Esthétique Fondamentale et Traditionnelle* (Paris, c. 1910), p. 120.
61. Signac's diary entry for 24 May 1897. 'Extraits du journal inédit de Paul Signac: 1897–1898', *Gazette des Beaux-Arts* (April 1952).
62. The Salon des Indépendants opened in 1884, the Société Nationale des Beaux-Arts in 1889, and the Salon d'Automne in 1903.
63. A. N. Benois, *Memoirs* (Moscow, 1990), book 4, vol. ii, p. 149.
64. A. France, 'Steinlen et son exposition', *Revue Universelle* 102 (1904), p. 43.
65. In the Soviet Union, Steinlen was for a long time presented as a leading artist of so-called progressive art, even to the extent of being honoured as 'a chronicler of the life of the Parisian proletariat' and 'a forerunner of the October Revolution'.
66. Rewald recalled how in conversation with Maillol, the artist always pronounced the name Vollard as *voleur* ('thief'). J. Rewald, 'Maillol Remembered', *Aristide Maillol: 1861–1944*, (New York, Solomon R. Guggenheim Museum, 1975), p. 11.
67. *Ibid.*, p. 21.
68. M. Denis, *Aristide Maillol* (1925), quoted in W. George, *Aristide Maillol et l'âme de la sculpture* (Neuchâtel, 1964), p. 215.
69. J. Cladel, *Maillol: Sa vie, son oeuvre, ses idées* (Paris, 1937).
70. H. Frère, *Conversations de Maillol* (Geneva, 1965), p. 137.
71. *Ibid.*
72. *Aristide Maillol* (ex. cat., Lausanne, Musée des Beaux-Arts, 1996), p. 45.
73. *Ibid.*
74. M. Golberg, 'Beethoven et Bourdelle', *Cahiers Mensuels* 11–12 (1901).

The Twentieth Century: Insight and Hyperbole

1. It was Renoir who brought Valtat to Vollard's attention. The enterprising dealer bought up almost all his works for a song (20 francs a painting), but was unable to make enough profit from them and in the end was prepared to relinquish his monopoly. 'I cannot continue to take your pictures,' he wrote to Valtat on 1 July 1911. 'Over almost the fifteen years that I have taken everything that you have done, I have sold very little. As I alone have your paintings, all the other dealers dissuade amateurs from buying them; it is essential that Druet, that Fénéon should have some of them – in short, in your interest as well as mine it would be a good idea to make a change.' *Louis Valtat (1869–1953): Retrospective*, ex. cat. (Musée des Beaux-Arts de Bordeaux, 1995), p. 33.
2. *Seascape* was mockingly reproduced alongside pictures by Matisse, Derain, Manguin, Puy and Rouault in *L'Illustration* on 4 November 1905.
3. L. G. Cann, *Laprade* (Paris, 1930), p. 18.
4. *Picart Le Doux* (Paris, 1945), p. 40.
5. Paintings by Marquet, Derain, Vlaminck, Manguin, Friesz and Puy were shown in the seventh hall of the Salon d'Automne of 1905. The room quickly became known as the 'cage of wild animals' or *cage centrale*. It was then that the critic Louis Vauxcelles, having seen in the same room a sculpture by Albert Marque entitled *Portrait of Jean Baignerès*, which was in the style of Renaissance sculpture, exclaimed: 'Donatello parmi les fauves!' ('Donatello among wild beasts!').
6. Marquet owned one of Corot's early landscapes.
7. Daulte, 'L'Oeuvre de Marquet', *Albert Marquet: Fondation de l'Hermitage* (Lausanne, 1988), p. 25.
8. H. Matisse, 'Role et modalité de la couleur', *Ecrits et propos sur l'art* (ed. Dominique Fourcade) (Paris, 1972), p. 199.
9. *Henri Manguin: 1874–1949*, ex. cat. (Paris, Musée Marmottan, 1989), p. 129.
10. *Ibid.*, p. 25.
11. *Ibid.*, p. 132.
12. Notice of an exhibition of Jean Puy's work in *L'Intransigeant*, 12 January 1911 (quoted in G. Apollinaire, *Apollinaire on Art: Essays and Reviews 1902–1918* (New York, 1972), p. 130).
13. This was undoubtedly felt by Sergei Shchukin, who placed Puy's *Portrait of the Artist's Wife* alongside his Cézannesque *Woman in Blue* in his gallery. This juxtaposition is interesting for the fact that the prototype for Puy's *Woman in Blue* was very possibly *Woman with a Book* (1902–4; Washington, DC, Phillips Collection; R.945), in which the heroine is shown in the same dress as in *Woman in Blue* from the Shchukin collection.
14. Notice of an exhibition of Friesz's work at the Galerie Druet in *L'Intransigeant*, 6 April 1910 (quoted in G. Apollinaire, *Apollinaire on Art: Essays and Reviews 1902–1918* (New York, 1972), p. 75.
15. M. Gauthier, *Othon Friesz* (Geneva, 1957), p. 61.
16. In particular, according to André Salmon the painting made a significant impression on Robert Delaunay (A. Salmon, *La Jeune peinture française* (Paris, 1912), p. 28).
17. Hepp, 'Le Salon d'Automne', *Gazette des Beaux-Arts* (November 1908), pp. 390–1.
18. Words spoken by Vlaminck to his friend, the art critic F. Vanderpyl (quoted in M. Sauvage, *Vlaminck, Sa vie et son message* (Geneva, 1956), p. 15).
19. *Ibid.*, p. 53.
20. Letter from Derain in Collioure to Vlaminck, 28 July 1905: M. de Vlaminck, *Lettres à Vlaminck* (Paris, 1955), p. 155.
21. Vlaminck's words of 1921 (quoted in M. Sauvage, *Vlaminck, Sa vie et son message* (Geneva, 1956), p. 53).
22. *Ibid.*, p. 39.
23. *Van Dongen: Le Peintre*, ex. cat. (Paris, Musée de l'art moderne, 1990), p. 22.
24. Malraux, 'Un homme qui "est"', *Formes* 1 (December 1929), p. 5.
25. 'Matisse Speaks', *Art News Annual* 21 (1952) (quoted in *Ecrits et propos sur l'art* (ed. Dominique Fourcade) (Paris, 1972), p. 118.
26. 'It is to Gustave Moreau', said Matisse, 'that I owe my knowledge of the Louvre: nobody went there any more. Moreau took us there and taught us how to see, how to interrogate the Masters.' P. Courthion, 'Rencontre avec Matisse', *Les Nouvelles Littéraires* (27 June 1931), p. 1.
27. Van Gogh's friend, the Australian artist John Russell, either sold or gave this drawing to Matisse.
28. Matisse probably knew this painting by Gauguin because at the turn of the century it was in the Galerie Vollard, which he used to frequent.
29. H. Matisse, 'Notes d'un peintre', *La Grande Revue* (25 December 1908) (quoted in *Ecrits et propos sur l'art* (ed. Dominique Fourcade) (Paris, 1972), pp. 49–50.
30. J. Guichard-Meili, *Matisse* (Paris, 1967), p. 48.
31. E. Tériade, 'Constance du Fauvisme', *Minotaure* 9, vol. ii (1936), p. 3.
32. A. Kostenevich, 'La correspondance de Matisse avec les collectionneurs russes', in A. Kostenevich and N. Semionova, *Matisse et la Russie* (Moscow/Paris, 1993), p. 91.
33. *Ibid.*, p. 91.
34. L. Aragon, *Henri Matisse: roman* (Paris, 1971), vol. i, p. 142.
35. H. Matisse, 'Notes d'un peintre', *La Grande Revue* (25 December 1908) (quoted in *Ecrits et propos sur l'art* (ed. Dominique Fourcade) (Paris, 1972), p. 49.
36. *Ibid.*, p. 44.
37. 'Le tour du monde d'Henri Matisse: Entretien avec Tériade', *L'Intransigeant*, 27 October 1930.
38. G. Charbonnier, 'Entretien avec Henri Matisse', *Le Monologue du peintre*, vol. ii (Paris, 1960).
39. Letter from Matisse to A. Romm of 19 January 1934 (Archive of the Pushkin Museum, Moscow: F. 13, Coll. 6, No. 127/7).
40. These enormous canvases are shown to much better effect in their present location, in one of the rooms of the Winter Palace.
41. G. Charbonnier, 'Entretien avec Henri Matisse', *Le Monologue du peintre*, vol. ii (Paris, 1960), p. 12.
42. Letter of 22 August 1912, first published in A. H. Barr, *Matisse: His Art and His Public* (New York, 1951), p. 555.
43. Radio interview with Matisse, 1942. Unfortunately the tape of the interview has not survived and now only exists in Barr's English translation: A. H. Barr, *Matisse: His Art and His Public* (New York, 1951), p. 562.
44. 'Conversations with Matisse', *Protiv techeniya* [*Against the Flow*] 8 (5–18 November 1911).
45. H. Matisse, 'Le Chemin de la couleur: propos recueillis par Gaston Diehl', *Art present* 2 (1947).
46. F. Vanderpyl, *Peintres de mon époque* (Paris, 1931), p. 125.
47. C. MacChesney, 'A Talk with Matisse, Leader of Post-Impressionism', *New York Times Magazine*, 9 March 1913.
48. M. Sembat, 'Henri Matisse', *Les Cahiers d'aujourd'hui* 4 (April 1913), p. 194.
49. In a letter of 19 April 1913 Matisse invited Ivan Morozov to see *Arab Café* (Archive of the Pushkin Museum, Moscow: F. 13, Coll. 6, No. 127/5). On 15 September he wrote to Camoin saying that *Arab Café* had been sold to Shchukin and was probably already in Moscow (D. Giraudy, 'Correspondance Henri Matisse – Charles Camoin', *Revue de l'Art* 12 (1971), p. 16).
50. G. Apollinaire, 'La Vie artistique: Henri Matisse', *L'Intransigeant*, 17 April 1913.
51. M. Sembat, 'Henri Matisse', *Les Cahiers d'aujourd'hui* 4 (April 1913), p. 191.
52. *Ibid.*, p. 192.
53. G. Hilaire, *Derain* (Geneva, 1959), p. 29.
54. *Ibid.*, p. 30.
55. R. Allard, *Signs of Renewal in Painting: The Blaue Reiter Almanac*, ed. Wassily Kandinsky and Franz Marc (London, 1974), p. 109; English translation of German edition, *Der Blaue Reiter* (München, 1965).
56. G. Apollinaire, 'Le Salon des Indépendants', *La Revue des Lettres et des Arts* (1 May 1908) (quoted in G. Apollinaire, *Apollinaire on Art: Essays and Reviews 1902–1918* (New York, 1972), p. 44).
57. G. Hilaire, *Derain* (Geneva, 1959), p. 101.
58. *Ibid.*, p. 50.
59. *Ibid.*, p. 45.
60. A. Breton, *La Beauté convulsive* (Paris, Musée national d'art moderne, Centre Georges Pompidou, 1991), p. 98.

61. The paintings of the Blue Period have been interpreted in numerous and various ways – from the long-held opinion that the period was influenced by the work of El Greco, to the recent attempt by Norman Mailer to emphasise the strictly Freudian nature of Picasso's work, arguing that 'the Blue Period also speaks from the depth of his sexual fear' (*Portrait of Picasso as a Young Man* (New York, 1995), p. 64). Such theories lead only to the conclusion that there can be no single interpretation of the artist's creative method, and it would be wrong to dismiss out of hand the fact that Picasso's immediate predecessors – the Symbolists – may also have influenced this monochrome period.

62. J. Richardson (with the collaboration of M. McCully), *A Life of Picasso*, vol. i: *1881–1906* (New York, 1991), p. 224.

63. P. Daix, *Picasso* (New York/Washington, 1965), p. 35.

64. G. Apollinaire, 'Les Jeunes: Picasso, peintre', *La Plume*, 15 May 1905 (quoted in G. Apollinaire, *Apollinaire on Art: Essays and Reviews 1902–1918* (New York, 1972), p. 14).

65. Matisse held this conviction until the end of his life, saying: 'Il faut regarder toute sa vie avec des yeux d'enfant' ('One must observe all one's life with the eyes of a child'). On another occasion he expressed the same idea slightly differently: 'Il faut être enfant toute sa vie tout en étant un homme, tout en prenant sa force dans l'existence des objets' ('One must remain a child all one's life while still being a man, and always taking strength in the existence of objects') (quoted in *Ecrits et propos sur l'art* (ed. Dominique Fourcade) (Paris, 1972), p. 321.

66. D. Ashton, *Picasso on Art: A Selection of Views* (New York, 1972), p. xxvi.

67. J. Richardson (with the collaboration of M. McCully), *A Life of Picasso*, vol. ii: *1907–1917* (New York, 1996), p. 32.

68. C. Roy, *L'Amour de la peinture: Goya, Picasso et autres peintres* (Paris, 1956), p. 85.

69. Richardson cites this source in support of the Hermitage's, or rather Shchukin's, title for the painting, *Dance with Veils*, as against the name generally accepted in the West: *Nude with Drapery*. According to Richardson, Picasso himself used the former (J. Richardson, *A Life of Picasso*, vol. ii: *1907–1917* (New York, 1996), pp. 36–7).

70. M. de Zayas, 'Picasso Speaks', *The Arts* (26 May 1923), p. 325.

71. A. Liberman, 'Picasso', *Vogue* (1 November 1956), p. 133.

72. J. Richardson (with the collaboration of M. McCully), *A Life of Picasso*, vol. ii: *1907–1917* (New York, 1996), p. 87.

73. D. Souchère, *Picasso in Antibes* (New York, 1960), p. 3.

74. In El Greco's *Discovery of the Fifth Seal* (1608–14; New York, Metropolitan Museum), the overall upward movement of the characters is subordinated to a pyramidal composition. Researchers have suggested that Picasso used this painting, which related to some of his favourite work, as a starting-point for *Les Demoiselles d'Avignon*. In *Les Demoiselles* he was still far from achieving the dynamic unity of El Greco's canvas, but he came near to it a year later with *Three Women*.

75. D.-H. Kahnweiler, *My Galleries and Painters* (New York, 1961), p. 57.

76. C. Zervos, 'Conversation avec Picasso', *Cahiers d'Art* 10 (1935), p. 177.

77. One of these pictures, *Woman Farmer (half length)*, featured with good reason in a recent major exhibition of Picasso's portraits in New York and Paris. See *Picasso and Portraiture: Representation and Transformation*, ex. cat., ed. W. Rubin (New York, Museum of Modern Art, 1996), p. 272.

78. H. Parmelin, *Picasso: the Artist and His Model, and Other Recent Works* (New York, 1965), p. 15.

79. Conversation between Picasso and William Rubin (W. Rubin, *Picasso in the Collection of the Museum of Modern Art* (New York, 1972), p. 72).

80. G. Georges-Michel, *De Renoir à Picasso* (Paris, 1954); quoted in D. Ashton, *Picasso on Art: A Selection of Views* (New York, 1972), p. 35.

81. Letter to Kahnweiler of 12 June 1912: J. Golding, *Le Cubisme* (Paris, 1965), p. 149.

82. The discovery was made by A. A. Babin, and first published in J. Richardson, *A Life of Picasso*, vol. ii: *1907–1917* (New York, 1996), p. 272.

83. I. Ehrenburg, *Lyudi, gody, zhizn* [*People, Years, Life*], vols i–ii (Moscow, 1961), p. 128.

84. F. Will-Levaillant, *La Lettre dans la peinture cubiste: Actes du premier colloque d'Histoire de l'Art Contemporaine tenu au Musée d'Art et d'Industrie* (Saint-Etienne, 1971; Paris, 1973), p. 53.

85. Robert Delaunay gave the first study for his picture *Eiffel Tower* (1909) to Laurencin as a wedding present, and she always kept it.

86. G. Apollinaire, *Les Peintres cubistes: Méditations ésthetiques* (Paris, 1913), p. 25.

87. J. Golding, *Le cubisme* (Paris, 1965), p. 45.

88. G. Apollinaire, *Soirées de Paris*, 15 June 1914; quoted in *Robert et Sonia Delaunay*, ex. cat. (Musée d'Art Moderne de la Ville de Paris, 1985), p. 145.

89. J. Toorop, *Le Fauconnier* (Amsterdam, 1916).

90. D.-H. Kahnweiler, *Juan Gris: Sa vie, son oeuvre, ses écrits* (Paris, 1946), p. 183.

91. From a lecture given at the Collège de France on 1 July 1923, published in 1924; quoted in F. Léger, *Fonctions de la peinture* (Paris, 1997), pp. 194–5.

92. P. Descargues, *Fernand Léger* (Paris, 1955), p. 61.

93. *Fernand Léger*, ex. cat. (Paris, Grand Palais, 1971), p. 91.

94. F. Fels, *Propos d'artistes* (Paris, 1925).

95. J. Chapiro, *La Ruche* (Paris, 1960), p. 39.

96. I. Ehrenburg, *Lyudi, gody, zhizn* [*People, Years, Life*], vols i–ii (Moscow, 1961), p. 227.

97. G. Rouault, 'Climat pictural', *La Renaissance* (special edition on Rouault, October/December 1937); quoted in Rouault, *Sur l'art et sur la vie* (Paris, 1971), p. 101.

98. G. Rouault, 'Sur l'art sacré: Réponse à une enquête de Maurice Brillant', *La Croix*, 11–12 May 1952; quoted in Rouault, *Sur l'art et sur la vie* (Paris, 1971), p. 118.

99. P. Courthion, *Raoul Dufy* (Geneva, 1951), p. 50.

100. *Ibid.*, p. 70.

101. H. Matisse, 'Notes d'un peintre', *La Grande Revue* (25 December 1908) (quoted in *Ecrits et propos sur l'art* (ed. Dominique Fourcade) (Paris, 1972), p. 49).

102. Recording of a conversation between Matisse and students, made in 1908 by Sarah Stein (quoted in A. H. Barr, *Matisse: His Art and His Public* (New York, 1951), p. 551).

103. R. Escholier, *Matisse, ce vivant* (Paris, 1956) (quoted in *Ecrits et propos sur l'art* (ed. Dominique Fourcade) (Paris, 1972), p. 305).

104. Recording of a conversation between Matisse and students, made in 1908 by Sarah Stein (quoted in A. H. Barr, *Matisse: His Art and His Public* (New York, 1951), p. 551).

105. A sickly-sweet classical copy of the *Doidals Aphrodite* is the famous *Venus and Cupid* by James Pradier (1836), which adorns the Winter Palace.

106. L. Delektorskaya, *Henri Matisse: L'Apparente Facilité: Peintures de 1935–1939* (Paris, 1986), pp. 14–15.

107. *Ibid.*, p. 16.

108. *Ibid.*

109. H. Matisse, 'Notes d'un peintre sur son dessin', *Le Point* 21 (July 1939) (quoted in *Ecrits et propos sur l'art* (ed. Dominique Fourcade) (Paris, 1972), p. 162).

110. This can be seen in surviving documentary footage. Lydia Delektorskaya also described this process.

111. H. Matisse, 'Notes d'un peintre sur son dessin', *Le Point* 21 (July 1939) (quoted in *Ecrits et propos sur l'art* (ed. Dominique Fourcade) (Paris, 1972), p. 161).

112. *Ibid.*, p. 162.

113. *Ibid.*, pp. 150–60.

114. 'Notes de Matisse sur les dessins de la série *Thèmes et variations*' (quoted in *Ecrits et propos sur l'art* (ed. Dominique Fourcade) (Paris, 1972), p. 164).

115. H. Matisse, *Jazz* (Paris, 1947).

Catalogue
Explanatory Notes

The catalogue follows the accepted style of the *catalogue raisonné*. The specifications of each work are given in a standard sequence: height preceding width, with measurements in centimetres. All information included by the artist at the time of the work's execution – signature, date, inscription – is reproduced where relevant, followed by the work's inventory number, and, where applicable, *catalogue raisonné* number. Any necessary information from gallery labels on the verso of the painting or drawing is also given. Titles of works are included in both English and French, except when the title is identical in both languages, in which case it is given only once. The French title is either the one which the artist gave the work originally, or the traditionally accepted title: in other words, the name under which the work first appeared at exhibition or entered a particular collection.

The Cyrillic abbreviation before each inventory number specifies to which particular section of the department of Western European Art at the Hermitage the work belongs. ГЭ (Государственный Эрмитаж – State Hermitage) is used for paintings in oil or tempera; Н. Ск. (Новая скульптура – New Sculpture) for nineteenth- and twentieth-century sculpture. The inventory numbers of works on paper or cardboard, in either pencil, indian ink, watercolour, gouache or mixed media, which are kept in the museum's department of drawings, are not preceded by an abbreviation.

A full listing of exhibitions and bibliographical sources has been omitted from the catalogue, being of interest primarily to the specialist. This detailed information, as well as photographic reproductions of all signatures on paintings, can be found in two volumes of the Hermitage catalogue published jointly by Giunti Editore, Florence, and Iskusstvo, Moscow, in the series *The State Hermitage: Collection of Western-European Painting. Catalogue raisonné in 16 volumes*. The two relevant volumes are: vol. xi, *French Painting, Early and Mid-Nineteenth Century*, by Valentina G. Berezina (Moscow–Florence, 1983); and vol. xii, *French Painting, Mid-Nineteenth to Twentieth Centuries*, by Anna G. Barskaya and Albert G. Kostenevich (Leningrad–Florence, 1991). A certain amount of exhibition and bibliographical information can also be found in the publication *Drawings, Watercolours and Pastels of the French Artists of the Second Half of the Nineteenth Century and the Twentieth Century in the Collection of the Hermitage*, by A. S. Kantor-Gukovskaya, ex. cat., Leningrad, 1985.

References to works in individual *catalogues raisonnés* are given by the number under which the work appears without reference to the volume number, since the majority of *catalogues raisonnés* number sequentially through volumes. The only exception is Zervos's thirty-three-volume catalogue of Picasso's paintings and drawings: here the number of the volume is designated in roman numerals, followed by the number of the work in arabic numerals. In Daix and Boudaille's single-volume catalogue of Picasso's Blue and Pink periods, the roman numeral indicates the section, and arabic the number within that section. References to Van Gogh's letters are made not by the page number but the number of the letter, as is now standard practice. The letters that precede the number indicate the recipient: B – Emile Bernard; T – Theo Van Gogh; W – Wilhelmina, and so on.

The provenance of each work is given in full, often with the addition of new, recently discovered information. The location of collections, galleries or museums which are repeated regularly is omitted: the following were or are located in Moscow: the collections of the Morozov brothers and of the Shchukin brothers (detailed information about these collections can be found in the first chapter); the First Museum of Modern Western Painting (1918–23; previously the collection of Sergei Shchukin); the Second Museum of Modern Western Painting (1918–23; previously the collection of Ivan Morozov); the State Museum of Modern Western Art (1923–48); the Tretyakov Gallery; the Pushkin Museum. Equally, the following galleries were or are located in Paris: Galerie Vollard; Galerie Bernheim-Jeune; Galerie Kahnweiler. The location of the Galerie Durand-Ruel is given to distinguish between its Paris and New York branches. St Petersburg is rendered as either St Petersburg, Petrograd or Leningrad depending on the historical context. The abbreviation 'Salon' designates the Salon des Artistes Français; the names of the other salons (des Indépendants, d'Automne, etc.) are given in full.

List of catalogues of the works of individual artists

A.
Ackerman, G. M., *Jean-Léon Gérôme: Monographie et catalogue raisonné*, Paris, 1992.

Aubrun
Aubrun, M.-M., *Jules Dupré, 1811–1889: Catalogue raisonné de l'oeuvre peint, dessiné et gravé*, 2 vols, Paris, 1974–82.

B.
Bauquier, G., *Fernand Léger: Catalogue raisonné de l'oeuvre peint*, vols i–v, Paris, 1990–6.

Certigny
Certigny, H., *Le Douanier Rousseau et son temps: Biographie et catalogue raisonné*, vols i–ii, Tokyo, 1984.

Claisse
Claisse, G., *Herbin: Catalogue raisonné de l'oeuvre peint*, Lausanne and Paris, 1993.

Compin
Compin, I., *H. E. Cross*, Paris, 1964.

D.
Dauberville, J., and Dauberville, H., *Bonnard: Catalogue raisonné de l'oeuvre peint*, 4 vols; vol. i: *1885–1905*, Paris, 1965; vol. ii: *1906–1919*, Paris, 1967; vol. iv: Paris, 1974.

D.–B.
Daix, P., and Boudaille, G., *Picasso, 1900–1906: Catalogue raisonné de l'oeuvre peint*, Neuchâtel, 1966; Eng. trans. 1967.

D.M.
Duthuit, C., *Henri Matisse: Catalogue raisonné de l'oeuvre sculpté* (ed. with the collaboration of Wanda de Guebriand), Paris, 1997.

D.–R.
Daix, P., and Rossellet, J., *Le Cubisme de Picasso: Catalogue raisonné de l'oeuvre 1907–1916*, Neuchâtel, 1979; Eng. trans. 1979.

D.S.
Daulte, F., *Alfred Sisley: Catalogue raisonné de l'oeuvre peint*, Lausanne, 1959.

Daulte
Daulte, F., *Auguste Renoir: Catalogue raisonné de l'oeuvre peint*, vol. i: *Figures, 1860–1890*, Lausanne, 1971.

Dorival–Rouault
Dorival, B., and Rouault, I., *Rouault: Catalogue raisonné de l'oeuvre peint*, 2 vols, Monte Carlo, 1988.

F.
Faille, J. B. de la, *The Works of Vincent Van Gogh: His Paintings and Drawings*, Amsterdam, 1970.

F.-L.
Fantin-Latour, V., ed., *Catalogue de l'oeuvre complet de Fantin-Latour: 1849–1904*, Paris, 1911; rev. Amsterdam and New York, 1969.

H.
Hellebranth, R., *Charles-François Daubigny: 1817–1878*, Lausanne, 1976.

H.-B.
Hahnloser-Buhler, H., *Félix Vallotton et ses amis*, Paris, 1936.

K.
Kellermann, M., *André Derain: Catalogue raisonné de l'oeuvre peint*, vol. i: *1895–1914*, Paris, 1992.

L.
Lemoisne, P.-A., *Degas et son oeuvre*, 4 vols, Paris, 1946.

M.
Manguin, L., and Manguin, C., eds, *Henri Manguin: Catalogue raisonné de l'oeuvre peint* (cat. by M.-C. Sainsaulieu), Neuchâtel, 1980.

P.–V.
Rodo Pissarro, L., and Venturi, L., *Camille Pissarro: Son art et son oeuvre*, 2 vols, Paris, 1939.

R.
Rewald, J. (with the collaboration of W. Feilchenfeldt and J. Warman), *The Paintings of Paul Cézanne: A Catalogue raisonné*, 2 vols, New York, 1996.

Reff
Reff, T., *Degas et son oeuvre* (a supplement compiled by T. Reff with the assistance of A. Reff), New York and London, 1984.

R.W.
Rewald, J., *Paul Cézanne: The Watercolours: A Catalogue Raisonné*, Boston and London, 1983.

Schmit
Schmit, R., *Eugène Boudin, 1824–1898*, vol. iii, Paris, 1973.

Valtat
Valtat, J., *Louis Valtat: Catalogue de l'oeuvre peint, 1869–1952*, Neuchâtel, 1977.

W.G.
Wildenstein, G., *Gauguin: Catalogue*, vol. i, Paris, 1964.

W.M.
Wildenstein, D., *Claude Monet: Biographie et catalogue raisonné*, 5 vols, Lausanne, 1974–1991.

W.R.
Wildenstein, A., *Odilon Redon: Catalogue raisonné de l'oeuvre peint et dessiné*, vol. i, Paris, 1992.

Z.
Zervos, C., *Pablo Picasso*, 33 vols, Paris, 1932–1978.

Separate monographs and publications

Apollinaire on Art
Apollinaire on Art: Essays and Reviews 1902–1918, New York, 1972.

Archives of the Pushkin Museum, Moscow, 1978
From the Archives of the Pushkin Museum: History of the International Links of the State Museum of Modern Western Art (1922–1939), second edition, Moscow, 1978.

Bailly-Herzberg, 1989
Bailly-Herzberg, J., ed., *Correspondance de Camille Pissarro*, vol. iv: *1895–1898*, Paris, 1989.

Barr, 1951
Barr, A. H., *Matisse: His Art and His Public*, New York, 1951.

Benois, 1990
Benois, A. N., *Memoirs*, 5 vols; vol. ii, Moscow, 1990.

Cézanne, 1978
Paul Cézanne, *Correspondance*, Paris, 1978.

Delektorskaya, 1986
Delektorskaya, L., *Henri Matisse: L'Apparente Facilité: Peintures de 1935–1939*, Paris, 1986.

Denis, 1957 and 1959
Denis, M., *Journal: 1884–1943*, vols i–ii, Paris, 1957; vol. iii, Paris, 1959.

Flam, 1986
Flam, J., *Matisse: The Man and His Art, 1869–1918*, Ithaca–London, 1986.

Giraudy, 1971
Giraudy, D., ed., 'Correspondance Henri Matisse – Charles Camoin', *Revue de l'Art* 12, 1971.

Hilaire, 1959
Hilaire, G., *Derain*, Geneva, 1959.

Kostenevich, 1993
Kostenevich, A., 'La correspondance de Matisse avec les collectionneurs russes', in Kostenevich, A., and Semionova, N., *Matisse et la Russie*, Moscow and Paris, 1993.

Leal, 1996
Leal, B., *Musée Picasso: Carnets: Catalogue des dessins*, 2 vols, Paris, 1996.

LVG
The Complete Letters of Vincent Van Gogh with Reproductions of all the Drawings in the Correspondence, 3 vols, New York and Boston, 1988.

Matisse, 1997
Matisse, La révélation m'est venue de l'Orient, Musei Capitolini, Roma, 1997.

Matisse/Fourcade, 1972
Matisse, H., *Ecrits et propos sur l'art* (ed. Dominique Fourcade), Paris, 1972.

Matisse in Morocco, 1990
Cowart, J., Schneider, P., Elderfield, J., Kostenevich, A., and Coyle, L., *Matisse in Morocco: The Paintings and Drawings, 1912–1913*, National Gallery of Art, Washington; The Museum of Modern Art, New York; State Pushkin Museum of Fine Arts, Moscow; State Hermitage Museum, Leningrad, 1990–1991.

Richardson, 1991
Richardson, J. (with the collaboration of M. McCully), *A Life of Picasso*, vol. i: *1881–1906*, New York, 1991.

Richardson, 1996
Richardson, J. (with the collaboration of M. McCully), *A Life of Picasso*, vol. ii: *1907–1917*, New York, 1996.

Rubin, 1989
Rubin, W., *Picasso and Braque: Pioneering Cubism*, The Museum of Modern Art, New York, 1989.

Sauvage, 1956
Sauvage, M., *Vlaminck: Sa vie et son message*, Geneva, 1956.

Signac, 1952
'Extraits du journal inédit de Paul Signac: 1897–1898', *Gazette des Beaux-Arts*, April 1952.

Vallotton, 1974
Vallotton, F., *Documents pour une biographie et pour l'histoire d'une oeuvre* (eds Gilbert Gaison and Doris Jacubec), vol. ii: *1900–1914*, Lausanne–Paris, 1974.

Venturi, 1939
Venturi, L., ed., *Les Archives de l'impressionisme*, vols i–ii, Paris–New York, 1939.

Paintings and Drawings

Yves Alix
1890, Fontainebleau – 1969, Paris

Alix studied at the Académie Julian in Paris, and then at the Académie Ranson under Denis, Bonnard, Vuillard and Sérusier. He worked in Paris, exhibiting from 1912 at the Salon des Indépendants, and from 1921 at the Salon d'Automne. He painted figure compositions, portraits and landscapes, made engravings, designed furniture and costumes, as well as theatre sets. In his later work he moved towards abstraction.

1. Court Scene (Palais de Justice), 1928 (page 364)
Scène du Palais de Justice
Oil on canvas. 61 x 50 cm
Signed bottom right: *Yves Alix*
⌐Э 8995

Finding herself in Paris in the autumn of 1928, K. A. Zelenina, curator of the State Museum of Modern Western Art, commissioned this picture for the museum with the help of M. F. Larionov. It was finished the same year and records the artist's impression of a visit to the Palais de Justice in Paris. The work is clearly influenced by Daumier, in particular his *Two Lawyers (In the Corridors of the Palais de Justice)* (1846–8; Lyons, Musée des Beaux-Arts). On 10 December 1929, Alix wrote to Zelenina from Paris: 'I enclose a receipt for 500 francs. I am very glad that my new series of works are to be represented in your wonderful museum' (Archives of the Pushkin Museum, Moscow, 1978, p. 36). These new works were the series of lithographs entitled *Paintings of the Palais de Justice* (now in the Pushkin Museum), which develop motifs similar to those in *Court Scene*.

Provenance: acquired from the State Museum of Modern Western Art in 1948; previously in the State Museum of Modern Western Art from 1929 (commissioned in 1928 and purchased for 500 francs).

Louis Anquetin
1861, Etrepagny, near Gisors – 1932, Paris

Anquetin studied at the Ecole des Beaux-Arts from 1882 under Bonnat, then Cormon. He was influenced by Impressionism and Japanese prints. Together with Gauguin and Bernard he took part in an exhibition of the Impressionists and Synthetists at the Café Volpini (1889), becoming one of the initiators of the Cloisonnism style. After 1890 he was influenced by Manet, Daumier and especially Rubens. Anquetin designed sets for the Théâtre-Antoine (1897), executed murals (1900–1), and designed tapestry cartoons at the Beauvais Manufactory (1919–20).

2. Bust of a Man (Self-Portrait), mid-1900s (page 228)
Buste d'homme (Autoportrait)
Watercolour on paper. 42.4 x 29.3 cm
Signed right, on the shoulder: *Anquetin*
43429

Anquetin has clearly modelled this drawing on the Flemish Baroque style and above all on Rubens, who, from the cycle of Maria Medici (1600–10; Paris, Louvre) to *Crucifixion (The Spear Wound)* (1620; Antwerp, Royal Museum of Fine Arts), frequently employed head profiles in his pictures. In particular, the drawing is similar to a satyr with bound hands at the bottom right-hand corner of the *Prosperity of Regency*, the eighteenth panel of the Maria Medici series. This deliberate echo can be explained by the artist's individual sense of humour. A comparison of this drawing with Anquetin's painted *Self-Portrait* (1894; formerly in the collection of Du Ferron-Anquetin) allows us to date it to the mid-1900s. A strip of paper has been added to the top part of the sheet by the artist.

Provenance: acquired from a private collection in Leningrad in 1939.

Jean-Francis Auburtin
1866, Paris – 1930, Paris

From 1888 Auburtin studied at the Ecole des Beaux-Arts. He exhibited at the Salon from 1892 and from 1895 to 1929 at the Salon of the Société Nationale des Beaux-Arts. He was awarded a silver medal at the Salon of 1900. Greatly influenced by Puvis de Chavannes, Auburtin was close to Henri de Régnier and Verlaine. He painted portraits, landscapes (mostly seascapes), allegorical and symbolic compositions, decorative murals (including the panels for the Zoology amphitheatre at the Sorbonne), and theatre sets.

3. Landscape with Overgrown Pond, c. 1899–1903 (page 190)
Paysage avec le pond envahi
Gouache and pencil on grey paper. 40 x 74.4 cm
Initialled bottom left: *AF*
46426

Provenance: acquired in 1975; previously in the collection of A. I. Shuster, Leningrad.

Joseph Bail
1862, Limonest, near Lyons – 1921, Paris

He studied in Lyons under his father, the local artist Jean-Antoine Bail, then in Paris under Gérôme and Carolus-Duran. From 1878 until the end of his life, he exhibited at the Salon, where in 1902 he was presented with an honorary medal. He was awarded medals at the Exposition Universelle: silver in 1889 and gold in 1900. He was influenced by Théodule Ribot. Bail painted mostly genre pictures and still lifes.

4. Kitchen-Boy, 1893 (page 84)
Le Marmiton à la cuisine
Oil on canvas. 71 x 100 cm
Signed and dated bottom right: *Bail Joseph 1893*
⌐Э 5202

The subject of this painting may have been suggested to Bail by Philippe Mercier's *Young Taster* (Paris, Louvre), painted some hundred and fifty years earlier. The artist had already experimented with a similarly anecdotal composition in 1889 with *His First Cigarette* (Salon of 1889; shown under the title *Young Smoker*, No. 91, and sold at auction by Sotheby's, New York, on 23 May 1997). In *Young Smoker*, as in this later Hermitage work, a kitchen-boy in a white apron and cap is shown beside a copper cauldron, obviously unsupervised. He is lolling casually and enjoying himself 'like a grown-up' – with a forbidden cigarette. The half-empty bottle of wine in the Hermitage picture suggests a different vice, but the artist's attempt at humour is based on the same device. The picture came to St Petersburg soon after its completion and as early as 1896 featured in an exhibition, *French Art in Aid of the Red Cross*. The same model of a boy in an apron appears in the picture *Dogs and Cats*, shown at the Salon of 1894.

Provenance: acquired from the State Museum Fund in 1920; previously in a private collection, Petrograd.

Paul Baudry
1828, La Roche-sur-Yon – 1886, Paris

He studied from 1844 at the Ecole des Beaux-Arts under Michel-Martin Drolling. He was awarded the Prix de Rome in 1850, and from 1850 to 1856 he worked in Italy. From 1852 to 1882 he exhibited at the Salon. His portraits were particularly admired. He also painted pictures with historical, allegorical and mythological themes, usually serving as little more than an excuse to depict the female nude. He carried out a whole series of prestigious official murals in the

monumental decorative style (for the Grand Opéra and the Panthéon in Paris, among others). He was a member of the Institut de France from 1870.

5. Portrait of P. A. Chikhachev, 1864 (page 86)
Portrait de P. A. Tchikhatchev
Oil on canvas. 73 x 59.5 cm
Monogrammed top left: *PB*; inscribed on the reverse: *Платон Чихачев на 51-м году жизни. Париж. Fev. 1864. Baudry* [Platon Chikhachev in his 51st year. Paris. Feb. 1864. Baudry]
ГЭ 4817

Platon Alexandrovich Chikhachev (1812–92), who came from an old and noble Russian family, followed in his elder brother Peter's footsteps and became a geographer and traveller. He took part in expeditions to Central Asia, Africa, and North and South America; he served in the war against Turkey, and in the suppression of the Polish uprising and the Crimean War.

Provenance: acquired from the State Museum Fund in 1920; previously in the collection of P. A. Chikhachev, St Petersburg.

Albert Besnard
1849, Paris – 1934, Paris

He studied from 1866 at the Ecole des Beaux-Arts under Jean-François Brémond and Alexandre Cabanel. He was awarded the Prix de Rome in 1874. From 1874 to 1883 he lived in Rome and London, then in Paris. He was influenced by the Impressionists and Burne-Jones. Besnard was one of the founders and vice-president of the Société Nationale des Beaux-Arts (1910–13). He was also director of the Académie de France in Rome (1914), then of the Ecole des Beaux-Arts from 1922. He was a member of the Institut de France from 1924. He travelled in Algiers and India. Besnard painted portraits and female nudes, engravings, and decorative monumental painting (for the Petit Palais, the Sorbonne and the Hôtel de Ville in Paris, among others).

6. Portrait of a Woman, 1890 (page 88)
Portrait de femme
Pastel on grey paper. 35 x 28 cm
Inscribed, signed and dated bottom left: *A la Ctesse de Fonlongue Respectueusement A Besnard Nice – 1890* [To the Countess de Fonlongue, Respectfully, A. Besnard, Nice – 1890]
45101

The dedication suggests that the Countess de Fonlongue is the subject of the portrait, which was presented to her by Besnard.

Provenance: acquired from the collection of J. Roman, France, in 1963 (donated by J. Roman).

Pierre Billet
1837, Cantin (Nord) – 1922

Billet studied under Jules and Emile Breton. He exhibited at the Salon from 1867, where he was awarded a third-class medal in 1873, and second-class in 1874. He painted landscapes and genre compositions on the theme of village life and the life of fishermen, following the example of the brothers Feyen who often painted scenes of oyster catching. He also made engravings.

7. Oyster Catching, 1884 (page 82)
La Pêche des huîtres
Oil on canvas. 115 x 180 cm
Signed and dated bottom left: *Pierre Billet 1884*
ГЭ 8538

In 1872 one of Billet's paintings on the life of fishermen, *High Tide, Normandy Coast*, which was being shown at the Salon, was instantly bought by the State for the Musée du Luxembourg (and twenty years later was moved to a still more prestigious location – the apartments of the president of the Senate). Billet, in an attempt to capitalise on this success, frequently produced work on the theme of oyster catching. This painting shows that with hindsight the true merit of Billet's painting is found less in the fishermen and their theatrical *mise en scène*, and more in the harsh landscapes of Normandy that form the backdrop.

Provenance: acquired in 1946; previously in a private collection, Leningrad.

Jacques-Emile Blanche
1861, Paris – 1942, Offranville

Blanche studied under Henri Gervex and Ferdinand Humbert. He exhibited at the Salon from 1882 to 1889, and at the Salon of the Société Nationale des Beaux-Arts from 1890 to 1922. A portraitist who painted many of the outstanding representatives of the artistic elite of Europe (including Mallarmé, Gide, Valéry and Proust), he also painted landscapes. As an art critic he wrote a series of books and articles on contemporary French art.

8. Portrait of a Woman, 1896 (page 87)
Portrait de femme
Oil on canvas. 91.5 x 73 cm
Signed and dated bottom right: *J. E. Blanche 96 Paris*
ГЭ 7709

The model is probably Russian but her identity is not known.

Provenance: acquired from the Antiquariat in 1931.

Pierre Bonnard
1867, Fontenay-aux-Roses, near Paris – 1947, Le Cannet, near Cannes

Bonnard studied at the Académie Julian (1887), where he met Sérusier, Denis and Ranson. The following year, when he entered the Ecole des Beaux-Arts, he met Vuillard and Ker-Xavier Roussel. After failing to win the Prix de Rome in 1889 he left the Ecole and with Sérusier, Denis and Vuillard established the Nabis group. The influence of Gauguin, Toulouse-Lautrec and Japanese woodcuts is apparent in his early works. At the turn of the century, Bonnard's work was highly praised by Renoir, Monet and Redon. He had his first one-man exhibition at the Galerie Durand-Ruel in 1896, and Vollard published several books with his illustrations. He painted mainly scenes of Paris and the Ile de France, Normandy, Dauphiné, and the Côte d'Azur. Although landscapes make up the majority of his work, he also painted still lifes, interiors and nudes. In later years the subject matter of his painting changed little, although after 1912 he no longer painted views of Paris. Bonnard travelled to various countries: Belgium and Holland (1906), England, Spain, Algeria, Tunisia (1908), and the USA (1926). He visited Hamburg (1913) and Rome (1921). He was particularly drawn to Le Cannet and Vernon. As well as painting and engraving, he also worked on theatre sets, book illustrations and sculpture.

9. Behind the Fence, 1895 (page 206)
Derrière la grille
Oil on cardboard. 31 x 35 cm
Signed and dated bottom left: *Bonnard 95*
ГЭ 7709 D. 98

Behind the Fence is influenced by Japanese art and demonstrates a feature that is characteristic of Bonnard's early work – the use of repeated squares as a decorative effect. A similar device of juxtaposing a female figure and a diagonal-patterned railing is employed in *Promenade* (Winterthur, private collection; D. 57). It is likely that the same model was also used for *Figure* (c. 1895, D. 96).

Provenance: acquired from the State Museum of Modern Western Art in 1934; previously in the collection of M. A. Morozov; collection of M. K. Morozova from 1903; Tretyakov Gallery (donated by M. K. Morozova) from 1910; State Museum of Modern Western Art from 1925.

10. Landscape in Dauphiné, c. 1899 (page 207)
Paysage en Dauphiné
Oil on wood. 45.5 x 56 cm
Signed bottom left: *Bonnard*; inscribed on the back: *Paysage vert* [Green Landscape]
ГЭ 7757 D. 331

This picture is also known as *Green Landscape*. In a letter to Ivan Morozov of 28 June 1907, Vollard specified the name of the painting that he had just received from the artist: 'the picture has the general title *Landscape in Dauphiné*' (archive of the Pushkin Museum, Moscow). The picture's subject is similar to *Panoramic View (Dauphiné)* (1894; D. 01744). It depicts the same valley in the foothills of the Alps close to Grand-Lemps, where Bonnard spent his childhood in his grandparents' home, and where he returned on several occasions as an adult. However, the Hermitage picture undoubtedly exhibits greater artistic skill than *Panoramic View*, and was most probably painted around 1899. The date suggested by Dauberville and others – c. 1905 – seems too late.

Provenance: acquired from the State Museum of Modern Western Art in 1934; previously in the Galerie Vollard; the collection of I. A. Morozov (purchased from Vollard for 1,500 francs) from 1906; Second Museum of Modern Western Painting from 1918; State Museum of Modern Western Art from 1923.

11. A Corner of Paris, c. 1905 (page 208)
Un coin de Paris
Oil on cardboard glued to wood. 49.2 x 51.8 cm
Signed bottom right of centre: *Bonnard*
ГЭ 9025 D. 332

Although this view is presented as a specific corner of Paris, probably in the neighbourhood of the Rue de Douai where the artist had his studio, it contains little that is recognisable. It is almost as though the viewer has been set a puzzle to solve, which can only be achieved or guessed at by looking closely: the posters on the wall and the figures of children almost merge with the background. Bonnard was always interested in posters and they appear several times in his early work. The theme of children's games on the streets of Paris attracted Bonnard as early as the 1890s. It is quite possible that this work was influenced by Louis Valtat's *Coming out of School* (mid-1890s; France, Kocher collection), which shows a group of children in an almost abstract way, as a combination of patches of colour.

Provenance: acquired from the State Museum of Modern Western Art in 1948; previously in the Galerie Vollard; in the collection of I. A. Morozov (bought from Vollard for 1,000 francs) from 1906; Second Museum of Modern Western Painting from 1918; State Museum of Modern Western Art from 1923.

12. Study of a Nude, c. 1906 (page 209)
Etude de nue
Pen and ink on paper. 15.1 x 10.7 cm
27237

This drawing was reproduced on the invitation to Bonnard's one-man exhibition at the Galerie Bernheim-Jeune in November 1906 (see Dauberville's catalogue, vol. ii, p. 18). The model has been identified as the artist's wife Marthe. The drawing was probably done not long before the exhibition, although Bonnard had drawn similar nudes before, for example in 1902 in his illustrations to *Daphnis and Chloe* by Longus.

Provenance: acquired in 1922; previously in the Galerie Bernheim-Jeune; collection of G. E. Haasen, St Petersburg.

**13. Early Spring (Little Fauns), 1909
(page 213)**
Premier printemps (Les Petits faunes)
Oil on canvas. 102.5 x 125 cm
Signed bottom right: *Bonnard*
ГЭ 9106 D. 540

Bonnard first turned his attention to pastoral themes in 1902 in his illustrations to *Daphnis and Chloe* by Longus, commissioned by Vollard. In 1907 he painted a medium-sized canvas, known by various titles: *Faun, Pan and Nymph*, *The Afternoon of a Faun* (D. 471), and a later painting (*c*. 1910) entitled *Fauns* (Switzerland, private collection; D. 329, attributed by Dauberville to 1905). It is only in these two canvases and the Hermitage picture that Bonnard includes mythological, Dionysian characters; indeed *Fauns*, which is painted in a more decorative style, develops the subject matter of the Hermitage composition still further: in the bottom left-hand corner a horned creature is making music in an identical pose. Among the works that foreshadow *Early Spring* is a pair of medium-sized panels, *Mother and Child* and *Father and Daughter* (Brussels, Lambert collection; D.458, 459), which each depict two figures against a landscape. The figures in these panels are later united in the Hermitage composition: the pose of the faun playing on a flute echoes the pose of the mother in the Brussels panel. *Early Spring* also preceded *Early Spring or Thoughts* (1908; Washington, DC, Phillips Collection; D. 508), in which the same view of Vernouillet is depicted, with minor alterations. A part of the same view is again reproduced in *Storm at Vernouillet* (1908; Switzerland, private collection; D. 509), which shows two children running from the storm – a subject that was occasionally used in Salon paintings of the last quarter of the nineteenth century. By swapping the real children of the 1908 canvas with mythological creatures, and setting them specifically in the landscape of Vernouillet with elements of contemporary architecture rather than in the unspoilt, impersonal natural landscape of the earlier work, Bonnard gives *Early Spring* a completely unexpected counterpoint. The artist's stay in Vernouillet in the spring of 1909 turned out to be very fruitful. Among the canvases painted at the time was *Rainy Landscape* (Helsinki, Atheneum Museum; D. 547), which partially repeats the landscape of *Early Spring*. Its date – 1909 – can be seen as confirmation of the date of the Hermitage picture.

Provenance: acquired from the State Museum of Modern Western Art in 1948; previously in the Galerie Bernheim-Jeune in 1909; the Bernstein Collection, Paris, from 28 June 1909; the Galerie Bernheim-Jeune again from 1911; the collection of I. A. Morozov (acquired from the Galerie Bernheim-Jeune for 5,000 francs) from 1912; Second Museum of Modern Western Painting from 1918; State Museum of Modern Western Art from 1923.

**14. Train and Barges (Landscape with
Freight Train), 1909 (page 212)**
Le train et les chalandes
Oil on canvas. 77 x 108 cm
Signed bottom right: *Bonnard*; dated on the
stretcher bar: *1909*
ГЭ 6537 D. 539

This picture was painted in the late spring of 1909 and was first shown as *Train and Barges* at Bonnard's one-man exhibition at the Galerie Berheim-Jeune in 1910. Ivan Morozov, who bought the picture at the exhibition, entered it in his hand-written catalogue

as *Landscape with Freight Train*, under which title it entered both the State Museum of Modern Western Art in Moscow, and the Hermitage. The picture depicts the environs of Vernouillet, a small town on the Seine, not far from Paris. The local church had long been known as a splendid example of thirteenth-century Romanesque architecture, but Bonnard was not interested in painting architectural monuments. At that time what really attracted him were the views that immediately opened up on the edge of the little town. Richard Thomson suggests that Bonnard's idea for the composition with the train was inspired by Monet's *Train* (1872; private collection) and Van Gogh's *Summer Evening, Arles* (1888; Winterthur, Kunstmuseum) (see *Monet to Matisse: Landscape Painting in France, 1874–1914*, ex. cat., National Gallery of Scotland, Edinburgh, 1994, No. 200).

Provenance: acquired from the State Museum of Modern Western Art in 1930; previously in the Galerie Bernheim-Jeune (acquired from the artist) from 1909; the collection of I. A. Morozov (acquired from Bernheim-Jeune for 3,500 francs) from 14 November 1910; Second Museum of Modern Western Painting from 1918; the State Museum of Modern Western Art from 1923.

15. The Seine near Vernon, *c*. 1911 (page 209)
La Seine près de Vernon
Oil on canvas. 41.5 x 52 cm
Signed bottom right: *Bonnard*
ГЭ 8700 D. 419

This landscape is one of a group of works executed in 1911, similar to *The Seine at Vernonnet* (Berne, Hahnloser Collection; D. 658) and still more so to *View of the Seine in May* (D. 659), which has exactly the same dimensions. All three paintings depict the same place, not far from the Villa Ma Roulotte which Bonnard rented in 1911, and bought the following year. Dauberville's catalogue dates the Hermitage picture to 1906, but with little justification.

Provenance: presented by L. Ya. Rybakova in 1941; previously in the I. I. Rybakov collection, Leningrad.

16. Morning in Paris, 1911 (page 210)
Le Matin à Paris
Oil on canvas. 76.5 x 122 cm
Signed left of centre: *Bonnard*
ГЭ 9107 (pair with ГЭ 9105) D. 641

Morning and *Evening in Paris* make up a pair of pictures of a district that was often painted by Bonnard in the period from 1893 to 1912. It was here, just off the Boulevard de Clichy and Boulevard des Batignolles, that Bonnard had his studio. The themes explored in the two works are apparent even in the earliest pictures he painted in this studio on the Rue de Douai: *On the Boulevard* (1893; D. 49) and *People in the Street* (*c*. 1894; D. 52). In 1898 Bonnard was commissioned by Vollard to produce a series of coloured lithographs entitled *Quelques aspects de la vie de Paris*, and elements of these lithographs – in particular the part-genre, part-iconographic approach – can be seen in the later Morozov paintings. Thus *A Corner of the Street* reveals motifs that are later employed in *Morning in Paris*: children, women, a little dog, a hand-cart. Part of the background of the picture is recognisable from another work from 1911 – *Fog on the Boulevard des Batignolles* (D. 638). Bonnard had depicted this crossing on the Boulevard des Batignolles in two earlier paintings: *The Hand-Cart* (1909; Merion, PA, Barnes Foundation) and *The Rag-and-Bone Men* (early 1910; New York, Salz collection; D. 640). The view in the background of the small work *The Hand-Cart* is repeated in the Hermitage picture, but its foreground shows an old man with a heavily laden cart. Returning to this theme in the considerably more important work, *The Rag-and-Bone Men*, the artist altered his construction of the foreground. The bottom left-hand corner is occupied by young women moving towards the viewer, and, in the centre, a coal cart is pulled by a donkey – a detail that allows us to identify the time of day as early morning, when the coalman delivers his goods. In the later canvas *Morning in Paris*, Bonnard rejected the theme of rag-and-bone men (shown in the aforementioned work

returning from Les Halles, and forcing the coalman to the side of the road), and instead limited himself to documenting the events of the early morning, transforming fundamental details into easily recognisable silhouettes.

Provenance: acquired from the State Museum of Modern Western Art in 1948; previously in the collection of I. A. Morozov (commissioned in January 1910 for 2,500 francs) from 1912; Second Museum of Modern Western Painting from 1918; State Museum of Modern Western Art from 1923.

17. Evening in Paris, 1911 (page 211)
Le Soir à Paris
Oil on canvas. 76 x 121 cm
Signed bottom right: *Bonnard*
ГЭ 9105 (pair with ГЭ 9107) D. 641

Bonnard's entire previous work can be seen as preparatory to the idea of a pair of pictures about Paris street life, linked by the traditional concept of the changing times of day. The fact that his studio was located on the Rue de Douai, which runs into the Place de Clichy where the Boulevard de Clichy meets the Boulevard des Batignolles, is also significant. This district was exceptionally lively, and from about 1895 to 1910 Bonnard returned constantly to the theme of street activity, giving a great deal of thought to the idea of a multiple composition that would create a more powerful impression than a single painting. In 1896 and 1900 he painted two triptychs of the Place de Clichy (D. 136, 237). The first is called *The Ages of Life*, and its central idea – the juxtaposition of people of different ages as a means of expressing various stages in life – is retained in the Morozov series, for in both Morozov paintings three characters of varying ages are depicted. *Les Batignolles ou le cheval de fiacre* (1895; Washington, DC, National Gallery of Art; D. 92 *bis*) was a source for *Evening in Paris*, as were the lithographs completed at the same time for the series *Quelques aspects de la vie de Paris* (particularly *Boulevard*, *A Square in the Evening*, and *Street in the Evening Rain*). In both *Evening in Paris* and the lithographs the Japanese influence is clearly visible. The frieze-like composition recalls the techniques of Kiyonaga, while the evening street scene is reminiscent of Hiroshige's coloured woodcut *Evening scene in Saruwakacho* from *One Hundred Famous Views of Edo* (1856).

Provenance: acquired from State Museum of Modern Western Art in 1948; previously in the collection of I. A. Morozov (commissioned in 1910 for 1,500 francs) from 1912; Second Museum of Modern Western Painting from 1918; State Museum of Modern Western Art from 1923.

18. On the Mediterranean (Triptych), 1911 (pages 214–5)
Mediterrannée
Oil on canvas. 407 x 152 cm (left panel); 407 x 152 cm (centre panel); 407 x 149 cm (right panel)
Signed and dated bottom left of right-hand panel: *Bonnard 1911*
ГЭ 9664, 9663, 9665 D. 657

In January 1910, Ivan Morozov, using the Galerie Bernheim-Jeune as an intermediary, commissioned a large triptych for the staircase of his house on Prechistenka Street, Moscow (a building that now belongs to the Russian Academy of Arts). The collector supplied Bonnard with a photograph of the staircase along with its

dimensions. The panels of the triptych were designed to be separated by demi-columns which the artist took into account when planning the whole composition. In the Salon d'Automne of 1911 the triptych was exhibited under the title *Mediterranean: Panels Between Columns*. The following year, Bonnard added to the triptych with two further large panels: *Early Spring in the Country* and *Autumn: Fruit Picking* (Moscow, Pushkin Museum; D. 717, 716). The basic themes of the triptych come from Bonnard's paintings of the 1890s, among which a series of decorative panels called *Women in the Garden* (1890–1; Zurich, Kunsthaus; D. 01715) can be singled out, in particular one showing a woman with a cat. The theme of children playing in the central section is found very often in Bonnard's work, but there are no close parallels. The figure in the right-hand section is featured earlier in the picture *Woman with a Parrot* (1910; collection of Wildenstein & Co.; D. 605). In June 1909 Bonnard stayed with Manguin at the Villa Demière in Saint-Tropez. *View of Saint-Tropez* or *The Alley* (Berne, Hahnloser Collection; D. 545) was painted at that time, and it was this painting that later formed the basis for the central section of the triptych. However, in transferring it to the large panel Bonnard altered its composition, removing individual details and adopting a more distant viewpoint onto the sea. By so doing he achieved an exceptionally airy, light tonality. Bonnard probably painted the landscape from memory: by 1910, when he began work on the triptych, *View of Saint-Tropez* had already been sold to the Bernheims. Bonnard painted several landscapes of Saint-Tropez in 1910 and again in March 1911 on his return there, but only one of them – *Palm-Tree* (1910; D. 621) – bears any similarity to *View of Saint-Tropez*, and therefore to the central panel of the triptych. When staying in Saint-Tropez in September 1910 at the invitation of Paul Simon, Bonnard wrote to his mother that the south struck him like a spectacle from *A Thousand and One Nights*. The impression this short visit made on him doubtless had an effect on the composition of the triptych, which depicts an autumnal rather than summer scene. In the same letter Bonnard describes how he and Simon called on a neighbour, where he saw a dark-haired girl with a huge pale-blue parrot; he added that he had now discovered the shingle, low walls, olive-trees and oaks. In the upper part of the right panel is an oak, and below is a girl with a parrot, although the parrot is not pale blue, like the one that Bonnard saw and originally painted in *Woman with a Parrot*, but green – a colour change dictated by the pictorial imperatives of the composition. The triptych was finished in May 1911. It was first exhibited at the Galerie Bernheim-Jeune and the Salon d'Automne, and then sent to Moscow in November of that year. There the canvases were glued directly to the walls between the demi-columns on the first floor of the main staircase, and the top corners were partially cut along the contour of the scroll of the capitals. Later, when the triptych came to the Hermitage in 1948, the missing sections were filled in and the canvases were lined and stretched.

Provenance: acquired from State Museum of Modern Western Art in 1948; previously in the collection of I. A. Morozov (commissioned for 2,500 francs) from 1911; Second Museum of Modern Western Painting from 1918; State Museum of Modern Western Art from 1923.

Léon Bonnat

1833, Bayonne – 1922, Monchy-Saint-Eloi, Oise

Bonnat studied under Madrazo in Madrid, where his parents lived, until 1853, and also at the Ecole des Beaux-Arts in Paris under Léon Cogniet (*c.* 1855). He won second prize in the Prix de Rome in 1857, and thanks to a stipend provided by his home town spent the next three years in Rome. He travelled to the East in 1870 (Palestine, Turkey, Egypt). He exhibited at the Salon from 1857 to 1922. Bonnat was a long-time friend of Degas and Manet. He was a member of the Institut de France from 1881 and director of the Ecole des Beaux-Arts from 1905. He worked on mythological, biblical and Oriental themes, and executed several murals, including in the Panthéon, but he is known above all for his portraits. An outstanding collector, Bonnat's collection is now divided between the Louvre and the Musée Bonnat in Bayonne.

19. Fountain by the Cathedral of St Peter in Rome, 1868 (page 80)
La fontaine près de la Cathédrale de Saint-Pierre à Rome
Oil on canvas. 46 x 38 cm
Signed and dated bottom right: *Ln Bonnat 1868*
ГЭ 7078

The Latin inscription on the marble plaque above the fountain on the north wall of St Peter's reads: *BENEDICTVS XIII. P.M. / AD AVGEN-DAM REI DIVINAE RELIGIONEM / ORNANDAM PRINCIPIS APOS-TOLORVM MEMORIAM / EX ARIS HVIVS SACROSANCTAE BASILI-CAE / VNAM ET VICINTI / SOLLENNI RITV DEDICAVIT* [Pope Benedict XIII, to extol this sacred place and to glorify the memory of the leader of the apostles, ceremonially dedicates twenty-one altars in his sacred basilica].

Provenance: acquired from the Antiquariat in 1933; previously in Gatchina Palace, near St Petersburg.

20. In the Mountains, 1870s (page 79)
A la montagne
Oil on canvas. 78.5 x 121.5 cm
Signed bottom right: *Ln Bonnat*
ГЭ 9108

In 1868 Bonnat, together with Gérôme, led a group of artists on a journey to the East, visiting Egypt, Sinai, Palestine and Turkey. He brought back more than seventy studies in oil, mainly landscapes. Only a few have survived, but it is likely that it was on the basis of these studies, which occupy an important place in Bonnat's work with his tendency towards naturalism, that this canvas was later painted back in France. It most probably represents a view of Palestine with Arab nomads in the foreground. The background is similar to Bonnat's study *Jericho Landscape* (1868; Dijon, Musée des Beaux-Arts). The influence of Gérôme, in particular his *Egyptian Recruits Crossing the Desert* (1857; Houston, private collection) is evident in Bonnat's treatment of the subject matter, although Bonnat's use of colour is considerably freer. In his use of colour he is closer to Fromentin and his analogous compositions with riders, especially *Falcon Hunt in Algeria* (1863; Paris, Musée d'Orsay). *In the Mountains*, with its exceptionally energetic brushwork and vivid colour range, is an important and unusual example of his compositions on Oriental themes: in other paintings such as *Egyptian Peasant-Woman with a Child* (1870; New York, Metropolitan Museum) and *Oriental Barber-Shop* (1872; Moscow, Pushkin Museum), the artist adheres to academic rules considerably more strictly, motivated by more ethnographic aims.

Provenance: acquired from the State Museum of Modern Western Art in 1948; previously in a private collection in Moscow; Rumyantsev Museum, Moscow (acquired between 1917 and 1923); State Museum of Fine Arts, Moscow, from 1924; State Museum of Modern Western Art from 1930.

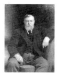

21. Portrait of Prince V. N. Tenishev, 1896 (page 87)
Portrait du prince V. N. Tenichev
Oil on canvas. 119.5 x 92 cm
Signed and dated top right: *Ln Bonnat 1896*
ГЭ 5172

The portrait was painted in Paris. Bonnat used his *Portrait of John Taylor Johnston* (1880; New York, Metropolitan Museum) as a model for the composition, an association that may have been suggested by the physical similarity of the two sitters. In addition, in both instances Bonnat probably used photographs – a method he often chose in the preparatory stages of his portraits. Vyacheslav Nikolaevich Tenishev (1843–1903) was a court chamberlain and an important industrialist, being the founder of the joint-stock company of the Bryansk factories and an honorary member of the Russian chamber of trade and industry. He initiated the production of the first

Russian automobiles. He received his training in communications engineering, and in 1895 he founded the Tenishev secondary school in St Petersburg, where he also taught. Tenishev's ethnographical work was highly valued by his contemporaries. He and his wife, Maria Klavdievna Tenisheva, collected works by Russian masters and helped them financially. In 1900 he was General Commissar of the Russian section at the Exposition Universelle in Paris.

Provenance: acquired from the State Museum Fund in 1923; previously at the Tenishev School, St Petersburg.

Eugène Boudin

1824, Honfleur – 1898, Deauville

Boudin lived in Le Havre from 1835, where he was apprenticed to a printer, but did not complete a specialisation. He became acquainted with Eugène Isabey and Constant Troyon, who were important influences, as were Corot, Daubigny and Jongkind. He painted landscapes, mainly the beaches of Normandy. Occasionally he painted still lifes and pictures of grazing cattle. In 1850 he exhibited two pictures at the Société des Amis des Arts du Havre, which led to a stipend from the municipality of Le Havre to study at the Ecole des Beaux-Arts in Paris (1851–3). He travelled extensively along the Atlantic coast, from Holland to Bordeaux, and he also visited Belgium and Italy. He exhibited at the Salon for the first time in 1859, where his works in pastel were much admired by Baudelaire. He later participated in the Salon des Refusés (1863). He took part in the first Impressionist exhibition in 1874. He was awarded a gold medal at the Exposition Universelle in Paris in 1889. From 1880 to the 1890s he was much influenced by his former pupil Claude Monet.

22. Beach at Trouville, 1893 (page 126)
Plage de Trouville
Oil on canvas. 56 x 91 cm
Inscribed, dated and signed bottom left: *Trouville 93 / E. Boudin*
ГЭ 10597 Schmit 3152

By the end of the nineteenth century Trouville, a medium-sized port on the English channel, was well known as a resort and as a popular place for bathing. Boudin loved the town and painted it frequently. His first Trouville pictures date back to 1860, while the last were completed in 1897. The compositional parameters of his Trouville paintings were already set by the beginning of the 1860s: the foreground is generally given over to the expanse of beach, usually at low tide, dotted with one or two figures; the line of the horizon is positioned relatively low, allowing the artist to extend the landscape area; and above, the generally overcast sky plays an important role in the painting's overall construction. Pictures such as *Beach at Trouville* (1863; private collection; Schmit 273), can be seen as prototypes for many later compositions, including this Hermitage canvas. It would appear that by constantly reinterpreting the subject matter, examining its every detail, Boudin managed to avoid repeating himself or falling prey to monotony. This canvas, one of his most important and most vital depictions of Trouville, demonstrates this extremely well. At Boudin's posthumous exhibition in New York the picture was shown under the title *Beach at Trouville: View from the Promenade-Pier, High-Tide, October* (*Exhibition of Paintings by the late Louis-Eugène Boudin*, Durand-Ruel Galleries, New York, 1898, No. 46).

Provenance: acquired in 1997; previously in the Galerie Durand-Ruel, Paris (purchased from the artist on 6 July 1894 for 800 francs); Carnegie Art Gallery, New York, from 1901; Durand-Ruel Gallery, New York; collection of D. M. Look, New York; Nivian Gallery, New York; Galerie Alex Maguy, Paris; Wildenstein and Co., New York; private collection, Switzerland.

William-Adolphe Bouguereau
1825, La Rochelle – 1905, La Rochelle

Bouguereau was the son of an Englishman who settled in La Rochelle, where the artist received his primary education. He moved to Paris in 1846 and studied at the Ecole des Beaux-Arts under François-Edouard Picot. In 1848 he won second prize in the Prix de Rome, and two years later, first prize, enabling him to travel to Italy and complete his art studies. From 1849 until his death he exhibited at the Salon, and together with Cabanel played a major role in directing the Salon's activities throughout the 1870s and 1880s. He was a member of the Institut de France from 1876. He painted pictures on biblical and mythological themes, as well as portraits. He also frequently undertook large-scale decorative painting for a number of French cathedrals.

23. Tobias Receives His Father's Blessing, 1860 (page 61)
Les Adieux de Tobias avec son père
Oil on canvas. 153 x 119 cm
Signed and dated bottom right:
W. BOVGVEREAV 1860
⌐Э 4426

The subject is taken from the apocryphal Old Testament Book of Tobit. The blind Tobit blesses his son, who is setting off from Nineveh to Media to recover the money he had earlier hidden there. The Archangel Raphael appears in human form to accompany Tobias on his journey. Tobit's wife Anna is seen behind him in tears. The picture is a variation of the slightly smaller *Return of Tobias* (1856; Dijon, Musée des Beaux-Arts), which was shown at the Salon of 1857, but which is not a pair to the Hermitage canvas. The painting resulted from a great deal of preparatory work and painstaking studies. In the preparatory charcoal cartoon of exactly the same dimensions (1860; private collection; *William Bouguereau: 1825–1905*, ex. cat., Montreal, Museum of Fine Arts, No. 25), each detail was already defined with such precision that nothing remained but to transfer the drawing onto canvas, and only a few secondary details in the background were added. On the cartoon there are even traces of the pin-pricks that Bouguereau used to ensure he traced each line accurately. The cartoon was preceded by preparatory pencil studies and even in these all the details of the composition were already formulated with total precision. Thus in the drawing showing Tobias (private collection; ex. cat. *William Bouguereau* as above, No. 26), his pose and even the folds of his clothes are depicted just as they were in the later finished picture. Only the shepherd's hat on his back is missing, a detail the artist introduced not simply as a reminder of the long journey ahead under a blazing sun, but also as a plastic element uniting the figures of Tobias and Raphael. Bouguereau's canvas was shown in 1861 at the St Petersburg exhibition *Pictures and Rare Works of Art Belonging to Members of the Imperial Household and to Private Individuals in St Petersburg* under the title *Tobit Blessing His Son* (No. 681).

Provenance: acquired from the Kushelev Gallery of the Museum of the Academy of Arts, Petrograd, in 1922; previously in the gallery of N. A. Kushelev-Bezborodko, St Petersburg, from 1860 or 1861 (purchased from the artist).

Alexandre Cabanel
1823, Montpellier – 1889, Paris

From 1840 Cabanel studied at the Ecole des Beaux-Arts in Paris under François-Edouard Picot. He was awarded the Prix de Rome in 1845 for historical painting; he then worked in Italy until 1850. He exhibited at the Salon from 1859 until his death, where he wielded great influence. He was a member of the Institut de France and professor at the Ecole des Beaux-Arts from 1863. Primarily a portraitist and historical painter, he also executed a series of decorative murals (at the Panthéon and private houses in Paris). He received numerous commissions from Napoleon III and foreign aristocracy.

24. Portrait of Prince K. A. Gorchakov, 1868 (page 86)
Portrait du Prince K. A. Gortchakov
Oil on canvas. 67 x 56 cm
Signed and dated top right: *ALEX. CABANEL 1868*
⌐Э 5093

Konstantin Alexandrovich Gorchakov (1841–1926), royal prince and court equerry, was the younger son of Alexander Mikhailovich Gorchakov, a famous government figure, diplomat and chancellor. He was married to the daughter of a Moldavian *gospodar* (prince). This portrait was painted in Paris. Count Sergei Witte described Gorchakov in his *Memoirs* thus: 'The younger Gorchakov was remarkably handsome, so much so that in Kiev and right until the end his appearance always attracted attention. But he, like Polovtsov, had an exceptionally unsympathetic character. Regarding both Polovtsov and Gorchakov, the question always occurs to me: What do these people need? They have status and great wealth, they are completely independent, yet it is in their nature to be obsequious to the strong, to people with power, for example, the grand dukes.' (S. Yu. Witte, *Memoirs* (Moscow, 1960) vol. i, pp. 182–3).

Provenance: acquired through the State Museum Fund from the Russian Museum, St Petersburg, in 1923; previously in the collection of K. A. Gorchakov, St Petersburg.

25. Portrait of Countess E. A. Vorontsova-Dashkova, 1873 (page 87)
Portrait de la Comtesse E. A. Vorontsova-Dachkova
Oil on canvas. 99 x 73 cm
Signed and dated top left: *ALEX. CABANEL 1873*
⌐Э 7600

Elizaveta Andreyevna Vorontsova-Dashkova (1845–?), *née* Countess Shuvalova, was the wife of I. I. Vorontsov-Dashkov, minister of the Imperial Court and Crown Domains, and subsequently Governor of the Caucasus. The portrait was painted in Paris.

Provenance: acquired from the State Museum of Modern Western Art in 1948; previously in the collection of the Vorontsov-Dashkov family, Moscow; State Museum of Fine Arts, Moscow; State Museum of Modern Western Art from 1930.

Emile-Auguste-Charles Carolus-Duran (Charles Duran)
1837, Lille – 1917, Paris

Carolus-Duran studied in Lille, and from 1859 in Paris at the Académie Suisse. His early work shows the influence of Spanish painting and Courbet. He was one of the founders of the Société Nationale des Beaux-Arts, and its honorary president from 1904 to 1913. From 1904 he was a member of the Institut de France, and from 1905 director of the French Academy in Rome. He painted landscapes, as well as historical, religious and mythological paintings, but above all portraits, which brought him great fame.

26. Portrait of Mme N. M. Polovtsova, 1876 (page 87)
Portrait de Mme N. M. Polovtsova
Oil on canvas. 206 x 124.5 cm
Signed and dated top left (partially missing): *...lus-Duran St. Petersbourg Juin 1876*
⌐Э 5175

Nadezhda Mikhailovna Polovtsova (1836–1908), *née* Yureneva, was by birth the illegitimate daughter of Grand Duke Mikhail Pavlovich and maid of honour 'K' [identity unknown]. She was adopted and raised by Baron A. L. Stieglitz, one of the most important Russian financiers and head of the State bank; she became the richest bride of the middle of the century. She inherited Stieglitz's entire fortune, much of which was squandered by A. A. Polovtsov, whom she married in 1861.

Polovtsov was a senator and later a secretary of state and member of the Council of State. Besides his financial affairs he showed a keen interest in art and was an honorary member of both the Academy of Arts and the Academy of Sciences. Carolus-Duran came to the Russian capital at his invitation. On 25 June 1876, P. M. Tretyakov, the founder of the Tretyakov Gallery, wrote to I. N. Kramskoi, one of the leaders of the Wanderers group, to inform him that at the beginning of June the French painter 'was sent for by Polovtsov, they say, indirectly so as to paint portraits of highly placed people... Carolus-Duran has painted five portraits in St Petersburg; I have not seen them, only heard about them from M. P. Botkin. Some people praise them, others are not so enthused. Here are the prices: a large female portrait, full length, for 30,000 francs... altogether they have earned him 84,000 in two months.' (Archive of the Tretyakov Gallery, Moscow.)

Provenance: acquired from the Museum of the Baron A. L. Stieglitz Central School for Technical Drawing, Leningrad, in 1926; previously in the collection of A. A. Polovtsov, St Petersburg (commissioned from Carolus-Duran for 30,000 francs).

Eugène Carrière
1849, Gournay-sur-Marne, Seine-et-Oise – 1906, Paris

Carrière attended the Ecole Municipale de Dessin in Strasbourg (1862–4) and the Ecole de Dessin Quentin de La Tour in Saint Quentin (1868–9), copying the pastels of Quentin de la Tour in the local museum. He left for Paris in 1869 and entered the Ecole des Beaux-Arts, where he studied in Cabanel's studio. At the beginning of the 1870s he worked in the lithography studio of Jules Chéret. He exhibited at the Salon from 1877 and at the Salon of the Société Nationale des Beaux-Arts from 1890, which he founded together with Puvis de Chavannes, Rodin and others. He was awarded the Grand Prix for engraving at the Exposition Universelle of 1900. From 1898 to 1903 he ran what was known as the Académie Carrière, a studio that Matisse, Derain, Puy and other young painters attended.

27. Mother and Child, late 1880s (page 187)
Mère et l'Enfant
Oil on canvas. 38 x 50.2 cm
⌐Э 9140

As in the majority of Carrière's work on the theme of motherhood, the model depicted here is the artist's wife. In earlier catalogues the painting appears under the incorrect title *Maternal Kiss*, a name it probably received because of its similarity in composition to an eponymous canvas in the Musée d'Orsay (c. 1892). Stylistically, however, the painting is closer to Carrière's works of the end of the 1880s.

Provenance: acquired from the State Museum of Modern Western Art in 1948; previously in the collection of I. S. Ostroukhov, Moscow; I. S. Ostroukhov Museum of Icon-Painting and Art, Moscow, from 1918; State Museum of Modern Western Art from 1929.

28. Woman Leaning on a Table, c. 1893 (page 186)
Femme accoudée à la table
Oil on canvas. 65 x 54 cm
Signed bottom left: *Eugène Carrière*
⌐Э 6565

Carrière's wife doubtless posed for this picture; the artist frequently painted her in similar poses. Stylistically the work is close to *The Artist's Family* (1893; Paris, Musée d'Orsay), in which the same figure appears in the left-hand side of the composition.

Provenance: acquired from the State Museum of Modern Western Art in 1931; previously in the collection of S. I. Shchukin (acquired before 1907); First Museum of Modern Western Painting from 1918; State Museum of Modern Western Art from 1923.

29. Woman with a Child, late 1890s (page 186)
Femme à l'enfant
Oil on canvas. 61.3 x 50 cm
Signed bottom right: *Eugène Carrière*
⌐Э 9139

In style this picture can be dated to around the late 1890s. Iconographically, it is close to *Motherhood* in the Musée Rodin in Paris and to several other compositions on the same theme.

Provenance: acquired from the State Museum of Modern Western Art in 1948; previously in the collection of S. I. Shchukin from 1904 or earlier; First Museum of Modern Western Painting from 1918; State Museum of Modern Western Art from 1923.

Paul Cézanne
1839, Aix-en-Provence – 1906, Aix-en-Provence

Cézanne studied at the Collège Bourbon in Aix, where he became friends with Emile Zola (the friendship ended in 1886 with the publication of Zola's novel *L'Oeuvre* in which the figure of Claude Lantier, a failed artist who commits suicide, showed a distinct similarity to Cézanne). He began to attend the Ecole Municipale de Dessin in Aix in 1856, and moved to Paris in 1861, working at the Académie Suisse where he met Pissarro and Guillaumin. He also met Monet, Sisley, Frédéric Bazille and Renoir. During the Romantic period he was influenced by Delacroix and Courbet. His work with Pissarro at Pontoise and Auvers (1872–3) marked the start of Cézanne's Impressionist period. He participated in the first and third exhibitions of the Impressionists (1874, 1877). He exhibited at the Salon in 1882, and at the Exposition Universelle in Paris in 1889 and 1900; in 1895 Ambroise Vollard organised his first one-man exhibition. Cézanne worked both in Aix and in Paris from 1888 to 1890, and then in his final years only in Aix. His late period, usually known as the period of synthesis, is exceptional not only for its genuine attempt at a structural approach to painting, but also for its increasingly expressive power. He painted landscapes, still lifes, figurative compositions and portraits.

30. Girl at the Piano (Overture to *Tannhäuser*), *c.* 1869 (page 148)
Jeune fille au piano (L'ouverture de *Tannhäuser*)
Oil on canvas. 57.8 x 92.5 cm
⌐Э 9166 R. 149

The picture was painted in Le Jas de Bouffan. The same wallpaper appears in the background of a later picture also executed in Le Jas de Bouffan entitled *Self-portrait in a Straw Hat* (1874–9; New York, Museum of Modern Art; R. 384), while the armchair is shown in the earlier *Portrait of the Artist's Father Louis-Auguste Cézanne Reading L'Evènement* (1866; Washington, DC, National Gallery of Art; R. 101). It is not entirely clear who is depicted in this painting. It has been suggested that the two women are Cézanne's mother and his elder sister Marie. However, Rewald has cast doubt on the suggestion that the woman knitting is the artist's mother, through comparison with *Portrait of the Artist's Mother* (1869–70; Saint Louis, Art Museum; R. 148) which was painted at roughly the same time. He also hesitated to identify the pianist as Cézanne's sister, although in a previous conversation he had agreed that the figure knitting was Marie and the girl at the piano was her youngest sister Rose. The second title of the painting refers to the music of Wagner, which Cézanne loved and which at that time was the banner of the artistic avant-garde. In a letter of May 1868 to Heinrich Morstatt, a musician who greatly encouraged the artist's enthusiasm for Wagner, Cézanne wrote: 'Not long ago I had the good fortune to hear the overtures to *Tannhäuser*, *Lohengrin* and *The Flying Dutchman*' (Cézanne, 1978, p.130). His interest in Wagner had undoubtedly emerged earlier. *Tannhäuser* was first performed in Paris in the spring of 1861, and Baudelaire instantly published an article about it, which Zola must have shown to Cézanne, who had just arrived for the first time in Paris. Work on *Overture to Tannhäuser* began in 1866. In August that year, Antoine

Marion, a friend of the artist, wrote to Morstatt that Cézanne 'stayed up until half-past one in the morning painting a marvellous picture ... It is to be called *Overture to Tannhäuser* (sic!). This painting belongs to the future, as the music of Wagner also does ... Here it is: a girl at the piano; white on blue; everything in the foreground. The piano is painted with thick brushstrokes, the old father sits in an armchair in profile; at the back of the room is a boy, listening to the music with a vacant look. The effect of the whole is fierce and overwhelmingly powerful' (*ibid.*, p. 149). In the summer of 1867 Marion wrote to Morstatt, who had returned to Germany, that Cézanne had begun several large canvases, one of which was devoted to the overture to *Tannhäuser*, but in lighter tones. In the same letter of 6 September 1867, Marion describes the second version in detail: 'He is again treating the subject which you already know about, the *Ouverture de Tannhäuser*, but in a totally different harmony of tones. He now uses very light tones and each figure is most carefully finished. There is the head of a fair-haired young girl which is both pretty and amazingly powerful; my profile is an extraordinary likeness and is also well built up; the whole picture is painted without that sharpness of colour and somewhat repulsive wildness. The piano is again beautifully painted, as in the other version, and the draperies as usual are magnificently true...' (R. vol. i, pp. 124–5). Clearly Manet's picture *Madame Manet at the Piano* (1867; Paris, Musée d'Orsay) had an influence on the second version, which reveals Cézanne's attempts at a greater simplicity and informality. Both of these first versions were painted on different canvases, for X-rays of the Hermitage picture have revealed no trace of other compositions. Neither of the earlier versions have survived, and it is likely that Cézanne was not happy with them and destroyed them. The date of the Hermitage picture creates particular difficulties. The artist's son supplied a broad date: 1865–70. Venturi at first suggested 1869–71, then 1867; Rewald suggested 1869–70, while in the catalogue to the latest retrospective (*Cézanne*, Paris–London–Philadelphia, 1995–6, No. 17) Henri Loyrette gave a marginally more specific date of *c.* 1869.

Provenance: acquired from the State Museum of Modern Western Art in 1948; previously in the collection of Maxime Conil, Monbriant; Galerie Vollard from 18 December 1899; collection of I. A. Morozov from 1908 (purchased from Vollard for 20,000 francs); Second Museum of Modern Western Painting from 1918; State Museum of Modern Western Art from 1923.

31. Self-Portrait in a Cap, *c.* 1873 (page 149)
Autoportrait à la casquette
Oil on canvas. 53 x 39.7 cm
⌐Э 6512 R. 219

Venturi attributed the picture to 1873–5, the time of Cézanne's closest co-operation with Pissarro. Rewald dated it to *c.* 1875. With its simplicity and solidity of structure the work is indeed similar to Pissarro's *Self-Portrait* (1873; Paris, Musée d'Orsay). In 1874, Pissarro painted a portrait of Cézanne (formerly in Basel, collection of Robert von Hirsch). However, to date the Hermitage painting to the same year purely on the basis of a similarity between these two representations of Cézanne is hardly expedient, as the artist looked virtually unchanged for a number of years, and always older than his age. Douglas Cooper suggested a more convincing date of 1872–3. In his opinion, this self-portrait was completed before Cézanne began working with Pissarro, backing up his argument with the observation that the entire picture is painted very thickly. *Self-Portrait in a Cap*, therefore, was most probably painted soon after the artist's move to Auvers at the beginning of 1873.

Provenance: acquired from the State Museum of Modern Western Art in 1930; previously in the Galerie Vollard (purchased before 1904); Havemeyer collection, New York, from 1904; Durand-Ruel Gallery from 1909 (placed on commission by Louisine Havemeyer, negotiated by Mary Cassatt, and acquired by Durand-Ruel for 7,500 francs); collection of I. A. Morozov from 1909 (acquired from the Galerie Durand-Ruel for 12,000 francs); Second Museum of Modern Western Painting from 1918; State Museum of Modern Western Art from 1923.

32. Bouquet of Flowers in a Vase, *c.* 1877 (page 149)
Bouquet de fleurs dans un vase
Oil on canvas. 55.2 x 46 cm
Signed bottom left: *P. Cézanne*
⌐Э 8954 R. 315

Venturi ascribed this painting to a group of still lifes which he dated to 1873–5. It is generally considered that the series was painted at Auvers, where Cézanne stayed from 1873 to 1874 with Dr Paul Gachet, and where he frequently met Pissarro. However, by including 1875 in his suggested date, Venturi did not exclude the possibility that the still life might well not have been painted at Auvers at all. Cézanne spent part of 1874 and 1875 in Paris and Aix. Cooper insisted on 1874–5, while the date suggested by the artist's son – *c.* 1875 – has survived in Vollard's archive. Theodore Reff ('Cézanne's Constructive Stroke', *Art Quarterly* 3 (Autumn 1962), p. 255), moved the date forward to 1877, which Rewald agreed with. Reff suggested that *Bouquet of Flowers in a Vase* was shown at the third Impressionist exhibition in the spring of 1877 under the title *Study of Flowers* and executed not long before then. His argument is based on the fact that the pictures sent to this exhibition were signed in red paint. Cézanne rarely signed his works, and the signature is thus both an exceptional feature and convincing evidence for Reff's hypothesis. The style of the group of flower still lifes, as identified by Venturi, is not consistent. From the compositional and painterly point of view the work that is closest to the Hermitage picture is *Vase of Flowers on a Floral Carpet*, (*c.* 1877; Paris, private collection; R. 316), in which the same vase is represented. Of all the still lifes in this group, these two canvases are notable for their greater finish, and a particular texture formed with thick and vigorous brushstrokes, which so impressed Victor Chocquet, the great collector who supported Cézanne, that he bought both pictures.

Provenance: acquired from the State Museum of Modern Western Art in 1948; previously in the collection of Victor Chocquet, Paris; Galerie Georges Petit, Paris (sold at auction by Chocquet's widow, 1–4 July 1899, No. 29); Galerie Durand-Ruel, Paris; collection of S. I. Shchukin from 1904; First Museum of Modern Western Painting from 1918; State Museum of Modern Western Art from 1923.

33. Fruits, 1879–80 (page 150)
Oil on canvas. 46.2 x 55.3 cm
⌐Э 9026 R. 427

Venturi placed this canvas within a group of still lifes with objects against a background of leaf-patterned wallpaper, and dated the entire group to between 1879 and 1882. He pointed out that there was a wallpaper like this either at Melun, where Cézanne lived from 1879 to 1880, or in Paris on the Rue de l'Ouest, where he lived from 1881 to 1882. Later scholars have attempted to challenge this method of grouping the paintings, claiming that wallpapers with geometrical and leaf patterns such as Cézanne depicted at this time could well have been found in places other than the Rue de l'Ouest. Sterling, Gowing, Rivière and other authors have tried to specify more precisely the time it took for these still lifes with wallpaper to be completed. This particular picture was probably painted around 1879–80. Rewald used the title *Milk Jug, Carafe and Bowl* but agreed with this date. The still life *Milk Jug and Apples* (New York, Museum of Modern Art; R. 426) is similar in composition, also depicting a crumpled napkin in the centre, a milk jug to the left, and leaf-patterned wallpaper serving as a backdrop. The archive of the Durand-Ruel Gallery contains evidence that the picture was acquired by the New York branch of the firm from Sarah Hallowell, one of Mary Cassatt's friends who acted as a publicist for Impressionist painting in America, acquiring works for the more go-ahead collectors. She often travelled to Paris and probably bought two still lifes from Père Tanguy in about 1891 (*Fruits* and *Milk Jug and Apples*). Up until his death, Tanguy was the sole dealer in Cézanne's work, and Vollard only began to sell his paintings in 1895. One can deduce, therefore, that Sarah Hallowell's purchases turned out to be too bold,

and none of the American collectors were interested in Cézanne's still lifes at that time, forcing her to offer them to the New York branch of the Durand-Ruel Gallery. Until then the firm had avoided all dealings with Cézanne's work. In 1945, Matisse precisely recalled these two still lifes by Cézanne that had travelled to the United States in vain: 'At Durand-Ruel's I saw two wonderful still lifes by Cézanne, with biscuitware, a milk jug and fruit on a matt dark-blue background. Père Durand pointed them out to me when I showed him some still lifes I'd painted. "Look at these pictures of Cézanne's that I can't sell," he said. "You'd do better to paint interiors with figures than this kind of thing".' (H. Matisse, 'De la couleur', Verve, vol. iv, No. 13, November 1945.) Matisse did not give the exact date of this conversation with Durand-Ruel, but it is reasonable to suggest that it took place at some time between 1899 and 1902.

Provenance: acquired from the State Museum of Modern Western Art in 1948; previously in the collection of Julian Tanguy from c. 1891; collection of Sarah Hallowell, Chicago, from 1891; Durand-Ruel Gallery, New York, from 21 February 1894 (purchased from Sarah Hallowell for $150); Galerie Durand-Ruel, Paris, from December 1895; collection of S. I. Shchukin from 1903; First Museum of Modern Western Painting from 1918; State Museum of Modern Western Art from 1923.

34. Banks of the Marne, 1888 (page 154)
Les bords de la Marne
Oil on canvas. 65.5 x 81.3 cm
Γ϶ 6513 R.623

The photograph of this picture in Vollard's archives is annotated by the artist's son: Marne 1888. We can thus assume that the picture was originally at the Galerie Vollard. While he was living in Paris in the summer of 1888, Cézanne painted several views of the banks of the Marne close to Créteil, not far from its confluence with the Seine. His visits to the Marne gave Cézanne the opportunity to unite two of the themes in landscape that particularly interested him at that time: trees and water. The same view of the bank, with a villa, is depicted from an almost identical viewpoint in another painting with the same title (Banks of the Marne II, private collection; R. 624). In yet another landscape, House on the Banks of the Marne (Washington, DC, White House; R.622), Cézanne chose a slightly more distant viewpoint. The villa, called in the Galerie Vollard receipt book 'little chateau on the water' (the description also indicates that Banks of the Marne II belonged at one point to Vollard himself), is best seen in the Hermitage picture. In his catalogue Rewald gives the three views the same date, although he extends it slightly: 1888–90. A watercolour of the same subject also exists (L. Venturi, Paul Cézanne: Son art, son oeuvre (Paris, 1936), No. 935).

Provenance: acquired from the State Museum of Modern Western Art in 1930; previously in the Galerie Vollard; Havemeyer collection, New York, from 1906; Galerie Durand-Ruel, Paris, in 1909 (placed on commission by Louisine Havemeyer, negotiated by Mary Cassatt, acquired by Durand-Ruel for 7,500 francs); collection of I. A. Morozov from 1909 (acquired from the Galerie Durand-Ruel for 18,000 francs); Second Museum of Modern Western Painting from 1918; State Museum of Modern Western Art from 1923.

35. The Smoker, c. 1890–2 (page 153)
Le fumeur
Oil on canvas. 92.5 x 73.5 cm
Γ϶ 6561 R. 757

The smoker's pose, leaning on his elbow, appeared in Cézanne's early work as the embodiment of steadfastness and calm in the picture Boy Leaning on His Elbows (1867–8; private collection, Switzerland; R. 135). On that occasion the artist was inspired by Bacchiacca's painting in the Louvre, Young Man, attributed at the time to Raphael. Cézanne was able to make use of an engraved reproduction which he apparently owned. A little over two decades later another character leaning on

his elbows appears – Boy in a Red Waistcoat (1888–90; Zurich, Stiftung Sammlung E. G. Buhrle; R. 658). Cézanne repeated the compositional outline of this painting down to the last detail (the table, the drapery in the corner, part of another picture in the background) in his Hermitage Smoker, in which the pose is shown at its most convincing. Among Cézanne's depictions of smokers, the closest to this work are Smoker Leaning on his Elbow (c. 1891; Mannheim, Kunsthalle; R. 756) and the watercolour sketch for this version (Merion, PA, Barnes Foundation; R.W. 381). The Mannheim smoker is shown in an identical pose in a canvas of the same size, but the background is a plain wall. His face has a less aloof expression because the pupils of his eyes are delineated. On the wall behind the Hermitage smoker are pictures by Cézanne himself. These pictures within the picture add an important emphasis, not only in terms of colour, but also intellectually, as a reflection of the artist's world view. The early still life of a bottle and apples (1868–9; now in Berlin, Neue Nationalgalerie; R. 138), which was kept at Le Jas de Bouffan for many years, as well as the bathers canvas hanging above it (Bathers in the Open Air, 1890–1; previously in the Krebs collection, now also in the Hermitage; R. 748), act as a reminder of the temptations of the outside world; they are by no means a coincidental background to this scene, which is suffused with the artist's longing to achieve internal harmony. Another Smoker in this pose, but shown almost full length, is in the Pushkin Museum in Moscow (R. 790). Previously it was thought that all three pictures were executed more or less at the same time. Venturi dated them to between 1895 and 1900. Douglas Cooper, however, did not consider that the style was consistent with confirmed works dated to between 1896 and 1900 and suggested 1893–4. Reff insisted on an even earlier date, while Rewald's view was that the Moscow picture was painted between 1893 and 1896, and that consequently the Mannheim and St Petersburg versions must have been executed around 1891. Cézanne's son noted the date 1890 on a photograph of the picture (Vollard archive). He also pointed out that the model for the Mannheim picture, and consequently for the Hermitage picture too, was the paysan (or gardener), Alexandre Paulin.

Provenance: acquired from the State Museum of Modern Western Art in 1931; previously in the Galerie Vollard; collection of I. A. Morozov from 1910 (purchased from Vollard for 35,000 francs); Second Museum of Modern Western Painting from 1918; State Museum of Modern Western Art from 1923.

36. Still Life with Drapery, c. 1894–5 (page 151)
Nature morte au rideau
Oil on canvas. 55 x 74.5 cm
Γ϶ 6514 R. 846

There is a wide variety of opinion as to the date of Still Life with Drapery – one of Cézanne's finest creations in the genre. A note in the Vollard archive by the artist's son suggested c. 1888–9. At first Venturi held out for 1895, then reconsidered in favour of 1900–5. Sterling suggested a date that is no less imprecise, though earlier: 1895–1900. Gowing, and later A. G. Barskaya and Rewald all said 1899. This point of view is based on the assumption that the still life was painted in Paris, where Cézanne was living at the time. Barskaya assumes that the leaf-patterned drapery was in the artist's Paris flat. It is also reproduced in his famous Mardi Gras (1888; Moscow, Pushkin Museum; R. 618), which was certainly painted in Paris. This suggestion, however, is not sufficient to establish the picture's date. The drapery, like the other objects, would not have been difficult to transport. We know that the porcelain milk jug, which appeared in various compositions of the 1890s as well as in Still Life with Drapery, was among the utensils in the studio at Aix. The composition is a more finished version of Still Life (Merion, PA, Barnes Foundation; R. 844), which is also variously dated. Rewald, in particular, has suggested 1892–4. It is unlikely that these two works were painted at very different times. Still Life with Drapery, although finished to a far greater degree than the Barnes Foundation Still Life, also seems in some way unfinished (particularly the napkin to the right). However, many works that Cézanne considered incomplete are now regarded as finished. Whether it was

intuition or a conscious decision, the artist stopped work on the picture at the very moment when further brushstrokes (above all, around the napkin), while adding to its external decorativeness, would have unbalanced the painting. The picture was probably painted in two goes. The napkin on the right was undoubtedly added some time after the composition was completed. The paint, applied to a thoroughly dried surface, has turned slightly transparent, and the table can be seen through it.

Provenance: acquired from the State Museum of Modern Western Art in 1930; previously in the Galerie Vollard; collection of I. A. Morozov from 1907 (purchased from Vollard for 17,000 francs); Second Museum of Modern Western Painting from 1918; State Museum of Modern Western Art, from 1923.

37. Large Pine near Aix, c. 1895–7 (page 155)
Grand pin près d'Aix-en-Provence
Oil on canvas. 72 x 91 cm
Γ϶ 8963 R. 761

Almost since childhood Cézanne had been greatly attracted to the image of an enormous pine. 'Do you remember', he wrote to Emile Zola on 9 April 1858, 'the pine planted on the banks of the Arc, and its shaggy head which overhung the abyss at its feet? That pine which protected our bodies from the ferocity of the sun with its foliage – Ah! May the gods protect it from the mortal blow of the woodcutter's axe!' (Cézanne, 1978, p. 19). Three decades later, the image of a powerful coniferous tree came to dominate the picture Large Pine (c. 1889; São Paolo, Museu de Arte), and several works painted a little earlier which show the same pine from the same viewpoint. It is clear that the tree had a personal significance for the artist. This group of works depicts the neighbourhood of Monbriant in the valley of the river Arc, near Aix, where the artist's sister and her husband, Maxim Conil, bought an estate in 1886. Traditionally, the pine in the Hermitage picture was thought to be one of the sights of Monbriant, and in several books the picture has been called Large Pine at Monbriant. Rewald proved that the pine in fact stood on the territory of Bellevue, a village that borders with Monbriant (the houses of Bellevue are visible in the distance). Rewald correspondingly called both pictures with the pine Large Pine and Red Earth (Bellevue). The first of them (Tokyo, Yoshii Gallery; R. 537) was painted a long time before the Hermitage Large Pine near Aix; Venturi dated it to 1886–7, while Rewald and Cooper suggested 1885. There is no doubt that the Hermitage picture appeared several years later, at the same time as two watercolours called Study for Large Pine (New York, Metropolitan Museum, and Zurich, Kunsthaus; R.W. 286, 287). Rewald gave the same date – 1890–5 – for both watercolours and the Hermitage painting. Venturi believed that both canvases of the large pine from Bellevue were painted at the same time, which cannot be the case. The fact that the trunk of the tree in the Hermitage Large Pine is thicker and the undergrowth taller clearly suggests a considerably later date. N. V. Yavorskaya, the curator of the State Museum of Modern Western Art, suggested that Large Pine near Aix could be dated 1895–7, which Theodore Reff subsequently endorsed. Furthermore, in comparison with the picture from the Yoshii Gallery, the Hermitage canvas is immeasurably more constructional in style. The earlier version was left unfinished by Cézanne, and was later 'edited' rather heavily. Shuffenecker bought it for a pittance and sold it on to Vollard, no doubt considerably more expensively, and – at his own admission – having finished it off by covering a third of the canvas with paint. The work that Shuffenecker did to 'improve' Cézanne's paintings was only discovered in the second half of the 1930s. Although he insisted that he did not do it for financial reasons, in fact it was precisely their unfinished look that had prevented Cézanne's pictures being sold more profitably at the beginning of the century. At the sale of Gagnat's collection in 1925, this 'finished' version of Large Pine fetched a record price of 550,000 francs.

Provenance: acquired from the State Museum of Modern Western Art in 1948; previously in the Galerie Vollard; collection of I. A. Morozov from 1908 (purchased from Vollard for 15,000 francs); Second Museum of Modern Western Painting from 1918; State Museum of Modern Western Art from 1923.

38. Mont Sainte-Victoire, c. 1896–8 (page 156)
Oil on canvas. 78.5 x 98.5 cm
⌐ Э 8991 R. 899

The artist's son believed that this landscape was completed around 1890. Venturi dated it to between 1894 and 1900, as it is so close in composition and viewpoint to the Cleveland Museum of Art painting (R. 900). Rewald called the Cleveland Museum version the later one and gave it a considerably later date (1904); for the Hermitage *Mont Sainte-Victoire* he suggested 1896–8. He explained that, in composing the landscape, Cézanne viewed the mountain from the road from Tholonet (in his catalogue the picture is called *Mont Sainte-Victoire above the Road from Tholonet*). Halfway from Tholonet to the mountain is the Château Noir (hidden behind trees in the picture), where Cézanne rented a room to work. The road has now been widened and straightened, but a comparison of the picture with a photograph of the area taken by Rewald in 1935 shows that, while carefully reproducing the actual details, Cézanne seriously distorted the perspective, moving the mountain forward considerably. The Hermitage landscape is distinct from other views of the Mont Sainte-Victoire in its particularly forceful understanding of perspective, impressed upon the viewer through the power of colour. The painting possesses a specific duality: the distant mountain appears to have been drawn forward, closer than would have been correct by the rules of classical perspective. The unusual extensiveness of the landscape is particularly striking when compared with the later Cleveland version, in which the mountain, seen from almost the same viewpoint, is set back at a considerably greater distance. The Hermitage painting is quite badly damaged at both top and bottom, due to the fact that before its delivery to I. A. Morozov it was not stretched but stored rolled-up. It is well known that Vollard managed to acquire a number of Cézanne's canvases in this condition.

Provenance: acquired from the State Museum of Modern Western Art in 1948; previously in the Galerie Vollard; collection of I. A. Morozov from 1907 (purchased from Vollard for 20,000 francs); Second Museum of Modern Western Painting from 1918; State Museum of Modern Western Art from 1923.

39. Lady in Blue, c. 1900 (page 152)
Dame en bleu
Oil on canvas. 90 x 73.5 cm
⌐Э 8990 R. 944

In his 1936 *catalogue raisonné*, Venturi, basing his judgement on its iconographical and stylistic similarities, placed this picture within a group of several other works which he dated to between 1900 and 1904. In the same group are *Italian Girl Leaning on a Table* (New York, private collection; R. 812), *Old Woman with a Rosary* (London, National Gallery; R. 808) and *Lady with a Book* (Washington, DC, Phillips Collection; R. 945). Now, however, this group is no longer taken to be inviolable, and the tendency has emerged to date each canvas separately. Venturi himself later suggested a more precise date for *Lady in Blue* – 1900 – while a photograph of the picture in the Vollard archives is marked 1899. The Hermitage work is generally grouped with *Lady with a Book*, in which the model is wearing the same dress and hat. Rewald even identified the two women, although mistakenly, and moved *Lady in Blue* to 1904. Reff believed that it was painted earlier – between 1900 and 1902. Gowing, who put *Lady with a Book* at 1902–3, suggested a considerably earlier date for the Hermitage

picture: 1892–6. He considered that *Lady in Blue* was painted in Aix on the Rue Boulegon. The tablecloth in the bottom right-hand corner of this painting also features in the still life *Apples and Oranges* (c. 1899; Paris, Musée d'Orsay; R. 847), as well as in *Italian Girl Leaning on a Table*, which is now generally dated to 1900. Taking into account the stylistic closeness between this latter work and *Lady in Blue*, it seems expedient to accept this date – c. 1900 – for the Hermitage canvas as well. The model remains unknown. Venturi mistakenly identified her as the artist's wife. Rewald suggested that the model could be Madame Bremond, Cézanne's housekeeper in Aix, and pointed out that the cut of the lady's dress was fashionable at the very end of the 1890s. Believing that the picture was painted in about 1904, he tried to explain that a slightly out-of-date look was shown here. For 1900, however, the dress was very much in fashion. Françoise Cachin sees in the left part of the background a corner of one of Cézanne's paintings, and claims that the picture is probably *Large Bathers* (1900–5; Merion, PA, Barnes Foundation; R. 856). Indeed Cézanne did 'quote' himself in this way on several occasions – in the Hermitage *Smoker* for example (cat. 35). If Cézanne was in fact placing his respectable model beside a picture of a whole group of naked women, something that is not now clear, it was no doubt an expression of his distinctive humour.

Provenance: acquired from the State Museum of Modern Western Art in 1948; previously in the Galerie Vollard; collection of S. I. Shchukin; First Museum of Modern Western Painting from 1918; State Museum of Modern Western Art from 1923.

40. Blue Landscape, c. 1904–6 (page 157)
Paysage bleu
Oil on canvas. 100.5 x 81 cm
⌐Э 8993 R. 882

There is no generally agreed date for this picture. Venturi placed it between 1900 and 1904, later extending it to 1900–6, while Rewald tended towards 1904–6. Gowing believed that *Blue Landscape* was painted around 1905 in the woods of Fontainebleau, although there is no concrete evidence that it was painted there, and indeed there is considerably more reason to think that it was done near Aix. *Blue Landscape* has certain stylistic features that echo pictures of the Château Noir, Mont Sainte-Victoire and other canvases which are usually dated to around 1904. The watercolour *Turn in the Road* (New York, Bitti Collection) shares certain similarities with the Hermitage work and perhaps shows the same landscape, though perhaps closest of all to *Blue Landscape* is the unfinished *Turn in the Road* (1902–6; Washington, DC, National Gallery; R. 930). In the central part of the Hermitage painting, the canvas has been ripped and subsequently restored. It has been suggested that the artist himself ripped it in an outburst of irritation; in any event, it arrived at the Galerie Vollard in that condition.

Provenance: acquired from the State Museum of Modern Western Art in 1948; previously in the collection of the artist's son, Paul Cézanne; acquired jointly by the Galerie Vollard and the Galerie Bernheim-Jeune in 1907; collection of I. A. Morozov from 1912 (purchased from Vollard for 35,000 francs); Second Museum of Modern Western Painting from 1918; State Museum of Modern Western Art from 1923.

Auguste Chabaud
1882, Nîmes – 1955, Graveson, near Avignon

Chabaud studied at the Ecole des Beaux-Arts in Avignon, then in Paris at the Académie Carrière, where he met Matisse and Derain, and at the Ecole des Beaux-Arts under Fernand Cormon. He exhibited at the Salon des Indépendants and the Salon d'Automne from 1907. He was close to the Fauvists, and in 1911 he was influenced by Cubism. After the First World War he moved to Graveson, close to Avignon. He painted landscapes and figurative compositions.

41. Square in a Small Town in Provence, 1910 (page 256)
Place dans un bourg en Provence
Oil on cardboard. 77 x 107.5 cm
Signed bottom right: *A. CHABAUD*
⌐Э 9086

403

The painting *A Corner of Vierge* (France, private collection; P. Cabanne, *Le midi des peintres* (Paris, 1964), pp. 82–3) shows the same Provençal view but in a different light and with figures in the foreground. However, it is also possible that the picture depicts Graveson, where Chabaud lived in 1910. In Autumn 1910, the Russian painter Valentin Serov, whose opinion I. A. Morozov always respected, wrote to him after visiting the Salon d'Automne: 'Yesterday I was at the Salon. I liked one French painter very much – Chabaud, underneath a large black canvas (two old women) was his other thing: a square in a small town (sun, dark shadows) excellent, strong, black – I would recommend buying it, if you like it. He made a great impression on several other artists as well.' (Archive of the Pushkin Museum, Moscow; quoted in B. N. Ternovets, *Letters: Diaries: Articles* (Moscow, 1977), p. 111).

Provenance: acquired from the State Museum of Modern Western Art in 1948; previously in the collection of I. A. Morozov from 1910 (purchased at the exhibition of the Salon d'Automne of 1910); Second Museum of Modern Western Painting from 1918; State Museum of Modern Western Art from 1923.

Charles Chaplin
1825, Les Andelys, Eure – 1891, Paris

The son of an Englishman, Chaplin only received French citizenship in 1886. He studied at the Ecole des Beaux-Arts (under Michel-Martin Drolling) from 1841, and exhibited at the Salon from 1845. A painter and draughtsman, he also practised lithography and etching. He began with religious compositions and realistic landscapes, but from the end of the 1850s concentrated on genre scenes depicting attractive girls, in which he exploited the techniques and themes of the Rococo. He painted mostly portraits, religious and genre compositions, and landscapes. In 1859 he turned to decorative painting with great success, and was commissioned by Napoleon III to paint the murals in the Salon des Fleurs in the Tuileries. He later painted a ceiling and panels in the Palais de l'Elysée, and in Demidov's house in Paris.

42. Young Girl with a Nest, late 1860s (page 81)
La jeune fille au nid
Oil on canvas. 93.5 x 56.5 cm
Signed bottom left: *Ch. Chaplin*
⌐Э 5688

In the Lyons Musée des Beaux-Arts there is a smaller version of this picture, in which the same model is shown half length. Chaplin's style changed little over almost three decades. However, from the date of the Lyons picture – 1869 – we can assume that the Hermitage picture was executed at more or less the same time.

Provenance: acquired from the State Museum Fund in 1920; previously in a private collection in St Petersburg.

Louis Charlot
1878, Cussy-en-Morvan – 1931, Cussy-en-Morvan

Charlot moved to Paris in 1898, where he studied at the Ecole des Beaux-Arts, but did not lose contact with his native Morvan. He exhibited at the Salon from 1902, and later at the Salon des Indépendants and the Salon d'Automne. He painted landscapes, portraits and scenes of peasant life.

43. Village in the Snow, c. 1910–11 (page 226)
Village sous la neige
Oil on canvas. 81 x 100.5 cm
Signed bottom right: *Louis Charlot;* inscribed and signed on the back: *Village sous la neige. Louis Charlot*
⌐Э 9174

The village shown is in Morvan, in the French Massif Central.

Provenance: acquired from the State Museum of Modern Western Art in 1948; previously in the collection of I. A. Morozov from 1911 (purchased at an exhibition of the Salon of the Société Nationale des Beaux-Arts); Second Museum of Modern Western Painting from 1918; State Museum of Modern Western Art from 1923.

Jules Chéret
1836, Paris – 1932, Nice

Apprenticed to a master lithographer at the age of thirteen, Chéret later studied under Horace Lecoq de Boisbaudran. He lived in England from 1856 to 1866, studying the technology of colour lithography. On his return to Paris he set up a studio, where he developed new methods of colour lithography. His posters, which decorated Paris from 1866 to 1900, influenced Toulouse-Lautrec and the Nabis group. He produced decorative murals, as well as designs for tapestries.

44. Masquerade, early 1890s (page 233)
Mascarade
Pastel on canvas. 36 x 27 cm
Signed bottom left: *Chéret*
⌐Э 43471

The character and content of this pastel was defined to a large extent by Chéret's posters, which were the main area of his activities. A comparison with the posters allows us to date this work to the beginning of the 1890s: the woman in the pastel can be seen in a similar pose in a poster of 1891, produced for the Elysée Montmartre.

Provenance: acquired in 1939; previously in a private collection, Leningrad.

Jean-Joseph-Benjamin Constant
1845, Paris – 1902, Paris

He studied at the Ecole des Beaux-Arts in Toulouse, and at the Paris Ecole des Beaux-Arts from 1867 under Alexandre Cabanel. He exhibited at the Salon from 1869, and was a member of the Institut de France from 1893. Constant travelled to Morocco in 1871. He painted Orientalist pictures and, from the middle of the 1880s, mainly portraits. He lived for many years in England, where his portraits of the aristocracy were highly successful. He executed a series of decorative murals in Paris (Hôtel de Ville, Sorbonne, Opéra-Comique).

45. Portrait of M. S. Derviz, c. 1899 (page 86)
Portrait de Mme M. S. Derviz
Oil on canvas. 133.5 x 100 cm
Signed bottom left: *Benjamin Constant*
⌐Э 5171

Marina Sergeyevna Derviz (1875–?), *neé* Schönig, was the second wife of Sergei Pavlovich Derviz. The Derviz family had a long-standing association with Benjamin Constant: he painted the *Portrait of Monsieur P. Derviz* (Salon, 1889, No.192), and a decade later the *Portrait of Monsieur J. von Derviz* (Salon, 1899, No.143). This portrait of Marina Derviz was exhibited at the celebrated Tauride exhibition (*Historical and Artistic Exhibition of Russian Portraits at the Tauride Palace*, St Petersburg, 1905), organised by Sergei Diaghilev.

Provenance: acquired from the State Museum Fund in 1923; previously in the collection of S. P. Derviz, St Petersburg.

Camille Corot
1796, Paris – 1875, Paris

Corot studied under the landscape artist Achille Etna Michallon from 1822, and also under Jean-Victor Bertin. He worked in the Ile-de-France region, as well as in Italy (1825–8, 1834, 1843). He travelled a great deal in France, and visited Switzerland, Holland and England. Corot exhibited at the Salon from 1827, and was awarded a medal at the Salon of 1833. He returned frequently to Ville d'Avray, near Paris, and also visited Barbizon and Fontainebleau. He was a friend of Millet, Rousseau and, in particular, Daubigny. He painted mainly landscapes, but also portraits and figurative compositions. After 1850 he retreated ever further from academic classical landscape painting towards a more lyrical interpretation of nature.

46. Landscape with a Lake, late 1860s – early 1870s (page 91)
Paysage au lac
Oil on canvas. 53 x 65.5 cm
Signed bottom right: *Corot*
⌐Э 5685

This picture did not appear in the complete catalogue of Corot's works compiled by Alfred Robaut, although there is no reason to doubt its authenticity, not only because of its provenance, but also because of its superlative artistic merit, which is particularly evident in the extremely delicate *valeur* technique, of which only Corot is capable. In his later lyrical landscapes – a genre he invented – Corot deliberately employed 'coulisse' compositions (elements at the side of an image directing the viewer's eye towards the central view in the distance), in particular in such masterpieces as *Memory of Mortefontaine* (1864; Paris, Musée d'Orsay) and *Mantes: Evening View of the Cathedral and Town through Trees*. In *Landscape with a Lake*, the 'coulisse' structure dominates the painting more distinctly than ever but is notable for its more diffuse atmosphere and the fluidity of the brushwork which was characteristic of the late 1860s and early 1870s. It is not possible to identify the place depicted in *Landscape with a Lake* with any certainty, due to the lack of specific topographical details, although it is reasonable to assume it is the neighbourhood of Ville d'Avray.

Provenance: acquired from the Yusupov Palace-Museum, Leningrad, in 1925; previously in the collection of the Yusupovs, St Petersburg, from 1879.

Charles Cottet
1863, Le Puy – 1925, Paris

Cottet studied at the Académie Julian in Paris under Alfred Roll from 1882; he also benefited from the advice of Puvis de Chavannes, whose painting, along with Courbet's, had a great influence on him. He made his début at the Salon of 1889, and then participated in the foundation of the Société Nationale des Beaux-Arts the following year. He also exhibited in the gallery of Louis Le Barc de Boutteville in Paris. In the 1890s he was close to the artists of the Nabis group, who greatly respected his work. In 1900 he was awarded a gold medal at the Exposition Universelle in Paris. As well as painting, he frequently worked on book illustrations.

47. View of Venice from the Sea, c. 1896 (page 229)
Venise: Vue de la mer
Oil on canvas. 55 x 82 cm
Signed bottom left: *Ch. Cottet*
⌐Э 9059

The picture was either painted from life or at least from direct experience (the remains of an Italian customs label would suggest as much). Cottet worked in Venice in 1896, and the following year exhibited his Venetian scenes – including, most probably, the two Hermitage canvases – at the Galerie Bing in Paris.

Provenance: acquired from the State Museum of Modern Western Art in 1948; previously in the collection of S. I. Shchukin before 1907; First Museum of Modern Western Painting from 1918; State Museum of Modern Western Art from 1923.

48. Seascape with Distant View of Venice, c. 1896 (page 229)
Marine avec Venise dans le lointain
Oil on canvas. 60 x 76 cm
Signed bottom right: *Ch. Cottet*
⌐Э 8900

This panorama, in contrast to *View of Venice from the Sea*, is constructed with a greater emphasis on the depiction of the elements. The latter's spatial reference points – the campanile of San Marco and the church of San Giorgio Maggiore – are here pushed back into the distance, making them not instantly recognisable; against the horizon they appear no larger than the sail of the small boat shown slightly closer.

Provenance: acquired from the State Museum of Modern Western Art in 1948; previously in the collection of S. I. Shchukin; First Museum of Modern Western Painting from 1918; State Museum of Modern Western Art from 1923.

Henri Edmond Cross (Delacroix)
1856, Douai – 1910, Saint-Clair, Var

Cross studied in Lille under the young Carolus-Duran, and later under Alphonse Colas. He moved to Paris in 1876 and attended the Ecole des Beaux-Arts, but was dissatisfied with the academic teaching. He made his début at the Salon of 1881 (to avoid confusion with Henri Eugène Delacroix, who had already made something of a name for himself at the Salon, he adopted an abbreviated English version of his surname). In his search for new directions in art, he met Monet and other Impressionists (1883). In 1884 he became close to Seurat and Signac, helping them to found the Salon des Indépendants (in 1891 he was elected vice-president of the Société des Artistes Indépendants). He played an important role in the emergence of Neo-Impressionism. Cross spent his latter years in Saint-Clair on the Cote d'Azur, travelling to Italy twice (1903, 1908). He painted portraits and multi-figured compositions, but the majority of his works were landscapes.

49. View of the Church of Santa Maria degli Angeli near Assisi, 1909 (page 159)
Eglise Santa Maria degli Angeli près d'Assise
Oil on canvas. 73.5 x 92 cm
Signed and dated bottom right: *Henri Edmond Cross 09*
⌐Э 8891 Compin 221

Cross spent two weeks in Assisi in the summer of 1908. The artist discovered the church of Santa Maria degli Angeli semi-ruined, following the earthquake of 1832 (the building was given a new façade in 1928). Cross was drawn to this church as one of Italy's most important places of worship. Work on the building as it is shown here began in 1569, absorbing the earlier chapel where St Francis of

Assisi had preached. The picture was painted after the artist returned to France, using preliminary drawings or sketches that have not survived. According to Isabel Compin, the work was painted some time between September 1908 and March 1909, but its date can be more narrowly defined to the first months of 1909. It was therefore one of the last, or even possibly the last, in Cross's series of six canvases showing views of Assisi and Perugia.

Provenance: acquired from the State Museum of Modern Western Art in 1948; previously in the Galerie Bernheim-Jeune; collection of S. I. Shchukin; First Museum of Modern Western Painting from 1918; State Museum of Modern Western Art from 1923.

Pascal-Adolphe-Jean Dagnan-Bouveret
1852, Paris – 1929, Quincey, Haute-Saône

Dagnan-Bouveret studied at the Ecole des Beaux-Arts from 1869 under Alexandre Cabanel and then under Jean-Léon Gérôme. He was awarded the Prix de Rome in 1876. He exhibited at the Salon from 1875 to 1889, where he was awarded medals of the third and first class (1878, 1880), and from 1890 at the Salon of the Société Nationale des Beaux-Arts. He was influenced by Jules Bastien-Lepage. From 1900 he was a member of the Institut de France. He was awarded the Grand Prix at the Exposition Universelle in Paris in the same year. Dagnan-Bouveret painted scenes of Breton peasants, genre and historical compositions, religious allegories and portraits. He enjoyed great success under the Third Republic. He also produced a series of decorative murals (for the Sorbonne, Palais de Justice, and others).

50. Young Watercolourist in the Louvre, c. 1891 (page 80)
Jeune femme aquarelliste au Louvre
Oil on board. 35.5 x 30.5 cm
Signed on the canvas of a picture leaning against the wall (left of centre): *P. A. J. Dagnan*; signed again on the stretcher frame of the same picture: *P. A. J. Dagnan f.*
Г→ 9787

Young Watercolourist was painted at a time when decorated fans were fashionable, a debt which both the Impressionists and artists of the Salon recognised. Dagnan-Bouveret's heroine is depicted painstakingly copying *Pèlerinage à Cythère* [*Pilgrimage to Cythera*] by Antoine Watteau (1717). The head of a man painted on the back of the canvas leaning against the wall is a caricature of the painter Gustave Courtois, Dagnan-Bouveret's closest friend. Together they taught at the Académie Colarossi, which was attended by young artists of both sexes.

Provenance: acquired from the Pavlovsk Palace-Museum in 1963; previously purchased at a sale at Boussaton's in Paris for Alexander III for 5,700 francs (c. 1891); collection of Alexander III at Gatchina Palace until 1941; Pavlovsk Palace-Museum from 1944.

51. Portrait of Princess O. V. Paley (Countess Hohenfelsen), c. 1902–4 (page 86)
Portrait de la Comtesse Hohenfelsen (Princesse O. V. Paley)
Oil on canvas. 126 x 100 cm
Signed bottom right: *Pas. Dagnan f.*
Г→ 9474

Olga Valerianovna Paley (1865–?), *née* Karnovich, was first married to Major-General E. A. Pistelkors, adjutant to Grand Duke Pavel Alexandrovich; she then married the Grand Duke in 1902, despite Nicholas II's express prohibition of the match. She received the title Countess Hohenfelsen, and later, in 1915, she was given the title of Princess Paley. For many years after their marriage the Grand Duke was forbidden to enter Russia, so the couple lived in Paris where this portrait was painted.

Acquaintances of Pavel Alexandrovich said that he was completely under his wife's thumb, and wondered how she came by the Bavarian title, Countess Hohenfelsen.

Provenance: acquired from the Antiquariat in 1931; previously in the collection of O. V. Paley, Tsarskoe Selo.

Charles Daubigny
1817, Paris – 1878, Paris

Daubigny studied under his father, the landscape painter Edmond-François Daubigny, as well as under François-Marius Granet (1836) and Paul Delaroche (1840). As a young man he copied the works of the Dutch masters in the Louvre, and studied engraving. He exhibited at the Salon from 1838. From 1843 he worked for some years in Barbizon and Morvan. A meeting with Corot in 1852 inspired them to work together on the same subject matter. Daubigny travelled a great deal in France and abroad (Italy, England, Spain, Holland). He was one of the most evident forerunners of the Impressionists, painting mostly landscapes.

52. Banks of the Loing, late 1860s (page 96)
Les Bords du Loing
Oil on canvas. 25.5 x 41 cm
Signed bottom left: *Ch. Daubigny*
Г→ 3529 H. 450

The picture has been variously dated by different scholars. Daubigny produced similar studies as early as the 1850s and 1860s, painting them on board a specially equipped studio-boat which he sailed through the rivers of Northern France. However, the particular vividness of the colours, which herald the arrival of Impressionism, suggests that this landscape was painted nearer the end of the 1860s. In his catalogue of Daubigny's work, Hellebranth left this painting undated. In all previous Russian publications, the painting has been called *Banks of the River Oise*. However, on the basis of archive material, Hellebranth ascribed the landscape to a series of pictures of the river Loing.

Provenance: acquired in 1919; previously in the collection of O. Ovsiannikova, Petrograd.

53. The Coast at Villerville, 1875 (page 97)
Bord de la mer à Villerville
Oil on canvas. 85 x 149 cm
Signed and dated bottom right: *Daubigny 1875*
Г→ 5694 H. 631

In the 1850s and 1860s Daubigny frequently depicted Villerville, a town four kilometres from Trouville; moreover many of these views were painted from nature, which cannot be said of this canvas, for Daubigny did not visit Villerville in 1875. The picture was painted in Paris from earlier studies. Compositionally the picture is similar to the landscapes painted in Villerville as early as the late 1850s, such as *The Coast at Villerville* (c. 1858; London, private collection), *The Coast near Villerville* (1859, Hartford, Wadsworth Atheneum) and, in particular, *The Coast of Villerville* in the Musée des Beaux-Arts in Marseilles, where the same part of the landscape is depicted, although viewed from the other side, so that the sea appears on the right rather than the left. The Hermitage picture has direct antecedents in two paintings of smaller dimensions: *Surroundings of Villerville* (c. 1874; H. 628) and *Villerville* (c. 1874, H. 629). N. V. Yavorskaya (in her book *Landscapes of the Barbizon School* (Moscow, 1962), pp. 229–31) believed that *Surroundings of Villerville* was a study for the Hermitage picture. It was exhibited in Amsterdam as *Le Pré de Graves à Villerville* (*Exposition de la Peinture française aux XIXme et XXme siècles*, Amsterdam, 1931). The two works are indeed identically composed, and show the same view. But the landscape shown at the Amsterdam exhibition is considerably less organised and picturesque; nor does it show the same attempts at achieving a

'grand style', which Yavorskaya rightly noticed in the Hermitage work, where the lines are smoother, the lighting calmer, the division of spatial planes more measured, and the whole appearance of the landscape more majestic. On the basis of these two studies, in 1870 Daubigny painted a large panorama (100 x 200 cm) of the same stretch of coast, entitled *Women on the Shingle near Villerville* (R. and A. Hellebranth, *Charles-François Daubigny: 1817–1878 (Supplement)* (Lausanne, 1996), No. 130), in which, compared to the Hermitage *Coast at Villerville*, the viewpoint is moved a little to one side.

Provenance: acquired from the Anichkov Palace, St Petersburg, in 1918; previously purchased for Alexander III by the Russian artist A. P. Bogolyubov at the end of the 1870s; Anichkov Palace, St Petersburg.

Edgar Degas
1834, Paris – 1917, Paris

Degas studied painting at the Ecole des Beaux-Arts in Paris (1855–6) under Louis Lamothe, a pupil of Ingres, who influenced his early work. At the Ecole he met Fantin-Latour and Bonnat. He undertook five journeys to Italy during the years 1856–60, where he studied and copied Renaissance masterpieces. He made his début at the Salon of 1865, and soon became good friends with Edouard Manet, visiting the café Guerbois, where he met Monet, Renoir, Sisley and Bazille. He visited London in 1871, and later travelled to New Orleans, USA (1872–3). Degas was one of the founders of Impressionism. He took part in all the Impressionists' exhibitions (1874–86), except for the seventh (1882) which he boycotted as a protest against Monet's and Renoir's participation (since they had not cut all ties with the Salon). In 1885 his eyesight began to deteriorate and for the last two decades of his life it was extremely poor. As well as painting, he produced drawings, engravings, monotypes and sculptures, emerging as an exceptionally bold innovator in each of these spheres.

54. Seated Dancer Adjusting her Shoes, c. 1880 (reverse of gatefold, page 119)
Danseuse assise ajustant ses souliers
Charcoal and pastel on grey paper. 47.3 x 30.5 cm
Signed bottom right: *Degas*
42160

Around the end of the 1870s and early 1880s the figure of the seated ballerina adjusting her ballet shoes started to appear in Degas's pictures of rehearsals and of the last moments before a performance. A particular example is *Before the Appearance* (c. 1880; Upperville, Virginia, Mellon collection; L. 530), in which the figure on the right-hand side is reminiscent of the dancer in the Hermitage drawing. Another drawing associated with this painting is *Dancer Adjusting her Shoe* (c. 1880; Bayonne, Musée Bonnat), which, although a little less detailed than the Hermitage work, is very close to it. Yet another close analogy is seen in the pastel *Dancer in a Green Tutu* (c. 1880–5; private collection). Degas subsequently returned to this pose on a number of occasions, varying it a little each time and adapting it to new themes. Thus, in *The Wait* (c. 1882; Los Angeles, J. Paul Getty Museum and the Norton Simon Art Foundation), on the bench next to a girl adjusting her shoes, sits her mother, who has brought her to the examination.

Provenance: acquired from the State Museum of Modern Western Art in 1935; previously in the Galerie Durand-Ruel, Paris, from 1898; collection of I. S. Ostroukhov (purchased from the Galerie Durand-Ruel for 1,200 francs) from 1903; the I. S. Ostroukhov Museum of Icon-Painting and Art from 1918; State Museum of Modern Western Art from 1923.

55. After the Bath, 1884 (page 115)
Femme s'essuyant après le bain
Pastel on paper. 50 x 50 cm
Signed and dated bottom right: *Degas 84*
42156 Reff 82

Among his many depictions of women drying themselves, this early study is exceptional in that Degas never repeated this compositional arrangement again. The solidity of the background, with the striped, flower-pattern wallpaper that was fashionable at the beginning of the 1880s, distinguishes this work from the other pastels in the series of works described by the artist at the last Impressionist exhibition of 1886 as 'the suite of female nudes bathing, washing, drying themselves, drying or combing their hair or having their hair combed'. This pastel was probably shown at the exhibition as well, although it is not possible to assert this unreservedly as no exhibition catalogue survives, nor do the names or dimensions of the pastels. Gary Tinterow, one of the organisers of the most important retrospective of Degas (New York, 1988), is sure that the Hermitage picture was at the 1886 exhibition, and indeed the evidence would seem to point to this conclusion: the picture still has a frame of the sort that the artist used at that time, and Degas, who never usually dated his pictures, did date those that were going into exhibitions. Tinterow even managed to find a description of the Hermitage *Woman at Her Toilet* (cat. 57) in a Paris newspaper review of the exhibition. The pose closest to the woman in the Hermitage pastel is *Woman in a Tub* (c. 1883; L. 738).

Provenance: acquired from the State Museum of Modern Western Art in 1934; previously in the collection of M. A. Morozov; collection of M. K. Morozova from 1903; Tretyakov Gallery from 1910 (donated by M. K. Morozova); State Museum of Modern Western Art from 1925.

56. Woman Combing Her Hair, c. 1885 (page 115)
Femme se peignant
Pastel on cardboard. 53 x 52 cm
Signed top right: *Degas*
42154 L. 848

Two other versions of the Hermitage pastel are known, both called *Female Nude Brushing Her Hair* (USA, Taubman collection; L. 849; New York, Metropolitan Museum; not listed in the Lemoisne catalogue). The American versions differ little from one another, except that the second is slightly taller. Lemoisne dated the Hermitage picture and the pastel from the Taubman collection to c. 1885. We can only surmise the order in which the three works were painted, but it is likely that the Hermitage picture was done first. Contemporary scholars give the American versions a later date: Tinterow suggests 1886–8, and Kendall 1888–90. Returning once again to his favoured motif in this picture, Degas substituted a square for a rectangular (or portrait) format. The woman's pose remains virtually unchanged, but here it is less graceful. Furthermore, the artist chose a different model, not conspicuous for her thinness. It has been suggested that Degas was inspired to make these changes after seeing Ingres's *Bather of Valpinçon* (1808; Paris, Louvre), one of his favourite works by this artist. Whereas in the American versions the figure is turned to the right, in the Hermitage picture she faces the left edge of the picture, which accentuates the dynamism of her pose: the legs seem to be trying to move forward, as does the torso, with the right hand moving energetically, and her hair not falling limply but pushed up. In the American pastels the rather bulky figure of the woman suggests a comparison with the overstuffed armchair in front of her. Degas returned to the motif of the Hermitage pastel again, right up until his series of *Nudes* in 1903 (L. 1422–7), frequently twisting the figure towards the other side. Furthermore, the woman is shown in a variety of poses: sitting in an armchair (*The Coiffure*, 1887–90; L. 935); on the edge of a bath (*Woman in the Bath*, c. 1894; L. 1173); and standing up (*Woman Drying Her Hair*, c. 1897; L. 1284). *Woman Brushing Her Hair* (c. 1897; L. 1283) is close to the Hermitage pastel, although more conventional and simplified in outline. According to Piotr Shchukin's notebook, which is preserved at the State Historical Museum in Moscow (folio 265/9), he paid Durand-Ruel 14,000 roubles for this picture.

Provenance: acquired from the State Museum of Modern Western Art in 1934; previously in the Vever collection, Paris; Galerie Durand-Ruel, Paris, from 1897 (from the sale of the Vever collection at the Galerie Georges Petit on 1–2 February 1897); Galerie Durand-Ruel again; collection of P. I. Shchukin (purchased from Durand-Ruel for 14,000 roubles) from 1898; collection of S. I. Shchukin from 1912; First Museum of Modern Western Painting from 1918; State Museum of Modern Western Art from 1923.

57. Woman at Her Toilet, c. 1889 (page 117)
La toilette
Pastel on paper. 56 x 59 cm
Signed bottom left: *Degas*
43788 L. 976

This pastel drawing was preceded by two studies (L. 977, 978) in which the woman's pose is the same, but the composition is compressed at top and bottom. In the Hermitage picture the draughtsmanship is central, while the studies are based upon the juxtaposition of generalised areas of colour. The same model is undoubtedly shown in two pastel drawings of 1889: *In Front of the Mirror* (Hamburg, Kunsthalle), and *Young Woman in a Hat* (L. 983, 984). In the catalogue of a recent exhibition of Degas's late work, Richard Kendall suggested a date for the Hermitage pastel drawing of 1896–9 (*Degas Beyond Impressionism*, London–Chicago, 1996, p. 48). It is true that at that time Degas did portray women brushing their hair on several occasions, but he addressed this motif at the end of the 1880s as well. It is quite possible that the subject matter of the picture was suggested by Japanese prints, in particular Kitagawa Utamaro's woodcut *Woman Brushing Her Hair* (1802–3).

Provenance: acquired from the State Museum of Modern Western Art in 1949; previously in the Galerie Durand-Ruel, Paris; Paul Cassirer Gallery, Berlin, between 1905 and 1909; collection of I. S. Ostroukhov, Moscow; I. S. Ostroukhov Museum of Icon-Painting and Art from 1918; State Museum of Modern Western Art from 1929.

58. After the Bath, c. 1895 (page 116)
Après le bain
Pastel, tempera and charcoal on grey paper glued to cardboard. 82.5 x 72 cm
Signed top right: *Degas*
43787 L. 1179

A decade prior to this, Degas had done another pastel called *After the Bath* (c. 1885; San Francisco, private collection; L. 886), in which the same pose is portrayed, but with more natural details. The Hermitage picture was directly preceded by a smaller study (Paris, Viau collection; L. 1180). It has the same grid, and the traces of vertical and horizontal lines divide the image in identical places. It was precisely this study, therefore, that was used to create the larger-scale Hermitage pastel. In the study the figure is very constricted. In transferring it, the artist added space to the right and top (these areas, incidentally, have a grid). Another counter-proof of the study also exists (L. 1180 *bis*), and this clearly foreshadows the Hermitage picture. In this study Degas has sought to work out the best relationship between the figure and the space. Working with pastel on paper was technically convenient for the artist – the fact that the paper could be simply cut out or added to made the search for the right composition much easier. *After the Bath* is executed on three horizontal strips of paper, glued to cardboard. Degas used grey paper, which served as a kind of 'tuning-fork' in his preliminary work. He certainly did not want the grid of horizontal and vertical lines used to transfer the composition to a larger scale to be noticeable. The fact that they are now is the result of a series of coincidences. The grid appeared in the work process after the early layers of pastel were treated with steam. The artist used this method both to achieve a smooth texture, and to make the painting more durable. After this, pastels were once more applied to the surface of the picture, so that all the straight lines and the framework around which the composition was constructed were covered. It was in this final state that the pastel was reproduced by Michel Manzi in 1897 (in his *Degas: Vingt dessins. 1861–1896*; Paris, 1897), and a year earlier it was shown in an exhibition at the Galerie

Durand-Ruel. A comparison with the reproduction shows that a hundred years ago the treatment of the body was a little smoother; the final layer, which Degas rubbed on by finger (as he was wont to do), made the texture of the picture a little softer. But this final application was probably not fixed thoroughly enough. By the time the picture came to Russia – exactly when this was is hard to say, but it was probably around the beginning of the century or a little later – part of the outer layer of paint concealing the grid had simply come away. Degas used this same motif for a bronze statuette, dated 1896–1911.

Provenance: acquired from the State Museum of Modern Western Art in 1948; previously in the Galerie Vollard; collection of I. A. Morozov from 1907; Second Museum of Modern Western Painting from 1918; State Museum of Modern Western Art from 1923.

59. Dancers, c. 1896–8 (page 119, gatefold)
Les danseuses
Pastel and charcoal on grey paper. 30.5 x 55 cm
Signed right of centre: *Degas*
41255 L. 1358

In the second half of the 1890s Degas concentrated on portraying four dancers (three ballerinas adjusting their shoulder straps and a fourth her hair), creating a fairly complex composition. The central work of the group is *Dancers* (c. 1898; Paris, Durand-Ruel collection; L. 1352), which is one of the masterpieces of the artist's late period. The figures depicted are the same as those in the Hermitage *Dancers*, but they are shown from the knee up. Along with other versions of this composition (*Four Dancers*, Baltimore, Evergreen House Collection; L. 1357; *Study of Ballet Dancers*, New York, Logan Collection; L. 1354; and others), the Hermitage pastel should be regarded as a study for the Durand-Ruel *Dancers*. In working on this motif, Degas used photographs that showed the individual dancers in poses similar to those of his pastels and drawings (the negatives are in the Bibliothèque Nationale in Paris); it has been suggested that the photographs were taken by the artist himself around 1895. The original charcoal drawings were of separate figures, which Degas then grouped together. The Hermitage pastel relates to the final phase and is one of the works that directly preceded the *Dancers* in the Durand-Ruel collection: the dimensions of the heads, as well as the gestures, are the same. It is true, however, that the colour scheme in the final composition is quite different; it is based on the contrast between green and pink tones with the introduction of red and orange for the flowers in the dancers' hair.

Provenance: acquired from the State Museum of Modern Western Art in 1948; previously in the Galerie Vollard; collection of I. A. Morozov from 1907; Second Museum of Modern Western Painting from 1918; State Museum of Modern Western Art from 1923.

Sonia Delaunay-Terk
1885, Gradizhsk, Ukraine – 1979, Paris

Delaunay-Terk's early years were spent in St Petersburg. From 1903 to 1905 she studied painting in Karlsruhe. In 1906 she moved to Paris where she studied at the Académie de La Palette. She married the famous art critic Wilhelm Uhde, and secondly Robert Delaunay (1910), whose creative theories she subsequently followed. She designed embroideries, painted large-scale decorative murals, and designed costumes for Diaghilev's *corps de ballet*.

Blaise Cendrars (real name: Frédéric Louis Sauser)
1887, La Chaux-de-Fonds, Switzerland – 1961, Paris

Cendrars was a French writer of Swiss origin. The son of a Swiss tradesman, he ran away from home at 15, travelled the world and tried many professions. He became acquainted with Apollinaire around 1910, and was then linked to the Cubists. He frequently turned to Russian themes. A master of free verse, Cendrars also wrote novels and essays.

60. The Poem of the Trans-Siberian and little Jehanne of France, 1913 (page 362)

La prose du transsiberien et de la petite Jehanne de France
Watercolour stencils on paper. 198 x 36.5 cm (entire scroll); 190 x 18 cm (left illustrated section).
Tirage-luxe, No. 47. Paris, Des Hommes Nouveaux publishers.
Dedications on imprint page: *à mon vieil cher ami simultané Sacha Sonia Delaunay-Terk*; in black ink on the left: *Blaise Cendrars à Smirnov le premier qui sur les ailes simultanées apporta le disque synchrome en Russie 1 janv. 1914*
46011

Cendrars' poem was based upon his impressions of his time in Russia from 1903 to 1907. The action takes place during the Russo-Japanese War of 1904 to 1905, and the revolution that followed in 1905–7. Cendrars and Sonia Delaunay collaborated to create a 'simultaneous book', where the text and accompanying illustrations combine to create a unified artistic effect. The drawing is quite unlike normal book illustration: by creating a rhythmical and colour structure that works in unison with the text, the artist went beyond a purely decorative effect and sought to convey the movement of light through the play of colour forms. The text contains ten different typesets, in itself a rare typographical experiment. It is thought that the elongated form of the entire composition was based on an image of the Eiffel Tower, which had become a preoccupation of Robert Delaunay. In fact the tower itself appears opposite the concluding lines of Cendrars' poem. The first *livre simultané* came out in November 1913 and made a significant impact on Parisian artistic circles. Articles and letters for and against the book were published in *Paris-Journal*, *Gil Blas* and *Soirées de Paris*. The original intention was to publish 150 copies, but in the end the total was considerably less. Robert Delaunay's idea was that the combined length of the total number of books printed – the scroll unrolled measures almost two metres – should equal the height of the Eiffel Tower. The first owner of the Hermitage copy of the book was A. A. Smirnov (1883–1962), a friend of Cendrars and Robert and Sonia Delaunay. Smirnov was a prominent Russian literary critic and privat-docent of St Petersburg University before and during the First World War. It is known that during this time in St Petersburg he gave lectures, in particular in the basement where the literary and artistic cabaret *The Stray Dog* took place. Smirnov would accompany his lectures with a demonstration of the poem, also using the 'synchronised disc' referred to in the dedications. The disc, like the poem, was meant to present 'an abstract spectacle of light in movement'.

Provenance: acquired in 1966; previously in the collection of A. A. Smirnov, Leningrad.

Maurice Denis
1870, Granville – 1943, Paris

Denis attended the Lycée Condorcet in Paris (1881–7) with Sérusier, Vuillard and Roussel. In 1888 he met Bonnard and Ranson at the Académie Julian. He then studied at the Ecole des Beaux-Arts, first under Lefebvre and then under Doucet. In 1889, with Sérusier, Bonnard, Vuillard and Roussel, he took part in the creation of the Nabis group. He was influenced by Puvis de Chavannes and Gauguin. He first exhibited at the Salon in 1890. He worked mostly in St-Germain-en-Laye, but visited Italy, Palestine and Russia. He often assumed the role of art critic and

theorist. From 1908 to 1919, he taught at the Académie Ranson. His best large-scale decorative work was done at the beginning of the twentieth century. In 1919 he established the Ateliers d'Art Sacré together with the artist Georges-Olivier Desvallières. He became a member of the Institut de France in 1932. He painted portraits and landscapes, mythological and allegorical compositions, but religious painting remained his greatest passion, as is shown by the decorative work he did for a series of French and Swiss churches.

61. The Meeting (The Visitation), c. 1892 (page 196)

La Rencontre
Oil on cardboard. 37.5 x 33 cm
Monogrammed bottom left: *MAUD*
Г Э 7710

The picture has been known by the title *The Meeting* since it was in Mikhail Morozov's collection, although the scene depicted is not an everyday encounter but the biblical visit of Mary to Elizabeth (Luke 1, 36–56). Compositionally this work is more in the Renaissance tradition, for example in the cousins' embrace, than Denis's later treatment of the same subject. Since Renaissance times the scene has been shown against a landscape background, and often in front of Zacharias's – Elizabeth's husband's – house. The picture was probably painted around 1892 and is similar to *Bretons with Large Shawls* (1892; St-Germain-en-Laye, private collection) and *Red Roofs* (c. 1892; St-Germain-en-Laye, Musée du Prieuré). Both works share the technique of broadly applied areas of flat colour and imprecisely delineated outlines.

Provenance: acquired from the State Museum of Modern Western Art in 1934; previously in the collection of M. A Morozov; collection of M. K. Morozova from 1903; Tretyakov Gallery from 1910 (donated by M. K. Morozova); State Museum of Modern Western Art from 1925.

62. Wedding Procession, c. 1892 (page 192)

Procession nuptiale
Oil on canvas. 26 x 63 cm
Signed bottom left: *M. Denis*
Г Э 8342

The closest version to this picture is *Procession under the Trees* (1892; New York, Altschul collection) in which the landscape background and individual figures are the same, but the subject is less obvious: the procession of girls in white dresses does not have to represent a wedding ceremony. It would seem that *Wedding Procession* immediately preceded *Procession under the Trees*, for the analogous details are less defined. Certain art historians believe that the Hermitage canvas was actually painted in 1893, since much of Denis's early work was autobiographical and he married Marthe Meurier on 12 June 1893. However *The Marriage of Marthe and Maurice Denis* (Saint-Germain-en-Laye, former collection of Dominique Maurice-Denis), a precise portrait of the young couple, is completely different. Also it would be wrong automatically to assume that the couple in the Hermitage painting are Denis and his wife: the groom in the picture has brown hair whereas Denis had dark reddish-coloured hair. The scene is more likely to be imaginary than based on reality. Denis dreamt of marrying Marthe from the moment he met her in 1890 but had to overcome his father's opposition. In the autumn of 1892 they were finally engaged. It was most probably then that *Wedding Procession* and *Procession under the Trees* were painted, a dating that would seem to be corroborated by the autumn landscape in both works. With the exception of some minor details, the composition of this painting is the same as in a pencil study (U. Perrucchi-Petri, *Die Nabis und Japan* (Munich, 1976), p. 176, No. 122) in which the only omission is the figure of a man in a top hat on the right. However, it is possible that *Wedding Procession* was also intended as a study for another, unrealised painting.

Provenance: acquired from a private collection, Leningrad, in 1939.

63. The Visitation, 1894 (page 197)

La Visitation
Oil on canvas. 103 x 93 cm
Monogrammed and dated bottom right of centre: *MAUD 94*
Г Э 6575

Denis returned to the theme of Mary's visit to Elizabeth (Luke 1, 36–56) on several occasions in his early work, starting with *The Meeting* (cat. 61). In his *Painting Notes* written during his honeymoon in 1893, Denis drew up a programme of religious compositions in which two *Visits* are mentioned. In the same year *Visitation with a Dovecot* (private collection) was completed, showing Elizabeth and Mary against a latticed hut (the framework for the future green tunnel). In the lithograph also entitled *Visitation* (1894), the composition is simpler and the hut is replaced by a latticed fence. In the Hermitage painting the motif is reworked still further: the simple rectangular fence becomes an open-work arcade with diagonal tracery intertwined with plants in autumn leaf. The lattice motif is taken from Japanese woodcuts which were popular with all the members of the Nabis (see Bonnard's *Behind the Fence*, cat. 9). In the foreground of *Visitation with a Dovecot*, Denis has included a horse and trap, a detail that seems to extend the parameters of the subject and hint at the journey undertaken by Mary. In the Hermitage canvas the trap, placed right in the background, is barely visible. The relationship between the figure and the background is changed dramatically. Both characters bear a close resemblance to Marthe Denis, as in other works by Denis of the 1890s. The scene is notable for a particular detail of dress which was characteristic of the turn of the century: Elizabeth is bare-headed since she is at home, whereas Mary, being on a visit, is wearing a hat fashionable for the time. The Visitation is usually marked by the Catholic Church on 31 May, but here it is clearly an autumnal scene. This is evidently explained by the fact that the picture was painted not long before the birth of Denis's son Jean-Paul (in October 1894); the artist often reflected landmark occasions in his own life through traditional subjects. The figure of Mary almost replicates the figure of the woman with a dish in Denis's large composition *Pilgrims of Emmaus* (1894; St-Germain-en-Laye, Musée du Prieuré).

Provenance: acquired from the State Museum of Modern Western Art in 1934; previously in the collection of S. I. Shchukin from 1899; First Museum of Modern Western Painting from 1918; State Museum of Modern Western Art from 1923.

64. Mother and Child, 1895 (page 193)

Mère et l'enfant
Oil on canvas. 45 x 38.5 cm
Two monograms bottom right, vertical and circular: *MAUD*
Г Э 8893

Denis's works on the theme of motherhood are generally undated, which makes it difficult to give a precise date to this canvas. Of the dated works, two that are iconographically close to *Mother and Child* are *Bathing a Child* (1899; Paris, private collection) and *Motherhood* (1895; Lausanne, Josefowitz collection). Despite the fact that the dress Marthe is wearing in *Bathing a Child* is very similar and perhaps even the same as the one in the Hermitage canvas, in their style of execution the paintings are very different. The understated style of *Mother and Child* is closer to the Lausanne *Motherhood*, which is dated by the artist himself. Denis's first child, Jean-Paul, is shown in the picture; he was born in October 1894 and died in February 1895. The Hermitage canvas, therefore, should also be dated to the beginning of 1895.

Provenance: acquired from the State Museum of Modern Western Art in 1948; previously in the collection of M. A. Morozov; collection of M. K. Morozova from 1903; Tretyakov Gallery from 1910 (donated by M. K. Morozova); State Museum of Modern Western Art from 1925.

65. Martha and Mary, 1896 (first version, verso of cat. 66) (page 194)
Marthe et Marie
Oil on canvas. 77 x 116 cm
☐ 9124

The painting depicts an episode from the Gospels (Luke 10, 38–42). The first time Denis worked on this theme was in the watercolour *Sacred Conversation* (1890; St-Germain-en-Laye, private collection), in which the scene of the dialogue between Christ and the two women is set in a rural landscape and takes up relatively little space. However, a conflict is clearly evident: Mary is listening intently to Christ's words, while Martha looks reproachfully at her sister. It is unusual that the action takes place on the terrace rather than indoors. Denis returned to this subject again a few years after his marriage. The motif had a special personal meaning for the artist because his wife was also called Marthe. She is easily recognised even in the silhouetted, undefined outlines of the female figures. Martha and Mary have the same features and are set in opposition to each other as if two hypostases of the same image, like light and dark, destined always to be together.

66. Martha and Mary, 1896 (page 195)
Marthe et Marie
Oil on canvas. 77 x 116 cm
Dated and monogrammed bottom right of centre:
MAUD 96
☐ 9124

Denis was not satisfied with his first version of *Martha and Mary* (cat. 65) and it remained only a study. He turned the canvas round, added extra vertical slats to the stretcher, and thus created a lighter, more spacious effect to the composition as a whole. In both versions, Denis did not adhere to his original idea – as revealed by a sketch that once belonged to Vollard (now in a private collection) – of a portrait-format painting. The basis for the pictorial treatment in *Martha and Mary* was established in *Pilgrims of Emmaus* (1894; private collection), in which Christ and the women entering are very similar iconographically to the characters in the Hermitage work. The decorative way in which the bare trees and well in the background are painted had already been seen in *Fields under Snow* (1895; Paris, collection of Jean-Baptiste Denis). The background is wholly realistic and depicts an almost identical view of Saint-Germain-en-Laye to that in *The Visitation* (cat. 63), except that here only the top part of the arcade is shown, shaded and not very visible against the dark green of the grass. By contrast, the yellow house and fence in the distance are more accentuated. It seems clear that various details in the composition are connected to concrete events in the artist's life. Thus Bouillon, a contemporary commentator on Denis's work, explains Martha's black dress as a sign of mourning for their son Jean-Paul, who had died the year before, emphasising at the same time that here too is a veiled hint at Maurice Denis's gentle acceptance of death, 'which is also a promise of resurrection' (J.-P. Bouillon, *Maurice Denis* (Geneva, 1993), p. 76). The picture contains a clear reference to Maeterlinck's play *Martha and Mary*, staged by a friend of Denis, Lugne-Poe, on 15 March 1895; it also expresses the artist's state of mind in the light of upheavals in his personal life – the tragic loss of his first child and his hopes for the future. Denis invested the painting with great significance and exhibited it at the Salon of the Société Nationale des Beaux-Arts in 1897.

Provenance: acquired from the State Museum of Modern Western Art in 1948; previously in the Galerie Vollard (acquired from the artist) in 1903; collection of S. I. Shchukin from 1903; First Museum of Modern Western Painting from 1918; State Museum of Modern Western Art from 1923.

67. Figures in a Spring Landscape (Sacred Grove), 1897 (page 198)
Figures dans un paysage de printemps (Le bois sacré)
Oil on canvas. 156.3 x 178.5 cm
Monogrammed and dated on the tree-trunk on the left: *MAUD 97*; circular monogram bottom right: *MAUD*
☐ 9567

The picture probably received the name *Sacred Grove* at the Galerie Vollard. The artist's title – *Figures in a Spring Landscape* – is written on the back of the canvas. In his diary for January 1909, Denis also called the painting *Spring in the Wood*. The name *Sacred Grove* corresponds with the view of contemporaries that the painting was based on Puvis de Chavannes's composition of the same name (1884; Lyons, Musée des Arts Décoratifs) – a work which was very popular at the turn of the century. Sérusier's painting *Sacred Grove* or *The Incantation* (1891; Quimper, Musée des Beaux-Arts) would also certainly have been known to Denis, but although he used a similar motif of three figures in a sacred grove, Denis did not adhere to the principles of synthesis, which Sérusier developed according to Gauguin's example. Artists of the Academy also frequently turned to similar themes. Denis would have certainly been acquainted with Franc-Lamy's *Renewal*, which was exhibited at the Salon of 1892 and was well known to both the public and critics. Denis developed the concept for the painting in the early 1890s with such works as *Trinity Evening* (1891; Mas-de-Januq, Dejean collection), and *Girls Who Could be Called Angels* (1892; Lausanne, Josefowitz collection). By then he had already adopted the technique of making an image in triplicate. Highly influential in the creation of the Hermitage composition was the combination of pagan, temporal and Christian motifs depicted in such works as *Triple Portrait of Martha the Bride* (1892; Saint-Germain-en-Laye, Musée du Prieuré), *Three Young Princesses* (1893; Saint-Germain-en-Laye, private collection), and *The Garden of the Wise Virgins* (1893; Paris, Lerolle collection). The similarity between this last picture, which refers to the parable of the wise and unwise virgins (Matthew 25, 1–13), and *Figures in a Spring Landscape* is unquestionable, while *Virginal Spring* (1894; Saint-Germain-en-Laye, Musée du Prieuré), a study for a proposed mural, depicts young women in a grove and is linked to the theme of awakening nature. *Figures in a Spring Landscape* was preceded by a study (oil on cardboard, 26.3 x 39 cm, ☐ 10271) and a sketch in mixed media (see cat. 68), given to the Hermitage by the artist's family. According to Alexandre Benois, it was at his initiative that Sergei Shchukin advised his brother Piotr to buy *Figures in a Spring Landscape* from Vollard (Benois, 1990, Book 4, vol. ii, p. 151).

Provenance: acquired from the State Museum of Modern Western Art in 1948; previously in the Galerie Vollard (purchased from the artist for 1,000 francs) from February 1899; collection of P. I. Shchukin from 1899 or 1900; collection of S. I. Shchukin from 1912; First Museum of Modern Western Painting from 1918; State Museum of Modern Western Art from 1923.

68. Study for Figures in a Spring Landscape (Sacred Grove), 1897 (page 199)
Figures dans un paysage de printemps (Le bois sacré): Esquisse
Pastel and colour pencil on paper. 33.3 x 49.8 cm
46550

This sketch shows how the artist searched for the best position for the figures in the centre and on the right. As in another study, also in the Hermitage, the figures are shown clothed. It would seem that the positioning of the main figure – on the left – was established immediately. The sketch does not contain certain details that appear in the finished painting, for example the garland and deer; the painting's complex symbolism developed slowly as it was created.

Provenance: acquired in 1977 (as a gift of the artist's son, Dominique Maurice-Denis); previously in the collection of Maurice Denis's family, Saint-Germain-en-Laye.

69. Holy Spring at Guidel, c. 1905 (page 199)
Fontaine de pèlerinage en Guidel
Oil on canvas. 39 x 34.5 cm
Monogrammed bottom right: *MAUD*
☐ 7711

Guidel is mentioned in Denis's diary entries for August 1905 when he was at Le Pouldu. The artist made several journeys with Marthe to the area around Quimper in Brittany, attending religious festivals and processions in Pont-Aven, Clohars and Guidel, which 'was situated in a valley, always fresh and of such an exquisite green' (Denis, 1957, II, p. 20). *Holy Spring* was most probably painted at that time, August 1905. It is particularly notable, in contrast to Denis's other work, for its vivid green tones. Evidently *Religious Procession in Guidel* (now in Lausanne, private collection) was painted a little later, and was given to Sérusier's wife. Ivan Morozov's acquaintance with Denis began from the moment he purchased this painting at the exhibition of the Salon des Indépendants of 1906.

Provenance: acquired from the State Museum of Modern Western Art in 1934; previously in I. A. Morozov's collection (purchased from the exhibition of the Salon des Indépendants for 850 francs) from 1906; Second Museum of Modern Western Painting from 1918; State Museum of Modern Western Art from 1923.

70. Bacchus and Ariadne, 1907 (page 200)
Bacchus et Ariane
Oil on canvas. 81 x 116 cm
Signed and dated bottom right: *Maurice Denis 1907*; signed and inscribed in pencil on the stretcher: *Maurice Denis. Bacchus et Ariane*
☐ 6578

In the summer of 1906, when Denis was working on *Bacchus and Ariadne*, Ivan Morozov visited the artist's studio in Saint-Germain-en-Laye. Although the painting was not finished, the collector purchased it and it was agreed that Denis would paint a pair to it (*Polyphemus*; Moscow, Pushkin Museum). In all probability *Bacchus and Ariadne* was retouched during the completion of *Polyphemus* and both works are dated to 1907. When he visited Denis, Morozov would also have been able to see *Beach with a Small Temple* (1906; Lausanne, Musée Cantonal des Beaux-Arts), which shows the Breton shore with young naked bathers in the foreground, just as in its destroyed sequel *Large Beach*. All these works are similar in composition, and contain motifs which are developed further in *Bacchus and Ariadne*. Thus in *Beach with a Small Temple* there is a young woman sitting on the cliff, while in versions of *Beach with a Spaniel* (1903; private collection, and Tahiti, Chinchong collection) a young man on a horse is shown in the background entering the water, just as he is in the later Hermitage picture. In *Bathing* (1906; private collection) a girl in a white shirt appears on the cliff to the left, and a sailing boat can be seen against the horizon to the right. Using a contemporary beach-resort scene to interpret ancient myth, Denis depicts the Brittany beach of Trestrignel, and Sept-Iles in Perros-Guirec – a favourite haunt since childhood. Denis's impressions of Italy, and particularly of the classical sculpture in the National Museum in Naples which he visited in 1904, are also apparent in the picture. The pose of the naked swimmer in the foreground mirrors the pose of *Venus Tying her Sandal*, a marble statue found in Pompeii, while the reclining figure of Ariadne on the cliff is evocative of *Sleeping Ariadne*, widely known from Roman copies of the third-century BC Greek original. It was when he was in Rome in January 1904 that Denis wrote in his diary: '*Bacchus and Ariadne* (the subject for a beach picture), Poussin's interpretation after Titian in the Academy of Saint Luke' (Denis, 1957, I, p. 223). It was probably at this precise moment that the idea for the Hermitage canvas was born, and Denis returned to this theme later when, in 1913, he painted *Ariadne as Twilight Approaches* (private collection).

Provenance: acquired from the State Museum of Modern Western Art in 1931; previously in the collection of I. A. Morozov (purchased

from the artist in 1906 for 4,000 francs) from 1907; Second Museum of Modern Western Painting, Moscow, from 1918; State Museum of Modern Western Art from 1923.

71–76. The Story of Psyche (pages 201–4)
L'Histoire de Psyche

Denis's decorative series depicts several episodes from the tales and short stories in *Metamorphoses*, or *The Golden Ass*, by Apuleius. I. A. Morozov commissioned the series from Denis in 1907 to hang in the concert room of his Moscow house on Prechistenka (the building is now owned by the Russian Academy of Arts). Measurements and photographs of the room were sent to the artist and he was given complete freedom as to the subject matter. Denis wrote to Morozov on 21 June: 'I have thought about the subjects I would like to choose for the decorative panels you commissioned from me… It seems to me that the story of Psyche, which is both idyllic and very mysterious, would be ideal; I've already composed five scenes, completely different from the ones conceived by Raphael at the Farnesina, but nevertheless in perfect accord with Apuleius's story… Before I go any further with my sketches, I want to be sure that you will give me complete freedom and have no objection to the story of Psyche as a subject.' Having received Morozov's approval, Denis wrote again on 14 September 1907, from Italy: 'I am here with my family on Lake Maggiore, and want to work on the Psyche sketches, which I began in Saint-Germain. I have brought them with me so that I can decorate them with Italian landscapes.' (Archive of the Pushkin Museum, Moscow.) In a letter to André Gide from Fiesole on 12 December 1907, Denis wrote: 'I have worked a great deal but without any significant results or revelations. I have prepared my future Psyche (the Moscow one); it will be very chaste in comparison with that of Giulio Romano.' (Denis, 1957, II, p. 90). In addition to the first five sketches, now in the Musée d'Orsay, the Italian trip produced some eighty studies and drawings: eight are in the Musée du Prieuré in Saint-Germain-en-Laye, others were sold at an exhibition organised by Denis at the Druet Gallery on his return from Italy and were dispersed among various collections. The main preliminary work was undoubtedly carried out in Italy, as is clear from the landscapes shown in the backgrounds of the sketches. By the summer, the compositional scheme of the sketches was transferred onto large canvases. Before sending the series to Moscow, Denis prepared it for the Salon d'Automne of 1908. He wrote in his diary: 'My life in Paris from 30 July until 21 August was spent at the Grand-Palais… in this huge building which I was allowed to enjoy temporarily.' (Denis, 1957, II, p. 94.) One of the artist's letters to Madame La Laurencie (dated 26 September 1908) helps to establish the completion date of the Morozov panels: 'The Salon d'Automne opens on Tuesday or Wednesday. All the same I am worried about what people will think of the Psyche, and more importantly what impression it will make on me, since I was in a fairly anxious state when I left the panels more than a month ago.' (Denis 1957, II, p. 96.) After the Salon d'Automne all five panels were sent to Moscow where in December they were mounted onto stretchers and fixed to the walls in frames of brocaded ribbon five centimetres wide. In his work on the panels Denis almost exactly followed the compositions and colours set out in the preliminary studies, which were painted at the Villa Bella Vista in Florence. Susanna Barazzetti-Demoulin has commented that the island depicted in the panel *Zephyr Carries Psyche to the Island of Bliss* is the island of Isola Bella on Lake Maggiore. She has also noted that the bed shown in the third panel was drawn by Denis in his travel album when he visited the Borromean islets on Lake Maggiore, and that the panel *The Vengeance of Venus* is based not only on the artist's impressions of the Giusti gardens in Verona, but also the Boboli gardens in Rome. According to Barazzetti-Demoulin's research, the drawings for the figures of Psyche and Cupid were done in Rome, the models being a beautiful young man from the Trastevere and a young girl from Campagna in Rome, who was well known at the city's Academy of Arts. (S. Barazzetti-Demoulin, *Maurice Denis*, Paris, 1945.) Marthe Denis served as a prototype for Venus in the

fifth panel; the prototype for Mars was Roussel and for Bacchus – Maillol. Denis had already depicted Maillol and Roussel as Magi in his *Adoration of the Magi* (1904; Dijon, Musée des Beaux-Arts), in which Marthe was the Virgin Mary. The theme of Cupid and Psyche had been used by many French artists of the nineteenth century, from Prud'hon and François Gérard to Bouguereau. Denis's work reveals to a certain extent the influence of Bouguereau's academic techniques, particularly in the first and fifth panels. For the third panel, arguably the best of the whole ensemble, Denis employed a strict iconographical system adapted from the Old Masters. Similar depictions of Psyche gazing at Cupid in the lamplight were painted by Vouet (Lyons, Musée des Beaux-Arts) and Subleyras (Brussels, Arenenbourg Gallery).

71. First Panel: Cupid in Flight is Struck by the Beauty of Psyche, 1908 (page 202)
Panneau premier: Amour s'éprend de la beauté de Psyche, objet innocent de culte des mortels et de la jalousie de Venus
Oil on canvas. 394 x 269.5 cm
9666

72. Second Panel: Zephyr Carries Psyche to the Island of Bliss, 1908 (page 202)
Panneau deuxième: Zephyr sur ordre d'Amour transporte Psyche dans une île de délices
Oil on canvas. 395 x 267.5 cm
9667

73. Third Panel: Psyche Discovers that her Secret Lover is Cupid, 1908 (page 203)
Panneau troisième: Psyche découvre que son mystérieux amant est Amour
Oil on canvas. 395 x 274.5 cm
Signed and dated twice, bottom left and in the centre on the edge of the medallion: *Maurice Denis 1908*
9669

74. Fourth Panel: The Vengeance of Venus: Psyche, Opening the Box of Dreams of the Underworld, Sinks into Sleep, 1908 (page 204)
Panneau quatrième: Soumise par Vénus aux plus rudes épreuves, Psyche, pour son malheur, cède une seconde fois à la curiosité; dans cette extrémité elle est secourue par Amour
Oil on canvas. 395 x 272 cm
9668

75. Fifth Panel: In the Presence of the Gods, Jupiter Grants Psyche Immortality and Celebrates her Marriage with Cupid, 1908 (page 204)
Panneau cinquième: Jupiter en présence des dieux, accorde à Psyche l'apothéose et celèbre son hymen avec Amour
Oil on canvas. 399 x 272 cm
9670

Provenance: acquired from the State Museum of Modern Western Art in 1948; previously in the collection of I. A. Morozov (all five panels commissioned for 50,000 francs) from 1908; Second Museum of Modern Western Painting from 1918; State Museum of Modern Western Art from 1923.

76. Study for the First Panel of The Story of Psyche, 1907 (page 201)
Esquisse pour le panneau premier de l'Histoire de Psyche
Pencil on paper. 72.5 x 50.2 cm
48149

This drawing was actually completed after a painted study (1907; Paris, Musée d'Orsay) so that Denis could determine more exactly the panel's linear composition. It was undoubtedly done in Rome at the end of 1907. It was important for the artist to check the figure of Psyche against the model, which is why this figure shows greater finish. In the study Psyche remained only an 'idea' of beauty; by working with a model Denis was able to realise his idea more effectively. It is true that when he transferred it onto a large-scale canvas it was as if he took a step backwards. The depiction of Psyche in the drawing is much more expressive than in the first panel.

Provenance: acquired in 1992 (gift of Dominique Maurice-Denis).

77–78. The Story of Psyche: Additional Panels, 1909 (page 205)
Histoire de Psyche: Panneaux complémentaires

Having arrived in Moscow in January 1909 at the invitation of Ivan Morozov, Denis wrote in his diary: 'My large decoration looks a little isolated in the big cold hall, all grey stone with mouse-grey furniture. It needs something to link it to the surroundings. But the general aspect is not without grandeur. My colours are as strong as they were at the Salon, but make a more harmonious whole' (Denis, 1957, II, p. 100). Denis reworked some individual sections of the panels, making them a little more restrained and in keeping with the architecture of the room. To achieve this he also had to paint some additional panels. He suggested creating two more large panels for above the doors (the sixth and seventh), four narrow panels (the eighth and ninth for the west wall, showing Cupid firing from a bow, and the tenth and eleventh representing Psyche to go on either side of the third and central panel), and two borders on each side of the door. Denis worked on all these additional panels after his return to France. As before, he first made drawings and studies. A small oil study for the seventh panel is in the Musée d'Orsay; there are also two preparatory drawings for the sixth panel and three for the seventh in the Musée du Prieuré. All these supplementary panels were completed by autumn 1909. Emile Druet wrote to Morozov on 23 October: 'This week I exhibited two… of your panels by Maurice Denis… They were very popular. I am having them packed. You will receive them soon.' (Archive of the Pushkin Museum, Moscow.) When the war began in 1941, all the panels – main and supplementary – were taken down from the walls of the Museum of Modern Western Art in Moscow and rolled up. They were only unrolled ten years later when they were handed over to the Hermitage, and it was then that the serious rubbing away of a layer of paint on the sixth and seventh panels came to light.

77. Sixth Panel: Psyche's Parents Abandon Her on the Summit of the Mountain, 1909 (page 205)
Panneau sixième: Les parents abandonnent Psyche au sommet de la montagne
Oil on canvas. 200 x 275 cm
Signed and dated bottom left: *Maurice Denis 1909*
9693

78. Seventh Panel: Cupid Carries Psyche to the Heavens, 1909 (page 205)
Panneau septième: Amour transfère Psyche au ciel
Oil on canvas. 180 x 265 cm
9694

Provenance: acquired from the State Museum of Modern Western Art in 1948; previously in the collection of I. A. Morozov from 1909 (eight additional panels for the series were commissioned for 20,000 francs); Second Museum of Modern Western Painting from 1918; State Museum of Modern Western Art from 1923.

André Derain
1880, Chatou, near Paris – 1954, Garches

Derain attended the Académie Carrière, where he met Matisse and Puy. He copied Old Master paintings in the Louvre. Derain met Vlaminck in 1900, and together they converted an abandoned restaurant into a studio in the Parisian suburb of Chatou. From 1904 he studied at the Académie Julian. Along with Matisse, he was one of the founders of Fauvism, participating in the Salon d'Automne of 1905. In the summer of the same year he worked with Matisse at Collioure. In autumn 1906 he met Picasso and other artists living in the Bateau-Lavoir. In 1907, under the influence of Picasso and Braque, he broke with Fauvism. Derain took part in the First World War, then turned to neo-classicism. He rarely painted in later life, favouring the decorative arts, theatre costumes and book illustrations. At that time he often sculpted as well.

79. Harbour, c. 1905 (page 280)
Le Port
Oil on canvas. 62 x 73 cm
Signed bottom right: *a. derain*
⊡ 6540 K. 116

Until not long ago it was thought that this painting was of the port of Le Havre, but the hills on the right-hand side of the painting contradict this. Douglas Cooper and John Rewald suggested independently of one another that the harbour is Mediterranean – either Collioure, Estaque or Cassis. The last is unlikely since Derain's paintings of Cassis were of a different style. *Harbour* is very similar to the landscapes Derain painted in Collioure. Stylistically the picture belongs to the works Derain completed in 1905, when he worked alongside Matisse in Collioure. He visited Estaque at that time, but mostly painted Collioure. The local character of *Harbour* is close in style to *Sailing Boats at Collioure* (New Jersey, Engelhardt collection) with its green coastal hill. A whole series of Collioure landscapes was shown at the Salon d'Automne of 1905; it is possible that *Harbour* was among them. Kellerman called the painting *Boats in the Harbour*, dating it to c. 1906.

Provenance: acquired from the State Museum of Modern Western Art in 1930; previously in the Kahnweiler Gallery; collection of S. I. Shchukin from 1913; First Museum of Modern Western Painting from 1918; State Museum of Modern Western Art from 1923.

80. Mountain Road, 1907 (page 281)
Route en montagne
Oil on canvas. 81 x 100 cm
⊡ 9126 K. 121

Mountain Road belongs to a group of works painted in 1907 in Cassis on the Mediterranean coast, which also includes *Near Cassis* (Ostende, Duvivier Collection), and *Cassis* (Troyes, Musée d'art moderne; K. 127). Kellerman calls the Hermitage painting *Landscape around Cassis*. This group is representative of the 'stained-glass' phase in Derain's Fauvist work. The study for *Mountain Road* is called *Landscape near Cassis* (Bern, Kunstmuseum; K. 120) and differs only in minor compositional details from the finished work. Another *Landscape near Cassis* (1907; New York, Museum of Modern Art; K. 119) is also linked to the Hermitage painting; it is smaller and was undoubtedly painted later. Derain preserved the overall composition but slightly modified the motif, and in so doing gave it more volume. The New York canvas signals a change from the 'stained-glass' phase to a clearly expressed adherence to Cézanne.

Provenance: acquired from the State Museum of Modern Western Art in 1948; previously in the collection of I. A. Morozov from 1908 (purchased at the Salon des Indépendants for 250 francs); Second Museum of Modern Western Painting from 1918; State Museum of Modern Western Art from 1923.

81. Houses by the Water, 1910 (page 321)
Les maisons au bord de l'eau
Oil on canvas. 61 x 102.3 cm
Signed bottom right: *a. derain*
⊡ 7720 K. 195

This picture is well-known under the title *Harbour*, and was so called in the catalogue of Sergei Shchukin's collection and in many subsequent publications. However, the landscape cannot be coastal. It was reproduced as *Houses by the Water* and dated 1910 by Hilaire (Hilaire, 1959, no. 84). The stylistic qualities and landscape motif indicate a date for the painting of 1910. It is clear that *Houses by the Water* depicts a flood, and it is known that the Seine flooded in 1910. It is possible Chatou is shown here; in particular, the church spire is identical to the one in Chatou. The study for the painting is in the Prague National Gallery, and is wrongly assumed to show Montreuil-sur-mer, a small town in the Pas-de-Calais region where Derain did indeed spend the summer of 1909 – but not of 1910. On the basis of the Prague study, attempts are often made to link the Hermitage canvas to Montreuil-sur-mer as well; thus, in Kellerman's catalogue (K. 196), both the Hermitage painting and the study are called *Houses at Montreuil-sur-mer*.

Provenance: acquired from the State Museum of Modern Western Art in 1934; previously in the Kahnweiler Gallery; collection of S. I. Shchukin from 1914; First Museum of Modern Western Painting from 1918; State Museum of Modern Western Art from 1923.

82. Still Life with Earthenware Jug, White Napkin and Fruit, c. 1912 (page 326)
Nature morte avec cruche et nappe blanche
Oil on canvas. 61 x 50 cm
Signed on the verso: *a. derain*
⊡ 8894 K. 318

The realistic depiction of the still life might suggest that this painting dates to the early period in the artist's work. However, it is impossible not to feel that Derain has already experienced the initial stages of Cubism and rejected it in favour of a more measured adherence to Cézanne (in particular, he uses Cézanne's method of *perspective plongeante*). The organisers of the 1967 *Derain* exhibition in Edinburgh dated the painting to 1911. Kellerman moved it forward to 1912. At that time Derain was uncertain as to which path to follow, at one moment rejecting the technique of bold simplification, the next embracing it. It is likely that *Still Life* (New York, Lipsey collection) was painted at the same time as the Hermitage work; the same objects are included in both pictures. The New York still life has rounded edges and the format is almost oval, but it should still be considered a variation of the Hermitage composition.

Provenance: acquired from the State Museum of Modern Western Art in 1948; previously in the Kahnweiler Gallery; collection of S. I. Shchukin from 1914; First Museum of Modern Western Painting from 1918; State Museum of Modern Western Art from 1923.

83. Rocks, 1912 (page 321)
Les rochers
Oil on canvas. 60.5 x 81 cm
Signed on the verso: *a. derain*
⊡ 6541 K. 208

The painting is from a group of works executed in Vers, near Cahors, in 1912. The closest to the Hermitage canvas is *Valley of the Lot at Vers* (1912; New York, Museum of Modern Art), which is the same size and depicts the same rocks but from a deeper perspective.

Provenance: acquired from the State Museum of Modern Western Art in 1930; previously in the Kahnweiler Gallery; collection of S. I. Shchukin from 1913; First Museum of Modern Western Painting from 1918; State Museum of Modern Western Art from 1923.

84. Still Life with Skull, 1912 (page 328)
Nature morte au crâne
Oil on canvas. 72 x 119 cm
Signed on the verso: *a. derain*
⊡ 9084 K. 300

This picture has no analogues in Derain's work. Certain aspects of the pictorial technique, as well as the inclusion of details such as the round-backed chair and the vase with vertical stripes, seen in works of 1912 and 1913, would suggest a similar dating for the Hermitage canvas. 1913 can be discounted since the painting was already in Shchukin's collection at the end of 1912.

Provenance: acquired from the State Museum of Modern Western Art in 1948; previously in the Kahnweiler Gallery; collection of S. I. Shchukin from the end of 1912; First Museum of Modern Western Painting from 1918; State Museum of Modern Western Art from 1923.

85. The Wood, 1912 (page 330)
Le Bois
Oil on canvas. 116.5 x 81.3 cm
Signed on the verso: *a. derain*
⊡ 9085 K. 229

The Wood was painted in Paris in the autumn or right at the end of 1912. It is based upon the artist's impressions of a summer stay in Martigues in Provence. Kellerman called the picture *Grove in Provence*. Derain found several analogous woodland motifs in the area around Martigues, which he interpreted in a conventional manner. The Hermitage canvas can be linked to two landscapes: *In the Wood* and *The Wood* (both in Bern, Rupf collection); it also shares features of *Tree Trunks* (Moscow, Pushkin Museum). The identically named work in the Rupf collection can be regarded as a study for the Hermitage picture: it depicts the same part of the wood with three trees in the foreground, although in terms of form the Hermitage composition is more sculpted and static. The same motif appears in an ink drawing (New York, Hirschland collection), which was possibly drawn from nature. In comparison to the Hermitage painting, the individual trunks and branches are positioned differently. *Grove at Sausset-les-Pins* (1913; Copenhagen, Statens Museum for Kunst; K. 246) is also similar to the Hermitage painting.

Provenance: acquired from the State Museum of Modern Western Art in 1948; previously in the Kahnweiler Gallery; collection of S. I. Shchukin from 1913; First Museum of Modern Western Painting from 1918; State Museum of Modern Western Art from 1923.

86. Table and Chairs, 1912 (page 327)
Table et chaises
Oil on canvas. 88 x 86.5 cm
Signed on the verso: *a. derain*
⊡ 9127 K. 294

The picture was most likely completed in the second half of 1912; by early 1913 it was already in Ivan Morozov's collection, and the Kahnweiler Gallery dated the picture to 1912 (No. 2044). Works of this period were characterised by their pictorial structure and concentric construction. The vase in the foreground is in exactly the same central position as in *The Game-Bag* (1913; Paris, Musée de l'Orangerie). A painting similar in composition to the Hermitage picture is *Still Life with Jug* (Prague, National Gallery). In Kellerman's catalogue the picture is ascribed to 1912 and called *Still life with Compotier*.

Provenance: acquired from the State Museum of Modern Western Art in 1948; previously in the Kahnweiler Gallery; collection of I. A. Morozov from 1913 (purchased from Kahnweiler for 1,600 francs); Second Museum of Modern Western Painting from 1918; State Museum of Modern Western Art from 1923.

87. Martigues (Harbour in Provence), 1913 (page 330)

Martigues (Port en Provence)
Oil on canvas. 141 x 90 cm
Signed on the verso: *a. derain*
⌐⌐ 9101 K. 241

Derain stayed on several occasions at the Mediterranean port of Martigues. In 1908 he painted a panorama of Martigues (Zurich, Kunsthaus) almost from the same viewpoint and similar in style to *Mountain Road* (cat. 80). However, in the summer of 1913 Derain concentrated more on detail and the depth of perspective. Through comparisons of the picture with contemporary photographs of Martigues, it is evident how the architecture of this provincial town – small cube-shaped houses in a simple configuration – prompted the geometrical style of painting, which at least superficially is reminiscent of Cubism. The geometrical approach brings into sharp relief the most essential elements of the natural motif: insignificant details are omitted, for example, from the depiction of the Chapelle d'Annonciation, and the upper part of the bell-tower is slightly changed so that a unified structure is achieved. Kellerman calls the work *View of the Harbour at Martigues*, and cites another smaller version (K. 242).

Provenance: acquired from the State Museum of Modern Western Art in 1948; previously in the collection of S. I. Shchukin from 1914; First Museum of Modern Western Painting from 1918; State Museum of Modern Western Art from 1923.

88. Still Life with Breadbasket, Jug and Wineglass, *c.* 1913 (page 328)

Nature morte
Oil on canvas. 100.5 x 118 cm
Signed bottom right: *a. derain*
⌐⌐ 6542 K. 286

The most likely date for the picture is early 1913 (it is included in the Shchukin collection's 1913 catalogue under the title *Still Life with Fish*). The same basket, jug and glass are found in *The Game-Bag* (Paris, Musée de l'Orangerie). Kellerman's suggested date of 1911 would seem too early. In the catalogue of Derain's retrospective (1994–5) this still life is dated to 1912.

Provenance: acquired from the State Museum of Modern Western Art in 1930; previously in the Kahnweiler Gallery; collection of S. I. Shchukin from 1913; First Museum of Modern Western Painting from 1918; State Museum of Modern Western Art from 1923.

89. Landscape with a Boat (Carrières-Saint-Denis), *c.* 1914 (page 329)

Paysage avec un bateau (Carrières-Saint-Denis)
Oil on canvas. 99 x 65 cm
Signed on the verso: *a. derain*
⌐⌐ 7719 K. 255

Previously this work was called *The Lake*. However, the blurred reflections on the water would seem to indicate a flowing river. By comparing the picture to other landscapes of 1913 to 1914 containing similar motifs, it is possible to conclude that the strip of water is in fact the Seine. Hilaire dates the canvas to 1914, and believes that it shows Carrières-Saint-Denis (G. Hilaire, *Derain* (Geneva, 1959), No. 115). Derain repeatedly worked in this small town on the Seine, not far from Chatou (now within the boundaries of Paris). A very similar motif is used in *Park in Carrières-Saint-Denis* (1909; Villeneuve d'Ascq, Museum of Modern Art), a post-Fauvist landscape, as yet untouched by the influence of Le Douanier Rousseau, with whom the artist became friends at that time but whose methods he turned to only several years later. Nonetheless, the treatment of the houses and trees in *Landscape with a Boat* can certainly be compared with *View of the Fortifications from the Porte de Vanves* by Rousseau (cat. 337). Kellerman dated the picture to 1913 and named it *Banks of the Seine at Carrières-sur-Seine*.

Provenance: acquired from the State Museum of Modern Western Art in 1934; previously in the Kahnweiler Gallery; collection of S. I. Shchukin from 1914; First Museum of New Western Painting from 1918; State Museum of Modern Western Art from 1923.

90. Young Girl in Black, *c.* 1913 (page 332)

Jeune fille en noir
Oil on canvas. 93 x 60.5 cm
Signed on the verso: *a. derain*
⌐⌐ 6577 K. 414

This picture, also known as *Girl in an Armchair* and *Study of a Young Girl*, is sometimes dated to 1913, sometimes to 1914. Evidently it was completed at the end of 1913 and immediately preceded *Portrait of a Young Girl in Black* (cat. 91). It is likely that *Portrait of a Young Girl* (1914; Paris, Musée Picasso; K. 415), a half-length portrait of the same model in the same chair, but with a shawl over her shoulders, is the final one in this series. All the paintings passed through Kahnweiler's gallery, and Kahnweiler dated this canvas to 1914 and *Portrait of a Young Girl in Black* to 1913. However, it seems more likely that *Young Girl in Black* was painted in 1913 directly after *Portrait of Madame Lucie Kahnweiler* (1913; Paris, Centre Georges Pompidou), a similar-sized painting in which the model is also shown in three-quarter profile.

Provenance: acquired from the State Museum of Modern Western Art in 1931; previously in the Kahnweiler Gallery; collection of S. I. Shchukin from 1914; First Museum of Modern Western Painting from 1918; State Museum of Modern Western Art from 1923.

91. Portrait of a Young Girl in Black, 1913–14 (page 333)

Portrait d'une jeune fille en noir
Oil on canvas. 116.5 x 89.3
Signed on the verso: *a. derain*
⌐⌐ 9125 K. 413

The painting was completed in Paris either at the end of 1913 or the very beginning of 1914. It is dated 1913 in a photograph album in the Kahnweiler archive. It is one of Derain's first works to reveal his persistent tendency to paint from life, which came to dominate his creative work after the First World War. A comparison of *Young Girl in Black* (cat. 90) with *Portrait of a Young Girl* (1914; Paris, Musée Picasso) confirms that the girl's appearance has been very faithfully reproduced. It is possible that Derain's singular sense of irony played a part in his choice of format, which is normally used for ceremonial or official portraits (*portraits d'apparat*). Miriam Simon has commented that in painting a front-on view of a rigid figure in a large white lace collar, Derain is somehow linking his heroine to Ingres's hieratic *Napoleon* (1806; Paris, Musée de l'Armée), who sits on his throne in a white ermine cloak (*André Derain: Le Peintre du 'trouble moderne'*, Musée d'art moderne de la ville de Paris, 1994, p. 226).

Provenance: acquired from the State Museum of Modern Western Art in 1948; previously in the Kahnweiler Gallery; collection of S. I. Shchukin from 1914; First Museum of Modern Western Painting from 1918; State Museum of Modern Western Art from 1923.

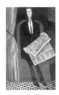

92. Portrait of an Unknown Man Reading a Newspaper (Chevalier X), 1911–14 (page 331)

Portrait d'un homme inconnu au journal (Chevalier X)
Oil on canvas. 162.5 x 97.5 cm
Signed on the verso: *a. derain*
⌐⌐ 9128 K. 425

In *Portrait of an Unknown Man*, or, as Guillaume Apollinaire nicknamed it, *Chevalier X*, Derain distorts nature to a greater extent than ever before in his work. Usually such distortion would be attributed to the influence of African art. It is true that the simplified form of

Chevalier X's head was suggested to some extent by the so-called Fang Mask from the Gabon, which Derain bought off Vlaminck in 1906 (now in the Centre Georges Pompidou, Paris). However in reality the picture presents a synthesis of many diverse elements. First, there is an element of parodying ceremonial portraits. Second, there are allusions to classical European art – from the chessboard patterns of late medieval miniatures in France and Van Eyck's *Arnolfini Marriage* (London, National Gallery), to the young Cézanne's painting of his father with a newspaper. A photograph of Derain's studio taken in 1914 shows, alongside *Portrait of an Unknown Man*, a Romanesque sculpture of the Virgin and Child that belonged to the artist; this was probably the greatest influence of all because Derain uses the same methods of distortion and simplification in the painting as was used in the statue. Inherent to the picture is its distinctive decorative style, created by juxtaposing large areas of colour with patterned surfaces – the mosaic floor and the newspaper. According to Kahnweiler and Salmon, Derain originally used a real newspaper glued to the canvas (a photograph of the picture at this stage exists; Braque and Picasso, who worked in collage using the same newspaper – *Le Journal* – clearly influenced Derain). The painting was completed in its first state in 1911. Then at the beginning of 1914 it underwent alterations: the armchair was originally lower (this is confirmed by an X-ray photograph), and the man's shoulders and arms were also redrawn. The ink drawing *Head of a Roman Emperor* (*c.* 1910–11; Troyes, Musée de l'art moderne) can be considered the study for *Portrait of an Unknown Man*. Derain gave the drawing to André Breton, who carefully kept a reproduction of *Portrait* although he never actually saw it.

Provenance: acquired from the State Museum of Modern Western Art in 1948; previously in the Kahnweiler Gallery; collection of S. I. Shchukin from 1914; First Museum of New Western Painting, Moscow, from 1918; State Museum of Modern Western Art from 1923.

Edouard Detaille
1848, Paris – 1912, Paris

From 1865 Detaille studied under Meissonier, and from 1867 until his death he exhibited at the Salon. He visited Spain, England, Austria and Algeria. In 1888 Alexander III invited him to Krasnoe Selo to attend military manoeuvres; as a result of the trip to Russia he did a number of paintings and drawings, and published an album dedicated to the Russian army. He painted predominantly historical and battle scenes, and also produced illustrations. His paintings of the Franco-Prussian War of 1870 to 1871 were widely known. Detaille had a keen interest in the theatre and opera, and was a friend of the composers Offenbach and Chabrier. He was a member of the Institut de France, and was commissioned by the State to paint important large-scale decorative compositions (for the Hôtel de Ville and Panthéon in Paris, among others). He also received commissions from the English and Russian courts.

93. Chorus of the Fourth Infantry Battalion at Tsarskoe Selo, 1889 (page 72)

Chanteurs du quatrième bataillon de tireurs dans Tsarskoe Selo
Oil on canvas. 79 x 119 cm
Signed and dated bottom left: *Edouard Detaille 1889*
⌐⌐ 4213

This painting was done after Detaille's visit to Tsarskoe Selo in 1888. The action is taking place on the territory of the Tsarskoe Selo Second Rifle Regiment of Life Guards, near the Gatchina Road leading out of the town.

Provenance: acquired in 1925; previously in the collection of Alexander III in the Winter Palace, St Petersburg.

**122. Roofs and the Cathedral in Rouen, 1908
(page 277)**
Les toits et la cathédrale de Rouen
Oil on canvas. 119 x 65.5 cm
Signed and dated bottom right: *Othon Friesz 08*
Г⊋ 9173

Pissarro painted this view of Rouen with the cathedral in the background (*The Old Market in Rouen*; New York, Metropolitan Museum) ten years before Friesz. Here Friesz, while turning to the same motif, has deliberately created an anti-Impressionist painting – its emphatic materiality is shown in the carefully outlined depiction of each building. By not distorting the real details of the landscape, Friesz creates an almost crystallised composition, comparable to the landscapes of early Cubism with their accentuated architectonics while at the same time offering a radical departure from them. Inspired by the lessons of Cézanne, Friesz – in contrast to Braque and Picasso – rejected the distortion of nature and its reduction to original form. A watercolour of Rouen cathedral by Friesz (1908) is in a private collection in Paris. The study for the painting, probably drawn from nature, went to auction at Christie's in London on 26 June 1984 (No. 330). Another study – in the Musée de Grenoble – is painted in a more restrained style and does not have the clear linear structure of the finished painting.

Provenance: acquired from the State Museum of Modern Western Art in 1948; previously in the Galerie Druet, Paris; collection of S. I. Shchukin; First Museum of Modern Western Painting from 1918; State Museum of Modern Western Art from 1923.

123. Hill, 1908 (page 278)
Colline
Oil on canvas. 61 x 74 cm
Signed bottom right: *Othon Friesz*
Г⊋ 6543

It has been suggested that the scene depicted is around Les Andelys, a small town in Normandy. However, at the exhibition of the Salon des Indépendants in the spring of 1908 the picture was shown under the name *Landscape (Provence)*. The motif in the right of the picture is developed in another work entitled *Landscape*, which was shown at an exhibition of the Association of West-German Artists (Sonderbund Westdeutscher Künstler, Städtischer Kunstpalast, Dusseldorf, 1910, No. 75).

Provenance: acquired from the State Museum of Modern Western Art in 1930; previously in the Galerie Druet, Paris, from 1908; collection of I. A. Morozov from 1908; Second Museum of Modern Western Painting from 1918; State Museum of Modern Western Art from 1923.

**124. Still Life with a Statuette of Buddha, 1909
(page 276)**
Nature morte au Bouddha
Oil on canvas. 51 x 42 cm
Г⊋ 6544

The picture was most probably painted in 1909 when it was shown at Friesz's one-man exhibition at the Galerie Druet (No. 47). Another still life with a statuette of Buddha (*Bois-Colombe* (near Paris), Dubois-Pedroc collection) was completed at the same time.

Provenance: acquired from the State Museum of Modern Western Art in 1930; previously in the Galerie Druet, Paris, from 1909; collection of I. A. Morozov (purchased from Druet on his behalf by Marthe Denis, wife of Maurice Denis, for 250 francs) from 1910; Second Museum of Modern Western Painting from 1918; State Museum of Modern Western Art from 1923.

**125. The Temptation (Adam and Eve), *c.* 1910
(page 276)**
La tentation (Adam et Eve)
Oil on canvas. 73 x 60 cm
Signed bottom left: *Othon Friesz*
Г⊋ 8960

The Temptation is a study for *Adam and Eve* (1910; present location unknown), which was exhibited at the Salon des Indépendants in 1910 (No. 1969) and was mentioned by Apollinaire as a significant achievement by the artist. For the study, Friesz has used an old canvas, cut from another large-format composition. Three preparatory drawings called *Adam and Eve* (in ink, pen and pencil) are in the Statens Museum for Kunst in Copenhagen. At the same time, Friesz painted another composition entitled *Adam and Eve* (M. Gauthier, *Othon Friesz*, Geneva, 1957, No. 62, dated 1910), a large decorative work depicting a fantastical flowering garden with various trees, flowers and animals. In this canvas Adam and Eve, although in the foreground, occupy a fairly modest place within the overall composition. Friesz's works depicting the Temptation in the Garden form part of a cycle of paintings on the theme of paradise, executed in 1910: *Paradise*, *Creation of Adam*, *Birth of Eve*, and *The Fall*.

Provenance: acquired from the State Museum of Modern Western Art in 1948; previously in the Galerie Druet, Paris; collection of I. A. Morozov from 1911 (purchased from Druet for 500 francs); Second Museum of Modern Western Painting from 1918; State Museum of Modern Western Art from 1923.

126. Tulips and Marguerites, 1910 (page 278)
Tulipes et marguerites
Oil on canvas. 64.8 x 80.8 cm
Signed and dated left: *Othon Friesz 10*
Г⊋ 7727

Although the influence of Cézanne is evident in the spatial construction of the picture, the decorative and chaotic arrangement of the bouquet is entirely typical of Friesz, who occasionally painted still lifes of flowers in which there is little of Cézanne, but rather a reflection of the artist's dual relationship with the main trends in the avant-garde at the beginning of the twentieth century.

Provenance: acquired from the State Museum of Modern Western Art in 1934; previously in the Galerie Druet, Paris; collection of I. A. Morozov (purchased from Druet for 500 francs) from 1911; Second Museum of Modern Western Painting from 1918; State Museum of Modern Western Art from 1923.

Eugène Fromentin
1820, La Rochelle – 1876, Saint-Maurice, near La Rochelle

Fromentin studied under the landscape painter Nicolas-Louis Cabat. He exhibited at the Salon from 1847. He travelled around North Africa (1846, 1848, 1852), and the impressions gained from these trips defined the subject matter of most of his pictures and travel sketches. He visited Venice (1869), Belgium and Holland (1875). Fromentin was a friend of Gustave Moreau and Georges Sand. He received the Gold Medal at the Exposition Universelle of 1867. He was one of the most important art historians of his time; his book on Dutch and Flemish artists of the sixteenth and seventeenth centuries entitled *Les Maîtres d'autrefois* (1876) was particularly well known, and was published many times over. He also made a significant contribution to fiction as one of the forefathers of the psychological novel (*Dominique*, 1863).

127. Night Robbers, 1868 (page 79)
Voleurs de nuit
Oil on canvas. 102.5 x 166 cm
Signed and dated bottom right: *Eug. Fr-n 68*
Г⊋ 6104

A slightly larger version of the Hermitage picture was painted earlier, with the subtitle *Algerian Sahara* (1865; France, private collection; *Eugène Fromentin*, ex. cat., Musée des Beaux-Arts, La Rochelle, 1988, No. 42). A preparatory drawing of the horse is also in the Musée des Beaux-Arts in La Rochelle. In previous Hermitage catalogues the painting has been called *Arabs Catching Horses* or *Desert Scene*.

Provenance: acquired from the State Museum Fund in 1920.

Paul Gauguin
1848, Paris – 1903, Atuona, Marquesas Islands

Gauguin spent his childhood years (1849–55) in Lima, Peru. As a sailor he sailed on the Southern seas (1865–71). He settled in Paris in 1871, working as a stockbroker and devoting his free time to art. In 1876 one of his landscapes was shown at the Salon. He became a regular visitor to the Café de la Nouvelle-Athènes, where he became good friends with Manet, Degas, Renoir and Pissarro. He gave up his stock market job in 1883 in order to work full-time on his painting. He exhibited at five Impressionist exhibitions (1879, 1880, 1881, 1882, 1886). In 1886 he lived for some of the time in Pont-Aven and some of the time in Paris, where he became acquainted with Van Gogh. In 1888 they lived together in Arles. Gauguin moved away from Impressionism at that time, having developed the style of Synthetism. In Brittany artists attracted to Symbolism grouped around him (the Pont-Aven School). In 1891 he left for Oceania (first Tahitian period, 1891–3). He wrote a book entitled *Noa-Noa*. He lived in Punaauia and Papeete during his second Tahitian period (1895–1901). In August 1901 he moved to the island of Dominica, and settled in the remote village of Atuona. Here he wrote *Racontars de rapin* ('Stories of a Dauber') and the book *Avant et après* ('Before and After'). Alongside his painting, he also produced woodcuts as well as sculptures in wood.

**128. Les Parau Parau (Conversation), 1891
(page 166)**
Les Parau Parau (Les potins)
Oil on canvas. 70.7 x 93 cm
Inscribed, signed and dated bottom left: *Les Parau Parau. P. Gauguin 91*
Г⊋ 898 W.G. 435

A later identically-named version of the Hermitage picture exists (1892; New Haven, Yale University Art Gallery; W.G. 472), in which the group of conversing Tahitians is moved further into the distance. The inscription *Parau Parau* is usually translated as 'gossip' or 'words, words'. A painting of the same name was sent to an exhibition in Copenhagen in December 1892. It is true that there is no consensus among experts about which version of the painting was exhibited in Denmark, but in an accompanying letter to Daniel de Monfreid, Gauguin defined the picture's name more precisely: *Parau Parau (Conversation ou les potins)*. And in a letter about the exhibition to his wife, Gauguin insisted that the catalogue should keep faithfully to the artist's titles. Two drawings from life of the heads of the Tahitians in the upper part of the Hermitage *Conversation* still exist (see J. Rewald, *Gauguin Drawings*, New York–London, 1958, Nos. 76, 93), while the woman sitting in the upper part of the picture is also present in *The Meal* (1891; Paris, Musée d'Orsay), completed at almost the same time.

Provenance: acquired from the State Museum of Modern Western Art in 1948; previously in the Galerie Durand-Ruel, Paris; private collection, Paris; Galerie Vollard, Paris; collection of I. A. Morozov from 1907 (purchased from Vollard together with *Landscape with Peacocks* (Moscow, Puskhin Museum) for 1,500 francs); Second Museum of Modern Western Painting from 1918; State Museum of Modern Western Art from 1923.

129. Fatata te Mouà (At the Foot of the Mountain), 1892 (page 165)
Fatata te Mouà (Au pied de la montagne)
Oil on canvas. 68 x 92 cm
Inscribed, signed and dated bottom right: *Fatata te Mouà. P. Gauguin 92*
⌐Э 8977 W.G. 481

The former Governor of Tahiti, Bengt Danielsson, has observed that the landscape depicts the south coast of the island. Gauguin lived there in the village of Mataiea from the end of 1891 to the middle of 1893. The large tree, the main feature of this landscape, also appears in two other works of 1892: *Women by the River* and *Matamua (In Former Times)* (W.G. 482, 467), and later in *Hina Maruru (The Festival of Hina)* (1893; W.G. 500) and in the Hermitage picture *Nave Nave Moe (Sacred Spring)* (cat. 132). The study *Women by the River* and *At the Foot of the Mountain* were the first to contain the motif of the tree, and unlike *Matamua* and the later compositions they have no religious or symbolic content. In the latter the motif of a large tree is linked in the artist's mind to the image of Hina, the Tahitian goddess of the moon. *Fatata te Mouà* was known for many years as *Large Tree*, which was the name it bore when it was acquired by Ivan Morozov from Vollard. However, as Charles Sterling has commented, the Tahitian title should be translated differently, and *Large Tree* was the title Gauguin himself gave to two other canvases completed a year earlier (W.G. 437, 439). The picture was shown at an exhibition of Gauguin's work at the Galerie Durand-Ruel in 1893 (*Exposition d'oeuvres récentes de Paul Gauguin*, Galerie Durand-Ruel, Paris, No. 26) and Gauguin refers to it in a letter concerning the sale in 1895: 'I am holding the prices at their catalogue level for a few more days, exclusively for friends who have been loyal to me during this time: *Fatata te Mouà*… 400' (see *Gauguin*, ex. cat., Paris, Musée de l'Orangerie, 1949, Appendix III).

Provenance: acquired from the State Museum of Modern Western Art in 1948; previously in the Galerie Vollard; collection of I. A. Morozov from 1908 (purchased from Vollard for 800 francs); Second Museum of Modern Western Painting from 1918; State Museum of Modern Western Art from 1923.

130. Pastorales Tahitiennes, 1892 (page 167)
Oil on canvas. 87.5 x 113.7 cm
Inscribed, signed and dated bottom right:
Pastorales tahitiennes 1893 Paul Gauguin
⌐Э 9119 W.G. 470

Although the picture was already completed by December 1892, Gauguin attached particular importance to it and dated it to the following year. In *Pastorales Tahitiennes* Gauguin takes up again the theme of Maori music, having explored it in three works completed just before the Hermitage canvas: *Matamua (In Former Times)* (1892; New York, private collection; W.G. 467), *Arearea I (Pastimes)* (1892; Paris, Musée d'Orsay; W.G. 468) and *Arearea II* (1892; Houston, Museum of Fine Arts; W.G. 469). In all these compositions two Tahitian girls are shown seated, one playing the flute while the other listens; in the first two compositions they are sitting by the large tree. The Musée d'Orsay painting is particularly close to *Pastorales Tahitiennes*, with a virtually identical landscape background; it can be seen as a smaller version of the Hermitage canvas. *Pastorales Tahitiennes* was probably preceded by a watercolour entitled *Tahitian Scene* (1891–2; Stockholm, Thielska Galleriet), which, in its faithful depiction of nature and unstylised treatment, can be seen as a preparatory study for the finished work. The watercolour, however, depicts three rather than two Tahitians, occupying different positions within the composition and striking slightly different poses. The figure of the seated woman in the watercolour does not appear in *Pastorales Tahitiennes* but is depicted later in the background of *Eü haere ia oe* (cat. 131).

Provenance: acquired from the State Museum of Modern Western Art in 1948; previously in the Galerie Durand-Ruel, Paris, from 1893; sale of Gauguin's paintings and drawings at the Hôtel Drouot (No. 5) on 18 February 1895; private collection, Paris; Galerie Bernheim-Jeune, Paris; Galerie Vollard, Paris; collection of I. A. Morozov from 1908 (purchased from Vollard for 10,000 francs); Second Museum of Modern Western Painting from 1918; State Museum of Modern Western Art from 1923.

131. Eü haere ia oe (Woman Holding a Fruit), 1893 (page 169)
Eü haere ia oe (Où vas-tu?). La femme au fruit
Oil on canvas. 92.5 x 73.5 cm
Signed, dated and inscribed bottom left: *P. Gauguin 93. Eü haere ia oe*
⌐Э 9120 W.G. 501

The motif of a Tahitian Eve goes back to *Te Nave Nave Fenua (Sweet Earth)* (1892; Kurashiki, Ohara Museum; W.G. 455). *Woman Holding a Fruit* can be usefully compared to *Sweet Earth*, being identical in size and scale, although in the latter work Gauguin's powerful heroine is depicted full-height, barely fitting the frame, and thus appears even more monumental. In *Woman Holding a Fruit* the figure of the woman is cut off from below – the artist's perspective moves upwards, and in this new arrangement the relationship between the figure and the background is changed: the sky has significantly greater prominence, while the surroundings as a whole are more tranquil, the structure more harmonious. The Hermitage picture was preceded by *E haere oe i hia* (1892; Stuttgart, Staatsgalerie; W.G. 478), similar in size but more elongated; this was the first version of the composition. Both Tahitian titles, inscribed by Gauguin himself on the canvases, are translated: 'Where are you going?' The Hermitage composition has not been widely known by this name because its subject matter is less clear than in the Stuttgart version. When Ivan Morozov acquired the painting he did not know the translation of the inscription, and so affixed the title *Woman Holding a Fruit*. This title does not contradict the symbolism of the work, nor does it demand the detailed explanation required by the artist's 'Where are you going?' Danielsson, well versed in Tahitian customs and way of life, has pointed out that Tahitians greet those they meet with the question 'Where are you going?' The woman is holding a vessel made from a pumpkin which doubtless contains water. In this case, however, the words 'Where are you going?' are not simply formulaic but pose a real question revealing the central idea of the picture. The two canvases have much in common: almost identical backgrounds with two Tahitians sitting to the left (they are asking the question), and almost the same amount of space given up to the central character. But here too is the essential difference between the two paintings: in the Stuttgart version the woman is holding a little animal that looks like a small dog with an unusual fluffy tail. No comparable example of this type of small animal exists in Gauguin's work. He frequently painted dogs – mangy island dogs similar to those depicted in *Pastorales Tahitiennes* (cat. 130), *Scene from the Life of the Tahitians* and *Motherhood* – but they look very different. The woman in the Stuttgart picture is also wearing a different skirt, without the yellow floral pattern, and the red colour is less festive. Most importantly of all, the woman herself is quite different. She is older, with a short neck and a more Mongoloid face: a flatter nose and thinner lips. She also holds herself differently, and the expression on her face is unequivocal. She reacts almost with suspicion to the 'Where are you going?' greeting, trying not to look in the direction from which it has come. There is an implicit sense of hidden drama and conflict. The Stuttgart version probably depicts Titi, who for a short time was Gauguin's lover, and whom he had sent for from Papeete. The tension that arose between them is reflected in the constrained pose of the woman. It seems that the strange animal she is holding owes more to Maori legend than to reality. It hardly looks like a dog, but then Tahitian dogs, as is seen in the Hermitage canvases, look completely different. It has long been noted that the female figure in the Stuttgart picture became the prototype for Gauguin's sculpture *Oviri (The Savage)* and for the Hermitage picture entitled *Idol* (cat. 138). The main difference between the two paintings is the depiction of the woman in the foreground. In the Hermitage canvas she is recognisable as Teha'amana, Gauguin's Tahitian *vahiné*, an identification made possible by comparing the Hermitage canvas with several earlier works accepted as depictions of Teha'amana (for example the drawing *Portrait of Teha'amana* (1892; Chicago, Art Institute), the sculpture *Head of a Tahitian Woman* (c. 1892; Paris, Musée d'Orsay; G. 98) and the painting *Vahiné no te vi (Woman with a Mango)* (1892; Baltimore Museum of Art; W.G. 449). It is surprising that in the extensive literature about *Woman Holding a Fruit* the central character has generally been regarded as a collective, unspecified figure. Iconographically the figure is based on a detail from a relief in Borobudur cathedral (Gauguin took a photograph of the cathedral with him to Tahiti). The painting *Landscape with Black Pigs and Crouching Tahitian Woman* (1891; Scotland; W.G. 445) includes a figure which Gauguin subsequently used in the central section of *E haere oe i hia*, and in the Hermitage version as well, having previously occupied a prominent place in another symbolic composition *Nafea Faa Ipoipo? (When will you marry?)* (1892; Basle, Kunstmuseum, Staechelin collection; W.G. 454). This figure is also depicted in *Te fare hymenee (House of Songs)* (1892; Annapolis, Mitchell collection; W.G. 477), and in Gauguin's drawings.

Provenance: acquired from the State Museum of Modern Western Art in 1948; previously in the Galerie Vollard; collection of I. A. Morozov from 1908 (purchased from Vollard for 8,000 francs); Second Museum of Modern Western Painting from 1918; State Museum of Modern Western Art from 1923.

132. Nave Nave Moe (Sacred Spring), 1894 (page 171)
Nave Nave Moe (Eau délicieuse/Douces rêveries)
Oil on canvas. 74 x 100 cm
Inscribed, signed and dated bottom left: *NAVE NAVE MOE P. Gauguin 94*
⌐Э 6510 W.G. 512

The painting's second title, *Sacred Spring* (traditionally used in Russia), originates from the catalogue of the 1895 exhibition and sale of Gauguin's work, where it was probably named by the artist himself (it is listed in the catalogue as *Eau délicieuse*). However, the Tahitian title inscribed on the canvas translates differently. Georges Wildenstein interpreted it as *The Joy of Repose*, while Bouge and Danielsson have suggested more precise versions: *Sweet Reveries* or *Sweet Dreams*. Gauguin painted the picture in between two journeys to Tahiti. It was completed at the beginning of 1894 after the creation of two stained-glass windows which Gauguin made at the end of the previous year for his Parisian studio: *Nave Nave* and *Tahitian Woman in a Landscape* (Paris, Musée d'Orsay) (W.G. 510, 511). Both windows contain the lily which Gauguin subsequently used in *Sacred Spring*. The Hermitage canvas was painted in Paris as a memory of Oceania, entirely composed from images dating to Gauguin's first Tahitian period. The studio in Paris was full of canvases brought back from the tropics. The figures in the foreground are found in *Te fare maorie (Maori House)* (1891; W.G. 436); the woman sitting naked in the centre is repeated in *Aha oe feii (So you are jealous?)* (1892; Moscow, Pushkin Museum; W.G. 461); and the woman standing next to her is seen in three pictures of 1892 (W.G. 472–4). The double-headed Tahitian god is also depicted in *Vairaoumati tei oa (Her Name is Vairaoumati)* (1892; Moscow, Pushkin Museum; W.G. 450). Richard Field has suggested that this sculpture represents the supreme god Taaroa and one of his wives (see R. S. Field, *Paul Gauguin: The Paintings of the First Voyage to Tahiti*, New York–London, 1977, p. 95). The picture Gauguin has most clearly drawn upon when painting *Sacred Spring* is *Women by the Bank of a River* (Paris, private collection; W.G. 574). Wildenstein dates it to 1898 – incorrectly, since the picture was obviously brought to Paris from Tahiti. It reproduces the right-hand and central sections of *Sacred Spring* and was painted if not from life then from living impressions in a fairly impressionistic manner. Gauguin later rejected this style in favour of more stylised and generalised synthetist compositions, steeped in religious meaning of a particular nature. The need to express these ideas is evident in the inclusion of the double-headed idol in the landscape (which was not present in *Women by the Bank of a River*) and the figures in the foreground of the Virgin Mary and Eve with an apple, both depicted as Tahitians.

Provenance: acquired from the State Museum of Modern Western Art in 1931; previously in the exhibition and sale of Gauguin's work at the Hôtel Drouot (No. 23) on 18 February 1895; collection of Emile Schuffenecker from 1895 (purchased for 340 francs); Dosbourg sale, Paris, on 10 November 1897 (No. 16; 160 francs); collection of Prince Wagram; Galerie Vollard; collection of I. A. Morozov from 1908 (purchased from Vollard for 8,000 francs); Second Museum of Modern Western Painting from 1918; State Museum of Modern Western Art from 1923.

133. Te Vaa (Canoe), 1896 (page 173)
Te Vaa (La Pirogue)
Oil on canvas. 95.5 x 131.5 cm
Inscribed, signed and dated bottom left: *Te Vaa P. Gauguin 96*
⌐Э 9122 W.G. 544

The Tahitian name for the picture translates as *pirogue*, or canoe. The idea for the canvas comes from *The Poor Fisherman* by Puvis de Chavannes (1881; Paris, Musée d'Orsay; study in Moscow, Pushkin Museum), which Gauguin saw at the Salon of 1881. *Te Vaa* was meant to be a Tahitian version of this painting. Following in Puvis's footsteps, Gauguin explores the theme of the family (in Russia for several decades the picture was called *Tahitian Family*) but treats it very differently. The characters in Puvis de Chavannes' work are separated spatially while here they are placed as close to each other as possible, with the result that the figure of the Tahitian woman is even shown in incorrect perspective. There exists a smaller version of the composition with a single figure entitled *The Poor Fisherman* (1896; Sao Paolo, Museu de arte; W.G. 545). Gauguin did a woodcut of the drinking fisherman, from which he made a print, painted it in watercolour, and stuck it into the manuscript of *Noa-Noa* (Paris, Louvre, Cabinet des dessins). He did the same with a watercolour of a group of Tahitians, in which one of the figures is recognisable as the woman in *Te Vaa*. The mountain is also reproduced separately in *Landscape for Te Vaa* (1896; Le Havre, André Malraux Museum of Fine Arts).

Provenance: acquired from the State Museum of Modern Western Art in 1948; previously in the collection of M. A. Morozov; collection of M. K. Morozova from 1903; Tretyakov Gallery from 1910 (donated by M. K. Morozova); State Museum of Modern Western Art from 1925.

134. Scene from the Life of Tahitians, 1896 (page 172)
Scène de la vie tahitienne
Oil on canvas. 90 x 125.7 cm
Signed bottom right: *P. Gauguin*
⌐Э 8980 W.G. 435

The date *96* is no longer visible, but was undoubtedly present when the picture was registered by the First Museum of Modern Western Painting in Moscow. Sergei Shchukin probably named the work; the vagueness of the title says much about the difficulty in understanding the subject. It is possible to suggest that the characters in the painting are preparing for some type of ritual activity, a theory supported by the time of day – approaching dusk. The ceremonial poses and serious expressions on the faces of the characters underline this sense of ritual. Indirect confirmation of this assumption is also found in the main iconographical source of the composition. Bernard Dorival has commented that the figure of the woman with a raised arm in the picture *The Summons* (1902; Cleveland, Museum of Art; W.G. 612) is based upon a figure on the east section of the Parthenon frieze – the relief of Eros and the Elders. In Gauguin's work the figure is shown in mirror image. In *Scene from the Life of Tahitians* this character is shown straight on and is much closer to the original. If one agrees with Dorival's observation, it is possible to conclude that the poses of the other characters in *Scene* were also taken from the Parthenon frieze: for example, the horseman at the back, and the two figures in the foreground on the right. Comparison of the Hermitage composition with the depiction of the Panathenaic procession on the Parthenon relief provides further evidence that

Scene from the Life of Tahitians may have religious overtones, especially since Gauguin viewed the customs and way of life of the Tahitians as a form of 'living' antiquity. Gauguin also used an ancient iconographical source for the man on the left (who has returned from hunting, and is looking sideways at the woman standing nearby): the warrior from the relief on Trajan's Column (Gauguin took a photolithograph of a detail of the relief with him to Oceania). He later repeated this portrayal of the hunter in one of his woodcuts (see M. Guérin, *L'Oeuvre gravé de Gauguin*, Paris, 1927, No. 64) and in the monotype *Return from the Hunt* (1902; Frankfurt am Main, Städtisches Kunstinstitut), which also includes a horseman. The preparatory drawing (1896) for the picture is in the collection of Lawrence Saphire in New York.

Provenance: acquired from the State Museum of Modern Western Art in 1930; previously in the collection of S. I. Shchukin (purchased before 1910); First Museum of Modern Western Painting from 1918; State Museum of Modern Western Art from 1923.

135. Infant (Nativity), 1896 (page 174)
Bébé (La Nativité)
Oil on canvas. 67 x 76.5 cm
Inscribed, signed and dated bottom left: *Bébé P. Gauguin 96*
⌐Э 6566 W.G. 540

Gauguin wrote to Daniel de Monfreid in November 1896: 'Soon I will become the father of a half-yellow baby – my wonderful Dulcinea has finally decided to enter the world.' In December the young Pau'ura, his second Tahitian wife, gave birth to a daughter, who only lived for ten days. Two canvases are connected with the birth and death of the baby, and were painted at the end of December: *Infant* and *Te Tamari no atua (Nativity)* (Munich, Neue Pinakothek; W.G. 541). It would seem that they were worked on simultaneously. Although the Munich version is significantly larger, both works merit equal attention: while sharing the same subject, they address various compositional problems. In the Munich picture the woman in childbirth occupies the entire foreground, whereas in the Hermitage version the scene is shown further back. The central position in the Hermitage canvas is given over to the Tahitian woman with her dead child (the embodiment of Tupapao – the spirit of the dead) and the angel of death in mourning clothes (in contrast to the angel of the Annunciation). The mother and angel are repeated with just a few changes to the background in the Munich canvas. And the halo, which is hardly visible in the Hermitage composition, is precisely drawn above the baby's head in *Te Tamari no atua*. There is also a similarity in the faces of the woman sitting with her dead child and the mother in childbirth, only the latter is younger if more emaciated-looking. For the background of both works Gauguin used a photograph of *Interior of a Stable* (1837) by Octave Tassaert from the collection of his godfather Gustave Arosa. In the Munich *Nativity* he reproduced Tassaert's composition exactly, whereas *Infant* is a freer version. The bull at the back is taken from his own *Christmas Night* (1894; New York, Small collection; W.G. 519). In 1897 the picture was shown at the fourth exhibition of *La Libre Esthétique* (No. 281) in Brussels, and in 1903 at his one-man exhibition at the Galerie Vollard (No 28).

Provenance: acquired from the State Museum of Modern Western Art in 1931; previously in the Galerie Vollard; collection of S. I. Shchukin from 1906 or 1907; First Museum of Modern Western Painting from 1918; State Museum of Modern Western Art from 1923.

136. Tarari Maruru (Tahitian Landscape with Two Goats), 1897 (page 178)
Tarari Maruru (Paysage tahitien avec deux chèvres)
Oil on canvas. 95.5 x 73 cm
Inscribed, signed and dated bottom right: *Tarari maruru P. Gauguin 97*
⌐Э 7707 W.G. 562

The picture's Tahitian name has not yet been satisfactorily deciphered. Danielsson has translated it as *The Satisfaction of Small Horns* or *The Satisfaction of Tarari*, if we can take Tarari as a proper name. The painting is linked to a large canvas completed in the same year entitled *Who are we? Where are we from? Where are we going?* (Boston, Museum of Fine Arts; W.G. 561). The figure of the woman on the right-hand side of the Hermitage canvas is similar both to the Tahitian woman beside the idol in the Boston canvas, and to the figure in its study *Tahiti: Characters from Who are we?...* (1897; New York, private collection; W.G. 560). The goats are also found in another picture of 1897, *Man Picking Fruit from a Tree* (cat. 137). The preparatory watercolour for *Landscape with Two Goats* was used to illustrate the manuscript of *Noa-Noa* (Paris, Louvre, Cabinet des dessins); it differs from the Hermitage canvas only in some small compositional details, in particular, the absence of the lily.

Provenance: acquired from the State Museum of Modern Western Art in 1934; previously sent by Gauguin to the Galerie Vollard, Paris, on 8 December 1898; Galerie Vollard; collection of M. A. Morozov; collection of M. K. Morozova from 1903; Tretyakov Gallery from 1910 (donated by M. K. Morozova); State Museum of Modern Western Art from 1925.

137. Man Picking Fruit from a Tree, 1897 (page 178)
Homme cueillant des fruits dans un paysage jaune
Oil on canvas. 92.5 x 73.3 cm
Signed and dated bottom left: *P. Gauguin 97*
⌐Э 9118 W.G. 565

Like *Landscape with Two Goats* (cat. 136), this picture is linked to the large composition *Who are we? Where are we from? Where are we going?* (Boston, Museum of Fine Arts; W.G. 561). The central position in the Boston panel is occupied by a man with his arm raised to pick fruit from a tree. He is depicted in the same way in the panel's preparatory canvas, which the artist called *Tahiti: Characters from Who are we?...* (1897; New York, private collection; W.G. 560): almost naked, in a simple loincloth. The symbolic role of the character, with the allusion to the tree of knowledge, is self-evident. However, in *Man Picking Fruit from a Tree* the philosophical idea is more indistinct, and the work is more like a simple everyday scene. With this in mind, it is possible to suggest that the Hermitage canvas was completed before the Boston panel. The man in the Hermitage composition also appears later in *Faa ara (Awakening)* (1898; Copenhagen, Ny Carlsberg Glypotek; W.G. 575).

Provenance: acquired from the State Museum of Modern Western Art in 1948; previously sent by Gauguin from Tahiti to the Galerie Vollard on 9 December 1898; Galerie Vollard; collection of S. I. Shchukin; First Museum of Modern Western Painting from 1918; State Museum of Modern Western Art from 1923.

138. Idol (Rave te hiti aamu), 1898 (page 175)
Rave te hiti aamu (L'idole)
Oil on canvas. 73.5 x 92 cm
Signed, dated and inscribed bottom left: *P. Gauguin 98. Rave te hiti aamu*
⌐Э 9121 W.G. 570

The artist's inscription has never been satisfactorily interpreted. It seems that Gauguin, with an imperfect knowledge of the Kanak language, made mistakes. L.-J. Bouge, the former governor of Tahiti, interpreted the inscription as *The Presence of an Evil Monster*. Danielsson, unable to give a coherent translation, gave the meaning of each word separately: *rave* – to seize, *te hiti* – monster, *aamu* – glutton. The idol was first depicted in this form in *E haere oe i hia* (1892; Stuttgart, Staatsgalerie; W.G. 478). The beast-like figure shown in *Idol* is clasping a creature with a fluffy tail, which is difficult to identify, although some of the artist's earlier works do offer clues: two monotypes (1894; see R. Field, *Paul Gauguin: Monotypes*, Philadelphia, 1973. Nos. 30, 31); two woodcuts (1894–5; see M.

Guérin, *L'Oeuvre gravé de Gauguin*, Paris, 1927, Nos. 48, 49); and, most importantly, a ceramic sculpture (winter 1894–5; G. 113). All these works are entitled *Oviri*, the word Gauguin wrote on the sculpture's pedestal. Danielsson and other researchers of the Tahitian inscriptions have translated the word as 'wild animal'. All these works, as well as the Hermitage *Idol*, reveal the development of Gauguin's antithesis to the theme of paradise, based on an Oceanic motif. The figure of a woman with a wild animal first appeared in the Stuttgart painting, and was then grotesquely exaggerated in the monotypes and, above all, in the sculpture of a gorilla-like creature. A dead wolf lies at her feet, while in her arms she holds a mongrel cub – the fruit of her union with the wolf. The image of *Oviri* in the sculpture is imbued with the esoteric, religious concept of resurrection and self-sacrifice in the cause of prolonging the race: the wolf perishes so that the cub can be born into the world. Gauguin singled out the sculpture of *Oviri*. He called it *The Murderer*, implying thereby that life and death are inseparable – a belief he held even before his trip to Tahiti. He wrote to Redon in September 1890 about one of his images: 'Not death in life, but life in death' (R. Bacou, *Lettres de Gauguin: Gide, Huysmans, Jammes, Mallarmé, Verhaeren… à Odilon Redon*, Paris, 1960, p. 194). The wolf depicted in the sculpture is an extremely important personal motif, for Gauguin compared himself to the solitary wolf and was pleased when Degas, quoting from La Fontaine's fable *The Dog and the Wolf*, compared him to one. The sculpture of *Oviri* is similar to the idol in the Hermitage picture that was reproduced as a woodcut; one print from the woodcut was painted in watercolour and used to illustrate the manuscript of *Noa-Noa* (Paris, Louvre, Cabinet des dessins), while another bears the following dedication: *A Stephane Mallarmé cette étrange figure, cruelle enigme. P. Gauguin. 1895* (Chicago, Art Institute). It was at the same time that Gauguin depicted the idol in the ceramic sculpture *Oviri (Wild Animal)* (1895; Paris, Musée d'Orsay). In October 1900 he wrote to Daniel de Monfreid in Paris asking him to return the sculpture of *Oviri* so that he could decorate his garden with it, and after his death – his grave. It is known that when working on the head of the statue, Gauguin reproduced the features of a mummy of a Marquesas supreme leader, who had passed through death to become a god. The sculpture shown in the Hermitage painting has often been seen as a depiction of the Marquesas god Tiki, but more recently the sculpture has been conclusively identified with *Oviri*.

Provenance: acquired from the State Museum of Modern Western Art in 1948; previously sent by Gauguin from Tahiti to the Galerie Vollard on 9 December 1898; Galerie Vollard; collection of S. I. Shchukin; First Museum of Modern Western Painting from 1918; State Museum of Modern Western Art from 1923.

139. Maternity (Women by the Sea), 1899 (page 179)

Femmes au bord de la mer (Maternité)
Oil on canvas. 95.5 x 73.5 cm
Signed and dated bottom right: *Paul Gauguin 99*
ГЭ 8979 W.G. 581

In March 1899 Pau'ura gave birth to a son whom Gauguin called Emile (his older son by Mette, who remained in Copenhagen, was also called Emile). Danielsson and various other experts associate two paintings with this event; after Wildenstein, they are usually called *Maternity I* (Hermitage) and *Maternity II* (New York, David Rockefeller collection). The New York canvas is notable for its brighter, more decorative effect; it also differs from the Hermitage work in that the dog and people in the background are absent. The New York work is undated, but was probably completed in 1899, most likely after *Women by the Sea*. The Hermitage composition is one of a series of ten canvases that Gauguin sent to Vollard in January 1900 with the following description: 'Three figures. In the foreground a seated woman breast-feeds her baby. To the right a small black dog. To the left a woman standing in a red dress with a basket. Behind, a woman in a green dress holding flowers. Background of blue lagoons against orange-red sand.' (J. de Rotonchamp, *Paul Gauguin*, Paris, 1925, p. 221). In creating

Women by the Sea, Gauguin has combined real-life observations, the iconography from Old Master scenes of the Adoration, and the compositional techniques of Puvis de Chavannes. Gauguin definitely knew Puvis's decorative panels *Young Girls by the Sea* (1879) and *Sweet Land* (1882). He also recalled his own characters from *Three Tahitians* (1897; Edinburgh, National Gallery of Scotland; W.G. 573). The figure of the woman holding flowers in the centre of the composition is one of the most recurring images in Gauguin's painting of the time, and appears in other works of 1899: *Two Tahitian Women (Breasts with Red Flowers)* (New York, Metropolitan Museum; W.G. 583), *Rupe Rupe* (Moscow, Pushkin Museum; W.G. 585), *Te Avae No Maria* (cat. 140) and various other works. The picture was shown at Gauguin's one-man exhibition at the Galerie Vollard in 1903 (No. 2).

Provenance: acquired from the State Museum of Modern Western Art in 1948; previously in the Galerie Vollard from 1900; collection of S. I. Shchukin from 1903 or 1904; First Museum of Modern Western Painting from 1918; State Museum of Modern Western Art from 1923.

140. Te Avae No Maria (The Month of Mary), 1899 (page 176)

Te Avae No Maria (Le mois de Marie)
Oil on canvas. 96 x 74.5 cm
Inscribed, signed and dated bottom left: *TE AVAE NO MARIA. Paul Gauguin 1899*
ГЭ 6515 W.G. 586

The picture is also known as *Woman Holding Flowers*, and was among the canvases that Gauguin sent to Vollard in 1903: 'Te Avae No Maria. A woman holding flowers against a yellow-green background. To the left a fruit tree and an exotic plant.' (J. de Rotonchamp, *Paul Gauguin*, Paris, 1925, p. 221). The Tahitian title translates as 'The Month of Mary' – the month dedicated by the Catholic Church to the Virgin Mary (May services). In Western Europe, too, the beginning of May has traditionally been celebrated as a pagan May festival focusing on the blossoming of nature, and it is this that is central to Gauguin's painting, emphasised by the yellow background and the depiction of the woman, her pose taken from the a relief at Borobudur entitled *The Ablutions of Bodhisatva* (*c*. 800). Gauguin took a photograph of the relief with him to Tahiti, and from 1898 to 1899 often returned to the pose of the stone figure from the Javan temple. The exotic plant also has a prototype in the Borobudur relief. The main components of the picture already appear in *Faa Iheihe (Tahitian Pastoral)* (1898; London, Tate Gallery; W.G. 569). The far left part of the composition was repeated with minor changes in *Rupe Rupe* (1899; Moscow, Pushkin Museum; W.G. 585) and became the main motif for *Te Avae No Maria*. Furthermore, the heroine's gesture is repeated in other canvases of 1899: *Three Tahitian Women against a Yellow Background* (cat. 141); two versions of *Maternity* (cat. 139) and *Te tiai na oe ite rata (Are you waiting for a letter?)* (W.G. 587).

Provenance: acquired from the State Museum of Modern Western Art in 1930; previously in the Galerie Vollard, Paris, from 1903 (sent by Gauguin from Atuona); collection of S. I. Shchukin (acquired before 1910); First Museum of Modern Western Painting from 1918; State Museum of Modern Western Art from 1923.

141. Three Tahitian Women against a Yellow Background, 1899 (page 177)

Trois femmes tahitiennes sur fond jaune
Oil on canvas. 68 x 73.5 cm
Signed and dated bottom right: *Paul Gauguin 99*
ГЭ 7708 W.G. 584

Like *Te Avae No Maria* (cat. 140), this painting was inspired by the bas-relief frieze from the site of Borobudur in central Java. This time Gauguin reproduced both the pose of the central figure and the pattern of foliage in the upper half of the canvas. Gauguin also developed the motif from the left part of the symbolic composition

Faa Iheihe (Tahitian Pastoral) (1891; London, Tate Gallery; W.G. 569), in which three Tahitian women are portrayed in a similar pose. They reappear in *Rupe Rupe* (1899; Moscow, Pushkin Museum). A yellow background links all four canvases. The painting cannot be considered purely decorative, for the symbolism of the works mentioned above operates here as well. The poses of the figures suggest a starting point for a symbolic interpretation: two women turning away from the one standing between them. A precise interpretation, however, has still not been discerned.

Provenance: acquired from the State Museum of Modern Western Art in 1934; previously in the Galerie Vollard (sent by Gauguin from Atuona) from 1903; Gertrude Stein collection, Paris, *c*. 1905; Galerie Vollard again; collection of I. A. Morozov, Moscow (purchased from the Galerie Vollard for 10,000 francs) from 1910; Second Museum of Modern Western Painting from 1918; State Museum of Modern Western Art from 1923.

142. Sunflowers, 1901 (page 180)

Les tournesols
Oil on canvas. 73 x 92.3 cm
Signed and dated bottom right: *Paul Gauguin 1901*
ГЭ 6516 W.G. 603

Although he executed this painting in Hivaoa in the Marquesas Islands, Gauguin used the compositional elements of a work he had created eleven years earlier, *To Make a Bouquet* (1880; Switzerland, Wintertur, Jäggli-Corti collection; W.G. 49). The sunflower motif came from Van Gogh. In 1881, when both artists were living in Arles, Gauguin painted *Van Gogh Painting Sunflowers* (1888; Amsterdam, State Museum of Vincent Van Gogh; W.G. 296). He turned to this theme again in 1901, producing four still lifes with sunflowers, including the Hermitage one (W.G. 602–604, 606). The still life *Sunflowers in an Armchair* (Zurich, Stiftung Sammlung Bürhle; W.G. 602) is compositionally so similar to the Hermitage picture that Wildenstein referred to both of them as *Sunflowers in an Armchair*, 'one' and 'two', respectively. There are subtle differences between them, however: the smaller Zurich canvas lacks the mystery of the Hermitage work; the armchair faces the front, and the head in the window is absent. Gauguin recreated the head in the window of the Hermitage canvas in a drawing he did for his manuscript *Before and After* (J. Rewald, *Gauguin Drawings*, New York, 1958, no. 119).

Provenance: acquired from the State Museum of Modern Western Art in 1931; previously in the collection of S. I. Shchukin (acquired before 1908); First Museum of Modern Western Painting from 1918; State Museum of Modern Western Art from 1923.

Henri Jules Jean Geoffroy
1850, Marennes (Maritime Charente) – 1924, Paris

Geoffroy studied under Levasseur and Adannes, and exhibited at the Salon from 1874 to 1924. He designed decorative murals commissioned by the state. He was a painter (mainly genre compositions), sculptor and illustrator.

143. Study of the Head of an Old Woman, 1880s (page 83)

Étude d'une tête de vieille
Oil on cardboard pasted on plywood. 45.5 x 39.5 cm
ГЭ 4249

This painting might have belonged to the Russian painter Igor Grabar, for his signature is located on the verso of the plywood: *Жеффруа, Париж, XIX век (80-ые годы) Игорь Грабарь* [Geoffroy, Paris, XIX c. (80s) Igor Grabar]. Although the painting was considered a portrait and was sent as such to an exhibition of European portraiture in Moscow (1972), it is actually a study for one of Geoffroy's genre compositions.

Provenance: acquired from the State Museum Fund in 1920.

Jean-Léon Gérôme
1824, Vésoul, Haute-Saône – 1904, Paris

From 1842 Gérôme studied at the Ecole des Beaux-Arts under Paul Delaroche, accompanying him to Italy in 1844. After returning to Paris, he studied briefly under Charles Gleyre, then again under Delaroche. From 1847 to 1903 he exhibited at the Salon. From 1863 he taught at the Ecole des Beaux-Arts and in 1865 he became a member of the Institut de France. He travelled extensively (Italy, Turkey, Egypt, Russia). He painted mostly historical and Oriental compositions, and portraits.

144. General Bonaparte with His Military Staff in Egypt, 1863 (page 66)
Le général Bonaparte avec son état-major en Egypte
Oil on wood. 21 x 33 cm
Signed and dated bottom left: *J. L. GEROME 1863*
⌐ Э 5798 A. 172B

This is a study for a large composition executed in 1867 and engraved by Adolphe Goupil, the present whereabouts of which are unknown. Entitled *Napoleon in Egypt* in early Hermitage catalogues, the picture is notable for its high level of detail and finish. Ackerman designated it one of Gérôme's best studies. A comparison of the two works reveals that the later canvas underwent few compositional changes. The painting depicts an episode from Bonaparte's Egyptian Campaign in the summer of 1799: exhausted and defeated, the commander-in-chief of the French expeditionary army is returning from Syria. Plague, disease, enormous casualties, and the futile siege at Acre made Bonaparte retreat and renounce his initial plans. Indeed, he said: 'Had Acre fallen, I would have changed the world.' One of the sources Gérôme apparently consulted for the painting was Horace Vernet's *Histoire de Napoléon* (Paris, 1842), which was copiously illustrated with prints. The chapter devoted to the Egyptian campaign contains a print of Napoleon on a camel; camels also appear in the final print of the chapter. Evidently Vernet's images had a profound effect on the young Gérôme when he first explored the theme of Napoleon's Egyptian campaign in his small painting *General Bonaparte in Egypt* (early 1840s; private collection; A. 4). Here, the commander is shown against a pyramid, sitting in proud isolation on his camel. Gérôme, then just starting out as an artist, had a rather confused idea of Egypt and camels. In around 1900 he returned to the theme once more with *General Bonaparte in the Desert* (present whereabouts unknown).

Provenance: acquired from the Anichkov Palace, Petrograd, in 1918; previously acquired for Emperor Alexander III at auction at the Gesellschaft Gallery in Vienna (no. 266) on 14 March 1872; Anichkov Palace, St. Petersburg.

145. Pool in a Harem, *c.* 1876 (page 76)
Bassin au harem
Oil on canvas. 73.5 x 62 cm
Signed on the marble, middle right: *J. L. GEROME*
⌐ Э 6221 A. 253

This painting was a success at the Salon of 1876, where it was exhibited under the title *Women at the Baths*. The motif of the harem baths recurred in many of Gérôme's later works (A. 339, 374–383, 520, 521, 533), perhaps the best being the *Moorish Bath* (San Francisco, Palace of the Legion of Honor). In 1875, a year before he completed the painting, Gérôme had gone twice to Istanbul where, accompanied by the court painter Abdullah Siriez and his former student Seker Ahmet Pasha, he visited several palaces. He stocked up on photographs of the palaces' interiors, supplied by the company Abdullah Frères. These he would use later when he painted backgrounds for his Oriental compositions. The decorative frame (not shown) which accentuates the scenery in the painting was probably made after a drawing by Gérôme or, at the very least, in accordance with his instructions.

Provenance: acquired from the Anichkov Palace, Petrograd, in 1918; previously acquired for Emperor Alexander III after the Salon of 1876; Alexander III's study, Anichkov Palace, St. Petersburg.

146. Sale of a Slave-Girl in Rome, *c.* 1884 (page 65)
Vente d'une esclave à Rome
Oil on canvas. 92 x 74 cm
Signed bottom left: *J. L. GEROME*
⌐ Э 6294 A. 328

In *Sale of a Slave-Girl in Rome* Gérôme departed from the composition of *Phryne* (Hamburg, Kunsthalle), which had enjoyed great success at the Salon of 1861. However, he retained its thematic starting point: a naked female slave covers her eyes in shame as men dressed in togas look on. The difference between the two canvases is compositional: in *Phryne*, both the slave and the tribunal are given equal representation; in *Sale of a Slave-Girl*, attention is focused on the heroine, who is so decisively placed in the centre that all the other characters seem purely to provide the setting. The painting was exhibited at the Salon of 1884, but not entered as an official entry (*hors concours*), with the note 'appartient a S.A.I. le Grand Duc Serge' [property of His Imperial Highness Grand Duke Sergei]. It is likely that shortly after, Gérôme produced another version of the Hermitage painting, this time with the scene shown from the stage rather than the hall. This smaller version, entitled *Sale of Slaves in Rome* (Baltimore, Walters Art Gallery; A. 329), is a replica of *Sale of a Slave-Girl in Rome*. Gérôme's work as a sculptor maybe inspired him to switch to a panoramic view, a perspective he would use many times in his later work. The preliminary drawing for the two figures on the right is located at the Fogg Museum (Cambridge, Mass., Harvard University). Many preliminary drawings for the figures of the Romans came to auction in the 1970s.

Provenance: acquired from the Antiquariat in 1930; previously in the collection of Grand Duke Sergei Alexandrovich (acquired before the Salon of 1884); collection of Grand Duchess Elizaveta Feodorovna (gift from Sergei Alexandrovich), St. Petersburg.

Pierre Girieud
1876, Paris – 1948, Nogent-sur-Marne

Girieud first studied art in Marseilles. In 1900 he moved to Paris and made his début two years later at the Berthe Weill Gallery. From 1903 he exhibited at the Salon des Indépendants, and from 1904 at the Salon d'Automne. In 1905 he visited Italy with Charles Dufresne. His work was influenced by the Impressionists, as well as by Van Gogh and Gauguin. In 1906 both he and Le Fauconnier joined Kandinsky's New Association of Artists in Munich. He painted still lifes, mythological scenes in a contemporary style, and landscapes (mainly scenes of Provence).

147. Peonies, 1906 (page 269)
Les pivoines
Oil on canvas. 81.5 x 65.5 cm
Signed and dated top right: *Girieud 06*
⌐ Э 8974

This work belongs to the cycle of peonies Girieud painted from 1905 to 1906, among them *Pink Peonies* and *Peonies and a Picture of Epinal* (private collection; both were exhibited at the Salon d'Automne of 1905). They all show the influence of Gauguin.

Provenance: acquired from the State Museum of Modern Western Art in 1948; previously in the collection of S. I. Shchukin from 1907; First Museum of Modern Western Painting from 1918; State Museum of Modern Western Art from 1923.

Vincent Van Gogh
1853, Groot Zundert, Western Brabant – 1890, Auvers-sur-Oise

At the age of sixteen, Van Gogh started working for the French art dealers Goupil & Co. in The Hague; then, from 1873 to 1875, in their London and Paris galleries. In 1876 he taught at a private school in London, and in 1878–9 he worked as an evangelist in the Belgian district of Borinage. Having decided that his true calling was painting, he went to Brussels, where from 1880 to 1881 he studied at the Académie Royale des Beaux-Arts. In 1882–3, he took art lessons in The Hague from a distant relative, the painter Anton Mauve. His influences included such painters as Josef Israëls and George Hendrik Breitner. In 1885–6 he took classes at the Academy of Arts in Antwerp. In 1886 he settled in Paris where, at Fernand Cormon's studio, he was acquainted with Pissarro, Gauguin, Bernard, Signac, and Toulouse-Lautrec. Although he did not receive recognition, he was able to continue painting thanks to the moral and financial support of his older brother Theo. In February 1888 he moved to Arles, where he was remarkably productive (he painted approximately 190 canvases in a little over a year). Gauguin arrived in October of that year, but their attempt to work together had disastrous consequences. In May 1889 Van Gogh was committed to the Saint-Paul-de-Mausole Asylum in Saint-Rémy-de-Provence near Arles. When he was not incapacitated by illness, Van Gogh worked feverishly in the asylum, producing some 150 paintings and 100 drawings in the year he was there. As well as landscapes, still lifes and portraits, Van Gogh painted variations of works by Delacroix, Millet, Daumier and Doré. In May 1890 he moved to Auvers. On 27 July 1890 he shot himself in the chest with a revolver and died two days later.

148. Memory of the Garden at Etten (Ladies of Arles), 1888 (page 161)
Souvenir du jardin à Etten (Femmes d'Arles)
Oil on canvas. 73 x 92 cm
⌐ Э 9116 F. 496

On 14 or 15 November 1888, Gauguin wrote to Theo Van Gogh that his brother's painting included a 'good Dutch garden'. Shortly after, Van Gogh informed Theo that he was working on two canvases, describing the first as 'a memory of our garden at Etten, with cabbages, cypresses, dahlias, and figures… Gauguin gives me the courage to imagine things, and certainly things from the imagination take on a more mysterious character' (LVG, T. 562). In another letter, probably sent later (according to Pickvance, on December 4), the artist wrote to his brother that he had nothing against working from the imagination because it allowed him to work at home: 'I don't mind working by a hot stove, but the cold, as you know, doesn't agree with me. It's just that I've spoiled the painting of the garden in Nuenen, and I think one needs to practice working from the imagination.' Van Gogh's reference to having spoiled his painting suggests that, without changing the composition, he overpainted it, making it one of his most thickly layered works. Breaking all conventions, Van Gogh saturated the painting with colour to such a degree that it almost became a bas-relief; as a result it has been a source of constant concern for subsequent generations in terms of conservation. That the same painting was mentioned as representing both the garden at Etten and the one at Nuenen suggests once more that Van Gogh created it from his imagination, combining elements of both. In this regard, Pickvance points out that the memory of Nuenen appears more intense, recalling the drawings of the Nuenen garden (particularly F. 1128; R. Pickvance, *Van Gogh in Arles*, Metropolitan Museum of Art, New York, 1984, p. 216). The canvas now bears the title the artist originally gave it, but for many years, from the moment it appeared in Shchukin's collection, it was known as *Ladies of Arles*. For Van Gogh, however, the word 'memory' was imbued with a special meaning. The memories of Etten were not purely 'Dutch', because they combined two realities: the distant North and local Provence. It is not surprising that having received a photograph of his mother from Theo shortly before this, he commented that the photograph was dear to him, and the only thing he did not like about it was that it resembled the original too much. In the latter half of November 1888, Van Gogh sent his younger sister Wilhelmina a

letter that contained a detailed description of *Memory of the Garden at Etten*: 'I have just finished the painting, so I can now put it in my room. It's a memory of the garden at Etten. Here's a description. It's a rather large canvas. Here are the details of the colours: the younger of the two women out walking is wearing a Scottish shawl with green and orange checks and is carrying a red parasol. The old woman is wearing a violet shawl, it's almost black. But the clump of dahlias, some of them citrous yellow, others pink and white, are like an explosion of colour against the sombre figure. Behind them are a few cedar shrubs and emerald-green cypresses. Behind the cypresses one can see a field of pale green and red cabbages, surrounded by a border of little white flowers. The sandy garden path is a raw orange colour; the foliage in the two beds of scarlet geraniums is very green. Finally, on the adjacent plane, there's a maid-servant, dressed in blue, who is working in a bed of white, pink, yellow, and vermillion-red flowers. Here you are. I know this is hardly what one might call a likeness, but for me it renders the poetic character and style of the garden as I feel it. All the same, let's suppose that the two women out walking are you and Mother; let us even suppose that there is not the least, absolutely not the least vulgar and fatuous resemblance; yet the deliberate choice of colour, the sombre violet with the clumps of violent citrous-yellow dahlias, suggests Mother's personality to me. The figure in the Scottish plaid with orange and green checks stands out against the sombre green of the cypress, the contrast of which is heightened even more by the red parasol – this figure reminds me of you, a vaguely symbolic figure like the characters in a Dickens novel. I don't know whether you'll be able to understand that you can create a poem by arranging colours in the same way that you can say comforting things in music. In a similar manner, the bizarre lines, purposely selected and multiplied, and meandering all through the picture, may fail to give the garden a vulgar resemblance, but may appear in our minds as in a dream, depicting its character, at the same time stranger than it is in reality' (LVG, W. 9). There may be two reasons for the discrepancy between some of the colours in the painting and the ones Van Gogh describes in the letter to his sister. First, the colours were unstable – the pink dahlias turned white just like the pink background in *Irises* (1890; New York, Metropolitan Museum of Art; F. 680); secondly, although Van Gogh wrote that he had finished the painting, he could have 'touched it up' if he thought he had in some way spoiled it. Since the painting is both symbolic and ambiguous, it is not surprising that Van Gogh tried to convince his sister that she was the young woman he had depicted. That woman, though, bears an even stronger resemblance to his cousin, Kee Vos-Stricker, with whom he was hopelessly in love. Most important of all, however, is the fact that both women are represented as *Arlesiennes*. For in this canvas, north and south intermingle: cypresses grow near cabbages; the Arlesian maid-servant in the flowerbed evokes the Dutch peasants of Van Gogh's earlier drawings. Symbols of life and death (such as the cypress tree) are also juxtaposed, while the garden path, like a river, seems imbued with a sense of passing time.

Provenance: acquired from the State Museum of Modern Western Art in 1948; previously in the Schuffenecker collection, Paris; collection of Julien Leclercq, Paris; Galerie Druet, Paris; collection of S. I. Shchukin; First Museum of Modern Western Painting from 1918; State Museum of Modern Western Art from 1923.

149. Arena at Arles, 1888 (page 162)
Arènes d'Arles
Oil on canvas. 74.5 x 94 cm
☐ 6529 F. 548

Although most scholars date this painting to around October and November 1888, in fact it could not have been done before November. Its creation is most likely linked with Gauguin's arrival in Arles and Van Gogh's subsequent efforts to master the idiom of Synthetism. Emile Bernard's *Breton Women in a Meadow* was the only painting Gauguin had brought with him and it was the first Synthetist work Van Gogh had seen. He did a copy of it (November 1888; Milan, Civica Galleria d'Arte Moderna), and probably shortly thereafter executed two paintings in which he attempted to employ the techniques of Synthetism exemplified by Gauguin and Bernard: *The Folie Arlesienne Dance-Hall*

(November 1888; Paris, Musée d'Orsay) and *Arena at Arles*. The former represents a transitional stage between Van Gogh's copy of Bernard's *Breton Women in a Meadow* and *Arena at Arles*, which was painted indoors. As the weather was bad, Van Gogh could not paint *en plein air*, so Gauguin urged him to paint from memory. As early as April, Van Gogh had written to Bernard about a visit to a bullfight where he was struck by the huge, colourful crowd of spectators. In a letter to his brother, he wrote: 'Yesterday I went to another bullfight. Five men taunted a bull with *banderillas* and scarves… The arena makes a fine sight when the sun is shining and there's a crowd' (LVG, T. 474). He did not express much interest in the ancient architectural monuments of Arles. The arena, which was built before the Christian era, is depicted in a manner that precludes comment on its architectural merits. Some of the figures obviously represent real people, although the woman in the lower left with the clearly defined features cannot be identified. Next to her is Mme. Ginoux, owner of the Café de la Gare in Arles, whose portrait Van Gogh painted in November of that year (Paris, Musée d'Orsay), and later did another version (New York, Metropolitan Museum of Art). The two small figures in the centre, a bearded man and a woman in a red dress, are the postman Roulin and his wife, close friends of Van Gogh. By placing the Roulin couple in the centre of the composition, Van Gogh highlights the theme of family, which was always very important to him. Next to the postmaster and his wife is another couple, a man in a hat and a woman in white. They represent the theme of lovers, which Van Gogh returned to on a number of occasions at the time, for example in *Lovers (The Poet's Garden)* (F. 485) and the drawing that accompanied letter no. 556 (Amsterdam, Rijksmuseum Vincent Van Gogh). Another thematic thread is provided by the group of women in the lower left of the painting. The multiple themes of *Arena at Arles* make it conceptually unique, although the concept itself is not fully realised and remains more of a study.

Provenance: acquired from the State Museum of Modern Western Art in 1931; previously in the collection of S. I. Shchukin from 1905; First Museum of Modern Western Painting from 1918; State Museum of Modern Western Art from 1923.

150. Lilac Bush, 1889 (page 163)
Le buisson
Oil on canvas. 72 x 92 cm
Signed bottom left: *Vincent*
☐ 6511 F. 579

On 9 May 1889 Van Gogh wrote to his brother Theo: 'I am working on two others – some violet irises and a lilac bush, two subjects taken from the garden. The idea of the need to work is coming back to me very strongly, and I think that all my faculties for work will return fairly quickly. Only work often absorbs me so much that I think I shall always remain absent-minded and be unable to do anything other than practise my craft' (LVG, T. 591). One of these subjects, the lilac bush, is the Hermitage canvas. It was painted in the garden of the Saint-Paul Hospital in Saint-Rémy, where the artist was undergoing treatment. The irises in the lower left recur as the central motif in another painting of the same size (private collection; F. 608). For Van Gogh, work was the best medicine. He was evidently very pleased with the painting because he signed it, something he did rarely and usually only when a painting reflected something deeply personal. *Garden of the Saint-Paul Hospital in Saint-Rémy* (Otterlo, Rijksmuseum Kröller-Müller), which was painted at the same time as the Hermitage work, is similar in both subject matter and execution. In both paintings a path is shown through the lush green verdure; in the Otterlo landscape it ends up at the wall of the hospital, and in *Lilac Bush* at the fence. Although a reminder of the artist's seclusion, this detail does not engender a feeling of hopelessness. In the Hermitage composition the sky, painted with the maximum concentration of colour, represents dreams of freedom. In de la Faille's *catalogue raisonné*, this painting is incorrectly attributed to Van Gogh's Arles period.

Provenance: acquired from the State Museum of Modern Western Art in 1930; previously in the collection of Julien Leclercq, Paris; collection of S. I. Shchukin (acquired before 1908); First Museum

of Modern Western Painting from 1918; State Museum of Modern Western Art from 1923.

421

151. Cottages, 1890 (page 164)
Les chaumières
Oil on canvas. 59.5 x 72.5 cm
☐ 9117 F. 750

On his first day in Auvers on 20 May 1890, Van Gogh wrote to his sister Wilhelmina: 'There are moss-covered thatched roofs here that are superb and that I'm certainly going to do something with' (LVG, W. 21). *Cottages* was one of the first canvases – perhaps the very first – that Van Gogh painted in Auvers and doubtless the one he had in mind when, on the day after his arrival, he wrote to his brother: 'Now I have a study of old thatched roofs with a field of peas in flower in the foreground and some wheat, background of hills, a study I think you will like' (LVG, T. 636). Alain Mothe published an old postcard of the motif used in the Hermitage canvas in his book on Van Gogh's stay in Auvers (*Vincent Van Gogh à Auvers-sur-Oise*, Paris, 1987, p. 29). Although in the fifteen years that separated the painting and postcard this particular view of Auvers had changed somewhat (gardens had appeared in front of the cottages), it is clear that Van Gogh, while adding a sense of dynamism in his use of space, portrayed the cottages realistically. The motif of a hillside with thatched cottages and wheat fields undulating in the wind first attracted Van Gogh when he was still living in Saint-Rémy, where he painted *Enclosed Wheat-Field* (Otterlo, Rijksmuseum Kröller-Müller; F. 720). On arrival in Auvers, he returned to the motif once more. Thus, these paintings can be viewed as links in a chain which connect the final two periods of his work. At the same time, the artist emphasises how his stay in the south has helped him better to see the north. The hillside with thatched cottages reappears in a reed-pen drawing highlighted with watercolour (Amsterdam, Rijksmuseum Vincent Van Gogh; F. 1640r), and the cottages alone in a pen drawing enclosed in a letter to his brother (no. 651; Amsterdam, Rijksmuseum Vincent Van Gogh). Van Gogh returned to this motif in one of his final paintings, which was maybe his very last work: *Thatched Roofs in Auvers* (July 1890; Zurich, Kunsthaus; F. 780).

Provenance: acquired from the State Museum of Modern Western Art in 1948; previously in the sale at the Hôtel Druot on 16 May 1908; collection of I. A. Morozov (purchased at the Hôtel Druot sale for 5,685 francs) from 16 May 1908; Second Museum of Modern Western Painting from 1918; State Museum of Modern Western Art from 1923.

Edmond Grandjean
1844, Paris – 1908, Paris

152. View of the Champs-Elysées from the Place de l'Etoile, 1878 (page 104)
L'Avenue des Champs-Elysées, vue de la Place de l'Etoile
Oil on canvas. 85.5 x 136.5 cm
Signed and dated bottom left: *E. Grandjean 1878*
☐ 5059

This canvas was painted for the Salon of 1878. Grandjean anticipated a warm reception because a landscape he had exhibited two years earlier, *Boulevard des Italiens* (1876), was well received. In composition the two paintings are very similar.

Provenance: acquired from the State Museum Fund in 1923; previously in a private collection, St Petersburg.

Charles Guérin
1875, Sens, Yonne – 1939, Paris

Guérin studied under Gustave Moreau at the Ecole des Beaux-Arts in Paris, where he met Matisse, Rouault, Manguin, and Marquet. He made copies of paintings of the Old Masters in the Louvre. His work was influenced by rococo art. In 1896 he made his début at the Salon; from 1897 he exhibited at the Salon de la Société Nationale des Beaux-Arts, and from 1903 at the Salon d'Automne. In 1923 he was one of the founders of the Salon des Tuileries. He taught at the Ecole des Beaux-Arts, where his students included Luc-Albert Moreau, André Dunoyer de Segonzac, and Jean-Louis Boussingault. As well as painting, he also illustrated a number of books (by Verlaine, Long, Prévost, Gauthier, Colette, and others).

153. Lady with a Rose, 1901 (page 236)
Dame à la rose
Oil on canvas. 52.5 x 37.5 cm
Signed bottom left: *Charles Guérin.*; signed and dated on the verso on the stretcher: *Charles Guérin 1901*
⌐ 7713

A reproduction of this painting appeared in the Moscow journal *Iskusstvo* [*Art*] in 1905, which shows that by that date it already belonged to Sergei Shchukin.

Provenance: acquired from the State Museum of Modern Western Art in 1934; previously in the collection of S. I. Shchukin from 1905 or earlier; First Museum of Modern Western Painting from 1918; State Museum of Modern Western Art from 1923.

154. Girl Reading a Book, c. 1906 (page 237)
Jeune fille au livre
Oil on canvas. 73.5 x 59 cm
Signed bottom middle: *Charles Guérin*
⌐ 9053

This painting is also entitled *Books*. It is dated to *c.* 1906, when it was shown in Germany at a travelling exhibition of Parisian artists.

Provenance: acquired from the State Museum of Modern Western Art in 1948; previously in the Galerie Druet, Paris; collection of I. A. Morozov (purchased from Druet for 1,000 francs) from 1907; Second Museum of Modern Western Painting from 1918; State Museum of Modern Western Art from 1923.

155. Nude, c. 1910 (page 236)
Femme nue
Oil on canvas. 116 x 89 cm
Monogrammed bottom right: *Chg*
⌐ 9115

The painting is dated to *c.* 1910, the year in which it was first shown at the Salon d'Automne (no. 508).

Provenance: acquired from the State Museum of Modern Western Art in 1948; previously in the Galerie Druet, Paris; collection of I. A. Morozov (purchased from Druet for 800 francs) from 1910; Second Museum of Modern Western Painting from 1918; State Museum of Modern Western Art from 1923.

Armand Guillaumin
1841, Paris – 1927, Orly, Val-de-Marne

Until 1891 Guillaumin worked for the railways, only painting in his spare time. In 1863–4 he attended the Académie Suisse, where he became friends with Cézanne and Pissarro. In 1863 he exhibited at the Salon des Refusés. He frequented the Café Guerbois, where he met Monet, Renoir, Sisley, and Bazille. He worked with Cézanne at Auvers and with Pissarro at Pontoise. He participated in most of the Impressionist exhibitions (1874, 1877, 1880, 1881, 1882, and 1886). In the second half of the 1880s he became good friends with several young artists, including Signac and Van Gogh. He achieved success relatively late in life, with exhibitions at the Galerie Durand-Ruel in 1894, and at the Galerie Bernheim-Jeune in 1901, as well as at the Salon d'Automne (1905–6). He painted landscapes, primarily views of Paris and its environs.

156. The Seine, 1867–8 (page 102)
La Seine
Oil on canvas. 26 x 50 cm
Signed bottom left: *Guillaumin*
⌐ 8904

157. Landscape with a Factory by the Seine, c. 1867 (page 102; verso of cat. 156)

The canvas is painted on both sides. The landscape on the verso depicts a view of the Seine in the Ivry district, with houses along the bank and two smoking factory chimneys. Evidently Guillaumin did not like this study, which is crossed out with a few brushstrokes. On the stretcher is a pencil drawing of a horse, similar to a pencil sketch of a horse in harness which Guillaumin himself dated to 1867 (C. Gray, *Armand Guillaumin*, Chester, CT, 1972, fig. 5). Gray's book contains a reproduction of a landscape entitled *Barges*, similar to the Hermitage painting and dated to 1868 (*ibid.*, fig. 7), all of which would suggest that *The Seine* was painted between 1867 and 1868.

Provenance: acquired from the State Museum of Modern Western Art in 1948; previously in the collection of S. I. Shchukin (acquired before 1908); First Museum of Modern Western Painting from 1918; State Museum of Modern Western Art from 1923.

Henri Harpignies
1819, Valenciennes – 1916, Saint-Privé, Yonne

From 1846 Harpignies studied under Jean-Aléxis Achard in Paris, and from 1848 to 1849 was with him in Brussels. He exhibited at the Salon of 1853. In 1850 and 1854 he worked in Italy and in 1878 he settled in Saint-Privé in Bourgogne. He was one of the most prolific landscape painters of his time.

158. Landscape with Two Boys Carrying Firewood, 1894 (page 94)
Paysage avec deux garçons transportant fagots
Oil on canvas. 43.5 x 29.5 cm
Signed bottom left: *h. harpignies*; inscribed on the verso: *Ce tableau est bien par moi, 9bre 94. H. Harpignies* [This painting was really done by me, 9bre 94. H. Harpignies]
⌐ 5691

Provenance: acquired in 1922; previously in the collection of A. M. Somov, Petrograd.

Ferdinand (Fernand) Heilbuth
1826, Hamburg – 1889, Paris

The son of a German rabbi, Heilbuth became a French citizen in 1876. He studied in Munich, Dusseldorf and Antwerp, and from 1841 at the Ecole des Beaux-Arts under Delaroche and Gleyre. He was good friends with Tissot. He made a number of trips to Italy. He exhibited at the Salon from 1857, in which year he received a second-class medal. He painted historical and genre pictures, as well as landscapes and portraits.

159. Boating on the Seine, 1875–6 (page 103)
En bateau sur la Seine
Oil on wood. 35 x 56 cm
Signed left, on the stern of the boat: *F Heilbuth*
⌐ 9008

Both the women's clothing and the boating motif, popular at that time, indicate that the picture was painted in the mid-1870s. The model for the woman in the black hat also appears in the painting *Bougival* (reproduced in: R. L. Herbert, *Impressionism: Art, Leisure and Parisian Society*, New Haven & London, 1988, p. 203). There she is portrayed with two women who are conversing against the background of a country landscape. Both women are depicted in another painting, which was done at around the same time, entitled *Conversation* (present whereabouts unknown; reproduced in M. von Boehn, *Die Mode. Menschen and Moden im Neunzehnten Jahrhundert nach Bildern and Kupfern der Zeit 1843–78*, Munich, 1908, p. 154).

Provenance: acquired from the State Museum of Modern Western Art in 1948; previously in the collection of Baron Jules de Hauff, Paris; collection of S. M. Tretyakov, Moscow; State Tretyakov Gallery from 1893; Pushkin Museum of Fine Arts, Moscow, from 1925; State Museum of Modern Western Art from 1930.

Paul-César Helleu
1859, Vannes – 1927, Paris

Helleu studied under Gérôme at the Ecole des Beaux-Arts in Paris, where he became good friends with John Singer Sargent. Other friends included Degas, Tissot, Whistler, Edmond de Goncourt and Marcel Proust. From 1884, to earn a living, he worked for the potter Joseph-Théodore Deck. He made over 2,000 prints, working mostly in etching and drypoint, sometimes in lithography. From 1893 he exhibited at the Salon de la Société Nationale des Beaux-Arts. He visited the United States three times. Helleu was a renowned portraitist of Parisian society.

160. Portrait of a Woman, 1909 (page 88)
Portrait d'une femme
Italian pencil, sanguine and chalk on paper. 76.3 x 56.5 cm
Signed and dated to the right of the woman's elbow: *Helleu Paris 1909*
27107

Provenance: acquired in 1926; previously in a private collection, Leningrad.

Jean-Jacques Henner
1829, Bernwiller, Alsace – 1905, Paris

Henner studied in Strasbourg under Gabriel-Christophe Guérin and from 1846 at the Ecole des Beaux-Arts under Michel-Martin Drolling and François-Edouard Picot. In 1858 he won the Prix de Rome and before 1865 lived in Italy. His influences included Coreggio and Titian. From 1863 to 1903 he exhibited at the Salon and in 1889 became a member of the Institut de France. He painted portraits and historical, religious and symbolic compositions.

161. Study of a Woman in Red, early 1890s (page 63)
Etude de femme en rouge
Oil on canvas. 55 x 38 cm
Signed top right: *J.J.Henner*
⌐ 9032

Until recently, this painting was entitled *Portrait of a Young Woman in Red*. However, it cannot be regarded as a portrait because it belongs to a specific genre that was designated in French academic

painting as *têtes d'expression*. Today, however, such heads would not be particularly distinguished for their expressiveness. Henner painted such profiles of red-haired young women (usually wearing a red dress) fairly frequently. His admirers generally associated such depictions with the image of Mary Magdalene. For many years, Henner painted red-haired women of the type represented in the Hermitage work. The woman portrayed here is most probably Mlle Dodey, who sat for the artist in the early 1890s, in particular for the painting *Mlle Dodey, the Artist's Model, in a Red Dress* (1893; Paris, Musée Henner). Works very similar to this study are in the Metropolitan Museum of Art in New York (*Young Woman Praying*) and the Museum of the Arts of Romania in Bucharest (*Woman with Red Hair*).

Provenance: acquired from the State Museum of Modern Western Art in 1948; previously in the collection of P. I. and V. A. Kharitonenko, Moscow; Pushkin Museum of Fine Arts, Moscow, from 1924; State Museum of Modern Western Art from 1930.

Auguste Herbin
1882, Quiévy, Nord – 1960, Paris

In his youth Herbin studied drawing at Cateau-Cambrésis, then attended the Ecole des Beaux-Arts in Lille. In 1901 he moved to Paris and initially painted in an Impressionist style. He made his début at the Salon des Indépendants in 1905, and exhibited at the Salon d'Automne from 1907. His work was influenced by Cézanne and Matisse, and he soon joined the Cubists. His own search for plasticity was stylistically similar to that of Juan Gris, whom he met at the Bateau-Lavoir, where he moved in 1909. In 1910 he exhibited at the Salon des Indépendants with Fernand Léger, Albert Gleizes, and Jean Metzinger, and two years later he participated in the Section d'Or exhibition. In 1917 he turned to abstraction. In 1931 he and Georges Vantongerloo founded the Abstraction-Creation group. He played a leading role in promoting abstract painting after the Second World War. He executed a series of large abstract frescoes connected with architecture.

162. Green Landscape, c. 1901 (page 190)
Paysage vert
Oil on canvas. 50 x 61 cm
Signed bottom right: *Herbin*
⌐Э 10141 Claisse 12

The painting combines lessons learnt from Impressionism with elements of the decorative style, and is notable for an understatement which originates from Symbolism, which at that time was gaining ground. It is likely that it was painted soon after Herbin moved to Paris in 1901.

Provenance: acquired in 1945; previously in the collection of P. A. Auer, Petrograd; State Museum Fund from 1921; Museum of the Academy of Arts, Leningrad, from 1927.

163. Flowers, 1905 (page 270)
Fleurs
Oil on canvas. 81 x 55 cm
Signed bottom left: *herbin*
⌐Э 8975 Claisse 66

A work similar in composition to the Hermitage painting is *Still Life with Books* (1905; Paris, private collection; Claisse 67), which includes the same vase of flowers, but against a background of books. It is likely that this canvas was painted earlier; a more abstract configuration of colour areas than books would have seemed appropriate for a new treatment of virtually the same still life arrangement of the vase. Added to which, the Hermitage painting is close in its painterly qualities to the still lifes completed *c.* 1906, in particular *Still Life with Apples and Red Flowers* (appeared at auction at Christie's, London, on 2 December 1966). *Flowers* was exhibited at the Salon des Indépendants in the spring of 1907.

Provenance: acquired from the State Museum of Modern Western Art in 1948; previously in the collection of Wilhelm Uhde; collection of I. A. Morozov (acquired from Uhde for 300 francs together with Herbin's *Portrait*, the fate of which is unknown) from 1908; Second Museum of Modern Western Painting from 1918; State Museum of Modern Western Art from 1923.

164. Mill on the Marne (Créteil), c. 1911 (page 321)
Moulin sur La Marne
Oil on canvas. 22 x 33 cm
Signed bottom right: *herbin*
Inscribed on the verso, on the stretcher: *Moulin sur la Marne. Créteil*
⌐Э 9022 Claisse 236

The picture belongs to a cycle of works dating to between 1910 and 1912, notable for their rejection of bright colour and schematised form resulting from the influence of Cubism. Two landscapes painted at the same time as the Hermitage work are similar to it in composition and treatment: *Mill at Créteil, View from the Embankment* (Claisse 237) and *The Mill Bridge* (Claisse 238). The landscape was shown at Herbin's one-man exhibition at the Galerie Moderne in Paris in March 1914, and dated in the catalogue to 1911. It was given exactly the same name as that inscribed in pencil, doubtless by the artist himself, on the stretcher.

Provenance: acquired from the State Museum of Modern Western Art in 1948; previously in the collection of S. I. Shchukin from 1914; First Museum of Modern Western Painting from 1918; State Museum of Modern Western Art from 1923.

Charles Hoffbauer
1875, Paris – 1957, Boston

Hoffbauer studied at the Ecole des Beaux-Arts under Gustave Moreau, François Flameng and Fernand Cormon. From 1898 to 1911 he exhibited at the Salon. In 1902 he received the Rosa Bonheur Prize and a scholarship to study in Italy. In 1910 he went to the United States, where he settled. In 1912 he became a member of the Architectural League of New York and the International Society. He painted genre and historical compositions as well as a series of large decorative works.

165. In the Restaurant, 1907 (page 337)
Au restaurant
Oil on canvas. 115 x 167 cm
Signed and dated bottom right: *Ch. Hoffbauer 07*
⌐Э 7319

The painting depicts the interior of a London restaurant.

Provenance: acquired from the State Museum Fund in 1931.

Victor Pierre Huguet
1835, Le Lude – 1902, Paris

Huguet studied under Emile Loubon in Marseilles and under Eugène Fromentin in Paris. In 1852 he travelled to Egypt, and in 1853 took part in the Crimean War. From 1859 to 1888 he exhibited at the Salon. He painted genre compositions (primarily on Oriental themes) and landscapes.

166. Arab Encampment, 1872 (page 78)
Les nomades arabes
Oil on canvas. 72 x 91 cm
Signed and dated bottom right: *V. Huguet 72*
⌐Э 6223

In an inventory of Alexander III's paintings, this work was entitled *Tents of Nomadic Peoples (View of the Steppe)* (no. 152).

Provenance: acquired from the Anichkov Palace, Petrograd, in 1918; previously in the collection of Emperor Alexander III, Anichkov Palace, St. Petersburg.

Eugène Isabey
1803, Paris – 1886, Montevrain, near Lagny, Seine and Marne

Isabey studied under his father, the miniaturist Jean-Baptiste Isabey. He made a brilliant début at the Salon of 1824, immediately winning first prize. He became a court painter during the reign of Louis-Philippe, and exhibited at the Salon until 1878. He travelled a great deal in France, and visited Algiers, Holland and England. He exerted considerable influence on such artists as Boudin and Jongkind. He was a painter, lithographer, and watercolourist. He painted landscapes (primarily seascapes), as well as genre and historical compositions.

167. After the Storm, 1869 (page 82)
Après l'orage
Oil on canvas. 36.5 x 60 cm
Signed and dated bottom right: *E. Isabey 69*
⌐Э 8570

The traces of a storm now past – including the ships cast ashore and at sea – enhance this romanticised rendering of the Normandy coast, which the painter visited several times. Neither the ships nor the people who have survived shipwreck reflect the period in which the painting was executed: the end of the 1860s.

Provenance: acquired in 1946; previously in a private collection, Leningrad.

Charles-Emile Jacque
1813, Paris – 1894, Paris

Jacque worked for an engraver specialising in cartography. In 1835 he began illustrating books and produced many etchings. In 1845 he turned to painting. In 1849 he went with Millet to Barbizon, where he stayed for six years and ran a poultry farm, and later cultivated asparagus. His work was influenced by Millet and Théodore Rousseau. When their friendship ended, Jacque's painting acquired a more arid tone. From the mid-1850s he painted primarily domestic animals. He wrote a book entitled *The Hen-House*, which he illustrated with prints and paintings.

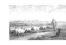

168. Landscape with a Flock of Sheep, 1872 (page 95)
Paysage avec un troupeau de moutons
Oil on cardboard. 32.5 x 53.5 cm
Signed and dated bottom left: *Ch. Jacque 1872*
⌐Э 9979

This is one of many compositions with sheep that Jacque painted in his studio. He would often add a flock of sheep to landscapes with views of Barbizon and its environs.

Provenance: acquired in 1966; previously in a private collection, Leningrad.

Charles Lacoste
1870, Floirac, Gironde – 1959, Paris

Lacoste studied in Bordeaux and moved to Paris in 1899, living alternately there and in his native Gironde. From 1901 to 1913 he exhibited at the Salon des Indépendants; from 1905 at the Salon d'Automne; and after the First World War at the Salon des Tuileries.

He also exhibited in Belgium. He painted mostly landscapes, as well as cartoons for tapestries, stage sets, and book illustrations.

169. Small House in a Garden, 1905 (page 191)
Maisonette dans un jardin
Oil on cardboard, 25 x 32 cm
Signed and dated bottom left: *Charles Lacoste 1905*
Inscribed in pencil on the verso: *Mortagne-sur-Gironde. Août 1905*
ГЭ 8922

Mortagne, where this work was painted, is a small town in Charente-Maritime.

Provenance: acquired from the State Museum of Modern Western Art in 1948; previously in the collection of S. I. Shchukin; First Museum of Modern Western Painting from 1918; State Museum of Modern Western Art from 1923.

170. Landscape of the South of France, 1912 (page 191)
Paysage du midi
Oil on cardboard. 24 x 33 cm
Signed and dated bottom left: *Charles Lacoste 1912*
ГЭ 8942

This painting reflects the influence of Roussel's southern landscapes, which Lacoste had seen at the Galerie Bernheim-Jeune. Both artists had a close affiliation with this gallery.

Provenance: acquired from the State Museum of Modern Western Art in 1948; previously in the Galerie Bernheim-Jeune, Paris; collection of P. P. Muratov (purchased at the Bernheim-Jeune exhibition of Lacoste for 200 francs) from 1914; State Museum Fund from 1920; Second Museum of Modern Western Painting from 1922; State Museum of Modern Western Art from 1923.

Pierre Laprade
1875, Narbonne – 1931, Fontenay-aux-Roses, near Paris

Laprade studied at Emile-Antoine Bourdelle's studio in Montauban, then from 1898 in Paris at the Académie Carrière, where he met Matisse, Derain, Puy, and Chabaud. He made copies of the Old Masters in the Louvre. In 1899 he made his début at the Salon de la Société Nationale des Beaux-Arts. From 1901 he exhibited at the Salon des Indépendants, and from 1903 at the Salon d'Automne. In 1908 he made the first of three trips to Italy. He took part in the First World War, after which he designed a series of stage sets. Illustrated many books; and painted landscapes and interiors.

171. Woman in Black, *c.* 1900 (page 255)
Dame en noir
Oil on cardboard. 55.8 x 46.5 cm
Signed bottom right: *Laprade*
ГЭ 8985

This painting, one of Laprade's rare early works, was among the first that he regarded as suitable for exhibition (it was shown in Lyons in 1902). Vollard discovered Laprade early in his career and shortly after the Lyons exhibition bought up all the paintings in his studio.

Provenance: acquired from the State Museum of Modern Western Art in 1934; previously in the Galerie Vollard, Paris; collection of I. A. Morozov (purchased from Vollard for 800 francs) from 1909; Second Museum of Modern Western Painting from 1918; State Museum of Modern Western Art from 1923.

172. Woman in a Garden, *c.* 1909–10 (page 254)
Dame dans un jardin
Oil on canvas. 50 x 73.5 cm
Signed bottom left: *Laprade*
ГЭ 4904

Also entitled *Woman Picking Flowers*, this picture resembles Laprade's depictions of Italian gardens painted between 1900 and 1910.

Provenance: acquired in 1921; previously in the collection of G. E. Haasen, St Petersburg.

Gaston La Touche
1854, Saint-Cloud – 1913, Paris

La Touche made his début as a sculptor at the Salon of 1874; from 1883 he exhibited his paintings there, winning the third-class medal the following year. Later he was awarded two medals at the Exposition Universelle, bronze in 1889 and gold in 1900. From 1890 he exhibited at the Salon de la Société Nationale des Beaux-Arts, when he moved from genre painting (the lives of the poor) to the stylisations and motifs of *fêtes galantes*. He designed a series of decorative murals for private residences (Edmond Rostand's villa at Cambo-les-Bains among others) and for government buildings (including the Hôtel de Ville in Saint-Cloud, and the Ministère de la Justice in Paris). He also created landscapes and compositions on religious themes.

173. The Last Supper, 1897 (page 189)
La Cène
Watercolour on paper. 78.3 x 56 cm
Signed and dated bottom left: *Gaston La Touche 97*
42337

This watercolour was exhibited at the exhibition entitled *One Hundred Years of French Painting 1812–1912* which was organised by the journal *Apollon* and the Institut Français in St Petersburg in 1912. It was the most significant exhibition of its kind to have occurred outside France at the turn of the century. The husband and wife Alexander Nikolaevich and Zinaïda Vladimirovna Ratkov-Rozhnov, friends of Alexandre Benois, probably acquired the watercolour in 1905 when they were living in Versailles.

Provenance: acquired from the State Museum of Modern Western Art in 1930; previously in the collection of Z. V. Ratkova-Rozhnova, St Petersburg; State Tretyakov Gallery from 1917; State Museum of Modern Western Art from 1924.

174. The Relics, 1899 (page 188)
Les reliques
Oil on canvas. 145 x 156.5 cm
Signed and dated bottom left:
Gaston La Touche 99
ГЭ 9653

In both the catalogue of Shchukin's collection and in subsequent publications, this painting appeared under the title *Transference of the Relics*. However, it is unclear whether the reliquary in the top right-hand corner of the canvas contains relics or some other kind of sacred object. At the Exposition Universelle of 1900, the canvas was entitled simply *Les reliques*.

Provenance: acquired from the State Museum of Modern Western Art in 1948; previously in the collection of S. I. Shchukin from 1900; First Museum of Modern Western Painting from 1918; State Museum of Modern Western Art from 1923.

Marie Laurencin
1883, Paris – 1956, Paris

Although she came from an affluent bourgeois family, Laurencin had to earn a living at an early age. She wrote poetry under the pseudonym Louise Lalanne until she decided to take up porcelain painting. She took evening classes at the Sèvres Art School and enrolled at the Académie Humbert, where she met Georges Braque around 1905. He introduced her to a circle of young artists and poets living in the Bateau-Lavoir, a run-down wooden building on rue Ravignan. Often referred to as 'the Cubists' muse', Laurencin exhibited with them, but she herself adopted only their techniques of simplification and slight geometricisation. She was Apollinaire's 'evil genius' (their relationship lasted from 1907 to 1912), and he played a major role in promoting her work. She was a painter, book illustrator, and stage designer.

175. Artemis, *c.* 1908 (page 324)
Arthémide
Oil on canvas pasted on cardboard. 35.5 x 27 cm
Signed bottom right: *Laurencin*; signed and inscribed in pencil on the verso: *M. Laurencin. Arthémide*
ГЭ 9000

This painting is dated to *c.* 1908 by analogy with Laurencin's *Portrait of a Woman* (1908; private collection), which was auctioned at the Galerie Motte in Geneva in June 1969 (No. 330). Both pictures portray the same face and pose. The drawing of the flowers in the background is also similar. In 1908 Laurencin also did an etching entitled *Girl with a Flower* that bears similarities to *Artemis*. By comparing the two works, it is noticeable how the artist worked on stylising the stem and tendrils in the sketch, while the painting reveals a greater degree of conventionality. Juxtaposing *Artemis* with *Self-Portrait* (1908; Tokyo, Marie Laurencin Museum) also reveals that Laurencin herself was the model for *Artemis*.

Provenance: acquired from the State Museum of Modern Western Art in 1948; previously in the collection of S. I. Shchukin from 1913 or 1914; First Museum of Modern Western Painting from 1918; State Museum of Modern Western Art from 1923.

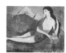

176. Bacchante, 1911 (page 325)
Oil on canvas pasted on cardboard. 32.7 x 41 cm
Signed bottom right: *Marie Laurencin*
ГЭ 9069

Like *Artemis*, this painting is primarily a self-portrait. *Bacchante*'s pose resembles that of the woman in the foreground of Matisse's *Joy of Life* (1905–6; Merion Station, PA, Barnes Foundation), a work certainly known to Laurencin. The artist also employs certain Cubist techniques, combining in one painting various viewpoints: the face in profile, the eyes and lips front-on.

Provenance: acquired from the State Museum of Modern Western Art in 1948; previously in the collection of S. I. Shchukin from 1913 or 1914; First Museum of Modern Western Painting from 1918; State Museum of Modern Western Art from 1923.

Jean-Paul Laurens
1838, Fourquevaux, Haute-Garonne – 1921, Paris

Laurens studied in Toulouse and at the Ecole des Beaux-Arts in Paris under Léon Cogniet. From 1863 he exhibited at the Salon. He was one of the most renowned history painters of his time. He designed prestigious decorative murals (including the apse of the Panthéon, Hôtels de Ville in Paris and Tours, the Salle de Capitole in Toulouse, the ceiling of the Théâtre de l'Odéon in Paris), as well as cartoons for tapestries for the Gobelins workshops in Paris. For thirty years he taught at the Académie Julian and was a professor at the Ecole des Beaux-Arts. He painted historical compositions and portraits, and also worked in etching.

177. The Last Moments of Maximilian, 1882 (page 69)
Les derniers moments de Maximilien
Oil on canvas. 222 x 303 cm
Signed and dated bottom right: *J. Paul Laurens 1882*
⌐Э 9671

In previous Hermitage catalogues this painting has appeared under the title *Emperor Maximilian of Mexico Before His Execution*. The Austrian Archduke Ferdinand Maximilian (1832–67) was designated Emperor of Mexico in 1864 by Napoleon III and then forced to wage war against the Republicans led by Juárez. When Napoleon III, under pressure from the United States, withdrew the French expeditionary army from Mexico, Maximilian's fate was sealed. The Republican war tribunal sentenced Maximilian, by then a prisoner in the Querétaro fortress, to death by firing squad. The execution took place on 19 June 1867. When Laurens conceived his painting, the events connected with the fall of Emperor Maximilian were still fresh in the minds of the French; tackling such a timely topic helped preserve its political punch. It has been suggested that Alfred Gossier's play *Juárez or the Mexican War* (1880) provided the impetus for the painting. The drama, which placed responsibility for the Mexican adventure squarely on Napoleon, was banned from the stage, but Laurens would have known the text since it had been published in Henri Rochefort's journal *La Lanterne*. A preparatory drawing (private collection) that shows Maximilian approaching the place of execution was obviously inspired by the play. For the finished painting, however, Laurens chose to depict the moment when the Emperor is told of his sentence. This scene is described in a work Laurens was certainly familiar with, *My Diary in Mexico*, by Prince F. Salm-Salm, an aide-de-camp of Maximilian. It was published in England (London, 1868), and in 1874 appeared in French translation. Laurens always took great care to ensure the historical authenticity of all details in his works. Among other things, he consulted an antique dealer in Paris about the weapons and spurs used by Mexican officers. He also availed himself of a copy of the Emperor's death mask. One of his students, Albert Fourier, who bore a striking resemblance to Maximilian, sat for the painting. Laurens made a series of studies for it, two of which are now well known: *Portrait of Albert Fourier* (private collection), and *Man Kneeling* (Musée de Moulin) (nos. 15 and 16 of the exhibition *Jean-Paul Laurens: 1838–1921. Peintre d'histoire*, Paris, Musée d'Orsay, 1997). Another study for the painting was shown for the first time at the Musée d'Orsay exhibition (no. 14; collection of Olivier Laurens), which contains a greater number of figures and various details which the artist corrected during the course of the work. Laurens completed the painting for the Salon of 1882, expecting the State to buy it, but the State did not oblige. Shortly after, Sergei Mikhailovich Tretyakov purchased the work and, in 1888, showed it in St Petersburg at an exhibition of contemporary French paintings.

Provenance: acquired from the State Museum of Modern Western Art in 1948; previously in the collection of S. M. Tretyakov from 1882; State Tretyakov Gallery; Pushkin Museum of Fine Arts, Moscow, from 1925; State Museum of Modern Western Art from 1930.

Albert-Charles Lebourg
1849, Montfort-sur-Risle, Eure – 1928, Rouen

Lebourg studied at the Ecole des Beaux-Arts in Rouen and then in Paris. His work was influenced by Van Goyen, Ruysdael, Corot, the Barbizon painters, and Monet. From 1872 to 1877 he was professor of drawing at the Société des Beaux-Arts in Algiers. During that time, independently of the Impressionists, he started to paint landscapes in different lighting and weather conditions. After returning to France, he studied for two years under Jean-Paul Laurens and then left him to join the Impressionists. In 1879 and 1880 he participated in Impressionist exhibitions. In the 1880s he worked primarily in the Auvergne region and then alternately in Paris and Rouen. From 1895 to 1897 he lived in Holland; in 1900 he visited London.

178. View of the Town of Pont-du-Château, c. 1885 (page 126)
Vue de Pont-du-Château
Oil on canvas. 31 x 58 cm
Signed bottom left: *A. Lebourg*
⌐Э 9280

In all previous publications, this painting has been called *Small Town by the River*. It depicts the small town of Pont-du-Château in Auvergne, famous for its fortress and Roman church, which can be seen in the far distance. The town received its name from the bridge on the river Allier. Lebourg often worked there, especially in 1885–6, when the picture was most probably painted. Among his various depictions of the town, the most famous are *Snow in Pont-du-Château* (1885; Clermont-Ferrand and Evreux, Musée des Beaux-Arts) and *Snow in Auvergne* (1886; Rouen, Musée des Beaux-Arts). The closest to the Hermitage canvas, however, is *Pont-du-Château in Autumn* (see L. Bénédite, *Albert Lebourg*, Paris, 1923, p. 112), which has a similar panoramic view of the river and bridge, and the town along the bank. Stylistically, the painting can also be related to the landscape *Laundresses at Pont-du-Château* (c. 1885; Norfolk, VA, Chrysler Collection).

Provenance: acquired from the State Museum Fund, Petrograd, in 1923.

Henri Le Fauconnier
1881, Hesdin, Pas-de-Calais – 1946, Paris

Le Fauconnier moved to Paris in 1900, and studied under Jean-Paul Laurens for a year, moving to the Académie Julian in 1902, where he met André Dunoyer de Segonzac, Roger de la Fresnaye, and Luc-Albert Moreau. From 1904 he exhibited at the Salon des Indépendants, and from 1907 at the Salon d'Automne. The beginning of his creative activity coincided with the birth of the Fauvist movement, which exerted a considerable influence on his work. Cézanne's exhibition at the Salon d'Automne of 1907 and the defection of numerous avant-garde artists, including some Fauves, to Cubism, prompted him to follow suit. From 1909 to 1913 Le Fauconnier was good friends with the Cubists of Montparnasse (Delaunay, Gleizes, Metzinger, Léger). In 1910 he joined Kandinsky's New Association of Artists (Neue Künstlervereiningung) in Munich, and in 1912 he became head of the Académie de La Palette. Before the First World War he exhibited in Germany, Switzerland and Russia, as well as in France. From 1914 to 1919 Le Fauconnier lived in the Netherlands and was one of the founding members of the pacifist movement Het Signal (1916), an organisation of Dutch painters and writers that promoted Expressionist art, but which remained close to nature. After returning to France in 1920 because his wife was seriously ill, Le Fauconnier became a recluse. In 1933 he visited London, Madrid, and Italy. He painted landscapes, interiors, and portraits.

179. Little Schoolgirl, 1907 (page 271)
La petite écolière
Oil on canvas. 73 x 92.5 cm
Signed and dated bottom right: *Le Fauconnier. 07*
⌐Э 8889

This painting reflects the influence of two canvases by Matisse depicting his daughter Marguerite reading, entitled *Reading* (1906; New York, Museum of Modern Art) and *Girl Reading* (1906; Musée de Grenoble). In 1908, a year after it was finished, the picture was shown at the first exhibition of the *Golden Fleece*, organised by N. P. Ryabushinsky, where it made a significant impact on young Moscow artists.

Provenance: acquired from the State Museum of Modern Western Art in 1948; previously in the collection of N. P. Ryabushinsky, Moscow (purchased at the *Golden Fleece* exhibition), from 1908; Chetverikova collection, Moscow; State Museum of Modern Western Art from 1940.

180. Village in the Mountains, 1910 (page 322)
Village dans les rochers
Oil on canvas. 74 x 93 cm
Signed bottom right: *Le Fauconnier*
⌐Э 9171

This painting depicts Ploumanach, a fishing village in Northern Brittany, where Le Fauconnier often worked from 1906 onwards. Stylistically, the painting is close to *Landcape with Cliffs, Ploumanach* (1910; Le Fauconnier exhibition, Crane Kalman Gallery, London, 1973, No. 2) and *Ploumanach, Chapel in the Mountains* (Paris, Loudmer collection). The same village is also shown in *Ploumanach* (1908; reproduced in *Le Fauconnier* (Introduction by J. Romains), Paris, 1927).

Provenance: acquired from the State Museum of Modern Western Art in 1948; previously in the collection of S. I. Shchukin from 1910; First Museum of Modern Western Painting from 1918; State Museum of Modern Western Art from 1923.

181. The Lake, 1911 (page 323)
Le lac
Oil on canvas. 92 x 72.5 cm
Signed bottom right: *Le Fauconnier*
⌐Э 9170

This painting was exhibited at the Salon d'Automne of 1911 as *Village on a Lake*, along with two other landscapes also painted on the shore of Lake Annecy. Apollinaire praised this canvas highly, noting Le Fauconnier's delicacy of colouring. The following year Wassily Kandinsky and Franz Marc published *The Lake* in the almanac *Blaue Reiter [Blue Rider]* in Munich. Depicted in the centre of the painting is Duingt Castle, one of the oldest castles in the Savoie region.

Provenance: acquired from the State Museum of Modern Western Art in 1948; previously in the collection of S. A. Poliakov, Moscow (purchased at the *Jack of Diamonds* exhibition in Moscow, No. 211, for 100 roubles), from 1912; State Tretyakov Gallery from 1919; State Museum of Modern Western Art from 1925.

182. The Signal, 1915 (page 363)
Le signal
Oil on canvas. 80 x 99 cm
⌐Э 9172

On 18 January 1933 Le Fauconnier informed B. N. Ternovets, director of the State Museum of Modern Western Art in Moscow, that the Dutch collector Willem Beffie would be visiting the museum: 'This collector, delighted with the way in which artistic and scientific organisations are run in the Soviet Union, told me that he would like to offer your Moscow museum of modern art one of my paintings, *The Signal*, of 1915. It is one of my most characteristic works, along with *Abundance* (recently acquired by the Stockholm Museum from Mr. Pauli), *Hunter* and the triptych *The Tramp*.' (From the archives of the Pushkin Museum, Moscow, 1978, p. 23.) In another letter to the Museum of Modern Western Art (to S. I. Lobanov, dated 15 July 1934), Le Fauconnier wrote: 'I also learned with great satisfaction that my painting *The Signal* will be part of your collection. Some art critics think that it is my best work' (*ibid.*, p. 25). The Hermitage composition is a mirror image of its watercolour study (formerly in the collection of Le Fauconnier).

Provenance: acquired from the State Museum of Modern Western Art in 1948; previously in the collection of Willem Beffie, Amsterdam; State Museum of Modern Western Art (donated by Willem Beffie) from 1934.

Jules Lefebvre
1836, Tournan, Seine-et-Marne – 1911, Paris

From 1852 Lefebvre studied at the Ecole des Beaux-Arts in Paris under Léon Cogniet. In 1861 he won the Grand Prix de Rome in the history painting category. From 1861 to 1867 he worked in Rome. He exhibited at the Salon from 1855 to 1910 and was awarded medals in 1865, 1868 and 1870. Lefebvre received the Grand Prix of the Exposition Universelle in 1889. He was a member of the Institut de France, a commander of the Légion d'honneur, and a jury member of the Exposition Universelle in 1900. He painted pictures on mythological, religious and allegorical themes, as well as portraits.

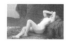

183. Mary Magdalene in the Cave, c. 1876 (page 64)
Marie Madeleine dans la grotte
Oil on canvas. 71.5 x 113.5 cm
Signed bottom right: *Jules Lefebvre*
⌐⌐ 4841

For a long time, this painting was entitled *Reclining Nymph* because of its rather frivolous, obscure treatment of a religious subject, although in the Salon of 1876 it was exhibited as *Mary Magdalene* (so titled by Lefebvre himself). Lefebvre painted nymphs fairly frequently, often in the same spirit as this work.

Provenance: acquired from the Winter Palace in 1926; previously in the collection of Alexandre Dumas *fils* (acquired after the Salon of 1876 as a pair to Lefebvre's *Reclining Woman*, which Dumas already owned), from 1876 to 1895; Winter Palace, St Petersburg (purchased by Nicholas II after the French Fine Art Exhibition in St Petersburg, 1895, No. 180, for 8,400 francs) from 1896.

Fernand Léger
1881, Argentan, Orne – 1955, Gif-sur-Yvette, near Paris

From 1897 to 1899 Léger was apprenticed to an architect in Caen. In 1890 he moved to Paris, where he worked as a draughtsman in an architect's office for two years. In 1903 he enrolled at the Ecole des Arts Décoratifs in Paris. He failed the entrance exam for the Ecole des Beaux-Arts, but attended classes taught by Gérôme and Gabriel Ferrier as an occasional student. He also attended the Académie Julian. Léger's early paintings were influenced by Impressionism; Cézanne's retrospective at the Salon d' Automne of 1907 also had a great impact on him. Having moved to La Ruche near Montparnasse, Léger met the Cubists, Delaunay, Cendrars, Apollinaire, Chagall, and Soutine (1908–9). From 1910 he exhibited at the Kahnweiler Gallery. In 1911–12 he participated in the meetings of the Section d'Or group. Léger was drafted into the French army at the beginning of the War in 1914 and was gassed at Verdun in 1916. He convalesced for more than a year. In 1920 he met Le Corbusier and Ozenfant and the following year he met Mondrian and Van Doesburg. At the Exposition Nationale des Arts Décoratifs in Paris in 1925, Léger painted large murals on the pavilions built by Le Corbusier and Robert Mallet-Stevens. With Le Corbusier he visited Greece in 1933 and the USA in 1935. From 1940 to 1945 he lived in the USA. After returning to France, he designed mosaics for the church of Nôtre-Dame de Toute Grâce at the plateau d'Assy in the Haute-Savoie (1946–9). In 1949 he began making ceramic sculptures and the following year established a special studio in Biot. Léger designed stained-glass windows for churches in Audincourt (1951) and Courfaivre (1954) in Switzerland, as well as for the University of Caracas, Venezuela (1954). He also worked in cinematography and the theatre.

184. Composition, 1924 (page 367)
Oil on canvas. 73 x 92 cm
Signed and dated bottom right: *F. LEGER-24*
⌐⌐ 9146 B. 384

The meaning of the painting is encoded not only in the decorative arrangement of the areas of colour, but also in the construction of the 'image of the machine'. Multi-coloured rectangles are placed in such a way so as to create the illusion that the red circles are spinning like a wheel. In 1924, Léger executed a series of abstract canvases founded on this principle. *Ballet mécanique*, a film without a script that Léger worked on that year, was also based on the interplay of geometric shapes. Léger even incorporated the human form, which resembled mechanical elements, into several canvases of the period, as is evident in the comparison of *Composition* with *Man in a Sweater* (1924; Jerusalem, Museum of Israel, B. 389; second version: Paris, Malengue collection, B. 390). The backgrounds of both canvases are similar in their rhythm and arrangement of colour. An eponymous study for the painting was sold at auction by Christie's in London on 25 June 1984 (no. 23).

Provenance: acquired from the State Museum of Modern Western Art in 1948; previously in the collection of B. N. Ternovets (acquired from the artist) from 1927; State Museum of Modern Western Art (donated by Ternovets) from 1927.

185. Postcard, 1932–48 (page 366)
La carte postale
Oil on canvas. 92.3 x 65.4 cm
Signed bottom right: *F. LEGER*
Inscribed and dated on the verso: *La carte postale, 2-me état, 1932–1948*
⌐⌐ 9726 B.819

The painting receives its name from the postage stamp located in the top left-hand corner, as well as from the popular greetings-card motif of the woman with a flower. Stylistically, the picture is similar to the compositions of the early 1930s, works that the painter himself described as 'vertical' art, with depth and perspective reduced to a minimum. A precise dating is hard to give because the painting remained unfinished at the beginning of the 1930s and was modified on Léger's return to France after the Second World War. In Boquier's catalogue, the painting is listed among the works of 1932. It is clear that in 1948 Léger could only have slightly retouched it, for it bears no traces of having been repainted. As early as 1929 Léger had depicted two women 'floating' in space with a rose alongside; the canvas was entitled either *The Two Graces* or *Dance* (B. 653, 654, 655). A brown, almost monochromatic painting with two figures, a rose, and a leaf appeared the following year, also entitled *Postcard* (Italy, Boffa collection; B. 743). There exists another version of this composition, in green tones, dated 1931. It is these versions of *Postcard* that reflect the first stage of composition. The Hermitage canvas, as well as a smaller eponymous version dated 1932 (46 x 33 cm, private collection, Paris; B. 820), represent the second stage. The details of the smaller *Postcard* differ only slightly from those of the larger Hermitage canvas: the overall tonal qualities are slightly different; the contours are not as sharply defined; the yellow flower in the centre that unifies the composition is absent; and the stamp is clearly delineated. Figures similar to those in the Hermitage painting reappear in *Composition with Three Figures* (1932; Paris, formerly Zervos collection) and in *Composition with Figures* (c. 1931; Philadelphia Museum of Art), the earliest preparatory study for *Postcard*. Various objects are juxtaposed so as to spark a chain of metaphorical associations: lips and leaves, breasts and the heart of a flower, and so forth. The earliest prototypes for the women in *Postcard* are the figures in *Dance* (1929; Musée de Grenoble). The theme for *Postcard* was clearly inspired by Léger's correspondence with Simone Herman. A passionate liaison with this woman, half his age, had begun in 1931 and continued until he was forced to leave France in 1940 (see 'Fernand Léger: Une correspondance poste restante', *Les Cahiers du Musée National d'art moderne*, Centre Georges Pompidou, Paris, 1997).

Provenance: acquired from the Pushkin Museum, Moscow, in 1953; previously given to Marshal I. V. Stalin by a group of Léger's students on the occasion of his seventieth birthday on 14 December 1949; exhibition of I. V. Stalin's presents, Moscow, from 1949; Pushkin Museum from 1953.

Edmond Lempereur
1876, Oullins, Rona – 1909, Oullins

Lempereur worked in Paris. From 1903 he exhibited at the Salon des Indépendants. His work was influenced by Monet, Gauguin and Toulouse-Lautrec. He painted landscapes and genre scenes.

186. Waiting (Moulin de la Galette), 1905 (page 336)
L'attente (Moulin de la Galette)
Oil on canvas. 55.5 x 46.5 cm
Signed bottom left: *E. Lempereur*
⌐⌐ 6560

This painting depicts a corner of the famous Parisian *café-concert*. Here Lempereur adheres to a compositional scheme that took shape in the early years of Impressionism in the works of Degas (*In a Café*, more famously known as *Absinthe*, 1875–6, Paris, Musée d'Orsay; L. 393) and Manet (*The Plum*, 1878, Washington, National Gallery of Art).

Provenance: acquired from the State Museum of Modern Western Art in 1931; previously in the collection of I. A. Morozov (purchased from the Salon des Indépendants exhibition for 300 francs) from 1905; Second Museum of Modern Western Painting from 1918; State Museum of Modern Western Art from 1923.

187. Bar Tabarin, 1905 (page 337)
Le bar Tabarin
Oil on canvas. 61 x 50 cm
Signed bottom left: *E. Lempereur*
⌐⌐ 8911

Bar Tabarin was painted at the beginning of 1905. The Tabarin music- and dance-hall, named after the eighteenth-century actor Antoine Tabarin, was opened in December 1904 on rue Victor Massé in Montmartre. It was located directly opposite Degas's house, something Lempereur probably knew. In any case, he associated *Bar Tabarin* and *Waiting (Moulin de la Galette)* with some of Degas's works: *Absinthe* (1875–6; Paris, Musée d'Orsay; L. 393), and the watercolours *Woman in a Café* (c. 1877; New York, private collection; L. 417) and *Women on a Café Terrace in the Evening* (1877; Paris, Musée d'Orsay; L. 419). *Bar Tabarin* was exhibited at the Salon des Indépendants in the spring of 1905.

Provenance: acquired from the State Museum of Modern Western Art in 1931; previously in the collection of I. A. Morozov (purchased from the Salon des Indépendants exhibition for 300 francs) from 1905; Second Museum of Modern Western Painting from 1918; State Museum of Modern Western Art from 1923.

Stanislas Lépine
1835, Caen – 1892, Paris

From 1855 Lépine lived in Paris, where he painted copies of Old Masters in the Louvre. He made his début at the Salon of 1859. He knew Daubigny, Théodore Rousseau, Diaz de la Peña and Millet, but most significant was his friendship with Corot, who offered him advice. From 1866 he exhibited at the Salon as a 'student of Corot'. In 1874 he participated in the first Impressionist exhibition. He received third prize at the Salon of 1884, and was awarded the gold medal at the Exposition Universelle of 1889. Despite such official recognition, his paintings never became popular, and he lived in penury. Lépine spent his final years in Orruit Castle as a guest of the famous collector Count Doria. He painted primarily the banks of the Seine, environs of Paris, and views of the Marne.

188. Landscape with a Bridge, early 1870s (page 103)
Paysage avec le pont
Oil on wood. 26 x 39.5 cm
Signed bottom left: *Lépine*
Ⴈ 5099

This is one of Lépine's views of the environs of Paris, a motif he often turned to in the early 1870s. Stylistically, the landscape is similar to such works as *The Seine at Bercy* (1870–2; Edinburgh, National Gallery of Scotland).

Provenance: acquired from the State Museum Fund, Petrograd, in 1923.

Léon Lhermitte
1844, Mont Saint-Père, Aisne – 1925, Paris

Lhermitte studied in the studio of Horace Lecoq de Boisbaudran, where he developed a close friendship with Jean-Charles Cazin, Alphonse Legros and Henri Fantin-Latour. He made his début at the Salon of 1864 and was awarded third prize in 1874. His work was influenced by Millet. In 1890 Lhermitte became one of the founders, and later president, of the Société Nationale des Beaux-Arts. In 1905 he became a member of the Institut de France. He painted mostly scenes of country life, landscapes, portraits, and occasionally religious compositions.

189. Landscape with a Peasant-Woman Milking a Cow, mid-1880s (page 99)
Paysage avec la paysanne traitant la vache
Pastel on paper. 41 x 50 cm
Signed bottom left: *L. Lhermitte*
Ⴈ 27315

This pastel was most probably painted in the mid-1880s when Millet's influence, noticeable here, was most profound. From then on, pastel became Lhermitte's favourite medium. Lhermitte would travel around France fairly frequently at this time, and *Landscape with a Peasant-Woman* would seem to depict Champagne.

Provenance: acquired from the Department of the Preservation of Historic Monuments in 1922; previously in the collection of A. I. Somov, Petrograd.

André Lhote
1885, Bordeaux – 1962, Paris

From 1893 to 1895 Lhote studied sculpture at the Ecole des Beaux-Arts in Bordeaux. In 1905 he abandoned sculpture to devote himself to painting. His work was influenced by Gauguin. In 1906–7 Lhote moved from Synthetism to Fauvism, and then around 1910 to an adherence to the work of Cézanne. From 1917 to 1920 he embraced a simplified form of Cubism in the manner of Juan Gris and Roger de la Fresnaye. From 1907 he exhibited at the Salon d'Automne and from 1908 at the Salon des Indépendants. In 1912 Lhote became one of the founders of the Section d'Or group. He was also a dedicated teacher at the Académie Nôtre-Dame des Champs from 1918 to 1920, and then at the Académie on boulevard Raspail (1920). In 1922 he founded the Académie André Lhote in Montparnasse. After the Second World War he exerted considerable influence on young artists. He painted large decorative works, designed cartoons for tapestries, and wrote a number of academic papers and treatises on art.

190. Green Landscape, 1920–1 (page 363)
Paysage vert
Oil on canvas. 55 x 46.5 cm
Signed bottom left: *A. LHOTE*
Ⴈ 8914

This landscape can be dated to 1920–1, for it reveals a movement away from the stylistic techniques of Cubism towards those of Cézanne.

Provenance: acquired from the State Museum of Modern Western Art in 1948; previously in the collection of Léopold Zborovsky, Paris (purchased from the artist for 600 francs) from 1925; State Museum of Modern Western Art (donated by Zborovsky) from 1927.

Maurice Lobre
1862, Bordeaux – 1951, Paris

Lobre studied at the Ecole des Beaux-Arts under Gérôme and Carolus-Duran. He exhibited at the Galerie Petit from the year it was founded in 1882, and at the Salon, where he was awarded an honorary mention in 1888. He won the gold medal at the Exposition Universelle in 1900. Lobre painted genre scenes, reminiscent of Forain, portraits, still lifes, landscapes, and interiors. His interiors of the Palace of Versailles were especially successful.

191. Hall of the Dauphin at Versailles, 1901 (page 227)
Le Salon du Dauphin, Versailles
Oil on canvas. 80 x 93.5 cm
Signed and dated bottom right: *M. Lobre 1901*
Ⴈ 6534

The painting depicts one of the apartments of the Dauphin, the father of Louis XVI. This room, with windows opening onto the park, is located on the first floor of the main building of the Palace of Versailles (now room no. 48). Shortly before Lobre painted this work, the room, which retained part of the original eighteenth-century decoration, was filled with paintings and sculptures by French eighteenth-century masters.

Provenance: acquired from the State Museum of Modern Western Art in 1931; previously in the collection of S. I. Shchukin, Moscow (acquired before 1908); First Museum of Modern Western Painting from 1918; State Museum of Modern Western Art from 1923.

Edouard Manet
1832, Paris – 1883, Paris

From 1850 to 1856 Manet studied in the atelier of Thomas Couture and also attended the Académie Suisse. In 1852–3 he visited Holland, Germany, Czechoslovakia and Italy. He copied works of the Old Masters in the Louvre, where he met Fantin-Latour (1857) and Degas (1859). Manet's painting was rejected by the Salon of 1859, despite the intervention of Delacroix. From 1861 he exhibited at the Salon, and in 1863 showed *Déjeuner sur l'herbe* and other works at the Salon des Indépendants. He met and became friends with Baudelaire. *Olympia*, which was exhibited at the Salon two years later, caused an uproar. In 1865 he visited Spain. In 1866 he met Monet, Cézanne, and Zola, who came to his defence. He organised a private exhibition of his paintings during the Paris Exposition Universelle of 1867. With Degas, Renoir, Monet, and Pissarro, he frequented the Café de la Nouvelle-Athènes in the Place Pigalle from 1872. He followed in Monet's footsteps and painted *en plein air* in the mid-1870s. Although he never exhibited with the Impressionists, Manet exerted a huge influence on the movement. He was a painter of portraits, landscapes, still lifes and nudes, a graphic artist and an engraver.

192. Portrait of Mme Jules Guillemet, c. 1880 (page 110)
Italian pencil on paper. 31.3 x 22 cm
Initialled bottom right: *E.M.*
43094

M. and Mme Jules Guillemet, owners of a fashionable shop on the Faubourg Saint-Honoré, were friends of Manet. The couple also appear in his picture *In the Conservatory* (Berlin, Neue

Nationalgalerie), and Mme Guillemet is depicted in several of Manet's watercolours and pastels, including *The Parisienne or Mme Jules Guillemet with an Uncovered Head* (Ordrupgaard Museum, near Copenhagen) and *The Parisienne* (1882; Los Angeles, Madd collection), as well as in drawings enclosed with Manet's letters to her. The Hermitage drawing was a study for the pastel portrait *Mme Jules Guillemet in a Hat* (c. 1880; Saint Louis, Art Museum).

Provenance: acquired in 1938; previously in a private collection, Leningrad.

Henri Manguin
1874, Paris – 1949, Saint-Tropez

From 1894 Manguin studied under Gustave Moreau at the Ecole des Beaux-Arts in Paris, where he befriended Matisse, Rouault, Guérin, and, most closely of all, Marquet. He copied the works of the Old Masters in the Louvre, and received advice from Pissarro. Manguin made his début at the Salon of the Société Nationale des Beaux-Arts in 1900; from 1902 he exhibited at the Salon des Indépendants, and from 1904 at the Salon d'Automne, where, the following year, he exhibited with other Fauves. From 1908 to 1910 he taught at the Académie Ranson. In 1909 Manguin visited Italy with Marquet. He worked primarily in Saint-Tropez, and spent the Second World War in Switzerland. He painted landscapes, still lifes, nudes and portraits; he also frequently painted in watercolour.

193. Landscape in Saint-Tropez, 1905 (page 266)
Paysage à Saint-Tropez
Oil on canvas. 50.5 x 60.5 cm
Signed bottom right: *Manguin*
Ⴈ 4854 M. 165

In 1905 Manguin rented the Villa Demière near Saint-Tropez, where he painted two of the Hermitage landscapes (see also cat. 194). They were probably among the 150 canvases Vollard bought wholesale from Manguin for 5,000 francs when he 'discovered' him. The motif of gnarled trees was a favourite of Manguin's during his Fauvist period. The house in the centre of the landscape is the so-called Château Martin. Executed in the summer of 1905, *Landscape in Saint-Tropez* was exhibited the same year at the Galerie Berthe Weill as *Wood, Evening* (*Exposition du groupe*, Galerie Berthe Weill, Paris, 1905, no. 30).

Provenance: acquired from the collection of G. E. Haasen in 1921; previously in the Galerie Vollard (purchased from the artist) from 1905; collection of G. E. Haasen, St Petersburg, from March 1906.

194. Path in Saint-Tropez, 1905 (page 267)
Allée à Saint-Tropez
Oil on canvas. 73 x 91.5 cm
Signed bottom left: *Manguin*
Ⴈ 4859 M. 167

Path in Saint-Tropez was painted at the Villa Demière in the environs of Saint-Tropez in the summer of 1905. *The Meadow, Villa Demière* (1905; private collection) was painted from the same perspective and at about the same time as the Hermitage picture. The figures on the right are the artist's wife, Jeanne, and their sons. In the *catalogue raisonné* of Manguin's paintings, the picture is called *Saint-Tropez, Jeanne with Her Sons*.

Provenance: acquired in 1921; previously in the Galerie Vollard (purchased from the artist) from 1905; collection of G. E. Haasen, St Petersburg, from March 1906.

195. Morning in Cavalière, 1906 (page 268)
Matin (Au bord du golfe de Cavalière)
Oil on canvas. 81.5 x 65 cm
Signed bottom right: *Manguin*
Ⴈ 8956 M. 215

One of Manguin's most successful works, this painting is also well known under other titles: *Woman on the Seashore; Woman Sitting by the Shore of the Gulf of Cavalière*; and *Morning*. The last harks back to Manguin's Fauvist period, when he spent the spring and summer on the shores of the Mediterranean, usually painting early in the morning and often depicting a female figure in a landscape. Completed in the spring or summer of 1906, the work belongs to a group of landscapes showing the area around Cavalière. Two of them, as well as the Hermitage canvas, portray Manguin's favourite model, his wife Jeanne, carrying the same umbrella (Germany, private collection, M. 210; *Jeanne with an Umbrella, Cavalière*, Bielefeld, Kunsthalle, M. 211).

Provenance: acquired from the State Museum of Modern Western Art in 1948; previously in the collection of S. I. Shchukin, Moscow (acquired from the Salon d'Automne) from 1906; First Museum of Modern Western Painting from 1918; State Museum of Modern Western Art from 1923.

196. Flowers, 1915 (page 269)
Fleurs
Oil on canvas. 41 x 33.5 cm
Signed and dated bottom right: *Manguin 1915*
ГЭ 4855 M. 490

This painting was executed at the very beginning of 1915 in Lausanne. Here Manguin repeats the compositional elements of two 1908 still lifes that depict flowers in a wineglass: *Anemones* (M. 297) and *Anemones and Jonquils* (both in private collections).

Provenance: acquired in 1921; previously in the collection of G. E. Haasen, Petrograd (acquired from the artist) from February 1915.

Georges Manzana-Pissarro
1871, Louveciennes – 1961, Menton

Manzana-Pissarro studied drawing and painting in watercolour under his father Camille Pissarro. To distinguish his work from that of his father and brothers, he signed his paintings with his grandmother's maiden name, Manzana. His artistic development was highly influenced by the Impressionists and by Cézanne and Gauguin, when they visited his father's house. In 1899 he visited his brother Lucien in London. He enrolled at the Ecole des Arts Décoratifs, where he studied interior, furniture and tapestry design, as well as the art of stained-glass windows. He made his début in 1893 at the second exhibition of the Neo-Impressionists. He also exhibited at the Salon des Indépendants. Manzana-Pissarro painted landscapes and figurative compositions in oil and in watercolour (sometimes with gold and silver, which satisfied his decorative tendencies). From 1939 to 1947 he lived and worked in Casablanca, Morocco.

197. Zebras at the Watering-Hole, c. 1906 (page 232)
Zèbres s'abreuvant
Gouache, watercolour and gold on paper. 66 x 53 cm
Signed bottom right: *G. MANZANA*
42161

This gouache is linked to Manzana-Pissarro's work on a screen, which was shown along with other works at his one-man exhibition in 1914 (*Exposition des oeuvres de Manzana-Pissarro*, Paris, Musée des Arts Décoratifs, Palais du Louvre, 1914). He exhibited *Woman with Zebras: Study for a Screen* (no. 46; present whereabouts unknown) in the tempera painting section. It is possible that *Woman with Zebras* (no. 94), which was shown in the gouache section, is this work. An eponymous drawing in Indian ink (no. 210) also existed.

Provenance: acquired from the State Museum of Modern Western Art in 1931; previously in the Galerie Vollard; collection of I. A. Morozov from 1907; Second Museum of Modern Western Painting from 1918; State Museum of Modern Western Art from 1923.

Albert Marquet
1875, Bordeaux – 1947, Paris

From 1890 to 1895 Marquet studied at the Ecole des Arts Décoratifs in Paris, where he met Matisse, and then from 1895 to 1898 under Gustave Moreau at the Ecole des Beaux-Arts, where he met Manguin, Camoin, Rouault and Guérin. He attended classes with Matisse and future Fauves at the Académie Carrière. From 1903 he exhibited both at the Salon des Indépandants and the Salon d'Automne. He exhibited in the so-called 'cage of wild beasts' – the seventh hall of the 1905 Salon d'Automne – along with Matisse, Manguin, Derain and Vlaminck, but Marquet was never more than a fellow-traveller of the Fauves. In 1905 he worked in Saint-Tropez with Matisse, in 1906 in Le Havre with Dufy, and in 1907 with Friesz and Camoin. He travelled a great deal, visiting England, Holland, Norway, Spain, Romania, Switzerland, Morocco, Egypt, Tunis, and the Soviet Union. He spent the Second World War in Algiers. He painted mostly landscapes, occasionally portraits and nude studies, and produced book illustrations.

198. Milliners, c. 1901 (page 258)
Les modistes
Oil on canvas. 50.5 x 61 cm
Signed bottom right: *marquet*
ГЭ 9030

The paintings *Milliners, The Painter's Mother and His Cousin* (c. 1900; formerly Paris, collection of Marcelle Marquet) and *Matisse's Wife Making a Tapestry* (c. 1905; Paris, private collection) form a special group in Marquet's oeuvre. The scenes of women engaged in needlework reflect in part the influence of Vuillard. *The Painter's Mother and His Cousin* is especially close to the Hermitage work. Marquet's mother is recognisable as the figure by the window on the left. According to his wife Marcelle's memoirs, the milliner was his mother's best friend, a woman she visited frequently. It is possible that the figure on the right represents Marquet's cousin, for there is a certain similarity with her portrait of 1902.

Provenance: acquired from the State Museum of Modern Western Art in 1948; previously in the Galerie Druet; collection of S. I. Shchukin; First Museum of Modern Western Painting from 1918; State Museum of Modern Western Art from 1923.

199. Port of Menton, 1905 (page 262)
Port de Menton
Oil on canvas. 50.5 x 61 cm
Signed bottom left: *marquet*
ГЭ 4906

In the summer of 1905 Marquet worked in Saint-Tropez. From there he travelled along the Côte d'Azure to Menton. The series of landscapes he painted at that time, primarily maritime, are notable for their bright colours. Besides the Hermitage painting, there is another well-known landscape of Menton Harbour (shown in February and March 1906 at the *Libre Esthétique* exhibition in Brussels). One of these two views of Menton was exhibited at the famous Salon d'Automne of 1905 (no. 1044), but it is impossible to determine which one because the exhibition catalogue provides neither dimensions nor any other information. The painting portrays the Promenade du Midi in Menton. The seventeenth-century cathedral of Saint-Michel, the town's principal tourist attraction, appears on the left behind the houses.

Provenance: acquired from the collection of G. E. Haasen in 1921; previously in the Galerie Bernheim-Jeune; collection of G. E. Haasen, St Petersburg.

200. Quai du Louvre and the Pont Neuf, 1906 (page 259)
Oil on canvas. 60 x 73 cm
Signed bottom left: *marquet*
ГЭ 6526

Following the example of Claude Monet, who had painted scenes from the windows of the Louvre (including the Quai du Louvre) in 1867, Marquet also executed a series of paintings of the embankment from a similar perspective in the summer of 1906. In the Hermitage painting, the Pont Neuf is almost hidden behind the leaves of the trees, while the Palais de Justice and Nôtre-Dame Cathedral appear in the distance. The landscape resembles other paintings in private collections in Paris: *Pont Neuf and the Ile de la Cité*, and *View of the Ile de la Cité from the Quai du Louvre*. The latter has more of a sketch-like quality and probably preceded the Hermitage painting.

Provenance: acquired from the State Museum of Modern Western Art in 1930; previously in the Galerie Blot, Paris; collection of I. A. Morozov (purchased from Blot for 700 francs) from 1907; Second Museum of Modern Western Painting from 1918; State Museum of Modern Western Art from 1923.

201. View of the Seine and the Henri IV Monument, c. 1906 (page 259)
Vue de la Seine et le monument de Henri IV
Oil on canvas. 65.5 x 81 cm
Signed bottom left: *marquet*
ГЭ 9151

In 1905, having moved to 25 Quai des Grands-Augustins, Marquet painted a series of views from the window of his studio, including *Quai des Grands-Augustins* (Paris, Centre Georges Pompidou); *Pont Neuf* (1906; Washington, DC, National Gallery); and *Pont Neuf on a Sunny Day* (1906; Rotterdam, Boymans–van Beuningen Museum). The upper half of *Pont Neuf on a Sunny Day* recreates the view seen in the Hermitage canvas; the Rotterdam landscape was painted towards the end of the summer, whereas the *View of the Seine* was most likely completed in late autumn. In the lower right-hand part of the picture, adjacent to the Pont Neuf, can be seen a square with Lemot's monument to Henri IV (1818), and the spit of the Ile de la Cité and the Pont des Arts further on, and the Louvre to the right.

Provenance: acquired from the State Museum of Modern Western Art in 1948; previously in the Galerie Druet; collection of I. A. Morozov (purchased from Druet for 700 francs) from 1908; Second Museum of Modern Western Painting from 1918; State Museum of Modern Western Art from 1923.

202. Saint-Jean-de-Luz, 1907 (page 262)
Oil on canvas. 60 x 81 cm
Signed bottom left: *marquet*
ГЭ 7726

At the end of the summer of 1907, Marquet made a brief trip to Saint-Jean-de-Luz, a small town on the Bay of Biscay (to which he returned in 1927 and painted a few landscapes). His trip in 1907 yielded two known works: this canvas and *Sunset, Saint-Jean-de-Luz* (France, private collection; exhibited at the Galerie Charpentier, Paris, 1952). The painting was acquired by S. I. Shchukin at the beginning of 1913 and just included in the catalogue of his collection. In October and November of the previous year it was exhibited at the second Post-Impressionist exhibition at the Grafton Gallery in London (it then belonged to Druet, who was always supportive of the painter).

Provenance: acquired from the State Museum of Modern Western Art in 1934; previously in the Galerie Druet, Paris; collection of S. I. Shchukin from 1913; First Museum of Modern Western Painting from 1918; State Museum of Modern Western Art from 1923.

203. Port of Hamburg, 1909 (page 263)
Le port de Hambourg
Oil on canvas. 66.5 x 80
Signed bottom right: *marquet*
ГЭ 8907

In the winter of 1909 Marquet lived in Hamburg, where he painted a series of landscapes of the commercial port. Thirteen views of the port were exhibited at his one-man exhibition at the Galerie Druet in 1910. The tugboat was the central motif in some of these views, among them the Hermitage painting and *Tugboat in Hamburg* (two versions exist: 1909, private collection; 1910, Paris, former collection of Marcelle Marquet). The same area of the port's water with the tugboat is also shown in *Port of Hamburg* (USA, private collection). A drawing entitled *Tugboat, Hamburg* (1909; France, private collection; Marquet exhibition, Musée de Lodève, no. 89) can be considered to be a preparatory drawing for the Hermitage *Port of Hamburg*. The painting depicts the northern arm of the Elbe River. Seen in the background is a pink band of warehouses along the Canal des Douanes, and in the centre the spires of two medieval churches: on the right, Sainte Cathérine and on the left, Saint Michel. The Hermitage canvas was probably exhibited at the Salon d'Automne in 1909 under the title *Hamburg in Winter on a Sunny Day* (Druet collection, no. 1132).

Provenance: acquired from the State Museum of Modern Western Art in 1948; previously in the Galerie Druet, Paris; collection of S. I. Shchukin; First Museum of Modern Western Painting from 1918; State Museum of Modern Western Art from 1923.

204. Bay of Naples, 1909 (page 264)
Naples
Oil on canvas. 62 x 80.3 cm
Signed bottom right: *marquet*; dated below in ink: *1909*
Г⋑ 9150

Marquet discovered Naples in 1908, and spent the summer of 1909 there. Eleven landscapes, brought back from Naples a few months earlier, were shown at an exhibition at the Galerie Druet in May 1910. Most of them depict Mount Vesuvius in the background, and the Bay of Naples dotted with boats, sailing vessels and tugboats. Of these, the closest to the Hermitage canvas in compositional structure and painterly style are *Naples: Sailing Boat* (1909; Bordeaux, Musée des Beaux-Arts) and *Naples: The Rower* (1909; Paris, private collection). *Vesuvius* (1909; Moscow, Pushkin Museum) is painted from the same viewpoint.

Provenance: acquired from the State Museum of Modern Western Art in 1948; previously in the Galerie Druet, Paris; collection of I. A. Morozov (purchased from Druet for 3,750 francs) from 1913; Second Museum of Modern Western Painting from 1918; State Museum of Modern Western Art from 1923.

205. Rainy Day in Paris (Nôtre-Dame Cathedral), 1910 (page 260)
Nôtre-Dame sous la pluie
Oil on canvas. 81 x 66 cm
Signed bottom right: *marquet*
Г⋑ 6526

From 1901, Marquet painted Nôtre-Dame Cathedral on many occasions under different lighting and weather conditions. When he moved to the Quai Saint-Michel in 1908, he could see Nôtre-Dame from the window of his studio. From 1908 to 1910 he executed a series of views showing the cathedral in the background. He reproduced the composition of the Hermitage painting in *Nôtre-Dame: Snow* (early 1910; Paris, private collection). The painting's date is established by the label on the stretcher which reads *January Flood. Nôtre Dame. 1910*. The painting depicts the end of the flood: the level of the Seine has already dropped, and the lower embankment, which overflows during floods, is no longer inundated.

Provenance: acquired from the State Museum of Modern Western Art in 1930; previously in the Galerie Druet, Paris; collection of I. A. Morozov (purchased from Druet for 1,800 francs) from 1911; Second Museum of Modern Western Painting from 1918; State Museum of Modern Western Art from 1923.

206. Place de la Trinité in Paris, c. 1911 (page 261)
Oil on canvas. 81 x 65.5 cm
Signed bottom right: *marquet*
Г⋑ 4905

The organisers of the Marquet exhibition of 1975, which was shown in Bordeaux and Paris, dated this painting to 1910. However, Francis Jourdain, who knew Marquet well, dated it to 1911, which is probably more accurate. The silhouette of the Sacré-Coeur Basilica in Montmartre, seen in the background, confirms Jourdain's opinion because the belfry of the church was only completed in 1910, and is here clearly visible. Marquet was apparently drawn to the Sacré-Coeur and the Eglise de la Trinité because of the similarities between them: in both buildings the vertical ascending lines are emphasised. The Eglise de la Trinité had also been painted by Renoir and Pissarro. Renoir had used a similar viewpoint in a painting completed around 1892–3 (Hiroshima, Art Museum). Marquet was probably familiar with these works, but he avoided the Impressionists' use of vibrant colour, focusing instead on conciseness of expression and a structural composition. In the spring of 1911, Marquet showed two landscapes of the Eglise de la Trinité at an exhibition at the Druet Gallery: one in sunny and the other in cloudy weather (nos. 27 and 28). The latter is the Hermitage painting, while the former probably belonged to Gallimard (it was exhibited again at the Salon d'Automne of 1911).

Provenance: acquired from the collection of G. E. Haasen in 1921; previously in the Galerie Druet, Paris; collection of G. E. Haasen, St Petersburg.

207. View of the Environs of Rouen, 1927 (page 263)
Vue aux environs de Rouen
Indian ink, reed pen, and pencil on paper.
21.3 x 31.2 cm
Signed bottom left: *marquet*
44969

In 1927 Marquet set out for Mailleraye, a small harbour on the Seine not far from Rouen, where a regatta was to be held. The visit resulted in the canvas *Regatta in Mailleraye* (1927; Bordeaux, Musée des Beaux-Arts), which depicts sailing boats before the race. The Hermitage drawing, which also shows the mouth of the Seine still deserted, apparently preceded not only the painting but the regatta itself. The drawing was done in two stages: first, Marquet made a pencil sketch outdoors; then he retouched it with pen and Indian ink in his studio.

Provenance: acquired (as a gift from the artist's widow) in 1959; previously in the collection of Marcelle Marquet, Paris.

Henri Matisse
1869, Le Cateau-Cambrésis, Picardy – 1954, Nice

In 1891 Matisse was a student at the Académie Julian. From 1892 to 1898 he studied under Gustave Moreau at the Ecole des Beaux-Arts with Rouault, Marquet, Manguin and Camoin. Following Moreau's advice, he painted copies of the Old Masters in the Louvre. In 1896 he made a successful début at the Salon of the Société Nationale des Beaux-Arts. In 1897 he met Pissarro. In 1901 he exhibited for the first time at the Salon des Indépandants, and in 1903 at the Salon d'Automne. In 1904 Vollard organised Matisse's first one-man exhibition. The summer of that year he spent in Saint-Tropez with Signac and Cross. From 1896 to 1904 he made the transition from tentative Impressionism to a more intense use of colour. Matisse spearheaded the Fauvist movement at the Salon d'Automne of 1905. The following year he met his future patron S. I. Shchukin. In 1908 he published 'Notes of a Painter'. He made several trips: Italy in 1907, Germany in 1908, Spain in 1910–11, Russia in 1911, Morocco in 1912–13. In 1917 Matisse settled in Nice. In 1927 he received the Carnegie Prize.

In 1930 he visited Tahiti once and the United States twice. Matisse received the Grand Prix at the Venice Biennale in 1950. His final significant achievement was the decoration of the Chapelle du Rosaire at Vence (1948–51). He planned every detail of the chapel, including the architecture, frescoes, stained-glass windows, furnishings, and priests' vestments. He was a painter, printmaker, sculptor, book illustrator and designer.

208. Blue Pot and Lemon, 1897 (page 293)
Pot bleu et citron
Oil on canvas. 39 x 46.5 cm
Signed top left: *Henri-Matisse*
Г⋑ 7698

This work can be dated to 1897 because of its similarity with *The Dinner Table* (1897; Paris, Niarchos collection), often regarded as Matisse's first Impressionist painting. *Blue Pot and Lemon* was not a study for *The Dinner Table*, but it was completed either around the same time or shortly after. Both paintings reflect a keen interest in the rendition of light. *Blue Pot* is also stylistically close to *Still Life with Apples* (1897; Chicago, Art Institute).

Provenance: acquired from the State Museum of Modern Western Art in 1934; previously in the Galerie Druet, Paris; collection of I. A. Morozov (purchased from Druet for 500 francs) from 1908; Second Museum of Modern Western Painting from 1918; State Museum of Modern Western Art from 1923.

209. Sunflowers in a Vase, 1898 (page 294)
Tournesols dans un vase
Oil on canvas. 46 x 38 cm
Signed bottom right: *Henri-Matisse*
Г⋑ 7706

Following Monet, Van Gogh and Gauguin, Matisse explored the sunflower motif because it presented possibilities for dynamic painting, above all in the use of broad brushstrokes suggestive of the flowers' very construction. Stylistically, the still life is similar to the works painted in Corsica and Toulouse in 1898 and 1899, such as *Small Fauve Landscape, Corsica*; *Mill Courtyard*; *Sick Woman, Ajaccio*; *Sunset in Corsica* (1898; New York, Sackler collection). *Sunflowers in a Vase* can best be compared with *Sunset in Corsica*, since sunflowers traditionally symbolise the sun, and both are painted in the same manner. At that time Matisse painted another still life with sunflowers, but shown in a jug with a handle (private collection; Flam, 1986, p. 58).

Provenance: acquired from the State Museum of Modern Western Art in 1934; previously in the collection of M. I. Tsetlin; State Museum Fund from 1918; State Museum of Modern Western Art from 1925.

210. Fruit and Coffee Pot, c. 1898 (page 293)
Fruits et cafetière
Oil on canvas. 38.5 x 46.5 cm
Signed bottom left: *H. Matisse*
Г⋑ 8892

This painting is often compared to *The Dinner Table* (1897; Paris, Niarchos collection). However, the play of light and shadow, the accentuated reflexes and the penetration of shadow into light suggest that Matisse has here made an important step forward: colour is now more important than light. There are no areas of accentuated colour in the tablecloth in *The Dinner Table*, but here they are crucial to the whole painting, for they unify the objects by means of colour. The picture is closely linked with two still lifes Matisse painted in Toulouse at the beginning of 1899: *First Orange Still Life* (Paris, Centre Georges Pompidou) and *Still Life Against the Light* (private collection). All three works depict the same coffee pot and tablecloth. The more transitional Hermitage canvas probably preceded the other two paintings; it was also painted in Toulouse, evidently at the end of 1898. An inscription on the verso (*Van de*

Velde) and a second pencil inscription on the stretcher (*pour M. Van de Velde*) suggest that the painting was intended for the famous Belgian architect Henri Van de Velde, although he never received it.

Provenance: acquired from the State Museum of Modern Western Art in 1948; previously in the Galerie Druet, Paris; collection of I. A. Morozov (purchased from Druet for 700 francs) from 1910; Second Museum of Modern Western Painting from 1918; State Museum of Modern Western Art from 1923.

211. Dishes on a Table, 1900 (page 294)
Vaisselle sur une table
Oil on canvas. 97 x 82 cm
Signed and dated bottom right: *Henri-Matisse. 1900*;
signature also visible bottom left under red paint:
Henri-Matisse
Γ϶ 6518

This painting is also known as *Still Life with Soup Tureen*, the title under which Matisse exhibited it at the Salon des Indépendants of 1902. It belongs to a group of still lifes of 1900 which depict the same chair (*Still Life with Harmonium*, Nice, Musée Matisse) and, in two cases, the same chocolate-pot (*Still Life with Chocolate-Pot*, Paris, Maguy collection, and *Vase of Flowers*, Paris, Musée Picasso). The same objects are portrayed in two Indian-ink drawings completed around the same time: *Still Life with Chocolate-Pot* (Bragaline collection) and *Study for Still Life with Chocolate-Pot* (Cateau-Cambrésis, Musée Matisse). In these drawings, the chair is absent and the composition is horizontal. It is difficult to determine whether they were preparatory drawings or done at the same time as the Hermitage canvas.

Provenance: acquired from the State Museum of Modern Western Art in 1934; previously in the Galerie Berthe Weill, Paris; collection of S. I. Shchukin from 1908; First Museum of Modern Western Painting from 1918; State Museum of Modern Western Art from 1923.

212. Dishes and Fruit, 1901 (page 295)
Poterie et fruits
Oil on canvas. 51 x 61.5 cm
Signed bottom left: *H. Matisse*
Γ϶ 7697

The painting is dated by a pencil inscription on the stretcher: *Henri Matisse, 1901*. The dual influence of Van Gogh (whose work was exhibited at the Galerie Bernheim-Jeune in 1901) and Cézanne coalesced in *Dishes and Fruit*: the pictorial structure is reminiscent of Cézanne's late-1870s still lifes, while in terms of composition the canvas is similar to Cézanne's unfinished *Still Life with Pitcher* (*c.* 1893; London, Tate Gallery; R 738).

Provenance: acquired from the State Museum of Modern Western Art in 1934; previously in the Galerie Berthe Weill, Paris; collection of S. I. Shchukin from 1908; First Museum of Modern Western Painting from 1918; State Museum of Modern Western Art from 1923.

213. Jardin du Luxembourg, c. 1901 (page 296)
Oil on canvas. 59.5 x 81.5 cm
Signed bottom right: *Henri-Matisse*
Γ϶ 9041

Matisse's Paris landscapes of 1901–2 bear certain similarities to the work of Gauguin, whose paintings Matisse had bought in 1899. Like the Post-Impressionist master, Matisse discarded small details from his work and constructed his landscapes from a few large and dynamic zones of colour. Although he was not inspired by the palette of the tropics, Matisse's colours in this painting are brighter than those generally used by Gauguin. *Beside the Road, Jardin du Luxembourg* (*c.* 1901; New York, private collection) is one of the studies for the the painting that has survived.

Provenance: acquired from the State Museum of Modern Western Art in 1948; previously in the Galerie Druet, Paris; collection of S. I. Shchukin from 1907; First Museum of Modern Western Painting from 1918; State Museum of Modern Western Art from 1923.

214. View of Collioure, c. 1905 (page 297)
Vue de Collioure
Oil on canvas. 59.5 x 73 cm
Signed bottom left: *H. Matisse*
Γ϶ 8997

Matisse worked in Collioure in the summer of 1905, and again in the spring and summer of 1906. *View of Collioure* (also known as *Roofs of Collioure*) is dated to either 1905 or 1906. The pencil inscription *1906* on the stretcher might have been made at the Galerie Bernheim-Jeune, but since the last digit was a correction, it is possible that the original date read *1905*. Stylistically, this makes more sense, for the painting fits in well with the Collioure series of 1905: *The Marina* (San Francisco, Art Museum); *Street in Collioure* (private collection); and *The Red Beach* (Santa Barbara, Ludington collection). These paintings share a close affinity with the Hermitage work. It was in 1905 that Matisse, rethinking the idiom of Divisionism, introduced large flat planes of pure colour alongside individual brushstrokes. The painting creates the impression of spontaneously applied colour, but an infrared photograph reveals that Matisse first made a precise pencil drawing of the composition's linear structure, and only then applied the paint. The picture shows the Chapelle Saint-Vincent in the seaside town of Collioure, located at the foot of the Pyrenees. In 1905, Matisse depicted the round belfry of the chapel in several paintings: *View of Collioure with the Chapel* (New York, Museum of Modern Art); *Collioure* (Tokyo, Bridgestone Gallery); *Port of Collioure* (Baltimore, Art Museum); and another *Port of Collioure* and *Drying the Nets, Collioure* (private collections).

Provenance: acquired from the State Museum of Modern Western Art in 1948; previously in the Galerie Bernheim-Jeune, Paris (purchased from the artist), from 15 February 1908; collection of S. I. Shchukin (purchased for 1,000 francs) from 9 January 1909; First Museum of Modern Western Painting from 1918; State Museum of Modern Western Art from 1923.

215. Dishes and Fruit on a Red and Black Carpet, 1906 (page 299)
Vaiselle et fruits sur un tapis rouge et noir
Oil on canvas. 61 x 73 cm
Signed bottom left: *Henri-Matisse*
Γ϶ 8998

This canvas was painted in Collioure in the summer of 1906. In the spring of that year, Matisse had made his first trip to North Africa, to Biskra, from where he travelled to Collioure. He brought back from Biskra Eastern fabrics and ceramics which he began to incorporate into his still lifes. The small Algerian rug shown here recurs in two other Collioure canvases of 1906: *Red Carpets* (Musée de Grenoble) and *Still Life with a Statuette* (New Haven, Yale University Art Gallery). The inclusion of the *porrón* in the composition would seem to confirm that the work was painted in Collioure; this type of Spanish wine-vessel was commonly used by the inhabitants of Collioure, which bordered with Spain.

Provenance: acquired from the State Museum of Modern Western Art in 1948; previously in the Galerie Druet, Paris; collection of S. I. Shchukin from 1908; First Museum of Modern Western Painting from 1918; State Museum of Modern Western Art from 1923.

216. Vase, Bottle and Fruit, c. 1906 (page 299)
Vase, bouteille, fruits
Oil on canvas. 73 x 92 cm
Signed bottom left: *Henri Matisse*
Γ϶ 7696

This picture is painted over part of an earlier still life with a cup and fruit, possibly oranges. A similar cup appears in *Still Life Against the Light* (1899; private collection). The wispy white brushstrokes against the dark background, combined with the vivid colours of the fruit and patterned tablecloth, almost create the effect of a pastel. There is some discrepancy as to the date of the painting. According to Matisse's daughter, Marguerite Duthuit, the still life was in her father's apartment as early as 1903, which accounts for some attempts to date it to 1902–3. However, the painting bears no similarities to other works of the period and is closer to later works such as *Pierre Matisse with a Rocking-Horse* (*c.* 1906; USA, private collection) and *Blue Still Life* (*c.* 1907; Merion, PA, Barnes Foundation). The same *toile de Jouy* that is depicted in the Hermitage composition appears in both of these paintings; later it would also feature in *Red Room* (cat. 220) and *Still Life with Blue Tablecloth* (cat. 225). The teapot on the right also appears in *Still Life with Blue Tablecloth*. Matisse was here depicting both these objects for the first time. Alfred Barr's dating of the work to 1907 cannot be accepted since in 1906 it had already been exhibited at the Galerie Druet (no. 46): an inscription on the verso reads *46 Nre Mte Camaïeu blue*. Early 1906 is thus the most likely date for the painting.

Provenance: acquired from the State Museum of Modern Western Art in 1934; previously in the Galerie Druet, Paris; collection of S. I. Shchukin from 1906; First Museum of Modern Western Painting from 1918; State Museum of Modern Western Art from 1923.

217. Lady on a Terrace, 1907 (page 298)
Dame sur une terrasse
Oil on canvas. 65 x 80.5 cm
Signed bottom left: *Henri-Matisse*
Γ϶ 9040

Lady on a Terrace, which portrays Matisse's wife Amélie, was painted in Collioure in the summer of 1907. Some scholars have suggested that it dates to 1906, but this is too early. Although Matisse here employs the vibrant colours of his 1906 canvases and accentuates them with the flow of vivid contours, these very contours create a linear composition more characteristic of his 1907 paintings. The most famous of these is *Luxury*, which also depicts the Collioure mountains in the background. The balustrade and mountains are again seen in *Interior at Collioure: The Siesta* (*c.* 1905; Ancona, private collection).

Provenance: acquired from the State Museum of Modern Western Art in 1948; previously in the Galerie Druet, Paris; collection of S. I. Shchukin from 1908; First Museum of Modern Western Painting from 1918; State Museum of Modern Western Art from 1923.

218. Bouquet (Two-Handled Vase), 1907 (page 300)
Bouquet (Vase à deux anses)
Oil on canvas. 74 x 61 cm
Signed bottom right: *Henri-Matisse*
Γ϶ 6522

According to an inscription on the verso, this picture was painted in the spring of 1907. Ivan Morozov bought the painting in the autumn of the same year, his first work by Matisse. The two-handled vase, which Matisse had apparently brought back from Biskra the year before, appears in other canvases as well, including *Still Life with a Greek Bust* (1908; private collection), and *Still Life with Dance* (cat. 226).

Provenance: acquired from the State Museum of Modern Western Art in 1930; previously in the Galerie Bernheim-Jeune, Paris (purchased from the artist) from 18 June 1907; collection of I. A. Morozov (purchased for 1,000 francs) from 1 October 1907; Second Museum of Modern Western Painting from 1918; State Museum of Modern Western Art from 1923.

219. Game of Bowls, 1908 (page 304)
Jeu de boules
Oil on canvas. 115 x 147 cm
Monogrammed and dated bottom left: *H. M. 08*
⌐Э 9154

Game of Bowls was painted very quickly at the beginning of the summer of 1908, and by the middle of that summer it was already in Moscow. It is not known whether Matisse had made any preparatory sketches for it. *Game of Bowls* belongs to a cycle of works linked by the theme of the Golden Age: *Joy of Life* (1905–6; Merion, PA, Barnes Foundation); two versions of *Luxury* (1907, Paris, Centre Georges Pompidou; and Copenhagen, Statens Museum for Kunst); the three-figure composition *Bathers with a Turtle* (1908; St Louis, Art Museum); and finally *Game of Bowls*. The poses of the figures in *Luxury* and *Game of Bowls* are very similar, while the Hermitage canvas is also close compositionally to *Bathers with a Turtle*, both in the generalised depiction of the landscape and in the arrangement of figures. The symbolic surroundings of *Game of Bowls* – an endless green meadow with a watery blue surface – came from *Bathers with a Turtle*, a canvas as large-scale as *Joy of Life* and the later *Red Room*. The obvious symbolism of *Bathers with a Turtle* and *Game of Bowls* is expressed in every aspect of style and content: the simplified landscapes, the number of figures, their nudity – all connected to the primordial state of humankind. While painting *Game of Bowls* as a 'male' counterpart to *Bathers*, Matisse went some way towards a kind of premeditated Primitivism. According to Picasso, with whom he was good friends at the time, Matisse developed this style because his sons Pierre and Jean were then just learning to draw. The crude contours and clumsiness of their childish daubings inspired their father to simplify and reduce form to its essence.

Provenance: acquired from the State Museum of Modern Western Art in 1948; previously in the Galerie Bernheim-Jeune, Paris; collection of S. I. Shchukin from 1909; First Museum of Modern Western Painting from 1918; State Museum of Modern Western Art from 1923.

220. Red Room (Harmony in Red), 1908 (page 301)
La chambre rouge (Harmonie rouge)
Oil on canvas. 180 x 220 cm
Signed and dated bottom left: *Henri-Matisse 1908*
⌐Э 9660

In the spring of 1908, Matisse moved into the Hôtel Biron on the Boulevard des Invalides (which now houses the Musée Rodin); the new, more spacious studio allowed him to undertake large-scale canvases. He soon began to paint *Harmony in Blue*, inspired by the decorative blue-patterned fabric of *toile de Jouy*, which he loved and which he kept in his studio until the end of his life. He had included the fabric a few years earlier in *Vase, Bottle and Fruit* (cat. 216), and subsequently in *Still Life with Blue Tablecloth* (cat. 225). In 1908, it also served as the background for *Portrait of Greta Moll* (London, National Gallery). Although the compositional scheme recalls his Realist *Breton Serving-Girl* of 1896 (which always remained in Matisse's collection) and the Impressionistic *The Dinner Table* of 1897 (Paris, Niarchos collection), Matisse imbues this work with new content, if this content is understood as an entirely new colouristic structure. An impression of how *Harmony in Blue* originally looked can be gained from the blue-green stripes of canvas that were covered by the frame, and from a colour transparency of the first version of the painting (reproduced in Flam, 1986, p. 231). That same year *Harmony in Blue* became *Harmony in Red*, better known in Russia as *Red Room*. On the eve of the 1908 Salon d'Automne, where *Harmony in Blue* was to be shown and then sent to Sergei Shchukin in Moscow, Matisse suddenly, and fundamentally, repainted it. On 6 August 1908 he wrote a letter to the Russian collector, which, like his other letters to Shchukin, did not survive the turmoil of the post-revolutionary years. However, a draft of the letter has been preserved in the Matisse archive in Paris: 'A month ago, I considered the G.N.M. [a large still life] finished and I hung it on the wall of my studio so that I could judge it at my ease. It was at that moment that

Druet photographed it. Then it seemed to me insufficiently decorative so I had no choice but to repaint it, which today I am very pleased I did, because even those who found it beautiful before, now find it much more so. I'm very pleased with the composition. I'm going to send you a photograph of it and I'll try to give you some idea of its colour by doing a sketch in watercolour. The price is 4,000 francs…' (Kostenevich, 1993, p. 92). The watercolour sketch, which was either attached to or formed part of the letter, has not survived.

Provenance: acquired from the State Museum of Modern Western Art in 1948; previously in the collection of S. I. Shchukin (purchased from the artist for 4,000 francs) from 1909; First Museum of Modern Western Painting from 1918; State Museum of Modern Western Art from 1923.

221. Study of a Nude, 1908 (page 302)
Étude de femme nue
Oil on canvas. 60.5 x 50 cm
Inscribed and signed bottom left: *à Monsieur J. Ostrooukhoff hommage respectueux. Henri-Matisse*; signed and dated on the verso, on the stretcher: *Henri-Matisse 1908*
⌐Э 6523

This study for the picture *Nude (Black and Gold)* (cat. 222) was a gift from Matisse to the painter I. S. Ostroukhov in January 1912. On 17 January, Ostroukhov wrote to A. P. Botkin telling him that he had received the painting. Ostroukhov had met Matisse in Paris, and in November 1911 accompanied him to St Petersburg and Moscow, showing him Moscow's cathedrals and ancient Russian painting.

Provenance: acquired from the State Museum of Modern Western Art in 1930; previously in the collection of I. S. Ostroukhov, Moscow (a gift from the artist), from 1912; I. S. Ostroukhov Museum of Icon-Painting and Art from 1918; State Museum of Modern Western Art from 1929.

222. Nude (Black and Gold), 1908 (page 303)
Nu (Noir et or)
Oil on canvas. 100 x 65 cm
Signed bottom right: *Henri-Matisse*
⌐Э 9057

The model depicted here appears in two drawings of 1908: *Nude* (Musée de Grenoble) and *Seated Nude* (New York, Metropolitan Museum of Art). According to the artist's daughter, the drawings were done in Munich. In the summer of 1908, Matisse worked in Munich in the studio of his friend and former student Hans Purrmann, where a German model sat for him. However, Marcel Sembat, author of the first book on Matisse, titled the painting *Italian Nude* (M. Sembat, *Matisse et son oeuvre*, Paris, 1920, p. 19). It is possible that the picture was executed in Paris on the Boulevard des Invalides, where Matisse's studio was located. *Nude (Black and Gold)* was one of four canvases Matisse selected to illustrate his 'Notes of a Painter' (published in *La Grande Revue* on 25 December 1908). The date is confirmed by two other similar depictions of nudes (cat. 221, 223) that Matisse dated to 1908, the first of which served as a study for *Nude (Black and Gold)*. That year Matisse also executed a small bas-relief, *Standing Nude* (1908; USA, private collection), in which the pose of the Hermitage *Nude* is reproduced in mirror image.

Provenance: acquired from the State Museum of Modern Western Art in 1948; previously in the Galerie Bernheim-Jeune, Paris (purchased from the artist), from 15 February 1908; collection of S. I. Shchukin (purchased for 1,000 francs) from 1 May 1908; First Museum of Modern Western Painting from 1918; State Museum of Modern Western Art from 1923.

223. Seated Nude, 1908 (page 303)
Femme nue assise
Oil on canvas. 81 x 52.5 cm
Signed and dated bottom left: *Henri-Matisse 1908*
⌐Э 9032

This is another of the four paintings selected by Matisse to illustrate his 'Notes of a Painter' (*La Grande Revue*, 25 December 1908). A drawing entitled *Seated Nude* (New York, Metropolitan Museum of Art) is related to the Hermitage painting: it shows the same model that features in both Hermitage works (see also cat. 222).

Provenance: acquired from the State Museum of Modern Western Art in 1948; previously in the collection of I. A. Morozov (purchased from the Salon d'Automne through the mediation of Blot for 1,000 francs) from 1908; Second Museum of Modern Western Painting from 1918; State Museum of Modern Western Art from 1923.

224. Nymph and Satyr, 1908–9 (page 305)
La nymphe et le satyre
Oil on canvas. 89 x 116.5 cm
Signed and dated bottom right: *Henri-Matisse 09*
⌐Э 9053

In the spring of 1907, Matisse executed a ceramic triptych for Karl Ernst Osthaus's villa in Hagen, Germany. The side panels depict a dancing nymph, while the middle panel portrays a satyr awakening a sleeping nymph. Unlike the later Hermitage version, the satyr in the ceramic panel is portrayed traditionally, with long hair and the legs of a goat. The nymph's legs are partially hidden by fabric. Correggio's *Jupiter and Antiope*, in the Louvre, served as the prototype for the ceramic panel. Matisse was of course familiar with other treatments of the motif, in particular Watteau's *Nymph and Faun*, also in the Louvre. When Matisse began *Nymph and Satyr*, which had been commissioned by Sergei Shchukin (who evidently knew the Hagen triptych), he discarded its mythological elements and changed the poses of the figures. Not only is *Nymph and Satyr* larger than the ceramic panel, it is immeasurably more vigorous and more intense in colour. Its expressionistic brightness of tone and openly sensual nature set it apart from Matisse's other paintings. Flam suggests that this sensuality had something to do with Matisse's infatuation for Olga Merson, his young Russian student (Flam, 1986, p. 248). The red-haired nymph, despite her caricatured depiction, bears a great similarity to the model of *Portrait of Olga Merson* (Houston, Museum of Fine Arts). Matisse worked on the painting in the Hôtel Cendrillon in Cassis in January 1909. On 7 February he wrote to Fénéon: 'I have finished, as you probably already know, the painting you sold to Monsieur Stschoukine, *Satyr Catching a Nymph Unaware*. I think that it must be dry, but as the colours cannot yet have hardened, I would ask you not to give it to be photographed until it is framed… I would like to remind you that M. Stschoukine is impatiently waiting for the picture and he made me promise to send it to him as soon as possible, *grande vitesse* to Moscow…' (*Henri Matisse*, Galerie Bernheim-Jeune, Paris, 1997). Matisse had started the painting in 1908 (he mentions it in a letter to Fénéon dated 26 November 1908). A photograph of the first version of the painting was probably taken at that time. It is possible, even without the use of X-rays, to see the earlier contours, now hidden by green paint, and to sense that in the earlier version the movement of the figures was even more dynamic.

Provenance: acquired from the State Museum of Modern Western Art in 1948; previously in the collection of S. I. Shchukin (purchased through the mediation of the Galerie Bernheim-Jeune for 3,000 francs) from 12 January 1909; First Museum of Modern Western Painting from 1918; State Museum of Modern Western Art from 1923.

225. Still Life with Blue Tablecloth, 1909 (page 300)
La nappe bleue
Oil on canvas. 88.5 x 116 cm
Signed and dated bottom left: *Henri-Matisse 09*
⌐Э 6569

This painting can be seen as a kind of postscript to *Red Room* (cat. 220). The starting point is once again the patterned *toile de Jouy*. Three years earlier this fabric had been depicted in *Vase, Bottle and Fruit* (cat. 216), and subsequently in 1908 in *Harmony in Blue*, which became *Red Room*. As in this 'panel for the dining-room of Monsieur S[hchukin]', Matisse has simplified the arabesques on the patterned fabric, rendering them more dynamic and their colours considerably brighter than in the original. In depictions of the *toile de Jouy* that pre-date *Harmony in Blue*, this dynamic simplification is not present. The coffee-pot on the left was previously depicted in *Dishes on a Table* (cat. 211) as well as in other compositions, but here it is painted in ochre tones, which provide a suitable contrast to the blue of the tablecloth. The painting was finished in January 1909. From Matisse's letter to Fénéon of 7 February 1909 it is clear that the canvas had already dried; the artist asks for it to be taken to Druet for photographing before being sent as quickly as possible to Shchukin, together with *Nymph and Satyr*. 'Could you also take with you the still life that he ordered from me and which could be sent at the same time?' (*Henri Matisse*, Galerie Bernheim-Jeune, Paris, 1997).

Provenance: acquired from the State Museum of Modern Western Art in 1931; previously in the collection of S. I. Shchukin (acquired from the artist for 3,000 francs) from 1909; First Museum of Modern Western Painting from 1918; State Museum of Modern Western Art from 1923.

226. Still Life with Dance, 1909 (page 308)
Nature morte avec *La Danse*
Oil on canvas. 89.5 x 117.5 cm
Signed and dated bottom right:
Henri-Matisse 1909
Г⸦ 9042

With this painting Matisse returned to a genre of still life interior that he had already used in *Corner of the Studio* (1900; Paris, private collection). Now, however, he has depicted one of his own works, namely the first version of *Dance* (1909; New York, Museum of Modern Art). Some sources mistakenly claim that the *Dance* shown here is the one commissioned by Sergei Shchukin, now in the Hermitage (cat. 230). When Shchukin wrote to Matisse that he was entranced by the panel *Dance*, he was referring to the first version, which Matisse had just begun. It is this version that can be seen in the photograph of Matisse in his studio taken by the distinguished American photographer Edward Steichen. The outline of the figures had only just been completed. Thereafter, the painter worked on both canvases simultaneously. Thus, this painting does not depict the studio at Issy-les-Moulineaux, as has sometimes been claimed, but the one on the Boulevard des Invalides, which Shchukin visited before 31 March 1909 – the date of his letter to Matisse confirming his commission of a new *Dance*.

Provenance: acquired from the State Museum of Modern Western Art in 1948; previously in the collection of I. A. Morozov (purchased from the artist for 5,000 francs) from 1910; Second Museum of Modern Western Painting from 1918; State Museum of Modern Western Art from 1923.

227. Lady in Green, *c.* 1909 (page 312)
La dame en vert
Oil on canvas. 65 x 54 cm
Signed and dated bottom left: *Henri Matisse*
Г⸦ 6519

Matisse spent the summer of 1909 at Cavalière, a Provençal port on the Mediterranean coast, where he painted *Lady in Green*, also known as *Woman with a Red Carnation*. For two paintings he completed in Cavalière – *Nude on the Seashore* (Paris, private collection) and *Seated Nude* (Musée de Grenoble) – the model was Brouty. The unquestionable likeness of the women in all three paintings would suggest that the Hermitage canvas is also a portrait of Brouty.

Provenance: acquired from the State Museum of Modern Western Art in 1930; previously in the Galerie Bernheim-Jeune, Paris (acquired from the artist), from 22 September 1909; collection of S. I. Shchukin (purchased for 2,500 francs) from 11 October 1909; First Museum of Modern Western Painting from 1918; State Museum of Modern Western Art from 1923.

228. Pink Statuette and Pitcher on a Red Chest of Drawers, 1910 (page 309)
Statuette rose et pot d'étain sur commode rouge
Oil on canvas. 90 x 117 cm
Signed and dated bottom right: *Henri Matisse 10*
Г⸦ 6520

Also known as *Still Life with a Pewter Pitcher*, this work was painted in Issy-les-Moulineaux. The wooden wall in the background recurs in *Pink Studio* (1911; Moscow, Pushkin Museum) and the chest of drawers in *Red Studio* (1911; New York, Museum of Modern Art). Matisse depicted the terracotta statuette of the reclining woman in other paintings between 1908 and 1912: *Sculpture and Persian Vase* (1908; Oslo, Nasjonalgalleriet); *Goldfish* (1909–10; Copenhagen, Statens Museum for Kunst); and *Interior with Goldfish* (1912; Merion, PA, Barnes Foundation). This Matisse statuette, famous for its several bronze castings, was executed in 1907 and recreates the pose of one of the nudes in *Joy of Life* (1905–6; Merion, PA, Barnes Foundation). The statuette was the also the point of departure for *Blue Nude (Memory of Biskra)* (1907; Baltimore Museum of Arts).

Provenance: acquired from the State Museum of Modern Western Art in 1930; previously in the collection of S. I. Shchukin from 1910; First Museum of Modern Western Painting from 1918; State Museum of Modern Western Art from 1923.

229. Girl with Tulips, 1910 (page 313)
Jeune fille aux tulipes
Oil on canvas. 92 x 73.5 cm
Signed and dated bottom left: *Henri-Matisse 10*
Г⸦ 9056

The painting depicts Jeanne Vaderin, or Jeanette, as the Matisses called her. Vaderin lived in Clamart, near Issy-les-Moulineaux, where she was recuperating after an illness. In 1910 she also posed for two bronze heads, *Jeanette I* and *Jeanette II*, the first of which is very like her portrayal in the painting. From 1911 to 1913 Matisse executed three more sculptures of Jeanette from memory, avoiding a physical likeness in order to explore purely artistic solutions. A charcoal drawing of Jeanne Vaderin sitting at a table with a vase of tulips (New York, Museum of Modern Art) can be linked to the Hermitage canvas. The drawing's prosaism and faithfulness to nature, its outward authenticity, would seem to indicate that it was the first study on this theme. *Girl with Tulips* was most probably completed in February 1910. Such a precise date can be surmised from the fact that the tulips signal the coming of spring, and by mid-March the work had already been exhibited at the Salon des Indépendants, where it was the only canvas shown by Matisse.

Provenance: acquired from the State Museum of Modern Western Art in 1948; previously in the Galerie Bernheim-Jeune; collection of S. I. Shchukin from 1910; First Museum of Modern Western Painting from 1918; State Museum of Modern Western Art from 1923.

230. Dance, 1910 (page 306, gatefold)
La Danse
Oil on canvas. 260 x 391 cm
Signed and dated bottom right:
HENRI MATISSE 1910
Г⸦ 9673 (pair to Г⸦ 9674; cat. 231)

The idea for *Dance*, as well as for its pair, *Music*, took five years to develop. The picture's composition can be traced back to *Joy of Life* (1905–6; Merion, PA, Barnes Foundation), which depicts a round-dance in the background. In 1907 Matisse made a wooden bas-relief

entitled *Dance* (Nice, Musée Matisse), showing the ecstatic movements of dancing nymphs, a motif which Matisse subsequently used in his vase painting. At the beginning of 1909, while Matisse was working on the first version of *Dance* (New York, Museum of Modern Art), Sergei Shchukin, having undoubtedly seen it, commissioned another version for the staircase of his Moscow residence. He requested that it be the same size as the first version, although in comparison to the New York panel, the Hermitage *Dance* is significantly more dynamic. In mid-March, Shchukin wrote to Matisse to say that he had received his letters 'with sketches of the large paintings' (Kostenevich, 1993, p. 163). He was referring to two watercolours, *Composition I* and *Composition II* (both in Moscow, Pushkin Museum), the first of which served as a sketch for *Dance*. There also exist two drawings of the composition, one in pencil (New York, Museum of Modern Art) and the other in charcoal (Musée de Grenoble), as well as a small watercolour that repeats the Shchukin version (1910; Paris, Sembat collection). *Composition II*, which Matisse had originally proposed to Shchukin, would – unlike *Music* – have represented a totally different complement to *Dance* (it was later realised as *Bathers by the River*, Chicago, Art Institute). When Shchukin commissioned *Dance*, it is clear that he and Matisse discussed all three subjects. According to Hans Purrmann, who witnessed its creation, the New York *Dance* was executed in a matter of one or two days. It is likely that Shchukin's version, unlike *Music*, was also completed extremely quickly. After he had finished the Shchukin panel, Matisse abandoned the theme of dance until 1932–3 when he painted a decorative mural commissioned by Albert C. Barnes (Merion, PA, Barnes Foundation; two preceding versions are in the Musée de l'art moderne de la ville de Paris). Matisse also drew on the compositional basis of the Shchukin panel for one of the illustrations to *Florilège des amours de Ronsard* (Paris, 1948). In 1938 Matisse executed a version of the Hermitage panel in gouache (New York, Davis collection), which then served as a model for a lithograph in the almanac *Verve* (1938). Another counterpart was a cut-out with red figures, a yellow-green hill and a black sky, which Matisse did towards the end of his life. It was auctioned at Sotheby's on 17 November 1986 (Japan, private collection).

Provenance: acquired from the State Museum of Modern Western Art in 1948; previously in the collection of S. I. Shchukin (commissioned in 1909 for 15,000 francs) from 1910; First Museum of Modern Western Painting from 1918; State Museum of Modern Western Art from 1923.

231. Music, 1910 (page 307, gatefold)
La Musique
Oil on canvas. 260 x 389 cm
Signed and dated bottom right:
HENRI MATISSE 1910
Г⸦ 9674 (pair to Г⸦ 9673; cat. 230)

On 31 March 1909, Sergei Shchukin wrote to Matisse: 'I find in your *Dance* panel so much nobility that I've decided to ignore bourgeois opinion and hang over my staircase a subject with nudes. At the same time I will need a second panel, whose subject could be music. I was very pleased to have your response: please accept my firm commission of 15,000 francs for the *Dance* panel and 12,000 francs for the *Music* panel. The amounts are confidential. I am very grateful to you and hope to receive a sketch of the second panel soon. There is a great deal of music-making in my house. Every winter there are about ten concerts of classical music (Bach, Beethoven, Mozart). The *Music* panel should reflect the character of the house a little. I have complete faith in you and am confident that *Music* will be as successful as *Dance*.' (First published with incorrect text breaks in Barr, 1951, p. 555; corrected in B. W. Kean, *All the Empty Palaces*, London, 1983, pp. 298–9). The 'primogenitor' of *Music* – as for *Dance* – was *Joy of Life* (1905–6; Merion, PA, Barnes Foundation). *Music* (1907; New York, Museum of Modern Art) was also influential, and Shchukin knew this work well, for it was located in the Paris apartment of Leo and Gertrude Stein, which he often visited. From this eponymous early painting, only the figure of the violinist survived. The coexistence of two ideas in one canvas – the calmness of

listening and the movement of dancing – could not be repeated in the Shchukin panel. *Music* was intended both to supplement and contrast with *Dance*; the former is as static as the latter is dynamic, while the figures in *Music* are as separate as they are linked in *Dance*. Matisse worked relentlessly on this composition, continually changing the positions of the figures. A close examination of the painting reveals outlines of figures that have been painted over. Matisse reworked the painting not just because he was striving for the maximum laconicism, but also to achieve the polar opposite of *Dance*. The woman in the right-hand corner has disappeared, giving way to a young male singer. *Music* came to embody the essence of male origins, *Dance*, the feminine. In the final version individual traits have been smoothed out and simplified. Originally a dog had stood at the violinist's feet, probably echoing a traditional symbol of the power of music (Orpheus as protector not only of people but also of animals through his music). Matisse was probably also influenced by Gauguin's *Arearea* (1892; Paris, Musée d'Orsay) for the dog (later painted over), and the two central figures. The canvas was completed in Issy-les-Moulineaux in the spring or summer of 1910. The sketch requested by Shchukin was probably never done: for this work Matisse made no sketches, preferring instead to experiment on the canvas itself.

Provenance: acquired from the State Museum of Modern Western Art in 1948; previously in the collection of S. I. Shchukin (commissioned in 1909 for 12,000 francs) from 1910; First Museum of Modern Western Painting from 1918; State Museum of Modern Western Art from 1923.

232. Spanish Still Life, 1910 (page 311)
Nature morte d'Espagne
Oil on canvas. 89.5 x 116.3 cm
Signed bottom right: *Henri-Matisse*
Γ⸱ 9043

The *Spanish* and *Seville* (cat. 233) still lifes were painted either at the same time or immediately one after the other, and are sometimes considered companion pieces. In spite of similar details, however, they explore different questions and do not form a harmonious pair. Western scholars tend to refer to both canvases as the *Seville Still Lifes*, calling the first one *Spanish* and the second one *Seville*. This designation has led to confusion and has created the impression that the *Spanish Still Life* was painted first, although we do not know this for a fact. Matisse painted the still lifes in response to Shchukin's letter dated 14 November 1910: 'I would now like you to paint two still lifes as large as the Munich canvas and somewhat in the same vein. I'd like to pay 5,000 francs for each canvas. I would also like to be given priority for further commissions.' (Kostenevich, 1993, p. 167.) Matisse was in Spain at the time but did not wait until he returned to France to begin work on Shchukin's canvases. He started work immediately, using the dimensions of the Munich *Still Life with a Geranium* (1910; Munich, Neue Pinakothek) which he had painted for Hugo von Tschudi, the director of the Neue Staatliche Galerie in Munich. More importantly, he again explored the motif of a geranium in a vase, combined with decorative fabrics.

Provenance: acquired from the State Museum of Modern Western Art in 1948; previously in the collection of S. I. Shchukin (commissioned by Shchukin for 5,000 francs) from 1911; First Museum of Modern Western Painting from 1918; State Museum of Modern Western Art from 1923.

233. Seville Still Life, 1910 (page 310)
Nature morte de Seville
Oil on canvas. 90 x 117 cm
Signed bottom right: *Henri-Matisse*
Γ⸱ 6570

Matisse included more decorative fabrics, found on his trip, in *Seville Still Life* than in *Spanish Still Life*. *Seville Still Life*, which was painted in the same Seville hotel room, has been titled various- ly: *Interior with Spanish Shawls* and *The Rose Room*. Matisse started

work on both canvases immediately after receiving Shchukin's letter dated 14 November 1910. Having already received a letter from Seville the following week, the collector thanked Matisse and asked him to send the paintings as soon as possible. Shchukin's letters allow a more precise dating for both canvases, which had previously been dated to 1910–11 or even 1911.

Provenance: acquired from the State Museum of Modern Western Art in 1931; previously in the collection of S. I. Shchukin (commissioned by Shchukin for 5,000 francs) from 1911; First Museum of Modern Western Painting from 1918; State Museum of Modern Western Art from 1923.

234. Family Portrait, 1911 (page 315)
Portrait de la famille du peintre
Oil on canvas. 143 x 194 cm
Signed and dated on the verso, on the stretcher:
Henri-Matisse 1911
Γ⸱ 8940

In December 1910 Shchukin asked Matisse to paint 'a picture with figures in clothes, perhaps a portrait of your family (Madame Matisse and your three children)…' (Kostenevich, 1993, p. 168). Matisse had himself thought about painting his family, but he was at something of a loss when the collector requested a family portrait in the spirit of Cézanne's *Card Players*. Matisse read Shchukin's letter in Spain just after visiting Granada, where he was greatly inspired by the Alhambra. Having accepted Shchukin's commission Matisse, although he shared the collector's admiration for Cézanne, did not want to paint the family portrait in the spirit of Cézanne. Instead, the decora- tive arabesques of the Alhambra evidently sparked an idea for *Family Portrait* and also reminded him of an exhibition on Muslim art he had seen that year in Munich. It is generally considered that while work- ing on *Family Portrait* Matisse was inspired by Persian miniatures. The question remains, which miniatures? Barr, for example, refers to a miniature of Princess Shirin by Bihzad, master of the Herat School (1500), although there is no evidence that Matisse knew this work (Barr, 1951, p. 540; cited in F. R. Martin, *The Miniature Painting of Persia and India from the 8th to the 18th Centuries*, London, 1912, vol. ii, ill. 67). Closer parallels can be drawn with *Gustaham Before the Magical Figure* – a miniature from Firdausi's *Shahnama* (1333; St Petersburg, Russian National Library). Although it is true that Matisse was not familiar with this particular miniature, he had seen others like it. Rémy Labrusse suggests that *Family Portrait* bears similarities in composition to an early seventeenth-century Persian ceramic panel from Isfahan, now in the Louvre (R. Labrusse, *La famiglia del Pittore: Matisse*, 1997, p. 137). Painting *Family Portrait* in the chosen style turned out to be extremely difficult. In the spring or early summer of 1911, while he was still working on it at Issy-les-Moulineaux, Matisse wrote to Michael Stein: '[The painting] is well on its way, but since it is not finished, that means nothing. This is not logical, but I am not sure if I will finish it. This all or nothing is quite tiring.' On the same postcard Matisse drew a sketch of *Family Portrait* (Barr, 1951, p. 153). Two preparatory drawings of Matisse's sons playing draughts have survived (Paris, Centre Georges Pompidou, and Cateau-Cambrésis, Musée Matisse): Pierre is sitting in a characteristic pose with his elbows on his knees, while Jean, on a chair rather than a stool, is preparing to make a move.

Provenance: acquired from the State Museum of Modern Western Art in 1948; previously in the collection of S. I. Shchukin (purchased from the artist) from 1911; First Museum of Modern Western Painting from 1918; State Museum of Modern Western Art from 1923.

235. Conversation, 1909–12 (page 314)
La conversation.
Oil on canvas. 177 x 217 cm
Γ⸱ 6521

The figures in this composition represent Matisse himself and his wife Amélie, although Matisse subsequently recalled that he had not intended to paint their portrait. The couple are depicted at their

country home at Issy-les-Moulineaux (as is indicated by the railing in the centre of the picture). The idea for the painting can be linked to Matisse's trip to Italy in 1907 when he visited Padua, Florence and Siena. The iconographic layout can be traced back to two- dimensional, two-figure compositions depicting the Annunciation in the works of the early masters of Florence and Siena. Simone Martini's *The Annunciation* (1333; Florence, Uffizi Gallery), for exam- ple, depicts the Archangel in profile on the left and the Virgin Mary in black on the right. This configuration also recalls the Paduan fres- coes of Matisse's favourite master, Giotto, whose *Annunciation* is presented in a humble, rather dark interior, while the central part of the composition is given over to the bright, almost luminescent, rec- tangle of the curtain. The rectangular window in *Conversation* per- forms a similar role. Giotto's colours, especially his rich blue, are also evoked. A few months or maybe even weeks before he started work on *Conversation*, Matisse wrote about Giotto in his 'Notes of a Painter': 'When I see Giotto's frescoes in Padua, I don't worry about knowing which scene of Christ's life lies before me. But I immedi- ately understand the feeling that emanates from it: it's in the lines, in the composition, in the colour, and the title of the fresco only confirms my impression' (Matisse, 'Notes d'un peintre', Matisse/ Fourcade, 1972, pp. 49–50). The mythological subtext of *Conver- sation* was also informed by Matisse's impressions of ancient Middle Eastern art, and Jack Flam has correctly identified an impor- tant source: the Hammurabi stele (*c*. 1760 BC), which came to the Louvre at the beginning of the century, where Matisse would have seen it (Flam, 1986, p. 252). The bas-relief at the top of the stele shows King Hammurabi standing before the seated god Shamash, who is dictating the laws to him. Matisse also drew on a later Mesopotamian stele with a similar relief, *Kudurru de Melisi* (HU II, *c*. 1907–8), which came to the Louvre from excavations at Susa (*c*. 1200 BC). In 1913 Matisse made two sketches of this stele (Matisse, 1997, pp. 132–3). With *Conversation*, Matisse did not sim- ply use the iconographic formulae of these ancient works: he had discovered one of the most important mythical motifs of Middle Eastern antiquity, which, after two thousand years, with the arrival of Christianity, was transformed into the Annunciation. Matisse's keen interest in variations of this motif, which was widely used both in Mesopotamia and in Ancient Egypt, especially during the reigns of Ekhnaton and Tutankhamun, was generated by the desire to create a work that was monumental in spirit and almost hieratic in meaning. Not surprisingly, Pierre Schneider and other scholars have inclined to the idea of Byzantine sources for *Conversation* (P. Schneider 'The Striped Pajama Icon', *Art in America*, 1975, No. 4, pp. 76–82). However, Schneider's thesis that *Conversation* is a reli- gious work is questionable. Compared to the religious art of its time, *Conversation* exhibits a deeper archetypal basis, as do *Game of Bowls* (cat. 219) and *Nymph and Satyr* (cat. 224). The composition of *Conversation* is a mirror image of a little-known painting by Bonnard also called *Conversation* (1890; *Pierre Bonnard*, ex. cat., Musée Rath, Geneva, 1981, no. 1). Bonnard's work anticipated Matisse's with its combination of irony and solemnity and its reli- gious and genre allusions. Bonnard was parodying the conventional structure of Renaissance and later academic annunciations. Matisse's painting depicts a secular scene: the morning conversa- tion of a married couple in the sitting room of their country home – he is wearing pyjamas, she a robe. With the seated woman seem- ingly giving orders, the 'conversation' appears to be more of a monologue than a dialogue. The title, therefore, assumes a slightly ironical character. *Conversation* used to be dated to 1909, which was confirmed by Alfred Barr after he consulted both Matisse and his son Pierre. Matisse told Barr that he had started the painting before *Dance* (A. Barr Archives, Museum of Modern Art, New York). Jack Flam believed that Matisse had already started the painting in 1908 and that he finished it in the spring of 1912, just before his exhibition at the Grafton Gallery in London (Flam, 1986, pp. 249–50, 494). It seems likely, from the extensive network of cracks in various parts of the canvas, that Matisse repainted the picture 'in a dry con- dition' after some time had elapsed. It is difficult to establish when the cracks appeared. However, even with the naked eye it is possi- ble to see that the positioning of the figures in the first version was slightly different.

Provenance: acquired from the State Museum of Modern Western Art in 1930; previously in the collection of S. I. Shchukin (purchased from the artist for 10,000 francs) from 1912; First Museum of Modern Western Painting from 1918; State Museum of Modern Western Art from 1923.

236. Vase of Irises, 1912 (page 317)
Le vase d'iris
Oil on canvas. 117.5 x 100.5 cm
Signed bottom left: *Henri-Matisse*
Г⋺ 8965

On 29 January 1912, Matisse travelled by boat from Marseilles to Tangiers on the advice of his friend Marquet. Two days later he wrote to his daughter from the Hôtel Villa de France: 'It's raining here, a real downpour. Apparently, it's been pouring for a month.' The unusually heavy rain did not prevent Matisse from appreciating the charms of the Moroccan flora: 'Despite the rain, it's been very mild and the flowers are all in bloom, convolvulus, heliotropes, nasturtiums and others' (letter to Marguerite dated 31 January 1912, Matisse Archives, Paris). More news followed a week later: 'I've begun painting a bouquet of blue irises' (Matisse Archives, Paris). Confined to his hotel, Matisse had started painting a vase of flowers in his room. The irises did not turn out blue: either the light was affected by the bad weather or he exhibited an unconscious desire to reflect Morocco in the flowers. Whatever the reason, the colour range in the picture evokes the hues in Moroccan dress and tiles.

Provenance: acquired from the State Museum of Modern Western Art in 1948; previously in the Galerie Bernheim-Jeune (acquired from the artist) from 24 May 1912; collection of S. I. Shchukin (purchased for 4,000 francs) from 13 July 1912; First Museum of Modern Western Painting from 1918; State Museum of Modern Western Art from 1923.

237. The Moroccan Amido, 1912 (page 318)
Le marocain Amido
Oil on canvas: 146.5 x 61.3 cm
Signed bottom right: *Henri-Matisse*
Г⋺ 7699

In his first letter to Matisse, which was sent to Tangiers on 1 February 1912, Shchukin wrote that he now preferred 'pictures with figures' (Kostenevich, 1993, p. 171). In another letter, dated 13 March 1912, Shchukin reminded Matisse of his promise (in a letter of 1 March, now lost) to send him 'a souvenir from Tangiers' (*ibid.*). This souvenir became the full-length portrait *The Moroccan Amido*. In April, as is indicated by the label on the verso, the painting was sent from Marseilles to Paris, where Matisse himself returned on 14 April. On 6 April Matisse had written to his wife that a young stable-boy from the hotel might be willing to sit for him (Matisse Archives, Paris). The painting was clearly done very quickly, in one or two sittings. Amido, Amidou or Hamido are diminutives of Mohammed. The young man did not work at the hotel where Matisse was staying; apparently the artist had come into contact with him while out riding in the country. Shchukin's 'souvenir' was thus this life-size portrait. Amido's face, like most of the Moroccan faces in Matisse's paintings, essentially expresses nothing; it is the colours that are expressive. To paint this elegant 'bouquet' of colours, Matisse has subtly drawn on the formula for a military portrait. When he asked Amido to be his model, he obviously discussed the details of traditional national costume, which consisted of a white shirt, turquoise waistcoat, violet knees breeches, a light orange scarf and a bag hanging on a golden ribbon. The actual costume was probably even more colourful, as is indicated by the trial colours on the stretcher: scarlet, green, blue, white and black. In

October of the same year Matisse mentioned in a letter to Charles Camoin that he was painting a Moorish woman on a terrace as a companion piece to 'the little Moroccan of last year' (Giraudy, 1971, p. 13). In saying 'last year' Matisse actually meant 'last season': *The Moroccan Amido* was done on his first trip to Morocco, and *The Moorish Woman* (the precise title is *Fatima the Mulatto Woman*, formerly in the Muller collection, Soleur, Switzerland) whose pose is almost an exact mirror image of Amido's, on his second. Having finished *Amido*, Matisse was in no hurry to send it to Shchukin, for he was clearly contemplating an ensemble of paintings with figures. The collector, however, who had spent July of that year in Paris and wanted to have the picture as soon as possible, certainly discussed with Matisse the need for a companion piece to *Amido*.

Provenance: acquired from the State Museum of Modern Western Art in 1934; previously in the collection of S. I. Shchukin from 1912; First Museum of Modern Western Painting from 1918; State Museum of Modern Western Art from 1923.

238. Zorah Standing, 1912 (page 318)
Zorah debout
Oil on canvas. 146.5 x 61.7 cm
Г⋺ 10044

Zorah Standing, which has the same dimensions and is painted in the same key as *The Moroccan Amido* (cat. 237), is often regarded as its companion piece. This is not entirely accurate, for Matisse's *Fatima the Mulatto Woman* is also similar. These three canvases are often referred to as the second Moroccan triptych. However, unlike the first, or Morozov triptych (*View from the Window, Tangiers; Zorah on the Terrace; Entrance to the Casbah*, 1912–13, Pushkin Museum, Moscow), this cannot be regarded as a triptych, for even though they are close in structure there is no evidence to suggest that Matisse intended to execute a triptych. Since Shchukin had expressed a strong desire to have a pair to *Amido*, Matisse accommodated him and painted *Fatima the Mulatto Woman*. Its colour scheme, however, is in a different register, and after finishing it, Matisse evidently felt that it did not form a true pair to *Amido*; he soon started another canvas of the same dimensions – *Zorah Standing*. In October 1912, the artist wrote to his children from Tangiers about the three paintings, including sketches of them in the letter. 'The three sketches below represent two Moorish women, one of whom is destined to be the companion piece to Shchukin's *Moroccan*' (undated letter to Marguerite and Pierre Matisse, Matisse Archives, Paris). The *Moorish Woman* referred to was *Fatima*. Shchukin, however, chose *Zorah Standing*, which better matched the decoration of his Pink Drawing-Room, where Matisse's paintings were hung. Together, *Amido*, *Zorah* and *Fatima* form a wonderful ensemble, but the differences in colour range prevent them from forming a perfect triptych. At the 1913 exhibition of Matisse's paintings and drawings at the Galerie Bernheim-Jeune, *Zorah Standing*, *Fatima the Mulatto Woman* and *Standing Riffian* (cat. 239) were exhibited together as a group (*Amido* was already in Moscow and could not be shown). The almost hieratic, solemn pose of *Zorah Standing* has induced Matisse scholars, Barr among them, to compare the work to Hans Holbein's *Christina of Denmark* (London, National Gallery). This comparison may be legitimate, but one should take into account that just before Matisse started work on *Fatima* and *Zorah Standing*, there was an exhibition of Persian miniatures at the Musée des arts décoratifs in Paris that he had probably seen. A comparison of *Zorah* with *Youth with a Golden Goblet* (*c.* 1610) by Riza-i 'Abbasi, which is in this museum, strongly suggests that Persian miniatures influenced Matisse's work. The composition of *Amido*, *Zorah Standing* and *Fatima* is characteristically Oriental and very similar to another work by Riza-i 'Abbasi, *The Cup-bearer*

(1627–8; Kiev, Museum of Western and Eastern Art), and to the miniature *Youth with a Toy* by an unknown seventeenth-century master (Cleveland Museum of Art). Another important influence was the art of Ancient Rus. Matisse had seen many front-on depictions of saints, full-size, in the Kremlin churches in Moscow, the Rogozhsky Cemetery and in the Yedinoverchesky Monastery. The icons of Ancient Rus, particularly those of Novgorod (both the Old Believers in the Rogozhsky Cemetery and I. S. Ostroukhov had in their possession panels painted in Novgorod), had made a profound impression on Matisse: the resonance and purity of colours introduced him to the use of an abstract bright red background. *Zorah Standing* was the most successful of the paintings in the suite of 'Moroccan figures', evidently because Matisse had painted Zorah earlier and more frequently than the other Moroccan models. *Zorah in Yellow* (New York, private collection), *Zorah Seated* (Paris, private collection) and a sheet of pen studies of Zorah's head (Boston, Isabella Steward Gardner Museum) were all done during Matisse's first visit to Morocco. Of the three depictions of the models on the Boston sheet, the sketch of the head in the top right-hand corner is so similar to the Hermitage work that it can be regarded as a preliminary study for it. As early as the end of March, Matisse, respectful of Muslim customs (Islamic Sharia Laws forbade women to show their faces in public), received permission from the owner of the Hôtel Villa de France, where he was staying, to use a separate room to paint an Arab woman. Matisse wrote about this, without naming the model, in a letter to his family dated 1 April 1912 (Matisse Archives, Paris). It is more than likely that the woman in question was Zorah. Matisse liked working with her, but he had to be careful. Zorah's brother eventually put a stop to the sittings.

Provenance: acquired from the Pushkin Museum, Moscow, in 1968; previously in the collection of S. I. Shchukin from 1913; First Museum of Modern Western Painting from 1918; State Museum of Modern Western Art from 1923; Pushkin Museum, Moscow, from 1948.

239. Standing Moroccan in Green (Standing Riffian), 1913 (page 319)
Marocain en vert debout (Le rifain debout)
Oil on canvas. 146.6 x 97.7 cm
Inscribed on a label on the verso: *Mr. Henri Matisse. Hôtel de France. Tanger.*
Г⋺ 9155

Matisse lived at the Hôtel Villa de France from October 1912 until mid-February 1913. In early November he wrote to his family that he was planning to do a picture of a Riffian, and on 21 November he told Marguerite that he had started on 'a canvas the same size as Shchukin's *Goldfish*. It's a portrait of a Riffian, a mountain dweller, magnificent and wild as a jackal' (Matisse Archives, Paris). Matisse mentioned *Goldfish* not only to indicate the size of the canvas but possibly also to link the two works. The effect of combining these two pictures was undoubtedly something Shchukin took into account. After meeting a representative of the warlike Riffian tribe in Tangiers, Matisse captured him enthusiastically in a drawing (private collection; sheets nos. 46–51 at the 1990 exhibition *Matisse in Morocco*) and two paintings. *Seated Riffian* (1912–13; Merion, PA, Barnes Foundation) is very large (200 x 160 cm), with the Riffian portrayed in heroic, larger-than-life dimensions. *Standing Riffian*, traditionally known at the Hermitage as *Standing Moroccan in Green*, is the smaller of the two paintings, but the colours are more vibrant. It has been suggested that *Standing Riffian* is a preparatory study (A. Humbert, notes to G. Diehl, *Henri Matisse*, Paris, 1954, p. 140), but this is incorrect as the paintings resolve very different problems: the similarity of the colour scheme belies significant differences in their emotional content. It was characteristic of Shchukin that, given the choice, he chose the smaller version. The drawing *Moroccan in Three-Quarter Figure* (1990 exhibition *Matisse in Morocco*, no. 47) may be considered a preparatory study for *Standing Riffian*. On 10 January 1913, Matisse sent a postcard to his son Jean from Tangiers with the inscription 'Tipo de la Kabila de Raisuli': 'I am sending you a chap from the village of Raisuli, a well-known bandit, who several

years ago robbed visitors in the outskirts of Tangiers. To appease him, the sultan made him governor of a province. So he became an official thief, robbing his own citizens' (Matisse Archives, Paris; postcard reproduced in *Matisse*, 1997, p. 148). The strong physical resemblance of the robber on the postcard to the Riffian who had posed for him no doubt inspired Matisse to send the postcard to his son.

Provenance: acquired from the State Museum of Modern Western Art in 1948; previously in the collection of S. I. Shchukin from 1913 (purchased from the artist); First Museum of Modern Western Painting from 1918; State Museum of Modern Western Art from 1923.

240. Bouquet (Arum Lilies), 1912 (page 317)
Le bouquet. Arums
Oil on canvas. 146 x 97 cm
Γ϶ 7700

In earlier catalogues this painting has been called *Bouquet of Flowers on the Veranda*. Shown here, however, is not a veranda but a hotel room in Tangiers, as indicated in particular by the bedside table on which the vase of flowers is standing. This is not the same room in the Hôtel Villa de France where Matisse stayed and in which *View from a Window* (the left panel of the Moroccan triptych) was painted, but another room that the owner of the hotel allowed him to work in. *Bouquet*, similar in motif to the 1913 *Blue Vase of Flowers on a Blue Tablecloth* (Moscow, Pushkin Museum), was thought to have been done around the same time. Shchukin's correspondence with Matisse, however, allows us to pinpoint the exact date it was painted. After receiving a letter from Matisse (now lost) with a list of paintings he had recently done for him, Shchukin thanked the artist in a letter of 15 January 1913 (Kostenevich, 1993, p. 173). This and other letters allow us to conclude that the painting in question was *Bouquet*. Taking into account the amount of time it took for a letter to reach Moscow from Africa, the painting may be dated to 1912. Of all the flowers he saw in Morocco, Matisse especially admired the irises and arum (calla) lilies, which became the subject of *Calla Lilies and Convolvulus* (1912–13; private collection, see *Matisse in Morocco*, no. 40), the only flower drawing of his Moroccan period. The petals, with their conical shapes and unusual white colour, and the leaves, resembling the tongues of enormous animals, fascinated the painter. This motif is depicted quite differently in the two large still lifes of flowers: *Bouquet* is done in Matisse's characteristically graphic style; even parts of the unpainted white grounding are incorporated, in the same way as the untouched area of a watercolour. *Blue Vase*, by contrast, is painted uniformily. It has been suggested that *Bouquet* is a kind of study for *Blue Vase* (L. Coyle, 'Paintings', *Matisse in Morocco*, 1990, p. 100). In the same catalogue Elderfield calls the painting a 'preparatory work' (J. Elderfield, 'Matisse in Morocco: An Interpretive Guide', *Matisse in Morocco*, 1990, p. 218). Others have expressed surprise as to why Shchukin uncharacteristically bought both the painting and the sketch. In this case, however, the collector had no choice. As Shchukin had commissioned two paintings by letter, he had to rely on Matisse's discretion. A sentence in the artist's letter to Shchukin dated 5 April 1913 suggests that this is indeed what happened: 'about the two paintings of flowers […] for your drawing-room' (only a draft of the letter has survived, Matisse Archives, Paris). Matisse clearly regarded both paintings as equally valuable, and the suspicion that he planned to combine them in a triptych is not unlikely. Pierre Schneider, Jack Coward and Laura Coyle have suggested three variations of a triptych in which both flower pictures appear. In each combination, they are assigned to the sides, while the central position is given either to *Standing Riffian*, *Goldfish* (Moscow, Pushkin Museum) or *Open Window at Tangiers* (private collection, *Matisse in Morocco*, 1990, pp. 273–4). On the other hand, the suggestion that *Bouquet* preceded *Blue Vase* is questionable and requires more concrete evidence. Matisse's art follows a logic which often entails consistent simplification. If one considers the 'pair of flower paintings' from this perspective, then *Bouquet* could have been done after *Blue Vase*.

Provenance: acquired from the State Museum of Modern Western Art in 1934; previously in the Galerie Bernheim-Jeune, Paris; collection of S. I. Shchukin from 1913; First Museum of Modern Western Painting from 1918; State Museum of Modern Western Art from 1923.

241. Arab Café, 1913 (page 320)
Le café arabe
Distemper on canvas. 176 x 210 cm
Γ϶ 9661

This painting is also entitled *Moroccan Café*. The simplicity and abstract quality of *Arab Café*, the largest and most important painting of the Moroccan period, was not achieved immediately, but only after a gradual refinement of the theme. The preparatory drawings *Café I* and *Café II* (private collection; reproduced in *Matisse in Morocco*, 1990, p. 140), which were done rapidly from nature, portray café life in some detail, despite their sketchy quality. They depict a specific interior, and details such as the pose of the man sleeping or the man with his head tilted back are conveyed with a few pencil lines. The Moroccans are shown sitting on rugs, having taken off their shoes, which are placed beside them. The row of shoes originally formed the lower edge of *Arab Café*, but were later painted over, although their traces are still visible. Matisse himself said that he was struck by the Arabs' ability to sit contemplating a flower or goldfish for hours. This contemplative motif occupies the foreground of the composition and is imbued with romantic meaning. With its elevated poetic mood, the painting stands apart from the preparatory drawings such as *Moorish Café* (private collection; *Matisse in Morocco*, no. 41), in which the artist already comes close to the concept of *Arab Café*. In the foreground of *Moorish Café* with its eight figures, there is an Arab smoking a pipe. Smoking hashish was permitted in the cafés of Tangiers, which might explain the relaxed poses of the figures. Matisse's aesthetic, however, led his painting away from what was naturalistic. The reclining poses of the male figures in *Arab Café* are reminiscent of other figures that embody the theme of paradise, in particular the women in *Joy of Life*. Music is introduced organically in both paintings. Although the violinist in the background of the Hermitage painting is not immediately noticeable, the musical motif is nonetheless important, for it emphasises the calm and static poses of the blank-faced figures. They are as isolated here as the figures in *Music*, painted for Shchukin; indeed, one of the main figures in the foreground is depicted in the same pose as that of the three young men in *Music*. In its painterly and compositional execution, *Arab Café* occupies a special place in Matisse's art, which scholars have attributed to Eastern influences. Barr, for example, cites as a possible influence Agha Reza's miniature *A Prince and His Guide* (1532), shown at a 1912 exhibition of Persian miniatures at the Musée des arts décoratifs in Paris (Barr, 1951, p. 160). One could mention other sixteenth- and seventeenth-century Persian miniatures that may, to a greater or lesser extent, have influenced Matisse's painting. The icons of Ancient Rus, particularly scenes of the Assumption, also played an influential role in his work at the time, although Matisse imbued such biblical motifs with a completely different meaning. A European source for *Arab Café* might also be cited: Ingres's *Odalisque and Slave Girl* (1839–40; Cambridge, Harvard, Fogg Art Museum), a painting Matisse knew well, although references to it are not readily apparent here. As is well known, Matisse's bronze statuettes of 1906–7, and his *Blue Nude*, were created as either variations or responses to Ingres's *Odalisque*. The position of the odalisque is taken in *Arab Café* by the recumbent man in the foreground. The musical motif is relegated to the background and Ingres's balustrade has been replaced by an arcade. Shortly after the beginning of the War, in 1941, *Arab Café* and other large canvases at the Museum of Modern Western Art in Moscow were taken off their stretchers and rolled up for safe keeping, before being 'evacuated'. Several years in this condition did not help *Arab Café*'s state of preservation. From the very beginning the colours were not durable because of the quality of the priming, which was quite diluted and bonded with water-soluble paint. And because Matisse had partly repainted the canvas,

the paint was unusually fragile and susceptible to stratification. After the War the painting had to be restored. The restoration was done by L. N. Iltsen and T. D. Chizhova at the Hermitage between 1961 and 1965. They used a special solution of synthetic resins to restore the painting, but it is still extremely fragile.

Provenance: acquired from the State Museum of Modern Western Art in 1948; previously in the collection of S. I. Shchukin from 1913 (purchased from the artist for 10,000 francs); First Museum of Modern Western Painting from 1918; State Museum of Modern Western Art from 1923.

242. Portrait of the Artist's Wife, 1913 (page 316)
Portrait de la femme d'artiste
Oil on canvas. 146 x 97.7 cm
Signed bottom right: *Henri Matisse*
Γ϶ 9053

This portrait of the artist's wife was painted in the summer of 1913 in Matisse's garden in Issy-les-Moulineaux. That year Matisse painted only a few paintings, partly because *Portrait* (as it was entitled at the 1913 Salon d'Automne, where it was the only work Matisse exhibited) took up so much of his time. In response to the critic Walter Pach, who remarked that the work's artistic liberties must have been the result of hurried work, Matisse replied that *Portrait* required more than a hundred sittings. On 15 September 1913, he wrote to Camoin: 'At the moment I'm very tired and need to eliminate all worries from my mind. I've done very little work this summer, but I've made progress on my large painting of *Bathers*, the portrait of my wife, as well as my bas-relief' (Giraudy, 1971, p. 15). In another letter Matisse wrote to Camoin: 'By chance, my painting (the portrait of my wife) is enjoying some success among progressives. But I'm not satisfied with it, it's just the beginning of some very laborious work' (Giraudy, 1971, p. 16). On 10 March 1914, Sergei Shchukin wrote to Matisse that he hoped soon to receive the 'portrait', which according to his information had already crossed the border (Kostenevich, 1993, p. 176). *Portrait of the Artist's Wife* turned out to be the final painting by Matisse that Shchukin acquired for his collection.

Provenance: acquired from the State Museum of Modern Western Art in 1948; previously in the collection of S. I. Shchukin from 1913 (purchased from the artist for 10,000 francs); First Museum of Modern Western Painting from 1918; State Museum of Modern Western Art from 1923.

243. Portrait of a Young Woman with Her Hair Down (L. N. Delektorskaya), 1933 (page 377)
Portrait de jeune femme défaisant ses cheveux (L. N. Delectorskaya)
Charcoal on paper. 50.4 x 33 cm
Signed bottom right: *Henri-Matisse*
46054

Lydia Nikolaevna Delektorskaya (1910–98) was Matisse's secretary for many years until his death, and from 1933 posed for many of his paintings and drawings. In his final years she helped him in creating his cut-outs. This drawing is the earliest of the completed easel works for which Delektorskaya posed and it precedes the pencil drawing *Portrait of a Woman with Her Hair Down* (Moscow, Pushkin Museum), which was dated by Matisse himself to 1933, which allows us to date the Hermitage sheet to the same year.

Provenance: acquired in 1968 (donated by L. N. Delektorskaya); previously in the collection of L. N. Delektorskaya.

244. Study of a Model Leaning on the Back of a Chair, 1934 (page 378)
Etude de modèle
Graphite pencil on paper. 24.8 x 32.5 cm
Initialled bottom right: *H. M.*
46061

According to Lydia Delektorskaya, who at the time was Matisse's studio assistant and his wife's companion, this drawing was done in Nice in 1934: 'One day he came to rest, with a sketch pad under his arm, and while I was absent-mindedly listening to the conversation, he suddenly said: Don't move! And opening his sketch pad he made a drawing of me in a familiar pose: my head resting on my arms, which were crossed over the back of the chair. These improvisations began to recur more and more frequently and soon Matisse asked me to pose for him. But it's this first sketch that was the source for the canvas *Blue Eyes*, the first painting Matisse did of me.' (Delektorskaya, 1986, p. 16.)

Provenance: acquired in 1968 (donated by L. N. Delektorskaya); previously in the collection of L. N. Delektorskaya.

245. Two Studies of a Woman's Head, 1935 (page 378)
Deux études de tête de femme
Graphite pencil on paper. 23.7 x 31.5 cm
Signed and dated bottom right:
Henri-Matisse 21/4/35
46059

Both sketches depict L. N. Delektorskaya.

Provenance: acquired in 1968 (donated by L. N. Delektorskaya); previously in the collection of L. N. Delektorskaya.

246. Portrait of a Woman, July 1935 (page 378)
Portrait de femme
Graphite pencil on paper. 25.4 x 16.4 cm
Signed and dated bottom right:
Juillet 35 Henri-Matisse
46065

This drawing belongs to a series that was executed in the summer of 1935 in Beauvezer (Alpes Basses), a mountain resort which Matisse visited with his family. The series, which depicts L. N. Delektorskaya, consists of 12 sheets. Ten of them were grouped together by Matisse in an album which he gave to the model as a gift in 1936, with the inscription: *This album contains ten drawings belonging to Mme Lydia Delektorskaya. H. Matisse 1936* (now in the Pushkin Museum, Moscow). The other two drawings of the series (one of which is in the Pushkin Museum, the other in the Hermitage), were probably given to Delektorskaya later, for they do not appear in the album. It is also possible that Matisse did not include *Portrait of a Woman*, clearly the best sheet of the series, because he wanted it to stand alone.

Provenance: acquired in 1968 (donated by L. N. Delektorskaya); previously in the collection of L. N. Delektorskaya.

247. Female Profile, to the left, 1935 (page 379)
Profil de femme, à gauche
Graphite pencil on paper. 28 x 38.2 cm
Signed and dated bottom left: *Henri-Matisse 35*
46063

This is a very rare example of a portrait in profile of Delektorskaya. Matisse almost always depicted her from the front, apparently believing that this angle better revealed her personality. Delektorskaya appears in profile with her head turned to the left in a photograph taken by Matisse around the same time (Delektorskaya, 1986, p. 132).

Provenance: acquired in 1968 (donated by L. N. Delektorskaya); previously in the collection of L. N. Delektorskaya.

248. Reclining Nude (Artist and Model), 1935 (page 380)
Nu couché
India ink and pen on paper. 37.8 x 50.5 cm
Signed and dated bottom left:
Henri Matisse 1935
46047

In April 1935, Matisse began work on his *Large Reclining Nude* (Baltimore Art Museum), which, after many revisions, was only completed at the end of October. In September he had started *Nymph in the Forest* (Nice, Musée Matisse) which he did not finish until seven years later. In a series of pen drawings entitled *Reclining Nudes*, which Matisse began at the end of 1935, the artist produced distinctive variations of the pose of the nude model. The Hermitage *Nude* is linked with the Baltimore one not only because of the similar position of the figure but also because of the surroundings, showing the square tiles in the background. In January the series was exhibited at the Leicester Gallery in London. In all the drawings in the series, the nude woman is depicted lying on a rug, with a mirror in the background partially reflecting her body, but each time she appears in a different position, giving each work an unexpected spatial orientation. The Hermitage sheet stands apart from the other works because it depicts both the model and the artist himself. In essence, the composition begins and ends with the artist: with pen in hand he draws the viewer into the space of the room; then, reduced in size, he stares out from the mirror at the pure and expressive contours of the young goddess who is posing for him.

Provenance: acquired in 1968 (donated by L. N. Delektorskaya); previously in the collection of L. N. Delektorskaya.

249. Window in Tahiti, 1 January 1936 (page 381)
Fenêtre à Tahiti
Graphite pencil on paper (two sheets of the same size glued together horizontally). 53 x 40.8 cm
Signed and dated bottom right:
Henri Matisse / 1er janvier 36
46057

In the spring of 1930, Matisse went to Tahiti, thereby fulfilling an old dream. He did not paint any pictures, limiting himself to a few drawings and photographs. 'Before going on my trip,' he recalled, 'I bought the very latest camera. But when I saw all that beauty, I said to myself, "I'm certainly not going to reduce this to a tiny image." It wouldn't be worth the effort. I prefer to keep it inside me. Because after a few years that's all I would have, everything would be replaced by this little document.' (R. P. Couturier, *La vérité blessée*. See Delektorskaya, 1986, p. 147.) From the hotel terrace, Matisse had in fact photographed the bay in Papeete and done several India ink drawings (private collection and Musée Matisse, Nice), in which he captured what was missing from the photographs: the spirit of Tahiti, its special light, and the wildness of the tropical vegetation. Two years later, in his illustrations to Mallarmé's poem *Window* (*Poésies de Stéphane Mallarmé*, Lausanne, 1932), Matisse changed the structure of the original drawing, striving for greater laconicism and elegance. Three years later, in August 1935, after being commissioned by Marie Cuttoli to do a cartoon for a tapestry, Matisse changed the composition of the etching to a monumental scale, and towards the end of October created the panel *Tahiti I* (Nice, Matisse). The cartoon, which was modelled after the panel (France, private collection), was finished in March 1936. While working on the cartoon, Matisse noticed that the colours did not match those on the panel, so he decided to create a different, more laconic version. The new panel, *Tahiti II*, (Cateau-Cambrésis, Musée Matisse), for which the Hermitage *Window in Tahiti* had served as a sketch, was finished on 15 March 1936.

250. Study of a Nude, 1936 (page 381)
Etude de femme nue
Graphite pencil on paper. 40.3 x 26.2 cm
Signed bottom right: *Henri-Matisse*
46056

This study of a female nude is related to two nudes done in the spring of 1936: *Nude Standing in front of an Open Door* (completed 13 March; New York, private collection) and *Nude Standing in front of the Fireplace* (begun 23 March and finished at the beginning of April; private collection). In her book, Delektorskaya placed the Hermitage drawing next to *Nude Standing in front of the Fireplace* (1986, pp. 172–3). She had posed for both works. She also included another large charcoal drawing of a standing nude that was executed at the same time (*ibid.*).

Provenance: acquired in 1968 (donated by L. N. Delektorskaya); previously in the collection of L. N. Delektorskaya.

251. Portrait of a Woman, *c.* 1939 (page 378)
Portrait de femme
Graphite pencil on paper. 26 x 20.2 cm
Signed bottom left: *à Lydia / H. Matisse*
47762

The drawing shows the Hungarian model known only by the initials W. J. She sat for Matisse in Paris in August 1939, in particular for the paintings *Marguerites and Scabias* (Merion, PA, Barnes Foundation), and *The Pink Table* (Paris, Centre Georges Pompidou). At that time she was also photographed by Brassaï (Delektorskaya, 1986, pp. 317, 323).

Provenance: acquired in 1984 (donated by L. N. Delektorskaya); previously in the collection of L. N. Delektorskaya from 1939.

252. Portrait of a Woman in a Hood, September 1939 (page 384)
Portrait de femme en capuchon
Graphite pencil on paper. 33.2 x 25.6 cm
Signed and dated bottom left:
à Lydia Délectorskaya / Henri Matisse / 9 / 39
46045

This drawing of Delektorskaya was executed in Rochefort-en-Yvelines in mid-September 1939. At that time Matisse painted an oil portrait of Delektorskaya in a hood, with the same composition and only slightly larger (collection of the Matisse family; L. Delektorskaya, *Henri Matisse, Contre vents et marées: Peinture et livres illustrés de 1939 à 1943*, Paris, 1996, p. 47).

Provenance: acquired in 1968 (donated by L. N. Delektorskaya); previously in the collection of L. N. Delektorskaya from 1939.

253. Young Woman in a Blue Blouse (Portrait of L. N. Delektorskaya), 1939 (page 382)
Jeune femme en blouse bleue (Portrait de Lydia Delectorskaya)
Oil on canvas. 35.4 x 27.3 cm
Inscribed, signed and dated bottom right:
A LYDIA H. MATISSE oct. 39
10157

At the beginning of the Second World War, Matisse had moved from Paris to Rochefort-en-Yvelines. According to Delektorskaya, this portrait was executed in Rochefort at the end of September 1939, but dated October, when the painter gave it to her as a gift. In that year he did another portrait of Delektorskaya (collection of the Matisse

family; unpublished), which is closer to the drawing *Portrait of a Woman in a Hood* (cat. 252). *Young Woman in a Blue Blouse* accurately captures Delektorskaya's physical features: her slightly asymmetrical face and raised shoulder. The portrait was done on a piece of canvas and tacked to a piece of wood. Later, the lower edge and holes made by the tacks were filled in, but not by Matisse. Delektorskaya found an unusual braided frame for the picture, which had Matisse's approval.

Provenance: acquired in 1971 (donated by L. N. Delektorskaya); previously in the collection of L. N. Delektorskaya (a gift of the artist) from 1939.

254. Still Life with Two Vases, 1940 (page 383)
Nature morte avec deux vases
Graphite pencil on paper. 53 x 40.8 cm
Signed and dated bottom left:
à Lydia Delektorskaya / Henri-Matisse mars 40
46053

At different stages of his creativity, Matisse often used an ornamental rather than a neutral background, which actively 'absorbed' the objects in the foreground. In this drawing, the large Etruscan vase acts as such a background; the small vase of flowers on the stool in front of it has a similar outline and is therefore not immediately visible. This Etruscan vase served as a prop in Matisse's studio and appeared in several drawings and paintings, including *Interior with an Etruscan Vase* (1940; Cleveland Art Museum).

Provenance: acquired in 1968 (donated by L. N. Delektorskaya); previously in the collection of L. N. Delektorskaya (gift of the artist) from 1940.

255. Still Life with Jug and Peaches, 1940 (page 383)
Nature morte: la cruche et les pêches
Graphite pencil on paper. 44.7 x 34 cm
Signed and dated bottom right: *Henri Matisse 40*
46055

The drawing relates to the well-known 1941 series of still lifes Matisse included in the publication *Themes and Variations* (*Dessins: Thèmes et variations*, ed. Fabiani, Paris, 1943). The first theme of the book includes six sheets with a jug and fruits that were executed in 1941; they depict variations of the same still-life arrangement. The drawing *Jug and Peaches* preceded this arrangement.

Provenance: acquired in 1968 (donated by L. N. Delektorskaya); previously in the collection of L. N. Delektorskaya (gift of the artist) from 1940.

256. Female Profile (Portrait of L. N. Delektorskaya), 1942 (page 386)
Profil de femme (Portrait de Lydia Delektorskaya)
Graphite pencil on paper. 53 x 40.7 cm
Signed and dated bottom left: *016 / Henri-Matisse 42*
46052

Matisse included *Female Profile*, one of the finest and most expressive portraits of Delektorskaya, in his collection *Themes and Variations* (sixteenth sheet in the 'O' series). As in several other series, the 'O' theme, which consists of eighteen variations, begins with an energetic charcoal sketch, followed by pencil drawings of the model in various positions. For the most part, Delektorskaya is depicted head and shoulders.

Provenance: acquired in 1968 (donated by L. N. Delektorskaya); previously in the collection of L. N. Delektorskaya (gift of the artist) from 1942.

257. Portrait of a Woman, February 1944 (page 379)
Portrait de femme
India ink and pen on paper. 52.4 x 40.3 cm
Signed and dated bottom right: *à Lydia Delectorskaya / 8 mai 1945 / Henri-Matisse 2/44*
46048

This sheet depicting L. N. Delektorskaya retains traces of corrections Matisse made during the course of the work. Striving for greater laconicism and expression, he painted over the lines of the collar with white paint.

Provenance: acquired in 1968 (donated by L. N. Delektorskaya); previously in the collection of L. N. Delektorskaya (gift of the artist) from 1945.

258. Portrait of L. N. Delektorskaya, 1947 (page 387)
Portrait de Lydia Delektorskaya
Oil on canvas. 64.3 x 49.7 cm
Signed and dated bottom right: *H. Matisse 47*
10023

This picture was painted in Vence and is one of the rare portrait-paintings of Matisse's final years. By dividing the model's face into two parts, blue and yellow, Matisse returns to the problems of colour that preoccupied him while he was painting *Green Line* (1905; Copenhagen, Statens Museum for Kunst). Here, however, he resolves them more simply and rationally. The style was clearly influenced by his work with cutouts – the technique of pasting a cutout of painted paper on a paper base. Despite the simplified and angular outlines, the painting is similar to the pen drawings of Delektorskaya, in particular the 1949 sheet, formerly in the John Rewald collection, New York. According to Delektorskaya, Matisse worked on two portraits at the same time. The other one, which was begun before the Hermitage painting, is part of the Matisse family collection.

Provenance: acquired in 1967 (donated by L. N. Delektorskaya); previously in the collection of L. N. Delektorskaya (gift of the artist) from 1947.

259. Woman with Bare Breasts, April 1948 (page 385)
Jeune femme aux seins nus
Charcoal on paper. 60.4 x 40.5 cm
Inscribed and dated bottom left:
à L. Delectorskaya / avril 48
46046

In 1951, the Maison de la Pensée Française issued 500 copies of a print based on this drawing to commemorate a Matisse exhibition that was held that year.

Provenance: acquired in 1968 (donated by L. N. Delektorskaya); previously in the collection of L. N. Delektorskaya (gift of the artist) from 1948.

Ernest Meissonier
1815, Lyons – 1891, Paris

Meissonier studied for a short time under Léon Cogniet, but as an artist developed primarily on his own. He copied paintings of the Old Dutch and Flemish Masters at the Louvre, and his work was greatly influenced by Gerard ter Borch and Gabriel Metsu. He first earned a living illustrating books: the Bible, Bossuet's *Discours sur l'histoire universelle* and Bernardin de Saint-Pierre's novels. Meissonier exhibited at the Salon from 1834 to 1877, where he received several awards: a third-class medal in 1840, second-class in 1841, first-class in 1843 and 1848, and a medal of honour in 1855. He became a member of the Institut de France in 1861 and one of the founding

members, then first president, of the Société Nationale des Beaux-Arts in 1890. Meissonier enjoyed the patronage of Napoleon III. He was a painter and illustrator, painting mostly historical, battle and genre paintings, as well as portraits.

260. Musketeer, 1870 (page 68)
Un mousquetaire
Oil on wood. 24.5 x 15 cm
Signed and dated bottom right: *E. Meissonier 1870*
5797

Meissonier liked to paint the same 'tried and tested' poses in his historical compositions. The position of the musketeer is similar to that in the canvas *Unbelievable* (1858; Paris, Rothschild collection) and later in *A Nobleman in the Time of Louis XIII* (1874). The artist did not choose this particular pose by chance; a surviving photograph shows a musketeer in this very pose and in similar attire at a ball held at the Palais des Tuileries in 1866. A dark fabric serves as the background for both the photograph and the Hermitage canvas. A drawing entitled *A Nobleman in the Time of Louis XIII* (formerly Paris, Charles Edmond collection) is very similar to, and may even be a preparatory sketch for, *Musketeer*.

Provenance: acquired from the Anichkov Palace in 1918; previously in the collection of Emperor Alexander III at the Anichkov Palace, St Petersburg.

Jean-François Millet
1814, Gruchy, near Cherbourg – 1875, Barbizon

From 1835 Millet studied in Cherbourg under Lucien-Théophile Langlois, and for a short time from 1837 at the Ecole des Beaux-Arts in Paris under Paul Delaroche. He exhibited at the Salon from 1840. In the 1840s Millet worked in Cherbourg, Le Havre and Paris, often painting portraits and nudes in the eighteenth-century Rococo style. In 1846 he met Troyon and Diaz de la Peña, and later became good friends with Théodore Rousseau, Charles Jacque and Daumier. A passionate Republican, in 1848 Millet participated in an open competition to create paintings symbolising freedom. In 1849 he settled in Barbizon and concentrated on painting scenes of peasant life. Millet's 'realistic allegories' of village life were inspired not only by life in Barbizon, but by daily readings of the Bible, which remained by his side throughout his life. Millet played a major role in simplifying the principles of Realist painting. After 1863, acceding to Rousseau's entreaties, he began to paint landscapes more frequently, as well as his 'peasant genre' compositions. A retrospective of his work at the Exposition Universelle of 1867 firmly established Millet's reputation.

261. Landscape with Two Peasant Women, early 1870s (page 98)
Paysage avec deux paysannes
Oil on canvas. 44 x 51 cm
Signed bottom right: *J. F. Millet*
10370

This is one of the artist's late works. It was probably painted in Millet's native Normandy, where the painter lived during the Franco-Prussian War. Millet found similar motifs in the environs of Cherbourg, where he painted, in particular, *Pasture in Normandy* (1871–4; Minneapolis Institute of Art), a landscape compositionally similar to the Hermitage canvas. *Priory in Vauville* (c. 1872; Boston, Museum of Fine Arts) can also be compared to *Landscape with Two Peasant Women*. Characteristic of all three paintings is the depiction of tiny human figures lost in a vast landscape.

Provenance: acquired from the chief administration of the Leningrad KGB in 1980.

Tony Minartz

1873, Paris – 1944, Paris

Minartz worked in Paris, and showed his works at various exhibitions from 1896 to 1914. From 1901 he exhibited at the Société Nationale des Beaux-Arts. Influenced by Toulouse-Lautrec and Forain, Minartz specialised in the depiction of music-hall and café scenes. He was also a landscape painter and graphic artist.

262. The Exit of the Moulin Rouge, 1901–2 (page 336)
Sortie du Moulin Rouge
Oil on canvas. 55.3 x 46.3 cm
Signed bottom left: *minartz*
⌐Э 8967

This scene takes place at the exit of the famous café-concert on Boulevard Clichy in Montmartre.

Provenance: acquired from the State Museum of Modern Western Art in 1948; previously in the collection of M. A. Morozov; collection of M. K. Morozova from 1903; Tretyakov Gallery (donated by M. K. Morozova) from 1910; State Museum of Modern Western Art from 1925.

Claude Monet

1840, Paris – 1926, Giverny, Eure

Monet spent his childhood in Le Havre where he started drawing caricatures. In 1858 he met Boudin, who introduced him to the principles of painting landscapes in the open air (*en plein air*). From 1862 he studied at Charles Gleyre's studio in Paris, where he became good friends with Renoir, Sisley and Frédéric Bazille. He made his début at the Salon of 1865, exhibiting two seascapes. In the second half of the 1860s he laid the foundations for Impressionist painting. In 1868 he met Edouard Manet and became a regular at the Café Guerbois, the meeting place of future Impressionists. In the autumn of 1870, at the start of the Franco-Prussian War, Monet went to London, where he discovered the work of Turner and the English landscape painters, and met Durand-Ruel. In the summer of 1871 he visited Holland, after which he settled in Argenteuil on the Seine, where he lived until 1878. Manet, Renoir, Sisley and Caillebotte visited him at Argenteuil. From 1878 to 1881 Monet lived in Vétheuil and from 1883 in Giverny. He participated in five Impressionist exhibitions (1874, 1876, 1877, 1879 and 1882). An exhibition at the Galerie Georges Petit in Paris in 1889 brought him success and financial independence. On three occasions between 1899 and 1901 he worked in London on his paintings of the Thames, and in 1908 and 1909 he visited Venice. In 1914 he began work on his *Waterlilies* series, which would be housed at the Musée de l'Orangerie shortly after his death. In his late period, he created cycles of canvases depicting variations of the same landscape theme.

263. Lady in the Garden, 1867 (page 101)
Dame dans le jardin
Oil on canvas. 82.3 x 101. 5 cm
Signed bottom left: *Claude Monet*
⌐Э 6505 W.M. 68

Lady in the Garden was painted in the garden of Monet's aunt at Sainte-Adresse near Le Havre (now part of the city itself). This is established by the label of the Galerie Durand-Ruel on the verso of the canvas, which bears the title *Paysage de Sainte-Adresse*, and further confirmed by the aunt's great-grandson and grandson of the 'lady in the garden', Jeanne-Marguerite Lecadre, the wife of Monet's cousin. Monet yielded to his father's wishes and spent the summer of 1867 in Sainte-Adresse. On 25 June he wrote to Bazille: 'I have already spent two weeks in the bosom of the family, and I am as happy and content as can be. Everybody is kind to me and rejoices at my every brushstroke. I am up to my ears in work, have twenty canvases on the go, some astonishing seascapes, figures and gardens, a bit of everything in fact' (W.M., vol. i, p. 324, letter 33). *Lady in the*

Garden was without a doubt one of those paintings; another was *Garden in Full Bloom* (Paris, Musée d'Orsay) which depicts part of the same garden located next to the house. The central work of this group, *Terrace at Sainte-Adresse* (New York, Metropolitan Museum of Art), also portrays the 'lady' of the Hermitage canvas in a white dress carrying a parasol. Since Matisse himself dated *Terrace* to 1867, Wildenstein's date of 1866 for *Lady in the Garden* seems unlikely. Wildenstein also arbitrarily entitled the painting *Jeanne-Marguerite Lecadre in the Garden*, but at that time Monet was not so much interested in portraiture as in the colour of the woman's dress. An X-ray of the picture revealed that to the right of where the woman is standing there was a figure of a man, subsequently painted over. It is possible that Monet originally intended to give the composition some kind of subject. It seems likely that Monet took the canvas to Paris that same year, where it may well have been seen by Adolph von Menzel. Menzel's *A Stroll in the Garden* (1867; Bremen, Kunsthalle) is a very similar work, showing a woman in white, but from the back. *Lady in the Garden* was shown at the fourth Impressionist exhibition in 1879 under the title *Garden* (no. 155).

Provenance: acquired from the State Museum of Modern Western Art in 1930; previously in the Lecadre collection, Sainte-Adresse; Mennier collection, Sainte-Adresse, from 1880; Lebas collection, Paris; Galerie Durand-Ruel, Paris, from 1893; collection of P. I. Shchukin from 1899; collection of S. I. Shchukin from 1912; First Museum of Modern Western Painting from 1918; State Museum of Modern Western Art from 1923.

264. Pond at Montgeron, 1876 (page 108)
L'étang à Montgeron
Oil on canvas. 174 x 194 cm
Monogrammed bottom right: *Cl. M.t.*
⌐Э 6562 W.M. 420

This picture, together with *Corner of the Garden at Montgeron* (cat. 265), was part of a decorative series that hung in the house of Ernest Hoschedé in Montgeron, a small town on the Yerres River in the environs of Paris. It is unclear how the paintings, which included *Turkeys* (Paris, Musée d'Orsay) and *The Hunt* (Paris, Durand-Ruel collection), looked as an ensemble. They were all the same height as the Hermitage canvas, but of varying widths. The financier and entrepreneur Ernest Hoschedé and his wife Alice, who was to become Monet's second wife, were two of those rare individuals who supported the Impressionists as they were struggling for recognition. Monet spent the autumn of 1876 at the Château de Rottembourg, the Hoschedés' estate at Montgeron. Unlike his usual practice of painting in the open air, Monet executed this canvas indoors from a preliminary study (private collection; W.M. 419). The woman with the fishing-rod has been taken to represent Alice Hoschedé, but her depiction, in keeping with the general tenor of the painting, is quite generic. The assumption is based on the fact that Monet painted Ernest Hoschedé in *The Hunt*. Although he turned to decorative painting, Monet nonetheless strove to reproduce impressions of nature accurately.

Provenance: acquired from the State Museum of Modern Western Art in 1931; previously in the Hoschedé collection, Montgeron/Paris; collection of I. A. Morozov (purchased for 10,000 francs) from 1907; Second Museum of Modern Western Painting from 1918; State Museum of Modern Western Art from 1923.

265. Corner of the Garden at Montgeron, 1876 (page 109)
Un coin de jardin à Montgeron
Oil on canvas. 175 x 194 cm
Initialled bottom right: *Cl. M.*
⌐Э 9152 W.M. 418

Like *Pond at Montgeron* (cat. 264), this painting was part of a decorative series commissioned by Ernest Hoschedé. Contrary to widespread belief, the Hermitage canvases do not form a pair, because they address different compositional problems. The study for the

painting, entitled *Roses in the Hoschedé Garden* (Nelson Harris collection; W.M. 417), differs from the finished work in that the perspective is slightly wider and the roses in the foreground are more accentuated. It is entirely possible that *Corner of the Garden* and *Pond at Montgeron* were both shown at the third Impressionist exhibition in 1877. This is difficult to establish with absolute certainty because the dimensions of the paintings were not included in the exhibition catalogue. However, the mention of Montgeron and the initials of their owner, Hoschedé, would seem to lend credence to this view. The fact that Monet showed the unfinished *Turkeys* at the exhibition makes it seem likely that he also included the two earlier Hermitage paintings, which would have been even more attractive.

Provenance: acquired from the State Museum of Modern Western Art in 1948; previously in the Hoschedé collection, Montgeron/Paris; Faure collection, Paris (acquired at the sale of Hoschedé's paintings for 50 francs) from 1878; Galerie Durand-Ruel, Paris, in 1907; collection of I. A. Morozov (acquired for 40,000 francs) from 1907; Second Museum of Modern Western Painting from 1918; State Museum of Modern Western Art from 1923.

266. Haystack at Giverny, 1886 (page 128)
Une meule près de Giverny
Oil on canvas. 60.5 x 81.5 cm
Signed and dated bottom right: *Claude Monet 86*
⌐Э 6563 W.M. 1073

The haystack motif had already attracted Monet in 1884–5 (W.M. 900–2, 993–5). Later, in 1890–1, it would dominate a series of large canvases, in which the same subject is painted in different lighting at different times of the day. The Hermitage picture appears as a transitional work between this series and the earlier paintings: the haystack is in the foreground but does not obstruct the panorama of the landscape. Monet also freely uses the device of an optical merging of tones, which for Seurat and Signac had almost become a scientific doctrine. A year before he painted the Hermitage canvas Monet had completed a landscape showing the same place from the same perspective, but without the haystack (USA, Mellon collection; W.M. 997). Behind Amsicourt, the empty plot of land in the foreground, there is a farm which, in 1888, Monet also included, though from a closer perspective, in *View of Giverny and the Surrounding Hills* (New Orleans, Stafford collection). Monet later built a studio to the right of the houses, where he painted his numerous *Waterlilies*.

Provenance: acquired from the State Museum of Modern Western Art in 1930; previously in the collection of S. I. Shchukin from 1904; First Museum of Modern Western Painting from 1918; State Museum of Modern Western Art from 1923.

267. Meadows at Giverny, 1888 (back of gatefold, p. 131)
Les prairies à Giverny
Oil on canvas. 92.5 x 81.5 cm
Signed and dated bottom left: *Claude Monet 88*
⌐Э 7721 W.M. 1202

The inscription on the verso of the canvas, *Prairie de Giverny: Temps moissoneux* [Meadow at Giverny: Harvest-time], confirms that the painting was executed after Monet's return from London, which he had visited in July 1888. Monet depicted the marshy area around Giverny on a number of occasions. His stepson, Jean-Pierre Hoschedé, remembered later that 'in the summer, with the coming of dry weather, [the meadow] became a foul marshy field covered with yellow irises. Many of Monet's canvases capture this memory.' (J.-P. Hoschedé, *Claude Monet, ce mal connu*, Geneva, 1960, vol. i, p. 77.) The same meadow recurs in four other canvases of 1888: *Morning Landscape* and *Evening in the Meadows* (W.M. 1205, 1206), and two compositions entitled *Walk in Giverny* (W.M. 1203, 1204) which depict members of Monet's family; the figures are arranged so that they echo the trees in the background.

Provenance: acquired from the State Museum of Modern Western Art in 1934; previously in the Galerie Durand-Ruel, Paris (acquired from the artist), from July 1891; Cauchin collection, Paris, from 1892; Galerie Durand-Ruel again from 1897; collection of S. I. Shchukin from 1899; First Museum of Modern Western Painting from 1918; State Museum of Modern Western Art from 1923.

268. Poppy Field, 1887 (page 131, gatefold)
Champs de coquelicots
Oil on canvas. 61 x 92 cm
Signed bottom right: *Claude Monet*
⌐⊐ 9004 W.M. 1255

In the 1870s and 1880s Monet frequently painted fields of poppies. This canvas differs in the overall absence of detail and its more dynamic execution. It has been dated variously, but is generally placed in the 1880s. The correct date appears to be 1890–1, when Monet painted a series of poppy fields (W.M. 1251–4) very similar to the Hermitage canvas in style and subject matter. The Essarts valley and Port-Villet hills in the environs of Giverny appear in the background of all these pictures, two of which were dated by the artist himself: the one now in the Smith College Museum of Art, Northampton (W.M. 1251) was dated 1890, while *Poppy Field* at the Art Institute, Chicago (W.M. 1253) bears the date 1891.

Provenance: acquired from the State Museum of Modern Western Art in 1948; previously in the Feydeau collection, Paris; Galerie Bernheim-Jeune (from the Feydeau auction in the Hôtel Druot on 11 February 1901); collection of M. A. Morozov; collection of M. K. Morozova from 1903; Tretyakov Gallery (donated by M. K. Morozova) from 1910; State Museum of Modern Western Art from 1925.

269. Cliffs near Dieppe, 1897 (page 130)
Sur les falaises près de Dieppe
Oil on canvas. 65 x 100.5 cm
Signed and dated bottom right: *Claude Monet 97*
⌐⊐ 8992 W.M. 1467

In late January and February 1897, Monet lived in Pourville on the coast of the English Channel, where he had previously worked in 1882 and 1896. In earlier depictions of the steep cliffs between Pourville and Dieppe, Monet had been attracted to the lapping of the waves, the austerity of the steep cliffs, and the eternal struggle between cliffs and sea. Now he becomes more contemplative: a pearly haze softens the sharp edges and reconciles the antagonists. At the beginning of February 1897, Monet wrote to Durand-Ruel: 'I've been working with great enthusiasm, but haven't been pleased with the weather: until now I've just been soaking in the rain' (Venturi, 1939). In a letter to his wife, sent from Pourville on 6 February, Monet wrote: 'The place where I started so many canvases, further up in the direction of Dieppe, will be closed to the public; some kind of organisation from Dieppe has rented the area from the Saint-Nicolas valley for various English games, shooting at targets and pigeons' (W.M. 1367). Nonetheless, Monet gained permission to visit these places. It is clear from his letters that several of the paintings he had started the year before were still unfinished, and the artist worked on them in February and March 1897. Monet had made a habit of simultaneously working on an entire series so that he could move from one canvas to the next. Circumstances had prevented him from completing the cycle of landscapes sooner: he had had to persuade the local inhabitants not to burn the grass near to where he had set up his easel. At the beginning of March his work was temporarily disrupted first by a storm, then by an exceptionally strong wind. The cycle, more accurately dated to 1896–7, consists of thirteen canvases. With two exceptions, the paintings all have the same dimensions and can be divided into two groups. Six paintings (W.M. 1465–70), including the Hermitage landscape (also known by the sub-title *Overcast Sky*), have the same composition, but differ in colour according to different lights. The group has sometimes been collectively referred to as *The Saint-Nicolas Valley near Dieppe*, a title Monet gave one of the paintings when it was exhibited at the Galerie

Georges Petit in 1898. Later, at the Durand-Ruel sale, this title was dropped.

Provenance: acquired from the State Museum of Modern Western Art in 1948; previously at the Galerie Durand-Ruel, Paris (acquired from the artist on 27 November 1901); collection of S. I. Shchukin from 1903; First Museum of Modern Western Painting from 1918; State Museum of Modern Western Art from 1923.

270. Waterloo Bridge: Effect of Fog, 1903 (page 129)
Waterloo Bridge. Effet de brouillard
Oil on canvas. 65.3 x 101 cm
Signed and dated bottom right:
Claude Monet 1903
⌐⊐ 6545 W.M. 1580

The verso of the canvas bears a label from the Galerie Durand-Ruel with the title *Waterloo Bridge. Effet de brouillard*. In 1899, 1900 and 1901 Monet spent a few weeks in London, staying each time at the Savoy Hotel on Victoria Embankment, with its wonderful view of the Thames and the Charing Cross and Waterloo bridges. The Waterloo Bridge series comprises 41 works (W.M. 1555–95), of which the overwhelming majority were begun at the Savoy in 1900 and 1901, but few were actually completed there; only three are dated 1900. This is confirmed in the memoirs of the artist John Singer Sargent, who visited Monet in London and saw about ninety canvases filling up his hotel room. This figure roughly corresponds to the sum total of paintings included in the London series with views of the Houses of Parliament and Charing Cross and Waterloo bridges. Probably begun in 1900, the Hermitage canvas was finished in Giverny. In March 1900 Monet wrote to Durand-Ruel that he was working continually, but because of the constant changes in the weather he was forced to begin more paintings than he was capable of finishing. The changing weather was not the only factor here: the work stretched out over several years because Monet was trying to express something more important than an impression of a specific motif or of an ephemeral atmospheric effect. Although the initial impulse for creating the London series was purely an Impressionistic attempt to capture the changes in the weather and lighting, the best canvases, including the Hermitage work, are characterised by the expression of a certain pantheistic mood. Of the canvases in this series, the ones closest to the Hermitage picture also depict Waterloo Bridge in a thick fog: *Waterloo Bridge: Foggy Morning* (Philadelphia Museum of Art) and *Waterloo Bridge: Effect of Fog* (1904; W.M. 1582).

Provenance: acquired from the State Museum of Modern Western Art in 1930; previously at the Galerie Durand-Ruel, Paris (acquired from the artist), from March 1906; collection of I. A. Morozov (purchased for 18,000 francs) from November 1906; Second Museum of Modern Western Painting from 1918; State Museum of Modern Western Art from 1923.

Henri Moret
1856, Cherbourg – 1913, Paris

Moret studied at the Ecole des Beaux-Arts under Jean-Léon Gérôme, but mostly under Jean-Paul Laurens. He made his début at the Salon of 1880, but soon moved away from the Academic style and started painting from nature. He met Gauguin in Pont-Aven in 1888, and the encounter changed the course of his artistic development. Gauguin would often come and work with Moret and other artists of the Pont-Aven group who moved the following year to Le Pouldu. Moret also became friends with Emile Bernard, Laval, Schuffenecker, and especially with Maufra. He was among the group of artists who exchanged pictures with Van Gogh, and was also deeply influenced by Monet. Moret worked primarily in Brittany, going to Paris only for meetings with Durand-Ruel, who exhibited his works from 1895. Moret visited Holland in 1900 and England in 1912. He painted mostly landscapes, but also scenes of peasants and fishermen from Morbihan.

271. Port Manech, 1896 (page 130)
Oil on canvas. 60.5 x 73.5 cm
Signed and dated bottom right: *Henri Moret 96*
⌐⊐ 9045

439

This canvas depicts the small bay of Port Manech, a little town on the Atlantic Ocean not far from Pont-Aven, where Moret worked from 1896 to 1897.

Provenance: acquired from the State Museum of Modern Western Art in 1948; previously at the Galerie Durand-Ruel, Paris (acquired from the artist) from 1901; collection of S. I. Shchukin from 1903; First Museum of Modern Western Painting from 1918; State Museum of Modern Western Art from 1923.

Alphonse-Marie de Neuville
1836, Saint-Omer, Pas-de-Calais – 1885, Paris

De Neuville studied under François-Edouard Picot and received advice from Delacroix. He exhibited at the Salon from 1859 to 1881 and was awarded two medals: the third-class medal when he made his début and second-class in 1861. During the Franco-Prussian War of 1870–1 he served on the battle-front north of Paris, and readily depicted it in his canvases, which brought him fame in France and subsequently throughout Europe. Together with Edouard Detaille he painted panoramas of battlefields. De Neuville also painted landscapes and genre scenes, and illustrated books on history and war.

272. Street in the Old Town, 1873 (page 105)
Rue de la vieille ville
Oil on wood. 51 x 34.5 cm
Signed and dated bottom left: *A. de Neuville 1873*
⌐⊐ 10107

It has been suggested that the old town depicted here is located in the Pays Basque Français (Pyrénées Atlantiques).

Provenance: acquired from V. V. Sheinbaum, Leningrad, in 1970.

273. Episode from the Franco-Prussian War, 1875 (page 70)
Episode de la guerre franco-prussienne de 1870
Oil on canvas. 51 x 74.5 cm
Signed and dated bottom left:
Alph. de Neuville 1875
⌐⊐ 9798

The painting develops a motif – the desperate defence of a house being besieged by German soldiers – that De Neuville had first addressed in his large canvas *The Last Rounds* (1872–3, Bazeilles Museum), which had brought the artist great success at the Salon of 1873.

Provenance: acquired from Pavlovsk Palace-Museum in 1958; previously in the collection of Emperor Alexander III at the Anichkov Palace; Gatchina Palace from 1884; collection of Pavlovsk Palace-Museum from 1941.

274. The Commander's Feast, 1875 (page 71)
Régalade du commandant
Oil on canvas. 37 x 55 cm
Signed and dated bottom right: *A de Neuville 1875*
⌐⊐ 8903

Iconographically the painting is related to scenes that appeared frequently in lithographs and the humourous journalistic press of the 1860s and 1870s. In particular De Neuville may have been inspired by such compositions as Daumier's 1862 work entitled *I never laughed so hard as I did at the funeral of the girl in Bourdin*. De

Neuville could also have been familiar with Daumier's watercolour, *Friends* (Baltimore Museum of Art), which was similar in composition to the Hermitage canvas, with a simple wooden table under a tree, and a figure in profile on the left who is leaning forward and holding a glass in his right hand, while his companion is shown face-on.

Provenance: acquired from the State Museum of Modern Western Art in 1948; previously in the collection of S. M. Tretyakov, Moscow; Tretyakov Gallery from 1892; Pushkin Museum of Fine Arts, Moscow, from 1925; State Museum of Modern Western Art from 1930.

Amédée Ozenfant
1886, Saint-Quentin, Aisne – 1966, Cannes

Ozenfant spent his childhood in Spain, where he received a classical education. After returning to his hometown, in 1904 he enrolled in the drawing course at the Ecole Municipale de Dessin Quentin de La Tour. In 1906 he moved to Paris to study architecture, but also continued painting. He enrolled at the Académie de la Palette, where he studied with Roger de la Fresnaye and André Dunoyer de Segonzac under Charles Cottet, Jacques-Emile Blanche and Desvallières. Ozenfant exhibited at the Salon de la Société Nationale des Beaux-Arts from 1908, at the Salon d'Automne from 1910, and at the Salon des Indépendants from 1911. Influenced by Cubism, he and Charles-Edouard Jeanneret, better known as Le Corbusier, revised many of Cubism's ideas on art: in 1918 they published *After Cubism*, which became the manifesto for a new style – Purism. Ozenfant's favourite genre was the still life; he also painted large-scale compositions. He devoted a great deal of time to teaching and in 1932 founded his own art school, the Académie Ozenfant, in Paris. He also established an art school in London (1935–8), and taught in the USA from 1938 to 1955.

275. Still Life with Dishes, 1920 (page 366)
Nature morte: La vaisselle
Oil on canvas. 72 x 60 cm
Signed and dated bottom right: *Ozenfant. Mil neuf cent vingt*
Г⊃ 9070

The plastic elements of this painting, one of the most characteristic examples of Purism, recur in several canvases of 1920, in particular in *Still Life* (New York, Solomon R. Guggenheim Museum) and *Composition* (Basel Kunstmuseum). A similar composition (Paris, La Roche collection) was published in the journal *L'Esprit nouveau* (1921, No. 7).

Provenance: acquired from the State Museum of Modern Western Art in 1948; previously in the same museum (acquired from the painter for 600 francs) from 1925.

Charles Picart Le Doux
1881, Paris – 1959, Paris

Picart Le Doux studied at the Ecole des Beaux-Arts under Jean-Léon Gérôme and at the Académie Julian. He made his début at the Salon des Indépendants in 1904, and also exhibited at the Salon d'Automne, the Salon de la Société Nationale des Beaux-Arts and the Salon des Tuileries. In 1937 he was awarded the Gold Medal at the Exposition Universelle in Paris. He taught at the Académie libre de Montparnasse. He painted nudes, still lifes with flowers, landscapes of Provence, and Paris and its environs. He also painted large-scale murals including the ceilings of the ship Normandie, panels for the government buildings in Tours, the Lycée in Vincennes, the Hôtel de Ville in the 17th arrondissement in Paris, among others. He also did engravings and book illustrations (for Baudelaire, Verlaine, Colette, Duhamel and others).

276. Landscape at Saint-Denis, *c.* 1906–10 (page 256)
Paysage à Saint-Denis
Oil on canvas. 46 x 54 cm
Signed bottom left: *Picart Le Doux*
Г⊃ 8955

Provenance: acquired from the State Museum of Modern Western Art in 1948; previously in the Galerie Vildrac, Paris; K. F. Nekrasov collection, Moscow; State Museum of Modern Western Art from 1927.

Pablo Picasso
1881, Malaga, Spain – 1973, Mougins, Alpes-Maritimes

Picasso received his first lessons from his father, José Ruiz Blasco, a teacher at the Escuela Provincial de Bellas Artes in Malaga. From 1895 to 1897 he studied at the Escuela de Bellas Artes in Barcelona, and in 1897 at the Academia Real de San Fernando in Madrid. After returning to Barcelona he became friends with the avant-garde artists who frequented the café Els Quatre Gats (The Four Cats) (1898–1900). In 1900 he made his first trip to Paris, where he exhibited a picture (*Last Moments*; destroyed) at the Exposition Universelle. In 1901 Vollard organised Picasso's first one-man exhibition. His Blue Period, from 1901 to 1904, developed primarily in Barcelona, characterised by a tragic view of the world. In 1904 Picasso finally settled in Paris in a studio at the Bateau-Lavoir and became friends with the poets André Salmon, Max Jacob, and Guillaume Apollinaire. His Rose Period, 1905 to 1906, was characterised by motifs from the lives of itinerant actors. Gertrude Stein introduced Picasso to Matisse. In 1906 his work was influenced by ancient Iberian sculpture. Other influences included Cézanne and African sculpture, which sparked a subsequent exploration of plasticity, leading to Cubism (1907). After meeting Diaghilev in 1916, he designed costumes and scenery for his ballets. Neo-Classicism dominated Picasso's work in the first half of the 1920s, after which various stylistic tendencies co-existed. The Spanish Civil War inspired him to paint Guernica in 1937. He spent the years of the German Occupation in Paris. After the Second World War he lived in southern France. He was a painter, graphic artist, sculptor and ceramicist.

277. The Absinthe Drinker, 1901 (page 335; verso with detail page 334)
La buveuse d'absinthe
Oil on canvas. 73 x 54 cm
Signed top right: *Picasso*
Г⊃ 9045 Z. I. 98; D.–B. VI. 24

In recent Western art criticism this painting is often, without sufficient basis, referred to as *Aperitif*, while in Kahnweiler's archive it is called *Woman with a Glass of Absinthe* (dated to autumn 1901). In Sergei Shchukin's catalogue it is entitled *Drunkard*. Iconographically, the canvas is related to Toulouse-Lautrec's *Dry Throat* (1889; Albi, Musée Toulouse-Lautrec) and Gauguin's *Café at Arles* (1888; Moscow, Pushkin Museum; W.G. 305). Picasso was obviously familiar with the latter work while painting *The Absinthe Drinker*, for it was being exhibited at Vollard's at the time. Moreover, depictions of a woman sitting alone in a café were commonplace in the paintings of the Barcelona artists who frequented Els Quatre Gats, and who in their turn had borrowed the motif from French turn-of-the-century painters. The theme of a woman in a café had appeared in Picasso's work as early as 1899–1900, while he was living in Barcelona. In the summer of 1901 he exhibited a pastel at the Galerie Vollard entitled *Absinthe* (New York, Jaffe collection; Z. I. 62), which can be seen as the work that led to *The Absinthe Drinker*. The elements of Impressionism present in the earlier pastel were soon rejected, as was the figure's energetic gesticulation. Another pastel called *Absinthe*, also in the Hermitage collection (formerly Holzdorf, Otto Krebs collection; Z. I. 81), occupies the middle ground between the early pastel and *The Absinthe Drinker*. In the Hermitage pastel the gesticulation is changed and a key detail in Picasso's work has emerged: the woman's left arm is now resting

on the table, her hand supporting her chin. The thick contour has become the basis of Picasso's style. Although *The Absinthe Drinker* preserves this gesture, the model has changed. The artist draws attention to the female figure's *chignon*, which resembles a Phrygian bonnet or the hat worn by prostitutes imprisoned in the Saint-Lazare Hospital. The hint at the absinthe drinker's profession is clear, and in the following year Picasso was to explore the motif on a number of occasions. The model's identity is unknown, but she also appears in *Woman with a Chignon* (Cambridge, Harvard University, Fogg Art Museum; Z. I. 96), *Young Woman with Arms Folded* (Geneva, Obersteg collection; Z. I. 100), and possibly *Woman with a Cigarette* (Merion, PA, Barnes Foundation; Z. I. 99). In each of these 1901 canvases, as well as in *The Absinthe Drinker*, the painting in the background alludes to the theme of loneliness. On the verso of the painting (see page 334), Picasso has begun another work, which he then painted over with thick blue and yellow paint. It probably portrayed dancers, possibly a version of the *French Cancan* (Geneva, Barbey collection; D.–B. V. 55). These works were apparently done at the same time as the *Absinthe* pastel from the former Krebs collection, in which the background depicts frenetic dancing in the café, a vivid hallucination of the prostitute's alcohol-sodden mind. Picasso was obviously dissatisfied with the composition and almost destroyed it, although his 'painting over' in itself represents 'action painting', which became popular half a century later. Living on limited means at the time, Picasso would often paint on both sides of the canvas or cardboard. When he turned the canvas over to paint another version of *The Absinthe Drinker*, Picasso did not prime it, which meant that he achieved a special matt finish with a clearly defined grain.

Provenance: acquired from the State Museum of Modern Western Art in 1948; previously in the Kahnweiler Gallery; collection of S. I. Shchukin from 1911; First Museum of Modern Western Painting from 1918; State Museum of Modern Western Art from 1923.

278. Two Sisters (The Visit), 1902 (page 339)
Les deux soeurs (L'entrevue)
Oil on canvas pasted on wood. 152 x 100 cm
Signed and dated top right: *Picasso 1902*
Г⊃ 9071 Z. I. 163; D.–B. VII. 22

After returning to Barcelona from Paris, Picasso wrote to Max Jacob on 10 July 1902: 'I want to paint a picture after a drawing that I'm sending you (*Two Sisters*); it's about a whore from Saint-Lazare and a mother' (handwritten by Picasso: see Richardson, 1991, p. 249). The letter was first published by Sabartès (J. Sabartès, *Picasso: Documents iconographiques*, Geneva, 1954, No. 70/w), but with a small error: the last word *mère* (mother) he had misread as *soeur* (sister). This produced the following interpretation of the subject: an encounter between a prostitute from the Saint-Lazare women's prison hospital in Paris and a nun (in Saint-Lazare nuns actually kept an eye on the children of imprisoned prostitutes). This explanation has lately been disputed: the woman on the right is perhaps not a nun but the prostitute's sister. In any case, it was Picasso who entitled the picture *Two Sisters*: the title is mentioned not only in his letter to Jacob but is also written on a sketch in Picasso's own hand (Z. VI. 436). *Les deux soeurs* is best rendered as *Both Sisters* – not an unimportant thematic nuance: by connecting both characters, whoever they may be, Picasso is depicting them as equals. Richardson correctly identifies the composition's ambivalence, interpreting it as an allegory of earthly and spiritual love (Richardson, 1991, p. 224). It may make more sense to interpret the painting as an embodiment of sin and redemption, but without any attempt at moralising, which was always alien to Picasso. At first the picture was to have reflected the artist's impressions of the Saint-Lazare prison hospital, which he had received permission to visit. Like all its visitors, Picasso was struck not only by the general spirit of the institution, but also by the presence of children, including infants. But in *Two Sisters*, as well as in other paintings inspired by his visits to Saint-Lazare, he did not include details that would indicate

that the characters were prostitutes. Their clothes and general appearance are stylised in such a way as to recall not so much the Paris newspaper reports of the lives of unhappy women as the works of El Greco. The Hermitage painting, in particular, has repeatedly been compared with the great Spanish master's *The Visitation* (1607–14; Washington, Dumbarton Oaks collection). One of the prototypes for *Two Sisters* was yet another *Visitation* – the sculptural group on the façade of the Hospital Latino in Barcelona (now in the garden of the Escuela arquitectural in Madrid). Eugène Carrière's canvas *Two Women with a Child* (present whereabouts unknown) also probably influenced the painting's subject matter. The sculptural quality evident in *Two Sisters* was developed in such works as *The Burial of Casagemas* (1901; Musée d'art moderne de la ville de Paris; Z. I. 55), which portrays two 'professional' mourners embracing each other, and *Two Women by a Spring* (1901; Madrid, Thyssen-Bornemisza collection; Z. I. 80). In the latter work, the figures are depicted in hospital caps (in Saint-Lazare they resembled Phrygian bonnets); one of them is holding an infant wrapped in a coat. Picasso was apparently dissatisfied with this painting because he did not finish it. The hospital bonnet worn by the figure on the left in *Two Sisters* can be seen in the preparatory drawings for the painting. The woman on the right reappears, with minor alterations, in *Mother and Child by the Sea* (1902; Japan, private collection; Z. VI. 478) which was painted either at the same time or shortly after the Hermitage work. A prototype for the woman on the left is the *Sleeping Absinthe Drinker* (1902; Glarus, Othmar Huber collection; Z. I. 120). A few preparatory drawings for the painting have survived: two are now in the Musée Picasso in Paris (Z. XXI. 368, 369) and two are in private collections (Z. VI. 435, 436). One of the latter bears the title *Les deux soeurs* in Picasso's handwriting. In the drawings, unlike in the painting, Picasso shows a handshake, while in the finished work the child in the arms of the woman on the right is more visible than in the drawings. Apart from these sketches, there are a whole series of preparatory drawings for the painting. The head of the figure on the right is found in a drawing at the Musée Picasso (Paris, Z. XXII. 37); the figure itself appears full length in a drawing at the Picasso Museum in Barcelona (J. T. Cirlot, *El nacimiento de un genio*, Barcelona, 1972, No. 255). In two other drawings in the same museum, the figure on the left is shown nude (*ibid.*, Nos. 267, 270). In drawing No. 267, the figure appears in its entirety, but the grid overlaying it indicates that it was intended to be transferred to canvas. This raises the question: did Picasso subsequently want to leave this figure nude in order to express his original concept – the juxtaposition of the nun and the prostitute? Or was he simply following academic rules by first drawing a nude study of the finished clothed figure? The former seems more likely since by then Picasso could paint whatever he wanted without preparatory sketches.

Provenance: acquired from the State Museum of Modern Western Art in 1948; previously in the collection of S. I. Shchukin; First Museum of Modern Western Painting from 1918; State Museum of Modern Western Art from 1923.

279. Head of a Woman (Portrait of Geneviève), 1902–3 (page 338)
Tête de Femme (Portrait de Geneviève)
Oil on canvas pasted on cardboard. 50 x 36 cm
Remains of destroyed signature and inscription top left: *à Henri Bloch Picasso*
ГЭ 6573　　　　　Z. I. 166; D.–B. IX. 14

Most scholars date this painting to the summer of 1903, which Picasso spent in Barcelona, yet it seems much more likely that it was painted in Paris at the end of 1902 or the very beginning of 1903. There is a striking similarity between the model depicted here and the woman whose features recurred in a number of works from that period, in particular in the pastel *Portrait of Geneviève* (present whereabouts unknown; Z. VI. 462). According to Richardson, Picasso confirmed that the pastel depicts Geneviève, 'Max Jacob's one and only mistress' (Richardson, 1991, p. 260). Jacob's liaison with this woman, which seemed rather improbable to his friends who knew of

his homosexuality, took place in 1902–3. Cécile Acker, the wife of a department store employee in Paris, was mostly known as Geneviève, and sometimes as Genoveva or Germaine. A chance encounter with Jacob in a Paris bistro had led to her moving in with him; she assured him that she would cost him nothing, for she earned a living knitting dolls' dresses. The twenty-year-old Geneviève's maternal concern for the twenty-seven-year-old poet, whom she was in essence supporting, destroyed the improbable affair after eight months. After overcoming his lack of desire for her and his conflicting emotions, Jacob sent 'la seule passion violente de ma vie' back to her husband. Jacob's ink *Portrait of Geneviève* is in the Nicole Rousset-Altounian collection (see Richardson, 1991, p. 261). Evidently it is again Geneviève who is portrayed, although less as a portrait, in *Head of a Woman* (1903; New York, Metropolitan Museum; Z. VI. 548), and in an ink drawing of the same name (1902–3; Paris, Musée Picasso; Z. VI. 466). The Hermitage *Head of a Woman* is painted over a figure of a woman shown almost kneeling, which Picasso has attempted to rub out; the contours, however, are now visible on close examination. This original composition probably dated to 1901, judging by the similarities with several drawings from the artist's sketch books of the time. Infra-red and X-rays have revealed the author's signature and inscription, which he removed. The painting also bore originally an inscription to the violinist Henri Bloch, for whom it was intended. In 1904 Picasso painted a portrait of Bloch's sister Suzanne, a famous opera singer (Sao Paolo, Museu de Arte). The well-known photograph of Picasso with a dedication to Suzanne and Henri Bloch also dates to that time.

Provenance: acquired from the State Museum of Modern Western Art in 1931; previously in the collection of S. I. Shchukin; First Museum of Modern Western Painting from 1918; State Museum of Modern Western Art from 1923.

280. Portrait of Benet Soler, 1903 (page 338)
Oil on canvas. 100 x 71 cm
Signed and dated top left: *Picasso 1903*
ГЭ 6528　　　　　Z. I. 199; D.–B. IX. 22

For a long time scholars assumed that this was a portrait of José-Maria Soler, but Palau-i-Fabre pointed out that the model's real name was Benet Soler Vidal (J. Palau-i-Fabre, *Picasso: Life and Work of the Early Years, 1881–1907*, Oxford, 1981). Benet Soler saw himself as a patron of artists and writers. His flat was located next to Els Quatre Gats, the favourite meeting place of Barcelona's avant-garde artists. Picasso maintained good relations with the fashionable Soler for a few years: he often dined in his flat and the tailor would make him clothes in exchange, so it is believed, for paintings. According to Max Jacob, Picasso took pains with his appearance, even when he was financially constrained. The *Portrait of Mme Soler* (1903; Munich, Neue Pinakothek; Z. I. 200) is the pair to the Hermitage work. Picasso also executed a painting entitled *The Soler Family* (1903; Liège, Musée des Beaux-Arts; Z. I. 203), which depicts Soler sitting on the grass with his daughter on his lap. These three pictures, although not a triptych, created an ensemble with the portrait of the wife on the left and the husband on the right. There are also some charcoal (Z. VI. 267) and colour pencil drawings of Benet Soler which date to 1900 (New York, Metropolitan Museum of Art; Z. XXI. 113).

Provenance: acquired from the State Museum of Modern Western Art in 1930; previously in the Soler collection, Barcelona, from 1903; Kahnweiler Gallery from 1913; collection of S. I. Shchukin from 1913; First Museum of Modern Western Painting from 1918; State Museum of Modern Western Art from 1923.

281. Two Figures and a Man's Head in Profile (verso of *Boy with a Dog*), 1904–5 (page 341)
Deux figures et tête d'homme en profil (verso de *Garçon au chien*)
Oil on cardboard. 41.2 x 57.2 cm
41158

These studies were done either at the end of 1904 or the beginning of 1905, before *Boy with a Dog*. They are preparatory sketches for the painting *Girl on a Ball* (1905; Moscow, Pushkin Museum; Z. I. 290) and were evidently done from a model. In *Girl on a Ball*, the athlete looks much younger. The pose of a girl balancing on a ball was borrowed from *Boy Balancing on a Ball* (1888; Washington, DC, National Gallery) by the German sculptor Johannes Goetz (see Richardson, 1991, pp. 346–7).

282. Boy with a Dog, 1905 (page 340)
Garçon au chien
Pastel and gouache on cardboard. 57.2 x 41.2 cm
Signed and dated top left: *Picasso. 05*
41158　　　　　Z. I. 306; D.–B. XII. 16

Boy with a Dog is one of the studies for the major composition of the Rose Period, *Family of Saltimbanques* (1905; Washington, DC, National Gallery; Z. I. 285). The boy in the Hermitage gouache appears in several works of the 1905 circus series, most closely in the gouache *Two Acrobats with a Dog* (1905; New York, Museum of Modern Art; Z. I. 300). In this gouache the boy standing next to the youth in checked harlequin tights is portrayed somewhat differently: he is half-naked and is stroking the dog with his other hand. The background is the same, but more specific: there is clearly a house in the upper-left corner. The New York gouache was exhibited from 25 February to 6 March 1905 at the Galerie Serrurier in Paris. It is clear that *Boy with a Dog* was painted just before *Two Acrobats with a Dog* and its date of completion can therefore be specified as no later than the middle of February 1905. That year the figure of the boy appeared again in a small drypoint etching, *Les Saltimbanques*, with two other characters – variations of the same image. It is clear from a sketch also called *Les Saltimbanques* (1905; Moscow, Pushkin Museum, Z. I. 287) that the boy with the dog in *Family of Saltimbanques* was intended to occupy a central position. An X-ray of the Washington painting has revealed that the composition of the sketch was faithfully transferred to the large canvas but later reworked; the dog was dispensed with and the boy's appearance changed. Picasso probably worked on *Boy with a Dog* and its 'female' version at the same time. *Girl with a Dog* (1905; present whereabouts unknown; Z. I. 286) depicts the back view of a girl stroking the same dog.

Provenance: acquired from the State Museum of Modern Western Art in 1934; previously in the collection of S. I. Shchukin; First Museum of Modern Western Painting from 1918; State Museum of Modern Western Art from 1923.

283. Reclining Woman and Nude Youth (verso of *Nude Youth*), 1904–5 (page 341)
Femme couché et garçon nu (verso de *Garçon nu*)
Gouache and charcoal on cardboard. 52 x 67.5 cm
40777

This drawing is related to the major cycle of the Rose Period dedicated to itinerant actors and acrobats, and is a sketch for an oil painting that was never realised. It was probably created concurrently with another depiction of acrobats at rest – the gouache *Family of Acrobats* (1905; Germany, private collection; Z. I. 289) which portrays a reclining woman and a young man sitting on her bed. Picasso's lover at the time, Fernande Olivier, is recognisable as the sleeping woman in the Hermitage drawing. Olivier claimed to have also sat for Cormon, Carolus-Duran, Boldini and Degas. She met Picasso in 1904, and by September 1905 she had moved in with him in the Bateau-Lavoir. Nonetheless, she rarely appears in Picasso's works of 1904 to 1905. It is interesting that in two other compositions of the end of 1904, *Sleeping Nude* (present whereabouts unknown; Z. I. 234) and *Contemplation* (private collection, Z. I. 235), Olivier is portrayed asleep. The most probable date for the gouache is the end of 1904 because the same characters are portrayed in the water-

colour *Les Saltimbanques* (Aquisgran, Ludwig collection) which Picasso himself dated to 1904. In the watercolour the youth is sitting on a couch, listening to the naked woman who is already up, brushing her hair.

284. Nude Youth, 1906 (page 342)
Garçon nu
Gouache on cardboard. 67.5 x 52 cm
Signed bottom right: *Picasso*
40777 Z. I. 268; D.–B. XIV. 8

The idea for the unrealised painting *The Watering-Place*, with several nude boys and horses, can be dated to the beginning of 1906 and was inspired by Gauguin's *Riders on the Beach* (Stavros Niarchos collection; W.G. 620). In the gouache (Z. I. 265) and pencil (D.–B. XIV. 14) sketches, a boy with a horse is portrayed in the centre. This motif had been separately developed in the large canvas *Boy Leading a Horse* (1906; New York, Museum of Modern Art; Z. I. 264), with the boy shown full-size. The same boy is shown in the Hermitage work, but in a slightly different pose, although the requisite circus box against which he is leaning indicates that he is still linked to the 'acrobat' motif. It is possible that *Nude Youth*, which dates to spring 1906, predated the series of young horsemen. Furthermore, *Nude Youth* exhibits neo-classical traits which were appearing in Picasso's work at this time. Picasso was undoubtedly studying the ancient sculpture at the Louvre. Everything about the boy, whom Richardson calls 'Ephebe', evokes statues such as the Parian *Kouros* (mid-6th century BC; Paris, Louvre). Richardson provides another hitherto unnoticed prototype for the Hermitage gouache: a Javanese sculpture of a standing figure whose pose the *Nude Youth* recreates (Richardson, 1991, p. 427). A plaster cast of the sculpture was displayed at the *Au lapin agile* cabaret, frequented by Picasso. A 1905 photograph of the cabaret's interior (Richardson, 1991, p. 373) shows both the Javanese sculpture (plaster copies of which were sold at the Exposition Universelle of 1900) and a painting of Picasso himself in harlequin's costume, inspired by his visits to the cabaret (1905; private collection; Z. I. 275).

Provenance: acquired from the State Museum of Modern Western Art in 1934; previously in the collection of S. I. Shchukin from 1914; First Museum of Modern Western Painting from 1918; State Museum of Modern Western Art from 1923.

285. Glass Vessels, 1906 (page 342)
Vaiselle en verre
Oil on canvas. 38.4 x 56 cm
Signed bottom right: *Picasso*
8895 Z. I. 343; D.–B. XV. 13

Picasso executed this painting in the Catalan village of Gosol in the summer of 1906. In the centre of the composition is a *porrón*, the glass vessel from which Spaniards pour wine directly into their mouths. The *porrón* also appears in the following works done at the same time: *Still Life with a Portrait* (1906; Washington, DC, Phillips Collection; Z. I. 342); the watercolour *Pitcher, Porrón, and Grapes* (private collection; Z. XXII. 458); and the watercolour *Porrón and Pitcher*, which was auctioned at Christie's in London on 28 November 1972. Richardson suggests that the Hermitage still life is imbued with an erotic subtext created by the *porrón*, a phallic symbol (Richardson, 1991, p. 441), though such a reading may be considered far-fetched. The inclusion of a *porrón* in the large painting *Harem* (1905; Cleveland Museum of Art; Z. I. 321), also painted in Gosol, might well be interpreted in such a way, but in *Glass Vessels* there is no such foundation for seeing these Catalonian utensils as a metaphor for sex.

Provenance: acquired from the State Museum of Modern Western Art in 1948; previously in the Kahnweiler Gallery; collection of S. I. Shchukin; First Museum of Modern Western Painting from 1918; State Museum of Modern Western Art from 1923.

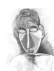

286. Bust of a Nude, 1907 (page 343)
Buste de femme nu
Oil on canvas. 61 x 47 cm
9046 Z. II. 31; D.–R. 32

This canvas is connected to *Les Demoiselles d'Avignon* (1907; New York, Museum of Modern Art; Z. II. 18), but it should not be seen as a study for any of the figures from the large composition. In the course of painting the Hermitage canvas, Picasso had changed his conception of the work: several studies, *Bust of a Nude* among them, had become a kind of laboratory for early Cubism. *Bust of a Nude* relates to the watercolour *Head* (late 1906; New York, Museum of Modern Art), and belongs to Picasso's Iberian phase. A comparison with the sculpture *Male Head* (Madrid, Museo Arquelogico Nacional) attests to the influence of ancient Iberian sculpture. Picasso purchased the sculpture in March 1907, but had probably been familiar with it earlier. Furthermore *Bust of a Nude* combines the influence of Iberian sculpture with the artist's new interest in African masks, all of which would seem to confirm a date of 1907. The Hermitage work was probably preceded by *Head of a Red Woman* (1907; Paris, Centre Georges Pompidou), a less geometric and schematic painting. *Bust of a Woman* (1907; Prague, National Gallery; Z. II. 16), on the other hand, was probably executed after the Hermitage canvas. The main difference between them is that the woman in the Prague study, also a bust and of the same size, is depicted in a dress, and her eyes are wide open.

Provenance: acquired from the State Museum of Modern Western Art in 1948; previously in the Galerie Vollard; collection of S. I. Shchukin; First Museum of Modern Western Painting from 1918; State Museum of Modern Western Art from 1923.

287. Dance with Veils, 1907 (page 344)
La danse aux voiles
Oil on canvas. 152 x 101 cm
Signed and inscribed on the back, in the middle of the stretcher: *Picasso 12 rue Ravignan XVIIe*
9089 Z. II. 47; D.–R. 95

This painting, also entitled *Nude with Drapery*, was inspired by studies for the second *demoiselle* from the left in *Les Demoiselles d'Avignon* (1907; New York, Museum of Modern Art). The nude was absent in the initial sketches for the painting, but once it appeared it so captured Picasso's imagination that by the end of the spring of 1907 he stopped work on *Demoiselles* for a while, and in May began to execute a large group of paintings and studies devoted to the dance-with-veils motif (more than 30 in all). The Hermitage work is the principal one of these, which Richardson believes to have been completed in August 1907. The following month the Steins, who had just returned from Italy, acquired the painting which had still not completely dried (Richardson, 1996, p. 38). It is likely that the etching on wood, showing the same figure, was also done at this time. This figure appeared in a sketch done in May for *Les Demoiselles d'Avignon* (Philadelphia Museum of Art; Z. II. 21), and shortly after was transferred to the large canvas. It is possible that the pastel *Sleeping Nude* also served as a starting point for *Dance with Veils*. It is usually dated to the summer of 1907, but it could have been executed earlier, in May or even April. It was Matisse's *Blue Nude (Memory of Biskra)* (Baltimore Museum of Art) that prompted Picasso to paint his own nude. At the time, Matisse's canvas was known for being the boldest depiction of a nude in avant-garde art. The scale and rigidity of *Dance with Veils*, which developed the motif of *Sleeping Nude*, were seemingly sparked by Picasso's rivalry with Matisse. By placing *Sleeping Nude* in a vertical position, Picasso was inspired with the idea for *Dance with Veils*. In the sketches for the Hermitage painting, including the one in the Baltimore Museum, the contrapposto pose is more visible: the woman appears to be sleeping, but the painter is looking at her not from the side but from above. The harsh brushstrokes, which define the painting's plasticity, were also used on the right-hand side of *Demoiselles*, reflecting the influence of African sculpture. Rubin attributes the stylistic features of a whole group of works, including *Dance with Veils*, *Vase with Flowers* (1907; New York, Museum of Modern Art; Z. II. 30) and *Woman in a Yellow Blouse* (Saint Louis, Pulitzer collection; Z. II. 43), to Picasso's familiarity with the wooden amuletic figures of Bakota in the Gabon (W. Rubin, *Picasso in the Collection of the Museum of Modern Art*, New York, 1972, p. 44). Although the painting's striking hatching recalls the grooves or notches on African sculptures, which represented tattoos, in Picasso's work it has a purely sculptural effect, which can be confirmed by comparing the use of the technique with his preparatory studies and sketches (nine sketches and studies are in the painter's private collection; there are further sketches in the Baltimore Museum of Art; in the Saimon collection in Los Angeles (Z. II. 674); the Stone collection in New York (Z. II. 676); and others).

Provenance: acquired from the State Museum of Modern Western Art in 1948; previously in the collection of Leo and Gertrude Stein (purchased from the artist) from September 1907; Galerie Vollard; collection of S. I. Shchukin from 1913; First Museum of Modern Western Painting from 1918; State Museum of Modern Western Art from 1923.

288. Friendship, 1908 (page 345)
L'amitié
Oil on canvas. 151.3 x 101.8 cm
Signed on the verso: *Picasso*
6576 Z. II. 60; D.–R. 104

A major work of early African Cubism, *Friendship* was probably painted in Paris at the beginning of 1908. Richardson (Richardson, 1996, p. 54) and Rubin (Rubin, 1989, p. 85) date it to 1907–8. Jean Laude regards it as a reinterpretation of a specific African sculpture, the statuette of the Senufo tribe (Mali, Upper Volta) (J. Laude, *La peinture française (1905–1914) et l'Art Nègre*, Paris, 1968, pp. 288–9). However, its African characteristics only develop the formal elements, which had been established earlier. Picasso had moved from the style of *Nude with a Napkin* (late 1907; Paris, private collection; Z. II. 48), preserving the motif of the napkin thrown across the hand, to a more energetic expression of form. He tackled the radical possibilities of sculptural interpretation such as its sharp delineation of planes. The painting's subject matter is almost sentimental: one woman carefully supporting another and leading her out of the water to what one assumes is the shore. The extreme simplification of form imbues the subject with elements of the grotesque. The title did not originate with the author, but was probably created by Shchukin, who feared that his family as well as visitors to his gallery would discern a lesbian motif in the painting. Evidently Picasso had originally conceived a large composition which would include the motif developed in *Friendship*, but he never brought this idea to fruition. At the end of 1907 a series of gouaches, entitled *Bathers in the Wood* (New York, Museum of Modern Art; Hanover, Sprengel Museum; Paris, Musée Picasso: D.–R. 126–8) had already appeared, as well as pen and pencil drawings inspired by Cézanne's compositions. In spite of the ambiguity of these works, one cannot but recognise the female pair on the left as the models for *Friendship*. Two preparatory gouache sketches for the painting are in the Pushkin Museum, Moscow (1908; Z. II. 58, 59). Another gouache sketch and a pen drawing, which preceded the painting, are in the Musée Picasso in Paris (Z. XXVI. 280; Z. VI. 1011).

Provenance: acquired from the State Museum of Modern Western Art in 1931; previously in the Kahnweiler Gallery; collection of S. I. Shchukin; First Museum of Modern Western Painting from 1918; State Museum of Modern Western Art from 1923.

289. Bathing, 1908 (page 343)
La baignade
Oil on canvas. 38.5 x 62.5 cm
Signed on the verso: *Picasso*
8896 Z. II. 93; D.–R. 184

Inspired by Cézanne's *Bathers*, this painting belongs to the cycle of works portraying nudes under an open sky: *Three Nudes* (Z. II. 53), *Friendship* (cat. 288) and *Bathers in the Wood*. It is possible that Picasso had intended to create a larger composition since the painting to some extent resembles a sketch. *Bathing* would seem to predate the drawing *Bathers* (1908; Paris, Musée Picasso), which is more realistic in style, with a reclining woman on the left, and a standing woman with a veil on the right (analogous to *Dance with Veils*, cat. 287). In both style and motif, *Bathing* can be linked with the pen drawing *Nude* (1908; Paris, Musée Picasso; Z. XXVI. 316). In February of 1908 Picasso created a small album of studies (Carnet 14, Musée Picasso, Paris), which contained nine drawings. It has just been published by Brigitte Leal (Leal, 1996, vol. i, pp. 199–201), but all the drawings are considered to be either sketches or studies for *Three Women* (cat. 301). However, only one page is in fact associated with *Three Women* (8V; Leal, 1996, vol. i, p. 200). The remaining drawings are sketches for the figures in *Bathing*. The first page (4R) is dated 8 February, which allows us to calculate when *Bathing* was created; the next page (6V) contains the standing nude. This standing figure, albeit radically altered, is located in the right part of the canvas. Two drawings on the next page (7R and 7V) depict the heads of the reclining figures in *Bathing*. Page 8V is the first sketch for *Three Women*; for this composition, as well as for three of the five bathers, Picasso had selected an almost square format. The remaining pages with five drawings (9–12) return once more to the idea of *Bathing*. At that time Picasso was clearly considering a large composition which he had originally planned to execute in the spirit of *Bathing*, but it had not materialised beyond a sketch.

Provenance: acquired from the State Museum of Modern Western Art in 1948; previously in the Kahnweiler Gallery; collection of S. I. Shchukin; First Museum of Modern Western Painting from 1918; State Museum of Modern Western Art from 1923.

290. Seated Woman, 1908 (page 345)
Femme assise
Oil on canvas. 150 x 100 cm
Signed on the verso: *Picasso*
Г⋺ 9163 Z. II. 68; D.–R. 169

This picture was painted in Paris in the spring of 1908. Fernande Olivier probably posed for the preparatory sketch, published in Carnet 15 (Leal, 1996, vol. i, p. 210; Paris, Musée Picasso; Z. II. 696), which was a work-in-progress from the summer of 1907 to the summer of 1908. There also exist three famous study drawings for this painting (Z. XXVI. 299–301). The pose of the woman is interesting because of its indecisiveness, which is explained by the preparatory sketch: the woman, sitting on the edge of the bed, is dozing off. Harsh, notch-like brushstrokes are still used here, but they play a subordinate role. After *Seated Woman*, Picasso painted a smaller version of this theme entitled *Rest* (spring 1908; New York, Museum of Modern Art; Z. XXVI. 303), this time using a half-length composition. Rubin suggests that Picasso did this because he was dissatisfied with the head and shoulders of the figure in the Hermitage composition (W. Rubin, *Picasso in the Collection of the Museum of Modern Art*, New York, 1972, p. 46). This explanation is not convincing as, despite the common motif, each painting has its own particular structure. It is more likely that Picasso wanted to create a version that was free of erotic allusions.

Provenance: acquired from the State Museum of Modern Western Art in 1948; previously in the Kahnweiler Gallery; collection of S. I. Shchukin from 1913; First Museum of Modern Western Painting from 1918; State Museum of Modern Western Art from 1923.

291. Woman with a Fan, 1907–8 (page 348)
Femme à l'éventail
Oil on canvas. 150 x 100 cm
Г⋺ 7705 Z. II. 67; D.–R. 168

In Shchukin's collection this painting was entitled *After the Ball*. The name was probably invented by the Moscow collector, for Picasso did not give his canvases such titles. The painting does have a discernible narrative, however, and a psychological subtext similar to that inherent in Salon painting. As early as 1904, in his first drawing *Far from the Ball* (Z. XXII. 86), Picasso had depicted a languorous woman with a moustachioed seducer. Here, however, the painting's meaning is not reduced to parody. By giving his geometricised creation life according to the conventions of psychological or narrative painting, Picasso imbues it with a special vitality, and the subject matter with a grotesque poignancy. An X-ray of the painting (see *Picasso and Portraiture: Representation and Transformation*, ed. W. Rubin, Museum of Modern Art, New York, 1996, p. 270) has revealed that the woman's head was radically revised: initially her eyes were wide open. The first version (probably dating to the spring of 1908) is related to the pencil drawing *Portrait of Fernande* (1908; Paris, Musée Picasso; Z. II. 700), page seven in Carnet 15 (Leal, 1996, vol. i, p. 203). Stylistically this drawing should be included in the works of 1907, when the painter started the album. Fernande's portrait followed a page with four sketches for the future painting: three show a schematic reworking of the entire composition, and the fourth (possibly the earliest) is a half-length depiction of a woman in which the displacement of the shoulders is only just noticeable (Z. II. 67). Three figure drawings come after the portrait (pages 8R, 9R and 11R; Leal, 1996, vol. i, pp. 203–4; Z. II. 701, 702). The eleventh page, notable for its greater finish, still harks back to the works of 1907, when the painting had apparently been started. It is the same size as the canvas, but bears a closer resemblance to the model; in particular, the shoulders are more sloping, the shading suggests real chiaroscuro. The breasts are not bared in this drawing. At some point Picasso had the idea of showing the *Woman with a Fan* standing full-length, as evidenced by the sketch on page 40 of Carnet 15 (Leal, 1996, vol. i, p. 208). Picasso reworked *Woman with a Fan* while he was working on the gouache *Seated Man* (spring 1908; Z. XXVI. 308). This is supported by the fact that there is a geometricised depiction of Fernande's head (it was clearly the basis for the first version of *Woman with a Fan*) next to the studies for this painting; Brigitte Leal has identified it incorrectly as a study for *Woman Farmer* (Leal, 1996, vol. i, p. 211). The egg-shaped head of the *Seated Man* is angled in such a way that the foreshortened chin becomes very small and the spherical top part of the head stands out. Picasso was evidently refining this device, inspired to a certain extent by the 'proto-Cubist' drawings of the sixteenth century, which revealed the geometric foundations of nature (Durer, Cambiaso, Bracelli, and so forth).

Provenance: acquired from the State Museum of Modern Western Art in 1948; previously in the Kahnweiler Gallery; collection of S. I. Shchukin from 1911; First Museum of Modern Western Painting from 1918; State Museum of Modern Western Art from 1923.

292. Dryad, 1908 (page 346)
Dryade
Oil on canvas.185 x 108 cm
Signed on the verso: *Picasso*
Г⋺ 7704 Z. II. 113; D.–R. 133

Linked with Picasso's bathing series of 1907–8 and inspired by Cézanne, *Dryad*, or *Nude in the Forest*, stands apart from this cycle and is therefore problematic for scholars from both a psychological and a chronological perspective: when was it painted? It is dated either spring, summer or autumn of 1908, and even a specialist like Rubin has had to settle on spring–autumn 1908. One of the forerunners of this painting was a pencil drawing in Carnet 15 (36R), *Woman in an Armchair* (1908; Paris, Musée Picasso; Z. II. 661), in which the figure in the armchair appears to be slipping out of it. Although this pose is recreated in *Dryad*, it is not fully articulated. For Steinberg the presence of the armchair establishes a connection with *Les Demoiselles d'Avignon*, in which the action takes place indoors (L. Steinberg, 'The Philosophical Brothel', *Art News*,

September 1972). Such a link, both thematic and formal, is even more apparent in the studies for *Demoiselles*. Steinberg also cites earlier works as sources for *Dryad*: the canvas *Nudes Embracing* (1905; Copenhagen, Statens Museum for Kunst), in which the pose of the female figure bears traits characteristic of the 1908 painting, and the drawing *Female Character* (1905; Paris, Musée Picasso), in which both pose and gesture express an invitation, and in which the letters *S. V. P.*, written by Picasso on the page itself, are decoded as *s'il vous plaît*. However, one cannot interpret *Dryad* in the same spirit as this sarcastic drawing of the Rose Period. This unprecedented parody on the *éternel féminin*, which combines both the gestures of invitation and threat, becomes a forbidding depiction of a cultish figure. The sense of horror was inspired by a source recently discovered by Richardson: the pose of *Dryad* is identical to that of the corpse hanging by the neck in an engraving from the second book of the renowned sixteenth-century anatomist Andreas Vesalius (A. Vesalius, *De Humani Corporis Fabrica*, 1543; see Richardson, 1996, p. 89). Guillaume Apollinaire, a lover of antiquarian books, probably introduced Picasso to this work. The idea of painting a standing nude took hold of Picasso in 1907; he did it for the first time in *Dance with Veils* (cat. 287) and in multiple studies for it. This one painting, however, did not exhaust all the motif's possibilities. Picasso had clearly wanted to paint a nude that would shock the public. At that time the preparatory works for *Dryad*, with their lewd gesture, appeared, as well as two drawings in the Musée Picasso, Paris, dating to June–July 1907. One, a pen drawing, is on the verso of the watercolour study for *Demoiselles* (Z. VI. 992) and the other is a pencil drawing (Z. VI. 912). Soon after, a whole series of sketches appeared which Zervos dated to 1907 (Z. XXVI. 145, 163–165, 180). Just before beginning work on *Dryad*, Picasso did a gouache sketch (Z. II. 112), in which another female figure is visible in the background. The sketch is notable for its more natural, more solid representation. A comparison with the finished painting leads to the conclusion that the latter's 'dissectedness' and vigorous laconicism did not emerge suddenly but evolved, as was also the case with *Woman with a Fan*.

Provenance: acquired from the State Museum of Modern Western Art in 1934; previously in the Kahnweiler Gallery; collection of S. I. Shchukin; First Museum of Modern Western Painting from 1918; State Museum of Modern Western Art from 1923.

293. Composition with a Skull, 1908 (page 349)
Composition avec tête de mort
Oil on canvas. 115 x 88 cm
Signed on the verso: *Picasso*
Г⋺ 9162 Z. II. 50; D.–R. 172

The skull motif harks back to the original concept for *Demoiselles*, in which Picasso had planned to juxtapose the sailor, surrounded by nude women, flowers, and fruit, with a student – a kind of allegorical *memento mori* – holding a skull. According to Zervos, it is likely that in the spring of 1907 Picasso executed three India-ink drawings of a skull and inkwell (Z. XXVI. 191–3). Recently, however, scholars have been inclined to date them to 1908, which allows us to connect them with the Hermitage painting. The nude woman in the painting in the upper-right corner of *Composition with a Skull* is reminiscent of the central figure in *Demoiselles* and of the *Nude* in the Boston Museum of Fine Arts (Z. II. 103). For a long time *Composition with a Skull* was dated to 1907, and only recently has this been revised. The Boston *Nude* is dated to the spring or summer of 1908, so *Composition with a Skull* could not have been done earlier. The formal structure of *Composition* is akin to Picasso's work of the spring and early summer of 1908, but it is notable for its unprecedentedly vivid colours, a feature ascribed to Matisse's influence. For this reason, the canvas was regarded as a link between Fauvism and Cubism, but *Composition with a Skull* is far too dramatic to be described as Fauvist. Moreover, the theme of death – which is here responsible for the blood-red colouring of the picture – was deeply alien to the Fauves. Theodore Reff offers a convincing explanation for both the painting's colour and its subject matter: he connects the genesis of *Composition with a Skull* with the suicide of Wiegels, Picasso's neighbour in the

Bateau-Lavoir (T. Reff, 'Themes of Love and Death in Picasso's Early Work', *Picasso in Retrospect*, New York, 1980). Recalling Fernande Olivier's account of the strong impact his suicide made on Picasso, Reff draws an analogy between this work and *Still Life with a Bull's Skull* (1942; Dusseldorf, Kunstsammlung Nordrhein-Westfalen), painted in response to the death of the Spanish sculptor Julio Gonzalez. Wiegels's funeral took place at the beginning of June 1908. The sketch (Moscow, Pushkin Museum; Z. II. 49) was probably done at that time, and shortly after, the painting itself. *Composition with a Skull* can be interpreted in two ways: as a traditional example of the *vanitas* genre, and as a kind of obituary. On the one hand, both the palette and the picture in a gold frame allude to art and life's highest values; on the other, they represent the profession or calling of the subject of this 'epitaph'. The nude woman in the upper right-hand part of the composition is suggestive of 'life's traditional pleasures', but she may also hint at prostitution. The pipe, a traditional detail in the *vanitas* still life, may be interpreted as evidence of the drug use (including hashish) which led to Wiegels's suicide. In the sketch, both the pipe and the pot are more sharply delineated than in the painting; the paintbrushes are absent and the palette is difficult to discern. Until recently very little was known about Wiegels, and for this reason many doubted that the painting was related specifically to his suicide, especially since Picasso himself was silent on this matter. However, after reviewing all the facts one cannot but accept Reff's contention, which is also supported by Richardson. Carl-Heinz Wiegels, who had arrived in Paris from Dusseldorf, had known many of the avant-garde artists: Matisse, Braque, Derain, Jacob and Apollinaire. A caricature of Wiegels by Pascin, and a photograph of him doing a drawing of Pascin on the terrace of the Café du Dôme, have survived (Richardson, 1991, p. 322). A painting by Wiegels of bathers, influenced by Cézanne, also exists. The work of the Master from Aix was probably much discussed by the inhabitants of the Bateau-Lavoir, where Picasso had invited the young German to live. Wiegels, however, could not fit into the Montparnassian artistic crowd. He was not a strong character, and he became addicted to drugs, having apparently been introduced to them by Picasso, who regularly took them at the time with Fernande. Eventually, Wiegels began having terrible hallucinations and talked incessantly about committing suicide. Picasso's close friend Manolo became so concerned that he moved in with him so that he could keep an eye on him. As soon as Manolo left, Wiegels overdosed, either on opium or hashish. The following morning the postman discovered the suicide. At that moment Picasso, who was painting a figure of a female nude, burst into the studio next door and saw a man hanging in the window. Fernande Olivier recalled: 'For some time the studio where he had died became a place of terror for us, and the poor man appeared to us everywhere, hanging as he had been the last time we saw him' (Richardson, 1996, p. 87). In the summer of 1908 Picasso took a photograph of the painting (private collection) against the background of *Three Women* (cat. 301) which he was working on at the time (A. Baldassari, *Picasso and Photography*, Museum of Fine Arts, Houston, 1997, p. 68).

Provenance: acquired from the State Museum of Modern Western Art in 1948; previously in the Kahnweiler Gallery; collection of S. I. Shchukin from 1912; First Museum of Modern Western Painting from 1918; State Museum of Modern Western Art from 1923.

294. Green Bowl and Black Bottle, 1908 (page 351)
Soupière verte et bouteille noire
Oil on canvas. 61 x 51 cm
Signed on the verso: *Picasso*
⌐⊐ 7702 Z. II. 89; D.–R.173

Like the other still lifes Picasso painted in the summer of 1908 in Paris, this painting depicts only a few objects, each with the most simple outlines. When selecting objects and the surrounding colour, Picasso deliberately juxtaposed forms with tones. Were it not for *Composition with a Skull*, this still life would represent the most tragic grouping of objects in Picasso's Cubist work. In contrast to the requiem-like *Composition*, there is no evidence to believe that

Green Bowl and Black Bottle reflects an actual event. However, the horror of Wiegels's suicide did not dissipate immediately and there is a sense that it still lingers in this still life. The picture, which was owned at the time by Gertrude Stein, was shown at the second Post-Impressionist exhibition at the London Grafton Gallery, one of the most significant displays of avant-garde art at the turn of the century.

Provenance: acquired from the State Museum of Modern Western Art in 1934; previously in the collection of Leo and Gertrude Stein, Paris; Kahnweiler Gallery; collection of S. I. Shchukin from 1912 or 1913; First Museum of Modern Western Painting from 1918; State Museum of Modern Western Art from 1923.

295. Pot, Wineglass and Book, 1908 (page 351)
Pot, verre and livre
Oil on canvas. 55 x 46 cm
⌐⊐ 6532 Z. II. 87; D.–R. 198.

This picture was painted in Paris in 1908. In the still lifes of the summer and autumn of 1908, Picasso explored the usual problems of representing volume and space, but he also explored a new departure in his work: the effect of optical refraction and the possibilities for geometric innovation. He was drawn to the wineglass not because of its physical characteristics but because of its clarity of form. By juxtaposing the pot with the wineglass, a construction which defines Cézanne's late still lifes, Picasso radically simplified its form.

Provenance: acquired from the State Museum of Modern Western Art in 1930; previously in the collection of S. I. Shchukin; First Museum of Modern Western Painting from 1918; State Museum of Modern Western Art from 1923.

296. Carafe and Three Bowls, 1908 (page 351)
Carafon et trois bols
Oil on cardboard. 66 x 50.5 cm
Signed on the verso: *Picasso*
⌐⊐ 8986 Z. II. 90; D.–R. 176

This is one of Picasso's most 'sculptural' compositions. It was painted either in Paris in 1908 or a little later in La Rue-des-Bois. It is related to *Pitcher, Vase and Fruit Bowl* (1908; Paris, Musée Picasso; Z. II. 63), once thought to have been done in Paris, but now attributed to the Rue-des-Bois period. Although the objects in the still life evoke the country realia of La Rue-des-Bois, Picasso used a motif he had developed earlier in Paris, in *Carafe, Bowl and Lemon* (Basel, Beyeler Gallery; Z. XXVI. 267). The ink sketch for this still life is in the Carnet (created by Picasso in May–June 1907) in the collection of Marina Picasso (43R, Z. XXVI. 241); the composition of *Carafe and Three Bowls* is reminiscent of the sketch, so Picasso may well have painted the canvas before his stay in La Rue-des-Bois. The style, however, suggests that it could not have been done before the spring of 1908. An X-ray has shown that the picture was painted over an earlier landscape probably created in 1901.

Provenance: acquired from the State Museum of Modern Western Art in 1948; previously in the Kahnweiler Gallery; collection of S. I. Shchukin; First Museum of Modern Western Painting from 1918; State Museum of Modern Western Art from 1923.

297. Small House in a Garden, 1908 (page 353)
Maisonette dans un jardin
Oil on canvas. 73 x 61 cm
Signed on the verso: *Picasso*
⌐⊐ 6533 Z. II. 80; D.–R. 189

The picture was painted in La Rue-des-Bois near Créteil, where Picasso, on the verge of a nervous breakdown, went in August 1908. Located on a road, with the River Oise on one side and the Forêt d'Halatte on the other, La Rue-des-Bois was a nondescript village with ten rather primitive buildings. It had nothing much to offer of

any particular interest, but from the point of view of the Cubist treatment of the natural motif, it was perhaps not a bad choice. Although Picasso had initially planned to stay longer, he lived there only a month and was remarkably productive. Of the *five* landscapes painted at La Rue-des-Bois, the one nearest to *Small House in a Garden* is another eponymous work now in the Pushkin Museum, Moscow (Z. II. 81). Both works were probably painted shortly after Picasso's arrival in La Rue-des-Bois.

Provenance: acquired from the State Museum of Modern Western Art in 1930; previously in the Kahnweiler Gallery; collection of S. I. Shchukin; First Museum of Modern Western Painting from 1918; State Museum of Modern Western Art from 1923.

298. Woman Farmer (half length), 1908 (page 352)
La fermière (en buste)
Oil on canvas. 81 x 65 cm
Signed on the verso: *Picasso*
⌐⊐ 6531 Z. II. 92; D.–R. 194

Picasso did two paintings and a series of drawings of the mistress of the house where he was living in La Rue-des-Bois in August 1908. The model for *Woman Farmer*, Marie-Louise Putman (1850–1939), was born in Flanders, but settled in France. After working as a cook, she married a shepherd and then moved to La Rue-des-Bois. When her husband died, she took over the farm, worked the land, and raised seven children by herself. Picasso was enchanted with this illiterate (she spoke French badly), corpulent and very tall (two metres) woman who embodied for him Mother Earth, a primordial state untainted by culture. Picasso was drawn to giants, possibly because he himself was not very tall. Madame Putman never sat for Picasso; he simply observed her, doing sketches of her from memory. Despite their schematic form, these sketches bear a remarkable resemblance to the original (evident from the photographs of Madame Putman recently published in Richardson, 1996, p. 94). Madame Putman's physical appearance – she was a large stocky woman with a thick neck – is accentuated in a preparatory drawing (collection of Marina Picasso, Geneva; Z. VI. 1008), but in the painting it becomes more grotesque and geometricised.

Provenance: acquired from the State Museum of Modern Western Art in 1930; previously in the Kahnweiler Gallery; collection of S. I. Shchukin; First Museum of Modern Western Painting from 1918; State Museum of Modern Western Art from 1923.

299. Woman Farmer (full length), 1908 (page 352)
La fermière (en pied)
Oil on canvas. 81.2 x 65.3 cm
Signed on the verso: *Picasso*
⌐⊐ 9161 Z. II. 91; D.–R. 194

This depiction of Madame Putman from La Rue-des-Bois was painted in August 1908 (see cat. 298). The geometrical blocks of angular planes that lend Picasso's composition its sculptural form had already appeared in the pencil sketches for the painting (Z. VI. 1002–4). Picasso's striving for monumentalism and simplicity was inspired by nature. The concept for the painting had already been conceived in the final preparatory drawing (collection of Marina Picasso, Geneva; Z. VI. 1004). The drawings accentuate the woman's enormous size: heavy sagging breasts, thick neck and massive fists (Picasso executed two studies of fists; Z. VI. 1909). One of the drawings portrays the *Woman Farmer* eight times in various positions (Paris, Musée Picasso; Z. VI. 1006). Evidently, such experiments convinced Picasso that a frontal view of the model would best convey her essence. The drawing in the collection of Marina Picasso shows that the artist originally intended to portray Madame Putman walking and carrying two full buckets. He then rejected the idea, no doubt wishing to avoid a comparison with painting of the 'peasant' genre which was widespread in the second half of the nineteenth century. Nonetheless, some trace of this original intention remains: the

woman farmer's fingers are shown bent as if carrying heavy buckets, and her arms are tensed as if from the effort.

Provenance: acquired from the State Museum of Modern Western Art in 1948; previously in the Kahnweiler Gallery; collection of S. I. Shchukin; First Museum of Modern Western Painting from 1918; State Museum of Modern Western Art from 1923.

300. Bouquet of Flowers in a Grey Jug, 1908 (page 351)
Fleurs dans un pot gris et verre avec cuillière
Oil on canvas. 81 x 65 cm
Signed on the verso: *Picasso*
⌐Э 8999 Z. II. 88; D.–R. 196

It is has been generally accepted that this painting was executed in La Rue-des-Bois. Both in its motif and its formal qualities, *Bouquet of Flowers* occupies a special place among the still lifes of 1908–9. The reference to the paintings of Henri Rousseau is not accidental, for Picasso was familiar with Rousseau's *Bouquets*. In addition, Picasso has drawn here on Cézanne's painterly motifs as well as those of the Old Masters. He had undoubtedly seen the simple wooden table with the open drawer in Cézanne's painting *Card Players* (Merion, PA, Barnes Foundation; R. 706), which at the time hung in the Galerie Vollard, where Picasso would go from time to time to sell Vollard his paintings. Picasso was also familiar with Chardin's *Portrait of Auguste Gabriel Godefroy* (c. 1738; Paris, Louvre), for an exhibition of this master's works had taken place in Paris in 1907. The still life on the table in *Portrait of Godefroy*, with the drawer facing the viewer and pulled slightly forward, occupies much of the painting. *Bouquet of Flowers in a Grey Vase* evidently followed *Still Life with a Bouquet of Flowers* (1908; New York, Stephen Hahn Gallery; Z. II. 94), a much smaller canvas with many more objects. Picasso moved away from both the refined formal play of this still life and its horizontal composition. He also discarded the soup bowl and all the vases but one, so that he could concentrate on depicting the bouquet, attempting to achieve a powerful effect of austere monumentalism, which up to then had never been an element of his still lifes with flowers.

Provenance: acquired from the State Museum of Modern Western Art in 1948; previously in the Galerie Clovis Sagot, Paris; Kahnweiler Gallery; collection of S. I. Shchukin from 1914; First Museum of Modern Western Painting from 1918; State Museum of Modern Western Art from 1923.

301. Three Women, 1908 (page 347)
Trois femmes
Oil on canvas. 200 x 178 cm
Signed on the verso: *Picasso*
⌐Э 9658 Z. II. 108; D.–R. 131

One of Picasso's major Cubist compositions, *Three Women* ends the period begun by *Les Demoiselles d'Avignon*. Picasso had apparently conceived this painting as early as 1907 and worked on it the following year. The concept of a multi-figure composition with bathers was inspired by Cézanne, whose variations of *Grandes baigneuses* (1900–5, London, National Gallery, R 855; 1906, Philadelphia Museum of Art, R. 857) had been exhibited at the Salon d'Automne of 1907, where they made a huge impression on Picasso, Braque, Derain, Friesz and other young avant-garde artists. Picasso produced many pencil, pen, charcoal, and watercolour sketches for the painting (approximately seventy in existence), which are in the Musée Picasso, Paris, the Museum of Modern Art, New York, Philadelphia Museum of Art, and other collections (Z. XXVI. 289–98). Scholars often date these sketches to early 1908, but Rubin (1989, p. 83) and Richardson (1996, pp. 54–5), who detect Cézanne's influence, date them to 1907. The charcoal study *Bathers in the Wood*, as well as other similar works that were not recast as large canvases, became the starting point for two major works of 1908: *Friendship* (cat. 288), which recreates the motif on the left, and *Three Women*, the group on the right. *Bathers in the Wood*

provides an important insight into *Three Women*. The women's conventional, yet strange, movements suggest that they are bathing; their elbows are raised because they are washing their backs. But in recreating the same scene on a large canvas, Picasso no longer attempts to explain the poses through subject matter. The canvas reworks the theme of the three graces from a contemporary perspective. Other Classical Greek influences include *The Dying Niobid* (5th century BC; Rome, Term Museum), which inspired the charcoal study for the figure on the left (New York, Nelson Rockefeller collection). Work on the canvas had entered a decisive stage by the spring of 1908. Matisse had exhibited *Bathers with a Turtle* (Saint Louis, Art Museum) at the Salon des Indépendants, and although Picasso had admired it, he wanted to challenge the Fauves' leader with his own rendition of bathers which would illustrate the contemporary principles of Cubism. On 26 May, he wrote to Gertrude Stein that the large canvas was progressing well. On 14 June, he added that the painters from the Salon des Indépendants had left for the South while he and Fernande were staying in Paris; then he reiterated that 'the large canvas is coming along but what a struggle it is!' (Richardson, 1996, p. 90). Picasso was clearly expecting his benefactor Gertrude Stein to buy *Three Women*, which she did. As evidenced by the numerous studies that he did for the painting, Picasso changed the configuration of the three figures several times. This indicates that he intended to merge the three bodies into a single movement. Picasso was constantly rethinking the painting and often used it as the background for photographs taken in his studio. At the beginning of the summer, Picasso had photographed his friend André Salmon standing in front of *Three Women*, when the painting, according to Pierre Daix, was still at an early stage (P. Daix, 'The Chronology of Proto-Cubism: New Data on the Opening of the Picasso–Braque Dialogue', *Picasso and Braque: A Symposium*, Museum of Modern Art, New York, 1992, p. 311). Daix maintained that Picasso photographed the canvas in its many stages, but these photographs are largely unpublished. The end of 1908 marked a critical period in Picasso's artistic development because the reworked *Three Women* heralded a transition to a more finished and organic style than was seen in his early Cubist works. Rubin suggests that the studies and sketches for *Three Women* are generally representative of African painting which is constructed on contrasting colours (W. Rubin, 'Cézannism and the Beginnings of Cubism', *Cézanne: The Late Work*, Museum of Modern Art, New York, 1977). And indeed the painting is ruled by the logic of tonal gradations. As the above-mentioned photograph by Salmon demonstrates, work on the painting was initially done in the spirit of African sketches: early on, even in *Demoiselles*, these works had exhibited stylistic inconsistencies, but *Three Women* is notable for its stylistic unity. A later photograph with Fernande Olivier and Dolly van Dongen shows that Picasso had moved away from the large parallel hatching found in the earlier works influenced by African sculpture (as in *Dance with Veils*, cat. 287). According to Rubin, the elimination of African elements was prompted by a renewed interest in Cézanne and by the acceptance of Cubist syntax, originating with Braque. Steinberg, who disagrees with Rubin, states that Picasso, far from adopting Cézanne's techniques, in fact opposed them (L. Steinberg, 'Resisting Cézanne: Picasso's *Three Women*', *Art in America*, 1978, no. 6), and that the influence of Braque's landscapes on *Three Women* has been greatly overstated. Unfortunately, the technological research undertaken by the Hermitage Museum has revealed little about the painting's early stages. Apparently, before repainting the canvas at the end of 1908, Picasso had erased an earlier picture. However, one can sense even now that the canvas was repainted. For example, the brushstrokes around the woman on the left are painted over other brushstrokes coming from another direction entirely, which had already hardened when Picasso began painting over them.

Provenance: acquired from the State Museum of Modern Western Art in 1948; previously in the collection of Gertrude Stein, Paris; Kahnweiler Gallery; collection of S. I. Shchukin from 1913 or 1914; First Museum of Modern Western Painting from 1918; State Museum of Modern Western Art from 1923.

302. Woman Playing the Mandolin, 1909 (page 354)
Femme jouant à la mandoline
Oil on canvas. 91 x 72.5 cm
Signed on the verso: *Picasso*
⌐Э 6579 Z. II. 133; D.–R. 236

The picture was painted in Paris no later than the spring of 1909; the modelling of the head recalls the drawings of this period. Daix and Rosselet date the work to the beginning of the year, and *Head of a Girl* (D.–R. 237) may be considered a study for it. *Woman Playing the Mandolin* represents the earliest depiction of a woman with a musical instrument in Picasso's oeuvre. Braque, who at the time was inseparable from Picasso, vividly recalled the impression Corot's paintings had made on Picasso, and it is possible that Picasso had seen one of Corot's *Mandolin Players*. The Hermitage canvas is similar to Corot's *Gypsy with a Mandolin* (Sao Paolo, Museu de Arte). Of the 1909 canvases, *Woman Playing the Mandolin* impresses with both style and subject matter. Picasso's innovations are, however, quite subtle. If the treatment of the figure seems conventionally 'sculpted', though with softer edges than in the works of 1908, then the objects surrounding the woman are depicted more realistically. It is clear that Picasso regarded them as being sufficiently geometric in themselves. It is possible that the work was influenced by Braque, who had painted a mandolin and books a year earlier (*Musical Instruments*, 1908; private collection. See N. Worms de Romilly and J. Laude, *Braque: Le Cubisme: Catalogue de l'oeuvre. 1907–14*, Paris, 1982, No. 7). The books and mandolin were combined in a still life arrangement and photographed by the artist in 1911 (the photograph is now in the Musée Picasso, Paris). However, Picasso did not reproduce these arrangements on canvas, using them only as an inspiration for the formal constructions of his paintings.

Provenance: acquired from the State Museum of Modern Western Art in 1931; previously in the Nemes collection, Budapest, from 1909 or 1910; Kahnweiler Gallery; collection of S. I. Shchukin from 1914; First Museum of Modern Western Painting from 1918; State Museum of Modern Western Art from 1923.

303. Man with Arms Crossed, 1909 (page 354)
L'homme aux bras croisés
Gouache and watercolour on paper pasted on cardboard. 65.2 x 49.2 cm
Signed on the verso: *Picasso*
43481

This gouache was executed in Paris in the spring of 1909. It is similar to *Man with Arms Crossed* (Z. XXVI. 411), as well as to several studies of a man's head (Z. II. 141, 166, 715, 747, 748; VI. 1113, 1152).

Provenance: acquired from the State Museum of Modern Western Art in 1934; previously in the Kahnweiler Gallery; collection of S. I. Shchukin; First Museum of Modern Western Painting from 1918; State Museum of Modern Western Art from 1923.

304. Nude, 1909 (page 355)
Nu
Oil on canvas. 100 x 81 cm
Signed on the verso: *Picasso*
⌐Э 7701 Z. II. 109; D.–R. 240

Painted in Paris in 1909, this work completes a small cycle of nudes, including *Bather* (New York, Bertram Smith collection; Z. II. 111), *Seated Woman* (Paris, Musée Picasso), and *Two Nudes* (Paris, private collection; Z. II. 116). Compared with the other paintings in this series, *Nude* is notable for its softer contours and more pronounced plasticity. The woman's body and gesture of the left hand are reminiscent of the figure in *Bather*. If in the latter work, a dual viewpoint was only hinted at, in *Nude* the attempt to show two views of an object simultaneously is more sustained. *Nude* is one of three paintings that appears in a photograph of Picasso's studio on the rue Ravignan, where he worked from 1905 to 1909 (Cahiers d'Art, 1950, No. 2, p. 278).

Provenance: acquired from the State Museum of Modern Western Art in 1934; previously in the collection of S. I. Shchukin from 1913; First Museum of Modern Western Painting from 1918; State Museum of Modern Western Art from 1923.

305. Vase with Fruit, 1909 (page 353)
Vase avec fruits
Oil on canvas. 91 x 72.5 cm
Signed on the verso: *Picasso*
⌐Э 9160 Z. II. 124; D.–R. 209

Also known as *Vase with Pears* and *Vase with Fruit and Wineglass*, this picture was painted in Paris at the beginning of 1909. At that time Picasso had executed a series of still lifes which were smaller and more rhythmically complex than those he had completed in the summer and autumn of 1908. Of the other paintings in the cycle done at the same time, the closest to the Hermitage canvas is *Fruit Bowl* (New York, Museum of Modern Art; Z. II. 121), and *Vase, Flask and Fruit on a Table* (New York, Whitney collection; Z. II. 126). The cycle reveals Cézanne's growing influence on Picasso, as evidenced by the examination of objects from various yet similar perspectives, the softer forms, and the depiction of seemingly condensed air. A small watercolour in the Musée de Grenoble entitled *Fruit Bowl* was clearly painted at the same time as the Hermitage canvas. It depicts, although less precisely, a similar bowl with apples and pears. This peculiar bowl, which belonged to Picasso, was shaped like the corolla of a flower; it was depicted either realistically or, as here, slightly simplified. The same bowl with pears appears in the background of *Queen Isabeau* (1909; Moscow, Pushkin Museum; Z. II. 136).

Provenance: acquired from the State Museum of Modern Western Art in 1948; previously in the Kahnweiler Gallery; collection of S. I. Shchukin; First Museum of Modern Western Painting from 1918; State Museum of Modern Western Art from 1923.

306. Brick Factory at Tortosa, 1909 (page 356)
La briqueterie à Tortosa
Oil on canvas. 50.7 x 60.2 cm
⌐Э 9047 Z. II. 158; D.–R. 279

Until recently this painting was entitled *Factory in Horta de Ebro*. Picasso spent from May to September of 1909 in Horta de Ebro, today called Horta de San Juan. Until fairly recently, scholars assumed that the works Picasso had brought back from Spain in 1909 were done there, but Daix has singled out a group of canvases that were painted while he was in Barcelona. This picture does not depict Horta de Ebro, although in all probability this was where it was painted. Palau i Fabre noticed that *Brick Factory at Tortosa* depicts palm trees which do not grow in Horta de Ebro, and general consensus has been that Picasso invented this part of the landscape. This, however, is an unsatisfactory explanation because all of the painter's distortions have a basis in reality. The tendency to represent objects as crystals, which culminated in the landscapes of the summer of 1909, was inspired by the scenery and architecture of Tarragon. The 'Cubist' structure of these places is clearly visible in the photographs Picasso took of the area and sent to the Steins in Paris: small stucco houses dot the landscape like cubes. A comparison of the canvas with the photographs reveals that Picasso captured Horta not realistically or even in a simplified, geometricised way; rather, as his beloved El Greco had done when he freely moved or set back houses in his views of Toledo, Picasso, ignoring topographical accuracy, followed the demands of rhythm and composition. He nonetheless managed to capture the character of the town, a point he underlined by sending the Steins the photographs. Picasso did not have to invent palm trees because they do in fact grow in Tortosa, the administrative centre of the region that includes Horta de Ebro. The town is located on the same Ebro River, and at the beginning of June Picasso stayed there on his way to Horta, from where, on 5 July, he sent a postcard with a view of Tortosa (it is possible that he went there once more). Tortosa was identified – verbally – as the place depicted in the Hermitage canvas by Maria-Luisa Borras of Barcelona. It is famous even today for its traditional brick

factories consisting of small barn-like buildings, its lean-tos for storing bricks, and rectangular smokestack. It is one of these factories that is shown in the Hermitage canvas. Painted in the same style, the landscapes showing the village of Horta de Ebro are notable for the mountainous terrain: *Houses on a Hill, Horta de Ebro* (New York, Museum of Modern Art), and *Reservoir, Horta de Ebro* (New York, David Rockefeller collection; Z. II. 157). Both landscapes belonged at one time to Gertrude Stein, who, in her memoirs, did not associate them with a particular place: 'That summer [Picasso and Fernande Olivier] went again to Spain, and he came back with some Spanish landscapes and one may say that these landscapes, two of them still at the rue de Fleurus and the other one in Moscow in the collection that Stchoukine bought and that is now national property, were the beginning of Cubism.' Together with *Houses on a Hill* and *Reservoir*, *Brick Factory at Tortosa* can be regarded as one of a group of stylistically similar architectural landscapes, subordinated to the principle of reverse perspective.

Provenance: acquired from the State Museum of Modern Western Art in 1948; previously in the Haviland collection, Paris, from 1909; collection of S. I. Shchukin; First Museum of Modern Western Painting from 1918; State Museum of Modern Western Art from 1923.

307. A Young Lady, 1909 (page 355)
Une jeune femme
Oil on canvas. 91 x 72.5 cm
Signed on the verso: *Picasso*
⌐Э 9159 Z. II. 195; D.–R. 332

Fernande Olivier was the prototype for *A Young Lady*, which Picasso painted after his return from Horta de Ebro. Here Picasso returns to the motif of *Nude in a Chair* (1909; private collection; Z. II. 174) for which Fernande had posed in Horta, and although he explores the Cubist device of 'faceted' form, he lessens the emphasis on the former sculpted effect, so that the figure has a more ephemeral look. Of course the painting is hardly a portrait of Fernande; certain elements – the hairstyle and line of the nose – are recognisable, but not to the extent that they are in the portraits Picasso painted in Spain. After returning to Paris, Picasso sculpted *Head of a Woman* (Paris, Musée Picasso), in which he again portrayed Fernande's features. This sculpture, possibly pre-dating *A Young Lady*, bears similarities to the painting in the angle of the head and 'faceted' representation of volumes; in the painting, however, this faceted effect is lighter and more direct, and unexpectedly acquires a painterly, almost impressionistic quality. *Bust of a Woman* (1909; Paris, private collection; D.–R. 335), another work based upon Fernande, is also close to the Hermitage canvas.

Provenance: acquired from the State Museum of Modern Western Art in 1948; previously in the Kahnweiler Gallery; collection of S. I. Shchukin; First Museum of Modern Western Painting from 1918; State Museum of Modern Western Art from 1923.

308. Table in a Café (Bottle of Pernod), 1912 (page 357)
Une table au café (Bouteille de pernod)
Oil on canvas. 46 x 33 cm
Signed on the verso: *Picasso*
⌐Э 8920 Z. II. 307; D.–R. 460

This picture was painted in June 1912. In a letter dated 20 June from Céret (Pyrénées-Orientales), Picasso told Kahnweiler that he had sent him several paintings: 'The other still life: the Pernod on a round wooden table, a glass with sugar and a strainer, and a bottle of absinthe labelled *Pernod fils* against a background of signs, mazagran, coffee, and Armagnac 50.' (Paris, Centre Georges Pompidou (collection of Kahnweiler-Leiris, donated by Louise and Michel Leiris), 1984, p. 168). In an earlier letter, dated 24 May, Picasso had asked Kahnweiler to send him some paintbrushes, stretchers, canvases, stencils and 'combs to make fake wood' (*ibid.*, p. 166). Picasso's interest in the technique of creating the illusion of wood traditionally used by house-painters, and the

decisive way in which he has depicted the wooden table, help us to date the picture to the first half of June 1912. The major components of the painting are the bottle of pernod (a brand of absinthe) and the glass from which it was drunk, combined with sugar. The inscriptions are important (Picasso had apparently wanted to apply them with stencils but changed his mind and used a brush instead), for not only do they contrast with the soft pink and green tones of the background but they also create word plays. The *CAF* (a truncated 'CAFE') in the centre of the canvas can also be read as *CLI* (from boulevard de Clichy, where Picasso's studio was located). Of the remaining abbreviations, the most striking is *AGRAN*, a shortened version of 'mazagran', the type of coffee imported from North Africa, which was usually served cold. The word plays in Picasso's late Cubist works sometimes seem to be cryptograms and are difficult to decipher. The *PERENOD* on the label of the bottle (instead of 'Pernod') can be taken as a juxta-positon of 'père-fils' (father-son), with 'nod', the land where Cain settled after killing Abel. The words *PERENOD FILS* lend themselves to further word plays. The 'D' at the end is barely visible, whereas the 'E' and 'N' in the middle seem to merge, so that at first glance *PERENOD* reads like 'Perno', which in Spanish means bolt (the corked bottleneck does in fact resemble a bolt). The 'VE' to the right of *PERENOD FILS* might represent the last two letters of the word 'cave', or small cellar, and the 'AR' in the upper right-hand corner, the beginning of the word 'armagnac'. The number *50* at the top refers to the price: 50 centimes. The colours are also ambiguous. The light green tones in the background, which had earlier been interpreted as signs of spring (the painting was dated to the beginning of spring 1912), in fact represent the colour of absinthe, as can be seen from a comparison with the wineglass in the pastel *Absinthe* (1901; formerly Krebs collection, now in the Hermitage; A. Kostenevich, *Hidden Treasures Revealed*, New York–St Petersburg, 1995, no. 67).

Provenance: acquired from the State Museum of Modern Western Art in 1948; previously in the Kahnweiler Gallery from 1912; collection of S. I. Shchukin; First Museum of Modern Western Painting from 1918; State Museum of Modern Western Art from 1923.

309. Musical Instruments, 1912 (page 358)
Instruments de musique
Oil, gypsum and sawdust on oilcloth.
92 x 80 cm (oval)
Signed on the verso: *Picasso*
⌐Э 8939 Z. II. 438; D.–R. 577

This picture has often been dated to 1913 (Zervos and others). However, the inscription on the verso which reads *Envoi – Picasso à Sorgues villa des Clochettes* (and on the stretcher in pencil *100 Sorgues*) proves otherwise. Picasso worked in Sorgues near Avignon in the summer of 1912. At that time he had already completed or begun other oval compositions on musical themes: *Guitar* (Oslo, Nasjonalgalleriet; Z. II. 357), *Still Life with Guitar and Violin*, Philadelphia Museum of Art; D.–R. 574), and *Violin* (Moscow, Pushkin Museum; Z. II. 358). In the largest picture of this group, the Hermitage canvas, Picasso worked on the complex problem of grouping together three musical instruments: guitar, violin and mandolin. The painted grey frame, whose concentric bas-relief emphasises the dynamism of the forms in the oval, was made according to Picasso's instructions or perhaps after one of his sketches.

Provenance: acquired from the State Museum of Modern Western Art in 1948; previously in the Kahnweiler Gallery; collection of S. I. Shchukin from 1913; First Museum of Modern Western Painting from 1918; State Museum of Modern Western Art from 1923.

310. Guitar and Violin, *c.* 1912–13 (page 358)
Violon et guitare
Oil on canvas. 65 x 54 cm
Signed on the verso: *Picasso*
⌐Э 9048 Z. II. 370; D.–R. 572

In 1912 Picasso painted a whole series of pictures and drawings on the 'violin-guitar' theme. In December he executed several vertical compositions which are approximately the same size as the Hermitage canvas. In these paintings a central vertical line is usually supported by the lines of the strings, the top is denoted by the curl of the violin, while the entire composition is centered on the instrument's sound hole. These paintings, many of which are collages made from newspaper cuttings, include *Composition with a Violin* (private collection), *Violin* (Paris, Centre Georges Pompidou), and others. Similar to *Guitar and Violin* in composition is *Violin on the Wall* (1913; Berne, Kunstmuseum). The Hermitage painting is also known as *Violin and Glasses on a Table*.

Provenance: acquired from the State Museum of Modern Western Art in 1948; previously in the Kahnweiler Gallery in 1913; collection of S. I. Shchukin from 1913; First Museum of Modern Western Painting from 1918; State Museum of Modern Western Art from 1923.

311. Tenora and Violin, 1913 (page 359)
Tenora et violon
Oil on canvas. 55 x 33 cm
Monogrammed bottom right: *P*, signed on the verso:
Picasso
ГЭ 6530
Z. II. 437; D.–R. 575

According to Zervos, this painting dates to the spring of 1913; it was published that same year in Shchukin's catalogue. It was then incorrectly entitled *Flute* (later *Flute and Violin*), since flutes are never found in Picasso's Cubist works. Until recently the picture was known as *Clarinet and Violin*. The clarinet appears in some of Picasso's 1911 compositions, for example *Clarinet* (Prague, National Gallery), a painting notable for its fractured construction. The Hermitage picture actually shows a tenora, a Catalan wind instrument similar to an oboe. The tenora usually accompanies the Catalan dance called the *sardana*. The painting was most probably done in Paris in January–February 1913, after Picasso returned from Barcelona, where he had been around the turn of the year. It is possible he brought the tenora back with him. A picture close to the Hermitage work is Braque's *Violin and Clarinet* (Prague, National Gallery), which is usually dated to spring 1912 but was more likely done later.

Provenance: acquired from the State Museum of Modern Western Art in 1930; previously in the Kahnweiler Gallery; collection of S. I. Shchukin from 1913; First Museum of Modern Western Painting from 1918; State Museum of Modern Western Art from 1923.

312. The Tavern, *c.* 1914 (page 361)
La guinguette (Le jambon)
Oil and sawdust on cardboard. 29.5 x 38 cm (oval)
ГЭ 8936
Z. II. 234; D.–R. 704

The picture is one of a group of three works (D.–R. 702–4). The tavern theme is established not only by the details in the still life (the lemon, ham, knife and fork, and napkin), but also by the words *MENU* and *REST* (restaurant) and by the truncated words in the left part of the painting: *boeu[f]* (beef), *veau* (veal), *trip[es]* (tripe). The utensils and food are arranged so that they are subordinate to the oval of the composition. The oval format was possibly chosen here to reflect the shape of the small table containing the food; the table is shown in the two other paintings in the group. The Hermitage picture has been variously dated from 1912 to 1914; a similar painting entitled *Restaurant* (private collection; Z. II. 347) has an equally unspecific date. Stylistically, *The Tavern* is much closer to the works of the first half of 1914. The Kahnweiler number 2115 on the painting's stretcher could not have appeared before this time (Derain's 1914 *Portrait of an Unknown Man Reading a Newspaper* (cat. 92) bears the number 1920). Kahnweiler, who was close to Picasso, generally bought and sold only newly created works at that time. *The Tavern* was one of Sergei Shchukin's final acquisitions.

Provenance: acquired from the State Museum of Modern Western Art in 1948; previously in the Kahnweiler Gallery in 1914; collection of S. I. Shchukin from 1914; First Museum of Modern Western Painting from 1918; State Museum of Modern Western Art from 1923.

313. Composition with Cut Pear, 1914 (page 360)
Composition. Compotier et poire coupée
Gouache, graphite pencil and wallpaper collage on cardboard. 35 x 32 cm
Signed and dated top right: *PICASSO 4/1914*
42159
Z. II. 481; D.–R. 678

Various decorative devices were deployed in this painting: the use of wallpaper and a combination of *frottage* (light rubbings of graphite) and pointillism. The overall effect is light-hearted, and it is no accident that such a painting was designated 'Rococo Cubism'. The optimistic mood reflects a happy period in the painter's life. He had moved in with Eva Gouel on rue Schoelcher in Montparnasse and had achieved true recognition. In March, one month before completing *Composition with Cut Pear*, his *Family of Saltimbanques* (Washington, DC, National Gallery) had been auctioned in Paris for a record sum.

Provenance: acquired from the State Museum of Modern Western Art in 1934; previously in the Kahnweiler Gallery in 1914; collection of S. I. Shchukin from 1914; First Museum of Modern Western Painting from 1918; State Museum of Modern Western Art from 1923.

314. Composition with Cut Pear and Bunch of Grapes, 1914 (page 360)
Vase à fruits et grappe de raisin
Collage on brown paper, gouache, size paint, graphite pencil and sawdust on cardboard.
67.7 x 52.2 cm
Signed bottom right: *Picasso*; another signature comprises part of the composition
43789
Z. II. 480; D.–R. 680

This work was executed in Paris in the spring of 1914. *Composition with Cut Pear* (cat. 313), which can be dated to April 1914, may be regarded as its companion piece. The entire structure of this composition is based on exploiting the various finishes to their best advantage. The most realistic detail is the marble-like table top (a technique Picasso borrowed from craftsmen/decorators); the most abstract is the white rectangle in the centre that suggests a fruit bowl, perhaps designated for the bunch of grapes in the upper half of the canvas. Similar to the Hermitage picture are *Still Life with a Bunch of Grapes, Pears, and a Pipe* (Z. II. 497) and a composition formerly in the Darius Milhaud collection (Z. II. 476).

Provenance: acquired from the State Museum of Modern Western Art in 1948; previously in the Kahnweiler Gallery in 1914; collection of S. I. Shchukin from 1914; First Museum of Modern Western Painting from 1918; State Museum of Modern Western Art from 1923.

315. Scenes from the Ballet *La Boutique fantasque*, 1919 (page 361)
Scènes du ballet *La Boutique fantasque*
Dark-brown ink and pen on paper. 28.8 x 40.8 cm
Inscribed, signed and dated bottom right:
A Léonide Miassine / Artiste qui j'aime / son ami / Picasso / Londres 1919
48155
Z. XXIX. 426

This drawing has been erroneously entitled *Cancan from 'La Boutique Fantasque'*. On the verso is an inscription of the Soulenburg Gallery in New York: *Miassine + Lopokova. The Cancan in La Boutique Fantasque.* The sheet depicts Leonid Miassine and Lydia Lopukhova, principal dancers in the ballet *La Boutique Fantasque.* Picasso portrayed the pair in five other drawings ('Picasso's

Paintings, Watercolors, Drawings and Sculpture: A Comprehensive Illustrated Catalogue: 1885–1973', *From Cubism to Neoclassicism: 1917–1919*, San Francisco, 1995, 19.198–19.202). Leonid Feodorovich Miassine (1895–1979) was an outstanding dancer and choreographer for Diaghilev's Ballet Russe (1914–21). Picasso became good friends with him while creating decorations and costumes for the ballet *Parade* (1917). After seeing the ballet, Apollinaire proclaimed Miassine the boldest of choreographers, saying that together with Picasso he had succeeded in accomplishing something nobody else ever had – marrying painting and dance. The Russian dancer appears in several of Picasso's works, including the drawing *Miassine as Harlequin*, also a gift from the painter (1917; formerly Cologne, Ludwig collection; Z. III. 26); a study for the painting *Harlequin* (1917; Z. III. 27); and, in an idealised form, in *Harlequin* itself (1917; Z. III. 28). He also appears in the pencil *Portrait of Leonid Miassine* (1919; Chicago, Art Institute; Z. III. 297). Lydia Vasilievna Lopukhova (1891–1981) was a renowned ballerina of the Mariinsky Theatre in St Petersburg; she became famous in 1910 for her role in the *Firebird* for the Russian seasons in Paris. From 1916 to 1924 she was the principal soloist in Diaghilev's company. In 1919 Picasso painted three different portraits of Lopukhova (Z. III. 298, 299; Z. XXIX. 414). Based on an old German ballet, *The Doll Fairy*, the one-act *La Boutique Fantasque* was mounted by Miassine to music by Rossini with sets by Derain. The première took place in London on 5 July 1919. Miassine and Lopukhova performed the title roles of male and female dolls in love with each other, who come to life at night in the doll boutique. For this drawing Picasso used a special kind of brown paper which absorbed different amounts of ink depending on the speed of his drawing. Fine lines required light, quick movements, while thick ones were achieved with a slower motion of the pen, allowing the ink to spread.

Provenance: acquired in 1991 (gift of M. I. Baryshnikov, received through the St Petersburg International Telemarathon); previously in the collection of L. F. Miassine (gift of the artist) from 1919; private collection, New York; collection of M. I. Baryshnikov, New York.

Fernand Piet
1869, Paris – 1942, Paris

Piet studied under Cormon, Carrière and Roll. He exhibited at the Salon, at the Salon des Indépendants from 1893, and at the Salon National de la Société des Beaux-Arts. He was awarded the Bronze medal at the 1900 Exposition Universelle. He painted landscapes and genre compositions of simple folk such as Breton peasants, laundresses, female street-vendors of Normandy, Provence, and so forth.

316. Market in Brest, *c.* 1899 (page 230)
Le marché à Brest
Oil on cardboard. 647 x 80 cm
Signed bottom right: *Piet*; signed and inscribed on the verso: *Marché à Brest Fernan Piet*
ГЭ 8989

Dated by analogy with the *Brest Market* exhibited at the Salon National de la Société des Beaux-Arts in 1899, this painting also depicts vegetable stalls at the market in Brest. Two main figures are recognisable here too: the greengrocer on the left and the elderly woman sitting on the right.

Provenance: acquired from the State Museum of Modern Western Art in 1948; previously in the collection of S. I. Shchukin from 1907; First Museum of Modern Western Painting from 1918; State Museum of Modern Western Art from 1923.

Camille Pissarro
1830, St Thomas, Danish Virgin Islands – 1903, Paris

Pissarro studied under the Danish artist Fritz Melbye on St Thomas and accompanied him to Venezuela from 1853 to 1855. He enrolled at the

Ecole des Beaux-Arts in Paris in 1855. Dissatisfied with the teaching at the school, he also attended the Académie Suisse, where he met Monet and Corot, who influenced his work. He exhibited at the Salon from 1859, and participated at the Salon des Refusés in 1863. At the beginning of the Franco-Prussian war, he went to Brittany, then to London where he studied the works of Turner and Constable. In 1871 Pissarro returned to France: both his house in Louveciennes and hundreds of his paintings were destroyed by German soldiers during the Franco-Prussian war. Pissarro worked in Louveciennes and Auvers, but from 1872 mainly in Pontoise, where he was joined by Cézanne. A founding and active member of the Impressionists, he participated in all eight Impressionist exhibitions from 1874 to 1886. Pissarro supported Gauguin early in his career. In 1884, after Pissarro met and became friends with Seurat and Signac, he joined the Neo-Impressionists. From 1886 to 1890 he embraced Pointillism. After many years of hardship, a one-man retrospective organised by Durand-Ruel finally brought him success. He moved to Eragny in 1885 and travelled to Moret, Le Havre, Dieppe, Rouen and London in search of new themes. Following Monet's example, he executed variations of the same motif. He painted mostly landscapes, but also still lifes, portraits and scenes of peasant life.

317. Boulevard Montmartre (Boulevard Montmartre after Midday; Sunny Weather), 1897 (page 124)
Boulevard Montmartre. Soleil après-midi
Oil on canvas. 74 x 92.8 cm
Signed and dated bottom right: *C. Pissarro 97*
Г⊃ 9002 P.–V. 933

On 8 February 1897, Pissarro wrote to his son Georges: 'I am returning to Paris to begin a series on Paris on the 10th of this month, the day after tomorrow. I've reserved a room at the Grand Hôtel de Russie on 1 rue Drouot from the 10th, and hope to paint about a dozen canvases. Durand very much liked the small ones I did, and he recommended I do the boulevard scenes in the same way, but large-scale, of course.' (Bailly-Herzberg, 1989, p. 323.) Having just settled into his hotel room, Pissarro wrote to his other son, Lucien: 'From my window I have a view of all the boulevards almost as far as Porte Saint-Denis, in any case as far as Bonne-Nouvelle' (Bailly-Herzberg, 1989, p. 324). In another letter to Georges, dated 13 February, he wrote: 'I have begun my Boulevard series, a stunning motif which I must convey at all costs; on the left is another motif which is terribly difficult, almost from the perspective of a bird in flight, vehicles, commuter trains, people between large trees next to large houses, all this must be balanced, it's simply unbelievable!… what can I say, I must find a way.' (Bailly-Herzberg, 1989, p. 325.) In two months Pissarro created a series of thirteen canvases with the same composition, in which a lantern in the foreground served as the point of departure for both perspective and tone. On 28 March Pissarro wrote that the paintings had been 'thoroughly reworked', but 'are being held back by the absence of the sun'. The series was executed on canvases of three standard formats: the largest was used for two paintings, the Hermitage picture and the one in the Melbourne National Gallery which depicts the Boulevard on a cloudy morning.

Provenance: acquired from the State Museum of Modern Western Art in 1948; previously in the collection of François Depeaux, Rouen; Depeaux sale of 21 April 1901; collection of M. P. Ryabushinsky, Moscow, from 1901; Tretyakov Gallery from 1917; State Museum of Modern Western Art from 1925.

318. Place du Théâtre Français, 1898 (page 125)
Oil on canvas. 65.5 x 81.5 cm
Signed and dated bottom right: *C. Pissarro 98*
Г⊃ 6509 P.–V. 1032

This was the view from a window at the Grand Hôtel du Louvre, where Pissarro worked in the winter and spring of 1898, executing a series of paintings showing the Place du Théâtre Français (now Place André Malraux) and the Avenue de l'Opéra. In a letter to his son Lucien dated 15 December 1897, Pissarro wrote: 'I have found a

room in the Grand Hôtel du Louvre with a splendid view of the Avenue de l'Opéra and a corner of the Place du Palais Royal. It's lovely to paint. Perhaps it is not too aesthetic, but I'm delighted that I can try to paint these Paris streets that everyone always says are so ugly when they are really silvery, luminous and alive. They're so different from boulevards, they are completely contemporary!!!' (Bailly-Herzberg, 1989, p. 418).

The paintings done at the Grand Hôtel du Louvre demonstrate various compositional approaches. In most of them, the viewpoint is from the left of the Avenue de l'Opéra, and only two – the Hermitage canvas and the one in the Los Angeles County Museum of Art – show the entire square. The Hermitage painting is the final one in the series: the colouring is determined by the spring foliage, whereas in the other compositions the trees are still bare. Pissarro had explored the motif of queues for the overcrowded commuter trains in two 1897 depictions of the Boulevard des Italiens (P.–V. 999, 1,000).

Provenance: acquired from the State Museum of Modern Western Art in 1930; previously in the Galerie Durand-Ruel (acquired from the artist) from April 1898; collection of P. I. Shchukin (purchased from Durand-Ruel for 4,000 francs) from 1898; collection of S. I. Shchukin from 1912; First Museum of Modern Western Painting from 1918; State Museum of Modern Western Art from 1923.

Pierre Puvis de Chavannes
1824, Lyon – 1898, Paris

In 1840 Puvis de Chavannes settled in Paris. In 1847 he studied under Henri Scheffer, and in 1848 under Delacroix for two weeks, then under Couture for three months. Renaissance and Classical painting, which he studied during two trips to Italy in 1847 and 1848, exerted a significant influence on his work. Puvis de Chavannes exhibited at the Salon from 1850, and was awarded the Salon's second-class medal in 1861. With Rodin and Meissonier, he became a founding member of the Salon National de la Société des Beaux-Arts, its vice-president in 1890, then president in 1891. He worked primarily as a muralist and executed murals for numerous public buildings: the Panthéon, the Sorbonne, and the Hôtel de Ville in Paris; the Musée de Picardie in Amiens; the Palais Longchamp in Marseilles; and the Boston Public Library. He painted allegorical and religious compositions, as well as portraits.

319. Woman by the Sea, 1887 (page 181)
Femme au bord de la mer
Oil on paper pasted on canvas. 75.3 x 74.5 cm
Signed and dated bottom left: *P. Puvis de Chavannes* 1887
Г⊃ 6564

In Russia this painting had been known as *Mad Woman by the Seashore*, even though the verso of the canvas bears an old label, *Femme au bord de la mer*, written in the artist's hand. Attempts have been made to link the canvas with Félix Pyat's 1858 short story *The Mad Woman of Ostende*, which appeared in an anthology in 1886. The story is about a fisherman's wife who goes mad looking for her husband on the deserted seashore shortly after his death at sea. It is possible that Puvis de Chavannes was familiar with Pyat's story, since the theme of a poor fisherman had a special appeal for him, but such direct references are not found in his work. Indeed, the 'madwoman' does not exhibit any obvious signs of madness. At the Puvis de Chavannes exhibition in Paris and Ottawa in 1976–7 (*Puvis de Chavannes: Catalogue de l'exposition*, Grand Palais, Paris; National Gallery of Canada, Ottawa, Paris, 1976), there were two works that can be related to *Woman by the Sea*: a watercolour with a woman on a deserted shore (no. 181), in which the figure is a mirror image of the one in the Hermitage canvas; and a sanguine drawing entitled *The Wheat Fairy* (no. 182), with an inscription by the painter, *La Fée aux blés*. The drawing depicts a woman holding a wreath made from ears of wheat. There is also an oil sketch, *The Fairy on the Sandy Shore* (Paris, private collection). Evidently Puvis de

Chavannes was experimenting with some rather abstract concepts which he illustrated with the same figure. Two years earlier, he had depicted a woman in the same pose standing in the background of *Vision of Antiquity* (Pittsburgh, Carnegie Institute).

Provenance: acquired from the State Museum of Modern Western Art in 1931; previously in the collection of I. S. Ostroukhov, Moscow; I. S. Ostroukhov Museum of Icon-Painting and Art from 1918; State Museum of Modern Western Art from 1929.

Jean Puy
1876, Roanne, near Lyon – 1960, Roanne

From 1895 to 1898 Puy took classes at the Ecole des Beaux-Arts in Lyon; the first year he studied architecture, then painting under Tony Tollet. After moving to Paris in 1898, Puy studied at the Académie Julian under Jean-Paul Laurens and Benjamin Constant. Influenced by the Impressionists, Puy transferred to the Académie Carrière in 1899, where he became friends with Matisse, Derain and Laprade. In 1905 Puy exhibited at the 'cage of wild beasts', the Fauves' room at the Salon d'Automne, with Matisse, Derain, Vlaminck and Manguin. Puy worked largely in Brittany and in the environs of Roanne. He painted landscapes, still lifes, portraits, and nudes. He was close to Vollard, whose book, *Le Père Ubu à la guerre* (Paris, 1920), he illustrated.

320. Landscape, c. 1903 (page 273)
Paysage
Oil on canvas. 48.5 x 73.5 cm
Signed bottom right: *Puy*
Г⊃ 8971

It is possible to date this painting through its similarity to *Noble Landscape* (1904; Roanne, Musée des Beaux-Arts), and especially to *Landscape, Saint-Alban-les-Eaux* (c. 1903; Paris, Centre Georges Pompidou), a gift from the artist to Matisse. Since both the latter canvas and the Hermitage one clearly depict the same place, it is appropriate to regard *Landscape* as a depiction of Saint-Alban-les-Eaux.

Provenance: acquired from the State Museum of Modern Western Art in 1948; previously in the collection of S. I. Shchukin; First Museum of Modern Western Painting from 1918; State Museum of Modern Western Art from 1923.

321. Summer, 1906 (page 273)
L'été
Oil on canvas. 76.6 x 112.5 cm
Signed and dated bottom left: *J. Puy 1906*
Г⊃ 7703

This composition was probably inspired by Shakespeare's *A Midsummer Night's Dream*. Depictions of the inhabitants of the kingdom of Titania and Oberon were often used at the end of the nineteenth century in England and France as a means of conveying an erotic subtext. Puy probably knew Henri-Camille Danger's *Elves* (1896), in which the wooded background is similar to this landscape. Puy, however, parodies his predecessors and gives a realistic and contemporary feel to the scene.

Provenance: acquired from the State Museum of Modern Western Art in 1934; previously in the Galerie Vollard; collection of I. A. Morozov from 1908; Second Museum of Modern Western Painting from 1918; State Museum of Modern Western Art from 1923.

322. Nude in an Interior (verso of *Portrait of the Artist's Wife*), 1909 (page 274)
Nu dans un intérieur (verso du *Portrait de Mme Jean Puy*)
Oil on canvas. 131.5 x 97 cm
Г⊃ 7450

The nude depicted here also appears in Puy's *Seated Nude* (1909; Geneva, Musée du Petit Palais).

323. Portrait of the Artist's Wife, 1909 (page 274)
Portrait de Mme Jean Puy
Oil on canvas. 131.5 x 97 cm
Signed and dated bottom left: *J. Puy 1909*
⌐Э 7450

Madame Puy often posed for her husband. Of the paintings that are close to this one in composition and date of execution, *Portrait of Madame Puy with a Bouquet of Flowers* (1908; Geneva, Musée du Petit Palais), in which she is again portrayed in profile, is most notable.

Provenance: acquired from the State Museum of Modern Western Art in 1948; previously in the collection of S. I. Shchukin; First Museum of Modern Western Painting from 1918; State Museum of Modern Western Art from 1923.

Odilon Redon
1840, Bordeaux – 1916, Paris

Redon spent his childhood and youth in Peyrelabade (Gironde), and later often returned to his family estate. From 1855 he studied in Bordeaux, where he took classes from the local painter Stanislas Gorin. In 1863 Redon met Rodolphe Bresdin, who exerted a significant influence on his work. Redon made his début at the Salon of 1864, and displayed his etchings at the Salon of 1867. After the Franco-Prussian War he settled in Paris, and in the 1870s worked in the woods of Fontainebleau and Brittany. Fantin-Latour introduced him to lithographs. From 1879 to 1899 Redon published thirteen albums of lithographs which reflected his literary and artistic interests: *Dans le rêve* (1879), *To Edgar Allan Poe* (1882), *Origines* (1883), *Hommage à Goya* (1885), *Gustave Flaubert* (1889), *Tentation de Saint Antoine* (1888–96), *Apocalypse* (1899), and so forth. Redon was a founding member and president of the Salon des Indépendants in 1884. He exhibited his drawings at the final Impressionist exhibition in 1886, although Impressionism, which had enriched his palette, was essentially foreign to him. Redon had a profound influence on the Symbolist movement.

324. Woman with Wild Flowers, c. 1895–8 (page 184)
Femme aux fleurs de champs
Pastel and charcoal on paper. 52 x 37.5 cm
Signed bottom right: *ODILON REDON*
46438 W.R. 428

In the 1890s Redon explored the use of colour, whereas previously he had worked more within the confines of black and white. *Woman with Wild Flowers* uses the same model as in *Closed Eyes* (1890; Paris, Musée d'Orsay) and *Veiled Woman* (c. 1895; Otterlo, Kröller-Müller Museum). This image recalls the painter's wife, but such depictions cannot be considered portraits because they lack specific details. Employing the same motifs throughout the 1890s, Redon often painted women's heads with flowers, images drawn from the imagination. It is possible that this painting alludes to a theme that attracted Redon – that of Ophelia – although the artist generally avoided such direct allusions.

Provenance: acquired in 1975; previously in a private collection, Moscow.

325. Woman Sleeping Under a Tree, 1900–1 (page 185)
Femme étendue sous un arbre
Tempera on canvas. 27 x 35 cm
Signed bottom left: *Odilon Redon*
43782 W.R. 677

The compositional starting point for this small canvas comes from Redon's early works, in particular *Woman Sitting under a Tree in the Woods* (c. 1875; Paris, private collection), a study painted in the spirit of Corot. A charcoal drawing entitled *Tree*, which was done at the same time, served as the prototype for the central detail of the Hermitage canvas. The tree is one of the more constant images in Redon's art, beginning with his boyhood drawings. The broad tree, similar to the one shown here, is an indispensable landscape element in such Symbolist works as *Centaur* (1883; Boston, Museum of Fine Arts); *The Sleep of Caliban* (c. 1900; Paris, private collection); *Buddha* (1904; France, Almen, Bonger collection); and *Saint Sebastian* (1910; Basel, Kunstmuseum). In all these paintings the tree has both compositional and symbolic significance. Redon was familiar with the idea of the tree as ancient symbol of eternal nature, an axis joining heaven and earth, but he ascribed additional meaning to it. In the lithograph *The Day* from his album *Dreams* (1891), the young tree with leaves turning green symbolises not only the coming spring but also light and day. In the Hermitage picture, which depicts night, the tree is bare. *The Sleep of Caliban*, which dates to around the same time, is the closest analogy to *Woman Sleeping Under a Tree*, and it shows the Shakespearean character lying under a very similar tree. Redon painted several decorative works at that time, and his painting had acquired a much richer colouring. On 21 July 1902, he wrote to M. Fabre: 'I have married Colour' (R. Bacou, *Odilon Redon*, Geneva, 1956, vol. i, p. 142).

Provenance: acquired from the State Museum of Modern Western Art in 1948; previously in the collection of S. I. Shchukin; First Museum of Modern Western Painting from 1918; State Museum of Modern Western Art from 1923.

Pierre-Auguste Renoir
1841, Limoges – 1919, Cagnes-sur-Mer (Alpes-Maritimes)

From 1854 to 1858 Renoir worked as an apprentice to a porcelain painter. In 1860 he received permission to copy paintings in the Louvre. In 1861 he studied in the studio of Charles Gleyre, where he became friends with Monet, Sisley and Bazille, and from 1862 to 1863 at the Ecole des Beaux-Arts. From 1864 Renoir exhibited at the Salon. From 1866 to 1868 his paintings clearly reflected Courbet's influence. In 1866 Renoir worked with Sisley in the forest of Fontainebleau and in Berck, and in 1867 with Bazille and Monet in Paris. Renoir frequented the Café Guerbois, the meeting place of the future Impressionists, and of Manet and Fantin-Latour, among others. An advocate of exhibiting independently of the Salon, Renoir participated in four Impressionist exhibitions: 1874, 1876, 1877 and 1882. In the 1870s he worked mostly in Paris, except for periods staying with Monet in Argenteuil in 1873 and 1974, and with Alphonse Daudet in Champrosay in 1876, then later in Vargemont and Dieppe. Trips to Algeria in 1881 and Italy in 1881 and 1882 resulted in his using brighter and lighter colours. In 1883 he travelled from Marseilles to Genoa with Monet, visiting Cézanne on the way back. From 1884 to 1887 he turned to a linear style of painting, expressing his dissatisfaction with Impressionism. The period from 1888 to 1898 is characterised by Neo-Baroque tendencies in his works. A Renoir retrospective at the Galerie Durand-Ruel in 1892 confirmed his reputation as the master of contemporary painting. In 1898 Renoir moved to Cagnes, near Nice, and from that time rarely left the South. He also worked as a sculptor.

326. Head of a Woman, c. 1876 (page 111)
Tête de femme
Oil on canvas. 38.5 x 36 cm
Signed bottom right: *Renoir*
⌐Э 7714 Daulte 357

Stylistically, this painting is close to works of 1875 and 1876. The background with the leaf design is characteristic of several 1876 canvases, among them *Portrait of Victor Chocquet* (Wintertur, Oscar Reinhart Collection; Daulte 175) and *Jeanne Durand-Ruel* (Merion, PA, Barnes Foundation; Daulte 179). A similar background recurs in

another Hermitage painting of the same period, *Woman in Black* (cat. 327), which Daulte in his catalogue of Renoir's paintings dates to 1880, without adequate evidence. Attempts to identify the model for *Head of a Woman* have proved unsuccessful. The suggestion that the 'Beautiful Anna' (Alma-Henriette Leboeuf), who posed for Renoir's *Nude* (1876; Moscow, Pushkin Museum) and Manet's *Nana* (1877; Hamburg, Kunsthalle), is the model here is also unsubstantiated. The model bears a closer likeness to the one in *Head of a Woman* (1874; Paris, private collection; Daulte 118).

Provenance: acquired from the State Museum of Modern Western Art in 1934; previously in the Galerie Vollard; collection of I. A. Morozov (purchased from Vollard for 20,000 francs) from 1913; Second Museum of Modern Western Painting from 1918; State Museum of Modern Western Art from 1923.

327. Woman in Black, 1876 (page 111)
Dame en noir
Oil on canvas. 65.5 x 55.5 cm
Signed middle right: *Renoir*
⌐Э 6506 Daulte 212

It is unclear who posed for this painting. Some sources say *Woman in Black* portrays Madame Hartmann, wife of the music publisher, while Daulte, who dates the canvas to 1876, suggests it depicts the 'Beautiful Anna' (Alma-Henriette Leboeuf). Although there is a definite similarity to the latter, it is more likely that a different model sat for this painting: she remains to this day the unknown 'lady'. Although he uses elements of pure portraiture in this work, Renoir's primary aim is to explore the use of black in all its gradations.

Provenance: acquired from the State Museum of Modern Western Art in 1930; previously in the collection of S. I. Shchukin (acquired before 1908); First Museum of Modern Western Painting from 1918; State Museum of Modern Western Art from 1923.

328. Portrait of the Actress Jeanne Samary, 1878 (page 112)
Portrait de Mlle Jeanne Samary
Oil on canvas. 174 x 101.5 cm
Signed and dated bottom left: *Renoir 78*
⌐Э 9003 Daulte 263

Jeanne Samary (1857–90) came from an artistic family. Her father was a violinist at the Opéra, her aunts prominent actresses at the Comédie-Française, and her older sister was a star at the Odéon. Herself a favourite at the Comédie-Française from an early age, Jeanne made her début at the renowned theatre at the age of eighteen, playing Dorina in Molière's *Tartuffe*. Two years later she was assigned almost all the roles of servant-girls or soubrettes in Molière's plays. From 1877, when he first started painting Samary, to 1880, Renoir executed no fewer than twelve portraits of her in pastel or in oil. (The oil paintings are listed in Daulte's catalogue: 228–31, 262–64, 277, 360.) The twenty-year-old Samary had quickly become a celebrity in Paris. The Salon of 1877 included two portraits of her, a painting by Georges de Dramard (whereabouts unknown) and a marble bust by David d'Anger (later lost). In both portrayals, the actress was shown in roles from the plays of the then fashionable Pailleron. Nor should it be forgotten that at the same time Renoir's canvas was on display at the Impressionist exhibition organised in protest against the Salon. Nothing in the portraits that Renoir painted of Samary in 1877 or later indicates her profession. One of his earliest portrayals of her, now in the Pushkin Museum (Daulte 229), was unquestionably a masterpiece of modern art. In April 1877 it sparkled, to quote Rivière, like a 'ray of sunshine' at the third Impressionist exhibition. It was this *Portrait of Mlle S…*, as Renoir entitled it for the catalogue, that Zola called 'the success of the exhibition'. It was, of course, not difficult for the spectators to decipher the initials of this woman in the pink portrait. Two years later, struggling for the recognition that would finally put an end to years of hardship, Renoir entered a competition with the masters of official

art on their own territory. A large-scale full-length canvas of Jeanne Samary and the *Portrait of Madame Charpentier with Her Daughters* (1878; New York, Metropolitan Museum) were entered for the Salon of 1879. However, only *Madame Charpentier* was successful. The influential mistress of the Salon, where all of Paris gathered, was able to ensure that 'her painting' was exhibited in the best possible light. Just before the opening, and without Renoir's knowledge, the canvas was covered with a lot of varnish by mistake. The varnish would not be removed until the 1960s, when it was already at the Hermitage: only then did its true beauty emerge. The unsuccessful showing of Renoir's *Portrait of Jeanne Samary* at the Salon of 1879 did not diminish the actress's popularity. Another, half-length, portrait of her by Louise Abbeme (private collection; C. Bailey, *Les Portraits de Renoir*, Musée des Beaux-Arts du Canada, Ottawa, 1997, p. 295) was also exhibited there. A depiction of the actress in the role of Antoinette in a comedy by Pailleron, *L'Etincelle*, also appeared in *L'Illustration* (13 December 1879). Jeanne Samary's fame continued to grow: popular response to *L'Etincelle* added to her earlier success-es in classical and contemporary plays. Renoir did not usually paint an actress playing a role, but the year before he had made an exception for Henriette Henriot when he painted *Madame Henriot as a Man* (1875–7; Columbus Museum of Art), in which he portrayed the actress as a page, a role she neither played nor could play. (Henriot did appear in the drama, but the page was an allusion to Meyer-beer's *Huguenots* at the Opéra.) Thus this full-length depiction of an actress that served as a springboard for the Hermitage *Samary* was nothing but a fantasy, and Renoir never showed it in his lifetime. The artist's unwillingness to portray Jeanne Samary in a role can be easi-ly explained. Renoir admitted that he rarely saw her perform: 'I do not like the acting at the Théâtre Français' (A. Vollard, *Auguste Renoir*, Paris, 1920, p. 169). On the other hand, the Hermitage por-trait is also a kind of fantasy: it contains nothing 'ordinary', not even the sense of being posed that was so characteristic of the realistic productions of the time. Indeed Madame Charpentier reacted to the painting by saying: 'She's very attractive, but where did those collar-bones come from!' (G. Rivière, *Renoir et ses amis*, 1921, p. 77). In Renoir's paintings, Jeanne Samary indeed looks more elegant than she does in the photographs taken of her at the time. There is also no hint of the vulgarity, to which she apparently was still prone. She is depicted in a ball gown, in which she might well have appeared at Madame Charpentier's, where the painter had apparently met her. Madame Charpentier's house was the meeting place for many promi-nent figures from artistic and literary circles. It is impossible firmly to establish whether Madame Charpentier's drawing-room served as the background for the Hermitage canvas, but the Japanese screen on the left suggests that it was. Another Japanese screen appears in the portrait of Madame Charpentier with her children, now in the Metropolitan Museum of Art in New York. This woman, who was Renoir's patron, and one of the first women to promote Japanese fashion in Paris, is portrayed with a Japanese fan in the Hermitage canvas *Woman on the Stairs* (c. 1876; formerly Gerstenberg collec-tion. A. Kostenevich, *Hidden Treasures Revealed*, New York, 1995, no. 20). According to Bailey (*Les Portraits de Renoir*, Musée des Beaux-Arts du Canada, Ottawa, 1997, p. 158), the background in the painting is a combination of the Charpentier mansion and the foyer of the Comédie-Française, but the painting itself was executed else-where. Renoir told Vollard that he had painted all his 'Samarys' in the garden on rue Cortot. Rivière and Renoir's son, Jean, confirmed that the full-length portrait was done in the studio on rue Saint-Georges. Jean Renoir also mentions sketches of the actress which the artist did in her parent's house. In 1878 Renoir painted a small half-length portrait (Switzerland, private collection; Daulte 277), which may be regarded as a study for the Hermitage picture.

Provenance: acquired from the State Museum of Modern Western Art in 1948; previously at the Galerie Durand-Ruel, Paris, from 1881; returned to the artist in 1884; Durand-Ruel Gallery, New York, from February to November 1886; acquired by Durand-Ruel from the artist for 1,800 francs on 29 December 1886; collection of Prince Edmond de Polignac, Paris (purchased for 2,000 francs), from 29 December 1886; again the Galerie Durand-Ruel, Paris (acquired for 4,000 francs) from 1897; La Salle collection, Paris, from 1897; Galerie Bernheim-

Jeune from 1898; collection of M. A. Morozov (acquired from the Galerie Bernheim-Jeune); collection of M. K. Morozova from 1903; Tretyakov Gallery (gift of M. K. Morozova) from 1910; State Museum of Modern Western Art from 1925.

329. Girl with a Fan, 1880 (page 113)
Jeune femme à l'éventail
Oil on canvas. 65 x 50 cm
Signed top right: *Renoir*
⌐⊐ 6507 Daulte 332

This painting, which had great success at the seventh Impressionist exhibition in 1882, is often dated to either 1880–1 or 1881. Since we now know that it was acquired by the Galerie Durand-Ruel on 6 January 1881, there cannot be any doubt that it was executed in 1880. In spite of Jules Dranet's somewhat mocking caricature of the *Girl with a Fan* and other notable works from this exhibition (*Charivari*, 9 March 1882), Renoir's canvas was sympathetically, even enthusiastically, received by some critics: 'Captivating in its modemi-ty and femininity' (A. Silvestre, 'Septième exposition des artistes indépendants', *La Vie moderne*, 11 March 1882); 'the power of his colours is especially surprising in *Girl with a Fan*' (A. Sallanche, 'L'Exposition des artistes indépendants', *Journal des arts*, 3 March 1882). It is generally assumed that Alphonsine Fournaise sat for the Hermitage picture, the central work of this period. She was the daughter of the owners of a restaurant in Chatou where the action of *The Luncheon of the Boating Party* (1880–1; Washington, DC, Phillips collection) takes place. It is Daulte's assertion that the subject of the Hermitage canvas was the 'Beautiful Alphonsine'. There are several pictures which critics regard as portrayals of this woman, but they clearly depict different women. Identification is made more compli-cated by the fact that Renoir often embellished women, just as his favourite eighteenth-century predecessors had done, reducing his images to a 'common denominator' and eliminating individuality. Comparison with a portrait which is unquestionably of Alphonsine Fournaise (formerly Cassirer collection; Daulte 331) does not support the contention that she sat for the Hermitage canvas. The almost identical dresses and hairstyles in the two paintings conceal very dif-ferent facial features. Returning to Meier-Graefe's assertion that the central figure in *The Luncheon of the Boating Party* is Alphonsine Fournaise, contemporary Renoir scholars (J. Isaacson and J. House among others) contend that it is impossible positively to establish her identity. After identifying the man on the left of the Washington canvas as Alphonse Fournaise, Meier-Graefe could not but identify the unknown woman as his sister. In spite of the physical resem-blance, one should not equate this unknown woman with the girl with a fan, partly because the former has dark auburn hair, and the latter pitch black. However, the woman drinking out of a tall wine-glass next to the unknown woman is another matter. Although the wineglass conceals part of her face and makes identification more difficult, it does not prevent us from drawing a comparison. According to Georges Rivière, Angèle, a frivolous Montmartre painter's model who moved in Renoir's circle, posed for one of the female figures. She is now believed to be the model for the woman with the wineglass. Rivière also points out that Angèle posed for *Woman with a Cat* (1880; Williamstown, The Sterling and Francine Clark Art Institute; Daulte 330). The model's resemblance, as well as the fact that the same red chair recurs in *Woman with a Cat*, allows us to conclude that Angèle was the model for *Girl with a Fan*. That both canvases were shown at the 1882 exhibition supports, albeit indirectly, the contention that they were executed around the same time. The idea of painting a model with a fan and a luxurious black bow in the bluish-black tones of her hair came, of course, directly from Renoir. Alphonsine Fournaise is portrayed with the same bow in the Cassirer painting, but in 1881 she was thirty-five years old, whereas the woman in the Hermitage picture is considerably younger. *Smiling Girl* (private collection; Daulte 277), dated 1879 in Daulte's catalogue, may be regarded as a study for *Girl with a Fan*. It makes more sense, however, to ascribe to it the same date as the Hermitage canvas.

Provenance: acquired from the State Museum of Modern Western Art in 1930; previously at the Galerie Durand-Ruel, Paris (purchased from the artist for 500 francs), from 6 January 1881; collection of I. A. Morozov (acquired from the Galerie Durand-Ruel for 30,000 francs) from 1908; Second Museum of Modern Western Painting from 1918; State Museum of Modern Western Art from 1923.

330. Child with a Whip, 1885 (page 114)
L'enfant au fouet
Oil on canvas. 105 x 75 cm
Signed and dated bottom right: *Renoir 85*
⌐⊐ 9006 Daulte 471

This painting depicts Etienne Goujon at the age of five. His father Etienne Goujon, a senator and subsequently secretary of the French Senate, commissioned four portraits of his children. The small bust portraits of his two elder sons, Pierre-Jean-Léon and Pierre-Etienne-Henri, were probably done from photographs and form a pair. The two paintings of his younger children, Marie and her brother Etienne, also form a pair; they are shown in a garden, and were obviously painted either entirely or largely in the open air. Describing these paintings as a pair requires some qualification: Marie's portrait enti-tled *Girl with a Hoop* (1885; Washington, DC, National Gallery) is as wide as the Hermitage canvas but a little taller. While both paintings share the same background, the girl in the Washington picture is posed in counterpoint to her brother in *Child with a Whip*. The Hermitage canvas belongs to the type of portrait that had already been established by *Child with a Watering-Can* (1876; Washington, DC, National Gallery). Stylistically, however, the later canvas marks an attempt to depart from some of the techniques of Impressionism: the little boy's face is painted in clearly defined lines that are unchar-acteristic of Impressionism, but typical of Renoir's so-called linear style. The painting's background clearly indicates that it was painted in the summer, but the exact date and circumstances are unknown. Almost nothing is known about Etienne Goujon (1880–1945): he did not acquire a profession and lived alone in the castle he inherited at Ferte, near Orléans.

Provenance: acquired from the State Museum of Modern Western Art in 1948; previously in the collection of Etienne Goujon, Paris; Galerie Vollard; collection of I. A. Morozov from 1913; Second Museum of Modern Western Painting from 1918; State Museum of Modern Western Art from 1923.

331. Landscape, 1902 (page 127)
Paysage
Oil on canvas. 14 x 19 cm
Signed bottom left: *Renoir*
⌐⊐ 8926

The verso of the canvas bears the date 1902 (not written by the author) which corresponds stylistically to Renoir's paintings of the time. As in such 1902 landscapes as *Le Cannet* (Merion, PA, Barnes Foundation), the painting depicts the Villa Printemps in Le Cannet, not far from Nice, where Renoir had settled at the beginning of 1902. The small dimensions of the landscape and the rather tense painterly style reflect the difficult conditions under which Renoir worked. As early as 9 March 1902, he had written to Durand-Ruel from Le Cannet: 'My health is so-so: it's almost always the same… I've settled in wonderfully and think that I'll bring you something interesting, although it is very difficult for me to work' (Venturi, 1939).

Provenance: acquired from the State Museum of Modern Western Art in 1948; previously in the Galerie Durand-Ruel, Paris; private collection, Moscow; Rumyantsev Museum, Moscow, from 1918; State Museum of Modern Western Art from 1925.

Georges Rouault
1871, Paris – 1958, Paris

From 1885 to 1890 Rouault was apprenticed to a stained-glass restorer, and at the same time took evening classes at the Ecole des Arts Décoratifs. In 1890 he enrolled at the Ecole des Beaux-Arts in a class taught by Elie Delaunay. Two years later Gustave Moreau took over the class and became attached to Rouault, exerting a profound influence on his work. Matisse, Manguin, Marquet and Guérin also studied under Moreau. After his teacher's death in 1898, Rouault became the curator of the Musée Gustave Moreau in Paris. From 1895 to 1901 Rouault exhibited paintings on evangelical and mythological themes at the Salon. His landscapes and sketches of 1900 and 1901 display signs of a new style, sparked by a religious crisis, which later became a variation on Expressionism. From 1902 to 1912 Rouault exhibited at the Salon des Indépendants, and from 1903 at the Salon d'Automne. In 1905 he exhibited at the Salon d'Automne with the Fauves, although he himself denied belonging to this group. In 1906 Rouault met Vollard, who seven years later would acquire all the paintings in his studio as well as the rights to his unfinished works. In 1947 Rouault sued Vollard's heirs, who had acquired the paintings that he had worked on for many years and which he had considered unfinished. Vollard's heirs had sold 119 paintings, but Rouault retrieved the 800 or so that were left. He burned 315 of them, and devoted the rest of his life to completing the remainder. As well as painting, he also made engravings (the cycle *Miserere* (1917–27), *The Lord's Passion* (1934–5) and others), designed the set and costumes for Diaghilev's ballet The Prodigal Son, made designs for tapestry and ceramics, and wrote poetry.

332. Girls, 1907 (page 290)
Filles
Pastel, watercolour and tempera on paper. 97 x 65 cm
Signed and dated (twice) top right: *G. Rouault 907*
43783 Dorival–Rouault 192

This painting belongs to the extensive cycle *Prostitutes* executed between 1903 and 1910. As Rouault could not afford to pay models, he and Marquet would invite prostitutes to pose for them. In Russia, which has traditionally avoided a precise rendition of 'the second oldest profession', the canvas has been known as *Girls*, from the moment it appeared in Moscow in 1908. *Girls* was preceded by a series of studies dating from 1903 to 1906. *Two Nudes (Girls)* (New York, Metropolitan Museum of Art), which dates to 1905–6, may be regarded as a study for the Hermitage picture. It has the same dimensions, and the same composition is painted in oil on both sides of the canvas (the verso with a mirror image). The Hermitage canvas was begun in 1906 (the '6' of the date is crossed out and corrected to '7'). Rouault painted another version of the canvas, entitled *Prostitutes* (1910; Bern, Kunstmuseum; Dorival–Rouault 193), which is notable for its dominant red hues. He produced two more variations with two standing female nudes (Dorival–Rouault 190, 191).

Provenance: acquired from the State Museum of Modern Western Art in 1948; previously in the Galerie Druet; collection of N. P. Ryabushinsky, Moscow, from 1908; Nosov collection, Moscow; First Proletarian Museum, Moscow, from 1918; State Museum of Modern Western Art from 1923.

333. Sketch of a Vase (verso of *Spring*), c. 1910–11 (page 291)
Esquisse de vase (verso de *Le printemps*)
Gouache and watercolour on paper. 72 x 57.4 cm
42157

From 1906 to 1913 Rouault devoted a lot of time to ceramics, encouraged by Ambroise Vollard who eagerly purchased plates and vases painted in a contemporary, avant-garde style. Bonnard, Vuillard, Denis, Roussel, Maillol, Van Dongen, Derain, Vlaminck, Puy, Friesz and Matisse all tried their hand at a medium that painters

had earlier avoided. They were able to appreciate the craft of ceramics fully with the help of the talented ceramicist André Metthey; Rouault visited him often in his studio in Asnières. The vases Rouault painted are notable for their simple traditional shapes. More often than not he depicted a female nude on the entire upper part of the vase. This study on the verso of *Spring* demonstrates the typical process used in ceramics. The study was probably done around 1910–11, when Rouault was very active in this field. At two of his exhibitions at the Druet Gallery in 1910 and 1911, Rouault showed over 100 works in ceramic.

334. Spring, 1911 (page 292)
Le Printemps
Watercolour and pastel on paper. 72 x 57.4 cm
Signed and dated bottom right: *G. Rouault 1911*
42157 Dorival–Rouault 775

This picture is painted as an oval, almost a tondo, on an even-sided sheet, with the passe-partout covering the painted frame that surrounds the landscape. In 1911 Rouault was living in Versailles, where he evidently painted *Spring*. The theme of a spring flood is rendered primarily with the help of thick fluid contours, a device Rouault had used earlier in a similar landscape, *The Flood* (1910; Paris, private collection). Attracted to ancient stained-glass windows from an early age, Rouault tried to reproduce within the idiom of contemporary painting the effect of Gothic cathedral windows. *The Baptism of Christ* (1911; Paris, Musée d'art moderne de la Ville de Paris; Dorival–Rouault 832), executed at the same time as *Spring* on a similar sheet and in the same style, is also an oval. Rouault may have identified the theme of the Baptism with spring: in antiquity baptisms were usually done just before Easter. The large oval gouache *Landscape, The Ride* (Dorival–Rouault 776) is similar to *Spring* both in motif and style.

Provenance: acquired from the State Museum of Modern Western Art in 1934; previously in the collection of I. A. Morozov (acquired on his behalf by Emile Druet from the exhibition of the Salon des Indépendants, No. 5278) from 1911; Second Museum of Modern Western Painting from 1918; State Museum of Modern Western Art from 1923.

335. Head of Christ, 1939 (page 371)
Tête de Christ
Oil on paper pasted on canvas. 65 x 50 cm
Signed bottom right: *G. Rouault*
10603

This painting belongs to a series of profiles of Christ executed at the end of the 1930s, including the *Humiliation of Christ* (1939; New York, collection of the Abrams family), and the earlier *Head of Christ* (1937–8; Tokyo, Yoshii Gallery; Dorival–Rouault 1542). The Hermitage painting recreates the composition of the earlier eponymous canvas, and the size is almost identical. However, the colour range is here more restrained and all secondary landscape details in the depiction of the tower with the cupola have been eliminated. Both works can be traced back to an engraving from the *Miserere* cycle bearing the author's inscription *Jésus honni*. At the time, Rouault was apparently also working on four other variations of this motif (Dorival–Rouault 1526–9), which are similar in size and are all entitled *The Passion of the Lord*. In each of these variations Christ's head is surrounded with an arc. Rouault's daughter Isabelle confirmed the authenticity of the painting; she is planning to include it in the third volume of the *catalogue raisonné* of Rouault's paintings.

Provenance: acquired in 1998; previously in the collection of Ambroise Vollard, Paris; private collection, France.

Henri Rousseau (Le Douanier Rousseau)
1844, Laval – 1910, Paris

Rousseau was self-taught, but it is not known when he took up painting. He copied paintings in the Louvre, the Musée du Luxembourg and Versailles (for which he received permission in 1884). In 1871 he started to work in the Paris municipal toll-collecting service. In 1893 Rousseau left his job as a customs officer to devote himself full-time to painting and that year he met the young poet Alfred Jarry. He earned a living teaching drawing and music and wrote music himself. As a playwright, he was a forerunner of the theatre of the absurd. From 1886 he exhibited at the Salon des Indépendants and from 1905 at the Salon d'Automne. Most of the works he created before 1900 have been lost. In 1906 Jarry introduced Rousseau to Apollinaire. Derain, Vlaminck, Delaunay and Picasso were all admirers of Rousseau. In 1908 a banquet was held in his honour in Picasso's studio in the Bateau-Lavoir. Rousseau painted landscapes, allegorical compositions, still lifes and portraits.

336. Tiger Attacking a Bull (In a Tropical Forest), c. 1908–9 (page 224)
Combat du tigre et du taureau. Un bois tropical
Oil on canvas. 46 x 55 cm
Signed bottom left: *Henri Rousseau*; inscribed and signed on a label on the verso: *Combat du tigre et du taureau. Reproduction de mon tableau exposé au Salon des Indépendants 1908. Henri Rousseau*
6536 Certigny 276

The painting Rousseau mentions in the inscription on the verso is now in the Cleveland Art Museum. The Hermitage canvas is a companion work and not a reproduction despite Rousseau's statement. The landscape in the Cleveland canvas is more exotic: the plants are much larger than the animals. Most critics believe that the Hermitage version was painted in 1908, although a later date is also possible, for Vollard acquired the painting on 5 August 1909. A series of works Rousseau had completed earlier anticipate the subject matter of the picture. He used the motif of an attacking tiger in, among other works, two large-scale canvases, *Storm in the Jungle* (1891; London, National Gallery) and *Tiger Attacking Hunters* (1904; Merion, PA, Barnes Foundation). Both the Hermitage and Cleveland works were directly influenced by Eugène Pirodon's etching of the Belgian Charles Verlat's painting, *Royal Tiger Attacking a Buffalo* (H. Certigny, 'Une source inconnue de Douanier Rousseau', *L'Oeil*, October 1979, pp. 74–5). The etching was first published in 1883 and secondly, in 1906, in the journal *L'Art*. The second publication clearly attracted Rousseau's attention because the following year he started work on *Tiger Attacking a Bull*. Pirodon's etching is a mirror image of Verlat's composition. It is possible that Rousseau 'corrected it' to avoid being accused of plagiarism. Verlat's painting and Pirodon's etching belong to the animal genre: the animal figures occupy most of the composition. In his painting, Rousseau shifts the emphasis to the depiction of his imaginary jungle. It is no accident that the title *In a Tropical Forest* was retained in Russia.

Provenance: acquired from the State Museum of Modern Western Art in 1930; previously in the Galerie Vollard from 1909; collection of S. I. Shchukin from 1912; First Museum of Modern Western Painting from 1918; State Museum of Modern Western Art from 1923.

337. View of the Fortifications from the Porte de Vanves, 1909 (page 224)
Vue de fortifications à gauche de Vanves
Oil on canvas. 31 x 41 cm
Signed bottom left: *Henri Rousseau*; inscribed, signed and dated on a label on the verso: *Vue prise commune de Vanves à gauche de la porte de ce nom. Septembre 1909. Henri Rousseau*
6535 Certigny 280

This painting, which depicts the road from Paris to Versailles, is also entitled *View of the Fortifications*. This small canvas may be called a landscape-memoir, for Rousseau worked at the Porte de Vanves when he collected poll taxes, an import duty on food and certain goods (later abolished), for the city of Paris. The Porte de Vanves (now part of the city with a metro station) was located outside the city limits of Paris.

Painted in early September, the picture was preceded by two earlier depictions of the environs of the Porte de Vanves, which can be dated to the spring of 1909. The first was a sketch, perhaps drawn from life, which belonged to Robert Delaunay (present whereabouts unknown; Certigny 278). The second was *View of the Fortifications* (Hiroshima, Art Museum; Certigny 279). Compared with the Hermitage work, the Hiroshima version, which only shows a single figure, is larger, the detail is more finished and the colour range more restrained. In 1985 the painting's old yellow varnish was removed.

Provenance: acquired from the State Museum of Modern Western Art in 1930; previously in the Galerie Vollard (purchased from the artist for 40 francs, together with *Quai d'Ivry*) from 12 September 1909; collection of S. I. Shchukin from 1912; First Museum of Modern Western Painting from 1918; State Museum of Modern Western Art from 1923.

338. Jardin du Luxembourg (Monument to Chopin), 1909 (page 225)
Oil on canvas. 38 x 47 cm
Signed and dated bottom right: *H. Rousseau 1909*; signed on a label on the verso: *Vue de Luxembourg. Monument de Chopin. Composition. Henri Rousseau*
⌐⌐ 7716 Certigny 281

The theme of people out walking is one that Rousseau turned to throughout his artistic life. A lady with the parasol also occupies a key position in the earlier *A Walk in the Woods* (1886–90; Zurich, Kunsthaus). In later works, isolated figures solemnly out walking alone appear more often, the trees become more two-dimensional and decorative. The series depicting parks in Paris (more often than not Montsouris), which developed the motif of paths enlivened by ladies with their requisite parasols and men with canes, can be dated to 1905–10. The Hermitage painting stands out from these other works in the inclusion of the monument to Chopin, which was done by the now-forgotten Georges Dubois. The word 'composition' in the inscription attests to the fact that the landscape was painted in a studio and not outdoors. A year earlier, drawing on his impressions of the Luxembourg Gardens, Rousseau had composed a landscape background for the painting *Muse Inspiring the Poet* (see page 30), in which he portrayed Guillaume Apollinaire and Marie Laurencin (one version is in the Kunstmuseum in Basel, the other is in the Pushkin Museum, Moscow). On 31 August 1908, Rousseau wrote to Apollinaire that he planned to go to the Luxembourg Gardens, where he had found a wonderful corner and where he had 'to capture the background'. An undated drawing, *A Corner of the Jardin du Luxembourg* (Japan, private collection; see ex. cat. *Banquet in Honour of the Customs Officer Rousseau*, Tokyo, 1985, No. 18), has survived, but it is not related to the Hermitage painting. The painting was undoubtedly completed not long before it was acquired by Vollard on 5 August 1909.

Provenance: acquired from the State Museum of Modern Western Art in 1934; previously in the Galerie Vollard from 1909; collection of S. I. Shchukin from 1912; First Museum of Modern Western Painting from 1918; State Museum of Modern Western Art from 1923.

Philippe Rousseau
1816, Paris – 1887, Acquigny

Self-taught, Rousseau studied for a while under Gros and Jean-Victor Bertin. At first he painted landscapes, then, after 1840, still lifes and allegorical depictions of animals. His work was influenced by the eighteenth-century masters Chardin, Oudry and Desportes. As a decorator he received commissions from the court of Napoleon III. From 1834 he exhibited at the Salon, where in 1845 he was awarded a third-class medal, and in 1845 and 1878, first-class medals.

339. The Hermit-Rat, late 1860s (page 73)
Une scène de la fable de Lafontaine 'Le rat-ermite'
Oil on wood. 25.5 x 21.5 cm
Signed bottom right: *Ph. Rousseau*
⌐⌐ 6603

A variation of this painting was exhibited at the Salon of 1852 and subsequently went to the Musée du Luxembourg. At the 1885 Salon, Rousseau exhibited yet another, larger variation entitled *The Rat that Retired from the World*, which enjoyed considerable success. This composition is reproduced in a charcoal drawing in the Philadelphia Museum of Art. Rousseau first turned to the motif in 1845, when, at the Salon, he showed *The City Rat and the Country Rat* (present whereabouts unknown), a work Théophile Gauthier regarded as Rousseau's masterpiece. In *The Hermit-Rat*, Rousseau turned to a subject which had earlier attracted Decamps. Lafontaine's fable tells the story of a rat who seeks refuge in a large chunk of cheese and refuses to help his friends in their struggle with the cats.

Provenance: acquired from the Museum of Everyday Life of the Leningrad Department of Education in 1931; previously in the Sheremetiev collection, St Petersburg.

Théodore Rousseau
1812, Paris – 1867, Barbizon

Rousseau studied at the Ecole des Beaux-arts under Joseph Rémond from 1827 to 1828, and under Guillaume Lethière from 1828 to 1829. At that time he was aleady making sketches at Fontainebleau. At the Louvre, Rousseau studied the paintings of Claude Lorrain and the seventeenth-century Dutch landscapists. He was influenced by Constable and Bonington. Rousseau exhibited at the Salon from 1831, but the jury rejected his paintings from 1835 to 1848. He achieved true recognition at the 1855 Exposition Universelle. Rousseau made several trips around France, sometimes with other landscape artists: Normandy with Paul Huet in 1831; Landes with Jules Dupré in 1844; Franche-Comté with Millet in 1861. From 1836 he worked mostly in the village of Barbizon, where he finally moved in 1847.

340. Landscape with a Ploughman, early 1860s (page 92)
Paysage au laboureur
Oil on wood. 38 x 51.5 cm
Signed bottom right: *Th. Rousseau*
⌐⌐ 7269

According to legend, which some regard as fact (see V. N. Berezina, *French Painting: Beginning–Middle of the Nineteenth Century*, Moscow–Florence, 1983), Rousseau could see the landscape in this composition from the studio of his house in Barbizon. There is no doubt that the painting reflects Rousseau's impressions of Barbizon, but even if the changes that have taken place there are taken into account, the view from Rousseau's house on the Grande Rue was nothing like this. In *Landscape with a Ploughman* Rousseau used only natural motifs, even though he created the composition not in the open air, but in his studio.

Provenance: acquired from Gatchina Palace-Museum in 1930; previously in the collection of Emperor Alexander III in Gatchina Palace.

Ker-Xavier Roussel
1867, Chênes, near Lorry-les-Metz, Moselle – 1944, L'Etang-la-Ville, near Paris

From 1886, together with Vuillard, Roussel studied at the Ecole des Beaux-Arts under Maillard, a Prix de Rome laureate, and in 1888 under Gérôme. At the same time he started attending the Académie Julian, where he became friends with Ibels, Ranson and Bonnard. Roussel, Denis and Vuillard formed the Nabis group in 1889. Roussel's marriage to Vuillard's sister in 1893 brought the two artists even closer together. His work was influenced by Puvis de Chavannes and by Japanese woodcuts. In 1899 he moved to L'Etang-la-Ville, where his Nabis friends visited him often. From 1901 he exhibited at the Salon des Indépendants, and from 1904 at the Salon d'Automne. In 1906 he taught at the Académie Ranson. At that time he undertook a trip to the South with Denis: in Saint-Clair they visited Cross, and in Aix, Cézanne. From 1902 to 1914, he spent every summer in Normandy. Between 1914 and 1916 he convalesced in Switzerland. In 1936 he started work on the mural painting *Pax Nutrix* for the Palais des Nations in Geneva. He was a painter, lithographer and book illustrator.

341. Mythological Subject, c. 1903 (page 217)
Sujet mythologique
Oil on canvas. 47 x 62 cm
⌐⌐ 9065

This painting is also entitled *Goat*, under which title it came to the Galerie Bernheim-Jeune. The picture does not depict a specific myth, but a variation on an arcadian theme. In depicting nudes in nature, Roussel touches on the mythological level of consciousness, which was inspired by his interest in seventeenth-century painting and suggested by the poses of the figures. In recreating games with animals, Roussel touches upon a Dionysian motif: Athenians worshipped Dionysus, who wore a black goatskin, and the god himself was called 'little goat'. In the context of this painting, the nude women can be taken as bacchantes. Roussel turned to mythological motifs from 1900. His earlier depictions of people with animals were placed in a contemporary everyday context, as in *Child with a Goat* (c. 1890; Paris, private collection). His mythologised compositions, which were probably influenced by Cross's work, reflect the style of Roussel's contemporaries. Here, the Nabis' sense of humour, for example, can be observed in the hairstyles, which were typical of the first few years of the twentieth century. The ancient subject matter would suggest that Roussel has depicted the Mediterranean coast. The picture is sometimes dated to c. 1906, which was when Roussel made a trip to Provence with Denis. But he went there in the winter, whereas the landscape clearly reflects autumn colours. Roussel had become familiar with the Mediterranean coast earlier. He went to Cannes as early as 1899 and from there to Venice with Vuillard. In its painterly qualities and its interpretation of the female figures, the work is similar to *By the Sea* (c. 1903; Paris, Musée du Petit Palais) and to *Bathers* (1903; Paris, Bernheim-Jeune collection), but especially to the studies that preceded this composition, a similarity which allows us to date *Mythological Subject* to c. 1903.

Provenance: acquired from the State Museum of Modern Western Art in 1948; previously in the Galerie Bernheim-Jeune; Nekrasov collection, Moscow (purchased from Bernheim-Jeune through the mediation of P. P. Muratov), from 1911; S. A. Poliakov collection, Moscow; Tretyakov Gallery from 1917; State Museum of Modern Western Art from 1925.

342. The Triumph of Bacchus (Fête Champêtre), 1911–13 (page 216)
Triomphe de Bacchus (Fête champêtre)
Oil on canvas. 166.5 x 119.5 cm
Signed and dated bottom right: *K. X. Roussel 913*
⌐⌐ 9165

The picture was painted in 1911, and exhibited at the Salon d'Automne of the same year under the title *Mythological Scene*,

along with its pair, *The Triumph of Ceres* (Moscow, Pushkin Museum). Bacchanalian scenes in the conventional style often appeared in a wide range of turn-of-the-century work, from Salon paintings to photographs of 'live scenes'. The photograph *Bacchic Joy*, which perhaps recalled the Hermitage canvas, was included in one of the Paris editions of Edouard Daelen's 1905 *The Morality of the Nude*. Far more famous was Bouguereau's painting of 1884 entitled *The Youth of Bacchus*. Roussel's work can be seen as his personal reaction to this hallmark of Salon art, and the early twentieth century's response from a position of anti-academism. Of the artists in the anti-academic camp, Roussel's direct predecessor in terms of such types of decorative compositions was Adolf Willette, who in 1904 had painted the Bar Tabarin Cabaret with frescoes entitled *The Games of Eve*, which depicted jubilant dancing in the open air. A little later Roussel himself used a similar motif, which served him well in his subsequent works of the 1910s. The central figure of the *Triumph of Bacchus* recalls a dancing figure in *Cupids and a Small Dog* (1905; Paris, private collection), in which there is also an analagous figure to the one shown in the far right of the Hermitage canvas. In 1913, after they were purchased by Ivan Morozov, both 'Triumphs' were retouched by the artist, acquiring an even more decorative character. This heightened degree of colouring can be linked to the work Roussel had done on the curtain at the Champs-Elysées Theatre in Paris. The theme of Bacchic dances in the open air was also used for a curtain commissioned by the architect Auguste Perret. According to B. N. Ternovets, director of the Museum of Modern Western Art in Moscow, Roussel repainted both canvases when he learned that they would be hanging next to works by Matisse. Ivan Morozov, however, did not like the new versions. Traces of the original greyish-brown tones can still be seen along the edges of the *Triumph of Bacchus*. It is difficult to determine how the pictures fitted into Morozov's collection. Neither of them has an obvious compositional orientation. When they arrived in Moscow, the paintings did not appear in Morozov's 1912 collection catalogue, and it is not known what the collector called them. The title traditionally used in both the Pushkin Museum and the Hermitage – *Fête champêtre* – originated from the Museum of Modern Western Art, and reflects the early Soviet tendency to demythologise works of art.

Provenance: acquired from the State Museum of Modern Western Art in 1948; previously in the Galerie Vollard from 1911; collection of I. A. Morozov (acquired from Vollard for 10,000 francs) from 1913; Second Museum of Modern Western Painting from 1918; State Museum of Modern Western Art from 1923.

Ferdinand Roybet
1840, Uzès – 1920, Paris

Roybet studied engraving at the Ecole des Beaux-Arts in Lyon, then, from 1864, in Paris. His work was influenced by Delacroix, Théodule Ribot and Antoine Vollon. He exhibited at the Salon from 1865 to 1892. In 1871 he went to Holland, where he copied paintings by Rembrandt and Hals. In 1872 he went to Algeria. He painted portraits, history and genre paintings, and nudes.

343. Odalisque (La Sultane), mid-1870s (page 77)
Oil on canvas. 70 x 82.5 cm
Signed bottom left: *F. Roybet*
⌐Э 7293

This picture was influenced by Courbet's *Woman with a Parrot* (1866; New York, Metropolitan Museum), which was exhibited at the Salon of 1866. The following year Courbet showed his 'Second-Empire Odalisque' once again, at his one-man exhibition. Then the work disappeared for a while, reappearing in a private collection in Dijon. However, the painting left a lingering impression on artistic circles in Paris. Roybet was also influenced by an earlier painting by Courbet entitled *The Awakening* (1864; Berlin, Gerstenberg Collection; destroyed during the Second World War), in which a figure was seated next to a reclining woman (the composition originally represented

Venus and Psyche). Other influences included Chassériau's *The Toilet of Esther* (1841; Paris, Louvre) and Ingres's *Odalisque with a Slave-girl* (1842; Baltimore, Walters Art Gallery), which both play on the contrast between the nude body of the white woman and the dark slave-girl. It is difficult to date Roybet's canvas with absolute precision, for the work of this half-forgotten artist has not received much scholarly attention. Some assistance is provided by the fact that in 1876 the future Alexander III visited several studios in Paris, acquiring paintings for his personal collection. Apparently Roybet's *Odalisque* (nicknamed *La Sultane* in Russia) caught the attention of the heir apparent. Usually during these visits, Alexander would select recently completed works or paintings that were still in progress. The rouble price of the painting which is listed in the old inventory suggests that the purchase was indeed made in Paris: the fact that it is not a round figure makes it likely that the painting was paid for in francs.

Provenance: acquired from the Antiquariat in 1931; previously in the collection of Emperor Alexander III at the Anichkov Palace, St Petersburg (purchased for Alexander III for 7,309 roubles).

René Seyssaud
1867, Marseilles – 1952, Saint-Chamas, Bouche du Rhône

Seyssaud studied at the Ecole des Beaux-Arts in Marseilles, and in 1885 under Grivolas in Avignon. At the end of the 1880s Seyssaud formed the Groupe des Jeunes with Gasquet, Lorrain and Lombard. Already at the beginning of the 1880s he and Valtat emerged as forerunners of the Fauves (Seyssaud later received the nickname 'the black Fauve'). In 1897 he exhibited at the Galerie Le Barc de Boutteville and attracted the attention of Vollard and Bernheim, and in 1900 he exhibited at the Galerie Bernheim-Jeune. In 1903 Seyssaud was one of the founding members of the Salon d'Automne, and also exhibited at the Salon des Indépendants and the Salon des Tuileries. After moving to Saint-Chamas in 1902, he lived the life of a recluse and was almost forgotten in Paris. Seyssaud painted mostly works on agricultural themes and southern landscapes, as well as portraits and figurative compositions.

344. The Road, 1901 (page 253)
La route
Oil on paper pasted on canvas. 32 x 49 cm
Signed bottom right: *Seyssaud*
⌐Э 8966

There is an inscription on the cardboard covering the verso: *Catalogue sous le N 237/10 16 juin 1901. Champs de Millet.* It has not been possible to establish at which exhibition Seyssaud showed this painting.

Provenance: acquired from the State Museum of Modern Western Art in 1948; previously in the collection of M. A. Morozov; collection of M. K. Morozova from 1903; Tretyakov Gallery (gift of M. K. Morozova) from 1910; State Museum of Modern Western Art from 1925.

345. Ploughing, 1902–3 (page 253)
Le labourage
Oil on cardboard. 45 x 60.5 cm
Signed bottom right: *Seyssaud*
⌐Э 9701

This painting probably depicts the environs of the artist's farm in Saint-Chamas, where he settled in 1902. At the beginning of the nineteenth century Seyssaud often painted ploughed fields, a motif that had symbolic meaning for him. Several works entitled *Ploughing*, possibly including the Hermitage canvas, were shown at Seyssaud's exhibitions at the Bernheim-Jeune Gallery from 1902 to 1903.

Provenance: acquired from the Pushkin Museum, Moscow, in 1953; previously in the Pushkin Museum (gift of the people of Saint-Chamas) from 1949.

Paul Signac
1963, Paris – 1935, Paris

Signac developed as a painter under Monet's influence, having started painting from nature. In 1883 he studied in the studio of Jean-Baptiste Bin, the mayor of Montmartre. Signac was one of the founding members of the Société des Artistes Indépendants in 1884 and became its president in 1908. At the Société's organisational meeting he met Georges Seurat and together they developed Divisionism, or Pointillism. Signac explored questions relating to the optical blending of colours. Pissarro invited him to participate in the final Impressionist exhibition in 1886; in that same year he met and became friends with Émile Verhaeren. In 1888 he visited Van Gogh in Arles, then Mallarmé. He became friends with Cross and Luce, joined their Neo-Impressionist movement, and after Seurat's death in 1891, became its leader and theoretician. From 1892 to 1911 he visited Saint-Tropez annually for several months at a time, then moved to Antibes. Signac travelled to Italy, Belgium, Holland, Greece and Turkey. An avid yachtsman, Signac painted primarily watercolours of seascapes and harbours. He was also a printmaker and book illustrator.

346. Port of Marseilles, 1906–7 (page 159)
Sortie de port de Marseilles
Oil on canvas. 46 x 55.2 cm
Signed bottom left: *P. Signac*
⌐Э 6524

This painting is similar to an eponymous landscape of the same size (1898; Otterlo, Kröller-Müller Museum). The Otterlo *Port* was painted not from nature but from memories of a trip to Marseilles. Although Signac recreated his earlier composition, he did not copy it to the last detail. The strokes in the Hermitage canvas are thicker, and the light purer, evocative of mosaic. Some of the details are also different, mostly in the depiction of the sailboat in the centre. 'The canvas that is progressing best of all', Signac wrote in his diary on 18 October 1898, 'and the one that works best is the very one I painted from memory, having used only a vague silhouette of the entrance into the port. One evening in the hotel I was colouring a sketch I had done during the day, and without thinking about making it realistic, I painted the sea and sky yellow, red and lilac, diffusing the colours from the centre, which was busy with ships, to the edges. And now this completely imagined product seems more realistic than the two watercolours I did from nature.' (From 'Extraits du Journal inédit de Paul Signac: 1897–98, 1898–99' (introduction and notes by J. Rewald), *Arts de France* 11–12, 1947.) In 1911 Signac painted a much larger *Port of Marseilles* (Paris, Musée d'Orsay), which is notable not only for its added detail – the clouds, boats, an additional sailing-boat – but also for its greater degree of detachment. The Hermitage landscape has generally been dated to 1907, when it was exhibited at the Salon des Indépendants, but the artist's granddaughter and researcher, Françoise Cachin, believes 1906 to be a more probable date.

Provenance: acquired from the State Museum of Modern Western Art in 1930; previously in the collection of I. A. Morozov (acquired from the exhibition of the Salon des Indépendants for 500 francs) from 1907; Second Museum of Modern Western Painting from 1918; State Museum of Modern Western Art from 1923.

Lucien Simon
1861, Paris – 1945, Paris

Simon studied at the Académie Julian under Didier and Robert-Fleury. In 1885 he exhibited at the Salon des Peintres Français, where he received an honourable mention, and from 1893 at the Salon de la Société Nationale des Beaux-Arts. He received the Gold Medal at the Exposition Universelle in Paris in 1900, and was awarded the Grand Prix at the Exposition Internationale des Arts et Techniques dans la Vie Moderne in 1937. In the early 1900s, together with Cottet, Ménard and Prinet, Simon joined the so-called 'Black Band', and in 1927 he became a member of the Institut de France. He

painted genre compositions, primarily scenes from the lives of Breton peasants and fishermen, as well as portraits and landscapes. He was a dedicated teacher; Yves Brayer, Georges Rohner and Henri Jannot studied under him.

347. The Artist's Children *c.* 1895–7 (page 230)
Les enfants de l'artiste
Watercolour and gouache on paper. 66 x 57 cm
Monogrammed bottom left: *L.S.*
18909

This watercolour was evidently painted in Brittany, where Simon usually spent the summer months. The artist A. N. Benois acquired it for M. K. Tenisheva to complete her collection, and this is how he remembered Simon and his friend Ménard: 'I very much liked the works they showed at the exhibition of painters in watercolour and pastel, and it was not difficult to persuade Princess Tenisheva to acquire a painting by both of these masters for "our" collection' (Benois, 1990, book 4, vol. ii, p. 145). About Simon he added: 'I was captivated by the free, cheerful and self-confident style of his oil paintings, and particularly his watercolours. I also liked his colours which were so light and fresh. I especially valued some of his portraits; there was so much cheerfulness and healthy simplicity in his Breton subjects! He has marvellously conveyed both the area's austere character and the inhabitants' primitiveness and wildness. The Simons themselves spent each summer in their charming villa on the seashore at Bénodet near Quimper; it was a beautiful place where one could enjoy the air, the sea, swimming and walking in the pine woods nearby…' (*ibid.*, p. 148). Simon subsequently painted his daughter again in *Portrait of Mademoiselle L. Simon* (*Peintures et aquarelles de Lucien Simon*, Paris, 1923, p. 52).

Provenance: acquired from the State Russian Museum, Leningrad, in 1930; previously in the collection of M. K. Tenisheva, St Petersburg, from 1897; collection of S. S. Botkin, St Petersburg, from 1903; State Russian Museum.

348. Breton Men and Women, *c.* 1907 (page 230)
Les bretonnes et les bretons
Oil on canvas. 35 x 47 cm
Signed bottom right: *L. Simon*
ГЭ 7442

The painting depicts peasants returning from church on Sunday. It can be dated by analogy with *Potato Picking* (1907; Quimper, Musée des Beaux-arts), which shows the same landscape but from a different perspective.

Provenance: acquired from the State Russian Museum, Leningrad, in 1932; previously in a private collection, Petrograd.

Alfred Sisley
1939, Paris – 1899, Moret-sur-Loing (Seine-et-Marne)

Sisley was the son of a wealthy English businessman who had settled in Paris. At the age of eighteen he went to London to study commerce, but the years he spent there (from 1857 to 1862) were devoted primarily to visiting museums and studying the works of landscape painters such as Constable and Turner. After returning to France, with his father's permission Sisley joined the studio of Charles Gleyre, where he became friends with Monet, Renoir and Bazille. Sisley's early paintings were clearly influenced by Corot and Daubigny. In 1866 Sisley made his début at the Salon. Together with Manet, Degas, Fantin-Latour, Monet and Pissarro, Sisley often joined in discussions about contemporary art at the Café Guerbois. From 1871 he was financially supported by Durand-Ruel. Sisley participated in four Impressionist exhibitions: 1874, 1876, 1877 and 1882. In 1874 and 1897 he visited England. In the early 1870s Sisley liked to work around Paris (Louveciennes, Argenteuil, Villeneuve-la-Garenne); in the mid-1870s he worked in Marly-le-Roi and Bougival; and in the

late 1870s in Sèvres. He spent the last ten years of his life in Moret-sur-Loing. In 1894 he painted in Normandy. His retrospective at the Galerie Georges Petit in 1897 was a failure. Sisley was primarily a landscape painter.

349. Villeneuve-la-Garenne, 1872 (page 106)
Oil on canvas. 59 x 80 cm
Signed and dated bottom left: *Sisley 1872*
ГЭ 9005 D.S. 40

Until recently this painting was entitled *Village on the Seine*, as it was known in Sergei Shchukin's collection. Sisley visited Villeneuve-la-Garenne, now a suburb of Paris, in the summer of 1872. The shady riverbank shown in the picture is on the island of Saint-Denis, from where Sisley liked to paint the town. Since a bridge was built across the river in 1844, such quiet places on the Seine became popular with Parisians for Sunday excursions. Sisley started painting in Villeneuve-la-Garenne in the spring of 1872. After setting up his easel not far from the bridge, with a view of Saint-Denis, he painted *Fishermen Drying Their Nets* (1872; Fort Worth, Kimbell Art Museum; D.S. 27) and three other landscapes (D.S. 36, 38, 47). At the height of summer, Sisley returned to the bridge in Villeneuve, this time painting three landscapes, with the island of Saint-Denis serving as the 'observation point'. While in the Hermitage canvas he focused on painting the view across the river, in the other two pictures he was attracted by a view of the bridge. The part of town depicted in *Villeneuve-la-Garenne* is located near the bridge. The two houses on the left also recur in the right half of *Bridge at Villeneuve-la-Garenne* (1872; New York, Metropolitan Museum of Art; D.S. 37) and seem to extend the view of the town. Berthe Morisot later painted a similar view of the bridge, entitled *Villeneuve-la-Garenne* (1875; present whereabouts unknown). It is believed that the painting was exhibited as early as 1872 at the Fourth Exhibition of the Société des Artistes Français at the German Gallery (no. 124), under the title *On the Seine* – an exhibition that was organized by Durand-Ruel. According to Piotr Shchukin's notebook (f. 265, ed. kh. 9), now in the State Historical Museum in Moscow, the painting was acquired from Durand-Ruel for 6,000 roubles.

Provenance: acquired from the State Museum of Modern Western Art in 1948; previously in the Galerie Durand-Ruel, Paris (acquired from the artist on 24 August 1872), from 1872; collection of P. I. Shchukin (acquired from Durand-Ruel for 6,000 roubles through the mediation of I. I. Shchukin) from 1898; collection of S. I. Shchukin from 1912; First Museum of Modern Western Painting from 1918; State Museum of Modern Western Art from 1923.

350. Windy Day at Veneux, 1882 (page 122)
La campagne à Veneux
Oil on canvas. 60 x 81 cm
Signed bottom right: *Sisley*
ГЭ 6508 D.S. 452

Daulte dates this painting, also known as *Fields Near Veneux*, to 1882. Durand-Ruel acquired it a year later. Sisley and his family had moved to Veneux-Nadon in 1880 and lived there until September 1882, when they settled in Moret-sur-Loing.

Provenance: acquired from the State Museum of Modern Western Art in 1930; previously in the Galerie Durand-Ruel, Paris, from 1883; collection of I. A. Morozov (acquired from Durand-Ruel for 12,500 francs) from 1905; Second Museum of Modern Western Painting from 1918; State Museum of Modern Western Art from 1923.

351. The River Bank at Saint-Mammès, 1884 (page 123)
La berge de la rivière à Saint-Mammès
Oil on canvas. 50 x 65 cm
Signed and dated bottom left: *Sisley. 84*
ГЭ 9167 D.S. 513

This picture was painted in the early spring of 1884, when Sisley lived in the small town of Les Sablons near Moret-sur-Loing. Sisley often painted in the environs of the town, including around the village of Saint-Mammès on the Loing River. On 7 March he wrote to Durand-Ruel: 'I have started up again and I have several canvases (riverbanks) in progress. I would like to take full advantage of the fine weather and not tear myself away from my easel. You would make me very happy if you were to send me 400 francs, and in two weeks I will send you everything I have finished' (Venturi, 1939, vol. ii, p. 58). Durand-Ruel did indeed receive *The River Bank at Saint-Mammès* on 24 March. In March 1884, Sisley kept a sketch book (Paris, Louvre, Cabinet des dessins), and one of the drawings (No. 22) shows the same motif as in the Hermitage picture. Sisley painted the riverbanks at Saint-Mammès on many occasions, and these works can be divided into several groups. The Hermitage canvas belongs to a series of landscapes which depict the bridge across the Loing River in the middle ground (D.S. 511–16). Another *River Bank at Saint-Mammès* (not in Daulte's catalogue) is similar to the Hermitage work (see ex. cat., *Around Impression*, Beyeler Gallery, Basel, 1966, no. 38).

Provenance: acquired from the State Museum of Modern Western Art in 1948; previously in the Galerie Durand-Ruel, Paris, from 1884; collection of I. A. Morozov (acquired from Durand-Ruel for 20,000 francs) from 1907; Second Museum of Modern Western Painting from 1918; State Museum of Modern Western Art from 1923.

Chaïm Soutine
1893, Smilovitchi, near Minsk – 1943, Paris

In 1907 Soutine ran away from home to Minsk, where he became apprentice to a photographer and studied drawing under Krüger. From 1910 he studied at a small academy in Vilna (now Vilnius), and together with his schoolfriends Marcel Kikoïne and Pinchus Krémègne he went to Paris in 1913. Soutine settled in La Ruche on Montparnasse and studied under Fernand Cormon, where he met Rivera, Léger, Zadkine and Lipchitz; he also became friends with Oscar Miestchaninoff, Marc Chagall and Amedeo Modigliani. His work was influenced by Rembrandt, Van Gogh, and the German Expressionists. From 1919 to 1922 he lived at Céret on the Spanish border. In 1923 Soutine attained international renown when the American collector Albert Barnes acquired over 100 of his paintings. In 1927 he had a one-man exhibition at the Galerie Bing in Paris, the only one held in France during his lifetime. He had several exhibitions in the United States. In 1929 Soutine moved to Lèves near Chartres. During the German occupation he refused to emigrate and sought refuge in Touraine. An aggravated ulcer forced him to go to Paris, where he died the next day after belated surgery. Soutine painted landscapes, portraits, and still lifes.

352. Self-Portrait, *c.* 1920–1 (page 370)
Portrait de l'artiste par lui-même
Oil on canvas. 54 x 30.5 cm
Signed bottom left: *Soutine*
ГЭ 10599

The picture came to the Hermitage dated by its former owners to 1916, but stylistically it belongs to the paintings of 1920–1. While in his other self-portraits, including those of 1918 and 1922, Soutine portrayed himself as a painter (either standing in front of one of his canvases or simply holding a palette), here he is not a *peintre maudit* (damned painter), but simply *maudit* – an outcast who does not need to worry about conforming to convention. Nothing in the picture indicates a profession: the emphasis is on the inner turmoil. Furthermore, despite a self-portrayal that verges on caricature, Soutine achieves a likeness that is rare in its expressiveness. Among Soutine's self-portraits, the closest to the Hermitage painting is *Self Portrait with a Beard* (1917; Paris, private collection; see ex. cat.,

Les peintres de Zborowski: Modigliani, Utrillo, Soutine et leurs amis, Hermitage Foundation, Lausanne, 1994, No. 40).

Provenance: acquired in 1997; previously in the Galerie Bing, Paris; private collection, Paris.

Théophile-Alexandre Steinlen
1859, Lausanne – 1923, Paris

Swiss by birth, Steinlen inherited his interest in art from his father, who taught drawing and lithography. Steinlen studied at an art school in Lausanne, and in 1877 worked as an apprentice designer in his uncle's textile factory in Mulhouse. In 1881 he moved to Paris, doing drawings for humorous newspapers and journals, including *Chat noir* from 1882 to 1887, *Le Mirliton* from 1885 to 1892, *Gil Blas illustré* from 1891 to 1900, *Rire* from 1895 to 1898, and *L'Assiette au beurre* from 1901 to 1905. His work was influenced by Millet and Daumier. In 1903 and 1912 Steinlen exhibited in Paris, in 1912 in Brussels, and in 1913 in Lausanne. He illustrated the books of Anatole France, Guy de Maupassant and others. He was a poster artist, painter, predominantly of landscapes, and sculptor.

353. Ball in a Paris Suburb, *c.* **1892 (page 234)**
Bal aux banlieux de Paris
Graphite and colour pencils and pastel on paper.
33.5 x 54.3 cm
Signed bottom right: *Steinlen*
24979

A small 1892 colour lithograph, *Ball Behind the Barrier*, which was made after the Hermitage drawing, allows for the approximate dating.

Provenance: acquired in 1922; previously in a private collection, Petrograd.

354. Cholera's Coming, 1898 (page 235)
V'là l'choléra qu'arrive
Pencil on paper. 47 x 35.3 cm
Signed top right: *Steinlen*
43491

This drawing appeared on the first page of the journal *Le Mirliton* (July 1898, no. 117), which featured songs (lyrics and music) composed by its publisher Aristide Bruant (1851–1925) and illustrated by Steinlen. The verso of the Hermitage picture bears a pencil inscription, *Mirliton*, and below it, a sketch of seated men and women. The lower half of the sheet shows some half-crossed-out sketches in blue pencil and a fragment of musical notation, as well as pencil inscriptions with instructions for the publisher: *Red. A 0m en largeur de la cadre – réduire d'ailleurs tous les dessins ensemble.* On the left of the passe-partout are the lyrics of a song by Aristide Bruant.

V'là l'choléra qu'arrive

Paraît qu'on attend l'choléra,
La chose est positive.
On n'sait pas quand l'arriv'ra,
Mais on sait qu'il arrive.
V'là l'choléra! V'là l'choléra!
V'là l'choléra qu'arrive!
De l'une à l'autre rive
Tout le monde en crev'ra.

Aristide Bruant 1884
Dessin original de Steinlen – Le Mirliton – No. 117. Juillet, 1898

[Cholera's coming
We seem to be expecting the cholera,
The thing looks certain.
We don't know when it's coming,

But we know it's coming.
Cholera's coming! Cholera's coming!
Here comes the cholera!
From one bank to the other
Everybody'll get it.

Aristide Bruant 1884
Original drawing by Steinlen – Le Mirliton – No. 117, July 1898]

Provenance: acquired in 1939; previously in the collection of R. Goldberg, Leningrad

Léopold Survage (Sturzwage)
1879, Wilmanstrand, Finland – 1968, Paris

Survage was the son of a Moscow piano manufacturer of Finnish origin. He studied at the Moscow School of Painting, Sculpture and Architecture under Leonid Pasternak and Konstantin Korovin, where he met Larionov, Falk, Saryan and Archipenko. Survage was profoundly influenced by the paintings by Cézanne, Gauguin and Matisse in Sergei Shchukin's collection. In 1908, acting on Shchukin's advice, Survage went to Paris, where for two months he studied at Matisse's art school. In 1910 he participated in the *Jack of Diamonds* exhibition in Moscow, and in 1911 exhibited with the Cubists at the Salon des Indépendants. The figurative nature of the compositions of the Rose (1914–19) and later periods are based on the principles of Cubism. In 1919, together with Gleizes and Metzinger, he helped revive the Section d'or. Soutine was close to the Group of Six composers and to Satie; he also illustrated the books of his poet-friends Eluard, Cocteau and Birot. He was awarded the Gold Medal at the Exposition Universelle in 1937. At the end of the 1950s he executed designs for tapestries and large-scale murals.

355. Landscape, 1925 (page 365)
Paysage
Oil on canvas. 54.3 x 73.3 cm
Signed and dated bottom right: *Survage 25*
9024

Landscape can be linked to Survage's set designs of the first half of the 1920s; it incorporates the Surrealist device of children's paper cut-outs used in theatrical games. As early as 1925, B. N. Ternovets visited Survage's studio to appraise the artist's work for the Museum of Modern Western Art, of which Ternovets was director. Two years later Survage donated this *Landscape* and *Landscape with a Red Figure* to the Moscow museum.

Provenance: acquired from the State Museum of Modern Western Art in 1948; previously in the same museum (donated by the artist) from 1927.

James Tissot
1836, Nantes – 1902, Château-de-Buillon, Doubs

In 1856 Tissot studied at the Ecole des Beaux-Arts in Paris under Louis Lamothe and Hippolyte Flandrin. He was friends with Degas, Whistler and Alphonse Daudet. From 1858 Tissot exhibited at the Salon, and from 1864 at the Royal Academy in London. In 1871 he moved to London fearing persecution for having participated in the Paris Commune; in 1882 he returned to Paris. Tissot refused to take part in the exhibitions of the Impressionists. In 1875 he visited Venice with Manet. In 1889 he was awarded the Gold Medal at the Exposition Universelle in Paris. In 1886 he made the first of three trips to the Palestine, which resulted in his moving away from historical and genre scenes of society life to compositions on the life of Christ and Old Testament themes. The sale of a large collection of watercolours and drawings inspired by his visits to Palestine, as well as the reproduction rights to his works on Biblical themes, made him a fortune.

356. Ruins (Voices Within), 1885 (page 62)
Les Ruines (Les Voix intimes)
Oil on canvas. 214 x 124 cm
4629

In Hermitage catalogues this painting has been entered as *Christ Comforting the Poor*. However, the artist's own title for the painting, and one that was used during his lifetime, was *Ruins* (it was published as such as a print in C. H. Levy's article 'James Tissot and his Work', *New Outlook*, London, p. 955; it was later reproduced in the monograph by M. Wentworth, *James Tissot*, Oxford, Mass., 1984, no. 196). At the 1903 sale of Tissot's work in Paris, the canvas was entitled *The Apparition*. It was probably then that it came to Russia, since until recently it had been considered lost in the West. The sale catalogue describes the painting thus: 'Dressed in sacerdotal robes, amidst the ruins of the Accounts Chamber, Christ comes to the assistance of a poor soul exploited by the Commune.' This interpretation, however, was far from Tissot's concept of the painting, which had much broader religious significance. It was this painting that signalled Tissot's conversion to Catholicism, and he was to devote the next part of his life and work to Christian subjects. *Ruins* actually treats a traditional subject – Christ and two companions on the road to Emmaus – in a noncanonical way: the artist clearly intends that the painting should be interpreted in the spirit of Christian-Social symbolism, as nurtured by the rebirth of Catholicism at the end of the nineteenth century. After completing *Ruins*, Tissot went to Palestine, where he worked on a major series of paintings on New Testament themes, in particular *The Life of Christ*, published in 1896.

Provenance: acquired from the State Russian Museum, Leningrad, in 1922; previously in the collection of the artist until 1903; posthumous sale of Tissot's work, Paris (L'Atelier de M. James Tissot, Paris, Hôtel Druot, lot 1) in 1903; Auer collection, Petrograd; State Russian Museum from 1918 or 1919.

Constant Troyon
1810, Sèvres – 1865, Paris

Troyon was the son of a decorator at the porcelain manufactory at Sèvres. At first Troyon also trained in porcelain painting. From 1833 to 1859 he exhibited at the Salon, where in 1846 he was awarded a First Class medal. Troyon painted landscapes from nature and studied the paintings of the eighteenth-century Dutch masters. In 1843 he met Dupré and Théodore Rousseau, then accompanied Dupré on his travels to Landes. He worked mostly in Paris and Barbizon. In 1847 he visited Holland; his work was subsequently influenced by Aelbert Cuyp and Paulus Potter. After 1849, without entirely abandoning landscape painting, he mostly painted animals.

357. Path in a Small Wood, early 1860s (page 94)
Chemin dans un petit bois
Oil on wood. 49 x 38 cm
Signed bottom left: *C. Troyon*
5696

This painting, also known as *Path Among Trees*, was acquired in Vienna for Grand Duchess Maria Feodorovna as a gift to her husband, the future Alexander III.

Provenance: acquired from the Anichkov Palace in 1919; previously acquired in Vienna for the heir, Grand Duke Alexander Alexandrovich, in 1867; collection of Emperor Alexander III, Anichkov Palace, St Petersburg.

Maurice Utrillo
1883, Paris – 1955, Dax

Utrillo was the son of the artist Suzanne Valadon and was adopted by the Spanish painter and journalist Miguel Utrillo. From 1902, on the advice of a doctor, Utrillo took up painting to break an addiction to alcohol that had started when he was still a child. He received no formal training in painting. His early works (between 1902 and 1906, in Montmagny) were influenced by the Impressionists. In his so-called 'white period' from 1907 to 1914, Utrillo's work was dominated by white. Defined contours characterise his cloisonné period from 1915 to 1920. He painted mostly views of Montmartre. From 1909 Utrillo exhibited at the Salon d'Automne and the Salon des Indépendants. In 1913 his first one-man exhibition was held at the Galerie Eugène Blot. He was occasionally hospitalised on account of his alcoholism and mental instability. Marriage to the painter Lucie Pauwels (née Valore) in 1936 made his life more stable.

358. Rue Custine in Montmartre, 1909–10 (page 257)
Tempera on cardboard. 51 x 73 cm
Signed bottom right: *Maurice Utrillo-V*
🖙 10598

This painting was not included in Petrides's catalogue (*Maurice Utrillo, L'oeuvre complète*, ed. P. Petrides, Paris, 1959–62), but was reproduced as a frontispiece to an earlier book on Utrillo by Adolphe Basler (*Maurice Utrillo*, Paris, 1931). Such a prominent position would suggest that the painting, which at the time was in the Lepoutre collection, held special significance for the artist. The painting depicts a view of the small rue Custine where it runs into the rue Caulaincourt. At about the same time, *c.* 1909, Utrillo painted another view of rue Custine (formerly Paris, Petrides collection; P. Petrides, *ibid.*, vol. i, no. 411) in which the foreground with the lamp is absent, and the viewpoint has shifted so that the left, rather than the right, side of the street is visible.

Provenance: acquired in 1997; previously in the Lepoutre collection, Paris; private collection, Lyon; private collection, Paris.

Félix Vallotton
1865, Lausanne – 1925, Paris

Valloton moved to Paris in 1882, where he studied at the Académie Julian from 1882 to 1885. He exhibited at the Salon from 1885, and copied the works of Renaissance Masters in the Louvre. He earned a living by making reproductive etchings. In 1889 Vallotton befriended Toulouse-Lautrec, Cottet and Vuillard, and from 1891 to 1893 wrote articles for the *Gazette de Lausanne*. In 1891 he started making woodcuts in his unique laconic style, and began contributing to various journals, including the *Revue Blanche*. In 1892 Vallotton joined the Nabis. In 1893 he met Maillol, and in 1897 Vollard organised an exhibition of his work. In 1898 Meier-Graefe published a book on Vallotton in Germany and France. In 1900 Vallotton became a French citizen. From 1903 he exhibited at the Salon. Vallotton was also a playwright and novelist, expressing his pessimism most powerfully in his 1907 novel *Deadly Life*. In 1908 he taught at the Académie Ranson. In 1910 he had his first one-man exhibition at the Galerie Druet (his friend Octave Mirbeau wrote the preface for the catalogue). In 1913 Vallotton visited St Petersburg and Moscow, then Italy. From the beginning of the First World War, he worked on symbolic anti-war compositions. Despite the success of his paintings in the post-war years, he was subject to depression. From 1920 to 1924 he painted primarily landscapes and still lifes.

359. Arcques-la-Bataille, 1903 (page 220)
Paysage. Arcques-la-Bataille
Oil on cardboard. 67 x 103.5 cm
Signed and dated bottom right: *F. VALLOTTON 03*
🖙 4908

This painting belongs to a series of landscapes that were painted in the summer of 1903 in the environs of Arcques-la-Bataille, a town located ten kilometres from Dieppe. In Vallotton's receipt book (where he numbered all his works) the series appears under no. 508. The Hermitage landscape is the largest in the series, and was executed not outdoors but in the studio, after a pencil drawing (Paris, private collection). Another preparatory drawing was reproduced in Rudolph Koella's article 'Vallotton's Rediscovery of the Classic Landscape' in S. Newman, *Félix Vallotton*, New Haven, Yale University Art Gallery, 1991, p. 177. The Hermitage picture shares affinities with the decorative landscapes created by Denis and the other Nabis as early as the 1890s, and clearly reveals how a natural view can be stylised in the manner of Japanese art. Vallotton could easily have found examples of such a whirlpool and silhouettes of trees in Hokusai's landscape woodcuts. The delicate gilded frame with its rounded corners highlights the play of flowing lines of the stream and the contours of the trees and shadows. The classical overtones of the painting were noted by Koella, who compared it to Poussin's *Spring* (1660–4; Paris, Louvre). The painting was shown under the title *Stream, Normandy* at Vallotton's one-man exhibition at the Galerie Bernheim-Jeune in 1906, as evidenced by the wax seal that is partially preserved on the verso. Vallotton was obviously talking about the Hermitage picture when, in a letter to his brother from Paris on 21 March 1911, he mentioned that on his way from Russia to Switzerland Haasen had purchased a landscape from him (Vallotton, 1974, letter 250).

Provenance: acquired in 1921; previously in the collection of G. E. Haasen, St Petersburg.

360. Interior, 1903–4 (page 221)
Intérieur
Oil on cardboard. 61.5 x 56 cm
Signed and dated bottom left: *F. VALLOTTON 04*
🖙 4902

This painting belongs to a series of interiors that Vallotton painted in Paris in 1903–4. The woman whose reflection can be seen in the mirror is Vallotton's wife, the daughter of the art dealer Bernheim-Jeune, who often sat for her husband. The seamstress reappears in *Interior, House-Maid Sewing a Yellow Dress* (1904; Paris, M. Gilbert collection). The interior in the Hermitage painting probably shows a room in the house on the rue Belles-Feuilles, where Vallotton's family had moved in 1903. The same apartment with the bedroom in the background is shown in *Interior with a Woman in Red* (1903; Lausanne, Galerie Paul Vallotton); indeed, the bed, wallpaper, and Vallotton's woodcuts over the bed are all identical. Since there is no mention of an interior in Vallotton's receipt book for 1904, but several for 1903 with the words 'rue Belles-Feuilles' (and the artist kept a very punctilious record), it is possible that the painting was in fact done in 1903. The Hermitage picture is clearly the one numbered 523: 'Interior: bedroom with two women, one of whom is sewing'. Vallotton could have signed the picture a few years later when he sold it to Haasen, and the error might have occurred then.

Provenance: acquired in 1921; previously in the collection of G. E. Haasen, St Petersburg (acquired from the artist for 500 francs), from 1908.

361. Lady at the Piano, 1904 (page 221)
Une dame au piano
Oil on canvas. 43.5 x 57 cm
Signed and dated bottom right: *F. VALLOTTON 04*
🖙 4860

This painting depicts Vallotton's wife, Gabrielle, at their country home in Varangeville, where the couple spent the summer of 1904 (from 1899 Vallotton usually spent the summer in Normandy). The entry number 527 in Vallotton's receipt book reads: *Woman Playing the Piano in a Country Interior, Varangeville*, which was shown at the Salon d'Automne of 1904; and number 528: *The Dining-room in a Country House* (1904; Lausanne, Galerie Paul Vallotton), which depicts Madame Vallotton in the same pose and wearing the same

housecoat. The painter probably meant this painting when he wrote to his brother on 30 December 1909, asking him to send Haasen some paintings that were in his possession: 'You can take, for example… the *Woman at the Piano*' (Vallotton, 1974, letter 241).

Provenance: acquired from the State Museum of Modern Western Art in 1948; previously in the collection of G. E. Haasen, St. Petersburg (acquired from the artist for 650 francs) from 1911; Hermitage Museum from 1921; State Museum of Modern Western Art from 1930.

362. Young Woman in a Black Hat, 1908 (page 222)
Jeune femme au chapeau noir
Oil on canvas. 81.3 x 65 cm
Signed and dated top right: *F. Vallotton 08*
🖙 5108

In Vallotton's receipt book this painting, no. 637, is entitled *Bust of a woman with a bared breast, wearing a black shawl, black hat with pink ribbon*. The picture is mentioned in a letter Vallotton wrote to his brother on 30 December 1909: 'If you want to send Haasen the paintings directly from your place, you can take… *Woman in a Black Hat*, for example' (Vallotton, 1974, letter 241). In 1908 *Young Woman in a Black Hat* was shown at the *Golden Fleece* exhibition in Moscow, together with two other paintings executed at the same time and linked by similar motifs: *Woman in a Green Hat* and *Nude*. In *Woman in a Green Hat* the shawl is similarly thrown over the woman's shoulder exposing her breast (*Golden Fleece*, 1908, nos. 7–9, pp. 20, 61).

Provenance: acquired from the State Museum of Modern Western Art in 1948; previously in the collection of G. E. Haasen, St Petersburg (acquired from the artist for 800 francs) from 1911; Hermitage Museum from 1921; State Museum of Modern Western Art from 1930.

363. Portrait of Mme Haasen, 1908 (page 222)
Portrait de Mme Haasen
Oil on canvas. 80 x 65 cm
Signed and dated top right: *F. VALLOTTON 08*
🖙 6765

On 8 June Vallotton wrote to this brother that he had agreed to paint a half-length portrait of G. E. Haasen's wife that would be no higher than one metre (Vallotton, 1974, p. 136). The letter was sent from Paris. The artist spent August in Lausanne and Berne, where the canvas was apparently painted. It is possible that Vallotton and Haasen disagreed about the price (the painting reached Haasen in 1909), as evidenced by the artist's letter to his brother dated 20 February 1909: 'I would like Haasen to accept the canvas in question, but tell him that from now the price will go up because I know that you must strike while the iron is hot; the prices will nonetheless be reasonable. If you could see the prices of Bonnard, Vuillard and Roussel – they are three times as high as mine and we're on an equal footing' (Vallotton, 1974, p. 164).

Provenance: acquired in 1921; previously in the collection of G. E. Haasen, St Petersburg (commissioned for 1,000 francs in 1908).

364. Portrait of G. E. Haasen, 1913 (page 223)
Portrait de M. Haasen
Oil on canvas. 81.7 x 100.5 cm
Signed and dated top left: *F. VALLOTTON 1912 + 1*
🖙 4901

Georgy Emmanuilovich Haasen was both a collector of modern art (of works by Bonnard, Vallotton, Marquet and Manguin among others) and an art dealer, being the partner of Félix Vallotton's brother, Paul. Haasen was the representative for the Swiss chocolate company Cailler in St Petersburg, where he lived from 1906 (his address appears in the 'All Petersburg' directory for that year). In early March

1913, Vallotton arrived in St Petersburg at Haasen's invitation and stayed in his house. On 5 March he wrote to his brother, giving his host's address, Kamennoostrovsky Prospekt, 59/1: 'I am delighted to be here and I began the portrait today; unfortunately, the weather is rather cloudy… Haasen and his wife are well; they are both very kind and go out of their way to please me' (Vallotton, 1974, letter 271). In the next letter, which was not dated but probably sent no later than mid-March, Vallotton wrote: 'The portrait is almost finished; it's turning out well and is full of interesting colourful details, as one can see almost the entire apartment which is quite gaudy' (Vallotton, 1974, letter 272). In a letter sent from Paris on 29 March, the artist returned once more to the subject of the painting: 'The portrait of Haasen is a good piece, a bit severe as always, but that's just me: I never see life as a great joke' (Vallotton, 1974, letter 273). Vallotton's receipt book contains a description of the painting: 'No. 910. Portrait of G. E. Haasen, frontal view, his arm resting on a table covered with a floral fabric; apartment background with curtains in many colours, in St Petersburg; canvas in 40' (according to the French standards of the time, 'in 40' for a figurative painting meant 81 x 100 cm). Since Vallotton dated his painting '1912 + 1', it is possible that he started work on it in Paris (possibly from a photograph) as early as 1912.

Provenance: acquired in 1921; previously in the collection of G. E. Haasen, St Petersburg (commissioned for 1,500 francs) from 1913.

Louis Valtat
1869, Dieppe – 1952, Choisel, near Rambouillet

In 1881 Valtat moved to Versailles. From 1887 to 1891 he studied at the Ecole des Beaux-Arts in Paris, and also took classes at the Académie Julian, where he met artists of the Nabis group (he later exhibited with them at the Galerie Druet). From 1889 Valtat exhibited at the Salon des Indépendants. From 1894 to 1896 he lived in the South of France: in Collioure and Banyuls, where he befriended Maillol. In 1895 he collaborated with Toulouse-Lautrec on the set designs for Aurélien-François Lugné-Poë's play Chariot de terre cuite. In 1897–8 he lived in Agay. In 1899 he moved to Anthéor, where he built a villa, Roucas Rou, and lived until the First World War. From 1915 to 1924 he lived mostly in Normandy. Valtat knew Signac and Renoir; his work was influenced by the Neo-Impressionists and Van Gogh; and he developed a style favoured by the Fauves. From 1903 Valtat exhibited at the Salon d'Automne. He painted landscapes, portraits and still lifes, and also worked as a sculptor. In 1948, having completely lost his sight, he stopped working.

365. Young Women in the Garden, c. 1898 (page 248)
Une réunion de jeunes femmes
Oil on canvas. 65 x 80 cm
Signed bottom right: L. Valtat
ГЭ 7722

There is no general consensus about the dates of this and other paintings by Valtat depicting women and children in the parks of Paris. Cogniat dated two related canvases to 1898: People in the Bois de Boulogne and Young Women in the Bois de Boulogne (R. Cogniat, Louis Valtat, Neuchâtel, 1963, p. 49, 122). The figures in the foreground of People in the Bois de Boulogne – a little girl in a white hat and a lady in a light dress fixing her hair – appear with minor changes in the Hermitage canvas. Three other paintings that are close in style and theme to Young Women in the Garden would seem to confirm the contention that the Hermitage canvas was painted in 1898: Fashionable Ladies Out Walking, Walking in the Luxembourg Gardens and Children's Games. The artist's son, Jean Valtat, himself dated these paintings to 1898 (Valtat, 1977, 207–9).

Provenance: acquired from the State Museum of Modern Western Art in 1934; previously in the Galerie Vollard; collection of I. A. Morozov (purchased from Vollard for 1,000 francs) from 1907; Second Museum of Modern Western Painting from 1918; State Museum of Modern Western Art from 1923.

366. The Boat, 1899 (page 249)
La barque
Oil on canvas. 81 x 101 cm
Signed and dated bottom right: L. Valtat 99
ГЭ 5108

The card index at the Second Museum of Modern Western Painting indicates that the verso of this painting bore a pencil inscription that was barely legible: L. Valtat. Cagnes. Since it is no longer visible, it is impossible to establish whether it was inscribed by the artist. According to Vollard, when I. A. Morozov purchased the picture, he was told that Valtat had painted it in Banyuls-sur-Mer, and indeed Valtat had worked in Banyuls-sur-Mer and Collioure at that time. The organisers of the 1995 Valtat retrospective in Bordeaux reject the possibility that it might have been done in Banyuls-sur-Mer, insisting that the painting belongs to a series that was created in Agay, where the artist worked at the beginning of 1899 (Louis Valtat: Exposition retrospective, Musée des Beaux-Arts, Bordeaux, 1995, no. 39). Both the motif of children playing in the sand and the nature of the landscape make it unlikely that The Boat was painted in the winter. Finally, the catalogue of Valtat's works compiled by his son, Jean Valtat, contains a version of the Hermitage composition entitled Boat at Anthéor (Valtat, 1977, 12) and incorrectly dated to 1891. It depicts the same landscape in the background, but the boat and figures are arranged somewhat differently. This version was reproduced by Valtat and dated to 1899 (Valtat, 1977, 250). The contention that the entire group of paintings was painted in Agay is confirmed by Mother and Children on the Beach (Bordeaux, Musée des Beaux-Arts), which is dated and inscribed by the artist Agay/99. This canvas depicts the family of a local fisherman, Bompart, and it is possible that the same people are shown in the Hermitage painting. Valtat evidently painted Children in the Boat (c. 1899; private collection; Louis Valtat exhibition, Petit Palais, Geneva, 1969, no. 16; incorrectly dated in the catalogue to 1905) around the same time. The motif of a woman with children depicted against the background of a boat hauled up onto the sand recurs in a small painting, The Boat (1899; Bordeaux, Musée des Beaux-Arts), in which the woman is wearing a red dress and is seated; the sea, not the rocky cliff, forms the background.

Provenance: acquired from the State Museum of Modern Western Art in 1948; previously in the Galerie Vollard; collection of I. A. Morozov (purchased from Vollard for 1,000 francs) from 1906; Second Museum of Modern Western Painting from 1918; State Museum of Modern Western Art from 1923.

367. Violet Cliffs, 1900 (page 250)
Les falaises violettes
Oil on canvas. 65.5 x 81.5 cm
Signed and dated bottom left: Valtat 19[00]
ГЭ 8961

This painting is better known as The Surf. Valtat's original title, Violet Cliffs, was preserved on the label pasted on the stretcher. The date on the painting is illegible, which explains why it was read as 1901, and even 1911, which is hardly likely as the picture was acquired by M. A. Morozov, who died in 1903. The same cliffs are shown in Seascape, but from the opposite side. Seascape was exhibited at the Salon d'Automne of 1905 and reproduced in L'Illustration (4 November 1905) on the famous page devoted to the emergence of the Fauves. The landscape is also similar to Red Cliffs of Anthéor (c. 1901; formerly Paris, J. Besson collection). Besson, who knew Valtat well, emphasised that it was in Anthéor that the painter's talents as a colourist emerged fully. It seems likely that the Hermitage landscape was painted there as well.

Provenance: acquired from the State Museum of Modern Western Art in 1948; previously in the collection of M. A. Morozov; collection of M. K. Morozova from 1903; Tretyakov Gallery (gift of M. K. Morozova) from 1910; State Museum of Modern Western Art from 1925.

368. Young Girls Playing with a Lion Cub, c. 1905–6 (page 252)
Jeux d'enfants (Jeunes filles jouant avec lionçeau)
Oil on canvas. 81.5 x 100.5 cm
Monogrammed bottom right: L. V.
ГЭ 6574

The original title, Children's Games, with its humorous subtext, appears in pencil on the stretcher and was probably written by Valtat himself. The motif of this painting relates it to the 1906 compositions with four bathers (Valtat, 1977, 603–605), the most important being the large-scale Bathers (1906; Geneva, Musée Petit Palais), while the background bears similarities to the 1905 landscapes of Agay and Esterel.

Provenance: acquired from the State Museum of Modern Western Art in 1931; previously in the Galerie Vollard; collection of I. A. Morozov (purchased from Vollard for 800 francs) from 1908; Second Museum of Modern Western Painting from 1918; State Museum of Modern Western Art from 1923.

369. Bay of Anthéor, c. 1906–7 (page 250)
Le golfe d'Anthéor
Oil on canvas. 74 x 93 cm
Signed bottom left: L. Valtat
ГЭ 8887

This painting is traditionally dated to 1907, the year it was first exhibited at the Salon d'Automne. It could, however, have been painted earlier, for in motif and style it is close to Sailing-boat (1906; private collection), which depicts the Bay of Anthéor with the hills in the background.

Provenance: acquired from the State Museum of Modern Western Art in 1948; previously in the Galerie Vollard; collection of I. A. Morozov (purchased from Vollard for 1,000 francs) from 1907; Second Museum of Modern Western Painting from 1918; State Museum of Modern Western Art from 1923.

370. Landscape of the South of France, c. 1908 (page 251)
Paysage du midi
Oil on canvas. 60 x 73.5 cm
Signed bottom right: L. Valtat
ГЭ 7718

This canvas has traditionally been dated to 1909, the year it was exhibited at the Salon d'Automne, but its more likely date of execution is 1908 when Valtat was working in Provence, for he spent the summer of 1909 in Normandy. Stylistically, too, the painting is close to works of 1908.

Provenance: acquired from the State Museum of Modern Western Art in 1934; previously in the Galerie Vollard; collection of I. A. Morozov (purchased from Vollard for 1,000 francs) from 1907; Second Museum of Modern Western Painting from 1918; State Museum of Modern Western Art from 1923.

371. Sun through the Trees, c. 1908–9 (page 251)
Soleil dans un sous-bois
Oil on canvas. 66 x 82 cm
Signed bottom right: L. Valtat
ГЭ 7717

This painting, which depicts the mountainous hills of Esterel in the background, was exhibited at the Salon d'Automne of 1909, and it is generally to this year that it is dated. However it is possible that it could have been painted slightly earlier. In technique it is similar to Valtat's 1908 painting Red Cliffs of Anthéor (private collection).

Provenance: acquired from the State Museum of Modern Western Art in 1934; previously in the Galerie Vollard; collection of I. A. Morozov (purchased from Vollard for 800 francs) from 1909; Second Museum of Modern Western Painting from 1918; State Museum of Modern Western Art from 1923.

Maurice de Vlaminck
1876, Paris – 1958, Reuil-la-Gadelière, Eure et Loire

Vlaminck did not receive any formal training and began to study painting only in 1899. From 1893 to 1896 he had been a professional cyclist, from 1893 to 1896 a music teacher and member of an orchestra, and from 1898 to 1899 a journalist with anarchist leanings. In 1900 Vlaminck met Derain and shared a studio with him in Chatou. The Van Gogh exhibition of 1901 exerted a profound influence on him. In 1905 he made his début at the Salon des Indépendants and at the Salon d'Automne, where he exhibited with Matisse, Derain, Manguin and Friesz. In 1906 Vollard bought up all his paintings. That year he met artists and poets from the Bateau-Lavoir: Picasso, Van Dongen, Jacob, and Apollinaire. In 1908, influenced by Cézanne, he moved away from Fauvism. In 1911 Vlaminck visited London, and in 1913 he worked in Martigues and Marseilles with Derain. After the First World War he moved to Valmondois, and in 1925 he settled in Ruéil-la-Gadelière. He experimented with set designs and cartoons for tapestries; turned to lithographs and woodcuts; wrote poetry, articles and novels, including *D'un lit dans l'autre* in 1902 and *Tout pour cela* in 1903, with illustrations by Derain.

372. View of the Seine, *c.* 1906 (page 279)
Une vue de la Seine
Oil on canvas. 54.5 x 65.5 cm
Signed bottom left: *Vlaminck*
⌐Ə 9112

View of the Seine depicts Chatou in the outskirts of Paris, where Vlaminck worked with Derain. The bridge at Chatou, which Vlaminck painted on several occasions between 1905 and 1907, can be just made out on the right background. Vlaminck explored a similar motif in *Boats at Chatou* (1906; Geneva, Mayer collection) and *Bridge at Chatou* (1907; Berlin, National Gallery).

Provenance: acquired from the State Museum of Modern Western Art in 1948; previously in the Galerie Vollard; collection of I. A. Morozov (given to him by Vollard as a free addition to a number of paintings purchased by Morozov) from 1908; Second Museum of Modern Western Painting from 1918; State Museum of Modern Western Art from 1923.

373. Small Town, *c.* 1908–9 (page 283)
Bourg
Oil on canvas. 73.4 x 92.3 cm
Signed bottom right: *Vlaminck*
⌐Ə 6539

This painting should be dated to late 1908/early 1909, for it appeared in the Kahnweiler Gallery around that time. Nonetheless, in terms of technique *Small Town* stands apart from other works of 1908. Evidently *Landscape*, which came to auction at Christie's on 1 December 1967 and was dated 1909, was painted at the same time as *Small Town* since it depicts the same place. It has been suggested that the little town may be Valmondois in the Seine and Eure, not far from Paris.

Provenance: acquired from the State Museum of Modern Western Art in 1930; previously in the Galerie Kahnweiler from 1909; collection of S. I. Shchukin; First Museum of Modern Western Painting from 1918; State Museum of Modern Western Art from 1923.

374. Small Town on the Seine, *c.* 1909 (page 282)
Bourg au bord de la Seine
Oil on canvas. 81.3 x 100.3 cm
Signed bottom left: *Vlaminck*
⌐Ə 9111

From the moment this painting was acquired by S. I. Shchukin, it became known as *Small Town by a Lake*. However, the water is not a lake, but the Seine, which Vlaminck often painted at the time. It can be suggested that the small town is Bougival, where the painter worked in 1909–10 (see cat. 375); it is shown from a different viewpoint and more conventionally than in the eponymous painting. For the sake of comparison it is worth mentioning that another painting in Shchukin's collection which has incorrectly been taken to show a lake – Derain's *Landscape with a Boat* (cat. 89) – also depicts the Seine. *Small Town on the Seine* was influenced by the example of Cézanne, to which Vlaminck turned in about 1908; in fact it is possible to determine exactly which of Cézanne's paintings inspired him: *Lake Annecy* (1896; London, Courtauld Institute; R. 805), as well as three versions of *Banks of the Marne* (cat. 34, 1888; R. 622, 623, 624). At the beginning of the century all these paintings were in the Galerie Vollard, with which Vlaminck was connected, and so he must have known them. *Small Town on the Seine* can be dated to *c.* 1909 because by early 1910 it was already in the Galerie Kahnweiler (the gallery's label has survived with the number '569': paintings with numbers near to it passed through the gallery at this time).

Provenance: acquired from the State Museum of Modern Western Art in 1948; previously in the Galerie Kahnweiler from 1910; collection of S. I. Shchukin from 1910; First Museum of Modern Western Painting from 1918; State Museum of Modern Western Art from 1923.

375. Bougival, *c.* 1909 (page 284)
Oil on canvas. 73 x 92 cm
Signed bottom left: *Vlaminck*
⌐Ə 9113

Until recently this painting was known as *Small Town with a Church*. Sauvage (Sauvage, 1956, p. 95) determined that the town is Bougival, and he dated the picture to 1910. However, it was more likely to have been painted in 1909, which is when it appeared at the Kahnweiler Gallery. Vlaminck later painted another *Bougival* (at one point in the Perls Gallery, New York) which Sauvage dated to 1911. It also depicts the town's main attraction, the church of Nôtre-Dame (which dates back to the 12th or 13th century), but from a different viewpoint.

Provenance: acquired from the State Museum of Modern Western Art in 1948; previously in the Galerie Kahnweiler from 1909; collection of S. I. Shchukin; First Museum of Modern Western Painting from 1918; State Museum of Modern Western Art from 1923.

376. Landscape with a House on a Hill, *c.* 1925–6 (page 368)
Paysage avec une maison sur une colline
Oil on canvas. 33 x 41 cm
Signed bottom left: *Vlaminck*
⌐Ə 10174

This painting is related to a group of landscapes from the mid-1920s that depict villages in the Oise region. Its romantic details – the lone house on the hill, the scattered bare bushes, the overcast sky – are characteristic of the series.

Provenance: acquired in 1972; previously in the Ginger-Sery collection, Leningrad.

Edouard Vuillard
1868, Cuiseaux, Saône et Loire – 1940 La Baule, near Saint-Nazaire

In 1877 Vuillard moved to Paris and studied with Roussel under Diogène Maillart. After a brief stint at the Ecole des Beaux-Arts, where he studied under Gérôme, he started attending classes at the Académie Julian, where he befriended Bonnard, Ranson, Sérusier and Denis. Vuillard was a founding member of the Nabis in 1889. He grew very close to Bonnard, with whom he studied the paintings of the Old Masters at the Louvre and those of contemporary artists at the Musée du Luxembourg. Vuillard's work was influenced by Gauguin. He shared a studio with Bonnard and Denis. From 1892 he began to paint large-scale murals, starting with six panels for Paul Desmarais; a year later he created a series of nine panels for Alexandre Natanson. Vuillard met Mallarmé. In 1896 he started work on an album of lithographs, *Landscapes and Interiors*, that were commissioned by Vollard. In 1901 Vuillard exhibited at the Salon des Indépendants; from 1903 to 1911, at the Salon d'Automne; and from 1899 to 1914 at the Galerie Bernheim-Jeune with Bonnard. In 1905 he and Bonnard visited Spain, and in 1913 they went to Germany. In 1906 Vuillard taught at the Académie Ranson. From 1917 to 1924 he lived alternately in Paris and Vaucresson. In 1936 Vuillard, together with Denis and Roussel, painted decorative murals for the League of Nations building in Geneva. In 1937 Vuillard became a member of the Institut de France. He painted interiors, landscapes, portraits and still lifes, and also worked in the theatre.

377. In The Room, 1899 (page 218)
Intérieur
Oil on cardboard pasted on wood. 52 x 79 cm
Signed and dated top right: *E. Vuillard 99*
⌐Ə 6538

Due to the final digit of the date being unclear, this painting is sometimes dated to 1893 and sometimes 1899. The difficulty lies in the fact that between 1893 and 1899 the artist's style changed little. However, 1899 can be regarded as the correct date because towards the end of the 1890s Vuillard showed a preference for bright colours rather than the grey, ochre and neutral tones which dominate his earlier work (and to some extent this painting as well). Furthermore, in the interiors of 1898 and 1899, in particular *Two Armchairs* (1898; Paris, private collection) and *The Sitting-Room with Three Lamps* (*c.* 1899; Zurich, Zumsteg collection), the figures and the furniture are placed in a similar relationship to one another within the space of the painting. A comparison with Vuillard's colour lithographs from his series *Landscapes and Interiors*, published by Vollard the same year, offers further support to the contention that the Hermitage canvas dates to 1899. The organisers of the 1968 *Vuillard and Roussel* exhibition held in Munich and Paris entitled the painting *Interior with a Stove* and dated it 1899. It is possible that the man standing by the table in the middle of the painting is Cipa Godebski, whom Vuillard painted on a number of occasions. In any case, his depiction here resembles the *Man with a Pipe* (late 1890s; Paris, private collection), which is indeed a portrait of Godebski.

Provenance: acquired from the State Museum of Modern Western Art in 1930; previously in the collection of S. I. Shchukin (acquired before 1908); First Museum of Modern Western Painting from 1918; State Museum of Modern Western Art from 1923.

378. Children, *c.* 1909 (page 219)
Enfants
Tempera on paper pasted on canvas. 84.5 x 77.7 cm
Signed bottom right: *E. Vuillard*
42153

Children was painted in Saint-Jacu-de-la-Mer, a village on the Normandy coast to which Vuillard had been invited by Alfred Natanson. Part of Saint-Jacu-de-la-Mer is visible behind the balcony. Vuillard maintained close ties with the three Natanson brothers – sons of a wealthy banker – who founded the *Revue Blanche*. All three brothers were very interested in Vuillard's paintings, and the

youngest, Alfred, owned several of his works. In 1900 Vuillard paint-
ed a portrait of Alfred and his wife. Alfred Natanson was also a
writer who wrote under the pen-name Alfred Atis; he collaborated
with Tristan Bernard. His daughter recalled the summer of 1909 in
Saint-Jacu, when Vuillard painted both her and her sister, while in
the next room her father and Tristan Bernard were working on a new
play called *Les Costauds des Epinettes*. The pencil study for the
painting (Paris, private collection; B. Thomson, *Vuillard*, London,
1988, p. 96) was clearly done from life. It already shows the basic
outline of the composition, but comparison with the Hermitage paint-
ing reveals that it served only as a point of departure, for while
working on the painting Vuillard made major changes. The sisters
changed places, and the rug moved from the right to the left. A
Japanese screen with a floating composition appeared, introducing
an aspect characteristic of the art of the Nabis. A similar screen is
visible in a photograph taken in 1895 of Thadée Natanson and
Bonnard in Vuillard's house (Th. Natanson, *Le Bonnard que je pro-
pose*, Geneva, 1951, No. 1). In the sketch the children are clearly sit-
ting on a couch; this is only suggested in the painting, in which they
play a smaller role. Their faces cannot be seen, and they themselves
have been transformed into patches of colour that are no more sig-
nificant than the other areas of colour – the rug, screen or door – in
the painting.

Provenance: acquired from the State Museum of Modern Western
Art in 1934; previously in the Galerie Bernheim-Jeune; collection of
M. O. Tsetlin, Moscow; Rumyantsev Museum, Moscow; State
Museum of Modern Western Art from 1925.

Félix Ziem
1821, Beaune, Côte d'Or – 1911, Paris

After graduating in architecture from the Ecole des Beaux-Arts in
Dijon in 1839, Ziem started working as an architect in Marseilles in
1840. He visited Italy around the same time, which was when he
decided to become a painter. Ziem accepted an invitation from Prince
G. G. Gagarin, whom he met in Italy, to go to Russia, where he lived
from 1841 to 1843. His work was influenced by Corot and the
painters of the Barbizon school, and he was friends with Théodore
Rousseau. In 1847 Ziem visited Italy and Turkey, and in 1864 he went
to England. From 1849 to 1868, and again in 1888, Ziem exhibited at
the Salon. In 1861 he settled in Martigues. From the mid-1850s he
began to paint mostly views of Venice and Constantinople, as well as
numerous watercolours.

 **379. Harbour in Constantinople, 1880s
(page 78)**
Port de Constantinople
Oil on canvas. 82 x 142 cm
Signed bottom left: *Ziem*
Гэ 5782

This painting was exhibited at the 1888 *Exhibition of French
Painters in Support of the Red Cross Nurses* in St Petersburg,
where it was acquired for the Emperor's collection. It is also known
as *Evening in Constantinople*.

Provenance: acquired from the Anichkov Palace, St Petersburg, in
1918; previously in the collection of Emperor Alexander III at the
Anichkov Palace (acquired for 10,000 francs) from 1888.

Sculpture

Albert Bartholomé

1848, Thivervnal, Seine et Oise – 1928, Paris

Bartholomé first studied painting under Barthélemy Menn in Geneva, and under Gérôme in Paris. He was a close friend of Degas with whom he often travelled around France. In the 1880s many artists and writers – Degas, Rafaëlli, Mary Cassatt, Blanche, Geoffroy and Huysmans – gathered regularly in Bartholomé's house. He started studying sculpture independently in the mid-1880s without receiving any formal training. His most important work is the 1899 Monument to the Dead at the Père-Lachaise cemetery in Paris. From 1879 to 1886 he exhibited at the Salon, and from 1892 at the Salon of the Société Nationale des Beaux-Arts, of which, in 1914, he became vice-president and then, in 1921, president. At the 1900 Exposition Universelle in Paris he won the Grand Prix.

380. Weeping Girl, _c._ 1895 (page 239)
Jeune fille en pleurs
Marble. _h._ 26 cm; _w._ 40 cm
Signed on the right of the base: _ABartholomé_
H. Cк. 2077

The death of Bartholomé's young wife Perie in 1887 inspired him to take up sculpture: most of his works are connected with the theme of mourning. Bartholomé achieved the best results with his miniature portrayals of solitary mourners such as the _Weeping Girl_, which can be dated to the mid-1890s. In the Musée d'Orsay there is a bronze sculpture of the _Weeping Girl_ (1894), which was acquired by the French government from the Salon of the Société Nationale des Beaux-Arts for the Musée du Luxembourg in 1894. A stone sculpture of a weeping girl is in the Musée des Beaux-Arts in Mulhouse.

Provenance: acquired in 1937.

381. Adam and Eve, early 1900s (page 238)
Adam et Eve
Marble. _h._ 163 cm; _w._ 56 cm
Signed on the edge of the base: _ABartholomé_
H. Cк. 1303

This work, depicting the expulsion of Adam and Eve from the Garden, follows a traditional iconographic formula whose foundations were laid by Masaccio's frescoes at the Brancacci Chapel of Santa Maria del Carmine in Florence.

Provenance: acquired from the House of Arts (house of S. P. Eliseyev), Petrograd, in 1923; previously in the collection of S. P. Eliseyev, St Petersburg.

Emile-Antoine Bourdelle

1861, Montauban – 1929, Le Vésinet, Seine et Oise

Bourdelle studied at the Ecole des Beaux-Arts in Toulouse from 1876 to 1884; after winning a competition to go to Paris, he studied at the Ecole des Beaux-Arts under Alexandre Falguière and Jules Dalou from 1884 to 1886. He exhibited at the Salon from 1884. Bourdelle worked as Rodin's assistant from 1893 to 1903, and was deeply influenced by him. The study of Ancient Greek and medieval sculpture shaped Bourdelle's individual style, as can be seen in _Hercules the Archer_ (1909) and in the bas-reliefs at the Théâtre des Champs-Elysées (1912–13). He created a whole gallery of portraits, largely historical, including Beethoven, Rembrandt, Ingres, Daumier and Carpeaux. He also executed a series of monuments: a memorial commemorating those who died in the Franco-Prussian War of 1870–1 in Montauban (1893–1902); to the poet Adam Mickiewicz in Paris (1909–29); to General Alvear in Buenos Aires (1912–23); and a monument entitled _France_ in Montauban (1925–32). Bourdelle taught at the Académie de la Grande Chaumière. He visited Italy, Greece and Czechoslovakia. He was a sculptor, painter (including frescoes), graphic artist, and book illustrator.

382. Large Tragic Mask of Beethoven, 1901 (page 245)
Grande masque tragique de Beethoven
Bronze. _h._ 77 cm
Signed on the side of the neck: _Bourdelle_; founder's mark: _cire A. Valsuani perdu_ and sculptor's monogram: _EAB_
H. Cк. 2429

Bourdelle executed over fifty sculptures as well as a whole series of drawings and pastels of Beethoven, who, alongside Bach, always remained his favourite composer. A small bust done in 1888 laid the foundation for the works to follow: it captured Beethoven's physical features, but, more importantly, it expressed his total immersion in the world of music. Bourdelle's Beethoven cycle may be divided into three periods: the first from 1888 to 1891; the second, 1901–1910; and the third, 1925–29. The most important work of the first period is _Beethoven with a Large Mane_ (1888–91) which bears the inscription: _Mon domain c'est l'air, quand le vent se lève, mon âme tourbillonne_ [Air is my element, when the wind rises, my soul swirls]. _Large Tragic Mask of Beethoven_ begins the second period. It was followed by a 1902 sculpture, _Large Tragic Mask_, which bears the inscription: _Moi je suis Bacchus qui pressure pour les hommes le nectar délicieux_ [I am Bacchus who produces delicious nectar for people].

Provenance: acquired after the 1972 Bourdelle exhibition at the Hermitage in 1973; previously in the collection of the sculptor's daughter, Rodia Dufet-Bourdelle.

383. Portrait of Ingres, 1908 (page 244)
Portrait d'Ingres
Bronze. _h._ 82 cm
Signed on the edge of the left shoulder: _Emile-Antoine Bourdelle_; mark on the back near the foot of the bust: _BY Bourdelle_; founder's mark to the right on the opposite edge: _M. Hehwiller Fondeur N9_
H. Cк. 2431

The image of Ingres occupied a central place in Bourdelle's consciousness from an early age. It is unlikely that Bourdelle remembered the great master, for he died when Bourdelle was only six years old. But in Mountauban's small artistic milieu, Ingres was the subject of much talk, the more so as Bourdelle's first teacher was Ingres's student. From early on this young provincial who dreamed of conquering Paris must often have thought of the example of Ingres, also originally from Montauban, who had succeeded so brilliantly in the capital. In his depictions of the renowned painter, Bourdelle drew on Ingres's own late self portraits, such as _Self-Portrait at the Age of 78_ (1858; Florence, Uffizzi Gallery). But Bourdelle radically altered and dramatised the image, rejecting all the conventions of decorum (for example, Ingres would invariably remind the public of his order of the Légion d'honneur) and even of clothing. In 1908 Bourdelle executed two versions of a portrait of Ingres, each showing a man who is domineering, strong-willed and introspective. The type illustrated by the Hermitage work (with other casts at the Musée Bourdelle in Paris and the Musée Ingres in Montauban) is characterised by a heightened dynamism in both the turn of the head and the expression of the face, as well as by a great spontaneity of execution. A second version, seen in examples at the Stockholm National Gallery and the Musée Bourdelle, is more grandiose and closer to Ingres's own self-portraits.

Provenance: acquired after the 1972 Bourdelle exhibition at the Hermitage in 1973; previously in the collection of the sculptor's daughter, Rodia Dufet-Bourdelle.

384. Eloquence, 1916–18 (page 244)
L'éloquence
Bronze. *h.* 47 cm
Monogrammed on the neck under the right ear: *AB*
Founder's mark on the base: *A. Valsuani cire perdue*
H. Cκ. 2430

This sculpture is connected with Bourdelle's work on the monument to General Alvear, one of the leaders in Argentina's war of independence. Bourdelle received this commission primarily because Dalou and Rodin had recommended him 'as the best candidate' to the Organising Committee responsible for commissioning the monument. Bourdelle had executed a preparatory model as early as 1912, and the following year signed an agreement binding him to certain conditions. The committee proposed that the sculptor 'depict the general on a horse, as well as four allegorical figures symbolising Alvear's work and character: Strength, Victory, Freedom and Eloquence'. Bourdelle worked alone and under difficult conditions. He had to build the wooden model for the pedestal by himself: with the advent of the First World War, it became almost impossible to find workers. Following a centuries-old tradition for monuments of this kind, Bourdelle resolved the statue of the horse fairly quickly, but the allegorical figures required much thought. He admitted later that he had redone each figure between six and eight times. In the first version, these figures were sitting at the foot of the pedestal, then yielding to the vertical lines of the work, they 'stood up'. Bourdelle replaced the soldiers who had embodied the allegories with women, then resumed work on the seated figures. After doing many sketches and studies, he produced the final version. In 1916 Bourdelle finished the models for the standing figures which were 122 cm tall; in 1920 they were increased in size by threefold and exhibited at the Salon. Six years later the monument was unveiled on the Plaza de la Recoleta in Buenos Aires. Traditionally, allegorical characters play a secondary role in multi-figured monuments. In the Monument to General Alvear, however, their sculptural beauty surpasses that of the horse, the crowning centre of the work. Moreover, the plastic qualities of some of the studies, especially that of the head of *Eloquence*, are even more impressive than those on the finished monument itself. Bourdelle's first plaster cast of the 1918 study is at the Musée Bourdelle in Paris.

Provenance: acquired after the 1972 Bourdelle exhibition at the Hermitage in 1973; previously in the collection of the sculptor's daughter, Rodia Dufet-Bourdelle.

Albert-Ernest Carrier-Belleuse
1824 Anizy-le-Château – 1887, Sèvres

From 1840 Carrier-Belleuse studied at the Ecole des Beaux-Arts under David d'Angers. In 1851 he made his début at the Salon, where in 1861 he was awarded the third-class medal, and in 1867 the medal of honour. Carrier-Belleuse was Director of Art at Sèvres porcelain manufactory. He executed ornamental sculptures for government buildings and private residences, and also sculpted portraits and mythological compositions.

385. Satyr and Bacchante, mid-1870s (page 132)
Satyre et bacchante
Terracotta. *h.* 60 cm
Signed on the front of the base: *A. Carrier*
H. Cκ. 946

This terracotta group, which used to be dated to the end of the 1870s, was probably executed in the mid-1870s. The bacchante bears a clear resemblance to Mademoiselle Croizette, whose terracotta bust Carrier-Belleuse had exhibited at the 1874 Salon (now at the Comédie-Française in Paris). It did not go unnoticed: at the time all of Paris was talking about the latest productions at the Comédie-Française featuring this actress. *Satyr and Bacchante* is very similar to another terracotta with the same dimensions and configuration, *Triton Carrying A Nymph* (London, Barclay collection), in which the nymph depicts the same model.

Provenance: acquired from the Anichkov Palace in 1928; previously in the collection of Alexander III at the Anichkov Palace, St. Petersburg.

Jules Dalou
1838, Paris – 1902, Paris

From 1854 Dalou studied at the Ecole des Beaux-Arts under Carpeaux and Duret. He competed unsuccessfully for the Prix de Rome four times. From 1867 he exhibited at the Salon, and from 1890 at the Salon of the Société Nationale des Beaux-Arts. In 1870–1 Dalou participated actively in the Paris Commune, and after its suppression in 1871, emigrated to England, where he was supported by Alphonse Legros. From 1872 to 1879 he exhibited at the Royal Academy in London. In 1875 he visited Belgium. In 1879 he returned to Paris after a general amnesty was declared. Dalou executed a series of memorial portraits and tombs, and from 1879 to 1899 worked on the allegorical monument the *Triumph of the Republic* in the Place de la Nation in Paris. In his final years he worked on a monument to labour.

386. Peasant Woman Nursing an Infant, *c.* 1874 (page 135)
Paysanne au nourrisson
Terracotta. *h.* 125; *w.* 70
Signed on the base near the left foot: *Dalou*
H. Cκ. 1065

Juno Nursing Hercules (drawing in M. Dreyfus, *Dalou, sa vie, son oeuvre*, Paris, 1903, p. 58) preceded *Peasant Woman Nursing an Infant* and other explorations of this motif. In 1872 Dalou depicted his wife nursing an infant and that same year exhibited the plaster statuette as *Maternal Joy* at the Royal Academy in London (now at the Musée du Petit Palais in Paris). Around 1880, under the title *Parisienne Nursing an Infant*, this group was cast in ceramic, and in 1907 in Sèvres biscuit. At the 1873 exhibition at the Royal Academy, Dalou showed the terracotta *Motherhood* (London, Tate Gallery), once again portraying his wife and daughter. This time he depicted the mother as a Breton peasant-woman in traditional heavy clogs and headscarf, sitting on an upturned basket. In both instances Dalou's point of departure was *Juno Nursing Hercules*: the nursing of an infant was presented within a mythological framework, but being dissatisfied with the work, he began to explore contemporary variations. The 'Breton-Woman and Child' soon became very popular and inspired Dalou to create larger variations: one is at the Hermitage, the other at the Victoria and Albert Museum in London. The terracotta in the Tate Gallery is relatively small, only 44 centimetres high. Making the most of the motif's popularity, Dalou executed other small replicas in terracotta and marble, and later the Sèvres manufactory issued an example in biscuit after the plaster model (Paris, Musée du Petit Palais). There is also a bronze version of the smaller replica. Dalou did not stop there: in 1874 he returned to the 'bourgeois' version of *Motherhood* (terracotta sculpture at the Musée du Petit Palais; other bronze casts also exist). In 1874 the heir to the Russian throne, the future Alexander III, visited Dalou's studio, where he became acquainted with different versions of *Motherhood*. Apparently an agreement was reached at that time to create a large-scale version of *Peasant Woman Nursing an Infant*.

Provenance: acquired from the Anichkov Palace in 1928; previously in the collection of Alexander III at the Anichkov Palace, St Petersburg.

387. Sleeping Child, *c.* 1879 (page 133)
Enfant endormi
Bronze. *h.* 21; *w.* 18
Signed behind the right shoulder: *Dalou*; founder's mark: *cire perdue/ A. A. Hébrard*
H. Cκ. 2402

Sleeping Child can be traced back to the studies for the *Monument to the Queen of England* (Paris, Musée du Petit Palais), which was commissioned by Queen Victoria for Windsor Chapel. Dalou had worked on the monument – a large terracotta group depicting an angel with children – in 1876–8. Later, when the sculptor was already in Paris, the founder Hébrard made bronze castings from the terracotta studies using the technique of *cire-perdue* (lost-wax). The terracotta original is in the Musée du Petit Palais in Paris.

Provenance: acquired from L. A. Varshavskaya, Leningrad, in 1969.

388. Bather, *c.* 1890 (page 136)
Baigneuse
Bronze. *h.* 34.5 cm
Signed on the base: *Dalou*
H. Cκ. 1465

This statuette depicts Mademoiselle Gilardi, who posed for Dalou at the end of the 1880s. At that time Dalou did a portrait bust of her, *Bust of a Young Woman* (plaster model in the Musée du Petit Palais, Paris), which was cast in bronze around 1890.

Provenance: acquired from the State Museum Fund in 1927.

389. Young Girl in a Fichu, early 1890s (page 137)
Jeune fille en fichu
Marble. *h.* 40 cm; *w.* 25 cm
Signed under the base at the back: *Dalou*
H. Cκ. 2377

Provenance: acquired from N. G. Kulev, Leningrad.

390. The Day is Over, late 1890s (page 136)
Journée remplie
Bronze relief. *diam.* 16.7 cm
Front inscription: *JOURNEE REMPLIE*; signed bottom left: *DALOU*
H. Cκ. 2357

This bronze relief is probably one of Dalou's late works. Its theme is almost parodic: since antiquity, sculpted horsemen in every form – from monuments to medals – have symbolised strength and power. However, the pose of Dalou's figure, sitting crosswise on his horse, and the downcast appearance of the animal, convey neither pathos nor heroism.

Provenance: acquired in 1959.

Prosper d'Epinay
1836, Port Louis, Mauritius – 1914, Paris

From 1857 to 1860 D'Epinay studied under Jean-Pierre Dantan the Younger in Paris, and in 1861 under Luigi Amici in Rome. From 1874 to 1890 he exhibited at the Salon, and in 1881 had his first one-man exhibition at the Royal Academy in London. He painted portraits, including caricatures and nudes, as well as mythological and biblical compositions.

391. Beggar-Cupid, 1887 (page 133)
Amour mendiant
Marble. *h.* 103 cm
Signed and dated on the base: *1887. D'Epinay Pros*
H. Cκ. 940

The technique of creating the effect of transparent cloth in marble goes back to Stefano Maderno's *Santa Cecilia* (1599; Rome, Church of Saint Cecilia). In the middle of the eighteenth century Antonio Corradini used it often in both his secular and religious statues. Pietro Marchetti, professor and director of the Accademia di Belli Arti in Carrara, must be considered the direct forerunner of D'Epinay

in the masterly portrayal of a draped body. D'Epinay was undoubtedly familiar with the work of this sculptor of the first half of the nineteenth century. His *Beggar-Cupid* recalls Marchetti's *Bust of a Veiled Infant* (*c.* 1840; Los Angeles, County Museum of Art).

Provenance: acquired from the Anichkov Palace in 1928; previously in the collection of Alexander III at the Anichkov Palace, St. Petersburg.

Aristide Maillol
1861, Banyuls-sur-Mer –1944, Perpignan

In 1881 Maillol went to Paris to study painting, and in 1883 enrolled in the department of sculpture at the Ecole des Arts Décoratifs. In 1885, after several unsuccessful attempts, he entered the Ecole des Beaux-Arts, where he studied painting under Gérôme and Cabanel. In 1889 Maillol became good friends with Bourdelle, and in 1892 met Gauguin. Maillol was influenced by the works of Gauguin, Puvis de Chavannes and Denis. He studied Gothic tapestry design at the Musée de Cluny. In 1893, after abandoning painting, he opened a small tapestry studio in Banyuls. In 1896 he exhibited his sculptures for the first time at the Salon, and at that time befriended members of the Nabis. In 1900 he gave up tapestry design because of failing eyesight and devoted himself to sculpture. In 1902 Vollard organised Maillol's first one-man exhibition. In 1905 Rodin introduced Maillol to Count Harry Kessler, who became his patron and commissioned the relief *The Desire*. Maillol executed a portrait of Renoir in 1907, having persuaded him to take up sculpture. In 1908 Maillol accompanied Kessler and Hugo von Hofmannsthal to Greece. In 1910–11 he completed an ensemble of sculptures commissioned by I. A. Morozov, entitled *The Seasons*. In 1912 he started work on a monument to Cézanne that was rejected by the municipality of Aix in 1925. In 1928 and 1930 Maillol visited Greece, and in 1936 Italy. He also made lithographs and illustrated books by Ovid, Longus, Verlaine and Ronsard.

392. Standing Bather Adjusting Her Hair, 1900 (page 240)
Baigneuse debout se coiffant
Bronze. *h.* 26 cm
Monogrammed on the base: *AM*; founder's mark at the back: *A. Bingen et Costenoble Fondeurs. Paris*
H. Cκ. 1691

A slightly altered version of this statuette was done in 1926.

Provenance: acquired from the State Russian Museum in 1930.

393. Nude, 1900 (page 242)
Femme nue debout
Bronze. *h.* 67 cm
Signed near the right ankle on the base: *Aristide Maillol*
H. Cκ. 1729

Another version of this statue, *Woman Bather without Drapery* (1900), is notable for its full frontal pose in which the female figure is adjusting her hair with her right hand. Drawings in which Maillol explored a more natural and expressive arrangement preceded this statue, including *Young Girl in Profile* (*c.* 1899; Paris, Musée Maillol). *Standing Nude* develops the motif of the wooden statuette *Standing Nude with Raised Arm* (1898; Winterthur, Oskar Reinhart Collection), which depicts the same model. I. S. Ostroukhov was inspired to acquire *Standing Nude* after S. I. Shchukin had purchased a cast of this sculpture. *Standing Nude* quickly achieved recognition at the beginning of the century: Rodin and Denis, among others, acquired casts of it.

Provenance: acquired from the State Museum of Modern Western Art in 1931; previously in the collection of I. S. Ostroukhov, Moscow; I. S. Ostroukhov Museum of Icon-Painting and Art from 1918; State Museum of Modern Western Art from 1929.

394. Crouching Woman, 1900–2 (page 241)
Femme s'accroupie
Bronze. *h.* 17 cm
Monogrammed on the base: *AM*; founder's mark on the back: *A. Bingen et Costenoble Fondeurs. Paris*
H. Cκ. 1719

This work may be interpreted as Maillol's response to Rodin's eponymous sculpture (1880–2). Using an identical pose, Maillol has not only recreated the figure in miniature (Rodin depicted the woman life-size) but he has also liberated it from the powerful inner tension which informs Rodin's work. The original was done in plaster in Banyuls around 1900, and was given to Vollard, along with several other small works. The terracotta version, also known as *Woman with a Crab*, was shown at the Maillol exhibition at the Galerie Vollard in 1902. The statuette became so popular at the beginning of the century that Vollard issued a number of bronze casts, though how many exactly is difficult to determine. There is another copy in Russia at the Pushkin Museum in Moscow, which came from Ivan Morozov's collection. Many years later Maillol did a drawing, *Woman with a Crab* (1930; Paris, Musée Maillol), after the motif of the sculpture. The motif of a woman crouching later determined the content of one of Matisse's early canvases, *Women Bathers with a Turtle* (1908; St Louis, Art Museum).

Provenance: acquired from the Antiquariat in 1930; previously in the Galerie Vollard Gallery.

395. Woman Covering Her Face with Her Hand, 1900 (page 240)
Se voilant les yeux
Bronze. *h.* 22 cm
Signed on the back of the seat: *Aristide Maillol F*
H. Cκ. 1718

This sculpture is also known as *Shame*, a title that cannot be attributed to Maillol, for the sculptor never ascribed psychological motivations to the gestures of his figures.

Provenance: acquired from the Antiquariat in 1930.

396. Girl Kneeling, 1900–2 (page 241)
Jeune fille à genoux
Bronze. *h.* 22 cm
H. Cκ. 2344

This pose was frequently employed by European sculptors in the nineteenth century. For example, Lorenzo Bartolini's *Prayer* (1835; Milan, Museo Poldi-Pezzoli) depicts a nude girl on her knees. Maillol was undoubtedly familiar with the work of Bartolini, who was a close friend of Ingres: at the Ecole des Beaux-Arts, where Ingres was idolised, Bartolini's sculpture was placed on an equivalent level to the great master's paintings. Despite employing the same pose, Maillol has liberated it from the pathos and conventional references that characterise official art. Maillol returned at least three times to this pose which allowed him to achieve a unified and defined silhouette. In 1895 he portrayed Princess Bibesco in this manner in a small bronze statuette. The hand gesture was particularly problematic. In Bartolini's sculpture the hands clasped in prayer convey not only a religious motif but also a sense of forced emotion – everything that was foreign to Maillol's aesthetic beliefs. In his variations of the statue, Maillol preserved the figure's pose but experimented with the position of the hands, trying to 'neutralise' the gesture. In one version the hands are resting on the hips, in another, touching the heels, and in a third hanging down naturally. There is also a version without hands. The original of *Girl Kneeling* was done in Banyuls from local clay. Rewald, who knew the sculptor and was one of the first to study his work, dated it to 1900 (J. Rewald, *Maillol*, Paris, 1939).

Provenance: acquired from A. M. Kovalev in 1955.

397. Spring without Arms, 1910–11 (page 243; detail page 242)
Printemps sans mains
Bronze. *h.* 169 cm
Signed on the front of the base: *Aristide Maillol*; cast number on the back of the pedestal: *2/6*; founder's signature: *Alexis Rudier*
H. Cκ. 2727

This work is linked to the ensemble of sculptures Maillol did for Ivan Morozov's music-room. Of the four statues in the group, symbolising the seasons, the one entitled *Spring* (1910–11) is at the Pushkin Museum in Moscow. In 1910 this figure was missing both arms and head, but in the final 'Morozov' version *Spring* became a nude trying on a garland of flowers. It is as if she is looking at herself in the mirror, raising her head and extending her neck a little. Maillol worked on the 'without arms' version at the same time, doing away with any form of gesture in order to achieve a more unified silhouette. Six casts were made of the statue, the Hermitage one being the second. According to Dina Vierny, in whose gallery the statue was once kept, the light patina was done by Maillol himself.

Provenance: acquired in 1997; previously in the collection of the sculptor; Gallery of Dina Vierny, Paris; private collection, Paris, from 1982.

Henri Matisse
For his biography see page 429 of the Paintings and Drawings section.

398. Standing Nude, 1906 (page 374)
Nu debout, bras sur la tête
Bronze. *h.* 26.5 cm
Signature and cast number on the base: *Henri Matisse 7/10*; founder's mark: *C. Valsuani cire perdue*
H. Cκ. 2414 D.M. 22

Ten casts were made of this sculpture, and as the number on the base indicates, the one at the Hermitage is the seventh. The others are at the Philadelphia Museum of Art, the Städtische Museen, Heilbronn, and the Kunstmuseum, Göteborg, as well as in private collections. Matisse's work on this statuette, which is also known as *Standing Nude with Raised Arms*, can be traced back to his painting *Joy of Life* (1905–6; Merion, PA, Barnes Foundation) in which a nude woman with raised arms is depicted on the left-hand side. The figure was reproduced separately in a preparatory pen drawing (1905; private collection; Barr, 1951, p. 321). Matisse evidently thought of doing a sculpture of the figure after finishing *Joy of Life*; around that time he did a pen drawing entitled *Woman Undressing* (*c.* 1906; Flam, 1986, p. 153). The title itself indicates the significance the hand gesture had acquired for the subject. However, in his nude sculptures Matisse always avoided any allusion to clothes or accessories. A comparison with the picture reveals that Matisse's treatment of the nude changed. The languor expressed by the fluid contours of the figure in *Joy of Life*, symbolic of the Golden Age, has gone. The entire plasticity of *Standing Nude*, called to life in three dimensions, is imbued with far greater energy.

Provenance: acquired (as a gift of L. N. Delektorskaya) in 1971; previously in the artist's private collection; collection of L. N. Delektorskaya (acquired for 40,000 francs) from 1951.

399. Torso, 1909 (page 373)
Torse debout
Bronze. *h.* 25 cm
Cast number and monogram on the left leg: *10 HM*; founder's mark on right foot: *C. Valsuani cire perdue*
H. Cκ. 2393 D.M. 44

Ten casts were made of this sculpture, which is also known as *Torso without Arms and Head* and *Nude, Paperweight*. Two of the casts are in museums: the Hermitage has the ninth, the other is in the Musée Matisse in Nice. The remaining casts are in private collections. The figure's dynamism is reminiscent of that seen in ancient sculptures of

the Goddess of Victory. Matisse's sculpture can be traced back, whether consciously or not, to the *Nike* by Paionios of Mende (*c.* 420 BC; Olympia, Archaeological Museum), as well as to a lesser degree the Nike of Samothrace (*c.* 190 BC; Paris, Louvre), which Matisse knew from his student years.

Provenance: acquired (as a gift of L. N. Delektorskaya) in 1967; previously in the artist's private collection; collection of L. N. Delektorskaya (acquired for 40,000 francs) from 1951.

400. Study of a Foot, 1909–10 (page 373)
Etude de pied
Bronze. *h.* 30 cm
Cast number and monogram on the base: *0/10 HM*; founder's mark: *C. Valsuani cire perdue*
H. Cк. 2392 D.M. 43

The cast number *0/10* indicates this was a trial cast done before the bronzes were issued. The other casts are in the Musée Matisse in Nice, the Musée de Grenoble, the Nasher collection in Dallas, and in private collections. The appearance of this sculpture is probably connected with Matisse's work on the panel *Dance* (cat. 230), and has therefore generally been dated 1909, although this is open to question. In the catalogue for the Matisse sculpture exhibition held in the Museum of Modern Art, New York, in 1972, Alicia Legg dated *Study of a Foot* to 1900, based upon evidence of Rodin's influence (A. Legg, *The Sculpture of Matisse*, Museum of Modern Art, New York, 1972, p. 9). Such a date, however, is much too early, and Rodin's influence is exaggerated. For the sculpture, Matisse may also have drawn upon his *Study of a Foot* (*c.* 1895; private collection), a tracing of the plaster cast of a classical statue. Gone is the naturalistic study of details characteristic of his student drawing; the emphasis here is on the expression of movement, on the very act of creation. Matisse seems to be more interested in the act of sculpting itself, expressing the energy of the work rather than rendering a part of the human body. A sheet with two sketches (1909; Chicago, Art Insitute), one of which depicts an ankle, appeared around the same time as the sculpture *Study of a Foot*, and is clearly linked with the artist's work on *Dance* and *Music*.

Provenance: acquired (as a gift of L. N. Delektorskaya) in 1967; previously in the artist's private collection; collection of Marguerite Duthuit, the artist's daughter, from 1954; collection of L. N. Delektorskaya from 1964.

401. Crouching Venus, 1918–19 (page 374)
Vénus accroupie
Bronze. *h.* 25.5 cm
Cast number and monogram on the back of the base: *HM 9*; founder's mark: *C. Valsuani cire perdue*
H. Cк. 2394 D.M. 63

Ten casts were made of this sculpture, the Hermitage one being the ninth in the series. The others are in private collections and at the Art Museum in Baltimore. When he started work on the painting *Music* (1907; New York, Museum of Modern Art) and, in particular, on the eponymous panel commissioned by Shchukin (cat. 231), Matisse had started to include a female figure crouching on one knee. In the course of reworking the Shchukin panel, when it still contained female figures, the woman in profile at the far lower right inspired Matisse to create a sculpture: *Large Crouching Nude, Olga* (1910) was the result. A little earlier, when he had to determine the pose of the central figure of *Music* (in its 'female' stage), Matisse produced a sheet with two sketches: a figure front-on, and an ankle (1909; Chicago, Art Institute). Much later, this drawing led to the sculpture *Seated Nude with Her Arms Around Her Knees* (1918). It was then that the memories of working on *Music* and of his affair with Olga Merson came together in the Hermitage work. In the summer of 1918 Matisse returned from the South to Issy-les-Moulineaux and spent some time at the Louvre, where he found a Classical version of the motif he was working on. After returning to Nice, he created the sculpture, in essence a 'translation from antiq-

uity to modernity' for Matisse's *Venus* recreates fairly accurately the pose of the *Crouching Venus* in the Louvre (Roman copy of the 3rd century BC original). Matisse's statuette, also known as *Venus Crouching, Michelangelo*, reflects his impressions of the work of Michelangelo.

Provenance: acquired (as a gift of L. N. Delektorskaya) in 1967; previously in the collection of the artist; collection of L. N. Delektorskaya (acquired for 60,000 francs) from 1951.

402. Henriette I (Large Head), 1925 (page 376)
Henriette I. (Grosse tête)
Bronze. *h.* 29.2 cm
Monogram and cast number on the back of the base: *H M …/10*; founder's mark: *C. Valsuani cire perdue*
[Inventory number not yet assigned]

In the autumn of 1920 Matisse had begun to work in Nice with Henriette Darricarrère, a model who would pose for him until 1927. Matisse was attracted to Henriette's beauty, youth and artistic nature: she played the piano and studied ballet, and thus was entirely convincing when she posed either as a violinist, ballerina, or simply reading. Darricarrère was the model Matisse painted the most during his 'Odalisque' period: *Odalisque with Raised Arms* (1921; Tokyo, Bridgestone Museum of Art); *Odalisque in Red Culottes* (1921; Paris, Centre Georges Pompidou); *Hindu Pose* (1923; private collection); and many others. One of the final painted portrayals of Henriette – *The Dancer* (1927; formerly Krebbs collection) – is also in the Hermitage. Matisse portrayed Henriette in three sculptures that he executed in 1925, 1927 and 1929. At first he sculpted the head of his model in such a way that it stood out from his other works in its fluid plasticity and apparent closeness to nature. However, the portrait's realism should not be overstated, for it is no accident that it bears the sub-title *Large Head*. Matisse deliberately made the face fuller, the neck shorter and fatter, compressed the hair, and generally exaggerated the volume and materiality of his subject. Each detail serves not so much to convey physical likeness as to release the energy that seems to be bursting out of this sculpture. Two years later Matisse developed further his fascination with spheres in *Henriette II*. This time he essentially no longer needed a model, but rather explored the purely sculptural problems of combining the various generalised forms of the head.

Provenance: promised as a Gift of Millennium from the Sara Lee Corporation; previously in the Ahrenberg collection, USA; collection of Nathan Cummings, New York, from 1965; the Sara Lee Corporation.

403. Henriette III, 1929 (page 376)
Henriette III
Bronze. *h.* 40 cm
Monogram and cast number on the back of the base: *HM 7/10*; founder's mark: *C. Valsuani cire perdue*
H. Cк. 2418 D.M. 75

This work represents the seventh of ten casts. The others are at the Hirshhorn Museum and Sculpture Garden in Washington, the National Museum of Wales in Cardiff, the Musée Matisse in Nice, the Musée des Beaux-Arts in Dijon, and in private collections. Two years after he created *Henriette II*, when Henriette Darricarrère was no longer sitting for him, Matisse executed a third version, also known as *Large Smiling Head*. The sculpture captures a faint likeness, but it would be hard to recognise the elegant and charming Henriette in the suddenly aged and broad-faced woman depicted. It appears that Matisse had moved away from depicting physical beauty to concentrate on purely sculptural problems. In his third version, Matisse departed from the smooth spherical exterior of *Henriette II* and exaggerated the facial features even more: the furrows over the brows are more pronounced and the chin juts further forward. Matisse seemed to be more interested in drawing attention to the process of sculpting itself rather than to the finished product: the soft clay coming to life under his fingers, but still not transformed fully into a real object; the traces of the

palette-knife, the rough edges to which pieces were added, the bumps and dents in the bronze. The sculptor's attitude towards his work is different from that of the portrait painter: the sculpture is a self-validating act of creation that expresses itself even in the fact that the base is made from the same material and forms a single sculptural whole with the head.

Provenance: acquired (as a gift of L. N. Delektorskaya) in 1971; previously in the artist's private collection; collection of L. N. Delektorskaya.

404. The Birth of Venus, 1930 (page 375)
Vénus à la coquille I
Bronze. *h.* 30.5 cm
Monogram and cast number on the lower part of the shell at the back: *HM 4/10*; founder's mark: *C. Valsuani cire perdue*
H. Cк. 2413 D.M. 79

The Hermitage work is the fourth of ten casts of a sculpture that was created in Nice. The others are in the Museum of Modern Art, New York, the Baltimore Art Museum, the Musée Matisse in Nice, the Minneapolis Institute of Art, and in private collections. Although it does not resemble the pseudo-Oriental beauties that dominated his paintings in the 1920s, this statuette brings to a close the large cycle of 'Odalisques' Matisse had developed throughout that decade. The compositional concept for *The Birth of Venus* had already been formulated in the 1921 *Odalisque in Red Culottes* and in the 1923 *Hindu Pose*; in each instance the hands of the seated or partially reclining model are behind her head with the fingers interlaced. A whole group of these portrayals dates from the mid-1920s, and two are particularly close to the pose of *The Birth of Venus*: the lithograph *Large Nude in an Armchair* and its sculptural equivalent, the 1925 *Seated Nude*. Five years later Matisse found his inspiration in the Ancient Greek terracottas that depict *The Birth of Venus*. Statuettes such as *Aphrodite Anadyomene* from Alexandria (3rd century BC; Athens, National Museum) are so similar to Matisse's work that one can only conclude that he was familiar with one of them. The drawing *The Birth of Venus* (*c.* 1930; private collection; P. Schneider, *Matisse*, Paris, 1984, p. 563) is notable because it combines Matisse's impressions of antiquity with the harem fantasies of his Odalisque period. In 1932 Matisse created a second version of *The Birth of Venus*: it is a little higher so that the base becomes inseparable from the work itself, as was the case with *Henriette III*, which he had completed earlier.

Provenance: acquired (as a gift of L. N. Delektorskaya) in 1971; previously in the artist's private collection; collection of Marguerite Duthuit, the artist's daughter, from 1954; collection of L. N. Delektorskaya from 1970.

405. Standing Nude (Katya), 1950–1 (page 375)
Nue debout, Katia
Bronze. *h.* 45 cm
Monogram and cast number on the base: *HM 5/10*; founder's mark: *Valsuani cire perdue*
H. Cк. 2486 D.M. 83

This work is the fifth of ten casts. The others are at the Musée Matisse in Nice, the Nasher collection in Dallas, and in other private collections. The motif of a standing nude figure with hands behind her head was first depicted in the painting *Joy of Life* (1905–6; Merion, PA, Barnes Foundation), then in the sculpture *Standing Nude* (cat. 398). Matisse returned to this motif in later works, including the charcoal drawing *Standing Nude Seen from Behind* (1936; private collection). The 1950 pen drawing done in contours, *Standing Nude*, evidently prepared the way for the eponymous sculpture (also known as *The Broken Waist*), which turned out to be the last in Matisse's oeuvre. The terracotta model at the Musée Matisse in Nice was given to the foundry in 1953, three

years after it was finished. During that time it had dried out and cracked. Matisse decided not to repair it, so the sculpture was cast with the cracks. Photographs of Matisse at work on *Standing Nude* show the statuette in its early state: it was less expressive and more realistic. The differences between *Standing Nude* and the *Standing Nude* of 1906 can be partly explained by Matisse's desire to express his impression of a model whom he had nicknamed 'the plane tree'. The Russian model's real name was Katya or Katya-Carmen. She had sat for Matisse for several works in 1950–1, including *Katya in a Yellow Blouse* (1951; private collection; *Matisse*, 1997, pp. 234–5) and *Woman in a Blue Gandoura* (1951; Cateau-Cambrésis, Musée Matisse). Katya also posed for the sculptor Hanna Orlova, who portrayed her in one of the bronze statues on the Place du Trocadéro.

Provenance: acquired (as a gift of the artist's daughter, Marguerite Duthuit) in 1978; previously in the artist's private collection (1950–4); collection of Marguerite Duthuit from 1954.

Auguste Rodin
1840, Paris – 1917, Meudon

In 1854 Rodin studied at the Ecole Spéciale de Dessin et de Mathématiques, where he was taught by Horace Lecoq de Boisbaudran and Jean-Baptiste Carpeaux. He failed three times to gain a place at the Ecole des Beaux-Arts. In 1864 he studied at Antoine-Louis Barye's studio. His first major sculpture, *Man with a Broken Nose*, was rejected by the Salon. To earn money Rodin made models for porcelain figurines that were issued by the Sèvres manufactory. As assistant to Carrier-Belleuse, Rodin participated in important commissions (such as the house of the Marquise de Paiva on the Champs-Elysées). In 1871 Carrier-Belleuse gave him contractual work in Brussels (decorative sculptures for the façade of the Bourse, the Palace Academy), where Rodin lived until 1875 and worked with Antoine Van Rasbourgh. In 1875 he visited Italy, where Michelangelo's sculptures made a profound impression on him. In 1880 he received a commission from the French government to create the main doors for a proposed museum of decorative arts in Paris. Rodin chose as his subject the *Gates of Hell* based on Dante's *Inferno*, and he worked on these doors until the end of his life. In 1884 he received a commission from the City of Calais to create a monument to Eustache de Saint-Pierre. The monumental *Burghers of Calais* was completed five years later, but was erected only in 1895. Rodin's monument to Balzac, commissioned by the Société des Gens de Lettres, created a furore. A one-man exhibition in 1900 finally brought him success and acclaim. Rodin was a founding member of the Société Nationale des Beaux-Arts and became its vice-president in 1890. Bourdelle, Despiaux and Pompon all worked as his assistants. Apart from sculpture, Rodin also worked as a graphic artist and watercolourist.

406. Man with a Broken Nose, 1863–4 (page 138)
L'homme au nez cassé
Bronze. *h.* 50 cm; *w.* 40 cm
Signed below on the reverse: *Rodin*
H. Cк. 292

In 1863 Rodin rented an abandoned stable in a working-class district of Paris and asked Bibi, an unemployed man, to pose for him. Rodin was attracted to his wrinkled and unusual face. The choice of subject established Rodin's anti-Salon tendencies. In the course of the work, on a cold winter's night, the clay froze and cracked, and the back of the head fell off. What was left – essentially a mask (the work's other title is *Mask of the Man with a Broken Nose*) – eventually came to be regarded as a masterpiece of realistic sculpture. Rodin himself regarded *Man with a Broken Nose* as his first significant work which, in his own words, 'determined all the future work'. He submitted it to the Salon of 1864 but the jury rejected it. A bronze cast of *Man with a Broken Nose* was first shown at the Salon of 1878 under the title *Portrait of M...* At the time people were struck by its similarity with a portrait of Michelangelo by Daniele da Volterra (mid-16th century; now in the Louvre), which was exhibited at the Exposition Universelle of 1878 in the section on Italian sculpture from private collections. Not only the

physical resemblance but, more importantly, the significance of an unknown old man's face, has since then made the critics and public alike see in Rodin's work a portrait of either Michelangelo or Socrates. In 1872, after putting the finishing touches to the first version, Rodin executed *Bust of a Man with a Broken Nose*. An example in terracotta is in the University Art Museum at the University of Texas in Austin; an 1875 version in marble, which was also exhibited at the Salon, is in the Musée Rodin in Paris. Around 1900, Samuel Isham commissioned a *vase-jardinière* (now in the Museum of Fine Arts, Boston) which is adorned by two heads, one of which clearly parodies the *Man with a Broken Nose*. In all, Rodin created eleven versions of the sculpture.

Provenance: acquired in 1946.

407. The Age of Bronze, *c.* 1877 (page 139)
L'age d'airain
Plaster. *h.* 173 cm
Signed upper right on the base: *Rodin*
H. Cк. 1741

When a plaster cast of this statue was first exhibited at the Cercle artistique in Brussels in January 1877, it was entitled *The Vanquished*. From the beginning the idea was to depict a wounded warrior as expressed by an earlier title for the sculpture, *The Wounded Soldier*. In Rodin's words: 'First, I wanted to depict a wounded soldier, leaning on a spear, using as my model the Belgian soldier who had posed for me' (G. Coquiot, *Rodin à l'Hôtel de Biron et Meudon*, Paris, 1917, p. 100). According to his biographers, Rodin had chosen the amateur model Auguste Neyt from a dozen soldiers. There was indeed a spear in the preliminary stages: it can be seen in a drawing by Rodin that was published in Maillard (L. Maillard, *Auguste Rodin: Statuaire*, Paris, 1899, p. 6; present whereabouts of the drawing are not known). Furthermore, the spear was broken. However when the sculpture was shown, the spear was absent, leaving the gesture of the left hand unexplained; the right hand, which was raised toward the head, expressed despair. The symbolism of the work, evoking the tragedy of the Franco-Prussian War, was obvious. After being exhibited in Brussels, the statue appeared that same year at the Salon in Paris under the title *The Age of Bronze*. Rodin had probably decided to move away from direct comparisons with the present. The sculpture was also known as *Primitive Man*, *Man Awaking* (as it was entered in the 1900 Rodin exhibition catalogue), and the *Awakening of Mankind*. According to scholars, Rodin finally settled on *The Age of Bronze* because he was influenced by the ideas of Hesiod, who divided the history of humankind into four ages: Gold, Silver, Bronze and Iron. It was during the Bronze Age that the world came to know war and injustice. The titles referring to an awakening also have a Classical Greek origin: the myth, as retold by Ovid, about Deucalion and Pyrrha, who survived the flood and recreated man from stones. The sculpture was poorly received by critics at the Salon. They found the title pretentious, as the statue seemed to be only a study, devoid of meaning. Rodin was also accused of having used a life cast for the figure. Such accusations would not have been made had Rodin executed the work in bronze or marble. But the plaster and, more significantly, the life-size dimensions of the sculpture contributed to the scandalous rumours that he had cast the figure from life. Several leading sculptors came to his defence. Rodin himself showed the members of the Institute photographs of Neyt posing (holding an iron rod for his spear). A comparison of the statue with the photographs immediately underlines the absurdity of these accusations. It is generally assumed that Rodin began work on the statue in 1875, just before he left for Italy, and that he finished it a year and a half later. He himself told Gustave Coquiot: 'For months I worked only on this sculpture. I remember, by the way, my visits to the Museum of Naples, where I examined the statue of Apollo for the best position of the leg for supporting the full weight of the body. A copy from nature! But you see they don't understand what that means' (G. Coquiot, *Rodin à l'Hôtel de Biron à Meudon*, Paris, 1917, p. 100). Rodin had gone to Italy to study Michelangelo's work, but even had he not made the trip, the Renaissance master would still have left his mark. The parallels between *The Age of Bronze* and Michelangelo's *Dying Slave* (1513; Paris, Louvre) – in particular the turn of the body, the counterpoint, the movement of the arms – have long been noted. The first bronze cast of

the sculpture was commissioned by the French government and exhibited at the Salon of 1880, where it won a third-class medal. It was then exhibited in the Jardin du Luxembourg, and is now in the Musée Rodin in Paris. As *The Age of Bronze* became one of Rodin's most popular works, it was recast many times: by 1945 Rudier alone had made 150 casts. After the sculpture was finished, Rodin made a pen drawing of it (Paris, Louvre). According to Dmitry Ivanovich Tolstoy (Musée Rodin archives, Paris), Rodin donated the Hermitage cast to the Russian Imperial Academy of Arts in 1914 in recognition of being made an honorary member. Count Ivan Ivanovich Tolstoy, who was then the academy's vice-president and probably the man responsible for conferring the honour, expressed his gratitude to Rodin in turn.

Provenance: acquired from the Institute of Proletarian Decorative Art (formerly the Academy of Arts), Leningrad, in 1931; previously in the Russian Imperial Academy of Arts, St Petersburg (gift of the artist), from 1914.

408. Eternal Spring (second state), after 1897 (page 141)
Le Printemps éternel
Marble. *h.* 77 cm
Signed on the edge of the base: *A. Rodin*
H. Cк. 1298

The idea for *Eternal Spring* is connected with the initial stages of Rodin's work on *The Gates of Hell*. A photograph from around 1881 has survived in which the still unfinished plaster sculpture *Eternal Spring* appears in the background of the relief of *The Gates of Hell*, of which it was to become a part. Rodin himself emphasised the importance of the theme of love for *The Gates of Hell*: 'Look at these lovers, condemned to eternal torture. They inspired me to depict love in its various states. I should say passion, for, above all, the work should be alive' (W. G. Byvanck, *Un Hollandais à Paris*, Paris, 1891, p. 8). The model for the female figure had also posed for the *Torso of Adèle* (1882). Rodin used this torso in *The Gates of Hell*, and later in *The Fallen Angel* (1895). The original version of *Eternal Spring* was cast in plaster (1884; Philadelphia Museum of Art) and entitled *Zephyr and Earth*. When Rodin first exhibited the bronze version at the Salon of 1897, he called it *Cupid and Psyche*, which is why traces of wings could be seen on the back of the male figure. When E. S. Eliseyeva purchased *Eternal Spring* from Rodin, it was entitled *The Conqueror Love*. The casting of the sculpture in marble and bronze required that significant changes be made to the right side: the base had to be widened so that it could support the man's hand and legs. Other marble examples of the sculpture are in the Budapest Museum of Fine Arts (Szepmuveszeti Muzeum), the Ny Carlsberg Glyptotek in Copenhagen, the Museum of Decorative Arts in Buenos Aires and the Metropolitan Museum in New York. The bronze version, which belonged to I. A. Morozov, is now in the Pushkin Museum in Moscow; over 140 bronze casts were made in the nineteenth century. Rodin's contract with the foundry of Leblanc-Barbedienne did not include a limit to the number of casts that could be made.

Provenance: acquired from the House of Arts (house of S. P. Eliseyev), Petrograd, in 1923; previously in the collection of S. P. and V. S. Eliseyev, St Petersburg (purchased by V. S. Eliseyeva from the artist for 10,000 francs), from January 1906 to 1917.

409. The Sinner: A Study, *c.* 1885 (page 140)
Damnée. Étude
Bronze. *h.* 20 cm; *w.* 37 cm
Signed on the left side of the figure: *A. Rodin*; inscribed further to the right on the figure's back: *bi musée Rodin 1966*; founder's mark on the right side of the figure's back: *Georges Roudier Fondeur Paris*
H. Cк. 2397

This sculpture owes its existence to Rodin's work on the series *The Gates of Hell*, the decorative doors for the Musée des Arts Décoratifs, commissioned by the French government. There is no similarly crouched figure in the final version of the portals, but side figures on the lower part of the pilaster are close to it. When the sculpture was transferred

to the Hermitage from the Musée Rodin in Paris, it was entitled *A Sinner Struck by Lightning*. The gift bore a note: 'In gratitude to the Hermitage for the safe-keeping of Rodin's works.'

Provenance: donated by the Musée Rodin, Paris, in 1968.

410. Poet and Muse, *c.* 1905 (page 141)
Le Poet et la Muse
Marble. *h.* 63 cm; *w.* 77 cm
Signed on the edge of the base: *A. Rodin*
H. Cᴋ. 1301

Two different approaches in Rodin's treatment of 'the poet and muse' theme can be discerned: on the one hand he was paying homage to Victor Hugo, whom he knew and respected; and on the other he was using the motif, without a specific poet in mind, to express that exalted feeling without which true poetry would be impossible. The first approach led to the creation of the monument to Victor Hugo; the second, to the miniatures that were intended not for public admiration, but for intimate contact. The monument to Hugo, commissioned for the Panthéon in 1889, was problematic because Rodin did not want to create a work according to the conventions of the time. Dalou, for example, had done just that: his 1886 relief, *The Apotheosis of Victor Hugo*, depicts a muse with lyre in hand giving her blessing to an Olympian poet in a toga and crowned with a laurel wreath. In his first sketch, Rodin, striving to avoid the commonplace, depicted the renowned Romantic poet in the nude, accompanied by three muses (1889–90; Meudon, Musée Rodin). Rilke compared the muses to thoughts emphasising the loneliness of the poet. Rodin himself, however, was not completely satisfied with his work; it clearly lacked unity. In the second version (1890; Meudon, Musée Rodin), Rodin depicted Hugo not as a hero but as he knew him: an old man in civilian clothing. The image of the thinker took shape gradually, but the nude muses over his head remained. The configuration of the sculpture recalls *Satyr and Bacchante* (cat. 385) and other two-tiered compositions by Carrier-Belleuse, Rodin's former patron. Other versions followed, and only two of the muses survived. Despite its many transformations, the monument to Victor Hugo remained a pastiche of well-wrought, but disparate details. Unlike the monument to Hugo, Rodin's *Poet and Muse* achieves a sense of unity, both in the working of the marble and in the composition's internal meaning. Here Rodin was dealing not with a historical personality and the conventions of panegyrics, but with the idea of the contemplation of poetry itself, as the poet, in a state of reverie, clings to his muse. According to Rodin, the strength of love has the power to create everything, including art and religion, it is 'the axis of the world'. A passionate man, Rodin did not perceive love in metaphysical terms, but portrayed it, one way or another, as essentially erotic. However, in contrast to his many erotic drawings, which were not meant for public view, his sculpture abides by the moral standards of the nineteenth century. It would have been inconceivable for Rodin, an avid reader of Ovid's *Elegies to Love*, to depict the poet and muse according to the conventions of Neo-Classicism, with traditional robes and accoutrements (lyres, laurel wreaths, and so forth). Instead he portrays them as a couple of young nude lovers. The sculpture is known under several titles: *Poet and Muse*, *Reverie*, *Awakening*, and *Ideal Love*, as it was called when S. P. Eliseyev commissioned it from Rodin in 1905. On 6 October 1906, the secretary of the firm Zebaume & S. Blanc Réunies, which handled Rodin's affairs, wrote to him that S. P. Eliseyev had enquired about his progress on *Ideal Love*, and a month later, citing the collector's impatience, asked about the possibility of packing the statue and whether it was finished (Archives, Musée Rodin, Paris).

Provenance: acquired from the House of Arts (house of S. P. Eliseyev), Petrograd, in 1923; previously in the collection of S. P. and V. S. Eliseyev, St Petersburg (commissioned in 1905), from 1906 to 1917.

411. Cupid and Psyche, 1905 (page 142)
Amour et Psyché
Marble. *h.* 26 cm; *w.* 52 cm
Inscribed, signed and dated on the edge of the base: *Amour et Psyché. A Rodin 1905*
H. Cᴋ. 1299

When he turned to one of the most popular subjects in French art, Rodin did not worry about following convention as Denis had. The nude Cupid and Psyche were usually depicted in a scene with a lamp, at the very moment when Psyche discovers that her lover is the god of love. Rodin, however, had no intention of simply illustrating Apuleius's fable. The erotic scene required a literary reference, which was done with the inscription, although it was uncharacteristic of Rodin to inscribe the title on the work itself. There is another marble version of *Cupid and Psyche* (present whereabouts unknown; *Rodin: Eros und Kreativität*, Munich, 1991, p. 206).

Provenance: acquired from the House of Arts (house of S. P. Eliseyev), Petrograd, in 1923; previously in the collection of S. P. and V. S. Eliseyev, St Petersburg, from 1906 to 1917.

412. Romeo and Juliet, 1905 (page 144)
Roméo et Juliette
Marble. *h.* 71 cm
Inscribed, signed and dated on the edge of the base:
Roméo et Juliette. A. Rodin 1905
H. Cᴋ. 1300

Like *Eternal Spring*, this sculpture is a variation on the theme of the kiss, which can be traced back to the original concept of *The Gates of Hell*. Hugely popular, *The Kiss* was first conceived as a portal detail; it then became an independent constituent. The subject itself is of little significance: the kiss may be *Paolo and Francesca*, *Adam and Eve*, or *Intimacy*. The sculpture *Romeo and Juliet* does not so much represent the Shakespearean characters as embody passion itself. Rodin used such titles to avoid accusations of immorality. For a long time, however, *Romeo and Juliet* and other portrayals of this passionate embrace were considered to be more erotic than was acceptable at the turn of the century. The statue was made in plaster in 1902. In 1906 another marble version (Chicago, Alsdorf collection) was created. After they had acquired the statue for their St Petersburg apartments, the Eliseyevs set it apart from their other Rodins. According to the poet Irina Odoevtseva, 'Rodin's *Kiss* stood in the dressing-room, which was painted in the Pompeian style; the statue had been banished there because the chaste owner of the Eliseyev mansion found it indecent, and then it was forgotten by the new owners' (I. Odoevtseva, *On the Banks of the Neva*, 1967, p. 213).

Provenance: acquired from the House of Arts (house of S. P. Eliseyev), Petrograd, in 1923; previously in the collection of S. P. and V. S. Eliseyev, St Petersburg, from 1906 to 1917.

413. Portrait of V. S. Eliseyeva, 1906 (page 145)
Portrait de V. S. Elisseieva
Marble. *h.* 63 cm; *w.* 56 cm
Signed, inscribed and dated on the edge of the base: *A. Rodin. Barbe de Eliseieff Paris octobre 1906*
H. Cᴋ. 1302

This portrait is a replica of the one that was exhibited at the Salon de la Société Nationale des Beaux-Arts and which is now in the Musée Rodin in Paris. The portrait of Varvara Sergeyevna Eliseyeva (?–1945), née Kudryavtseva, was commissioned by her husband, Stepan Petrovich Eliseyev (1857–1935), a well-known financier and businessman in St Petersburg. Eliseyeva's father was a commercial councillor and hereditary honorary citizen of St Petersburg. She played an active role in her husband's philanthropic undertakings, in particular as trustee for the S. P. Eliseyev House of Charity for the Poor. On 25 October 1906, V. S. Eliseyeva, after returning to St Petersburg, wrote Rodin a letter in which she expressed her gratitude for his having worked so patiently on her portrait. It took almost a year, however, for the portrait to be made in marble. On 10 October 1907, she sent Rodin a telegram in which she conveyed her concern about receiving the bust.

Provenance: acquired from the House of Arts (house of S. P. Eliseyev), Petrograd, in 1923; previously in the collection of S. P. and V. S. Eliseyev, St Petersburg, from 1906 to 1917.

465

414. Portrait of the Japanese Dancer Hanako, 1908 (page 143)
Portrait de la danseuse japonaise Hanako
Plaster. *h.* 14 cm
H. Cᴋ. 2362

Hanako was the stage name of the Japanese dancer Ohta Hisa (in Japanese, Hanako means 'little flower'). At the age of sixteen she became a geisha, then left for Europe, where three years later she met the famous American dancer Loie Fuller. In 1904 Fuller persuaded her to join her troupe and Hanako began performing as a mime. Rodin met her two years later and was immediately struck by her ability to express the most subtle nuances of emotion. No one sat for Rodin as often as Hanako: between 1906 and 1912 Rodin made 53 sculptures and numerous drawings of her. Rodin's biographer, Judith Cladel, attributed this feat to Hanako's ability to hold the most difficult poses for a very long time. The Hermitage example of Hanako's portrait comes from the collection of the sculptor Naum Petrovich Yasinosky, who was a student of Rodin.

Provenance: acquired from M. N. Yasinovsky in 1960; previously in the collection of N. P. Yasinovsky, Petrograd.

Charles Valton
1851, Pau – 1918, Chinon

Valton studied under Barye, Frémier and Levasseur. He made his début at the Salon of 1868, winning the third-class medal in 1875, and the second-class medal in 1885. He was awarded medals at the 1889 and 1900 Exposition Universelle in Paris. He depicted mostly animals and scenes of peasant life.

415. Wounded Lioness, 1890s (page 134)
La lionne blessée
Bronze. *h.* 29 cm; *l.* 46 cm
Signed on the edge of the base: *C. Valton*
H. Cᴋ. 2246

This statuette was clearly executed under the influence of Barye's small bronze, *Tiger Attacking a Peacock*, and his larger works such as *Jaguar Devouring a Rabbit* (1852; Paris, Louvre).

Provenance: acquired from the State Museum of Modern Western Art in 1948; previously in the State Museum of Modern Western Art (acquired through the State Museum Fund) from 1927.

416. Woman with a Cow, late 1890s (page 134)
Femme avec une vache
Bronze. *h.* 26 cm; *w.* 36 cm
Signed on the base, at the foot of the peasant-woman: *C. Valton*
H. Cᴋ. 2041

Provenance: acquired from Filosofov, Leningrad, in 1936.

Index

Entries in italics refer to illustrations